The Pleasures of
ANTIQUITY

The Pleasures of
ANTIQUITY

BRITISH COLLECTORS OF GREECE AND ROME

Jonathan Scott

Published by
Yale University Press
for the
Paul Mellon Centre for Studies in British Art

Designed by Elizabeth McWilliams

Printed in China

Library of Congress Cataloging-in-Publication Data

Scott, Jonathan, 1940–
 The pleasures of antiquity / by Jonathan Scott.
 p. cm.
Includes bibliographical references and index.
 ISBN 0-300-09854-5 (cl : alk. paper)
 I. Marble sculpture, Classical – Collectors and collecting – Great Britain – History. 2. Marble sculpture, Classical – Private collections – Great Britain – History. I. Title.
 NB70 .S36 2003
 733'.075 – dc21

 2002151345

A catalogue record for this book is available from The British Library

Contents

Preface

In 1882 the German scholar Adolph Michaelis introduced his *Ancient Marbles in Great Britain*, the definitive catalogue of British collections at that time, with the words:

> No other country in Europe can at this day boast of such a wealth of Private Collections of antique works of art as England, which in this particular resembles the Rome of the sixteenth and seventeenth centuries.

Today many of the cabinets that he recorded have been dispersed but a few survive. Some have been absorbed into the public ownership of the British Museum, the Ashmolean, the Fitzwilliam, the National Museums and Galleries on Merseyside and the National Trust.

The purpose of this book is to examine how these collections were assembled, to give details of most of the principal collectors, to describe the mechanics of Grand Tour collecting, to visit the beautiful galleries created for the sculptures acquired in Greece, Italy and Turkey, to consider the impact of antiquities on contemporary taste and, finally, to observe how the process unwound as interest waned and many of the collections were gradually dispersed. There are many gaps: I have not sought to update Adolf Michaelis's great work, *Ancient Marbles in Great Britain*, published in 1882 and still a prime source of information, I have not dealt with the collectors of British antiquities, whose objectives differed from those of Grand Tourists, I have barely touched on the collecting of medals, as coins were known, and I have excluded the Egyptologists, who, initially at any rate, bought their scarabs and mummies as mere curios and who rarely tried to incorporate Egyptian details into their decorative schemes. Throughout I have resolutely kept to the Latin names of the ancient deities portrayed in these antiquities, even when the object originated in Greece, because most Grand Tourists used the Latin forms rather than the Greek.

The story begins with a bang in the early seventeenth century, when Lord Arundel, the Duke of Buckingham and Charles I assembled impressive collections of antiquities, all of which were dispersed or barbarously ill treated soon after the deaths of their owners. During the later years of the Stuart period, Lord Pembroke bought some of the Arundel Marbles and went on to add rather indiscriminately to his collection at Wilton, but it was not until the 1740s and '50s with the formation of the much more selective galleries at Holkham and Castle Howard that British collectors began to buy antique busts and statues worthy of their imposing country seats.

In the second half of the eighteenth century the hunt for antiquities became a regular part of the Grand Tour, although such collecting was often motivated more by fashion

than by enthusiasm for the classical past. A whole excavating industry developed, largely promoted and financed by British entrepreneurs, who explored the Roman Campagna under fixed licences exactly like a modern mining company, yielding a portion of all discoveries, as a royalty, to the papal collections but retaining the balance for sale to visiting Tourists and to their mail order customers in England. As a result of their excavations, a large quantity of Roman statues or Roman copies of Greek originals came onto the market, coupled with a parallel supply of engraved gems and 'Etruscan' vases. These were regularly supplemented by replicas of the best statues in the galleries of Florence and Rome for those buyers who wanted imposing but relatively cheap versions of antiquity. Several large collections were assembled, some beautifully housed, like William Weddell's at Newby, where Robert Adam designed the gallery, or Henry Blundell's in the Pantheon at Ince, while others were densely crowded with no such elaborate settings, like the marbles in the London house of Charles Townley, the most distinguished collector of the age. Collecting was not, however, accompanied by much scholarly investigation – that was dismissed as suitable only for pedants. Despite their connoisseurship, the three most significant collectors of the eighteenth century, Townley, Sir William Hamilton and, albeit to a lesser extent, Richard Payne Knight, all fell under the sway of that remarkable charmer the Baron d'Hancarville, the influence of whose seductive but dubious scholarship persisted into the following century.

The Cult of the Antique had an invigorating impact on contemporary taste and created a demand for authoritative sources of classical detail which could be used by architects and designers. This in turn led to a number of architectural books by Adam, Wood and, above all, Stuart and Revett and their successors who, under the auspices of the Society of Dilettanti, produced a series of majestic volumes on the buildings of Greece and Asia Minor. The publication of Sir William Hamilton's vases was also, in part, intended to provide a source book for designers. In fact, the greatest acquisition of antiquities of all time, that of Lord Elgin's Marbles from Athens, was made almost accidentally as a by-product of such architectural studies. When, however, the sculptures from the Parthenon were displayed in London in 1807, they instantly revolutionized attitudes towards antiquity. Original Greek works were now recognized as being indisputably superior to those of the Romans or to Greco-Roman copies but they were virtually unobtainable. Thereafter, although a few collectors bought antiquities to set off the modern sculpture in their galleries or as mere interior decoration, large-scale collecting overseas became an official enterprise, conducted on behalf of the British Museum with the muscular aid of the Royal Artillery and the Royal Navy. Private collecting in England gradually fell out of fashion, despite a brief revival when a few *nouveaux riches* imitated the patrician buyers of an earlier age. After the Hope marbles had been sold in 1917, many other Grand Tour collections were dispersed and the choicest pieces were bought by museums in the United States and in Europe.

In recent years, biographies of Lord Arundel, Lord Elgin, Sir William Hamilton, Thomas Hope and Sir John Soane have been written, exhibitions have been devoted to the collections of Arundel, Hamilton and Richard Payne Knight, articles have been published on several other collectors and the Universities of Liverpool and Cologne have issued catalogues of some of the surviving British collections, including the Ince Blundell busts, the Hope marbles at Port Sunlight, and the antiquities at Broadlands, Chatsworth, Farnborough, Holkham, Petworth and Woburn Abbey. Hitherto, however,

no overall history of this interesting aspect of British taste and collecting has appeared. I hope that this survey will fill the gap, although I am well aware that many of the collectors and, above all, Charles Townley, deserve much more detailed attention than the brief summaries that I have given. I reluctantly decided that to devote more attention to Townley or to any other individual collector was not possible within the scope of a book like this, while Elgin's story is so well known that it seemed unnecessary to repeat it in full.

I have been interested in the economics of collecting and the fluctuations in prices. Many dealers and collectors refer to the cost of their antiquities in Roman crowns (*scudi*) or in *zecchini* (worth two *scudi*). Because of the relative stability of the exchange rate throughout the whole of the eighteenth and early nineteenth centuries, it is simplest to assume that there were four *scudi* or two *zecchini* to the pound and to translate these into the prices of 2002 by multiplying by 60. Thus a statue sold in Rome in the eighteenth century for 1000 *scudi* cost its owner about £250, or £15,000 in today's money. These figures are only a guide, because, in previous centuries, the cost of living was relatively low in relation to the price of works of art, which had not been raised to current levels by asset inflation. A Tourist with an annual income of £5000 was considered to have the spending power of an oil tycoon.

I think it is always useful for authors to explain why they first became involved in their subjects. In my case, an old-fashioned Oxford education in Literae Humaniores inspired my initial interest in the arts of Greece and Rome, an interest that was quickened some years later when I was studying Piranesi, a notable dealer in doubtful antiquities. I was curious to know how he and his fellow excavators, restorers, fakers and dealers operated to supply the British Grand Tourist market. When I was Chairman of the U.K. Reviewing Committee on the Export of Works of Art, I was heartened to discover that the authorities in Rome had operated a not dissimilar export control system – I only wished that I had had as high sounding a title as the Papal Antiquary, which could have helped when dealing with tricky exporters. The acquisition of the Townley papers by the British Museum provided a fascinating opportunity to read about the activities of one of the most notable collectors. This book is the product of these interests.

I should like to thank numerous friends who have generously allowed me to pick their brains, including Malcolm Baker, the late Ilaria Bignamini, Ruth Guilding, John and Eileen Harris, Ian Jenkins, Nicholas Penny, Francis Russell, Diana Scarisbrick, Charles Sebag Montefiore and Keith Thomas, and the owners of many of the collections and their custodians, who have given me access to their marbles and gems, the librarians who have helped me to locate books, manuscripts and photographs, Brian Allen and the Paul Mellon Centre for their generous assistance with funding part of the cost of the illustrations, and the staff of Yale University Press. I must also genuflect in awe in front of the massive achievement of two books, *Taste and the Antique* by the late Francis Haskell and Nicholas Penny, and John Ingamells's edition of the Brinsley Ford Archive, *A Dictionary of British and Irish Travellers in Italy 1701–1800*, which provide such essential information about the acknowledged masterpieces of clasical sculpture and the visitors who came to admire them. Finally, I record with gratitude the tolerance of my dear wife, Annabella, in permitting me to indulge my enthusiasm for antiquity when I ought to have been helping her in the garden.

<div align="right">Lasborough 2002</div>

The First Collectors

COLLECTING ANTIQUITIES IN ITALY

Medieval Europe lived under the shadow of its classical past. Dante chose Virgil as his guide through Hell and Purgatory and even in distant Britain Geoffrey of Monmouth claimed a Trojan ancestry for King Arthur. Italian humanists sought not only old manuscripts of classical authors but also miniature portraits on coins and gems and the busts, statues and medallions of emperors and divinities which could give life to the stories from their ancient texts. In Venice there was a trade in such objects as early as the fourteenth century. Mantegna, an artist who seems to have breathed the air of ancient Rome, had his own archaeological museum in Mantua and it was to the reigning Duchess, Isabella d'Este, that he reluctantly ceded his most prized bust of the empress Faustina only weeks before he died, ill and in debt, in 1506. Cosimo de' Medici amassed the best collection of engraved gems in all Italy and yet the Medici were just one of the Florentine families who acquired antiquities.

Enthusiasm kindled slightly later in Rome; Sixtus IV (1471–1484) gathered together on the Capitol a number of bronze statues, including the *She-wolf* and the *Spinario*, but it was Julius II (1503–1513) who established the papal collection when he laid out the garden of the Belvedere courtyard in the Vatican and transferred to it his famous *Apollo*, the *Laocoön*, the *Sleeping Ariadne* (then known as *Cleopatra*), *Commodus as Hercules*, *Hercules and Antaeus*, *Venus Felix* and the *Tiber*. These statues were placed in niches or above fountains in imitation of the gardens of the ancients. The successors of Julius, Leo X (1513–1521) and Clement VII (1523–1534), were both Medici who preferred to augment their family collections rather than those of the Vatican, but they added the *Nile* and the *Torso* respectively and the Farnese pope, Paul III (1534–1549), completed the display when he acquired the *Antinous*. The Belvedere group of statues formed an acknowledged canon of antique excellence (fig. 1).

The papal collections did not, however, have a monopoly of all the most renowned works in Rome.[1] The villas of the Medici, Ludovisi and Borghese families on the Pincio contained notable antiquities which had been acquired through the families' papal connections during the sixteenth and early seventeenth centuries, there were galleries of ancient marbles in the Mattei, Barberini and Giustiniani palaces, and the Farnese palace, one of the grandest in Rome, boasted classical statues worthy of Michelangelo's architecture. The pope's outdoor display set a precedent for other collectors. The Cesi family arranged their marbles in a famous and much visited garden almost under the shadow

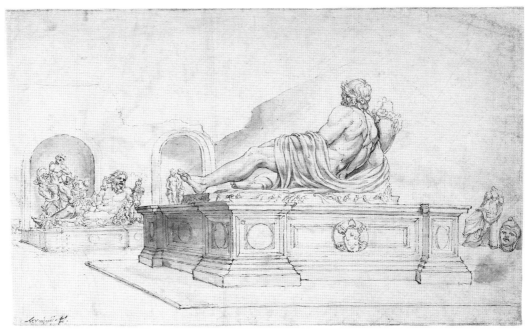

1 Marten van Heemskerck (attr.), *Belvedere Court of the Vatican*, British Museum

of St Peter's, while the Soderini laid out the ruins of the Mausoleum of Augustus on the banks of the Tiber as a setting for their collection (fig. 2).

In the middle of the fifteenth century Rome became a construction site. The ancient ruins were quarried for building materials and, as foundations were dug for new palaces in the city and for suburban villas further out from the centre, fresh antiquities were continuously being resurrected to feed the appetite for further excavations. The most spectacular find was the *Laocoön*, which came to light near the basilica of S. Maria Maggiore in 1506, while the *Farnese Bull* reared out of the ruins of the Baths of Caracalla in 1545 and the *Farnese Hercules* the following year, to be appropriated by the family of the reigning Farnese pope. The treasure hunt also produced a supply of lesser fragments, ornamental friezes, broken statues, vases and chipped funerary inscriptions, which were available to decorate the façades of palaces and villas, set into the warm ochre plaster. Other scraps of antiquity were erected as ornaments to stand along walks of ilex and cypress in gardens where fountains splashed into ancient sarcophagi. Since it was not easy to achieve appropriate symmetry with sculptural collages on external walls, Polidoro da Caravaggio devised the brilliant idea of frescoing *trompe l'oeil* marble reliefs onto the street fronts of a palace; his series of episodes from the story of Niobe, executed like a strip cartoon over the façade of the Palazzo Milesi in about 1527, was one of the most famous decorative schemes of the century.

An English visitor in the early years of the seventeenth century was amazed:

There is moreover no house of any worth, that is not replenished with infinite numbers of ancient Statues; so that a man might think, in respect of the number, that in ancient time the inhabitants were employed about nothing else. Courts, Galleries, every room is adorned with them, and in many rooms heaped one upon another,

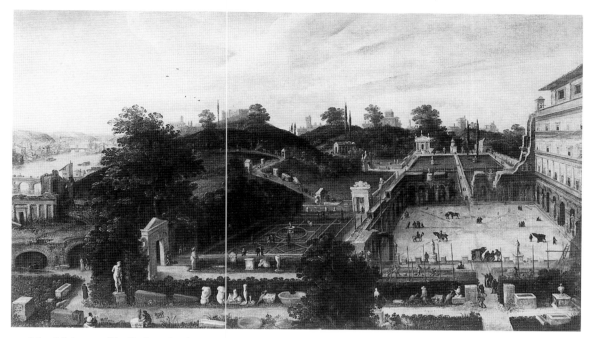

2 Hendrick van Cleef, *Cesi Garden, Rome*, National Gallery, Prague

there be so many. And yet, for all this multitude, it is a strange thing to see at what inestimable prices they hold every one of them; nay, it is almost an impossibility, by any means, or for any money to get one of them away, they hold them in so great estimation. Nevertheless, every day amongst their Vineyards, and in the ruins of old *Rome*, they find more, which, in whose ground soever they be found, at a certain price, do now belong to the Popes, who distribute them in their own Palaces, to their favourites or kinsmen, and sometimes as presents to Princes.[2]

Statues were trophies of the highest prestige; they were beautiful objects in their own right, especially after judicious repairs to the injuries of time, and they had the glamour of association with Rome's classical past. The *Farnese Bull* and the *Laocoön* had actually been described by Pliny the Elder, while busts of the emperors implied a continuous link with imperial authority. In the last years of the sixteenth century and the early years of the seventeenth, in order to emphasize the splendour of these objects and the wealth of the families that could afford them, many of the collections were magnificently redisplayed in special galleries.

While Cardinal Ferdinando de' Medici acquired a villa in Rome in 1576 and proceeded to reconstruct it in order to show off some of the family's best known trophies, his brother, the Grand Duke Francesco I, set about reorganizing his Florentine collections in the Uffizi. Coins, gems and small bronzes were transferred to the Tribuna, which contained the greatest treasures, and busts and statues, including local Etruscan discoveries, were displayed in other galleries, to which any visitor could be admitted on request. The Gonzaga in Mantua and, on a lesser scale, their kinsmen in Guastalla and Sabbioneta were avid collectors of statues and gems; in the last years of the sixteenth century, Duke Guglielmo created the Galleria della Mostra in the Castello to display his sculptures along

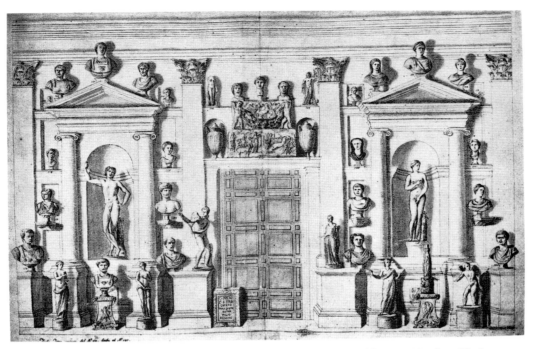

3　Anton Maria Zanetti, *View of the Statuario Pubblico, Venice*, 1736, Biblioteca Marciana, Venice

with the family's superb accumulation of paintings. Many Venetian families owned important collections, which included Greek statues, acquired through trading contacts or military outposts in the eastern Mediterranean. The most famous of these, belonging to the Grimani, was left to the Republic as the Statuario Pubblico. By 1596 these marbles had been arranged in niches, over the doors and on plinths, set one above the other in a carefully orchestrated display, as an annexe to the Biblioteca Marciana 'so that foreigners after seeing the Arsenal and the other marvels of this city could also see these antiquities in a public place as a spectacle', as Giovanni Grimani had stipulated (fig. 3). In neighbouring Verona there were more family collections, including that of the Giusti, who punctuated their famous garden with classical inscriptions. Between 1605 and 1607, Carlo Emanuele of Savoy created a gallery in his palace in Turin and invited Federico Zuccaro to decorate it. In the south of Italy the same enthusiasm gripped the Viceroy in Naples and great nobles such as the Carafa, who decorated their palaces with marbles and bronzes found in the region. Throughout the peninsula these collections were jealously guarded.[3]

COLLECTING OUTSIDE ITALY

European potentates could not hope to acquire important antiquities in the same way as the Italians, but they were not content with lesser fragments which would have looked shabby in the splendour of their new palaces. When the French king François I asked for the newly found *Laocoön* and was told (unsurprisingly) that it was not available,

he decided to make do with copies of the best statues in the Vatican and, thanks to the energetic efforts of Primaticcio, by 1543 he was able to decorate the gardens of Fontainebleau with a spectacular display of bronzes taken from casts which the Italian artist had procured, 'antique figures, which came out so well that they rivalled the originals, as may be seen in the Queen's Garden at Fontainebleau, where they were placed to the great satisfaction of the king, who created there virtually another Rome'. These modern copies were more highly prized than original paintings by Raphael and Titian in the royal collection. A century later, Louis XIII obtained further casts, although they were not, in fact, used for bronzes. It was Louis XIV who continued the programme of bringing copies of 'all that is beautiful in Italy' to adorn the gardens of Marly and Versailles. In Spain a similar procedure was adopted when Philip IV sent Velásquez to Rome in 1650 to acquire furnishings for a newly converted palace and the artist returned not only with paintings but with an array of plaster casts and some bronze copies of the most famous ancient statues in Rome.[4]

Duke Albrecht V of Bavaria followed another course when, in the 1560s, he planned his Antiquarium in Munich and commissioned Niccolo Stoppio and Jacopo Strada to furnish it. In this case, the aim was different; Albrecht and his successor, Wilhelm V, sought principally to create a gallery of ancient portraits and Strada, who bought much of his material from Venetian collections, was not particular whether every bust was authentic, or even an original antique. When he sent his purchases to Vienna for restoration, the marble workers polished the heads to a condition worthy of their new setting and also gently improved them into a better likeness of ancient coin types so as to justify the imperial titles optimistically inscribed on their plinths. The Antiquarium contained, for the most part, 'decorators' pieces' rather than important antiquities – and, as a result, the gallery, though somewhat altered and rearranged, is one of the most harmonious ensembles north of the Alps.[5]

Antiquities were, of course, only one feature, albeit an important one, of the galleries and cabinets which 'great persons' were creating at this period as encyclopaedias of historical and scientific knowledge. Books and manuscripts of every age, paintings and prints to illustrate stories from the Bible and classical mythology, portraits of famous men, arms and armour, carved ivories, geological specimens, mathematical instruments, astrolabes and telescopes, stuffed birds and crocodiles, abnormal fetuses, shells and corals, together with the horn of the narwhal and a preserved cockatrice, were all enthusiastically accumulated.

> There be those so much taken with Michael Angelo's, Raphael de Urbino's, Francesco Francia's pieces, and many of those Italian and Dutch painters, which were excellent in their ages; and esteem of it as a most pleasing sight to view those neat architectures, devices, escutcheons, coats of arms, read such books, to peruse old coins of several sorts in a fair gallery; artificial works, perspective glasses, old relics, Roman antiquities, variety of colours . . . Who will not be affected . . . to see those well furnished cloisters and galleries of the Roman cardinals, so richly stored with all modern pictures, old statues and antiquities? . . . Or in some prince's cabinets, like that of the great duke's in Florence, or Felix Platerus in Basil, or noblemen's houses, to see such variety of attires, faces, so many, so rare, and such exquisite pieces, of men, birds, beasts, etc., to see those excellent landskips, Dutch works, and curious cuts of Sadeler of Prague, Albertus Dürer, Goltzius, Vrintes, etc., such pleasant pieces of perspective,

Indian pictures made of feathers, China works, frames, thaumaturgical motions, exotic toys etc.

The omnivorous curiosity of the age is breathlessly set out in Robert Burton's catalogue of the various scholarly delights capable of dispelling melancholy.[6]

THE ENGLISH BACKGROUND

In England the passion for antiquities developed slowly. At the outset of his reign Henry VIII was eager to shine as a renaissance monarch, rivalling François I and the emperor Maximilian, and employed Italian craftsmen to work on his palaces and the tomb of his parents in Westminster Abbey, but, after the break with Rome in 1530, dark clouds of religious intolerance blotted out further contacts with Italy. His daughter Elizabeth was neither a builder nor a collector herself. Although her long reign saw the erection of many great prodigy houses, the Thynnes and Willoughbys and Cecils, even Bess of Hardwick, who created them, were content to decorate their walls with tapestries and, for the most part, portraits. Almost without exception, they looked to the Low Countries both for pattern books of architecture and for such artists as they required. When busts of Roman emperors were needed to dignify Lord Lumley's houses, modern versions were used. The only antiquities that found their way into English collections were Roman coins, valued as portraits by a few rich collectors, Lord Burghley, for instance, and the second Earl of Pembroke.[7]

It is not in the least surprising that the English lagged behind the rest of Europe in acquiring antiquities. Such things were unlikely to be appreciated until an interest in collecting contemporary sculpture and painting had developed.[8] More fundamentally, admiration of the splendours of ancient Rome could be inspired only by visits to Italy. English attitudes to Italy were, however, ambivalent. The poems of Tasso and Ariosto, Boccaccio's *Decameron* and other Italian story books and treatises were widely read, at least in translation, but approval for the manners of Castiglione's *Courtier* was tempered by distrust of Macchiavelli's *Prince*. The English view of Italian morality was coloured by rumour, prejudice and fiction. The cruel injustices and ingenious murders carried out in Webster's *Duchess of Malfi* and *The White Devil* seemed quite normal behaviour for Italians and, although Shakespeare was vague about the geographical setting of his plays, his audience knew what he was doing when he located the bloodthirsty factions of Montagues and Capulets in an Italian city.

Roger Ascham, a good classical scholar, who had been tutor to the young princess Elizabeth before she became queen, made his position quite clear in his book, *The Schoolmaster*, published in 1570; he thought that 'the fancy that many young gentlemen of England have to travel abroad, and namely to lead a long life in Italy', was 'marvellous dangerous'. 'Some Circe shall make him, of a plain Englishman, a right Italian. And at length to hell, or to some hellish place, is he likely to go.' For Ascham, the saying *Inglese italianato e un diavolo incarnato*, originally applied to Cardinal Reginald Pole, was a salutary warning, 'If some do not yet well understand what is an Englishman Italianated, I will plainly tell him: he that by living and travelling in Italy bringeth home into England out of Italy the religion, the learning, the policy, the experience, the manners

of Italy . . .' Ascham's own brief experience had been enough for a lifetime: 'I was once in Italy myself, but, I thank God, my abode there was but nine days. And yet I saw in that little time, in one city [Venice], more liberty to sin than ever I heard tell of in our noble city of London in nine years.' Similar views were expressed by Thomas Nashe in his picaresque tale, *The Unfortunate Traveller*, published in 1594:

> *Italy*, the Paradise of the earth and the Epicure's heaven, how doth it form our young master? . . . From thence he brings the art of atheism, the art of epicurising, the art of whoring, the art of poisoning, the art of Sodomitrie . . . It is now a privy note amongst the better sort of men, when they would set a singular mark or brand on a notorious villain, to say, he hath been in *Italy*.[10]

Above all, there was the fear of the Church of Rome. Protestant pastors viewed the growing confidence of the Italian Counter-Reformation in precisely the same way that rulers of East European countries viewed the luxuries of Capitalism during the Cold War years. They were dangerous temptations which could seduce the minds of impressionable youth from the paths of true Protestant or Communist virtue. Licences to travel generally specified that the applicant was not permitted to visit Rome, particularly since it was full of religious exiles eager to proselytize a fellow countryman. A traveller was liable to be suspected not only of apostasy but of treason as well, if it became known that he had disobeyed. Such hostility to the Church of Rome was only to be expected since Pius V had excommunicated Queen Elizabeth in 1570, pronouncing her a bastard and a heretic, while Sixtus V had supported the expedition of the Spanish Armada in 1588.[11]

It was necessary for the Protestant, in any case, to exercise considerable discretion when entering the Papal States, because the officers of the Inquisition were liable to imprison heretics. Perhaps because of the precautions taken, few English visitors were detained and when John Mole, the tutor to Lord Roos, was incarcerated in 1608, it was an exceptional case. Sir Robert Dallington, a visitor at this period, warned 'Let me only say of *Rome*, because it is the Seminary and Nursery of English fugitives, (& yet a place most worthy to be seen) . . . that it is suspected of all, known to many, & proved by some, & amongst these by myself, to be dangerous . . .'[12] The dangers were not only moral ones. The kingdom of Naples and the duchy of Milan were territories of the King of Spain, who was frequently at war with England; the countrymen of Sir Francis Drake were not welcome to enter Spanish boundaries. Furthermore, travel in the south was hazardous 'from the spoiling of banished men, vulgarly called Banditi', whose brutal exploits were to become a regular subject of paintings and prints in the succeeding century.[13]

Despite all this, Englishmen continued to visit Italy throughout the reign of Elizabeth. Their objectives were generally practical, to study in Italian universities or to improve their statecraft by familiarizing themselves with different systems of government, a wide variety of which was to be observed in the different states. At the lower end of the social scale, merchants established outposts or agencies, chiefly for the sale of English cloth, the nation's principal export, and for the import of luxury goods, silks, glass and currants.

The succession of James I (1603–1625) brought about a complete change. In 1604 the pacific monarch ended the state of war with Spain and established an embassy in Venice, the city most sympathetic to Britain because of its independence from Rome, its nautical traditions and its sturdy mercantile base. The presence of an ambassador there facil-

itated diplomacy throughout the peninsula as well as trade and cultural exchanges. Although France continued to be the most popular destination for overseas travel, the number of British visitors to Italy grew rapidly. Whereas, however, the Elizabethan travellers had generally been serious young men setting out to study medicine at Padua or the political systems of Venice and Tuscany, the next generation, more numerous, richer and less concerned to prepare themselves for a career in public service, flew like autumn swallows to the warm south, so much of which had been recently inaccessible, drawn by curiosity and the pursuit of pleasure. Venice and Tuscany were the still the most favoured regions, but the beauty of the bay of Naples and the opportunity to learn *haute école* from famous riding masters tempted travellers to the southern kingdom. Rome was also visited, but briefly and with caution.

All classes crossed the channel, young noblemen with several servants in train, sons of prosperous country gentlemen, recusants glad of the chance to visit their co-religionists more easily, tiro merchants, travelling to broaden their horizons and explore new markets. Many young visitors regarded their period abroad as a prelude to, or even a substitute for, their studies at Oxford, Cambridge or the Inns of Court. Francis Bacon recommended that they should be accompanied by a 'tutor or grave servant', whose role was to direct their attention to the main sights, control expenses, moderate drinking and whoring and, above all, ward off dangerous contact with the seductive blandishments of English religious exiles. Fynes Moryson provides a compendium of useful tips for the traveller: he should carry the minimum of cash to reduce the dangers of theft, it was preferable to arrange letters of credit through a merchant in Venice, stipulating the number and weight of coin in which payment was to be made, and, since the provider of cash would not know the presenter of the bills, he should ask the merchant to send letters to his factor 'expressing the most rare marks of your body, by which you may be made known to him'. Moryson advised the traveller to adopt the dress of the country in which he was staying and, above all, to learn the language. 'Let him not take it ill, that any man should laugh at him, for that will more stir up to endeavour to learn the tongue more perfectly, to which end he must converse with Women, Children, and the most talkative people; and he must cast off all clownish bashfulness.' The Italians were very easygoing but 'the chief cause of quarrels there, is either making love to other men's private concubines, or the keeping of a private concubine to a man's self'. Moryson also gave useful health tips about avoiding southern heats and taking a spoonful of syrup of currants or boiled prunes as a laxative.[14]

The growth of Italian travel merely for pleasure was viewed with alarm by some writers. Thomas Palmer in *An Essay of the Meanes to make our Travailes, into forraine Countries, the more profitable and honourable*, published in 1606, acknowledged that 'Italy moveth most of our Travellers to go and visit it, of any other State in the world.' He agreed that it might be visited for practical reasons such as health, study in the universities, the polishing of manners and learning about political systems, but he dismissed the viewing of 'special galleries of monuments and old aged memorials of histories' as being 'a fantastical attracter, and a glutton-feeder of the appetite, rather than of necessary knowledge' and he sternly abjured any stay in Rome, 'the Forge of every policy, that setteth Princes at odds, . . . the tempter of Subjects to civil dissensions, & the seller of all wickedness and heathenish impieties, or the machedivell of evil policies and practices'. Joseph

Hall, the future bishop of Norwich, felt much the same when he published *Quo Vadis?* eleven years later in 1617:

> There are two occasions wherein Travel may pass, Matter of traffic [i.e. commerce], and Matter of State . . . It is the Travel of curiosity wherewith my quarrel shall be maintained . . . These Lap-wings that go from under the wing of their dam with their shell on their heads, run wild. If Tutors be never so carefull of their early charge, much must be left to their own disposition . . . Do we send our sons to learn to be chaste in the midst of *Sodom?* The world is wide and open; but our ordinary travel is southward into the jaws of danger: for so far hath Satan's policy prevailed, that those parts which are only thought worth our viewing, are most contagious; and will not part with either pleasure or information, without some tang of wickedness.[15]

Most young men ignored such anxious admonitions.

THE FIRST COLLECTIONS IN ENGLAND

Since, at this time, the pursuit of important antiquities was reserved for princes and prelates, it was appropriate and inevitable that the first notable British collector should have been Henry, Prince of Wales. Although his father, James I, was not interested in the visual arts, his mother, Anne of Denmark, compensated for this indifference by amassing a large collection of paintings and by employing Inigo Jones as her architect and the designer of stage sets and costumes for her court masques. Henry was a precocious youth who, when he was only sixteen, set out to create in Richmond Palace the splendid galleries and gardens of delight of which he had heard reports from visitors to Fontainebleau, Florence and Prague.[16]

In 1610 he started to acquire paintings through courtiers and the ambassador in the Hague. His enthusiasm was fostered by gifts of seascapes from the Dutch States and of portraits of famous men from the Florentine court. This was followed by a much more significant acquisition; the Tuscan agent was informed that 'he would like some little stucco statues, about a *braccia* high [a yard – he misjudged the size], that one finds there by worthy men, such as Giovanni Bologna and others, and amongst them he would like to have in the same size, the Rape of the Sabines that is in the great Piazza in Florence'. The prince did not realise that such statuettes were made of bronze, not plaster, an excusable error since no such works existed in England at this date. A group of fifteen bronzes by Pietro Tacca and Antonio Susini was assembled and sent over in 1612 as a present from the Grand Duke himself, who was keen to secure the prince as a son-in-law. It was a shrewd gift. When the little figures were unwrapped in Richmond Palace, Henry was delighted; he kissed and fondled them and personally arranged them in one of his cabinets. The pieces were, of course, all modern works but many of the subjects, *Hercules and the Centaur, Nessus and Deianeira, Venus, Diana* and *Pomona*, were taken from classical mythology. It was a sideways but very significant approach to the ancient world.

At the same time the prince bought two collections of real antiquities. From Abraham van Hutton he acquired 'antiquities of medals and coins' for the very substantial sum of

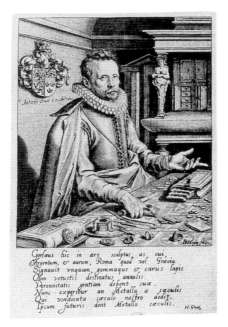

Gorlæus sic in ære sculptus, as cui,
Argentum, & aurum, Roma quod vel Græcia
Signauit vnquam, gemmaque & carus lapis
Olim vetustis destinatus annulis
Perennitatis gratiam debent suæ.
Nunc experitur an Metalla a sæculis
Qui vindicata sæculo nostro dedit,
Ipsum futuris dent Metalla sæculis. H. Svet,

4 Jacob de Gheyn, *Abraham Gorlaeus*, *Dactyliotheca*, frontispiece

£2200, paid in two instalments in 1611, and the following year he secured from Hans van Dirbige the famous cabinet of gems, coins and medals that had belonged to Abraham Gorlaeus of Delft. A catalogue of the latter, *Dactyliotheca*, had been published in 1601 with a frontispiece showing the collector proudly gesticulating to a selection of engraved gems, set in rings, and to his coins, neatly stored in shelves that slid into boxes disguised as books (fig. 4). There was little text but a series of plates illustrating the gems and their settings.[17]

Coins, often described as medals, were particularly sought after because scholars at this period, fascinated by the combined studies of physiognomy and numismatics, were trying to match the features of kings, consuls and emperors, stamped on coins, with the characters described in the histories of Sallust and Livy, of Suetonius, Tacitus and Plutarch. Contemporary attitudes are encapsulated in a letter from Sir Thomas Roe to the Countess of Bedford, dated December 1626:

I have recalled . . . that I saw you marshalling of ancient coins and medals . . . so that I have presumed to entertain you . . . with the enclosed catalogue of such, as in this pilgrimage I have collected . . . This curiosity of antiquities, though by some severe men censured, hath yet divers uses besides delight, not to be contemned: they are a kind of lay humanity, teaching and enciting devotion to moral virtue, as well, and more safely than images among the new Romans, to the contemplation of divine mysteries. They propose a lively chronology on the one side, and a representation of history, heroic or great actions, on the other. They carry in them a shadow of eternity, and kindle an emulation of glory, by seeing dead men kept long among the living by their famous deeds.

Intaglios and cameos were also collected. These tiny precious and semi-precious stones, agate and amethyst, cornelian and sardonyx, emerald and chalcedony, were carved like seals in exquisite miniature form to show the gods of Olympus with their attributes, mythical beasts, trophies of arms, portraits and scenes of everyday life. Unlike most other types of antiquity, intaglios are often perfectly preserved and can stab with a magical ray of pleasure as the indistinct image on the stone suddenly takes a recognizable form when turned at the right angle to catch the light. Cameos have different charms and are easier to read because the figures, carved through the coloured layers of an agate, stand out in clear relief against the contrasting background. In their cameo portraits the ancient artists often achieved the virtuosity of a miniature by Hilliard. Moreover, the manufacture of cameos was a living tradition, encouraged by the Tudor monarchs, who had been portrayed in a series of carved gems, and later maintained by Charles I. It is not surprising that Prince Henry succumbed to their lure.[18]

Alas, these promising, if extravagant, beginnings came to a sad end when the prince died in November 1612 at the age of eighteen. His younger brother, Charles, inherited his collection and, in due course, his acquisitive enthusiasm.

LORD ARUNDEL

The royal precedent was followed by Thomas, Earl of Arundel, head of the noble house of Howard.[19] He was a melancholy figure, black suited, austere and reserved, ambitious to restore his family's primacy in the peerage, but lacking the skills necessary for success as courtier, ambassador or soldier. His true métier was as a connoisseur and collector who gave his friendship and patronage to great artists, including Rubens, Van Dyck and Inigo Jones. In the words of Horace Walpole, he was 'the father of virtù in England'. His family's prominence had been their misfortune; his great-grandfather, the Earl of Surrey, and his cousin, Queen Catherine Howard, had been beheaded under Henry VIII, his grandfather, the fourth Duke of Norfolk, had suffered the same fate under Elizabeth, and his father, Philip, Earl of Arundel, had died after ten years imprisonment in the Tower of London, without ever seeing his son. Despite these disasters, Arundel was a devoted ancestor worshipper, glorying in his family history with an enthusiasm that was fostered by some of his antiquarian kinsmen, but he was to extend his interest in the past beyond mere genealogy and the circle of antiquaries, such as Sir Robert Cotton, who assisted him.[20]

In 1612 Arundel and his young wife, Aletheia, daughter of the Earl of Shrewsbury, went to Spa in the Low Countries for a health cure and then proceeded to Italy to stay in Padua. On this occasion they were recalled in haste by the news of Prince Henry's death, but they had fallen in love with Italy and in the next year returned for a longer stay. Arundel's visit was quite different from the pleasure-seeking tours of his teenage compatriots, bent on evading their guardians in order to enjoy the bordellos of Venice; he was aged twenty-seven, he went with his wife and, instead of a tutor, he was accompanied by the court architect and designer, Inigo Jones. They first visited Venice, where Arundel made a state entry as King James's Ambassador Extraordinary, and, when the ceremonials were over and the party had thoroughly explored the city, they went on to Vicenza and Bologna before settling in Tuscany, where they took lodgings in a Sienese monastery in order to learn the language and avoid both Medici court ceremonial and other British visitors.

In December, Arundel and Jones moved south, braving 'vile hostarias, one Mattress, & one blanket, and neither any bolster, or anything else'; they visited Naples and stayed in Rome with the marchese Vincenzo Giustiniani in his palace near the piazza Navona. Giustiniani was a notable patron, whose collection included paintings by Caravaggio, Guido Reni, Claude and the Carracci, as well as a gallery of ancient sculpture. The marchese took Arundel under his wing and, seeing his guest's enthusiasm for the antique, organized a little excavation in the Forum to recover some carefully pre-seeded fragments. Arundel must have realized how hard it was for a foreigner to acquire any worthwhile antiquities in Rome – indeed, the collection of his host, a Genoese by origin, was extensive rather than distinguished – and he therefore added to his own

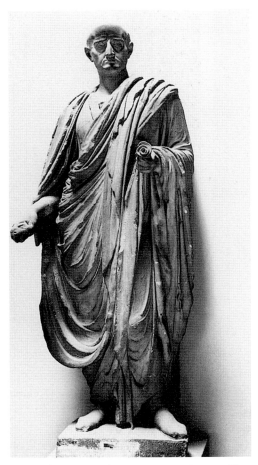

5 Egidio Moretti, *Roman wearing a Toga*,
Asmolean Museum, Oxford

6 Wenceslas Hollar, Pictorial map of London,
detail showing Arundel House

modest purchases some statues of Roman figures com-missioned from the unmemorable sculptor Egidio Moretti (fig. 5). He then returned home by way of Flo-rence and Genoa, reaching London by New Year 1615. He came back, after these intensive studies of Italian art and architecture, infected with an incurable collecting fever which was to recur in virulent bouts throughout the rest of his life and could be medicated only by expen-sive purchases of paintings, drawings and antiquities. There was an excuse, however; he had seen at first hand the prestige and status that a great collection bestowed on its owner and he was determined to use his acquisi-tions as a means of re-establishing the glories of the house of Howard.[21]

Arundel's father-in-law, Lord Shrewsbury, died in 1616, leaving his estate between his three daughters. The legacy enabled the Arundels to refurbish the old family palace, Arundel House, as well as their house in Greenwich and their suburban villa in Highgate. Arundel House, just south of the Strand to the east of Somerset House, was a picturesque but very old-fashioned muddle of courts, crenellated lodgings, a great hall, stables and passages, with extensive gardens stretching down to the Thames (fig. 6). Arundel, however, was spending so much money on his collections and, in particular, his paintings from Italy and the Low Countries that he had insufficient personal funds to rebuild the whole complex, even if his feelings of family piety had permitted. Nevertheless, he obtained designs from Jones for minor alterations and refurbished the long wing that extended towards the river in order to display some of his new collections, particularly the marbles that he had shipped from Rome. He was so proud of the results that he commissioned from Daniel Mytens a pair of full-length portraits of himself and his wife, sitting in the new galleries.

Arundel is shown presiding over two rows of life-size classical statues which stand on identical plinths down both sides of a barrel-vaulted gallery, while two female deities at the end flank an arch with a view over the river (fig. 7). Unlike contemporary Italian collections the room contains no busts, reliefs or inscriptions, although exam-ples were introduced at a later date. His wife is portrayed sitting in the lower gallery which is hung with portraits and opens onto the garden. The settings are rather fanci-ful because contemporary views all show that the river

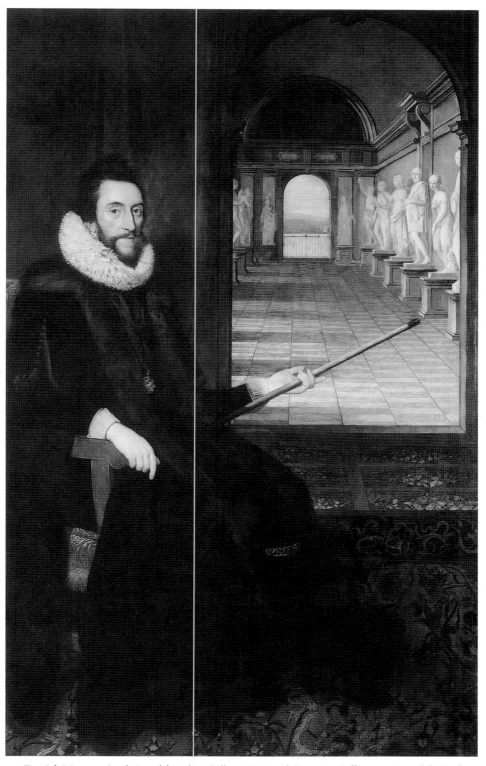

7 Daniel Mytens, *Lord Arundel in his Gallery*, National Portrait Gallery at Arundel Castle

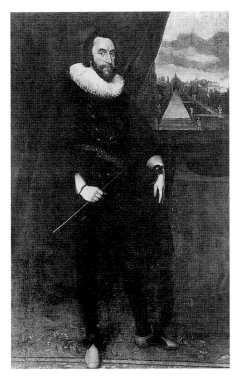

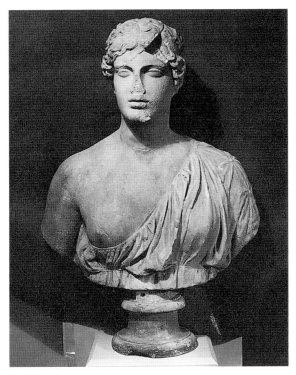

8 Unknown artist, *Lord Arundel*, Private Collection

9 *Faustina*, marble bust, Ashmolean Museum, Oxford

front of the galleries at Arundel House had two mullioned and square-headed windows on each floor and that the water came close up to the end of the building, which would have precluded any possibility of the arched opening or the garden vista. Even if the settings are only an approximation of the real interiors of Arundel House, these portraits are as much the *locus classicus* of seventeenth-century taste as Zoffany's picture of Charles Townley in his gallery is the icon of the eighteenth-century Grand Tour (see fig. 157).[22] Following the example of Pope Julius II's Belvedere courtyard, Arundel also laid out part of his garden with statues. In the background of another portrait sketchy marble figures are shown standing on a parapet that runs round an upper terrace (fig. 8). Even foreign visitors were impressed:

> Foremost amongst the objects worthy to be seen, stood the beautiful garden of that most famous lover of art, the Earl of Arundel; resplendent with the finest ancient statues in marble, of Greek and Roman workmanship. Here were to be seen, firstly, the portrait of a Roman Consul, in long and graceful drapery, through which the form and proportion of the body could be readily perceived. Then there was a statue of Paris; and many others, some full length, some busts only; with an almost innumerable quantity of heads and reliefs, all in marble and very rare [fig. 9]. From the garden one passed into the long gallery of the house . . . In the same gallery were some of Holbein's best portraits.[23]

The collection at Arundel House was to be the owner's monument and was to be open to visitors, like the great Italian collections, as he made clear in the draft of his will drawn up in 1617:

> that my son James Maltravers [then aged ten] may succeed me in my love and reverence to Antiquities & all things of Art, I give unto him all my statues & pictures whatsoever with all inscriptions or monuments of stone, which I desire he may take so much a love unto as that he may increase those I leave; howsoever I charge him deeply that he may never part with any of those things which (God knoweth) I have gathered with so much travail & charge . . . My desire is that all gentlemen of Virtue or Artists . . . may always be used with courtesy & humanity when they shall come to see them . . .

His desire was already being fulfilled the following year when Jacob de Gheyn, who visited the collection with Constantijn Huyghens, made sketches of some of the antiquities.[24] Such displays were totally novel in London; Sir Francis Bacon, 'coming into the Earl of Arundel's Garden, where there were a great number of Ancient Statues of naked Men and Women, made a stand, and as astonish'd cried out: *The Resurrection.*' To the English visitor, accustomed only to brightly painted monumental sculpture in churches, Arundel's toga-clad marbles must indeed have resembled the shrouded dead.[25]

This garden display was not unique in England. Arundel had been preceded by several earlier antiquarians who had been inspired by classical learning to decorate their gardens with inscriptions found in the remains of Roman settlements in Britain. These humble gatherings contained no statues but they included altars and tombstones. Arundel's uncle, Lord William Howard of Naworth, had an array of relics from Hadrian's Wall at Naworth Castle, Sir Robert Cotton, who had visited the same region in 1599 with William Camden, the father of British archaeology, decorated his summer house at Cottington with similar inscriptions, Francis Godwin, Bishop of Llandaff in the early years of James I, gathered fragments from Carleon at his episcopal palace at Mathern near Chepstow and several other enthusiasts assembled their own epigraphical trophies.[26]

Arundel's medley of restored pieces from Rome was augmented by further acquisitions as opportunity arose. At this time, the current royal favourite was Robert Carr, Earl of Somerset, an odious character, who felt that he needed some status symbols to show off the splendour of his position; he was, therefore, buying paintings and tapestries from abroad and had commissioned Sir Dudley Carleton, the ambassador in Venice, to help. Carleton obliged him by purchasing a distinguished collection of classical statues from Daniel Nys, a merchant dealer of French origin who traded in Venice, and he offered them to the favourite, together with a group of paintings by Titian, Tintoretto, Veronese, Bassano and other Venetian artists, but, before the sale could be finalized, Somerset had been disgraced. Dismayed but undeterred, Carleton, who was thus 'by mischance made a merchant', tried to sell the package to Arundel, tempting him with a free sample in the form of 'a great antique head of Jupiter'. Arundel accepted the head, which he promptly located in pride of place in his garden, at the end of the vista running from the door in the centre of his gallery, and he went on to buy the pictures; but he hesitated over the statues, which he was perhaps temporarily unable to afford, and he lost interest altogether when Lord Roos, an erratic young member of the Cecil family, pre-

sented him with all the antiquities that he had gathered on his recent foreign travels. Carleton had to find another buyer and, in due course, made an exchange with Rubens, swapping his statues for some tapestries and a group of the artist's paintings, which he hoped would be easier to sell. The complex transaction is interesting for a number of reasons: it shows how difficult it was at this stage to interest English buyers in antiquities, it illustrates the surprisingly entrepreneurial way in which English officials abroad sought to trade and it raises doubts over Arundel's connoisseurship if he turned down a collection which could attract Rubens's experienced eye.[27]

Arundel now turned to another source of antiquities. The Ottoman Empire, based in Constantinople, covered the whole of the eastern Mediterranean, including Greece and Asia Minor. Within its boundaries lay the relics of numerous ancient cities which were regarded by the Turks merely as stone quarries for military fortifications or the burning of lime. Venetian merchants had been acquiring Greek antiquities from this source for several centuries, as Arundel would have been aware from his stay in the Veneto. The region was also much visited by English travellers from the Levant Company, the most profitable part of whose business was the import of currants from Greece. As the ambassador to the Porte complained, the English 'can hardly digest bread, pastries, broth and bag-puddings without those currants'. In 1621, when James I restored Arundel to the office of Earl Marshal of England, he bestowed on him the dues levied on the value of currants imported into the country, worth some £3000 a year. Arundel was, therefore, in direct contact with merchants trading to a fertile source of statuary and able to provide both credit to buy, and ships to transport, the bulky commodities that he was seeking.[28]

Arundel never visited the region himself but he asked Sir Thomas Roe, the ambassador, to look out for antiquities and backed this up with a request to help his agent 'John Markham, a very honest Gentleman and my friend, . . . to enable him or such as he shall employ to find Antiquities; to do it safely and without interruption.' Unfortunately, Markham died not long after his appointment, whereupon another agent, the Reverend William Petty, was despatched to continue the task. After a career as a schoolmaster and a Cambridge don, Petty had joined the Arundel household in the role of children's tutor in 1613 and had spent some time in Italy. Arundel had recognized that he was just the man for his purposes 'for he doth not only love antiquities extremely, but understands them very well'. As Roe later commented: 'There was never man so fitted to an employment, that encounters all accident with so unwearied patience, eats with Greeks on their worst days, lies with fishermen on planks at the best, is all things to all men, that he may obtain his ends, which are your Lordship's service.'

Petty reached Smyrna in December 1624 but, before he arrived in Constantinople, the situation became more complicated. The previous year, King James's new favourite, George Villiers, Duke of Buckingham, had accompanied Prince Charles to Spain in his attempt to woo the Infanta Maria. Even though a Spanish bride was not forthcoming, the royal party was much fêted and, for the first time, they were exposed to the artistic riches of a great court. Charles promptly set about the task of forming his own brilliant but short-lived collection, while Buckingham was also inspired to start buying on his own account and he too sent instructions to Roe, asking him to acquire antiquities on his behalf.

Roe, anxious to please the influential favourite and innocently unaware that Arundel regarded Buckingham as an upstart, assumed that he could use Petty's superior connois-

seurship to assemble a package of antiquities that could then be divided equally between the two collectors. He was, indeed, rather worried about his own lack of technical knowledge of the subject and ambivalent about the quality of the goods that he was assembling: he had, for instance, acquired

> a stone taken out of the old palace of Priam in Troy, cut in horned shape; but because I neither can tell of what it is, nor hath it any other beauty, but only the antiquity and truth of being a piece of that ruined and famous building, I will not presume to send it you; yet I have delivered it to the same messenger that your lordship may see it, and throw it away.

Roe's first project was outrageously ambitious. The Golden Gate of Constantinople, erected by Theodosius the Great to celebrate his victory over Maximus in 388, had been used by the Byzantine emperors for their state entries to the city and, although it had been walled up and enclosed in the city's fortifications by the Turks, it still retained twelve large reliefs, half of which were the target of Roe and Petty. The plan was to persuade an imam to declare that the mythological figures depicted were offensive to the faith, whereupon they could be taken down and, after a discreet period, exported. This failed, as did efforts to approach the vizier, the captain of the fortress and the officer in charge of the walls, because, without authority, no one dared to erect the necessary scaffolding, thirty or forty feet high, particularly since the fort was also the Grand Signor's prison. As Roe explained in a letter to Arundel, it was like dismantling part of the Tower of London. When eventually, two years later, Roe felt that he was on the brink of success, after bribing the Treasurer himself, he was frustrated by a swell of popular superstitious fears that, if the reliefs were removed, some disaster would strike the city. It is sad that the scheme was unsuccessful because, over time, these antiquities simply disappeared.

While the ambassador tried bribery in Constantinople, Petty set off to ransack the Ionian coast, determined to act solely for Arundel and with no intention of dividing his spoils with Buckingham. It was hard work. He had to convert the classical Greek that he had learned at Cambridge to the demotic spoken by the Greek communities living in Asia Minor. Constantly on the alert for Turkish pirates who scavenged the coastal waters, he lived rough on his island-hopping caique with Greek sailors who 'feed off Onions, Garlic and dried fishes . . . and instead of a banquet, they will give you a head of Garlic roasted in the ashes and pleasantly call it a pigeon'. Excavations required particular tact because, although the inhabitants cared very little for the ruins among which they lived, they automatically assumed that any digging was for buried treasure, which was rightfully their own. Petty visited Pergamum and Samos with some success, before being shipwrecked near Ephesus in a great storm which sunk both his acquisitions and, almost as important, the *firman* or passport with which Roe had equipped him. Having lost his papers, he was imprisoned as a spy by the authorities until he was recognized by a friendly Turk, who was able to procure his release. Quite undeterred, the robust divine proceeded to Chios, where he assembled a salvage team to dive for the sunken cargo and, with some considerable difficulty, recovered his losses. Soon afterwards, he was compensated for this setback at the expense of a rival prospector. A Monsieur Samson, who was at this time employed by the leading French scholar, Nicolas Peiresc, to do exactly what Petty was doing, had assembled a group of classical inscriptions. When Petty

arrived at Smyrna, he found that the unfortunate Frenchman had been imprisoned, leaving his marbles undefended. A higher offer secured the cache, which included the *Marmor Parium*, for Arundel's collection. Petty then moved on to Athens and the Peloponnese, where he spent the summer of 1626, before returning to London having 'raked together 200 pieces, all broken, or few entire', as Roe reported.[29]

The scholars of London were thrilled by the arrival of these additions to the collection, particularly the inscriptions, which arrived at Arundel House in early January 1627. As soon as he heard the news, Sir Robert Cotton hastened round to his friend, John Selden, although it was dark, and insisted that they should pay a visit as soon as day dawned, bringing with them Patrick Young, the king's librarian, and Richard James, a fellow of Corpus Christi College. The following year, twenty-nine Greek inscriptions and ten in Latin, together with some additional fragments, were published with a scholarly commentary by Selden as *Marmora Arundelliana* and were greeted with pleasure even by Peiresc, whose delight in good scholarship outweighed disappointment at his losses in Smyrna. The little volume, devoted to the newly fashionable study of epigraphy, demonstrated to the world Arundel's serious interest in the past.[30]

The statues that Petty brought back were all subjected to heavy restoration in a special workshop on the river bank, because limbless torsos were unacceptable in seventeenth-century galleries, but the architectural fragments, which could be disposed round the gardens in the Italian fashion, were left untouched. Both Van Dyck and Inigo Jones copied and incorporated pieces into their paintings and designs. Arundel could have been justly proud when Charles I and Henrietta Maria visited Arundel House in December 1628; without any papal or royal influence to help him, he had created a collection that could stand comparison with the galleries of Italy.[31]

There were further acquisitions the following year. While Petty had been prospecting for his employer, Roe had tried to carry out his instructions on behalf of Buckingham. It was not easy because he had to rely on what he called 'ignorant instruments', traders, consuls and local bishops, and he had to lay out money without seeing what he was buying. To add to his problems, Buckingham was no antiquarian and expected his marbles to be as smooth as if they had come straight from the yard of a monumental mason. 'Neither am I so fond of antiquity (as you rightly conjecture)', he told the ambassador, 'to court it in a deformed or misshapen stone; but where you shall meet beauty with antiquity together in a statue, I shall not stand upon any cost your judgement shall value it at.' In the end Roe was forced to send out one of his own servants 'that hath seen many collections in Italy, and pretends to know. I have given him two rules, beauty and hard marble. I . . . have furnished him with a command, the captain bashaw's letter, the patriarch's recommendation and sufficient credit.' These impressive resources produced 'one whole statue, 8 foot high, not much defaced' and 'another wanting the head, in the old famous Corinth', together with some other fragments, but, worn out by his travels round Attica and the Peloponnese, the servant died and, to increase Roe's problems, some of his finds had not been assembled but had been reburied in the sand until a ship's captain could be persuaded to make a detour to collect them. By the time that Roe's marbles, procured with so much difficulty, finally arrived in London, Buckingham was dead and Arundel was able to add them to his own collection.

In subsequent years Arundel seems to have decided to be more selective and to aim for fewer but more important targets, each time without success. In 1636 Petty, whose relentless energy was now deployed in the Italian markets, tried on his behalf to negotiate the export of the great Egyptian obelisk lying in fragments in the Circus of Maxentius near the Appian Way outside Rome, but a licence was not forthcoming for this trophy, which was shortly afterwards erected as the centrepiece of Bernini's Fountain of the Four Rivers in the piazza Navona. Roman export licence problems also frustrated efforts to buy the famous statue of *Meleager* in the Pighini palace, despite an attempt to use the influence of the papal agent in London, and the Gaddi family in Florence could not be persuaded to sell their notable *Torso*. It comes as a surprise to find that the papal authorities were restricting the export of antiquities at this date, but such was the prestige of these objects that even cardinals had to apply for permission to send marbles out of Rome. Export controls are not a modern phenomenon. There was also a prohibitively expensive scheme for casting Trajan's Column in bronze and an attempt to buy the Duke of Lerma's collection of antiquities in Madrid.[32]

In addition to his marbles, Arundel bought other important antiquities such as the bronze head of a poet (fig. 10), which was so prized that it was included by Van Dyck in a portait of the earl and his wife. He was also a passionate collector of coins and gems; many of them came from the cabinet that Daniel Nys had acquired from the Dukes of Mantua and had first offered to Charles I. Arundel's collection of over 250 cameos and intaglios, 'onyxes, sadonyxes, jacinths, jaspers, amethysts etc., more and better than any prince in Europe', comprised a series of exquisite pieces, including the signed intaglio by Felix of *The Theft of the Palladium* (fig. 11) and the signed cameo by Tryphon of the *Marriage of Cupid and Psyche*, as well as imperial Roman portraits of the highest quality (fig. 12) and charming miniature views of everyday life. Some gems may also have found their way to his drawers from Prince Henry's cabinet.[33]

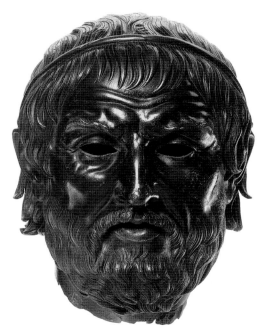

10 *Head of Sophocles*, Hellenistic bronze, British Museum

11 Felix, *The Theft of the Palladium*, intaglio, Ashmolean Museum, Oxford

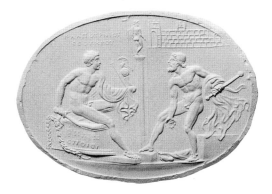

12 *Octavia as Diana*, intaglio, British Museum

Lord Clarendon, who disliked Arundel, affected to doubt his scholarly interest in antiquity:

> he was willing to be thought a scholar, and to understand the most mysterious parts of antiquity, because he made a wonderful and costly purchase of excellent statues whilst he was in Italy and Rome (some whereof he could never obtain permission to remove from Rome, though he had paid for them), and had a rare collection of the most curious medals; whereas in truth he was only able to buy them, never to understand them; and as to all parts of learning he was most illiterate, and thought no other part of history considerable but what related to his own family.[34]

It is true that Arundel was himself no scholar. There is no evidence that he appreciated the difference between Greek sculptures acquired by Petty and run of the mill Roman antiquities bought on his first visit to Italy, but such discrimination was unknown at this period, even in Rome. On the other hand, through his friendship with serious antiquaries such as Sir Robert Cotton, he was able to appreciate the historical and artistic significance of his collection and the importance of making it available to others both through publication and by welcoming visitors to see it. The marbles and gems were, of course, only a part of the great treasures that he amassed; Arundel House contained a marvellous gallery of paintings by old and modern masters, including works by Raphael, Titian, Correggio, Sebastiano del Piombo, Dürer, Holbein, Rubens and Van Dyck, a superb collection of old master drawings and a library of the finest books and manuscripts, to say nothing of his heraldic and genealogical accumulations. It was, however, the re-creation in London of the sculpture galleries and gardens of Rome that had the greatest impact on his contemporaries and assured his reputation as 'the Father of virtù in England'.

It is sad that he had so little time to enjoy what he had brought together. During the late 1630s he was busied on diplomatic and military affairs, which kept him away from London, and, when the Civil War broke out in 1642, he left England in gloomy dismay, moving first to Antwerp, then Rheims and finally to Italy. John Evelyn, who visited him in Padua a few months before his death in 1646, records a pathetic picture:

> I was invited to Breakfast at the Earl of Arundel's; I took my leave of him in his bed, where I left that great & excellent Man in tears upon some private discourse of the crosses that had befallen his Illustrious family; particularly the undutifulness of his Grandson Philip's turning Dominican Friar, the unkindness of his Countess, now in Holland; the misery of his Country now embroiled in a Civil War, &c.[35]

The fate of the collection is no less melancholy. The marbles at Arundel House were neglected during the war and after the Restoration Arundel's grandson, Henry Howard, later Duke of Norfolk, was not the least interested in his inheritance. When John Evelyn persuaded him to present the inscriptions to Oxford University in 1667, only 136 out of the original total of some 250 were transferred, the rest having disappeared or been used as building materials. His diary records with satisfaction:

> These precious Monuments, when I saw miserably neglected, & scattered up & down about the Gardens & other places of Arundel-house, & how exceedingly the corrosive air of *London* impaired them, I procured him [Arundel's grandson] to bestow on the *University of Oxford*; this he was pleased to grant me, & now gave me the Key of the Gallery, with leave to mark all those stones, Urns, Altars &c: & whatever I found had Inscriptions on them that were not statues. This I did, & getting them removed & piled together, with those which were incrusted in the Garden walls, I sent immediately letters to the *Vice-Chancellor* what I had procured . . .

In 1678 the Duke decided to demolish the old house and redevelop the site, whereupon some of the busts and statues were acquired by Lord Pembroke, while others, considered to be unsaleable, were left in the garden under a colonnade. As construction work proceeded, so much spoil was tipped onto the roof of this building that it collapsed, damaging the marbles that it was intended to protect. Then, in 1691, when the duke proceeded to develop the garden as well, the best of the shattered statues were sold for £300 to Sir William Fermor, later Lord Lemster, who transported them to Easton Neston. They remained there until 1755, when they were presented to Oxford University, which now holds the bulk of what is left of Arundel's collection. A few statues found their way to the garden of Thorpe Hall in Northamptonshire, where they suffered 'more from the weather in this moist situation, than from age', as a visiting antiquary noted. They were 'much damaged' by the time of a sale of the contents of Thorpe in 1789 and have now vanished.

The marbles that remained on the site of Arundel House were either given to a family servant, who used them to decorate a pleasure garden in Lambeth, or were dumped to stabilize a marshy site in Kennington. The relics at Lambeth were rescued in 1717 by John Freeman and Edmund Waller, who divided them between their country houses, Fawley Court, near Henley, and Hall Barn, near Beaconsfield. The Kennington dump was explored and the battered fragments were re-excavated not long after their burial; a few pieces went to Lord Burlington's villa at Chiswick, six headless and limbless trunks were later sent to the Norfolk seat at Worksop, where all but one were destroyed in a fire in 1761, and the drum of a column was taken down to White Waltham as a roller for the bowling green. Yet more relics came to light when the streets on the site of Arundel House were redeveloped in the 1970s. The gems had a better fate; they were kept by the countess after her husband's death and, after a complex series of transactions, passed in the mid-eighteenth century to the fourth Duke of Marlborough, in whose family they remained until 1875. They are now dispersed among a number of museums and private collections.[36]

The assembly of marbles at Arundel House may have stayed intact for barely thirty years, but it was of fundamental importance in the history of British collecting. Arundel

showed that the acquisition of antiquities need not be reserved for princes and cardinals. Furthermore, his arrangement of statues, reliefs and inscriptions in the sculpture gallery and round the walls and terraces of his garden faithfully reproduced in London the displays that so impressed English visitors when they walked round the Statuario Pubblico in Venice or the courtyards of Roman palaces. In 1634 Henry Peacham, tutor to Arundel's sons, adding a new chapter, *Of Antiquities*, to his manual, *The Complete Gentleman*, justifiably praised his patron 'to whose liberal charges and magnificence this angle of the world oweth the first sight of Greek and Roman statues, with whose admired presence he began to honour the gardens and galleries of Arundel House about twenty years ago, and hath ever since continued to transplant old Greece into England'.[37] The quality of the collection was variable, ranging from awkward modern statues by Moretti through unexceptional Roman torsos to important fragments from the Great Altar of Pergamum and graceful Attic *stelae*, which testify to Petty's taste and industry. It is, however, quite remarkable that pioneering enthusiasm should have achieved so much.

THE DUKE OF BUCKINGHAM

Arundel's rival as a collector was George Villiers, Duke of Buckingham. He had come to London in 1614 at the age of twenty-two with nothing to commend him but a good knowledge of French, charming manners and an exceptionally handsome face. King James, ever susceptible to male beauty, was captivated and, within two years, had made him Master of the Horse, Knight of the Garter and a viscount, with a grant of land worth £80,000; an earldom followed in 1617, a marquisate in 1618 and the dukedom of Buckingham in 1623. Honours such as these needed to be reflected in sumptuous living, in magnificent houses and splendid furnishings.

In 1619 Buckingham took into his service Balthasar Gerbier, a painter of French Huguenot origin who had come over from Holland, and appointed him 'to the contrivance of some of his habitations, to choose for him rarities, books, medals, marble statues and pictures'.[38] Gerbier travelled round Europe, buying suitable pieces for his employer, and he accompanied him as a member of the royal entourage on the marriage expedition to Spain. This visit persuaded Buckingham that classical statues should be added to his shopping list and, as discussed earlier, he sent difficult instructions to the ambassador in Constantinople to procure antiquities as long as they were not 'deformed or misshapen'; he wanted high class interior decoration, not venerable fragments.

A good opportunity presented itself in 1625 when the favourite went over to Paris to bring back Charles's young bride, Henrietta Maria, and met Rubens, who was working there at that time. Rubens was an international figure, a brilliant artist, a respected diplomat and the friend of princes at half the leading courts of Europe; he was also very rich and had assembled a distinguished collection of paintings and antiquities to decorate his palatial house in Antwerp. The classical statues and busts were housed in a specially constructed circular chamber, where they were set in paired niches, divided by marble pilasters and lit, like the Pantheon, by an oculus in the roof. Buckingham suggested that he should buy some paintings and antiquities from the artist's collection. Rubens was not very keen to sell any of his antiquities, many of which he had acquired from Sir

Dudley Carleton only a few years previously, 'the most costly and most precious . . . which no prince or private person, whoever he may be, on this side the mountains can have'. At this time, however, he was busied with diplomatic affairs, which involved him in expensive travel and display, and since Buckingham seemed an important figure on the international stage, he was prepared to court the British favourite, not only by painting his portrait but also by agreeing to sell him a package of paintings and antique gems and statues. It was beneath Buckingham's dignity to visit Antwerp himself in order to see the goods that he was buying. This task was delegated to Gerbier, who, during the winter of 1626/27, acted as a go-between in the Anglo-Spanish peace negotiations and also in Buckingham's art dealing. In May, when agreement had finally been reached on both the list of goods to be acquired and their price, arrangements were made to despatch them to England. Thus, by chance, many of the antiquities, originally bought in Venice for the collection of James's favourite, the Earl of Somerset, were eventually sold to Buckingham, his successor. Scholars like Peiresc were dismayed that this group of antiquities was disappearing overseas, 'because it could not have been in worthier hands or in a place where it could appear to better advantage or serve to benefit the public', and he vainly hoped that Buckingham would at least pay extra to have the collection published.[39]

The duke's new possessions were shipped to York House, the London residence that he had recently acquired from Francis Bacon, just down river from Whitehall. The old house was being rebuilt by Gerbier to provide a splendid modern setting for his master's court entertainments and it was here that the collection of antiquities was arranged, interspersed among the great paintings that Gerbier had been buying from Rubens and other European owners and not separately displayed like the marbles at Arundel House. The antiquities were later moved to the duke's suburban villa, Chelsea House. An inventory of goods there, taken in 1635, when Buckingham's widow remarried, lists almost 200 gems in twelve cases and 100 pieces of sculpture, some thirty of which can definitely be identified with articles shipped to Carleton from Venice and sold by him to Rubens. A number of these, including, for instance, a Greek *stele*, must have been acquired by Venetian traders in the eastern Mediterranean. There were also some bronze and plaster copies of famous Roman statues such as the *Farnese Bull* and the *Spinario*. According to a French visitor to London in 1637, there were twenty or thirty pieces of sculpture in the lower gallery, above which ran a long gallery, full of paintings and a series of putative busts of Julius Caesar, Augustus, Nero, Seneca, Faustina and other desirable subjects from Roman history. The long gallery extended into a square marble-paved Cabinet Room which contained a black marble table laid out with small statues; the Closet, overlooking the river and the garden, was reserved for smaller antiquities and a cabinet full of crystal, amber and other rarities, while the Great Chamber was decorated with over forty busts and statues, including a huge bust of Laocoön, a head of Cicero and some funerary chests with inscriptions.[40]

Dizzily elevated beyond his abilities as a statesman or a commander, Buckingham was murdered by an assassin in August 1628 just at the point when his incompetence might have shaken even Charles's confidence in his favourite. His collection was to remain in London for only another twenty years. His young son, the second duke, like many royalist supporters, lived in exile for some years after the end of the Civil War, but, thanks to the influence exercised on his behalf by powerful friends, he managed

13 *Hecate*, Rijksmuseum van Oudheden, Leiden

to ship part of his father's collection to Holland. In the seventeenth century, there were few means of accumulating, storing and, in particular, transfering wealth; landed estates, urban property and mortgages were immobile, bullion was in short supply and hard to transport, and shares in trading companies or mercantile ventures were extremely risky and depended upon good contacts within the merchant community, which could not easily be maintained from abroad. Works of art and antiquities, on the other hand, were an international commodity, which provided a long-term, albeit illiquid, investment. Transferred abroad, they could be realized or used as security for loans to meet living expenses over a period of time. For some years the young Buckingham was thus able to maintain himself abroad by sales from his father's collection, just as émigrés from St Petersburg sold their diamonds and Fabergé eggs to survive after the Russian Revolution. Some of the marbles, which were bought by Reinier van der Wolff, a Dutch brewer, are now in the Rijksmuseum van Oudheden, Leiden (fig. 13), while a number of the gems, acquired for Gaston, duc d'Orléans, and bequeathed to Louis XIV, are now in the Cabinet de Medailles, Paris.[41]

THE COLLECTION OF CHARLES I

The other great collection of antiquities formed in England in the first half of the seventeenth century was, of course, that of the king himself. When he succeeded to the throne in 1625 he had already inherited the antique gems and the modern bronzes in the antique manner that his elder brother had started to acquire before his untimely death. It was, however, the visit to Madrid in 1623 that inspired him to form a gallery of international paintings and works of art so that the decoration of his royal palaces might not be restricted to an old-fashioned hang of portraits and tapestries more appropriate to the previous century. He returned from Spain with gifts of paintings by Titian and Veronese and Giambologna's marble group of *Samson and the Philistine*, which he gave to Buckingham, but much more was required. At exactly the right time an ideal purchasing opportunity arose; the collection of Ferdinando Gonzaga, Duke of Mantua,

was reported to be available. Charles immediately sent out his master of music, Nicholas Lanier, who was himself an artist, to investigate. Lanier visited Mantua in August 1626 and, since he was inexperienced in major art deals, he engaged the services of Daniel Nys (the merchant who had sold a collection of antiquities to Sir Dudley Carleton a few years earlier) before returning to London to confirm that the Mantuan pictures would match Charles's artistic ambitions. The death of Ferdinando and the succession of his brother, Vincenzo II, complicated matters, particularly since the citizens of Mantua were furiously indignant when they learned of the plan to sell the ducal treasures; but civic rage was of no avail and Vincenzo agreed a deal with Nys, who transferred to Venice a large part of the collection, great works by Raphael, Correggio, Titian and Caravaggio, ready for shipment to England. By 1628 most of the paintings had arrived in London.

That was only the first part of the Mantuan saga. Vincenzo died shortly after the sale and his successor, Carlo of Nevers, in need of further cash, decided to dispose of Mantegna's famous series of paintings, *The Triumphs of Caesar*, as well as the classical antiquities that Nys had already been urging the king's advisers to buy. Nys agreed with Lanier that, in principle, the king would make the further acquisition but, at this point, he saw a chance to improve his profit on the transaction by acting as principal rather than agent. Accordingly, he raised a loan of £10,500 to purchase for his own account the second tranche of the collection, which he then duly offered to Charles. The king, however, had not formally agreed to the details of the transaction and, since he needed every penny available to launch Buckingham's expedition to La Rochelle, he delayed payment. This was very inconvenient for Nys, who found himself having to finance the cost of holding the goods for longer than he had expected. In February 1629 he sent a catalogue to his contact, Dudley Carleton, who was by then in favour with the king and had been ennobled as Viscount Dorchester. The catalogue, which is still in the royal collection, consisted of drawings of all the statues and busts on offer with indications of their size and was clearly intended to show that most of the pieces were not mere fragments (one was, in fact, Michaelangelo's *Sleeping Cupid*) but were suitable decoration for a royal gallery (figs 14 and 15); the drawings were rolled up in a packet of prints of Mantegna's *Triumphs of Caesar*. Meanwhile, as a fall back, Nys privately offered the collection to Marie de' Medici and Cardinal Richelieu as well. The following year, despite the fact that he had still not been paid, he sent some of the statues over to England, 'the refuse' as he called them, in the hope that the sight of such treasures would loosen the royal purse strings because, as he told the king, the best was still to come. In a desperate note he added, 'If his Majesty does not promptly come to my assistance, my honour, myself, my wife and seven children are entirely lost.'

The royal advisers were firm, however; payment would not be made until all the statues and paintings had reached England. By 1631 the unfortunate dealer's creditors, who could wait no longer, raided his premises in Venice to seize what assets they could for the recovery of their debt. There they found a Raphael, three Titians, three versions of the *Sleeping Cupid*, one modern and one, it was modestly claimed, by Praxiteles, as well as that by Michelangelo, 'a large figure in antique copper, very rare', and 'a Figure of a woman sitting in marble; some say *Venus delli Ely*, others *Helen of Troy* . . . the finest statue of all', estimated at 6000 *escus* (fig. 16), all of which Nys brazenly pretended to

14 Drawing from the Mantuan catalogue, The Royal Collection © 2002, Her Majesty Queen Elizabeth II

15 Drawing from the Mantuan catalogue, The Royal Collection © 2002, Her Majesty Queen Elizabeth II

have forgotten, although they were the king's property. In August 1632 these goods were finally despatched to London. The deal reflects badly on Charles, who had overcommitted himself and then allowed his agent to go bankrupt, but Nys deserves little sympathy for the way in which he tried to keep back part of the goods bought by the king and for his covert negotiations with the French.[42]

Most of the Mantuan marbles had been acquired by Duke Guglielmo, who had been importing antiquities from Rome in the 1570s, to add to the earlier collection of his grandmother, Isabella d'Este, and further purchases had been made by Duke Vincenzo I in the early years of the seventeenth century. They were a mixed assortment of Hellenistic and imperial Roman pieces, with numerous standard busts of emperors and unnamed youths, and, as we have seen, they included a few renaissance figures. In all, Charles acquired over ninety statues and more than 190 busts, but, unlike Arundel's collection, his Mantuan pieces included no inscriptions or reliefs, which Nys may have considered insufficiently decorative for Stuart taste.

The costs did not end with the purchase price; the royal accounts for 1631–2 refer to 'piecing and mending the limbs and joints of divers Statues of White Marble which were

broken and defaced in their carriage by Sea' and there was a requirement for numerous pedestals to be specially made in the royal workshops. The choicest busts, together with the little bronzes inherited from Prince Henry, were arranged in the Chair Room and the Long Gallery and Privy Chamber at the end of it in the old palace of Whitehall, where the king kept some of his favourite paintings. It is a pity that frail royal finances never permitted any scheme for the comprehensive rebuilding of Whitehall to house the splendid new collections or to match Inigo Jones's Banqueting House which towered incongruously over the primitive clutter of courtyards and passages.[43]

The statues and the rest of the busts were displayed out of doors; a colonnade of fifteen columns, faced by a grille, was erected in the Orchard Garden at St James's, where, as a French visitor recorded, 'one may see the rarest wonders of Italy in a great number of stone and bronze statues', and the others were divided between the gardens of the queen's palaces, Somerset House and Greenwich.[44] The antiquities were augmented by rather clumsy bronze copies of famous Roman statues, including the *Borghese Gladiator*, the *Spinario*, the *Belvedere Antinous* and *Commodus as Hercules* and the *Diana* from France, which were cast by Hubert Le Sueur from moulds acquired in Rome. These were displayed at St James's and

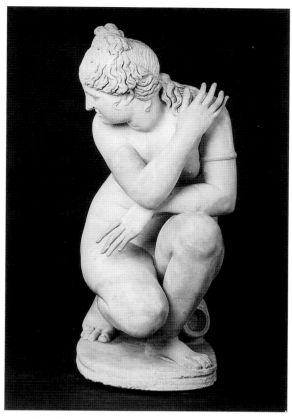

16 *Crouching Venus*, The Royal Collection © 2002, Her Majesty Queen Elizabeth II, on loan to the British Museum

Greenwich, together with a number of busts of philosophers, also made by Le Sueur. Perhaps the intention was to remind the French queen of the gardens of Fontainebleau which were lined with such bronze copies of statues from Rome.[45] It is as surprising as it is disappointing that there seem to be almost no contemporary descriptions of how the these statues were arranged, nor are there any Stuart equivalents of the scenes of European collectors in their galleries, real or imaginary, which were a popular subject for artists of the Low Countries at this period. Evidently, the king, reserved as always, considered that his private galleries and gardens were not to be divulged to the popular gaze.

The royal collection also contained a small selection of Greek marbles. In 1628 Sir Kenelm Digby, 'that noble and absolutely complete gentleman', as Peacham describes him, made an expedition to the Mediterranean, ostensibly to harass the French but, in fact, to engage in some vigorous piracy. This culminated in a successful engagement off Scanderoun in the Levant and an urgent request from the local British merchants that he would go home and stop damaging their trade. Digby, who has left a naively ingenuous account of this voyage, obviously thought that the king would be pleased by a gift of some fashionable marbles and he therefore stopped at Delos on his return.

To avail myself of the convenience of carrying away some antiquities there, I busied them [the sailors] in rolling of stones down to the seaside, which they did with such eagerness as though it had been the earnestest business that they came out for, and they mastered prodigious massy weights; but one stone, the greatest and fairest of all, containing 4 statues, they gave over after they had been, 300 men, a whole day about it . . . But the next day I contrived a way with masts of ships and another ship to ride over against it, that brought it down with much ease and speed.

These fragments, so rudely torn from the temple of Apollo, were presented to the king.[46]

Peacham maintained that Charles had 'amply testified a Royal liking of ancient statues, by causing a whole army of old foreign Emperors, Captains, and Senators all at once to land on his coasts, to come and do him homage, and attend him in his palaces . . .' but it seems that the king collected antiquities because a seventeenth-century monarch was expected to display a certain number of statues and bronze casts rather than out of a passion for the classics. Although the royal inventories mention a head of Nero 'bought by the king when he was prince' and busts 'bought by his Majesty out of Spain' and 'bought by my Lord Marshal's [Arundel's] means', there was no continuous pattern of collecting. Furthermore, if he had loved antiquities as Arundel did, he would not have delayed the delivery of the Mantuan marbles for several years by withholding payment from Nys. The attitude of 'the greatest royal connoisseur of paintings in the world', as Rubens called him, was quite different towards his picture collection and the artists whom he brought over from Italy and the Low Countries.[47]

The king's collection survived intact for as short a period as that of Buckingham. In 1649, soon after his execution, inventories of 'the late king's goods' were compiled on Parliament's orders as a prelude to one of the greatest art sales ever held. The proceeds were to be used to pay off the king's creditors. The contents of all the royal palaces were itemized from a state bed with its hangings, valued at £1000, to a pair of fire-bellows in the chimney, worth five shillings, and all the paintings and statues were catalogued. Over 400 items of statuary are recorded from St James's, Somerset House and Greenwich, including the marbles from Mantua, some pieces specifically described as Greek and a number of modern works. Le Sueur's copies of the *Borghese Gladiator* and *Commodus as Hercules* were among the most valuable items, estimated at £300 and £200 respectively, while a little figure of the *Spinario* (charmingly described as *Pick-thorn*), was estimated at £80. The most highly valued antiquities were the *Crouching Venus* (Nys's *Venus delli Ely*) and a *Niobid*, catalogued as a *Flying Sabine*, valued at £600 each, *Tiberius as a Priest* was next at £500, while most of the imperial busts from Mantua were marked at between £50 and £150. None of the antiquities, however, matched Bernini's bust of the king, which was priced at £800.[48]

The years after the Civil War were not a propitious time to unload the expensive splendours of the royal collection; to many it seemed disloyal to scavenge the martyred king's property and, while there was a modest appetite for paintings, the taste for antiquities had not yet caught on among British collectors. Parliament, therefore, resolved that some of the goods should be distributed directly in lieu of cash to groups of the king's creditors. Accordingly, many of the great paintings and most of the statues were parcelled out among syndicates of former royal servants and suppliers, who generally appointed one of their number as a dealer to turn their grand but unwelcome posses-

sions into cash. In this way many of the goods 'were bought up by agents from beyond the seas and so were transported' to be sold off to collectors like Cardinal Mazarin. Peter Lely managed to acquire one of the best pieces, the *Crouching Venus*.[49]

Despite these sales, authority was given for some treasures to be reserved for the continuing use of the State 'by reason of their Rarity or Antiquity', including Mantegna's *Triumphs of Caesar*, Raphael's Tapestry Cartoons and some of the statues. Sixteen of the latter were erected in unimaginative square plots, like chessmen, as decoration for the Privy Garden in Whitehall. This did not meet with universal approval. There were complaints that 'Romish and Heathenish images' did not make a good show in a Commonwealth's garden and the devious intriguer, Sir Balthasar Gerbier, tried to pander to the popular mood by denigrating the king for having wasted money on 'braveries and vanities: on old rotten pictures on broken nosed marble' and for accepting gifts of 'antique idols'. In 1653 one Mary Netheway wrote to Oliver Cromwell asking him to destroy the statues of *Venus*, *Adonis* and *Apollo* because the wrath of God would continue until such pagan images had been cleansed from Jerusalem. Worse was to come; in 1659 a cook, armed with a blacksmith's hammer, entered the Privy Garden during sermon time and set about the figures there, causing considerable damage before he could be arrested, but he was released with no more than a caution, thanks to some influential sympathisers who thought that classical statues deserved the fate of the idols of Baal.[50]

At the time of the Restoration in 1660 many of the Charles I's luckless creditors were still stuck with his antiquities. To take advantage of this situation, a proposal was made to buy back 'divers statues and pictures of the King's which were sold to sundry persons, and would now be of great use in beautifying the gardens and lodgings of the King's houses, and which could be bought in for very small sums of money'. Thomas Chiffinch, the royal recovery agent, made efforts to reacquire some of the antiquities – his portrait shows him displaying a statue of *Venus*, a bust and a handful of gems and coins, a sample of what he had recovered (fig. 17). Charles II, however, was not very interested in these trophies, nor were his successors. In the time of William and Mary, the statues in the Privy Garden remained on view, but all the others were shut away in lumber rooms, where few were safe. After the great fire, which destroyed the palace of Whitehall in 1698, most of the survivors disappeared. Few of King Charles's acquisitions remain in the royal collection today. The

17 Jacob Huysmans attr., *Thomas Chiffinch*, National Portrait Gallery

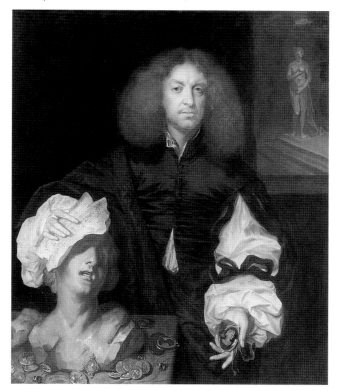

cameo of *Claudius* and some of Le Sueur's bronzes are at Windsor, the *Crouching Venus* is on loan to the British Museum and the surviving busts are divided between Hampton Court and Kensington Palace.[51]

Neither Buckingham nor the king recognized the importance of the block purchases of antiquities that they had made from Rubens and the Gonzagas. What mattered to them, or their advisers, was ownership of an international commodity that was scarce and expensive, rather as tycoons today buy instantly recognizable Renoirs and Van Goghs which flash multi-million dollar signs across the room to the least art-minded. As Peacham argued, 'the possession of such rarities, by reason of their dead costliness, doth properly belong to princes or rather to princely minds'.[52] Arundel, however, was rather different. He also collected in order to show off the distinction of his family but he was so much in love with Italy that he combined this display with the re-creation of the ambience of a Roman *palazzo* and its garden. His efforts seemed rather eccentric to his contemporaries, whose attitudes, typical of the British when confronted by any unfamiliar art form, are mirrored in Marmion Shakerley's comedy *The Antiquary*, first produced in 1636. In this play the author satirizes the enthusiasm for collecting of 'the great silver box that Nero kept his beard in', 'the urn that did contain the ashes of the Emperors', a manuscript in Cicero's own handwriting and Pompey's breeches – 'he was called Pompey the Great from wearing of these great breeches'. The Antiquary's nephew complains that

> he sits
> All day in contemplation of a statue
> With ne'er a nose, and doats on the decays
> With greater love than the self-lov'd Narcissus
> Did on his beauty.[53]

Mockery of such enthusiasms also occurs in John Earle's *Micro-Cosmographie*, 1629, where the Antiquary is satirized among other characters.

> He is a man strangely thrifty of Time past . . . He is one that hath that unnatural disease to be enamour'd of old age, and wrinkles, and loves all things (as Dutchmen do Cheese) the better for being mouldy and worm-eaten . . . a broken Statue would almost make him an Idolater . . . His estate consists much in shekels, and Roman Coins, and he hath more pictures of *Caesar*, than *James* or *Elizabeth*. Beggars cozen him with musty things which they have rak't from dung-hills . . . He loves no Library, but where there are more Spiders' volumes than Authors, and looks with great admiration on the Antique work of Cob-webs.

The casual treatment accorded to the galleries of Arundel, Buckingham and the king after the deaths of their owners shows how little noseless busts and limbless torsos were appreciated at this period. A rather shaming conclusion overcasts the dazzling start to the first phase of British collecting.

Collecting under the Later Stuarts

PEDANTS AND POLYMATHS

From the start of the Civil War in 1642 until the end of the seventeenth century, most British collectors ignored classical statuary. Cavaliers, expelled by the Commonwealth regime, had ample opportunity to see the great collections in Italy and France, some of them even set up as art dealers to eke out a living in exile, but all were precluded by poverty and the lack of suitable accommodation from emulating King Charles, Arundel or Buckingham in acquiring major antiquities.

Interest continued, however, in smaller, cheaper and more portable items. Sir Kenelm Digby, the spoiler of Delos, wrote in 1647 to Cassiano dal Pozzo about the acquisition of intaglios 'even if they don't seem to be very fine objects either for their beauty when set in finger rings and worn as jewellery or for the art and perfection of the engraving' and he remarked that Thomas Killigrew had a stock of good specimens at low prices.[1] John Michael Wright, the Scottish portrait painter, who was studying in Rome at the same time, collected gems while he was there and John Evelyn, also in Italy at this period, became such an enthusiast that he took every opportunity of examining English collections after the Restoration from the remains of Charles I's cameos in Whitehall to an excellent group belonging to 'a conceited old Hat Maker in Blackfriars'.[2]

Most of the collections formed at this time comprised little more than tourist souvenirs, which have long since been dispersed. One, however, survives more or less intact because its owner, John Bargrave, bequeathed it to the library of Canterbury Cathedral on his death in 1680. There it remains, together with the original wooden presses made to contain it and two portraits of the donor. Bargrave had been ejected from his fellowship at Peterhouse, Cambridge, in 1644, because of his royalist sympathies, and had to live in Europe until the Restoration, occasionally taking young men on the Tour of Italy. His cabinets preserve a microcosm of the scholarly tastes of his time, both classical and scientific, all carefully catalogued (fig. 18). The classical antiquities include several little bronze figures, a Romulus 'from the Quirinal Hill when S. Maria della Vittoria was built', an Aesculapius 'from the ruins of the temple of St Bartholomew', 'two old sacrificing priests, one if not ancient, yet cast from ancient, the other modern', a knuckle of brass for games, a fragment chipped off the obelisk that Lord Arundel had wanted to buy, an intaglio ring given by one of the young men whom he led round Italy, and a lamp and a bottle from the Catacombs, and to these Bargrave added pumice from Aetna and Vesuvius, a dried cameleon, beads, shells, crystals, a chamois horn, optical instruments, a

18 John Bargrave's cabinet open to show Roman coins and native beads, Canterbury Cathedral Library

mummified finger from a Franciscan cemetery (he regretfully turned down the offer of a mummified child), a Red Indian tobacco pipe and ribbons from Loreto 'for curiosity – to know the folly'. There must have been dozens of similar agglomerations.[3]

Collecting was not restricted to objects acquired overseas. The Great Fire of London in 1666 kindled new curiosity about domestic antiquities as workmen, excavating foundations for new buildings, dug down to the footings of ancient walls and Sir Christopher Wren himself was sufficiently interested to offer his own conjectures about the limits of Roman Londinium. City doctors and tradesmen eagerly sought out newly found fragments of pottery, lamps, tiles and coins. Towards the end of the century, when John Strype set to work on a revised edition of Stow's Elizabethan *Survey of London*, he was able to add a whole appendix 'Of divers Roman and other Antique Curiosities found in London before and since the great Fire'.[4]

One of these enthusiastic amateurs was John Conyers, an apothecary, 'who made it his chief Business to make curious Observations and to collect such Antiquities as were daily found in and about London' with a view to making them available 'to the Divine, the Naturalist, Physician, Antiquary, Historian, or indeed any person of Curiosity'. Another was John Bagford, a shoemaker turned bookseller, who collected anything he could recover from 'the subterraneous parts of London'. Then there was John Kemp, originally a sword-cutler, who found it more profitable to become a dealer in antiquities. His collection, or rather dealing stock, which included continental as well as domestic antiquities, became one of the sights of London and was the subject of an elaborate catalogue, with appendices on various learned topics, published after the owner's death in 1717. A German traveller who visited Kemp's house near Charing Cross in 1710 recorded two large rooms containing over two hundred 'statuettes, idols, utensils and other such things' as well as a cabinet of coins. He doubted, however, whether all the exhibits were genuine because the lower part of the walls of the first room were inset with Greek and Latin inscriptions instead of panelling and, in many cases, the lettering looked so new 'that one would dare swear that the letters had only this moment been engraved'. In fact, some of the Greek inscriptions were authentic, because they had been acquired from the French traveller Jacob Spon, and Spon had procured them on a tour of the eastern Mediterranean made in 1675 and 1676.[5]

Another collector of minor antiquities at this period was Dr John Woodward, an argumentative polymath, whose first love was geology – he bequeathed his enormous col-

lection of fossils to Cambridge University, which still maintains the post of Woodward Professor. He had come to London in the 1680s where, by energetic self-promotion, he contrived to be appointed Gresham Professor of Physick (i.e. Medicine) and elected a Fellow of the Royal Society. Like many other Fellows at this time, he was as much at home in the world of antiquity as he was in matters of science and he applied some of the fees that he extracted from his patients to create a 'Treasury of all Sorts of Commodities and Utensils, sacred and profane, of ancient Heathen Rome'. The result was a 'curious collection of Roman antiquities, not only of urns, but gems, signets, rings, keys, *stylus Scriptorius*, *res turpiculae*, ivory pins, brass *fibulae*, &c.' There was also his notorious shield which clearly illustrates the limitations of connoisseurship at this time.[6]

19 Dr John Woodward's Shield, British Museum

This shield first surfaced sometime during the reign of Charles II, when it was acquired by a London ironmonger. It passed from him to John Conyers, the apothecary, and eventually, in 1693, to the geological doctor. It is an Italian renaissance parade shield, made in the previous century, a circular iron disk, rather under twelve inches in diameter, embossed with a grotesque face in the centre and, in the lower half, with a scene of classical warriors milling around on either side of a large pair of balances, while the upper half depicts an ancient city (fig. 19). The subject was quickly identified as Brennus, the victorious leader of the Gauls, haggling with the Romans over the amount of gold required to bribe him to quit the city, a story well known from the histories of Livy and Plutarch. Woodward was thrilled with his trophy and circulated descriptions, engravings and even plaster casts to leading scholars both in England and overseas. Long debates ensued and many theories, almost wholly based on literary sources and not on archaeological evidence, were put forward to fix the precise date and purpose of the shield and to explain the anachronisms of the buildings and armour depicted. Although one or two scholars questioned the object's authenticity, almost all the learned were happy to accept that it was genuine and were so eager to show how ingeniously they could explain away the inconsistencies of the iconography that they never paused to ask themselves the fundamental question: is this object actually old? In their defence, it has to be said that there was, at this time, nothing similar in England, ancient or modern, with which they could compare the shield and the engravings in foreign publications on the antique did not give a complete encyclopaedia of ancient ornament.

The scholarly debate, extended over many years, had the very opposite effect of what Woodward had hoped. In 1714 a group of the grandest wits of the Augustan age,

including Alexander Pope, Jonathan Swift, John Gay and the genial physician Dr John Arbuthnot, established a club 'to write a satire in conjunction, on the abuses of learning; and to make it better received, they proposed to do it . . . under the history of some feigned adventures'. They called themselves the Scriblerians, taking their name from Martin Scriblerus, comic stories of whose life they composed at their meetings in Dr Arbuthnot's lodgings in St James's Palace. The account of the child's christening, 'what befel the Doctor's Son, and his Shield, on the Day of the Christening', was aimed directly at Dr Woodward. In this episode, Martin's father determines to show off his newborn son to a group of fellow pedants in the manner of the ancients, cradled in an antique buckler; when the maid enters the room with the child, he intones: 'Behold this rust – or rather let me call it this precious Aerugo – behold this beautiful Varnish of Time, – this venerable Verdure of so many Ages.' He then withdraws the cover from his cradled heir, only to drop both shield and son to the floor because the maid, 'extremely concerned for the reputation of her own cleanliness and her young master's honour', had scoured the shield clean of its precious patina.[7]

The Scriblerian satire on pedantic learning was a further skirmish in the great Battle of the Books, a debate that had started some twenty years earlier, as to whether the ancients had set unattainable standards of excellence in all the arts or could sometimes be surpassed by the moderns. Although it was a sterile controversy, chiefly memorable for the contributions of Jonathan Swift, it set the tone for the age. Scholars, like the great Richard Bentley, a protagonist of the moderns, might triumph in argument but the wits, who mocked excesses of learning, won the sympathies of men of taste. This had a fundamental effect not only on literary studies but on all research into the past that depended on a careful sifting of evidence from small, unglamorous fragments. Despite the publication in the early years of the eighteenth century of such useful works on local antiquities as John Horsley's pre-eminent *Britannia Romana* and the regular exploration of the subject of domestic Roman remains by the Society of Antiquaries, refounded in 1717, most elegant connoisseurs thought that fragmentary mosaics, chipped pots and rusty utensils were not worthy of their attention and left them to the curiosity of country parsons and the lawyers and tradesmen of London. George Ogle, who was himself a good scholar and translator, wrote disdainfully in 1737,

> There arises in most People an Aversion and Prejudice against the Study of Antiquities . . . Professors of this Study, generally seem to have no other Point in View, than merely to . . . exercise a Kind of out-of-the-way Curiosity . . . A Reasonable Man will yet find just Cause to condemn the Conduct of those passionate Admirers, who, to acquire the Character of Profest Antiquarians, lay out all their Time in the Search, and all their Substance in the Purchase of Curiosities without knowing . . . what Good they may produce.

Such views were echoed by Horace Walpole's comment later in the century:

> Roman antiquities . . . such as are found in this island, are very indifferent, and inspire me with little curiosity. A barbarous country, so remote from the seat of empire, and occupied by a few legions, that very rarely decided any great events, is not very interesting, though one's own country – nor do I care a straw for the stone that preserves the name of a standard bearer of a cohort, or of a colonel's daughter.[8]

Not everyone felt like this. The most attractive of the early archaeological collectors was a Scottish lawyer, Sir John Clerk of Penicuik.[9] After studying at Glasgow and Leiden, he set off on a Grand Tour through Germany to Vienna and then, in 1697, to Italy where he stayed until the following year. He visited Venice, Bologna, Naples and Florence and spent some time in Rome, where he was given legal tuition by Monsignor Caprara, one of the Auditors of the Rota. Clerk's collection started with a legacy of dubious antiquities, a head of Cicero, a bust of Otho, a little statue of Diana of Ephesus and a few other things, bequeathed by a 'learned Antiquary and philosopher' in Rome, who 'kept weekly Assemblies of Virtuosos at his House'.

On his return to Scotland, he practised law and in 1707 was appointed one of the Barons of the Exchequer, which kept him busy during Court terms but left plenty of time for his country estates and his classical studies. Fortunately his properties in Midlothian and Dumfriesshire were in a part of Scotland abounding in Roman remains which he investigated and collected with enthusiasm. In 1724 he took his fifteen-year-old son, James, together with the scholar Alexander Gordon to explore Hadrian's Wall. They started in Newcastle and visited all the camps along the way, pausing to do some excavating at Housesteads, where they discovered three altars, a figure of a legionary and a bas-relief, which were brought back to Penicuik.[10] Enthused by this expedition, Clerk began to correspond with some of the leading antiquaries in England, including Roger Gale, William Stukeley and Lord Pembroke, and he submitted learned papers on ancient burial practices and on Roman pens to the Royal Society and the Society of Antiquaries. In 1727 he visited London where he met the Duke of Devonshire, who showed him 'a most valuable Treasure of Books, Antiquities, Medals and other Curiosities', he was introduced to Lord Pembroke and took up his invitation to make an expedition to Wilton, he visited Lord Burlington at Chiswick, he saw the museums of Dr Sloane and Dr Mead and he examined Dr Woodward's shield, the authenticity of which he doubted. Throughout his long life, he maintained his classical studies and archaeological interests; in his seventies he was still visiting camp sites and reading Horace's *Ars Poetica*, 'which I am persuaded to have read 50 times before'.

In a draft letter in Latin to a Dutch friend he gives a charming account of his collection at Penicuik:

> In the upper part of the house is the library . . . There you will find books in all departments of literature – theological, legal, philosophical, mathematical, historical, medical. There is plenty of the classics . . .
>
> But lest my library should be quite empty of the monuments and delights of the arts, you may see there certain ancient bronze and marble statues, altar-pieces, inscriptions, and that sort of thing, as far as the slenderness of my fortune permitted. There are also in the museum a number of Greek and Roman coins, incised vases, traces of a picture of ancient workmanship . . . for so I would imitate Julius Caesar and Augustus (according to Suetonius), and even if I had not the example of such great men, I should regard it as a mean thing to build up a library of huge volumes on antiquities, and yet to disdain as useless the very objects which the most learned men, as Graevius, Gronovius, and Montfaucon, have explained with such expenditure of time and toil. The things themselves speak and for the most part explain themselves; but descriptions, however accurate, present to the mind only confused or shadowy ideas.[11]

In 1755 when the budding young architect Robert Adam, who was studying in Rome, heard of Clerk's death, he wrote, 'It's a pity the old Bod defunked before he saw some of my Antique collection of curiosities. I'm sure it would have revived the old soul of him for half a dozen years longer.' He was probably quite right.[12]

Such serious enthusiasts were unusual at this period. There were, however, several collectors who assembled antiquities as a necessary part of their museums because such objects had been a standard feature of every European virtuoso's cabinet since the mid-sixteenth century and were, indeed, included in the Royal Society's own Repository.[13] Foremost among these collectors was the successful doctor, Sir Hans Sloane. On his return from Jamaica in 1689, where he had been physician to the Governor, Sloane combined a lucrative medical career with a central role in the intellectual life of London as First Secretary of the Royal Society. He crammed his houses, first in Bloomsbury and then in Chelsea, with an enormous accumulation of natural phenomena. To the nucleus of botanical specimens, which he had assembled as a young man on his travels, he added dried plants from China and Japan, shells, insects, zoological trophies and minerals and a variety of ethnographical material, all in the manner of the Tradescants earlier in the seventeenth century. When Evelyn visited the collection in 1696, he noticed only the 'natural productions' and these continued to be the principal attraction that the doctor courteously showed to all interested visitors.[14]

In 1702, however, Sloane was bequeathed the 'rarities' of William Courten, which included some antiquities, and he subsequently added to these, not so much because he was interested in antiquity – he did not, for instance, correspond with contemporary scholars on the subject – but to round off his collection. Having decided to add antiquities to his natural specimens, he became a voracious buyer. He purchased minor items, including Greek vases, from the collection of Cardinal Filippo Antonio Gualtieri and terracottas, lamps and little bronzes from the notorious Sterbini, 'a true trading Italian', who imported doubtful curiosities to auction in London, he acquired inscriptions from John Kemp's sale, pieces of tessellated pavement from Woodchester and Caerleon and recently discovered fragments from Reculver, Wroxeter and Castor, and he built up a very large cabinet of coins and gems. Most visitors were impressed by the sheer bulk of the doctor's accumulations and yet they somehow felt that the overall effect was slightly comic.[15]

When Sloane died in 1753, he left instructions that the whole of his collection was to be offered to a list of public bodies in turn. Horace Walpole, who was one of the nominated trustees, wrote:

> You will scarce guess how I employ my time; chiefly at present in the guardianship of embryos and cockle-shells. Sir Hans Sloane is dead and has made me one of the trustees to his museum, which is to be offered for twenty thousand pounds to the King, the Parliament, the royal Academies of Petersburg, Berlin, Paris and Madrid. He valued it at four score thousand, and so would anybody who loves hippopotamuses, sharks with one ear, and spiders as big as geese![16]

With admirable speed, within five months of Sloane's death, Parliament had approved the acquisition of his collections, together with the Harleian Library, to form the basis of the British Museum. Sloane's antiquities were, however, gradually submerged by the Museum's subsequent acquisitions with the result that not all of his pieces are now identifiable.

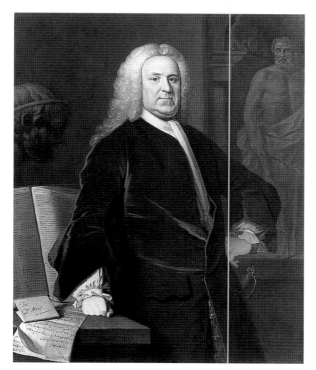

20 Allan Ramsay, *Dr Richard Mead*, National Portrait Gallery

21 Bacchic mask, bronze, British Museum

Another well known collecting doctor at this time was Richard Mead, a man who, as Dr Johnson said, 'lived more in the broad sunshine of life than almost any other (fig. 20). Mead studied medicine first in Holland and then in Italy, taking a degree at Padua in 1693, and visiting Rome and Naples before returning to London in 1696. His common sense and congenial manners won him a large clientele and at the height of his career he was earning a very substantial income of between £5000 and £6000 a year. He had an excellent taste in pictures, owning works both by old masters, Holbein, Poussin, Claude, Ribera, Rosa, Rubens and Jordaens, and by contemporary painters, Panini and Canaletto, as well as by the consumptive Watteau, who came to England to consult him. As his biographer, Matthew Maty, records, 'his large and spacious house in Great Ormond Street was converted into a Temple of Nature, and a Repository of Time. He built a Gallery for his favourite Furniture, his Pictures, and his Antiquities.' Here he offered all-embracing hospitality; 'the Scholar took his place near the Naturalist, and the Mathematician near the Antiquarian, or the Painter'. Like other Fellows of the Royal Society, he had his array of natural curiosities, fossils, snakes in preserving jars, salamanders and frogs, but his classical antiquities were of an unusually high quality and had clearly been selected with a fine aesthetic judgement. He owned, for instance, the bronze head of *Sophocles*, formerly in the Arundel collection (see fig. 10), and an exquisite bronze Bacchic mask, which was particularly remarked upon by Elizabeth Montagu when she visited Mead's house in 1742 (fig. 21); both of these are now in the British Museum. He also acquired some interesting fragments of mural painting from the Baths

of Titus in Rome, which had been illustrated in Bellori's *Sepolchri dei Nasonii*, and some volumes of drawings of antique statues and wall paintings from collections in Rome. In the sale after his death the contents of his cabinet were bought by some of the most discriminating collectors.[17]

A third of these magpie collectors was Edward Harley, second Earl of Oxford, the great bibliophile. He displayed some urns, bronze lamps, busts and marble figures as part of a jumble of curios that included an Indian shield, bows and arrows, a Chinese calculating machine, a Jewish frankincense pot and a silver-mounted rhinoceros horn. He also owned a few items from the Arundel collection, 'four Roman earthen plates (1 broke)' and a bronze Venus. These were, however, no more than incidental to his famous library of books and manuscripts.[18]

COINS

It is significant that at this period most of the general collections of small antiquities were made by professional men. The only field in which both they and the grandees of the court competed was numismatics. As discussed earlier, Henry, Prince of Wales, and Lord Arundel were avid collectors of medals, as was Archbishop Laud, who presented his collection to Oxford University. After the Restoration, the fashion continued. Towards the end of his life, John Evelyn, who had always been an enthusiast, published *A Discourse of Medals* to give advice to fellow collectors on how to appreciate 'the most lasting and (give me leave to call them) Vocal Monuments of Antiquity'. He suggested that the best sources of coins were country people, who might have made discoveries in the fields, goldsmiths and pawnbrokers, tinkers and founders, who were frequently offered old pieces as security for loans or as bullion to be melted down, and, finally, ambassadors or merchants in the Levant. 'But above all, Inquiry is to be made, where any Cabinets or Collections of Medals are to be disposed of, whether by Auction or privately . . . Traffic for Medals between Gentlemen and the Curious, either by Money or Exchange, is ever esteem'd an honourable Commerce.' He warned, however, that numerous fakes were in circulation and gave tips on how to spot them. He had rehearsed the arguments for coin collecting even more eloquently some years before in a letter to Samuel Pepys:

> . . . men curious of books and antiquities have ever had medals in such estimation, and rendered them a most necessary furniture to their libraries; because by them we are not only informed whose real image and superscription they bear, but they have discovered to us, in their reverses, what historical exploits they performed; their famous temples, basilicae, thermae, amphitheatres, acqueducts, circuses, naumachias, bridges, triumphal arches, columns, historical and other pompous structures and erections . . . We come by medals to understand the ancient weights and measures, and the value of moneys; you will see there when it was that princes assumed the radiant crowns, and what the diadem was . . . You will therefore be curious of having the first Caesars, the great Julius (after his Pharsalian victory) being the first honoured with having his effigies, old, lean, and bald as he was . . . Who is not delighted to behold the true effigies of the famous Augustus, cruel Nero, and his master Seneca? Vespasian, Titus, Nerva, Trajan, Antoninus, Severus, the great Constantine and his devout mother Helena?

Joseph Addison in his *Dialogues upon the Usefulness of Ancient Medals* provided a different rationale for collecting coins: after explaining briefly how they supplied details of the physiognomy of famous men, representations of ceremonies, buildings, statues and deities and an unquestionably accurate chronological sequence, he went on to show how they could be used to illustrate passages from the classical poets, proving his case with copious quotations from the authors of antiquity. His essay was directed at the man of taste in his library as well as the pedant with his coin trays. Pope mocks the latter with Scriblerian satire in a poem addressed to Addison:

> With sharpen'd sight pale Antiquaries pore,
> Th' inscription value, but the rust adore;
> This the blue varnish, that the green endears,
> The sacred rust of twice ten hundred years!

The widespread popularity of the subject is indicated by the subscription list of *Del Tesoro Britannico*, published in 1719 and 1720. Nicola Francesco Haym, an Italian musician who successfully introduced Italian opera to London and supplied librettos for Handel and other composers, had a parallel career as a publisher of antiquities. His first two volumes were devoted to a description of coins in British collections. His subscribers included eight dukes, two duchesses, nineteen other members of the nobility, leading figures of London intellectual life such as Dr Arbuthnot, Pope and Addison, and, among other active collectors, Sir Andrew Fountaine and Sir Hans Sloane. The coins that Haym illustrated came not only from the great collections of the Duke of Devonshire and Lords Pembroke and Winchilsea, but also from those of Fountaine, Sloane, Christopher Wren (the son of the architect), the antiquarian dealer John Kemp and William Sherard, the consul in Smyrna.[19] In the provinces coin collecting was equally popular. Ralph Thoresby, the Leeds antiquary, assembled an enormous hoard of medals of all ages, as part of his rambling museum. Over the coming years coin cabinets were regularly recycled by auction following the death of a collector.[20]

LORD PEMBROKE

In the years following the Restoration of Charles II in 1660, a number of great houses were built or refurbished but there were few significant collections of pictures and antique statuary was shunned. The virtuoso and, in particular, his wife had a greater passion for the sparkling colours of Japanese porcelain, which enlivened their cabinets more effectively than a display of old marbles.[21]

The one exception among the nobility of the late Stuart period was Thomas Herbert, eighth Earl of Pembroke (fig. 22). His grandfather, one of Shakespeare's 'incomparable pair of brethren' to whom the First Folio was dedicated, was the patron of Van Dyck and the rebuilder of Wilton, where he installed one of Le Sueur's bronze copies of the *Borghese Gladiator* in the garden. Connected to all three of the first British enthusiasts for antiquities, he was bred to be a collector: his mother was a niece of the first Duke of Buckingham, his great uncle, the third earl, had married Lady Arundel's sister, while Charles I, as John Aubrey records, 'did love Wilton above all places' and was a frequent

22 George Vertue, *Lord Pembroke,* drawing inscribed by Vertue 'The Er. Pembroke the manner of habit as I saw him' and by Horace Walpole 'This is very exact & like him', British Library

visitor. Like other members of his family, Thomas visited Italy as a young man, although on that occasion he only bought 'fans, gloves and two or three pictures sent for small tokens' for his female relations. On succeeding to the title in 1683, he played a dignified part in public life, holding a variety of high offices of state but seldom occupying any important functional role. He was, for instance, Lord High Admiral, although he had never been to sea. A contemporary has left the following description:

> He is a good Judge in all the several Sciences; is a great Encourager of Learning and Learned Men; a lover of the Constitution of his Country, without being of a Party and yet esteemed by all Parties. His Life and Conversation being after the Manner of the Primitive Christians; Meek in his Behaviour; Plain in his Dress; speaks little; of a good Countenance, though very ill Shaped; tall, thin and stoops.[22]

Pembroke seems to have started to collect a year or two before he succeeded to the earldom. It is not possible, however, to establish the precise dates of his acquisitions, the prices he paid or the agents he used, for lack of any surviving papers or accounts. It is known that he bought from a number of sources, the first being the Arundel collection from which Arundel's grandson, the Duke of Norfolk, sold off busts, statues and architectural fragments in about 1680. A column of Egyptian granite, capped with a bronze statue of Venus, was brought down from London to be erected in the entrance courtyard at Wilton and two columns of black porphyry were incorporated into the arch over the buffet in the Dining Room. Thirty-seven statues were acquired from the interior of Arundel House, together with some reliefs and 128 busts, but the statues that had been exposed in the garden were so honeycombed by London pollution that Pembroke offered a substantial premium to take only those marbles that had been kept indoors and left all the rest.[23] There was then a gap in his collecting during the reigns of William and Mary and Anne, while he was occupied with affairs of state. At this time he may have satisfied his acquisitive urges by making additions to the coin collection that had been started by his great-grandfather. This was kept in his London house in St James's Square, where he delighted to discuss his treasures with visiting scholars. In June 1701 Ralph Thoresby recorded:

. . . of all the nobility, none was so agreeable to me as the truly noble Earl of Pembroke, whose incomparable museum of medals entertained me several days . . . my lord would have me promise to dine with him the next day at three, when the Council would be over, desiring, in the meantime, the perusal of my manuscript catalogue of my coins.

Some eight years later he described the collection as 'much enlarged since I saw it before'.[24]

Agents were employed by Pembroke to inspect goods and negotiate their purchase on his behalf, as Pope indicates:

> He buys for Topham drawings and designs,
> For Pembroke statues, dirty gods and coins;
> Rare monkish manuscripts for Hearne alone,
> And books for Mead, and butterflies for Sloane.

Jonathan Swift was used on one occasion to look at a mosaic pavement that had been discovered in Leicester. He wrote to Pembroke in June 1709, 'I have sent Sr Andrew Fountaine a very learned Description of an old Roman Floor (I hope he has communicated to Dr Sloane and Dr Woodward) which is to be sold a Pennyworth. There are only two Objections against buying it; First, that it cannot be taken up without breaking, and secondly, that it will be too heavy for Carriage.'[25]

With the succession of the Hanoverians, Pembroke took a less active part in politics, which gave more time for his books, visiting scholars and, above all, his marbles. The largest purchase was made in about 1724 when he acquired more than eighty busts, twenty-three statues and seven reliefs from the Palais Cardinal in Paris. This collection, which principally consisted of marbles acquired in Rome, had been established by Cardinal Richelieu and had then passed to Cardinal Mazarin, who enlarged it considerably, adding marbles from the London sales of Charles I's assets. On Mazarin's death in 1661, his nephew and niece succeeded to the property. Scandalously, one day in 1670, the niece's crazy husband set about the statues with a hammer, especially any that exposed embarrassing marble nudity, and many of the pieces acquired by Pembroke showed the marks of this assault.[26] Further purchases were made from the collection of the Giustiniani family, Lord Arundel's friends, in Rome, and yet more busts, many of them modern, came from the collection of Giuseppe Valletta in Naples, part of which had been bought by an English doctor in 1720 and then resold the following year after the collapse of the South Sea Bubble.[27] Pembroke also acquired five sarcophagi from the *columbarium* of the freedmen of Livia. These had been offered in the first instance to the young Duke of Beaufort, following their excavation on the via Appia outside Rome in 1726, but the duke had lost interest in them after securing another more important sarcophagus. One visitor records that thirty waggon loads of marble arrived at Wilton in the three years from 1725 and 1728.[28]

There was a perverse methodology to Pembroke's collecting. He eschewed all those minor antiquities that delighted the tradesmen of London, cameos and intaglios, small bronzes, inscriptions on plinths and, because they were repetitious, cinerary urns, although he did allow himself to retain one marble chest, which was supposed to have been the

23 *Hesiod*, marble bust, second century
A.D. from the Mazarin collection,
formerly at Wilton House

24 Carey Creed, *Curtius* relief

receptacle for the ashes of the poet Horace. He excluded altars, because they all looked too much alike, although any which were carved with reliefs were admitted to the collection. He also excluded fragmentary pieces, nameless busts and, as he fondly imagined, any modern works or modern copies of ancient statues. Apart from a few specimen pieces that he thought were of great antiquity, he claimed to avoid anything that came from what he considered to be any inferior source such as Egypt, Etruria or Magna Graecia 'because sculpture did not flourish there until after the best period'. This enabled him to concentrate, as he believed, on works from 'the best ages', especially sculpture from Periclean Athens and imperial Rome. With happy credulity, however, he made exceptions for the busts of *Hesiod* (fig. 23) and *Epicurus*, although they fell outside these eras, because, according to Cardinal Mazarin's catalogue, the portraits were unique. To the enthusiastic collector it seemed incontrovertible that his favourite pieces must date from the age in which literary sources said that the greatest masters had flourished and he therefore gladly accepted the attribution of three statues to the hand of Cleomenes, the sculptor whose name was inscribed on the *Medici Venus*. A similarly extravagant fable was attached to a relief of 'Curtius on Horse-back leaping into the Earth which opens with a Flame of Fire. It is of the finest Work by a Greek Sculptor, brought from Corinth by Polybius who was sent thither by Scipio after it was burnt.' Despite this impressive history, the sculpture was, in fact, wholly modern (fig. 24).

Pembroke was for ever categorizing his collection into divisions by chronology and place of origin, although, since he assumed that most of his busts had been done from the life and since he was apparently unaware that many of his reliefs were not antique, these categories had little validity. He also subdivided the marbles by theme: those illustrating religious, civil and military matters; portraits, which were split between divinities, heroes and historical characters; what he called 'actions', which embraced both allegories and mythological scenes; and, finally, depictions of objects and utensils, of the sciences, of the arts and of customs.[29]

He was obsessed by portraits. According to the author of an early catalogue of the collection, 'Bustos he was particularly fond of, as they expressed with more strength and exactness, the lineaments of the face. Besides the viewing of these brought to the spectator's mind the history and glorious exploits of ancient Kings and Heroes.' This idea that it was possible to read a man's character from his physiognomy was typical of the age. It was, therefore, a matter of pride that no head, however undistinguished, that entered his collection could be allowed to remain anonymous and he and his librarian must have spent long hours bent over the plates of coin portraits in Ezekiel Spanheim's *Dissertationes de Praestantia et Usu Numismatum antiquorum* to identify some feature that could justify the attribution of a suitable name and the inscription of a new title on any vacant plinth. His own enormous coin collection also provided a useful encyclopaedia of faces to help in the process of identification. It was, of course, a hopeless task. As Horace Walpole commented, 'An ancient [virtuoso] indeed would be a little surprised to find so many of his acquaintance new baptised. Earl Thomas did not, like the popes, convert pagan chiefs into Christians, but many an Emperor acts the part at Wilton of scarcer Caesars.' The busts were mounted on very fine marble plinths, which particularly caught the visitor's eye.[30]

Pembroke was suspiciously blind to the possibility of forged antiquities despite the fact that, when it came to his coins, where fakes were known to be prevalent, he was rather proud of his ability to spot them, as he demonstrated to Ralph Thoresby, when he came to see his collection in 1701. On that occasion, Pembroke displayed

a strange variety of counterfeits, in some the metal genuine, but inscription false; in others, one side of the medal genuine, the other counterfeit; in others, one part of the metal right, the other side soldered to it wrong; with a medal of the two famous Paduan brothers, whose counterfeits are not only hard to be distinguished from the originals, but to be preferred to bad ones, though genuine.[31]

In the case of statues and bas-reliefs, however, he preferred to believe that, when an attractive work came from a collection that contained genuine antiquities, the piece was unquestionably antique, even if the previous owner had probably bought it as a contemporary work direct from some French, Italian or Flemish sculptor's studio (fig. 25). Once he had slotted a marble into one of his categories, fanciful theories were spun around it and the details were categorically entered into his manuscript 'Book of Antiquities' as if they were facts. These were, however, liable to modification to suit his audience. When the well known antiquary William Stukeley arrived at Wilton in 1723, Pembroke changed his tune, claiming that the collection was not confined to the sculpture of 'the best ages' but comprised a didactic range of pieces, capable of illustrating the

25 *Drunken Silenus*, seventeenth–century relief, formerly at Wilton House

art of all periods. He invited Stukeley to catalogue the collection but, although a start was made on the project, his constant interference so confounded the scheme that it was abandoned. Stukeley described Pembroke's activities at Wilton:

> He is very busy from morning to night in marshalling his old fashioned Babies as Sir Isaac Newton calls 'em; he is distributing them in proper classes, such as Busto's, Inscriptions, basso rilievos, Statues, etc. These he is placing in distinct Rooms, his Egyptian, Syrian, Lydian, Thracian, Greek, Roman Marbles. Then he is mustering by themselves the old Greek Persons, the learned Persons, the Consular, the Emperors, the Divinities, etc. So that you may suppose that he generally walks 10 miles a day in his own house and sometimes in his Slippers and sometimes is so busy that unless Ladies come to visit him he will fob off his beard (as he calls it) for two or three days.

Some distinguished contemporaries were, however, less impressed, as Joseph Spence records:

> Sir Isaac Newton, though he scarce ever spoke ill of any man, could scarce avoid it towards your virtuoso collectors and antiquarians. Speaking of Lord Pembroke once, he said, 'Let him have but a stone doll and he's satisfied. I can't imagine those gentlemen but as enemies to classical studies; all their pursuits are below nature.'[32]

Pembroke's dates and attributions seem laughable today. At the time, however, there existed no accurate chronological framework and, like Dr Woodward's shield, the antiquities at Wilton, which comprised the largest collection at that time in England, were inevitably misjudged if they were examined by scholars who had an extensive knowledge of classical literature but little familiarity with marbles in other European collections. Moreover, Pembroke had been advised on his acquisitions by Sir Andrew Fountaine, a well known virtuoso, who was famed for his antiquarian skills and had twice

been to Italy.[33] Visitors to Wilton were all equally impressed. The antiquary, Roger Gale, was so enthusiastic that he felt that all the marbles should be published since they were the best north of the Alps, while Sir John Clerk, who had particularly admired the spurious relief of Curtius, declared that the collection would 'befit the house of a great King'. Half a century later, attitudes had changed. When Charles Townley visited Wilton, he annotated a copy of the guidebook and concluded that only 45 items were 'of sufficient merit and preservation to be admitted in a collection of marbles', while 200 were 'modern or mutilated' and he overlooked 30 other pieces. He frequently commented 'modern', 'rubbish' or 'mutilated so much as to be unworthy of notice'.[34]

In his last years Pembroke determined that the whole of his collection should be published with separate volumes on the statues, the coins and the paintings. It was to be the first of a series of catalogues which proud owners were to issue over the next two centuries, describing their collections. Instead of printing the lists from the manuscript 'Book of Antiquities', he commissioned an obscure artist by the name of Carey Creed to illustrate a selection of the statues, reliefs and busts. These were published shortly before Pembroke's death in a slim volume of seventy-four plates, issued without any introduction or text, apart from the owner's dogmatic attributions beneath each figure. The plates, which are quite unlike reproductions of statues in Italian, Flemish or French scholarly works at this period, seem to be deliberately vague, like prints of drawings from an artist's sketchbook, and the captions are printed as facsimile manuscript. It was as if Pembroke, in his heart of hearts, knew that some of his claims were dubious and wanted to reduce the possibility of criticism by scholars, who might have attacked his assertions more boldly if the plates had given a more conventionally accurate representation of the originals. Clerk, who was disappointed by the publication, wrote that Pembroke's manner of writing convinced him:

> that the several accounts at the foot of each figure in his Book of Statues are truly his own. It seems he has there set down his notion of each piece, and has obliged the etcher or engraver to make it, as he wrote it, part of the copper-plate. I was surprised at first to find some things asserted as dogmatically in this book, and in such a manner as did not become the publisher . . .

Foreigners were even less polite: a few years later Winckelmann mockingly suggested that Cleomenes should have been sent straight to Wilton to carve the Curtius relief.[35]

There are uncomfortable indications that Pembroke was not only cavalier in his attributions and in the stories that went with them, but was responsible for some faking himself to support his own theories. At one stage he developed an interest in early writing and he even took to transcribing and annotating some of his inscriptions in pencil on the adjacent wainscot for the benefit of visitors. When he failed to procure specimens of what he wanted from the consul in Smyrna, he seems to have invented some suitable examples to supplement gaps in his collection. He claimed that his research into epigraphy dated back to his early youth, because a note in the 'Book of Antiquities' states that he had himself measured the letters in ancient inscriptions when in Rome. Such scholarly dedication is possible but would have been remarkably precocious in 1676. Perhaps in later life he persuaded himself that he had done more than buy fans for his womenfolk when travelling in Italy as a young man. In 1733 Thomas Hearne confided

26 Wilton House, the Double Cube Room with some of Lord Pembroke's busts as originally arranged

to a friend his suspicions that a supposedly archaic *boustrophedon* inscription and a relief had been applied to an altar since it had entered the Pembroke collection ten years earlier. 'Should it not be genuine, 'twould make other things in that Collection suspected,' he wrote, adding in a subsequent letter, 'I understand Lord Pembroke insinuated, as if it was brought from Persepolis.'[36]

There is no doubt about Pembroke's enthusiasm for his collections. He seems, however, to have had a dangerous amount of knowledge; he had read enough to be able to devise optimistic theories about the sculptures in his house but was unable to apply any judgement to them. Then, as he grew older, he was tempted to doctor his marbles to fit his theories or provide examples of rarities which he lacked. To him it probably seemed no more reprehensible than providing a name for an anonymous bust on the basis of a coin type. His position made it hard for anyone to disagree, because the visiting scholars whom he generously entertained at Wilton would have hesitated to contradict a nobleman who had held the offices of Lord President of the Council, Viceroy of Ireland and Regent of the realm.

The marbles were arranged and frequently rearranged in the great series of reception rooms at Wilton. A fire, which damaged the north side of the quadrangle in 1704, pro–

46

27 Robert Nanteuil, *Cardinal Jules Mazarin in his Gallery*

vided an excuse for some rebuilding so as to display the collection to better advantage. A grand entrance vestibule was created with an apse like the end of a basilica in which was placed a statue of *Apollo* from the Giustiniani collection together with eleven busts. The Vestibule led into the Hall, which was rebuilt on the model of Inigo Jones's Banqueting House in Whitehall and eventually contained the largest pieces, including some of the sarcophagi. In another part of the house, the Basso-relievo Room was lined with two rows of mainly seventeenth-century reliefs, all supposedly antique. In the Double Cube twenty-six busts complemented the noble canvases by Van Dyck (fig. 26), while in the Single Cube seventeen busts and some altars and reliefs were arranged beneath the portraits. Only the Withdrawing Room, the Dining Room and the bedrooms were spared a large quota of marbles. In the end, there was no attempt to display the collection didactically, despite Pembroke's elaborate categorizations. Statues and busts were disposed according to size, deities being indiscriminately paired with historical characters or personifications to suit the decorative scheme. He would, in fact, have preferred to locate them all in one long gallery but he had so many statues that 'were this Collection to be set with Harmony together (though on both sides) with the common Distance between, it would require the Length of 1000 Feet. Such a Gallery is only fit

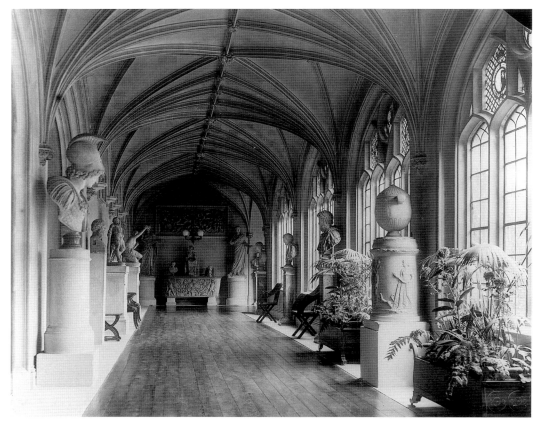

28 Wilton House, Cloisters before the sale of part of the collection

for a Royal Building.'[37] Instead, he replicated at Wilton the sort of interiors, some wholly devoted to marbles and some combining sculpture with paintings, which he had seen in Italian palaces on his youthful travels. He must also have known the print showing Mazarin seated in the gallery from which so many of the marbles at Wilton had come, a gallery in which antique statues were ranged beneath the cardinal's paintings (fig. 27).

After Pembroke's death in 1733, Creed's booklet of illustrations was felt to be an inadequate record of the sculptures. Detailed descriptions of the collection were, therefore, published in 1751 and 1769, based on the manuscript account with all its fables. From these books it appears that the collector's son, who was a gifted amateur architect, and his grandson were both responsible for altering some of the displays, while keeping the general arrangement. In the early years of the nineteenth century, parts of Wilton were rebuilt to improve circulation within the house and the collection was reorganized round an internal cloister, designed by James Wyatt (fig. 28). It is disappointing that no detailed pictorial record survives to show the arrangement of the marbles in those parts of the house that Wyatt changed.[38]

After a visit to Wilton in the 1870s, the German scholar Adolf Michaelis acknowledged that there were some interesting specimens but he was shocked by 'the large

number of spurious pieces, the abominable restorations, and the absurd nomenclature' and he dismissed the eighteenth-century guidebooks to the collection as 'models of untrustworthiness and uncritical style'. He was quite right and yet his austere probity blinded him to the naive charm of Pembroke's display. His strictures devalued the merits of the whole ensemble, as a result of which much of the collection was dispersed as mere fakes in the 1960s simply because the statues bore over-ambitious names. Even Christopher Hussey, describing Wilton for *Country Life* in 1963, shortly after the sale, could dismiss the ensemble without regret:

> As arranged by Westmacott the walls . . . and much of the floor were overcrowded with the largely fragmentary classical sculptures, reliefs and inscriptions of the Arundel and Mazarin marbles, which, notwithstanding their historical interest, have come today to possess diminished aesthetic and technical importance. The recent sale of much of the venerable clutter [see fig. 205] has left all the more decorative pieces . . .

Most of what remains of Pembroke's collection at Wilton is still to be seen in the Cloisters, some sarcophagi are in the visitor centre and a few pieces stand in the garden.[39]

ARCHITECTURAL DECORATION

When Lord Pembroke started to collect antiquities in the 1680s, he was almost on his own and yet, by the time of his death, half a century later, great houses throughout England were being decorated with classical statues, busts and reliefs, both ancient and modern. It is important to stress the decorative aspect of collecting at this stage. Few of the owners of these houses had Pembroke's scholarly, if wayward, interest in antiquity and none of the most significant collectors of Italian paintings in the late Stuart period (the Earls of Exeter, Shaftesbury and Sunderland, Lord Somers and Sir Thomas Isham) bought marbles.[40] The renewed taste for the antique was more influenced by a change in architectural fashion.

During the reigns of William and Mary, Anne and the first Georges, the magnates who governed the nation built palaces which could proclaim their influence over the surrounding county. The architects of the age, Talman, Vanbrugh, Gibbs and their Palladian successors, created magnificent country houses to make the desired political statements and, to reinforce the message, they designed grandiose entrance halls and saloons, the principal rooms for impressing the visitor. As the size of these rooms increased, a new style of decoration was introduced; wainscot panelling, inappropriate for a very large chamber, started to give way to bare walls, ribbed with giant pilasters, while the never very convincing allegorical creatures painted by Verrio and Laguerre were transformed into figures of marble or plaster, straddling pediments over doorways and gesticulating from niches. Classical statues and busts fitted ideally into such decorative schemes but, since the uninformed visitor might be disturbed by the effect of time's mutilations, there was a preference for copies or, at any rate, for well restored pieces of antiquity. As an alternative, stuccoists improvised elegant deities and sculptors, such as Rysbrack, carved marble reliefs, more satisfactorily Roman than anything that could have been imported

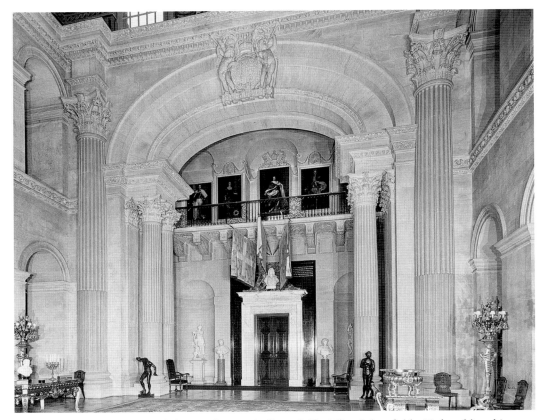

29 Blenheim Palace, Hall with bronzes by Massimiliano Soldani Benzi dwarfed by Vanbrugh's architecture

from Italy. This style of decoration first began to appear at the turn of the century and, by the time that the cult of Palladio had become architectural orthodoxy in the 1720s, it had spread throughout the country. At the same time, lead versions of classical deities appeared among the topiary work of the fashionable Dutch gardens that extended before the façades of the new houses.[41]

King William himself had thought of decorating his new palace at Hampton Court with 'a large parcel of Statues and Busts' for which he agreed to pay £500, 'being cheap, the marbles entire at £50 each and the busts at £15, the prime cost and no more than they cost in Italy', but he died in 1702 before the unfortunate merchant had been paid and Queen Anne instructed that the goods should be taken away. In the end, however, they were retained and dispersed round the Privy Garden. The statues were modern works which were considered perfectly acceptable for a royal palace. In the same way, Vanbrugh's original design for the saloon of the Duke of Marlborough's new palace of Blenheim incorporated a number of modern Italian statues of classical deities and, although, in the final plan, the room was painted by Laguerre, four excellent bronze copies of the most famous Florentine antiquities, the *Medici Venus*, the *Dancing Faun*, the *Arrotino* and the *Wrestlers*, were commissioned in 1709, through the consul in Leghorn,

30 Peter Tillemans, Arundel Marbles composed as the *'Tomb of Germanicus'* at Easton Neston, inscribed 'Tomb of Germanicus and his wife Agrippina with the statue of Jupiter on an Altar . . . over it the standard of Greek measure', British Library

to decorate the Hall (fig. 29). They were, in fact, much too small to suit Vanbrugh's giant architecture.[42]

The casual attitude towards genuine antiquities is exemplified by the fate of the remains of the Arundel Marbles. They were acquired by Lord Lemster in 1691 as ornaments for his formal garden at Easton Neston. Then, when he decided to rebuild the house in about 1695, the better preserved statues were brought indoors and placed in niches to decorate the severely grand stone hall and staircase, which Nicholas Hawksmoor had designed, while busts were used as ornaments over the windows of one façade and a sarcophagus and various fragments were composed as a folly in the garden (fig. 30):

At the end of the terrace . . . is Germanicus's tomb; it is formed thus, viz. an alcove or arch is in the middle, and upon a large oblong pedestal stands the Sarcophagus, or tomb of Germanicus . . . ; upon the tomb is set a round pedestal, and on that a marble statue of Jupiter less than the life; on each side of this pedestal are fine bustos of two women, and on each side of this arch or alcove are doric pilasters, which support a pediment, in which there is a basso relievo the figure of a man as big as the life, with his arms extended.

31 John Talman, Design for a
Cabinet, Victoria and Albert
Museum

There were also two greenhouses full of statues 'as if it was the shop of a statuary'. Although Lemster was a sympathetic owner, who welcomed scholars to his house, he used the statues mainly for architectural decoration and did not appreciate them as works of art in their own right.[43]

John Talman, son of the architect William, had a similar attitude towards antiquities. When he was travelling in Italy in 1709, he was eager to secure 'fine marbles, shafts of pillars & statues &c' as decoration either for Blenheim or for the houses of other potential clients, the Duke of Devonshire, the Earls of Halifax and Pembroke or Lord Somers. Better still, he hoped that such elements could be incorporated into a new royal palace, suited to the 'greatness of a Queen who has a soul to do as glorious things in arts at home as she has done in arms abroad'. Among his drawings there is a design for a small cabinet, crowded with columns, reliefs, statues, busts and bronze lamps, which indicates the rich style of decoration that he hoped to introduce into England (fig. 31). He was unsuccessful, but it is interesting to note that he was travelling in Italy with the rising young artist and architect William Kent who may well have been influenced by his friend's taste for using antiquities as architectural decoration when he came to work for his own patrons, the Earls of Burlington and Leicester and Sir Robert Walpole. Late Stuart interest in Italian marbles owed more to the Muse of Architecture than to those of History or Sculpture.[44]

Grand Tour Collecting in the Early Eighteenth Century

ITALIAN TRAVEL

After the Treaty of Utrecht had brought an end to the War of the Spanish Succession (1702–13), it became possible once again to visit the cities of Europe with freedom. As overseas travel became easier, an increasing number of young men went on a Grand Tour, mainly to the Low Countries, France and Italy, but, as the century progressed, Italy became the predominant destination. Most visitors were accompanied by bear-leaders, as their tutors were called, and many of them recorded their impressions in letters home or, if the bear-leaders were sufficiently earnest, in stilted journals that dutifully described the paintings seen and the ruins, palaces and churches visited each day. Much space was always devoted to the discomforts of travel, the flea-infested inns, the lameness of the post horses and the impertinence of customs officials. Sometimes the account is at second-hand through the tutors' letters or the lists of expenses incurred during the expedition. From 1717 on, when James III, the Old Pretender, took up residence in Italy, there is a further source of information about visitors in the form of the despatches from the British envoys in Venice and Florence and their agents, who kept a suspicious eye on the comings and goings of potential Jacobite sympathisers.

A Tour was regarded as the most suitable finishing school for young men who had completed their university studies and but had not yet entered Parliament, started a legal or military career or sunk into the comfortably torpid routine of a country squire. For most visitors the objectives had changed from those of their forebears in Tudor and Stuart times. Interest in statecraft and the constitutions of different states had disappeared. Although the affectation of foreign manners was ridiculed, it was still considered important to visit the provincial courts and the houses of the local nobility, even if this meant suffering the tedium of attending *levées* and evening *conversazioni* at which the visitor knew no one and found little to refresh the mind, still less the inner man. For many, music was an attraction and enthusiasm for the opera sometimes led to a dangerous passion for a leading singer. More significantly, increasing attention was paid to works of art and, in particular, to the antiquities in the principal cities. The young men had just emerged from what was an almost wholly classical education, while their tutors were usually either classical dons or classically educated clergymen. Inevitably, therefore, visits to classical ruins were almost obligatory, although the enjoyment or dislike of ancient

sites was generally in proportion to the tourists' enjoyment or dislike of their recent studies. Many were frankly bored but some were inspired to acquire antiquities as mementos of their Italian travels. The city guides, known as *ciceroni*, who specialized in giving conducted tours to visitors, often acted as middlemen for making their purchases.[1]

It must be stressed that the enthusiasm for collecting antiquities was part of a general pattern of acquisition that was facilitated by the rise in national prosperity. There was a relative scarcity of domestic art and, in any case, fashionable taste preferred work by foreign masters to the production of native artists, smoky canvases by the Carracci to history scenes by contemporaries. This resulted in a strong demand for Italian and Dutch paintings, both secular and religious, for old master drawings, majolica dishes, scagliola table tops, bronzes and fine porcelain, both oriental and Meissen. The foreign paintings and ornaments that Hogarth introduced into the scenes of his *Marriage à la Mode* were intended as a sarcastic comment on the popularity of foreign *bon ton*.

The Italian antiques trade was based in Rome because of the concentration of both materials and visitors. The export of important antiquities was, however, severely restricted. No marble could be shipped from the Tiber quays in Rome to Civitavecchia, the port for transhipment, before the Papal Antiquary had inspected the goods and granted an export licence. In practice, this was seldom a problem for British buyers in the early eighteenth century, because the quality of the goods acquired was generally not very high. In addition to freight and insurance, the buyer had to pay an export tax at the rate of 3 or 4 per cent on the value of the goods (which the Papal Antiquary was 'feed' to agree at a low figure) and British import duty of 20 per cent of the Papal Antiquary's valuation, if the officer at the Customs House in London could be persuaded to accept it.

If influential pressure to obtain an export licence was needed on any occasion, the British made use of Cardinal Alessandro Albani, the nephew of Pope Clement XI (1700–21). As a young man Albani had served in the papal cavalry but he had been forced to retire on account of his poor eyesight, which was no bad thing because he preferred the study of antiquities to military manouevres. He was created a cardinal by Innocent XIII (1721–4) and became the regular supporter of Hanoverian interests in the complex world of Vatican politics. He was one of the very few Roman connoisseurs at this period who was an active collector of antiquities but he was one of those collectors who also enjoy dealing and he was often willing to trade his statues with other enthusiasts. Having disposed of most of his first collection in 1733, he proceeded to build up another on a rather more sophisticated basis, latterly under the guidance of the abbé Winckelmann, who became his librarian in 1758. He was even prepared to act as purchasing agent himself for favoured collectors. To Bubb Doddington, for instance, the rich but rather comic figure whose podgy features are immortalized in Hogarth's *Chairing the Member*, he supplied five statues for 1500 *scudi* in 1751 to go in the new gallery of his house in Hammersmith, although he failed to persuade him to buy further marbles from the Villa d'Este at Tivoli, and the following year he helped to arrange a shipment of modern statues by Francavilla for the Prince of Wales.[2]

Numerous less eminent dealers were available to supply those who were interested in making purchases. At one end of the scale, there was the shepherd, drawn by Pier Leone Ghezzi as he wandered round, plucking the visitor's sleeve to offer medals discovered

32 Pier Leone Ghezzi, *Philipp von Stosch with a Group of Antiquarians*, Albertina, Vienna

in the Campagna, much as his descendants molest the unwary today. At the other end hovered Francesco de' Ficoroni, author of several antiquarian pamphlets and a guidebook to the antiquities. He courted all visitors to Rome, acting as a *cicerone*, if required, and supplying marbles and gems, but he had a dubious reputation for sharp practice, impartially swindling Italian vendors and British buyers and dealing in stolen goods as well. There was also an indigent Prussian baron, Philipp von Stosch, a serious scholar, particularly on the subject of gems, who bought on behalf of several Grand Tourists. He was, however, in receipt of a pension from the British government to act as a spy on Jacobite visitors and was regarded with some suspicion. In an unusually complex caricature Ghezzi depicts himself sketching a group of antiquaries gathered round a fragmentary male torso with significantly emphasized bare buttocks; Stosch is shown wearing a nightcap and a Teutonic monocle, guarded by his pet owl, as he sits haggling over gems with fellow enthusiasts, who include Ficoroni (fig. 32).[3]

When a visitor did succumb to the collecting urge, these dealers could arrange for one of the many sculptors at work in Rome to supply deficient limbs for a battered trunk or to produce replicas of favourite statues. Payment was settled through a correspondent banker and, once an export licence had been obtained, the goods were shipped up the coast from Civitavecchia to Leghorn, where transport back to England was organized by the colony of British merchants, most of whom were based in Tuscany. In important cases, as when bronze replicas were being commissioned for the Duke of Marlborough, the resident consul himself was involved.

To cater for the growing number of tourists, a series of new guidebooks was produced throughout the eighteenth century. Two, in particular, had an impact on the way in which the visitor viewed the country. In 1705 Joseph Addison published his *Remarks on Several Parts of Italy &c. in the Years 1701, 1702, 1703*. Addison tried to make his travellers see Italy through the eyes of the ancient authors, concentrating on the classical past as if the architectural triumphs of renaissance and baroque Italy hardly existed – he does not even describe St Peter's. As Horace Walpole put it, he 'travelled through the poets, and not through Italy; for all his ideas are borrowed from the descriptions, and not from the reality'. Nevertheless, the fame of the essayist of the *Tatler* and the *Spectator* won many readers for his *Remarks*, which superseded the dangerously papist descriptions of Richard Lassels's *The Voyage of Italy*, first published in 1670. 'Great Addison . . . with his satchel of school-books hanging at his a –' was safer reading and provided bear-leaders with ample material for instructing their charges.[4]

The second and more influential volume was *An Account of some of the Statues, Bas-reliefs, Drawings and Pictures in Italy with Remarks* by Jonathan Richardson, published in 1722, just after the twenty-eight-year-old author had completed a two-year Tour. Richardson was the son of a respectable portrait painter of the same name, who was an excellent connoisseur and had acutely trained the young man's eye on old master drawings. He described the most important pictures, especially in Florence and Rome (but not in Naples which he never visited), and listed the principal antiquities with brief comments: 'a great Taste', 'very great Style', 'incomparable', 'has a lovely Sweep' but also 'not of a good Style', 'of undoubted Antiquity . . . and not at all the less for the Badness of the Work; for the Ancients had Indifferent Hands as well as we'. He spared no pains in his investigations; in the gardens of the Villa Medici, for instance, he scrambled up a piece of the ancient Wall of Rome so that he could mount the figures of Cleopatra and the Niobe group and consider their features at close quarters. He was careful to point out where the most famous statues had been restored and, by indicating the joints between the old and the new, he showed potential purchasers of antiquities how they could detect repairs to any marbles that they might consider buying themselves. His *Account*, checked and co-written by his father, was a useful pocket-sized compendium and provided the tourist with a remarkably balanced and sensible commentary on works that were all too often regarded with unthinking adulation. Even Winckelmann was to speak well of it.[5]

The whole business of the Tour is vividly satirized by William Cowper in *The Progress of Error*.

> From school to Cam or Isis, and thence home;
> And thence, with all convenient speed, to Rome,
> With rev'rend tutor, clad in habit lay,
> To tease for cash, and quarrel with all day;
> With memorandum-book for ev'ry town,
> And ev'ry post, and where the chaise broke down; . . .
>
> The youth, obedient to his sire's commands,
> Sets off a wand'rer into foreign lands . . .
>
> Ere long, some bowing, smirking, smart abbé
> Remarks two loit'rers that have lost their way;

And, being always prim'd with *politesse*
For men of their appearance and address,
With much compassion undertakes the task
To tell them – more than they have wit to ask:
Points to inscriptions wheresoe'er they tread,
Such as, when legible, were never read,
But being cank'red now, and half worn out,
Craze antiquarian brains with endless doubt;
Some headless hero, or some Caesar shows –
Defective only in his Roman nose;
Exhibits elevations, drawings, plans,
Models of Herculanean pots and pans;
And sells them medals, which, if neither rare
Nor ancient, will be so, preserved with care . . .

The squire, once bashful, is shame fac'd no more,
But teems with powers he never felt before; . . .

Returning, he proclaims, by many a grace,
By shrugs, and strange contortions of his face,
How much a dunce that has been sent to roam
Excels a dunce that has been kept at home.

Although the poem was published in 1782, the picture could have been painted at almost any time during the eighteenth century.[6]

THE DIFFICULTIES OF COLLECTING

By the end of the seventeenth century, the competitive collecting rivalry between the leading Italian families had virtually come to an end and the process began to unwind with the sale of some of their collections. In 1720 part of the Giustiniani marbles was sold. Four years later Philip V of Spain secured the Odescalchi collection, which had been assembled by Queen Christina of Sweden in the previous century. Then in 1728 the Elector of Saxony bought all the antiquities belonging to Prince Chigi, as well as thirty statues acquired in recent years by Cardinal Albani. All these exports were frowned upon. In 1686, provoked by the loss of some important statues to France, Innocent XI issued an edict restricting the export of antiquities without a licence and this was rein-forced by further edicts of Clement XI in 1701 and 1704. Since, however, decrees were less effective than cash, the flight of marble deities and emperors was only checked when Pope Clement XII bought the balance of the Albani collection for 60,000 *scudi* and trans-ferred it to the Capitol, where a new museum was established in 1734.[7]

During this period, Lord Pembroke was the only British connoisseur who sought to compete with such royal collectors. As Willem Bentinck, half-brother of the Duke of Portland, explained to his mother from Rome in 1727, 'Antiquities good and preserved as they ought to be [i.e. not too heavily restored] are not to be had by Strangers unless by chance, or some good luck of theirs, and even in those cases one must be upon his

guard because of all the tricks that are played.'[8] This was the general opinion: the genuine article was hard to find, overpriced and, because of the papal restrictions, difficult to export without very strong political influence. It was easier to buy reproductions or else paintings by old masters, which were not fenced with such stringent controls and would, in any case, be more appreciated back in England. Furthermore, reproductions looked smarter to the untutored eye. Hamlet Winstanley, who was in Rome in 1723, chiefly to buy pictures for the Earl of Derby, wrote back:

> I have seen several Busts Antique and Modern . . . the Antique ones are poorly done and the best of the Modern ones are copied from the finest Antique. There are several of the Modern ones that are originals, but I think the copies from the Antique are much finer & better done. The antique things that are to be sold nowadays are very poor, and their chief value is their antiquity . . . the Antiques & Modern busts which I saw was all one price, that is 40 Crowns [*scudi*] a bust.[9]

For this reason George Parker, who was travelling in Italy from 1719 to 1722, chose to buy casts and bronzes to send home to Shirburn Castle, which his father, the Lord Chancellor Macclesfield, had recently acquired. Bronze copies of the *Medici Venus* and the *Dancing Faun* and busts of *Plautilla* and *Geta* were provided by Pietro Cipriani, who had assisted Soldani with the casts made for the Duke of Marlborough a few years earlier. To these Parker added thirteen small bronzes, of which three were copies of modern works by Bernini and Legros and ten were copies of famous antique statues, including the *Wrestlers*, *Germanicus*, the *Boar*, the *Hermaphrodite* and the *Medici Venus* and *Dancing Faun* (again), as well as a series of plaster busts, all supplied from Florence. The busts were intended to go above the bookcases in the library, while the small bronzes still stand on soft leather mats provided to stop them scratching the tops of the tables on which they were to be set. Parker was advised about these purchases by his bear-leader, Edward Wright, a competent virtuoso whose letters were to form the basis of a popular guide-book, and by John Molesworth, the former envoy to Tuscany. Wright gives a vivid description of the thrill conveyed by the statues of Florence and Rome that had inspired his pupil's purchases:

> There is a People of Statues in Rome. Ficoroni told us . . . that he has counted eleven thousand four hundred and odd, that are antique . . . Of all the Entertainments in Italy, there is nothing, I think, more agreeable than that which arises from the Observations of the antique Statues. To see the Emperors, Consuls, Generals of Armies, Orators, Philosophers, and Poets, and other great Men, whose fame in History engag'd our earliest Notice, standing (as it were) in their own persons before us, gives a Man a Cast of almost two thousand Years backwards . . . we can see Tully [Cicero] declaiming, and Caesar dictating. We can see the Beauties of those early Times, the Faustina's, the Livia's, the Sabina's, the Plautilla's . . . As the Statues give us the Pleasure of seeing the Persons of these great Men, so the Basso-Relievo's give us authentic Information of their Customs; in their Wars, their Triumphs, their Sacrifices, their Marriages, Feastings, Funerals, and many other Particulars.[10]

A few years later, General James Dormer, friend of Alexander Pope and a member of the Kitcat Club, acquired a collection similar to Parker's. He bought small bronze copies

both of antique statues, such as the *Apollo Belvedere* and the *Farnese Hercules*, and of Mannerist works. He never visited Italy himself but he may have been in touch with Cipriani, who is mentioned in the family correspondence, and he had an agent buying for him in Paris in 1739. An inventory lists twenty-two bronzes in the Parlour at Rousham, ten in the Hall, nine in the Dining Room and others elsewhere in the house, as well as twenty busts in the Library. William Kent, who remodelled the house and garden, designed plinths and brackets to display the bronzes in the Hall and the Painted Parlour which he was redecorating in about 1740 (fig. 33). 'The general . . . is still bronzo mad', he wrote. At the same time, some copies of antiquities in lead and

33 Rousham, the Parlour with Kent's brackets for bronzes

stone were bought from Cheere and Scheemakers to adorn niches on the façade of the house and the glades in the exquisitely landscaped garden.[11]

It was safer to buy copies because tourists had good reason to be wary of 'the tricks that are played', as Willem Bentinck warned. Lord Annandale, for instance, was in Italy between 1718 and 1720, when he acquired over three hundred paintings and also a few ancient marbles. He left the latter with the sculptor Agostino Cornacchini to be restored, but when his nephew, Lord Hope, visited Rome a few years later and made enquiries about them, they had disappeared. Ficoroni was suspected of being the culprit. As Annandale sadly warned Hope, 'None of these wretches are to be trusted with the value of one single sixpence further than you can see them.'[12]

PAPER MUSEUMS — AND THE ALTERNATIVE

Faced with these difficulties, some lovers of antiquity preferred a completely different course of action. Richard Topham, for instance, who was Keeper of the Records of the Tower of London and M.P. for Windsor, formed a large library on architecture and archaeology and a comprehensive encyclopaedia of prints and drawings of the statues in all the principal collections in Rome. By 1709 he was already discussing the latter project with John Talman who wrote to him from Italy:

> If a design . . . of copying all the antiquities in such manner as to form a complete corpus of the antique statues and gems &c were to be carried on, it would be very proper to begin in this place [Rome], wherein so many valuable remains are extant. But an undertaking of this nature would require both time and money . . .[13]

Talman seems to have had in mind the publication of a series of prints for which 'the Curious' would subscribe, rather as, at a slightly later date, members of the Society of

34 Pompeo Batoni, *Young Satyr*, drawing from the Topham collection, Eton College

Antiquaries commissioned prints of British antiquities. Today it is difficult to imagine the problems of obtaining reliable images of distant monuments in the years before photography or to appreciate the potential value of collections such as dal Pozzo's Paper Museum. Although the corpus of prints proposed by Talman could well have been popular, especially if accompanied by some text in English, nothing came of the idea. In fact, such a series might not have been a very profitable venture, following the publication of Paolo Alessandro Maffei's *Raccolta di Statue antiche e moderne* in 1704, which provided a collection of prints of all the best known statues in Rome, although not those in other cities. It was issued by Domenico de' Rossi, the leading Roman print seller.[14]

Undeterred by Talman's warning about the expense, Topham later made contact with Francesco Ferdinandi, known as Imperiali, a natural choice because he was popular with British visitors not only as a portrait painter and tourist guide but also as a teacher of British painters, who worked in his studio. At Topham's request, Imperiali employed a number of artists to provide systematic reproductions of the collections in each of the palaces of Rome and from the studio of Francesco Bartoli he also procured watercolour copies of antique paintings, which had become a topic of great fashionable interest. The collection today contains fifty-three red chalk drawings after the antique by the young Pompeo Batoni. His careful outline delicately softens the hard contours of the marble and the tints of his finely flecked shading convincingly describe the moulding of a bas-relief as well as the full three dimensionality of a statue. So exquisite is the detail that the overall impression is slightly misleading; Batoni seems to illustrate pieces of graceful Capodimonte porcelain rather than classical statuary (fig. 34). Nevertheless, they are among the most beautiful of all the works of art derived from antiquity. On his death, Topham's remarkable collection was transferred to the library of Eton College, where it remains.

Lord Coleraine also preferred to make a 'paper museum'. Despite his peerage, he was an outsider rather than a conventional grandee and his seat, Bruce Castle, was an old

manor house at Tottenham in Middlesex. His family had academic interests, his grandfather corresponded learnedly about coins with William Courten and Dr Woodward, his father translated Lucian and his sister committed the extraordinary social solecism of marrying his Oxford tutor. His own domestic life was unconventional; his wife, the rich heiress of a Governor of the Bank of England, thought proper 'utterly to forsake his bed and house' within three years of marriage and, despite all entreaties, refused his offers of reconciliation. He therefore formed 'a solemn engagement and connection' with a Huguenot clergyman's daughter, who bore him an illegitimate child. He was one of the very few peers in regular attendance at the meetings of the Society of Antiquaries, which now owns his collection of papers on British antiquities.

In 1723, on one of three visits to Italy, he 'made a noble collection of prints and drawings of all the antiquities, buildings and pictures in Italy', which he subsequently bequeathed to Corpus Christi College, Oxford, together with his library of Italian books. The enormous collection of prints is pasted into folios. There is good coverage of Florence, Bologna and Venice but over half the volumes are devoted to Rome, which is depicted district by district. His interests spanned contemporary architecture, painting by both ancient and modern masters and every form of antiquity. He must have been one of the best customers of the de' Rossi print shop in Rome and, when no reproduction was available, he bought drawings of busts and statues instead. A couple of these are signed by Hamlet Winstanley. They are, however, run of the mill sketches, lacking the delicacy of the reproductions that Batoni made for Topham. The careful indexation of the folios shows that Coleraine intended them for serious study, although no publication was derived from either this or Topham's collection.[15]

In contrast to these compilers of paper museums, most Tourists who collected real, or supposedly real, antiquities had modest ambitions. A typical example is Conyers Middleton, who accompanied Coleraine for part of his visit in 1723. He was a tiresomely polemical Cambridge don, who had had to leave the university after a prolonged dispute with Richard Bentley, the Master of his college. Although Middleton posed as a virtuoso, he bought antiquities, not 'out of any regard to their beauty or sculpture, but as containing what the Italians call some erudition in them, and illustrating some rite or custom of old Rome, alluded to by the ancient writers'. Some twenty years later, in 1745, he published a description of the objects in his collection, *Germana quaedam antiquitatis eruditae monumenta*, with dissertations on their significance, just before he sold the lot for £131 to his former Cambridge pupil Horace Walpole, who wanted to augment his own recent purchases in Italy. Middleton's little museum comprised exactly the sort of minor pieces that could be exported without licence problems: small bronzes and marbles, lamps, Priapic amulets, glass vessels, gems, coins and a fragment of a sarcophagus. They did, however, provide material for displays of donnish erudition.[16]

THE DUKE OF BEAUFORT

Willem Bentinck's reference to good luck was not wide of the mark because the single most significant acquisition made at this period was a gift rather than a purchase. The young Duke of Beaufort came to Italy on his Grand Tour in 1726 and 1727. Rich, malleable and with great potential influence, he was eagerly courted by the Old Pretender's

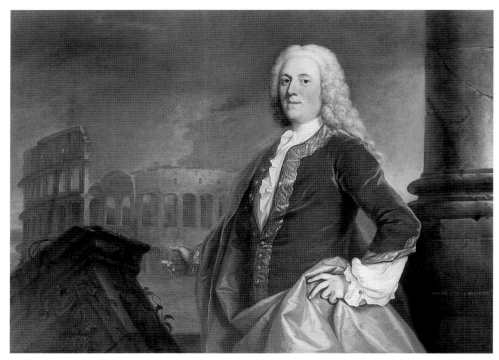

35 Andrea Soldi attr., *Duke of Beaufort*, The Duke of Beaufort, Badminton House

entourage, who hoped that he might be as loyal to the house of Stuart as his ancestor had been during the Civil Wars. He gave splendid entertainments in honour of the exiles and spent on a princely scale. In his portrait, attributed to Andrea Soldi, he is shown gesturing towards the Colosseum with a lordly air as if the ruins were no more than a decorative folly on his Gloucestershire estates (fig. 35).

In Florence Beaufort ordered an outstandingly important *pietra dura* cabinet from the Grand Duke's workshops. In Rome he spent over 30,000 *scudi* on pictures and marbles, using Ficoroni as one of his advisers. The paintings were of variable quality, comprising attractive canvases by Guercino, Pietro da Cortona and Salvator Rosa but also works optimistically attributed to Leonardo and Raphael. Antiquities were a natural addition to this grand haul. A *columbarium* or communal tomb, containing a large number of urns and sarcophagi of the freedmen of the empress Livia, had recently been discovered near the Appian Way. After a hasty excavation, the tomb itself had been demolished and the marbles divided between two cardinals, Alessandro Albani and Melchior de Polignac. Beaufort appears to have shown sufficient interest in these antiquities that, when the discovery was published, he was reported to have acquired the principal pieces but then Cardinal Alberoni offered him a much finer sarcophagus. Beaufort accepted it instead and abandoned the *columbarium* group which, as discussed earlier, was subsequently acquired by Lord Pembroke. Alberoni, who was a keen supporter of the Old Pretender, clearly intended that his gift should confirm Beaufort's Jacobite sympathies and rightly judged that the young man would prefer a single highly decorative piece to a series of

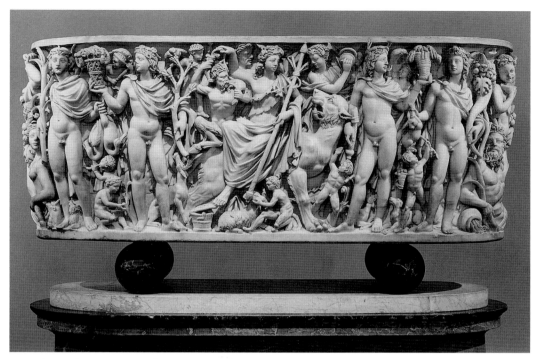

36 The Badminton Sarcophagus, Metropolitan Museum of Art, New York, Purchase, Joseph Pulitzer Bequest, 1955 (55.11.5).

historically interesting but less striking marbles. Albani, however, was piqued that his antiquities had been rejected and tried to stop the grant of an export licence. Giovanni Francesco Guernieri, who acted as the duke's agent to ship his purchases back to England, reported in June 1728 that the Cardinal resolutely opposed the export of the urn from Rome because it had already been published and the antiquaries of Rome regarded it as very important (fig. 36). Eventually the sarcophagus was shipped to England and in 1733 it was placed in the entrance hall at Badminton on a base designed by William Kent. There it remained for over 200 years until it was sold to the Metropolitan Museum in New York in 1955. It is a superbly carved work of the early third century A.D., featuring Bacchus riding on a panther, flanked by the four seasons, a river god and mother Earth interspersed with a crowd of playful cherubs.[17]

ANTIQUITIES AS ARCHITECTURAL DECORATION: WALPOLE AND BURLINGTON

The one person who might have had the influence to buy antiquities on a royal scale at this time was Sir Robert Walpole, the Colossus who dominated the British political scene as prime minister for over twenty years under George I and George II. In 1722, the year after he became First Lord of the Treasury, he started to rebuild Houghton Hall, his family home in Norfolk. It was to be one of the most sumptuous houses in England,

37 Houghton Hall, Staircase
with the bronze copy of the
Borghese Gladiator, formerly at
Wilton House

magnificently furnished and filled with a collection of old masters so distinguished that
their block purchase by Catherine the Great, thirty-four years after Walpole's death,
caused an outcry in Parliament. In contrast, however, to the furniture and paintings, which
were of the highest quality, the antiquities acquired were relatively unimportant because
they were regarded only as architectural ornaments.

 In 1725 William Kent took over the design of Houghton. On the staircase, which rises
the whole height of the house, he placed a bronze replica of the *Borghese Gladiator*, a
gift to Walpole from Lord Pembroke. It had been dismissed from the garden at Wilton
as surplus to requirements because it was a mere copy, albeit a very fine one, and, as
such, did not fit Pembroke's collecting criteria. Kent had no such scruples. He con-
tinued the Roman atmosphere of the staircase by placing *trompe l'oeil* paintings in gri-
saille on the walls, mythical scenes and busts of classical goddesses in artfully shaded niches
(fig. 37). The noble Stone Hall opens off the staircase. To greet the visitor on entry to
the parade rooms everything had to be crisp, splendid and immaculate, fitting Colen
Campbell's description, 'all in Stone, the most beautiful in England'. It might have been
possible to buy sculptural decoration in the form of bas-reliefs from sarcophagi similar
to those that Pembroke or Beaufort had recently acquired, but, despite their authen-

38 Houghton Hall, the Stone Hall

ticity, they would not have suited Kent's scheme because they would have been unmatched, asymmetric and thus insufficiently decorative. Michael Rysbrack was therefore commissioned to carve four reliefs to go over the doors, partly based on engravings of Roman antiquities from Bernard de Montfaucon's recently published encyclopaedia, *L'Antiquité expliquée*, and from Bellori's *Veteres Arcus Augustorum*. For the chimneypiece, he executed a larger panel, depicting a *Sacrifice to Diana*, the goddess of the chase, surmounted by a fox's mask – as befitted a prime minister who opened his gamekeeper's reports before his government papers. Sir Robert's brother, the ambassador in Paris, procured a full-size bronze replica of the *Laocoön* as a suitable trophy for the centre of the wall opposite the chimney. Once again, a fine copy was preferred to an original antiquity. To complete the ensemble, Kent designed a set of console brackets to receive busts (fig. 38).

Edward Walpole, Sir Robert's second son, who was visiting Italy on his Grand Tour in 1730, hoped that he might find something for Houghton but he wrote home:

I have seen every statue and piece of that kind of antiquity that is worth seeing at Rome among which there is nothing to be had that could possibly serve your purpose.

39 (*right*) Chiswick House, the Gallery with Lord Burlington's replicas

40 (*facing page*) William Kent, *The Exedra*, *Chiswick*, Trustees of the Chatsworth Settlement

Those that are valuable and most entire are either entail'd or in the hands of people that won't part with them. I have desired Mr. Swiney whom I believe you must know, to procure you two such if he can meet with them.

- Since Cardinal Albani was seeking a buyer for his collection at about this time, he might have been expected to supply the marbles required, but Walpole probably decided that the goods on offer were too numerous or too antiquarian for Houghton. Albani did not give up because, the following year, he presented busts of *Commodus* and *Septimius Severus* to General Charles Churchill, who was then in Rome, in the hope of persuading an English purchaser to acquire the rest of the collection. Churchill gave the busts to Sir Robert, who was still not tempted to acquire any more from this source. In the end, some other heads were bought to decorate the Hall. Most of them were antique or composed of antique fragments, but they included a renaissance piece, described as a self-portrait by Baccio Bandinelli. They were selected for their homogeneous size and colour rather than their importance as antiquities.[18]

Lord Burlington, the protagonist of the Palladian revival, was another Grand Tourist who was more interested in the architectural effect of his statues than in their antiquarian importance. He visited Italy in 1714/15 and made a second expedition four years later. On his first trip, after toying with the idea of buying a *Meleager*, he came home with only a marble table top and some porphyry vases. On his second visit he wrote to Sir Andrew Fountaine, '*Cosucci* are so scarce since you drained Italy that I could find

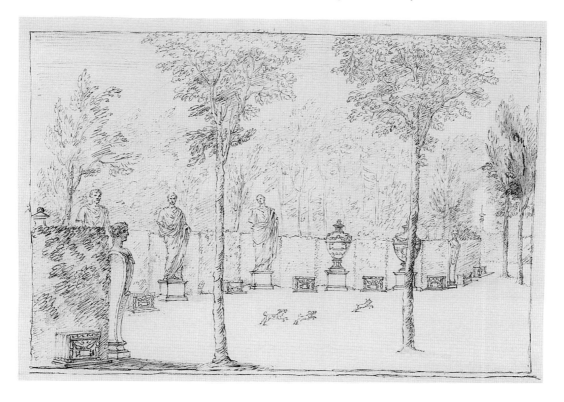

nothing but some tables at Genova and some drawings of Palladio at Venice.' The latter were to become his most prized possessions but he was not led on from an enthusiasm for Palladio and his Roman master, Vitruvius, to assemble a Pantheon of Roman deities.

He employed William Kent to build his villa at Chiswick. Kent's original design for the central octagon contained no spaces for busts, the present selection being an after-thought. In the Gallery that opens off the Octagon, the statues of *Venus, Diana, Mercury* and a *Muse* are modern works by Peter Scheemakers and by Burlington's mediocre Italian protégé, Giovanni Battista Guelfi (fig. 39). When it came to the layout of the influential gardens, which are full of vases, togaed statues and herms, Kent used some fragments of the Arundel Marbles that had been dumped as hardcore on the wharfside in Kennington and subsequently been re-excavated and repaired. A marriage relief, origi-nally exported by Petty from Asia Minor, was set into the base of an obelisk by the gate and three torsos were re-headed to stand among modern busts and urns in the exedra at the back of the house (fig. 40). Burlington would have been just as happy to use statues made by Arundel's man, Egidio Moretti, had they been available. He must, however, have allowed himself a wry smile if ever news reached him in the Elysian Fields about his beloved Chiswick. The Portland stone seats, which Kent designed for the exedra (and which are now at Chatsworth), seemed so authentically ancient that a nineteenth-century guidebook solemnly described them as having come from the Roman Forum. 'These are doubtless the identical seats upon which the senators were reposing in majestic gravity and awful silence, when Brennus entered Rome.'[19]

LORD CARLISLE

Although most visitors to Italy in the early years of the eighteenth century were only interested in acquiring decorative features for their houses and gardens, two Grand Tourists, Thomas Coke, first Earl of Leicester, and Henry Howard, fourth Earl of Carlisle, began to form important collections at this time. Both started their travels during the reign of Queen Anne, although they made most of their purchases some twenty or thirty years later. They advanced the connoisseurship of antiquity many leagues beyond the naive and pedantic attitudes of Dr Woodward and Lord Pembroke.

Carlisle, styled Lord Morpeth until his father's death, was growing up at the time that Vanbrugh was erecting the massive splendours of Castle Howard on the family estates in Yorkshire. In 1711 he entered Trinity College, Cambridge, which was then under the mastership of Richard Bentley, the foremost classicist of the age, and which included Conyers Middleton among its fellows. Either of these scholars could have been responsible for enthusing the young man with a love of the antique. On completing his studies in 1714, he set off for the Tour of Italy, as his father had done a quarter of a century earlier. In Rome Ficoroni pounced on this tempting target and made some sales. An English visitor noted: 'Lord Morpeth and several other young Gentlemen I have met with since their return from Rome, have laid some money, as two or three hundred pounds, in those things [medals etc.] in order to acquire taste and knowledge of antiquities and form a little Cabinet and Series of them.' In Venice, however, the young man succumbed to a hereditary failing for the gaming tables. He lost heavily and returned home after less than a year abroad. As befitted his status, he then entered Parliament and settled down patiently to wait until he should succeed to the family properties.

Lord Carlisle humoured his son's classical tastes by dotting the park round his new house with follies and temples, some of which housed lead replicas of antique statues purchased from Andries Carpentière's yard at Hyde Park Corner. Carpentière was a statuary who supplied standard lead copies of the most famous statues in Italy to numerous patrons, including the Duke of Chandos for Cannons and the Duke of Kent for Wrest Park. His prices ranged from £18 to £25 for a six foot statue but he was liable to be undercut by cheaper competitors who supplied similar goods. Buyers of these reproductions were not very much concerned about strict accuracy because some figures were copied from prints rather than taken from moulds. There was a brisk demand for such fashionable garden ornaments, the cheapness and widespread availability of which did away with the exclusive image attached to costly bronze replicas in the time of Charles I.

Neither Carpentière's routine copies nor Vanbrugh's striking garden architecture could satisfy the young Romanophile. In 1729 Nicholas Hawksmoor told Lord Carlisle, 'Lord Morpeth wishes your Lordship would be pleased to make some other Ornaments in the park of a different form from the pyramid, his Lordship thinking there are enough already.' Despite his interest in antiquity, Morpeth was not stirred to take care of the Roman inscriptions that his ancestor, Lord William Howard, had collected at Naworth, but which, as William Stukeley complained, were left to decay in the garden. They were eventually given to Sir Thomas Robinson, who had married one of the earl's daughters, and were taken to Rokeby, where some illegible fragments remain in the garden.[20]

In November 1738, within six months of his father's death, the new earl was back in Italy once again, taking his eldest son with him. Since his last visit he had had over twenty years to plan how to fill the great spaces of Castle Howard with furnishings and pictures to complement the frescoes by Pellegrini and the overdoors by Marco Ricci. In Rome he commissioned large *capricci* of classical ruins from Panini and in Venice he bought *vedute* by Canaletto, Marieschi and Zuccarelli. Panini's *capricci* provided a series of picturesque collages of all the ancient monuments grouped together as a fanciful *aide-mémoire* of what Carlisle and his son had seen during their stay in Rome. It was (and still is) an agreeable memory test to identify all the columns, porticoes and arches and recollect when each had first been visited. As well as pictures, Carlisle bought small bronzes and an impressive collection of antiquities.[21]

In Rome he used several dealers, Belisario Amadei, Girolamo Odam and the inevitable Ficoroni, as well as the merchant and banker Michele Lopez Rosa, and in Venice Antonio Maria Zanetti. Castle Howard offered scope for the display of far more marbles than could be bought on one short visit. The stock was not available and Carlisle would have driven up the prices against himself if he had appeared too eager. Before returning home in 1739 he therefore left instructions with the dealers to continue to supply him back in England with whatever they thought would be suitable, as and when it came on the market. This required a considerable act of faith on the part of the buyer, but he must have left such specific orders and shown so deep a knowledge of the subject that the dealers did not dare to send him pieces unless they were relatively authentic. The surviving letters from Ficoroni and, in particular, Zanetti show more than a conventional degree of respect for Carlisle's taste and discernment. In any case, the dealers were jealously aware that he was also buying from their rivals and they knew that, if they shipped inferior works, their client would have transferred his business elsewhere. They were very suspicious of the competition and Amadei, when offering Carlisle two busts, a statue and a piece of mosaic, specifically asked him 'not to mention my name to any of these antiquaries, especially signor Ficoroni'. On some occasions Rosa undertook the business of shipping the goods to Leghorn; he preferred to send them by land to Civitavecchia instead of despatching them by the normal route from the port of Rome 'so that they do not need to be examined by the officials . . . to avoid any inspections and dispute'.[22]

The quality of Carlisle's collection is remarkably high, given that he had to rely on written descriptions and, on some occasions, the offer of a set of drawings of the goods on offer. There are few complete fakes such as those that entranced Lord Pembroke and one or two of the doubtful pieces are of sufficient quality that they could well pass for antiquities. Some modern busts may well have been bought in the knowledge that they were not ancient – the image of the emperor was what mattered and, although a contemporary portrait was generally to be preferred, a copy of a well-known type was quite acceptable. Many of the statues had been much repaired but this was normal and the letters from the antiquaries specifically refer to the costs of restoration.[23]

Carlisle does not seem to have had a particular location in mind when buying his marbles. Most of the largest pieces were arranged in the Hall where busts flanked, or were placed above, the chimneypiece (fig. 41), with a matching display round the scagliola niche opposite (fig. 42), while statues were located inside and above this niche and against the giant pilasters that reach up to the arches beneath the dome. In this, the

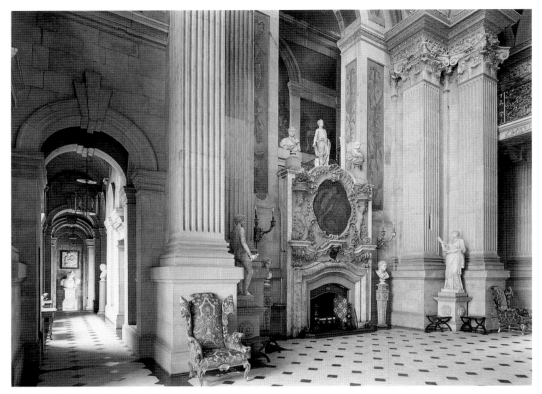

41 Castle Howard, the Hall

grandest room, he placed the most impressive pieces in his collection. It was not a com-
pletely successful arrangement because the statues are dwarfed by the architecture, which
really calls for sculpture on the scale of Michelangelo's *David*, while the busts are actu-
ally too large for the chimneypiece and the niche on which they are set and are out of
scale with the adjacent statues. By 1743, four years after Carlisle's return from Italy, the
antiquary Roger Gale told William Stukeley that the owner had received him very civilly
at Castle Howard and showed him 'his noble collection of antique bustos, statues, inscrip-
tions, &c., which he has most judiciously dispersed & ornamented his lower rooms with.'
Two years later the Countess of Oxford remarked that there were statues and busts in
every room, as is confirmed by the probate inventory on the earl's death.[24]

Apart from the marbles in the Hall, the main display was arranged in the Gallery at
the end of the east wing. When, in 1753, Carlisle entrusted the completion of the west
wing to his brother-in-law, Sir Thomas Robinson, a Grand Cabinet was created at the
opposite end of the house to provide new museum space. Although this room had not
been completed, it contained a large number of mosaics, urns, busts, statues and other
marbles at the time of Carlisle's death in 1758. This part of the house was in turn to be
altered in the early nineteenth century when the fifth earl employed Charles Heathcote
Tatham to redecorate Robinson's wing in a neo-classical scheme and much of the
sculpture was then reorganized. While the Hall still retains its busts and statues in their
original location, most of the other marbles are now arrayed down the Antique Passage

70

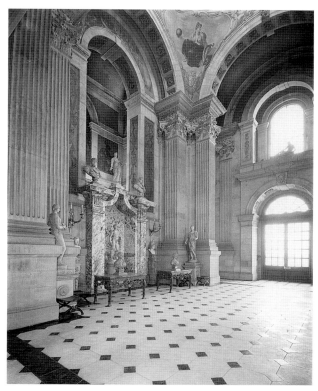

42 Castle Howard, the Hall

in a nineteenth-century display, which is not wholly satisfactory (fig. 43). Carlisle's collection remains substantially intact, although a few pieces of sculpture were sold in 1995.

Carlisle seems to have been even more passionate about gems than marbles and he bagged them with the skill of a patient marksman. Horace Walpole, visiting Rome in 1740, chronicles how he stalked Cardinal Ottoboni:

> They are now selling no less than three of the principal collections, the Barberini, the Sacchetti, and the Ottoboni: the latter belonged to the Cardinal who died in the Conclave. I must give you an example of his generosity, or rather ostentation. When Lord Carlisle was here last year, who is a great virtuoso, he asked leave to see the Cardinal's collection of cameos and intaglios. Ottoboni gave leave, and ordered the person who showed them to observe which my Lord admired most. My Lord admired many: they were all sent him the next morning. He sent the Cardinal back a fine gold repeater; who returned to him an agate snuff-box, and more cameos of ten times the value. *Voilà qui est fini*! Had my Lord produced more gold repeaters, it would have been begging more cameos.

Later, when Carlisle was back in England, Ficoroni sought to use similar bait on his behalf, another gold watch and some Meissen porcelain, to charm gems out of Princess Barberini. The price of a single gem was often equal to that of a marble bust.

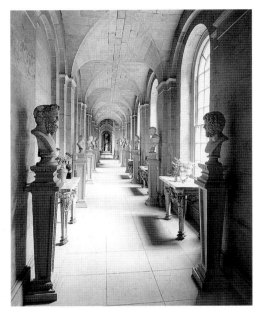

43 Castle Howard, the Antique Passage showing the nineteenth-century arrangement

Zanetti, who maintained a correspondence in rickety French until a few months before Carlisle's death, urged his friend to publish his collection but he did not contribute much to it because he was a collector himself and was constantly complaining about the difficulty of obtaining good gems:

English visitors to Venice, who are interested in this sort of thing, come to my house but I can tell their knowledge just by handling one of their gems. When they think that they are showing me treasures finer than my own which they have bought in Rome or Naples or Florence, they just give me copies to look at and absurd things which have taken them in and cost them dear. They believe that they are taking magnificent acquisitions back to London. For my part, I can hardly stop myself laughing and I often say to myself, 'No, no, I'll never find another Lord Carlisle.'

While he was on his first tour, Carlisle had acquired an intaglio supposedly signed by Aulus, a gem carver of the period of the emperor Augustus. Stosch included this stone in *Gemmae Antiquae Caelatae*, a book published in 1724, illustrating seventy gems from antiquity that were signed either with the name of the carver in the genitive case ('[the work] of Aulus') or with the name and a verb ('Aulus made [it]'). Genuine signatures of this sort are extremely rare and several of those described by Stosch were not, in fact, ancient. It was inevitable that, following his publication, ever more ingenious fakers would seek to increase the value of antique stones by inscribing false signatures or, more frequently, by forging new gems, complete with the names of carvers mentioned by Pliny or Suetonius. Carlisle made a speciality of these signed stones and, although many of them bore false names, he owned at least four gems with signatures that are today considered genuine.

His other classical gems were of a very high quality, especially some large portrait cameos of members of the family of Augustus, one of which is shown in his own portrait by Hans Hysing (figs 44 and 45). His enthusiasm was such that he was interested in fragments for their intrinsic merit, especially if they were improved by some lettering. The collection includes quite small chips, apparently broken off larger gems, depicting no more than the back of a head, a nose and chin or the bough of a tree, almost all of them carefully mounted in gold settings. The settings are, indeed, one of the most attractive features of the collection. As was usual at that period, most of the stones are mounted in rings and in many cases the hoops are finely pierced and chiseled with beading and tiny shells. An amethyst of *Jupiter* even has thunderbolts zigzagging up the shoulders of the ring, which would have made it quite impractical for wear. In fact, the rings were

44 Hans Hysing, *Lord Carlisle holding his cameo of Julia as Diana*, private collection

45 Cameo of *Julia as Diana* from Carlisle's collection, British Museum

not intended for use but were stored in a special inlaid case, kept in Carlisle's London house, where they were available to be seen by his connoisseur friends.

Inevitably Carlisle bought a number of forgeries, including the signed gems and the fragments, but many of his post-classical stones are so skilfully carved that there is continuing dispute as to whether or not some of them are ancient. He also acquired distinguished examples of the work of medieval and renaissance periods. Most of the collection, comprising 170 gems, was acquired by the British Museum in 1890.[25]

Carlisle's gems were distinguished but his importance as a collector lies in the array of busts and statues that he assembled. His collection, less controversial than that of Lord Pembroke, showed that it was possible for a British nobleman to buy like a cardinal of Rome. Because Castle Howard was one of the great sights of the north of England and was frequently visited, his marbles were well known and much admired. Sir William Hamilton, for instance, writing to the collector's son in 1802, recorded that a visit, made half a century earlier, had 'made a great impression on my mind [&] which I have never forgotten'.[26]

LORD LEICESTER

Lord Leicester's house and park at Holkham in Norfolk, together with his library and his collection of paintings, old master drawings and antiquities, epitomize the taste of

the Grand Tour at its apogee. The severe Palladian façades, flanked at the corners by pavilions, each the size of a substantial house, look out over Claudean vistas to a triumphal arch, a temple and an obelisk, to clumps of thickset Italian ilexes and to the broad still waters of the lake. The original site had been thoroughly unpromising, as a tablet over the front door records: 'This seat, on an open barren estate, was planned, planted, built, decorated, and inhabited the middle of the xvıııth century by Thos. Coke, Earl of Leicester.' The wording is justifiably proud, the setting and the collections are magnificent and yet, at the end, the personal history is tragic.[27]

Coke's parents both died when he was only ten, leaving him to the care of his maternal grandparents and an elderly cousin. These guardians provided excellent tutors for his education but, as he grew up, they felt that his excessive interest in cockfighting and foxhunting should be cured by overseas travels. He was therefore packed off in August 1712, at the age of fifteen, for a Tour that was to last for nearly six years. During his minority, careful stewardship had built up the prosperity of the large Norfolk estates that he had inherited and this enabled the circuit of Europe to be made in unusual style for a youth who was not, at that stage, a nobleman. There was a coach and four, two grooms, two valets, one of whom kept meticulously detailed accounts, and a bear-leader, Dr Thomas Hobart, a Cambridge don, who had just returned from conducting Lord Cornbury on a similar tour.

The first fourteen months were spent in France; then, in November 1713, the party crossed the Alps to Turin and spent Christmas in Florence. After a brief excursion to Venice, Coke moved to Rome where he visited all the palaces, studied the language, employed an instructor in architecture and improved his dancing. At this tender stage of his development, he started to buy paintings. 'I am become since my stay at Rome a perfect virtuoso, & a great lover of pictures', he boasted to his grandfather.[28] To guide this new passion, he hired William Kent, who was then studying painting in Italy, as his artistic mentor on a trip round northern Italy. The following year was spent in Switzerland, Germany and France until December 1715 when Coke sailed to Sicily. Then, after a brief expedition to Malta, he returned to Italy to be rejoined in Naples by Kent, who followed him back to Rome. Many pictures were bought here during the summer of 1716 and in September Coke spent 65 *scudi* on acquiring his first pieces of antique sculpture, a bust of *Lucius Verus* and a bas-relief. He continued to add marbles to his accumulation of paintings, drawings, books and manuscripts until he left Italy in June 1717. His homeward journey took in Vienna, Prague, Dresden and Paris before the final crossing back to Dover in May 1718.

In every field Coke made significant purchases. The most expensive of his antiquities was a charming figure of *Diana*, bought in Rome from Ignazio Consiglieri. According to Coke's agent, Matthew Brettingham the younger, writing in 1761, the statue was 'purchased and sent out of Rome . . . for which offence His Lordship (known at this time as Cavalier Coke) was put under arrest, but released soon after at the instances of the Grand Duke of Tuscany'. Coke's accounts record the purchase of the statue for the high price of 900 *scudi* and its restoration by the addition of a new head at a cost of 26 *scudi*, while a letter of Kent sheds further light on what he calls the *imbroglio*: when the authorities found that the statue had been despatched to Leghorn, they sent a courier to have it sequestered and 'would have confined Mr. Coke and I was to have been sent away

from Rome, but at last all was adjusted'. The high price probably conceals the cost of this adjustment. Since Coke was a good customer of Francesco Bartoli, the Papal Antiquary, and bought many drawings of ancient wall paintings from him, prison threats and grand ducal interventions seem unlikely.[29]

Coke's other purchases included a colossal figure to which a very fine head of *Jupiter* had been attached, bought together with a head of *Cybele* for 418 *scudi*, a statue of a consul, supposedly restored by Bernini, bought for 200 *scudi* from the Archiconfraternity of the SS. Annunziata, and two much repaired figures, a *Faun*, acquired for 110 *scudi*, and an *Apollo* that cost 90 *scudi*. Although these works were not among the greatest treasures of Rome, the *Diana* and the consular figure had both been illustrated in Maffei's *Raccolta di statue antiche e moderne*, which indicates their importance. Before

46 Francesco Trevisani, *Lord Leicester*, The Earl of Leicester, Holkham Hall

leaving Italy, Coke had his portrait painted by Francesco Trevisani; the young man, swathed in a silk robe, sits rather tensely on a lavish baroque throne, stroking a mastiff, but the head of a *Niobe* in the background indicates his serious tastes (fig. 46).

While he was in Italy he made a precocious decision to build himself a new house on his return so that he could display his steadily increasing collections in a suitable setting. Architecture was, therefore, a serious part of his studies on his travels and, although Kent was at this stage an artist rather than an architect, he too was forming his architectural taste on Italian soil and probably contributed to the young man's views about buildings. Coke was also influenced by Dr Hobart, the bear-leader, who organized the tour and unobtrusively guided his charge towards the delights of connoisseurship. It is perhaps significant that, when Hobart had accompanied the young Lord Cornbury in Italy a few years before, he had been exposed to John Talman's extravagant ideas about collectors' cabinets and his suggestion that Cornbury should commission a painting on the theme of 'Learning and the Arts as the chief accomplishment of a Nobleman in order to render himself an Ornament to his Country, showing Queen Anne receiving a group of Grand Tourists returning from Italy, surrounded by works of art and led by Minerva'.[30]

Soon after his return, Coke married the daughter of Lord Thanet and rented his father-in-law's London house to display his newly bought treasures. He had to defer hopes of putting to practical use the architectural studies that he had made in Italy because of a severe blow to his finances. Like many others, he speculated heavily in the South Sea Bubble and, when it burst in 1720, he was left with debts of £70,000. It was not until 1734 that his fortunes had recovered sufficiently for him to lay the foundations of a new house at Holkham. The design was the result of close collaboration between Coke himself

(ennobled as Lord Lovel in 1728 and as Earl of Leicester in 1744), his old friend William Kent, who provided the initial ideas, and Lord Burlington, who ensured that Palladian proprieties were strictly observed. The actual building work was supervised by a competent local architect, Matthew Brettingham the elder. Leicester, however, kept a close eye on every detail and was responsible for 'the choice and appropriation of every member and ornament, before any part was given to the workmen for execution'. By 1741 he was able to move into the Family Wing, but the main block was not roofed until 1749.

Leicester built Holkham in order to establish a seat appropriate to his position in the county as well as to house his precious collections. Kent's preliminary sketch for the Marble Hall left a space set into the steps for the great statue of *Jupiter*, which Leicester had bought in Rome, but, as the plans for the house developed, his patron decided not only to decorate the main reception rooms with the other marbles that he had acquired in Italy, but to create a grand Sculpture Gallery as well. Since he did not have enough statues and busts for this purpose, it was very convenient that his builder's son, Matthew Brettingham the younger, had gone out to Rome in 1747 to study architecture. Leicester commissioned him to buy a selection of antiquities of similar quality to those acquired some twenty years before. The survival of Brettingham's detailed account book shows precisely what he bought, his sources, the restorers employed and the costs of the exercise.

Brettingham's early initiatives were unlucky. The complex story shows the problems that the exporter had to face at this period. In May 1749 he paid the dealer, Belisario Amadei, 1000 *scudi* for five statues, a *Ceres*, a *Minerva*, a *Meleager*, a *Venus* and a smaller figure of *Isis* (now relabelled *Fortune*). The first two of these originally came from the collection of Cardinal Albani, to whom he had been given an introduction. All the statues had been restored by Bartolomeo Cavaceppi, the sculptor who played a major role in the supply of antiquities to British collectors in the second half of the eighteenth century. The *Isis*, in particular, had been laden with new attributes (a lotus flower on her head, a vase in one hand, the contents of her cornucopia in the other, as well as the snake coiled round it) and was worked over, as Michaelis remarked, 'to such a degree that it is often difficult to recognise the restorations'. Brettingham submitted them all to the Papal Antiquary, Ridolfino Venuti, who considered that they were too heavily repaired to be of any importance and granted an export licence, which was duly signed by the auditor of Cardinal Valenti, the Cardinal Secretary responsible for such matters. Shortly afterwards the cardinal was informed that Brettingham was trying to export a different batch of statues which were superior to those described in the documentation. He promptly revoked the licence. At this point, Venuti was temporarily superseded as Papal Antiquary by Carlo Costanzi, a prominent gem engraver, who, after examining the statues, upheld the block on the licence. In despair, Brettingham visited Cardinal Valenti 'who told me, (I believe) not without some dissimulation, that the Pope would not permit any Statues of value to go out of the State, and that he was sorry its being now so publicly [known] should hinder him from exerting his power secretly to serve me by some hidden means'.

Brettingham was at his wits' end, as he explained to Horace Mann, the British resident in Florence; he could not use the influence of Cardinal Albani, partly because he was hated by Valenti and partly because 'he is so great a dealer himself, and no one knows

but that they may [be] his own commodities, which he is soliciting to send away'. There were similar objections to using Amadei as an advocate because he was 'a great Dealer in the Clandestine way, for which reason he is held very Criminal with Cardinal Valenti'. Fortunately, Venuti was soon reinstated as Papal Antiquary and abbé Wood, who was a British member of Valenti's household, spoke up in Brettingham's favour. Even then the statues could not be freely exported because the banker through whom Amadei had been paid went bankrupt and it was necessary to go to law to resolve the matter, the course of justice being delicately eased by a letter from Leicester to Cardinal Corsini and by a curious present to Cardinal Valenti, consisting of six dozen bottles of cider, twelve of beer, some architectural books and a set of prints of Hogarth's *Marriage à la Mode*, the combined impact of which was considered preferable to a gold watch.

In March 1752, three years after the troublesome statues had been acquired, the case was finally decided, but not before Brettingham had had to pay out 364.77 *scudi* in lawyers' fees. He learned his lesson. His account book subsequently records a case of Tuscan wine to regale the Antiquaries, twelve pounds of chocolate to be distributed on fit occasions, a tip to the Customs officer for not showing an antique column capital to the Antiquary and an antique marble head, given as a present to Cardinal Valenti.[31]

Brettingham was not daunted by the commission to provide so many statues for the grand rooms that were being created at Holkham, even though he was not a seasoned connoisseur — he was, in fact, only twenty-four when he started to buy on Leicester's behalf — nor did the problems over his initial transaction deter him. All the same, he needed the help of a more experienced dealer to complete his purchases. It was probably Cardinal Albani who recommended Cavaceppi for this purpose, because the sculptor had restored many of the statues in his own collection. Cavaceppi's skills matched the requirements of the day for seemingly undamaged antiquities. He was adept at fitting new heads and limbs to ancient torsos with the smoothest of joints, at devising appropriate attributes to make a statue more interesting (adding a boar's head for *Meleager* to the base of a nude youth, for instance, and turning an anonymous draped female into an *Isis*) and at polishing the marble to a sleek finish appropriate for figures that were intended, like those for Holkham, to be seen at close quarters. He was also a dealer with a substantial stock of antiquities which he sold for his own account. Since Brettingham was buying works to fit into a precise architectural framework, he was naturally disposed towards matching pieces. Cavaceppi was quick to respond to this by restoring statues in such a way that they formed a pair. It is probable that the greater part of the goods exported by Brettingham was either bought from Cavaceppi or reworked by him.[32]

In addition to antiquities, Brettingham supplied copies of portraits of *Homer*, *Alexander*, *Seneca*, *Caracalla* and other well known personages, all by contemporary sculptors, and a large number of plaster casts. Despite his initial troubles with the export authorities, he continued to do a creditable job on Leicester's account until his return to England in 1754. He managed to buy some distinguished portrait busts, such as the *Thucydides*, the *Plato* and the young *Caracalla*, a head of *Venus* of such quality that it was once thought to have come from the Parthenon, a good *Bacchus* herm, dug up in a vineyard near the Lateran, some attractive mosaic fragments from Hadrian's Villa at Tivoli and at least thirteen respectable statues, the best of which is the *Faun*, which had originally belonged to Albani. This *Faun* was acquired from the cardinal in the condition in which

47 *Faun* or *Marsyas*, Holkham Hall

it had been excavated, 'encrusted over with the Tartar of the Earth', but, after cleaning in Cavaceppi's studio, it was revealed to be an exceptionally attractive piece, described as one of the two finest male statues imported into England during the whole of the eighteenth century (fig. 47).[33] Brettingham also found time to acquire a set of moulds of ancient statues with a view to selling plaster casts on his return to England.

Leicester supervised Brettingham's collection of marbles with the same attention to detail with which he oversaw the construction of his house. A letter to the young man's father, dated 11 October 1753, approves the acquisition of a number of busts. Leicester continues:

> As to the list of things he sent, the sarcophagus w'd be very well worth buying as we can have it for 50 crowns, which is cheap if it w'd do to stand before the verd antique side board table in the niche in my dining Room as a bason to wash the Glasses in, but if so big as to crowd up that niche c'd be of no use to me. Therefore I wish you'd send your son a drawing of that niche with the verd antique table on the Porphyry feet, that is to stand in it . . .
>
> As for the Empress, she won't fit my niche over the Chimney better than the Diana which I have measured just over six foot high so that if only in the common rank won't be worth my buying but sh'd she be of a very fine kind & the drapery very fine, she must be so cheap at 300 crowns that I w'd buy her tho' I have at present no place to put her in . . . As for Bustos these 4 that are coming will be as many as we shall want . . .[34]

Clearly Brettingham had to have prior approval before any purchase was made because Leicester knew exactly how he wanted everything to fit and how much he was prepared to pay.

While he distributed busts and casts elsewhere throughout the house, Leicester concentrated the most important pieces of his collection in the Marble Hall, the North Dining Room and the Sculpture Gallery.[35] Although Kent's plan of locating the *Jupiter* at the foot of the stairs in the Hall was abandoned, four statues and eight of Brettingham's plaster casts were eventually incorporated into this noble adaptation of a Palladian basilica. The four statues were situated prominently at the top of the stairs on either side of the door into the main Saloon, while the casts were assigned to a less prominent position behind the screen of columns (fig. 48). In the North Dining Room, niches surrounded with laurels and topped by eagles were created to house the colossal heads of *Venus* and *Aelius Verus*, acquired by Brettingham. These were complemented by brackets supporting portrait heads of *Marcus Aurelius* and *Geta*, set on modern busts of variegated marbles, which were chosen for the richness of their effect (fig. 49). The

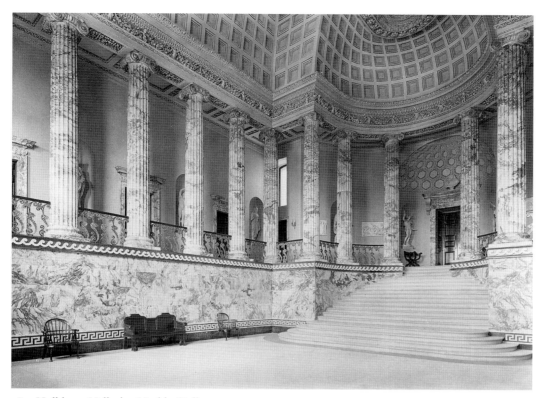

48 Holkham Hall, the Marble Hall

49 Holkham Hall, the North Dining Room

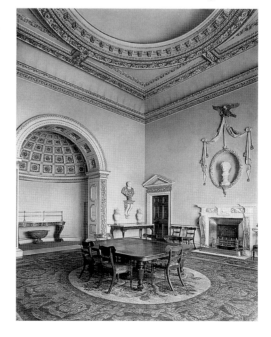

sarcophagus, however, which was too large to be set under the sideboard as a cistern for rinsing glasses, was relegated to the garden.

The Sculpture Gallery, which was still being decorated in 1755, runs the whole length of the west side of the house with apses at each end leading to octagonal Tribunes. To accommodate Leicester's original purchases and the statues that Brettingham was buying, there are eleven niches set into the walls of the Gallery itself, seven down the wall facing the windows and two at each end, and a further four niches in each of the two Tribunes, although one of the latter was eventually devoted to books rather than statues. There are also four brackets for busts in the Gallery and spaces for more of them between the broken pediments over the doors and niches in the Tribunes. Whereas

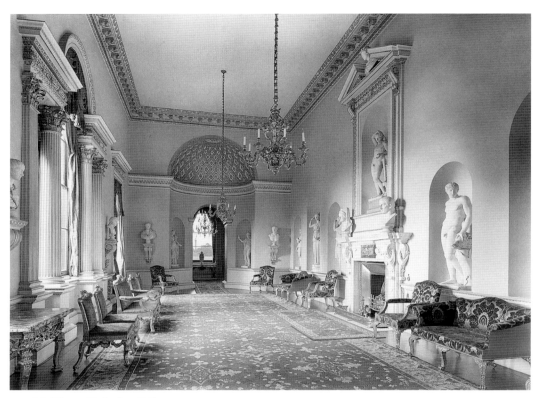

50 Holkham Hall, the Gallery

imperial portraits were distributed in the other rooms, the Gallery was reserved for Olympian deities and characters from Greek mythology. The two largest and finest statues, the *Diana*, which Leicester had bought with such difficulties himself, and the Albani *Faun*, were originally fitted with handles so that they could be turned on a pivot to reveal their beauties. The architectural details of the Gallery are derived from Palladio and Inigo Jones and the colour scheme of ivory and gold is deliberately restrained to avoid diverting attention from the marbles. The display does not resemble the crowded clutter at Wilton or the arrangement at Castle Howard, where the main pieces are dominated by Vanbrugh's pre-existing architecture, nor does it follow Roman precedents of mixing sculpture and painting or packing statues round with inscriptions, urns and decorative fragments. Instead, as was to be expected from a friend of Lord Burlington, familiar with his house at Chiswick, Leicester contrived a room such as Palladio might have built to display an arrangement of antique marbles in a Venetian villa, simple, austere but very grand (figs 50 and 51). 'Without exception, the most beautiful room I ever beheld', wrote the traveller Arthur Young in 1768.[36] It was not a cold museum space. Kent's set of gilt wood chairs and settees provided opulent seating for those occasions when the Leicesters were entertaining the county and the room was used as a gathering place for their guests before dinner. Fortunately the display still retains its original layout.

The other collections at Holkham were at least as splendid as the antique sculptures – great works by Rubens, Van Dyck and Guido Reni, a gallery of landscapes by Poussin,

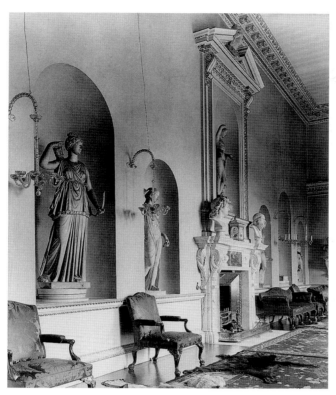

51 Holkham Hall, the Gallery

Dughet and Rosa, a cartoon by Raphael, portfolios of drawings by both old and contemporary masters, a codex of Leonardo and innumerable other fine manuscripts. Holkham and its contents formed a princely ensemble, appropriate for one of the great dynasties of the ruling oligarchy. And yet Leicester was to be miserably disappointed. His only son, Edward, Lord Coke, grew up a brutal drunkard. When the young man eventually agreed to take a wife, he left her on his wedding night without consummating the marriage. After prolonged disputes, the couple arranged a formal separation, never to be reconciled, and Leicester's hopes of an heir finally vanished when his son died childless at the age of thirty-five.

There is a pathos in the great collector's stubborn continuation of the course he had set himself. In 1752, the year before his son's death and at a time when he must have known that he would have no direct descendants to inherit Holkham, he was still doggedly buying statues from Rome to fill the niches in his Gallery. 'It is a melancholy thing,' he wrote to the younger Brettingham, 'to stand alone in one's own Country. I look around, not a house to be seen but my own. I am Giant, of Giant Castle, and have ate up all my neighbours – my nearest neighbour is the King of Denmark.' He was visited by few friends and no scholarly work emerged from his collections to follow up *De Etruria Regali*, which as a young man he had published from one of his manuscripts.[37] In 1759 he died, leaving Holkham still unfinished. His widow survived him to complete the decoration of the house, living there alone for another sixteen years. When her great-

52 Farnborough Hall, the Staircase with the bust of *Lucius Verus*

nephew, grandson of Leicester's sister, came to see her, the old lady told him: 'Young man, you are now for the first time at Holkham, and it is probable that you will one day be master of this house, but understand that I will live as long as I can.' She was as good as her word and, although the young man duly inherited Holkham, he only lived to enjoy it for a year. His son was created Earl of Leicester and he and his descendants have preserved the collection of antiquities intact.

A PORTRAIT GALLERY

The most surprising and least-known collection of this period is to be found at Farnborough Hall in Warwickshire. William Holbech, son of a country gentleman, went up to Oxford in 1716 but did not travel to Italy until some seventeen years later when he visited Rome, Florence and Venice in the years 1733 and 1734, together with his younger brother, Hugh, and bought paintings by Panini and Canaletto. He went on to acquire at least three dozen portrait busts and medallions over a period of time. The marbles included modern images of *Socrates, Julius Caesar, Caracalla* and some deities, but the majority were genuine antiquities, many from the Hadrianic and Antonine periods.

53 Farnborough Hall, the Hall

Although, like Pembroke, he was obsessed by portraiture, he seems to have been happy to collect heads of anonymous officials and matrons as well as emperors and he did not inscribe their plinths with imaginative designations.

Holbech set about remodelling his house ten or so years after his Tour, when he altered two of the façades and introduced very fine plasterwork. Three of the best antique portraits from the collection, a *Lucius Verus* and two Roman matrons, were placed on ornate brackets against ovals above the staircase (fig. 52). The Entrance Hall was also redesigned to incorporate many of the other marbles. Nineteen of them are set high up the walls in oval niches and above the Panini over the chimney and, since symmetry was important for the decorative scheme, Holbech resorted to the simple but barbarous expedient of slicing one bust down the middle and applying the resultant profiles to the wall as if they were a pair of deeply cut reliefs. The busts and plaques in the Hall are set too far above eye-level to be examined with ease, which at first suggests that this was another collection brought together merely as architectural decoration, but the quantity and quality of the marbles are too high for this (fig. 53). Furthermore, one bust, dating to the seventeenth century, bears a strong resemblance to Lord Arundel, which could indicate that Holbech wanted to assert his spiritual descent from the 'father of virtù', some of whose statues were then still at Easton Neston only a few miles away.

Tantalisingly, all the accounts and correspondence of this self-effacing country squire have disappeared and, since there is hardly any mention of him on his Tour (he was not a member of the Society of Dilettanti, although he was in Italy at the period when the founding members were travelling there), few clues indicate how he assembled such a collection. The Roman dealer Belisario Amadei was certainly involved. In a letter to Lord Carlisle, dated July 1745, he offered a group of six busts, including a larger than life one of *Lucius Verus*, 'wearing a band on the chest carved with a figure of Minerva, another of a standing Hercules and a Medusa with Neptune opposite'. This is unquestionably the fine portrait on the stairs at Farnborough. Having failed to sell the busts to Carlisle, Amadei sold them to Holbech instead.[38]

Farnborough and its marbles are now the property of the National Trust.

4

The Heyday of Collecting

NEW ATTRACTIONS

British visitors assailed the Continent in waves. There were large numbers in the 1730s. The tide ebbed during the War of the Austrian Succession (1742–8) but rose again, despite the Seven Years War (1757–63), surged in the next decade and continued to flow strongly until the French revolutionary wars at the end of the century disrupted overseas travel.

From the fourth decade of the century visitors' interest in antiquities and archaeology increased noticeably. This was in some measure due to the spectacular discoveries at Herculaneum and Pompeii, the cities destroyed by the eruption of Vesuvius in 79 A.D. Desultory excavations had started at Herculaneum as early as 1707, by 1738 part of the theatre had been revealed and ten years later work commenced at Pompeii. The purpose of the digs was to unearth sculpture and paintings that the King of Naples could install in a new museum attached to his palace at Portici. The cities were not, therefore, systematically exposed but were reburied with rubble as the king's engineers moved on from one site to the next. It was not easy for visitors to obtain permission to make the torch-lit descent into the excavators' tunnels or to visit the royal museum in which fussy officials hovered to prevent anyone from sketching the exhibits before they had been published by the tediously dilatory Reale Accademia Ercolanense. Nevertheless, the discoveries created a sensation comparable only to the opening of Tutankhamun's tomb two centuries later. Tourists, attracted by the enchantments of the bay of Naples, were thrilled by the knowledge that, just a few miles down the coast, under the shadow of the still smoking volcano, workmen were unearthing the cities whose destruction was so familiar from the well-known letters of the younger Pliny. As Goethe put it some years later, few disasters had given so much delight to posterity.[1]

Meanwhile, in Rome the foundation of the papal museum in the Palazzo Nuovo on the Capitol in 1733 gave a further impetus to the promotion of classical antiquity, regularly boosted by the addition of new acquisitions such as the *Antinous*, the rosso antico *Faun* and the *Flora* from recent excavations at Hadrian's Villa near Tivoli. This site continued to be a fertile source of antiquities throughout the century. It was here, for instance, in 1736, that Monsignor Furietti discovered the pair of *Centaurs*, one old and the other young, for which he and his heirs were constantly bombarded with offers from British and other collectors. The statues were eventually acquired at a cost of 13,000 *scudi*, a large sum for the papal treasury, and transferred to the Capitol in 1765 (fig. 54).

54 Medal of Clement XIII celebrating the acquisition of the *Furietti Centaurs* for the Capitoline Museum

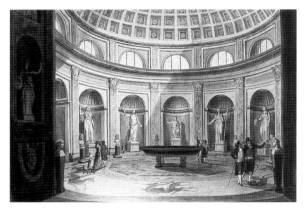

55 Louis Ducros and Giovanni Volpato, *Museo Pio Clementino, Sala Rotonda*

56 Villa Albani, the Salone

Later in the century, when nothing more could be crammed into the Capitoline galleries, the Museo Pio Clementino was created in the Vatican under Clement XIV (1769–74) and Pius VI (1775–99) to bring together the greatest statues from the renaissance papal collections, such as the *Apollo Belvedere*, the *Laocoön* and the *Nile*, and the fresh material compulsorily acquired from new excavations (fig. 55). To some extent, the Museo Pio Clementino compensated for the losses of the Farnese and Medici collections, which were removed from Rome by the heirs of the Farnese to Naples and by the heirs of the Medici to Florence.[2]

The Villa Albani, which was being built during the 1750s, provided another popular new display of marbles. After the sale of his first collection, Cardinal Albani had rapidly acquired more antiquities, many of them from Hadrian's Villa, including his famous relief of *Antinous*. The villa contained a series of glittering reception rooms, splendidly decorated with panels and frames of ormolu, stucco or scagliola and filled with antique statuary, which, thanks to the cardinal's notorious use of restorers, had all been smoothly repolished to suit the immaculate surroundings (fig. 56). The displays incorporated innovative techniques such as the use of glass panels to reflect the backs of the statues. The overspill of the collection was dispersed in the Coffee House and other pavillions in the

garden. Raffael Mengs decorated the principal gallery with what was probably the most celebrated contemporary painting in Rome, *Parnassus*, in which the artist incorporated portraits of two of the cardinal's illegitimate daughters among the Muses – he was a renaissance prelate in his taste both for women and for antiquities. Visitors, especially those from Britain, who were always generously welcomed by the now ageing cardinal, were delighted by his hospitality and by the elegance of the villa, which contrasted strongly with the dusty jumble of statues and sarcophagi to be seen in many of the old palaces of Rome. Villa Albani showed how well the antique could look in a modern setting.[3]

At this period even in England a collection of antiquities entered public ownership for the first time. In 1755, when it became clear that the extravagant habits of her son were likely to jeopardize his estate, the dowager Countess of Pomfret was prevailed upon to buy the remains of the Arundel Marbles at Easton Neston and give them to Oxford University. Sir Roger Newdigate, the Member of Parliament for Oxford, himself a diligent student of antiquity, was employed as an intermediary to negotiate the transfer. Some of the marbles were displayed in the Old Schools, an event that was celebrated by the Oxford Almanac for 1757 with an illustration of Minerva leading the University and her learned handmaidens out of a Gothic building to admire a selection of her new property. The gift and the subsequent publication of the marbles in *Marmora Oxoniensia* emphasized the growing appreciation of classical antiquities in Britain.[4]

THE DILETTANTI AND THE REDISCOVERY OF GREECE

Further proof of Britons' more serious interest in the past is given by the activities of the Society of Dilettanti, which had been founded in 1732.

> . . . some gentlemen who had travelled in Italy, desirous of encouraging, *at home*, a taste for those Objects which had contributed so much to their Entertainment *abroad*, formed themselves into a Society under the name of the Dilettanti, and agreed upon such Regulations as they thought necessary to keep up the Spirit of their Scheme.

Originally it was no more than a convivial dining club, 'for which', as Horace Walpole sourly commented, 'the nominal qualification is having been in Italy, and the real one, being drunk'. The carefree spirit of their meetings is delightfully portrayed by George Knapton, who painted portraits of many of the members in fancy dress as cardinals, Turks, gondoliers or, in the case of Sir Francis Dashwood, as a blasphemous St Francis, toasting the statue of a nude Venus (fig. 57). Of the original founders, William Ponsonby, later Earl of Bessborough, was the only notable collector of antiquities (see fig. 97). As time went on, however, some of the meetings of the Dilettanti took on a more serious purpose. The dinners were just as convivial, with toasts of *Viva la Virtù*, but the members took upon themselves to sponsor expeditions to the eastern Mediterranean to survey and publish the buildings of Greece.[5]

Travel in the Ottoman Empire was by then becoming an optional extension of the Grand Tour for the few enterprising adventurers who were willing to brave the discomforts and, indeed, dangers of such an expedition. Lord Sandwich had visited Athens

57 George Knapton, *Sir Francis Dashwood, Lord le Despencer,* Society of Dilettanti

and Constantinople in 1738, together with William Ponsonby and John Mackye, all three future members of the Dilettanti, and the artist Jean Etienne Liotard, who was to establish his reputation by portraits of sitters in Turkish dress. The trip was so successful that Sandwich made a further expedition to Egypt the following year. Joseph Spence, a bear-leader then in Rome, ruefully commented, 'A man that has been all over Greece, at Constantinople, Troy, the pyramids of Egypt, and the deserts of Arabia, talks and looks with a greater air than we little people can do that have only crawled about France and Italy.'[6]

Ten years later Lord Charlemont made a long tour of the same region, taking Richard Dalton with him as draughtsman. This was a fortunate choice because Dalton had studied under Agostino Masucci in Rome and had learned to produce attractive red chalk drawings of classical statues, some of which are now at Windsor. He was, therefore, particularly well-suited to the task of recording sculpture as well as buildings. The party had considerable difficulties in Athens because, when they produced measuring rods on the Acropolis to make accurate drawings, the Turks dismissed them under the impression that they were either spies mapping the fortifications or magicians looking for buried treasure. Eventually, however, they succeeded and the prints of the views sketched on the voyage were published with almost no text in 1751 as an appetiser for a 'work intended to illustrate the Antiquities of Greece, undertaken & finished under his Lordship's Direction & Patronage'. There were plates of the Parthenon, the Erechtheum, the Theseum, the Temple of the Winds and other Athenian monuments and details of the statues on the pediment of the Parthenon, some sections of the processional frieze and a caryatid. To these were added views of Constantinople, the pyramids and Sphinx and some reliefs from the Mausoleum of Halicarnassus, then displayed on the walls of the fort at Bodrum in Turkey. Dalton regretted that his party had been unable at the time to remove a similar block from the seashore for lack of appropriate transport – it was not sent off to London until a century later, when the British ambassador, Lord Stratford de Redcliffe, included it with the other fragments of the fort, destined for the British Museum. Since Charlemont seems to have been unable to follow through any of his projects of artistic patronage (his British academy in Rome collapsed and he had a notorious row with Piranesi over the dedication of the *Antichità Romane*) and, since Dalton became fully occupied when he joined the household of the Prince of Wales on his return to England, a larger publication never materialized. Nevertheless, Dalton's plates, crude and inadequate as they were, provided the first serious

reproductions of the Parthenon marbles by a British artist. He had not been blind to the merits of the sculpture. Even Piranesi, who was looking for allies in his attack against the growing interest in Greek art, had to record that, on his return from Greece, Dalton told him that 'some of the remains of the reliefs in the tympanum on the façade of the temple of Minerva [the Parthenon] were beautiful' – although he went on to say that, if everything else in Athens were to perish, it would be no loss to art lovers.[7]

A similar project to Dalton's had been planned a couple of years earlier. In 1748 James Stuart and Nicholas Revett, two British artists studying in Rome, issued a prospectus seeking support for a survey of the ruins of Greece, covering both architecture and sculpture, with 'exact delineations of the Statues and Basso-Relievos with which those buildings are decorated' because they would be 'extremely curious, as well on account of their workmanship, as of the subjects they represent'. The main purpose was, however, architectural. They wanted to provide an additional source of architectural ornament to supplement the rather restricted canon of components of Roman architecture available from the works of Palladio and Desgodetz.

> . . . as Greece was the great Mistress of the Arts, and Rome, in that respect, no more than her disciple, it may be presumed, all the most admired Buildings which adorned that imperial City, were but imitations of Greek Originals. . . . if accurate Representations of these Originals were published, the World would be enabled to form not only more extensive, but juster Ideas than have hitherto been obtained, concerning Architecture, and the state in which it existed during the best ages of Antiquity.

This was a controversial assertion at a time when Roman architecture was the accepted model of excellence.

Even though backing for the enterprise had been secured from members of the Society of Dilettanti, it was a slow process. Stuart and Revett left Rome for Venice in March 1750, but they missed the sailing of the currant boats that season and did not set off until January of the following year. They spent a considerable time taking measurements and making detailed drawings of the ruins in Athens and then visited Salonica and Smyrna before returning to England early in 1755. Stuart, who was to be responsible for the text, was a dilatory author and further delays were caused by the publication in 1758 of *Les Ruines des plus beaux monuments de la Grèce* by a Frenchman, Julien David Le Roy, whose inaccuracies had to be studied and exposed. As a result, the first volume of *The Antiquities of Athens* was not published until 1762, while the second, devoted to the buildings on the Acropolis, appeared only in 1789, shortly after Stuart's death. Despite their stated intentions of illustrating the statues and reliefs, Stuart and Revett concentrated on the more decorative buildings and on the dimensions of columns and ornamental details which might be of practical use to architects and their clients. The Parthenon was, therefore, left until the second volume and even then much of the sculpture on it was omitted as irrelevant.[8]

Other archaeological publications at this time were similarly focused on architecture. In 1750 James Dawkins set off from Naples with the noted art collector John Bouverie, Robert Wood, already an experienced Ottoman traveller, and Giovanni Battista Borra, an architectural draughtsman from Piedmont. The boat, which had been hired in England, was equipped with surveying instruments, gifts to bribe the Turks and a library of the classics.

58 Gavin Hamilton, *Dawkins and Wood discovering Palmyra*

The Life of Miltiades or Leonidas could never be read with so much pleasure, as on
the plains of Marathon or at the straights of Thermopylae; the Iliad has new beauties
on the banks of the Scamander, and the Odyssey is most pleasing in the countries
where Ulysses travelled and Homer sung.

In this spirit, the voyage was commemorated by Gavin Hamilton's painting of the trav-
ellers striding towards the ruins of Palmyra in Syria, clad in flowing togas (fig. 58). As
Wood explained, 'Architecture took up our chief attention' and the two volumes that
resulted, *The Ruins of Palmyra* and *The Ruins of Balbec*, published in 1753 and 1757, were
to provide examples of wonderfully rich ornamentation for architects to plagiarize. Since,
according to Dalton, Borra was 'only expert in drawing of Architecture', sculpture was
ignored and the marbles that they took home were inscriptions.[9]

In 1764, when the Dilettanti found that they had accumulated surplus funds, they
resolved to finance further exploration of the eastern Mediterranean. Accordingly,
Richard Chandler, an Oxford don who specialized in epigraphy, Revett, now famous

after the publication of the first volume of *The Antiquities of Athens*, and William Pars, a skilful landscape artist, were despatched on a tour of Greece and Turkey. The resultant *Ionian Antiquities*, published in 1769 with subsequent volumes issued over the next twenty years, were again devoted to architectural detail and the useful publication of inscriptions. Chandler sadly noted:

> It is to be regretted that so much admirable sculpture as is still extant about this fabric [the Parthenon] should be all likely to perish, as it were immaturely, from ignorant contempt and brutal violence. Numerous carved stones have disappeared; and many, lying in the ruinous heaps, moved our indignation at the barbarism daily exercised in defacing them.

His party acquired some fragments built into houses in the town below but were not more ambitious in their purchases.[10]

Since the indigenous Greeks were not the least interested in antiquities, while their Turkish rulers considered it positively meritorious to deface the images of idolatry, it might seem surprising that no efforts were made at this time to strip the Acropolis of its sculptures, a project that had been recommended by the French ambassador to the Porte as early as 1672. It should be remembered, however, that it was actually quite difficult to see and thus to appreciate the Parthenon frieze in its original position and, since the site was still technically a Turkish citadel, the military authorities were suspicious and unwelcoming. In any case, the processional reliefs fell into the same category as reliefs on sarcophagi, which were not as highly regarded as free-standing statues.

Nevertheless, interest in Greek architecture might have been expected to result in further exploration for Greek sculpture. Over a century before, at a time when the eastern Mediterranean was a fertile source of statues for Lord Arundel, Henry Peacham had written:

> . . . in Greece and other parts of the Grand Seignior's Dominions (where sometime there were more Statues standing than men living, so much had Art out-stripped Nature in these days) they may be had for the digging and carrying. For by reason of the barbarous religion of the Turks, which alloweth not the likeness or representation of any living thing, they have been for the most part buried in ruins or broken to pieces, so that it is a hard matter to light upon any there that are not headless and lame, yet most of them venerable for their antiquity and elegancy.

Despite these opportunities, relatively little was acquired in Greece or the Levant until the end of the eighteenth century apart from inscriptions and *stelae* or grave reliefs.[11] There was a reason for this neglect. Whereas the flat surfaces of dedications and public texts, which had been used as building materials, could be extracted without excavating, the search for statues generally involved digging, which, to the suspicious Turks, was associated with the search for buried treasure. Young men on their Tours could not be bothered to delay for the tedious process of negotiating with the local officials, who expected substantial bribes before they allowed sketching, let alone any prospecting in their territories. Furthermore, as will be discussed later, new excavations in Italy meant that it was at last possible to buy Roman marbles more freely, even if papal restrictions still prevented the export of any important piece.

NEW EXCAVATIONS

Demand for antiquities was not confined to British Grand Tourists. German princes, a few French travellers and, later in the century, the agents for Catherine the Great of Russia and Gustav III of Sweden were all competing for the same material. The British, however, were the most active, if not the richest, collectors and were best served by the dealers operating on their behalf.

In order to increase the supply of ancient material to meet this demand, new excavations were undertaken, particularly in and around Rome. These were all strictly supervised by the *Camera Apostolica*. As early as 1704 the *Camerlengo* or Chamberlain had promulgated a papal edict in the name of Clement XI, who took a particular interest in archaeology. The edict increased the force of previous regulations, declaring that:

> If, in the course of any properly licensed excavations that are now being made or will be made in the future, any paintings, stuccoes, pavements, figures or other works in mosaic, monuments, or tombs of any sort, are found underground, they must be reported immediately to our Commissioner of Antiquities or to the Antiquary, who is currently Francesco Bartoli. They may not be damaged or demolished without permission, which he will give without charge in our name, after a drawing has been made of those things which cannot be kept. It is declared that this order comprehensively applies not only to excavators, builders and other workmen, but also to the owners of the land, tenants, vine-dressers and all other persons concerned in the matter, on pain both of a fine of 100 *scudi*, half of which is payable to the *Reverenda Camera Apostolica* and the other half to the informant, and of corporal punishment, subject to our judgement, dependent upon the cases and persons concerned. Furthermore, since it is important both for ecclesiastical and profane knowledge that ancient inscriptions should be preserved, both those that are above ground and those that are buried, we expressly forbid anyone to move them from their position . . . without prior licence in writing from Mons. Bianchini.

The Chamberlain delegated the task of supervising the excavations to the *Commissario Soprintendente delle Antichità di Roma*, the Supervisory Commissioner for Antiquities in Rome or Papal Antiquary, who was responsible for issuing permits 'to make excavations, or have excavations made, for treasures, marbles, pieces of travertine, statues, mortar and other such things'. These regulations applied not only to excavators in search of antiquities but to builders looking for reusable marble and to farmers levelling awkward bumps in their vineyards. The licence was specific to a particular site and was not a general permit. The excavator did not have to buy his licence because the purpose of the system was to control digging rather than to raise revenue, but he often had to pay the owner of the site to allow him to explore his land. Joseph Addison records the system at the start of the eighteenth century:

> There are Undertakers in Rome that often purchase the digging of Fields, Gardens, or Vineyards, where they find any likelihood of succeeding . . . They pay according to the Dimensions of the Surface they are to break up, and after having made Essays into it, as they do for Coal in England, they rake into the most promising Parts of it . . . 'Tis pity there is not something like a public Register, to preserve the Memory of

such Statues as have been found from time to time, and to mark the particular Places where they have been taken up, which would not only spare many fruitless Searches for the future, but might often give a considerable Light into the Quality of the Place, or the Design of the Statue.

The subject was of sufficient interest for reports of excavations to be given in the *Diario Ordinario*.[12]

Excavators employed large teams of labourers, *Aquilani*, as they were called, taking their name from L'Aquila in the Abruzzi from which many of them came. Although licence applications would generally be made to explore areas where previous finds or unusual mounds in the terrain suggested that there was more to discover, chance always played a large part and a *cava* or dig was often unsuccessful. One of the leading contractors, Gavin Hamilton, gives a vivid account of the difficulties and costs of a typical excavation which he undertook at Hadrian's Villa in 1769. After describing how his attention had been drawn to some finds made in the lake of Pantanello, which had been explored by the grandfather of the current owner, a Signor Lolli, he continued:

I returned to Pantanello to . . . take a survey of the Lake surrounded on all sides with high ground, & no hopes left of draining it, but by a deep channel so as to carry off the water to the river Anio; my hopes were great, and nothing certain but the expence I . . . hastened out the best diggers I could get & set to work, cutting my drains through the vineyard of Signr. Domenico de Angiolis, where in some degree it had been made in the time of Lolli about 60 years ago. He insisted on having a sum of money for leave to clean out this old drain . . . I then got to work with my *Aquilani*, who in a short time found a passage to an ancient drain cut in the *tufo*. This happy event gave us courage in the hazardous enterprise & after some weeks' work underground by lamplight & up to the knees in muddy water, we found an exit to the water of Pantanello, which tho' it was in a great measure drained, still my men were obliged to work past the knees in stinking mud, full of toads & serpents & all kinds of vermin. A beginning of the *Cava* was made at the mouth of the drain . . . which we found choked up with trunks of trees & marble of all sorts, amongst which was discovered a Head now in the possession of Mr. Greville. This was followed by the vase of Peacocks & Fish now in the Museo Clementino. A fine Greyhound, a Ram's head & several fragments were afterwards discovered, when all of a sudden to our great mortification the rest appeared to have been dug by Lolli. This put a full stop to my career, & a council was held. In this interval I received a visit from Cav. Piranesi. Of a Sunday morning Providence sent him to hear mass at a chapel belonging to the Conte Fede, the Priest was not ready so that Piranesi to fill up time began a chat with an old man by name Centorubie, the only person alive that had been a witness to Lolli's excavations, & had been himself a digger . . . Centorubie pointed out the space already dug by Lolli & what remained to be dug . . . This Story gave new light and new spirits to the depressed workmen, a butt of the Canonico's best wine was taken by assault, 40 *Aquilani* set to work with two Corporals & a superintendent; two machines called *Ciurni* were got to throw out the Water that continued to gather in the lower part of this bottom. It is difficult to account for the contents of this place consisting of a vast number of trees cut down . . . intermixed with statues . . . As to

59 Thomas Jones, *Excavations at the Villa Negroni*, Tate Gallery

Busts and Portraits I found most of them had only suffered from the fall when thrown into this reservoir . . . Intermixed with the trees and statues, I found a vast quantity of white marble sufficient to build a lofty palace, a great number of columns of Alabaster much broke, as likewise of *giallo antico* & other precious marble, to which I may add broken vases, basso-relievos, ornaments of all sorts, in a word a confused mixture of great part of the finest things of Hadrian's Villa.

Hamilton goes on to enumerate the main items excavated and the collections where they were located.[13]

Although the excavations in Pompeii were often illustrated, there are not many views of digs in Rome or the Campagna. The activities of the *Aquilani* are, however, recorded by the Welsh amateur artist Thomas Jones, who shows excavations in progress at the Villa Negroni in Rome in about 1777. The workmen laboriously trundle their wheelbarrows of spoil up a steep slag heap of excavated rubbish, while a few spectators peer curiously into the exposed rooms to see the wall paintings that had been revealed – and that were subsequently bought for Lord Bristol. The foreground appears to be littered with discarded fragments which had been unearthed but not yet removed (fig. 59).

After the Papal Antiquary had evaluated the finds from an excavation, the *Camera Apostolica*, which had first pick, was entitled to take a one-third share for the papal

collections, while the remainder was split equally between the excavator and the owner of the site. The latter would generally sell his share to the excavator, who had to restore the ground and pay for any damage done to the crops or vineyard. In exceptional circumstances, the Papal Antiquary could claim the entire proceeds of an excavation but the *Camera Apostolica* then had to compensate the other parties. If the Antiquary decided that the statues in the papal allocation were surplus to requirements, the excavator could purchase them at an agreed valuation.[14]

There were only four Papal Antiquaries in the second half of the century. Ridolfino Venuti held the office from 1745 to 1763, to be succeeded by Winckelmann whose tenure was terminated by his murder in 1768. He was followed by the two Visconti: Giovanni Battista, the creator of the Museo Pio Clementino, who died in 1784, and his son Filippo Aurelio who continued in office during the brief period of the Roman republic, established in 1798, but lost his post on the expulsion of the French by the Anglo-Neapolitan force in 1799. G. B. Visconti's eldest son, Ennio Quirino, left Rome at this period and went on to become the Director of the Napoleonic Museum in Paris.[15]

The *Camera Apostolica* operated an admirable system, analogous to that by which many nations develop their mineral resources today. The entrepreneur was able to extract and export the marbles that his customers wanted, while the state benefited from what was, in effect, a production royalty on discoveries in its territory, but did not have to bear any of the high capital cost of the excavations. In this way, during the second half of the century, the Museo Pio Clementino was able to fill gallery upon gallery without risk and without the loss of a single major statue. Virtually every important find was retained and the entrepreneurs had to content themselves with works that, although attractive and highly saleable, were not considered to be of prime importance. It is a system that could well be reintroduced today by countries that see their strict controls on the export of art and antiquities regularly flouted by illicit excavation and brazen smuggling to supply overseas demand. The main drawback to the Roman regulations was that the excavations were conducted as treasure hunts, as was usual at that time, little attempt being made to comply with the requirement to take drawings of 'those things which cannot be kept'. The site of the find was usually recorded but not the precise details. It is also true that a certain amount of smuggling continued. Gavin Hamilton, in his correspondence with Lord Shelburne, refers to the occasional need for clandestine exports: 'As to the Antinous,' he wrote in 1772, 'I am afraid I shall be obliged to smuggle it, as I can never hope for a licence.' In most cases, however, rumours of discoveries soon leaked to papal spies through the gangs of excavators or restorers' workshops, which made it too risky for a dealer to try to conceal important finds.[16]

The Papal Antiquary also kept an eye on sales from the collections of impoverished princely families. Nepotism no longer provided them with sinecures at the levels of former times, their agricultural estates were deplorably ill-cultivated, as foreign visitors frequently commented, and the great palaces that they inherited needed to be maintained. *The English Shoemaker in Rome*, a comedy by Giovanni Gherardi de' Rossi, makes sport of the situation; an impecunious Roman *conte*, who hires out his coach to foreign visitors and introduces them to the nobility for a fee, conspires with Rosbif, a charlatan *cicerone*, to fleece tourists such as the London shoemaker, who pretends that he is a lord in order to gain acceptance in Roman society.[17]

Prince Giuseppe Mattei was so heavily in debt that he had to sell off the marbles assembled by his forebears two centuries earlier. His collection, like that of most of the Roman princes, was protected by a deed of entail, which could be broken only by papal decree. This gave the Papal Antiquary a strong bargaining position and, as a result, in 1770, thirty-four of the best pieces were pre-empted for the new Vatican museum at a bargain price of 4300 *scudi*, in return for which the prince was allowed to sell the remainder to British dealers for their clients. A three-volume catalogue, *Monumenta Mattheiana*, was published to record the dispersal. The Mattei were not unique. The Barberini, Altieri and Capponi palaces provided further antiquities and the Duke of Modena sold off ornaments from the Villa d'Este at Tivoli, which his family no longer occupied. As in the case of the Mattei, the Papal Antiquary was flexible in his negotiations with indigent families and was prepared to allow them to sell the bulk of their collections overseas, provided that the Museo Pio Clementino could make the first selection.[18]

THE ANTIQUITIES ON OFFER

The marbles available to the aspiring collector fell into distinct types. The most highly prized and expensive were life-size statues of mythological deities and heroes which resembled, albeit at a distance, the *Medici Venus* or the *Apollo Belvedere* and which were invariably described as Greek. Smaller versions of these works were also very popular. Statues of Roman consular figures or members of the imperial families, although less admired than idealized divinities, were acceptable provided that their identities could be established or at least conjectured.

The next category comprised busts or antique heads, which were often set on a new neck above modern drapery. These were always in demand because they were generally in a better state of preservation than statues and were easier to ship and to accommodate back in England, where, inserted in a gallery of the owner's ancestral portraits, they gave a flattering impression that the family was endowed with Roman *gravitas*, even if not actually descended from the Caesars. Jonathan Richardson had, after all, told his readers:

> No Nation under Heaven so nearly resembles the ancient Greeks and Romans as we. There is a haughty Courage, an Elevation of Thought, a Greatness of Taste, a Love of Liberty, a Simplicity, and Honesty among us, which we inherit from our Ancestors and which belongs to us as Englishmen, and 'tis in These the Resemblance consists.[19]

Conveniently for the dealers, busts were also in good supply. The original portraits of the emperor and his family had been widely copied for distribution throughout the empire and numerous modern replicas were manufactured to supplement the genuine article, the skilful restoration of deliberately broken noses and ears being adduced as proof of the busts' authenticity. Heads of identifiable deities or of recognizable imperial figures were generally preferred to unnamed portraits even if the characterization of the latter was more vivid. Augustus, Livia, Vespasian, Antoninus Pius, Faustina and Caracalla were especially popular because they enabled the owner to show off his knowledge of phrenology and demonstrate from each imperial wrinkle the accuracy of the historians' pen

portraits. Even the great Gibbon, a sceptic in many matters, paid at least nine visits to the Uffizi to admire what he considered to be its greatest treasure, the series of busts from Julius Caesar to Caracalla, and to read their characters from the marble like every other Tourist.

Although Lord Pembroke was enthusiastic about bas-reliefs, they were not generally in great demand, probably because large sarcophagi were expensive to ship and, if acquired, usually ended up in the garden. Dedicatory altars, however, and cinerary urns or chests (the marble boxes in which the ashes of the dead were stored) were always popular because they provided useful pedestals for busts and statues. Table tops of antique origin were also in demand. These were either large slabs of antique marble or specimen cubes of different marbles, culled from the ruins; alternatively, suitable sections of decorative mosaic pavements were cut up and mounted for this purpose. In addition to these larger items, the Tourist brought home numerous smaller souvenirs including terracottas, 'Etruscan' vases, bronze statuettes, coins and gems. Only the latter fetched high prices because scholarly interest in vases and bronzes did not develop in England until the last quarter of the eighteenth century.

One category of antiquity was significantly absent. The ancient authors gave the highest praise to painters such as Apelles and yet, to the great disappointment of both scholars and *virtuosi*, few of the wall paintings that surfaced from excavations either in Rome or at Pompeii and Herculaneum merited such applause. Dr Mead, it is true, did buy some fragments, which seem to have disappeared, but, in general, Tourists shunned such temptations. They were wise to do so because the available fragments were invariably either outright fakes, like the notorious *Jupiter Kissing Ganymede*, with which Mengs tricked Winckelmann, or were so heavily repainted that they were effectively modern. Damp and decay have ensured that almost no examples remain in British collections. Brilliantly coloured reconstructions of purely decorative schemes were, however, extremely popular and were included in the print portfolios of many Tourists.

THE DEALERS AND TOUR GUIDES

Spasmodic excavations had always been made in Rome whenever any new building work was undertaken and Tivoli continued to be explored throughout the century, but the major surge of archaeological activity started only in the 1760s. Italian entrepreneurs were completely overshadowed by a small group of British dealers, Thomas Jenkins, Gavin Hamilton, Colin Morison and Robert Fagan, who undertook most of the speculative work. All four, having started off in Rome as artists, found it more profitable to deal in antiquities instead. They conducted their own excavations and also acted as middlemen when old family collections in Rome were dispersed.

The most prominent and least scrupulous of them was Thomas Jenkins (fig. 60). He started his career in Rome as a painter of portraits and landscapes in the early 1750s, but he soon dropped this work and began to supply old masters and antiquities to British visitors. It was through commerce, not art, that he obtained the capital necessary to set up his business. According to Thomas Jones, 'he luckily contracted for part of a Cargo of an English Ship at Civitavecchia, which being disposed of to great Advantage in Rome,

60 Anton von Maron, *Thomas Jenkins*, Accademia di San Luca, Rome

he thereby laid the foundations of his future fortune.' He always had a mixed reputation, especially among the artistic community, who felt that he was liable to do them down, and among Jacobite sympathizers, who regarded him as a British government spy. Fellow dealers, jealous of his success, used to spread rumours about the quality of his goods – on one occasion he complained to the Duke of Dorset that Lord Shelburne and several other visitors 'were pleased to see with their ears and by giving attention to . . . the Scotch crew [i.e. the Scottish dealers, Hamilton, Morison and Byres] were afraid to trust their eyes'. In 1757 he was elected a Fellow of the Society of Antiquaries, sponsored by Thomas Hollis, and for the next fifteen years he continued to send communications to the Society with details of interesting excavations in the hope that any Fellows visiting Rome or wanting to start a collection would use his services. Lyde Browne did indeed do so, to Jenkins's considerable profit. As his fortunes prospered, he took large apartments in a house on the Corso and in a villa at Castel Gandolfo where he could display his wares to most tempting effect, paintings as well as marbles, because he dealt in dubious old masters as well as botched antiquities. He undertook his own excavations, he issued a regular catalogue of goods on offer and in 1776 he even established a banking business in order to extend his influence and facilitate the finance of the objects in which he dealt. Everyone knew him, British and foreign royalty visited him and he was such a favourite with Clement XIV that there was talk that he would be made a cardinal. His greatest coup was the acquisition of the contents of the Villa Negroni in 1784. 'This purchase makes as much noise in Rome', he wrote, 'as Pitt or Fox in London.' It was a transaction that called for all his negotiating skills because he had to persuade the authorities to grant him export licences and his customers to pay the high prices that the important collection merited.[20]

Some people saw through him. Joseph Nollekens, for instance, had come to study sculpture in Rome, where he worked in Cavaceppi's restoration studio. He was employed by Jenkins on occasions, fabricating extensions to terracotta reliefs or staining newly restored marble limbs with tobacco juice to provide an instant patina. He frankly recalled:

> I got all the first, and the best of my money, by putting antiques together. Hamilton, and I, and Jenkins, generally used to go shares in what we bought; and as I had to match the pieces as well as I could, and clean 'em, I had the best part of the profits. Gavin Hamilton was a good fellow, but as for Jenkins, he followed the trade of supplying the foreign visitors with Intaglios and Cameos made by his own people, that he kept in a part of the ruins of the Coliseum, fitted up for 'em to work in slyly by

themselves. I saw 'em at work though, and Jenkins gave a whole handful of 'em to me to say nothing about the matter to anyone else but myself. Bless your heart! he sold 'em as fast as they made 'em.[21]

The saga of the Newby *Venus* shows Jenkins at his sharpest (fig. 61). Gavin Hamilton had acquired a headless female statue, valued at 300 *scudi*, from the cellars of the Barberini palace. He traded it for some other marble with the sculptor Pietro Pacilli who added a head, first scraping away its carved veil in order to make a better fit, and sold the piece to Jenkins in 1764 for 1000 *scudi*. (An alternative version of the story was that the statue had been bought from Hamilton by Jenkins and was restored by Cavaceppi.) Jenkins proceeded to market the *Venus* as an intact statue and the following year persuaded William Weddell to purchase it for an enormous sum, variously estimated at between £1000 and £4000, the highest price ever paid for a statue by a British collector in the whole of the eighteenth century. The exact price was a strict secret and Weddell continued to pay Jenkins an annuity until his death, which accounts for the varying

61 *Venus*, formerly at Newby Hall

values. After Jenkins had sold the *Venus*, he had to obtain an export licence, which he procured by insinuating to the authorities that the statue was destined for the British royal collection and by emphasizing how unsuitable it would be for the papal museum to acquire a female nude of this sort. In fact Winckelmann, as Papal Antiquary, decided that, since both arms, one leg, one buttock and parts of one foot and of the base were modern and since the head was not the original, there was no need to refuse an export licence. Finally, in order to minimize the export duty, Jenkins declared all the restorations to the customs officers, thus justifying a valuation of only 300 *scudi*. The statue was shipped back to Newby Hall in Yorkshire, where it remained until its sale at Christie's in 2002 for some £8 million, the highest price ever achieved by an antiquity. At Newby it had wisely been set in a niche to conceal the giraffe-like proportions of the neck – which are very evident at the joint of the torso and the new head. Despite this feature, it is one of the prettiest versions of the *Medici Venus*, the attractions of which were enhanced in the eyes of an eighteenth-century viewer by the fact that she wears armlets (one restored) like the equally celebrated *Crouching Venus*, also in the Medici collection. The sale of a *Minerva* to Weddell was no less profitable. After another customer had returned a head of *Minerva*, which had been sent from Rome on approval at a price of £100, Jenkins saw that it would fit well with a trunk that Nollekens had bought for only £50. They agreed to act in partnership on the deal and Jenkins sold the newly re-headed figure for a price that was reported to be as high as £700 or even £1050. Despite transactions of this sort, virtually every major collector of antiquities used Jenkins's services because he always had desirable goods on offer either from new excavations or from princely collections out of which he had made acquisitions. Charles Townley, for instance, a most discriminating connoisseur, continued to deal with him by mail order for some twenty-five years, relying on a regular supply of drawings of new items in stock, but he had to keep strict control over any restoration work that was required.[22]

Jenkins's appetite for securing a lucrative sale sometimes jeopardized his banking judgement. He extended substantial credit to James Barry, a profligate buyer of paintings and antiquities, after the young man's father had instructed his own bankers not to honour his bills. In the end Barry had to return some of his purchases to Jenkins in order to reduce his indebtedness. Even then, it was part of the dealer's sales technique to express delight that he had recovered treasures that he had been sorry to sell in the first place. He drew money out of his business in his latter years to finance a property development at Sidmouth, which was a prudent commercial diversification. When he was eventually forced out of Rome in 1798 by the French invasion, he fled back to England, swathed in a belt full of the gems into which he had converted part of his business capital – it was the best way of taking his money out of the country. He died shortly after his arrival.[23]

Gavin Hamilton was rather a different character, a respected artist and a dealer of taste and comparative honesty (fig. 62). After he had finished his studies at Glasgow University in 1748, he came to Rome, where he worked under Agostino Masucci. He managed to establish himself as a successful painter, specializing in heroic scenes from the *Iliad* and events from the annals of Rome, which he sold both to British visitors and to Roman patrons. Even Winckelmann praised the Grecian forms and antique calm of his heads. Gradually, however, he gave up painting for his activities as a dealer. He handled some

outstandingly important paintings by Leonardo, Raphael, Domenichino and Poussin, but his real interests lay in antiquities. His reputation in Roman society gave him the inside edge when buying from princely families such as the Barberini and from Cardinal Albani. Since domestic supplies were inadequate because of the 'great scarcity at present of good antiquities which go at immense prices', he found it necessary to undertake excavations himself. We have seen how he participated in the *cava* of Pantanello with Piranesi in 1769. This was followed by excavations at Tor Columbara on the Appian Way in 1771, at Ostia, the ancient port of Rome, between 1772 and 1776, and at Roma Vecchia and Monte Cagnolo in 1774. From time to time he told Townley that he intended to give up excavating in order to return once more to his painting, 'too long neglected', but the resolution never lasted long and he was soon

62 William Daniell, *Gavin Hamilton*, National Portrait Gallery

back at work on his old sites. In 1792, when he was exploring the Borghese family's estates at Gabii, the finds were so extensive that Prince Marc' Antonio had to add galleries to the Villa Borghese to house them and as late as 1796 he was considering making contact with Sir William Hamilton to try his luck in the Kingdom of Naples.

Whereas Jenkins regarded antiquities as a commodity to be sold at a high mark up, Hamilton had a genuine enthusiasm for the marbles that he excavated and took pride in helping his clients to build important collections. His greatest problem was how to decide which client should have first refusal of his finds. Townley felt obliged to remonstrate with him on several occasions when he thought that he was not being offered the most important pieces. 'I do not pretend to every fine thing that falls into your hands', he protested, 'but I desired that you would not send me inferior things when you have better in your possession.' Hamilton's death in 1798 spared him the turmoil of the French invasion.[24]

Colin Morison, another Scottish artist, came to Rome in 1754 to study under Mengs but made his living principally as a *cicerone*. When he conducted James Boswell round Rome in 1765 the pair of them spoke in Latin, at the visitor's suggestion, during their tour of the city. Since his clients often wished to buy pictures and marbles, he acted as dealer as well as guide, a lucrative combination, and, like Jenkins and Hamilton, he also was involved in excavations. In 1774 he was said to have made £1500 from this source. He was unusual, however, in that he used his skills as a sculptor to restore some of the statues that he dug up. Although he had a high reputation as a scholar, it seems that he was as prone to embroidering the history of his antiquities as everyone else. At one stage he owned a copy of the relief of *Bacchus Visiting Icarius*, which was sold by Jenkins to

63 Robert Fagan, *Self-portrait with his Wife*, private collection

Charles Townley. When Piranesi published a plate of Morison's relief, improved by the addition of a priapic figure, he noted that the scene represented the progress of one of Nero's orgies – which was presumably how Morison described it to his gullible Tourists.[25]

Robert Fagan, the last of these excavators, was a generation younger. He settled in Rome in 1784 where he made a name as a portrait painter. His self-portrait with his bare-breasted young wife is a striking, if surprising, image of conjugal love (fig. 63). In the 1790s he participated in a number of excavations, both with Hamilton and on his own account. In 1794 he was given the rare privilege of a general excavation licence rather than a permit specific to a designated site, a favour that was probably owed to the fact that he was operating on behalf of Prince Augustus, one of the younger sons of George III. They explored the remains of a Roman villa at Campo Iemini, where they discovered, among other statues, an attractive figure of *Venus* with a particularly fine head. The reputation of this statue was so great that it was only possible to extract an export licence from the reluctant authorities because the *Venus* had been promised to the Prince of Wales. Fagan was also responsible for excavations on the via Appia for Sir Corbet Corbet in 1793 and at Ostia and Tor Boaccina. By professing republican sympathies during the Napoleonic invasion he was able to stay on in Rome and profit by exporting freely in the panic as the princely families unloaded their treasures – he was lucky enough to handle the lucrative sale of Prince Altieri's Claudes. He then moved to Sicily where he became British consul general and conducted further excavations at Tyndaris and Selinunte but his last years were troubled and he committed suicide in 1816.[26]

These were the principal British excavators at this period, but there was one other important dealer. James Byres, yet another Scot who had come to Rome to study art, was Morison's rival as the foremost *cicerone* for visitors (fig. 64). A course of antiquities under his remorseless tuition was an intensive, if not necessarily enjoyable, experience, although Edward Gibbon was impressed when he employed his services in 1764. Byres was responsible for the export of Poussin's *Seven Sacraments* and other important paintings and, although he did not participate in any excavations, he handled the sale of several antiquities, including the *Portland Vase*. This little blue glass vessel with white cameo decoration had been famed since the seventeenth century for its beauty, the technical skill of its manufacture and the puzzle of its iconography. Byres bought it from Donna Cordelia Barberini Colonna in about 1780, when her card debts were pressing, and sold it a couple of years later to Sir William Hamilton, who then resold it together with some other pieces to the Duchess of Portland. It was one of the most famous and most expensive antiquities to be exported from Rome to England in the eighteenth century.[27]

By the 1760s these British entrepreneurs had taken most of the business from the Italian antiquarians who had supplied earlier collectors. Even Cavaceppi was affected. In the previous decade he had sold marbles to Brettingham both for Lord Leicester at Holkham and for Lord Egremont at Petworth and had provided what might be termed 'furnishing antiques' for a number of other British collections, but thereafter he took second place to Jenkins and Hamilton and, although he continued to sell to some British Tourists, he ceased to be their main supplier. He was, however, kept very busily employed restoring the pantheon of mutilated antiquities that was being unearthed by the excavators and, through his close friendship with Winckelmann, he succeeded in replacing his British business with direct sales to German collectors. He also sold casts and copies of antiquities if required.

Between 1768 and 1772 Cavaceppi published three volumes of his *Raccolta d'antiche statue*, each containing sixty plates of antiquities that he had restored (fig. 65). He listed all the great Italian, British, German and Russian collections where his work was to be seen, as well as illustrating many of the statues available in his own museum, for which the *Raccolta* provided a useful advertisement. The publication contained essays on 'The Art of restoring Ancient Statues' and on 'The Tricks that are played in the Antique Sculpture Trade', despite, or perhaps because of, the fact that he had himself been responsible for selling deliberate fakes to some Tourists. The third volume gives an indication of the prices that a collector could expect to pay: a head with minor restoration work to the nose and lips would cost 50 *zecchini*, an intact head would be twice as expensive and one of supposedly 'Greek' workmanship would cost even more. A life-size statue with repairs to the arms and legs would be valued at 500 *zecchini* but if the

I.Bogle Pinx.t et Sculp.t

James Byres Esq.r Rome.

Published as the Act directs y.e 1.st Feb.ry 1782

64 John Bogle, *James Byres*

65 *Cavaceppi's Studio*, from *Raccolta d'Antiche Statue*

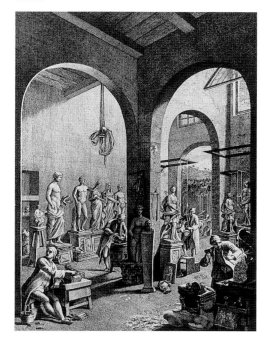

restorations were limited to only a hand or foot the price would be 800 *zecchini*. 'For Greek statues of a sublime style, the value increases immoderately.'

His concluding advice to the intending purchaser was to avoid false economy. 'No sensible person should throw his money about like a madman, but in this business the freest spender makes the best bargain.'[28]

PIRANESI

More than any other artist or writer, Giovanni Battista Piranesi formed the eighteenth-century's image of ancient Rome. From 1748, when he returned to the city from his native Venice, until his death in 1778, he conveyed his vision of antiquity, poetic, sublime but rather idiosyncratic, in a series of large topographical etchings, the *Vedute di Roma*, and in a number of richly illustrated archaeological works, in which he vigorously propounded the case for the superiority of Roman, or even of Etruscan, art over the newly rediscovered buildings of Greece. He argued the case in his prints by exaggerating the scale of the ruins in relation to the tattered pygmies who wander round them and by emphasizing the decorative splendour of the work of Roman architects. He was popular with most British visitors. Robert Adam, who became a close friend, described his 'amazing and ingenious fancies' as being 'the greatest fund for inspiring and instilling inspiration in any lover of architecture'. The admiration was mutual because Piranesi dedicated his work on the Campus Martius to the Scottish architect.

In 1761 Piranesi moved to a house in the strada Felice, now the via Sistina, near the top of the Spanish Steps. It was ideally placed to catch the visiting Tourists as they came up to the Pincio to watch the sunset. At first he sold only his prints and books in the house, but in due course he too began to deal in antiquities. The business seems to have developed by accident as the by-product of a planned archaeological work on the antiquities of Tivoli. It was during his exploration of the site of Hadrian's Villa that, as noted above, he participated with Gavin Hamilton in the draining of Pantanello. Hamilton kept all the major pieces of sculpture, while, according to his account, Piranesi took 'a great number of Fragments of Vases, Animals of different sorts, and some elegant ornaments and one Colossal head'. From these fragments, rejuvenated as from the cauldron of Medea, there emerged an impressive series of ornate vases, brackets and candelabra, all of which were marketed as intact antiquities with a provenance from Hadrian's Villa. They could be used as physical evidence to demonstrate 'the Magnificence of the Romans' to doubting philhellenes. Many of these pieces were illustrated in a series of etchings dedicated to visiting Tourists, who were happy to pay for the privilege of a flattering inscription at the bottom of one of the prints, even if they did not buy any marbles themselves. The resultant collection of over one hundred plates was published as *Vasi, Candelabri, Cippi* in 1778, the year of the artist's death. By that time, six rooms in his house had been given over to the display and sale of antique fragments, which spilled down the staircase, into the garden and onto the street outside, to the dismay of his landlord. 'The Cavalier's house is really the most curious thing that ever was seen.' Jenkins told Townley, 'I really wonder it does not tumble down, the Landlord with reason has entered a Protest in case of Accidents . . .'[29]

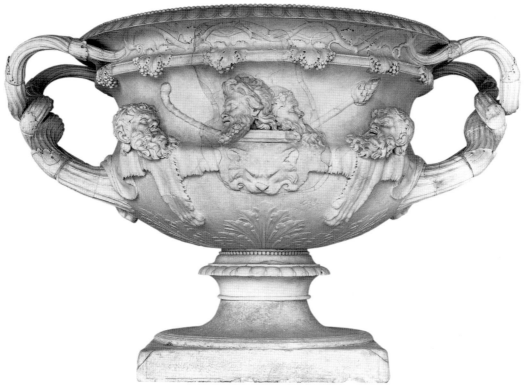

66 *The Warwick Vase*, Burrell Collection, Glasgow

The most famous of Piranesi's antiquities was the *Warwick Vase* (fig. 66). According to the captions to the plates describing this creation in *Vasi, Candelabri, Cippi*, it was discovered in Pantanello in 1770; 'both the composition and the well contrived carving show the perfection of the arts in the age of Hadrian.' Piranesi started by making a plaster model to indicate his reconstruction of the vase, sticking to it the relatively few antique fragments, and then set about finding a buyer to pay for the complete restoration. Sir William Hamilton agreed to undertake responsibility. 'It is only now upon the point of being finished', he wrote in the summer of 1775, 'it has cost me near £300, for I was obliged to cut a block of marble at Carrara to repair it, which has been hollowed out and the fragments fixed on it.' Hamilton offered the vase to the trustees of the British Museum, and, when they turned it down, he persuaded his nephew, Lord Warwick, to buy it for Warwick Castle. There it remained in a greenhouse in the garden until 1978 when it was sold and subsequently acquired for the Burrell Museum in Glasgow.

The vase was outstandingly popular. Napoleon listed it as one of the trophies that he wished to install in the Louvre after the conquest of Britain. Throughout the nineteenth century replicas in varying sizes were produced in silver, bronze and stone to decorate entrance halls, dining room sideboards and formal gardens. No one questioned its authenticity. And yet, it contains remarkably little antique work at all. It is a brilliant reconstruc-

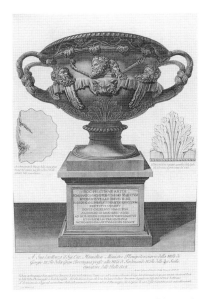

tion in which the restorer's acute intuition has sorted a few remnants, like pieces of a jigsaw puzzle, into an ingenious but seemingly inevitable pattern. The composition is so coherent that no alternative rearrangement of the ancient fragments seems possible. All the same, Piranesi's deceitfulness is incorrigible; the captions to his plates give no indication of the extent of the repairs and the detail of the acanthus decoration at the base is illustrated as an example of elegant antique carving, whereas it is wholly modern (fig. 67).[30]

Piranesi was quick to cater for the vase-mania that was then sweeping Europe. Another elaborate marble urn, also with a supposed Pantanello provenance, was sold to George Grenville for Stowe and many smaller examples, suitable for the decoration of chimneypieces, went to other visitors. Edward and Harriot Walter bought a pair, now in their descendant's house at Gorhambury in Hertfordshire (fig. 68), and Lord Palmerston secured some for Broadlands in Hampshire. John Campbell, later Lord Cawdor, bought an urn with a snake round the rim, which had been illus-

67 Giovanni Battista Piranesi, *Warwick Vase*, *Vasi, Candelabri, Cippi*

68 Chimneypiece and vases by Piranesi, the Gorhambury Estates Company, Gorhambury

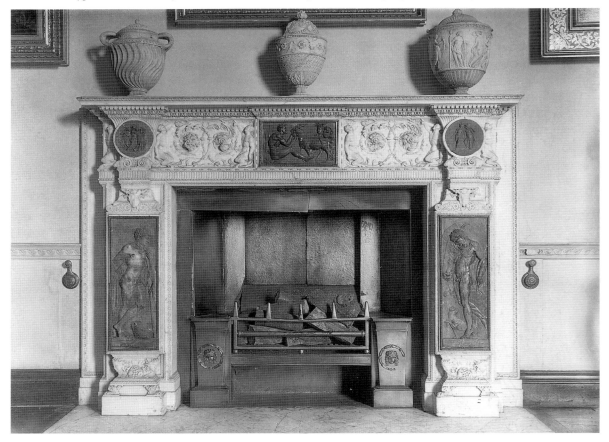

trated in *Vasi, Candelabri, Cippi* (fig. 69). It passed from Cawdor to Charles Townley and was thus acquired by the British Museum as part of the Townley collection. A note in the British Museum's catalogue early in the nineteenth century primly records:

> This article is not worthy of the collection in which it is placed. It was originally the capital of an ancient column, but it owes its present form and appearance to the taste and skill of Piranesi. It was sold as an antique urn by the manufacturer to Lord Cawdor, from whose hands it passed into those of Mr. Townley. I had this anecdote from Mr. Tresham, who actually saw Piranesi engaged in the fabrication of this forgery.[31]

Piranesi's workshop also produced some imposing candelabra, designed to show off the magnificence of Roman decoration, all with a supposed Pantanello provenance. They were collages of ancient scraps infilled with modern work and modelled on the Barberini candelabra, which had been acquired for the papal collection after Winckelmann had refused Jenkins an export licence. In 1775 Sir Roger Newdigate bought two of these creations for 1000 *scudi* and presented them to Oxford University (fig. 70). Chimneypieces were also concocted out of a mixture of antique fragments and modern marbles with striking effect (see fig. 68).

69 Vase converted from a column capital, given to Charles Townley by Lord Cawdor, British Museum

70 Giovanni Battista Piranesi, *Newdigate Candelabrum*, *Vasi, Candelabri, Cippi*

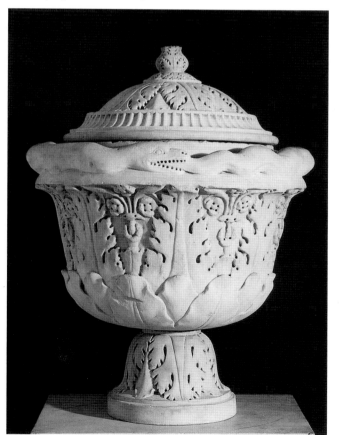

RESTORATION AND FORGERY

Buyers of antiquities were well aware that almost everything that they acquired had undergone restoration, but they were no more prepared to accept limbless fragments than the Duke of Buckingham had been when ordering antiquities from Turkey in the previous century. There were indeed few statues that were considered to be acceptable in an unrestored condition, like the *Belvedere Torso*. Even the latter did not appeal to all tastes. As Jenkins remarked to Hamilton, 'Lord Tavistock would not give him a guinea for the finest torso ever discovered.'[32] There was, therefore, very seldom any question of leaving a statue without head or limbs. Opinion about the desirability of repairing fragments did not start to change until the debate on the restoration of the Elgin Marbles in the early years of the nineteenth century.

The first task for the dealer, who had acquired a broken statue from an excavation, was to identify the original subject or type – a Venus, a Mercury, a Meleager, a satyr. The technique was then to devise appropriate attributes which would make the statue more interesting and thus more saleable. The problem was, as Reynolds pointed out in the Tenth *Discourse*, that all classical figures looked very much the same: 'Take from Apollo his Lyre, from Bacchus his Thirsus and Vine-leaves, and Meleager the Boar's Head, and there will remain little or no difference in their characters.' A restorer, such as Cavaceppi or, later in the century, Carlo Albacini, was commissioned to carve the missing limbs and the *cadeuceus*, boar's head or whatever else was deemed suitable to identify the figure, using a marble as similar as possible to the original and adopting the style of the ancient sculptor. The joints had to be made without destroying the antique work and the pins had to be securely fixed. The new work was then 'distressed' and sometimes deliberately broken and repaired so that it looked ancient and the whole statue was covered with a wax polish, mixed with marble dust, which camouflaged the joints between the new and the old. Lamentably, the original surface was often repolished to give a smoother finish. While it is easy to apply modern standards of authenticity and deplore this sort of restoration work, the results were undoubtedly more suited to the splendours of an eighteenth-century gallery than the limbless figures, now stripped of restorations, that stand in many museums today.[33]

By the nineteenth century, however, attitudes towards the repair of statues had changed. The art historian, Allan Cunningham, who worked for many years as secretary to the sculptor Francis Chantrey, complained:

> In this kind of jugglery [restoration work] the Italians excel all mankind – they gather together the crushed and mutilated members of two or three old marbles, and by means of a little skill of hand, good cement, and sleight in colouring, raise up a complete figure, on which they confer the name of some lost statue, and as such sell it to those whose pockets are better furnished than their heads . . . all fractures and patches and joints are concealed under a coat of yellowish colouring, which seems the natural result of time – and the rejoicing virtuoso treasures up in his gallery another legitimate specimen of the wonderful genius of Greece![34]

It was one thing to restore limbless statues but Piranesi's fabrications were another matter. Although he convinced himself that his re-creation of decorative objects in the style of

the Hadrianic era could provide examples of ornament for contemporary architects to copy, many critics felt that he went too far. James Barry refers to capitals adorned 'in so fantastic a manner, with so little of the true forms remaining, that they serve indifferently for all kinds of things, and are with ease converted into candelabras, chimney-pieces, and what not. Examples of this kind of trash may be seen in abundance in the collection of Piranesi.'[35] Such comments were so harmful to the artist's trade that some of the most elaborate pieces were still unsold at the time of his death and did not find a buyer until Gustav III of Sweden, who visited Rome in 1783, acquired the contents of the Piranesi museum *en bloc* and exported them to Stockholm.

GEM COLLECTIONS

Whereas there were restrictions on the export of marbles, it was possible to collect cameos and intaglios without hindrance. Although gems were covered by the export regulations that applied to other antiquities, the authorities recognized that they could never prevent the smuggling of such tiny objects. In any case, many of the most attractive pieces were forgeries such as those that Nollekens saw being manufactured for Jenkins or which had deceived even that knowledgeable connoisseur, Lord Carlisle. Despite the risk of fakes, many fine collections were assembled. Not everyone approved. Clearly Lord Chesterfield (whose brother, John Stanhope, was a collector) considered that such baubles were too insignificant to merit the attention of any but pedants. As he warned his son, who was visiting Italy in 1749:

> You are travelling now in a country once so famous both for arts and arms . . . View it, therefore, with care . . . Consider it classically and politically, and do not run through it, as too many of your young countrymen do, musically, and (to use a ridiculous word) *knick-knackically.* No piping nor fiddling, I beseech you; no days lost in poring upon almost imperceptible *intaglios* and *cameos*; and do not become a virtuoso of small wares. Form a taste of painting, sculpture, and architecture, if you please . . . ; those are liberal arts, and a real taste and knowledge of them become a man of fashion very well. But, beyond certain bounds, the man of taste ends, and the frivolous virtuoso begins.[36]

Such advice shows how long the Battle of the Books continued to affect attitudes to scholarship. A gentleman was not expected to know so much that he might risk being taken for a professional.

Many of the principal European collections were published in lavish portfolio volumes and wax or plaster casts of the most famous pieces were widely available so that connoisseurs could compare specimens. Gem cutters made copies of these stones, which were happily acquired by visitors to Italy in the same way that they bought replicas of the most famous statues. Despite the fact that cameos and intaglios were almost always mounted in ring settings, they appear relatively seldom on the fingers of visitors to Rome who had their portraits painted. When Reynolds depicted a group of members of the Dilettanti Society examining gems, none of the sitters wears a ring (see fig. 138) and Horace Walpole specifically comments on the comic Miller family in Bath that 'the Captain's fingers are loaded with cameos, his tongue runs over with virtù'. John Morritt

of Rokeby, who had just bought two cameos at the end of his Tour in 1796, was unusual in writing home to announce, 'These I shall sport as rings when I dine at Sedbury [a neighbour's house] or in places of the sort, and expect to show them off with no small *éclat*.'[37] The connoisseur generally kept his trophies in the drawers of a medal cabinet, along with his coin collection, or in special display boxes, bound as books and fitted like a jeweller's tray.

Although many of the gem collections of eighteenth-century visitors have now been dispersed, information about some of them is contained in a manuscript treatise, compiled by a German, Lorenz Natter. After studying the art of gem carving in Italy, where Stosch employed him to copy ancient stones, he led a peripatetic existence, travelling round the courts of Europe as a gem cutter and medalist. The French connoisseur Pierre Mariette accused him of faking intaglios, to which he made an indignant repy in *A Treatise on the ancient Method of engraving on precious Stones*, published in 1754. 'Mr. Mariette', he wrote, 'is much offended with those who put Greek names or inscriptions to modern Engravings. But he that sells a modern Copy of an Antique for an Original, not he that makes it, is to be blamed.' This rather naive defence, the response of the expert faker in every age, was sufficient for the members of the Society of Antiquaries, who elected him an honorary Fellow that year. While he was in England, he examined all the important British collections of gems with the intention of publishing a *Museum Britannicum* in imitation of Anton Francesco Gori's *Museum Florentinum*, which described and illustrated the best of the Medici gems. Unfortunately, however, even though he sold his own collection to raise funds, there was insufficient support to finance what was planned as a very lavish work with illustrations of over 500 cameos and intaglios from the best British cabinets.[38]

The greatest of these early gem collections was that created by William Cavendish, second Duke of Devonshire, who bought his gems through dealers in Paris, Haarlem and Rome. Like Lord Carlisle, the duke was especially keen on signed gems, the most distinguished of which were the exquisite *Theft of the Palladium*, signed by Dioscurides, the engraver to the Emperor Augustus, and *Hercules carrying a Bull*, signed by Anteros. 'Look on his antique gems . . . !' exclaimed his biographer with rapture, 'These were the collections of this great good lord.' The pick of his collection was recorded in a series of 100 plates, drawn by the French artist Auguste de Gosmond, for distribution among the duke's friends. Since his successors continued to buy gems, it is not easy to distinguish those acquired by the second duke from those added by his successors, but, by the time of the fourth duke, there were 385 specimens and the number had risen to some 560 by the beginning of the twentieth century.[39]

Natter made a separate catalogue of the Devonshire collection, which is still preserved at Chatsworth, and drew on it extensively both for his published *Treatise* and his planned *Museum Britannicum*. The only section of the latter to be printed was a booklet devoted to the gems of Lord Bessborough, issued with only three plates in 1761. There was a sad story behind this little publication. Bessborough's wife, who had died the previous year, was the grandaughter of the Duke of Devonshire and had inherited his passion for cameos and intaglios. On her death, Bessborough seems to have been unwilling to retain such personal mementoes and sold the entire collection to the Duke of Marlborough, although he kept all his other antiquities. The catalogue provides a brief record of his

gems, which had been acquired from numerous sources, including Natter himself, Stosch (in return for obtaining his arrears of government pension), Gabriel Medina (a Jewish merchant from Leghorn), Dr Mead's sale and Lord Chesterfield's brother.[40]

Disappointed that he could not attract enough subscribers for his book, Natter took his manuscript and drawings to St Petersburg, where he found employment as a medalist with the Empress Catherine, but he died in 1763 shortly after his arrival. Some time after his death, his treatise entered the Library of the Hermitage. He had drawings of gems from numerous collections, the most heavily represented being those of the Duke of Marlborough, Lords Rockingham and Carlisle, Thomas Hollis and a 'Mr. Shorer', possibly William Sherard, the consul in Smyrna. Although Natter had been unsuccessful in winning support for his publication, Thomas Worlidge, a portrait painter, had been issuing prints of gems from the mid-1750s. In 1768 these were eventually published in three volumes without any text as *A Select Collection of Drawings from curious antique Gems*, illustrating 180 gems from over thirty different collections, including those of the Dukes of Devonshire and Marlborough, the Duchess of Portland, Lord Bessborough (whose gems by then belonged to the Duke of Marlborough), Lords Carlisle, Clanbrassil and Montague, Matthew Duane and Thomas Dundas. Many of the stones reproduced were modern or were copies of ancient gems in well-known cabinets and, since some of the owners had never visited Italy, they must have formed their collections by purchase from merchants or in the London sale rooms. The popularity of Worlidge's prints is indicated by the publication of a similar work a few years later, John Spilbury's *A Collection of Fifty Prints from antique Gems*, the plates of which are in an identical format. Spilbury's examples were principally taken from three recent collections, those of the distinguished connoisseur Thomas Moore Slade, of Charles Greville, the nephew of Sir William Hamilton, and of the Duke of Northumberland's son, Lord Algernon Percy, who went on to amass a notable collection known as the Beverley Gems.[41]

Over and above these publications, there was an even larger source of information available from Josiah Wedgwood's ceramic imitations and from the vast collection of wax impressions of gems from all over Europe, created by the Scottish modeller James Tassie. By 1795 Tassie's stock comprised impressions of 15,800 gems, a set of which had been sent to Tsarskoe Selo at the request of Catherine the Great. It was available with a two-volume catalogue by Rudolph Eric Raspe, a learned antiquarian and geologist, who was not only Keeper of the Museum of Antiquities at Cassel but author of those delightful fantasies *The Adventures of Baron Munchausen*. Tassie's copies were available in two forms. His great skill lay in the production of replicas of each stone, using a glass paste that imitated the colour of the original. He also supplied the reverse impressions of the gems in sulphur, that is, in a red wax, or in white enamel, as if the stone had been used for its original purpose as a seal. These impressions, compressed in a border of crimped gold paper and individually marked with the catalogue number, were stuck on trays which were then mounted in boxes or miniature chests of drawers (fig. 71). The impressions were grouped by type and subject so that it is possible to compare all the representations of a particular god or hero in a variety of different styles. Having lost their original didactic purpose, these reproductions can be seen today in innumerable interior decorator's shops, remounted on velvet and elegantly framed, to provide finishing touches for fashionable drawing rooms.[42]

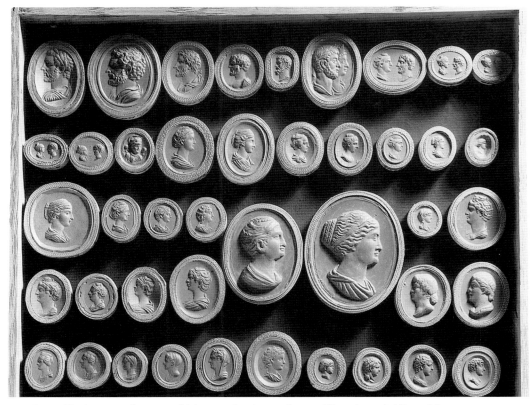

71 James Tassie, part of a tray of his reproductions of gems, Victoria and Albert Museum

The most famous collection of cameos and intaglios was that brought together by the fourth Duke of Marlborough. His interest in gems was aroused while he was on his Tour in 1761. He met Zanetti in Venice and managed to purchase two antique and two renaissance gems from him, a *Sabina*, an *Antinous*, a *Phocion* and a *Horatius Cocles*, for £600. The following year the Arundel gems, which had been offered to the British Museum for £10,000 in about 1755, passed to the duke's sister-in-law and were acquired by a family arrangement. At the same time, he bought the Bessborough collection for £5000 and he continued to add to his hoard with purchases from John Udny, the consul in Venice, the Roman dealer Girolamo Odam, the marchese Verospi, Sir Edward Dering (one of the few British sitters to Batoni to be depicted wearing a gem) and various other sources. He was persistent to obtain the very best. Although outbid by the Duke of Port-land for the brilliant but fragmentary portrait of Augustus, now in the British Museum, he eventually managed to add it to his hoard. He also patronized modern gem cutters such as Natter, Pichler, Burch and Marchant. The pick of the collection was published as *Gemmarum antiquarum delectus* in two volumes in about 1780 and 1791 with a text in Latin and French. The duke took great pride in his gems. When Reynolds painted a family group in 1778 the collector was shown holding a large Arundel cameo in his

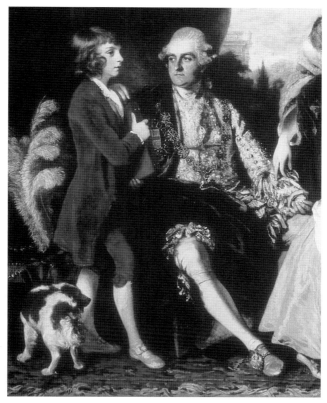

72 Sir Joshua Reynolds, *The Family of the Fourth Duke of Marlborough*, detail, The Duke of Marlborough, Blenheim Palace

hand, while his heir, Lord Blandford, was depicted carrying one of the ten red morocco cases, lined with green velvet, in which the gems were kept (fig. 72). The chimney piece in the Red Drawing Room in Blenheim Palace, where the portrait hangs, is decorated with a carving by Joseph Wilton derived from one of the most famous Arundel gems, the *Marriage of Cupid and Psyche* by Tryphon. The collection was sold from Blenheim in 1875 and was subsequently dispersed in 1899. A Marlborough intaglio of a *Swimming Nymph*, which was originally Lord Bessborough's, now sits on the author's finger. Marlborough spent far more on his gems than any of his contemporaries spent on their marbles, but he was not alone in paying high prices. Lord Fortrose gave Byres £500 for a single stone and George Grenville bought his *Phocion* from Jenkins for £400, the cost of a major statue. The market for good stones was sustained by purchases made on behalf of Catherine the Great, who was a greedily acquisitive buyer.[43]

Sir William Hamilton made use of his long stay as ambassador in Naples to acquire gems. Many of these came from excavations in and around the city, but he also bought from dealers in Rome such as Byres and he commissioned modern works from Pichler, Marchant and other carvers. A large number of gems were included in a batch of antiquities that he sold to the British Museum in 1772 and a second collection, which

included some very fine cameos (see figs 118 and 139), was sold to Sir Richard Worsley, in 1791.[44] The British Museum also possesses gems that belonged to two of the most notable collectors of the age, Charles Townley and Richard Payne Knight, whose collections will be considered later. The other important collection that entered the Museum in the eighteenth century was that of the Reverend Clayton Mordaunt Cracherode. This reclusive scholar devoted his life to assembling his library, a cabinet of coins and gems, a fine collection of prints and drawings and a quantity of shells and mineral specimens, just like the polymaths of the earlier part of the century. He left his whole collection, valued at £23,500, to the British Museum, of which he had been a trustee for fifteen years. His gems, which included a number of beautiful modern works by his friend Marchant, were assessed at £5000.[45]

5

Ten Collections of the Second Half of the Eighteenth Century

Only three substantial collections of marbles were formed in the first half of the eighteenth century. The noble earls who owned Wilton, Castle Howard and Holkham were enthusiasts for the antique, but they were also emphasizing the splendour of their families by decorating their family seats, as Lord Arundel had done, with a rare and princely commodity. During the second half of the century, when it became easier to buy marbles, some thirty significant collections were formed. While most collectors had an interest in the classics, their main motivation was to buy fashionable decoration for display in country houses. Some created attractive sculpture galleries and published lavish catalogues of their collections; others, however, spent a great deal of money in acquiring sculpture, only to lose interest altogether after their return to England. A prime minister commissioned a number of schemes to create a palatial setting for his antiquities in a great town house in Berkeley Square but left it to his son to build a proper Sculpture Gallery. In this chapter, the collections of some of the most prominent amateur enthusiasts will be discussed and, in the following one, those of Charles Townley, Richard Payne Knight and Sir William Hamilton, whose marbles, bronzes, gems and vases, assembled with greater scholarship, formed the basis of the collection of antiquities in the British Museum. Among these collectors, Townley was pre-eminent both for his own marbles and for his influence on many of his contemporaries.[1]

There are two notable absentees from this list. Whereas almost every other sovereign in Europe either owned a gallery of antiquities or had agents in Rome buying on his or her behalf, George III and his son, the Prince of Wales, later George IV, remained outside the fashion. This is the more striking since the king's brother, the Duke of Gloucester, had Jenkins as his guide when visiting Rome in 1772 and later attended excavations with Prince Barberini, while the king's son, Augustus, the future Duke of Sussex, was actively engaged in archaeological digs with Robert Fagan in 1793–4 and secured a well preserved statue of *Venus*, now in the British Museum, for his eldest brother. Consul Smith's pretty but modern gems were the only so-called antiquities to be acquired by George III, although there is no doubt that any problem over export licences would have been waived if a British royal collection had been contemplated. Perhaps it was because Lord Bute, the king's early mentor, was not himself a collector of such things or perhaps the chill of marble did not appeal to George III's homely tastes, while his

eldest son preferred immaculate new statues to torsos patched from the restorer's studio. No gallery of antiquities was planned for Buckingham House or for the unbuilt palaces at Richmond and no such room was included at a later date among the splendours of Carlton House or Windsor – still less in the Brighton Pavilion.[2] Meanwhile in Rome, the king's cousin, the Stuart Cardinal Duke of York, so far from showing any interest in antiquity, was responsible in 1783 for the barbarous destruction of the remains of the Temple of Jupiter near Albano to provide building materials for a local church.[3]

REPLICAS AND CASTS

Before any consideration of the important collections of these years, it is worth touching on the alternative convention. Many *virtuosi* preferred to show their interest in antiquity by displaying replicas of statues rather than originals when it came to decorating their houses. Fine copies or casts of the favourite pieces from the Uffizi and the Capitoline Museum demonstrated that the owners were properly imbued with Roman *gusto* and it was only natural that copies of antique statues should take their place in rooms where much of the architectural detail was directly copied from the Pantheon or the ruins of Palmyra or Spalato. Besides, it was easier to achieve the symmetry required for such interiors by using casts, which had the further advantage of being free from the disfigurement of unsightly cracks. It was inevitable that copies of the same statues should constantly reappear in all the great houses but, so far from becoming a cliché, they were appreciated by visitors with the enjoyment of a keen horticulturalist savouring the Kiftsgate rose in any number of National Trust gardens. When Horace Walpole commissioned in Rome a copy of the Mattei *Pudicitia*, then identified as *Livia*, the wife of Augustus, to be erected as a monument to his mother, he expected that the visitor to Westminster Abbey would recognize the antique quotation as readily as a line from a Horatian ode. Such copies were sometimes deliberately modified to avoid offending female delicacy. John Baxter, for instance, after ordering marble replicas of the nude *Apollino* and *Piping Faun* for Penicuik, wrote to explain that they were to have 'dresserie on their middle parts' (fig. 73).[4]

An outstanding array of replicas is to be seen at Wentworth Woodhouse. In 1749 the

73 Replicas of the *Apollino* and *Piping Faun*, modestly draped, Penicuik

Marquess of Rockingham wrote to his eighteen-year-old son Lord Malton, who was in Siena on his Tour, telling him that he was willing to provide up to £500 for the purchase of marble table tops and statues for his Yorkshire house, which was being rebuilt at that time. Wentworth Woodhouse, the palace for which this casual order was given, was no ordinary seat. Its enormous façade, which extends over 600 feet, is the longest of any country house in Britain. The interiors were to be appropriately magnificent. Malton replied that he would acquire some marble slabs for table tops, but he must have taken sound advice because he continued very firmly:

> As I hear it will be impossible to have antique Statues, and as the Models made from them in plaster of paris are so easily broke and at best have but a mean look, and will never be proper for so fine a Room as the Great Hall, I intend trying to get Copies done in marble of the best antique statues.

His father, always eager to outdo his despised neighbour, Lord Strafford, who, some years previously, had bought four replicas 'of very coarse and spotted marble' for Wentworth Castle, readily agreed that anything for Wentworth Woodhouse had to be of superior quality. Malton therefore commissioned eight copies, four from Roman sculptors, Giovanni Battista Maini (the *Callypygian Venus*), Filippo della Valle (the *Germanicus*, then in Versailles, and the *Capitoline Flora*) and Cavaceppi (the *Capitoline Antinous*), and four from British sculptors working in Rome, Simon Vierpyl (the *Apollino* and the *Dancing Faun*) and Joseph Wilton (the *Medici Venus* and the *Faun with a Kid*), the order being spread in this way so that the work could be speedily completed. The statues had no thematic link – there were two *Venuses* and two *Fauns*. They were selected for their grace and symmetry.

Soon after Malton's return to England in 1750, he succeeded as Marquess of Rockingham on the death of his father. The young man made it his business to ensure that his marbles were given a suitably grand setting in the Great Hall, commissioning designs for stucco panels to go above them from James Stuart, whose Athenian voyage he had co-sponsored while he was in Rome. It is easy to understand why it was felt that this huge room (60 feet square and 40 feet high) needed a uniform array of marbles to match the splendour of the decoration (fig. 74). Rockingham went on to become prime minister but, amid his political and his racing activities, he still found time to collect antique gems and coins, bronzes and a variety of decorative marble statues, which he seems to have acquired in the auction rooms or through dealers and agents in London. He also ordered from Nollekens an important sculptural group, *The Judgement of Paris*, which comprised free-standing statues of the three goddesses displaying their charms in different poses to a restored but antique figure of *Paris* (see fig. 96). The collection, which was split between his house in London and Wentworth Woodhouse, was never properly arranged in his life time and most of it was later crowded into a Museum Room at Wentworth Woodhouse by his nephew and heir, Lord Fitzwilliam (fig. 75). The contents of this room have now been widely dispersed, but most of the marble copies remain in the Hall.[5]

Rockingham could afford marble copies but plaster casts were cheaper and more usual. Thanks to the efforts of Matthew Brettingham and Joseph Wilton, who had been collecting moulds when they were in Italy and had brought them back to London, it

74 Wentworth Woodhouse, the Hall with Rockingham's replicas

was now much easier to procure satisfactory replicas of statues in England.[6] It continued to be difficult, however, to obtain bas-reliefs without incurring the cost of a good sculptor. Architects therefore adapted the ingenious device, introduced by Polidoro da Caravaggio for exterior use in the sixteenth century, and often applied grisaille paintings to the upper parts of walls, simulating marble reliefs. This combination of casts and grisailles was used by Robert Adam in the Gallery at Croome Court for Lord Coventry and in the Hall at Kedleston for Sir Nathaniel Curzon in the 1760s. The grisailles are, however, much more refined (and boring) than the dense turmoil of many sarcophagus fronts.[7]

The most impressive use of replicas was at Syon, the great house just outside London, which Robert Adam redecorated for the first Duke of Northumberland and his wife between 1762 and 1769. The duke had been in Italy in 1733–4 and was a founder member of the Dilettanti Society. In 1740 he married Lady Elizabeth Seymour, daughter of the seventh Duke of Somerset and heiress, through her grandmother, of the Earls of Northumberland; in 1750 he succeeded to the earldom of Northumberland by special remainder and in 1766 he was created a duke.[8] He and his wife lived magnificently on the Percy estates. Northumberland House by Charing Cross was refurbished and Alnwick Castle was remodelled, while at Syon Robert Adam fitted the interior of the old quadrangular house overlooking the Thames with one of the grandest series of reception rooms in Europe.

75 Wentworth Woodhouse, the Museum Room

The Doric Hall at Syon is both austere and splendid, all in white, with a black and white marble chequered floor (fig. 76). A plaster cast of the *Apollo Belvedere*, supplied by Joseph Wilton, stands in the coffered apse at one end, matched at the other by a fine bronze copy of the *Dying Gladiator*, acquired for £300 in 1765 from Luigi Valadier, the leading silversmith in Rome, while a number of antique busts and four statues line the walls.[9] These classical portraits replicate the ancestral images that an ancient Roman family would have displayed in the atrium of their house. The sober chill of the Hall is vividly contrasted by the brilliant colouring of the adjacent Anteroom (fig. 78). Twelve columns of dark green marble, *verde antico*, supporting the rich entablature, are surmounted by gilded Ionic capitals and above them stand gilt plaster casts of twelve antique statues (although one has been replaced by a copy of Canova's *Hebe*). Adam claimed that the columns, which his brother James had acquired in Rome, were antique pieces, recovered from the bed of the Tiber. Two more full-size Valadier bronzes, the *Belvedere Antinous* and the *Borghese Silenus*, stand between the windows and opposite them, gilt trophies of arms, derived from what Piranesi called the 'Trophies of Marius' on the Capitol, are applied to the wall panels in delicate plaster relief. The scagliola floor, echoing the pattern of the ceiling, completes the most opulent display of neo-classical splendour in the country.

The Ionic Anteroom leads into the Corinthian Dining Room, where six niched marble deities watch over the dining table, plaster casts not being considered appro-

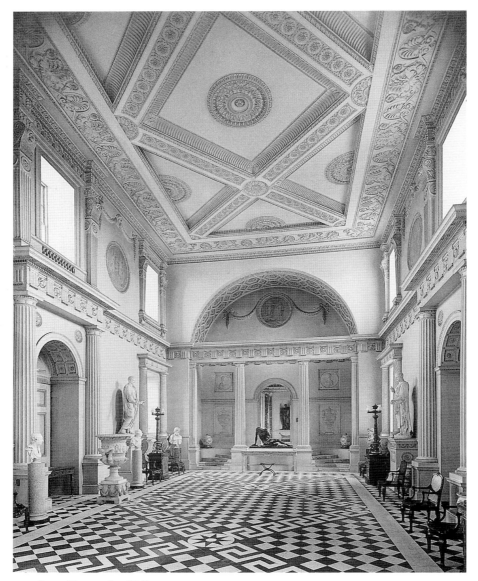

76 Syon House, the Hall

77 Syon House, the Long Gallery, *The Works in Architecture of Robert and James Adam*

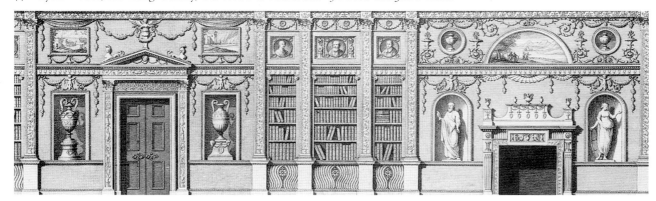

priate for such close proximity to the diners. The statues include works by Cavaceppi (*Ceres* – unusually for him an original statue rather than a restored piece), Della Valle, Hayward and Wilton (a copy of Michelangelo's *Bacchus*, not of an antiquity). In both the Hall and the Dining Room, as at Croome and Kedleston, Adam made use of grisaille panels for the upper walls to imitate bas-reliefs. The Long Gallery, fitted out as a library, is one of Adam's most successful adaptations of Roman archaeology. It was the room to which the duchess retired after dinner. Adam devised a series of shelves among the book-cases, like spaces in a funerary columbarium, to display antiquities, while the motif of the ancestral shrine is playfully continued by the fluted sarcophagus panels below the dado rail and by the series of portraits between the pilasters depicting dead Percys, real and imaginary. Horace Walpole claimed credit for the concept. 'The gallery is con-verting into a museum,' he wrote in 1764, 'in the style of a columbarium, according to an idea that I proposed to my Lord Northumberland'. The 'Statues, Vases, Tripods or other pieces of Vertu fit to stand in Niches' that the duke hoped to acquire through Hamilton in Naples never materialized – perhaps he could not wait for a supply of appropriately sized antiquities. The plan illustrated in Adam's *The Works in Architecture* was, therefore, dropped and books were used to fill the shelves instead (fig. 77). The duke could, of course, have afforded to buy original marbles throughout for Syon but he clearly felt that replicas were better suited to the decorative scheme of most of his new rooms, just as he hung modern copies of old masters in Northumberland House.[10]

78 Syon House, the Anteroom

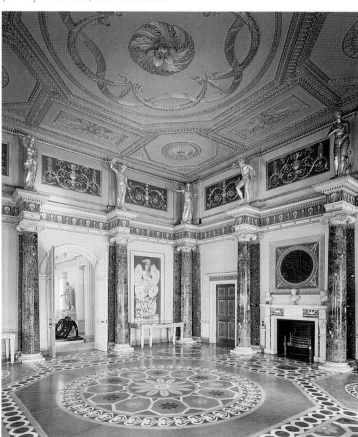

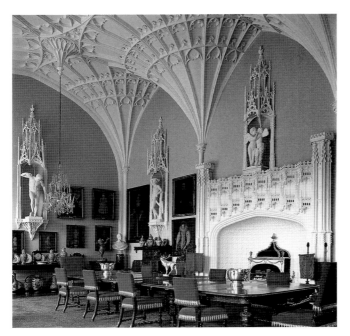

79 Arbury Hall, the Dining Room with casts in the niches

Classical casts were not always displayed in classical surroundings. There is a remarkable arrangement at Arbury Hall, Sir Roger Newdigate's Gothick revival house in Warwickshire. Newdigate, the man responsible for negotiating the acquisition of the Arundel Marbles for Oxford University, made Tours of Italy in 1739–40 and 1774–5. He was an exceptionally diligent and accurate recorder of antiquities, sketching everything from minor monuments along the Appian Way to the neglected arch at Aosta at the foot of the Alps (which Piranesi etched from his drawings) and carefully recording the layout of the main sculpture galleries in Florence and Rome. Although he acquired two of Piranesi's imaginative candelabra, which he gave to Oxford, for himself he only bought casts and one small sarcophagus relief, which, with a happy disregard for incongruity, were installed in his Dining Room at Arbury (fig. 79). There, in place of mailed warriors or monastic saints, the Florentine *Dancing Faun*, *Cupid and Psyche*, *Apollino*, and *Celestial Venus* and the Capitoline relief of *Sleeping Endymion* preside over the dinner table from their spikily crocketed niches beneath a fan-vaulted ceiling derived from medieval models.[11]

Replicas were extensively used, as we have seen, to punctuate vistas in the grounds of houses such as Castle Howard and Rousham. There were several at Stowe, but the *locus classicus* – in every sense – for the use of copies in this way is the landscape round Stourhead, laid out for Henry Hoare in the middle of the century. His Pantheon, overlooking the lake, contains Rysbrack's copy of the *Farnese Flora*, which, together with other deities, surround the sculptor's famous *Hercules*, based on the Farnese version, while a *Sleeping Ariadne* reclines in the Grotto (fig. 80) and yet more copies were set in niches round the Temple of the Sun.

Casts were also displayed for didactic purposes in the Duke of Richmond's house in Whitehall. In 1758 a gallery of replicas, most of them made by Joseph Wilton and Matthew Brettingham, was specifically opened as an academy in which young artists could learn to draw from the Antique. Although Brettingham had originally outlined a scheme for such an institution to his father in 1753, while he was working for Lord Leicester in Rome, he was not appointed keeper of the new academy, which was run by Wilton and the painter Giovanni Battista Cipriani. Horace Walpole was enthusiatic about an institution that rivalled 'the boasted munificence of foreign Princes', but within a couple of years the young duke's support had lapsed, while he was on military service abroad, and the casts were dispersed after a fire at Richmond House in 1791. Three years after the duke's academy was opened, the Dilettanti Society set up a committee to

consider the practicability of obtaining casts 'of the principal Statues, Bustos, and Bas Relievos great or small in order to produce something . . . that may be beneficial to the public', but the scheme came to nothing since the members of the Society never found a site for their intended club house.[12]

It is impossible not to regret the timidity of British *virtuosi* at this period. In contemporary Europe imaginative sculptural groups gesticulated over fountains, on bridges and in squares, they guarded staircases and picked marble volumes from library bookcases. It might have been expected that in England too, as a result of all the study of casts and replicas and the energy and expense put into their manufacture, demand for original sculpture would have followed, particularly at a time when so many exceptionally talented sculptors were at work. Sadly, however, these artists were almost solely employed in producing grand funerary

80 *Sleeping Ariadne*, Stourhead

monuments to dominate the chapels of Westminster Abbey and the chancels of rural parish churches. In the absence of patrons bold enough to decorate their entrance halls or their parks and stables with allegorical groups representing *British Liberty* or the *Glory of the Chase*, commissions for free-standing figures, such as those given by Henry Hoare to Rysbrack and Lord Rockingham to Nollekens, were disappointingly rare. It is, of course, true that the best sculptors working in Britain at this period were not really attuned to the neo-classical idiom but it was not until towards the end of the century that they were released from their almost exclusive concentration on church monuments and set to producing original work for domestic houses and gardens.[13]

LORD EGREMONT AT PETWORTH

Charles Wyndham, second Earl of Egremont, stout, self-indulgent and very rich, assembled one of the most important of all eighteenth-century collections of antiquities (fig. 81). Although the Sculpture Gallery that he built at Petworth House in Sussex was much enlarged in the nineteenth century, it retains its basic form and the marbles for which it was created. Egremont, a first cousin of the Duchess of Northumberland, inherited a noble patrimony through his mother, the favourite daughter of the sixth Duke of Somerset, 'the Proud Duke' who had rebuilt Petworth in great splendour in the late seventeenth century. In 1729, at the age of nineteen, he went on a Grand Tour of France and Italy, he entered Parliament six years later and succeeded as Earl of Egremont and owner of the Petworth estates in 1750. As an active Whig politician he spent much time in

81 William Hoare, *Lord Egremont*, The National Trust, Petworth

London, where he built Egremont House in Piccadilly to display the collection of over two hundred pictures which seem to have been his main interest.[14]

The Proud Duke had bought a few marbles as part of his refurbishment of the old house at Petworth. As early as 1683 he had an antique head of *Faustina* and the two large marble statues that fill the niches in the imposing Marble Hall are likely to have been acquired as part of his scheme of redecoration (fig. 82).[15] His grandson went on to add some seventy busts, statues and bronzes. His taste for the antique does not seem to have been inspired by his Grand Tour (his letters home are mostly concerned with his tutor's love affair with the widowed Lady Ferrers) but rather by emulation of Lord Leicester at Holkham. He used Leicester's architect, Matthew Brettingham the elder, to design Egremont House and the Petworth Sculpture Gallery and Leicester's agent, Matthew Brettingham the younger, to buy marbles. It was convenient that the latter was by this time free to act for other clients now that the sculpture collection at Holkham was effectively complete.

Whereas Egremont was buying pictures and furniture before he inherited Petworth, he did not acquire any antiquities until 1755, when he bought a bust of *Isis* at Dr Mead's sale. Shortly afterwards he paid Gavin Hamilton £50 for a bust of *Venus*.[16] Further purchases were made through Hamilton, but the agent employed to form the bulk of the

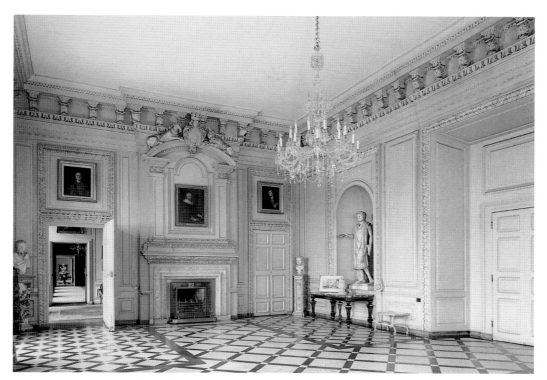

82 Petworth, the Marble Hall

collection was Matthew Brettingham the younger, who used Cavaceppi to make restorations, as he had done for Leicester. Egremont also bought from British collectors, paying Lyde Browne £315 for eleven busts and Lord Dartmouth £160 for four more in 1760. In all he acquired some twenty statues and over forty busts and heads.

He had seen from Leicester's example the advantages of devoting specific rooms to house the most important part of his collection. Accordingly in 1754, the year before he started to buy marbles, he commissioned Matthew Brettingham the elder to add a Sculpture Gallery at Petworth (fig. 83). This was done by glazing an open arcade, which was attached to the north front of the house, and adding a projecting bow to the centre of it in order to create a long narrow room with a bay window. There were niches for nine life-size statues with busts above them on the wall facing the arcade and brackets for more busts on the window side, while at either end of the gallery there were niches to take the two large statues of seated figures, which had been bought headless from the Barberini collection in Rome for 600 *scudi* and given new identities as *Demosthenes* and *Gallienus*. The resultant room was a similar but much plainer version of the Gallery at Holkham, which was still being decorated at this time. The plaster casts, which Brettingham the younger supplied, may have been used to fill the niches and recesses until sufficient original antiquities had been acquired to take their place. The arrangement

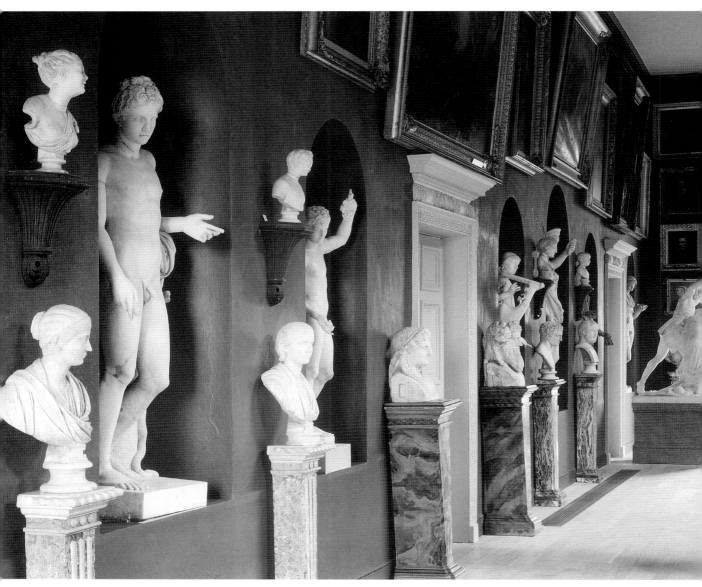

83 Petworth, the Gallery

was not, however, entirely satisfactory because, as Charles Townley complained when he visited Petworth some years later, the busts above the row of statues were too high and too ill lit to be appreciated properly. Many other busts were scattered round the house, particularly in the rooms and passages adjacent to the Grand Staircase, where they were placed on tables between Chinese porcelain for picturesque effect.[17]

The importance of the collection that Brettingham managed to assemble was fully recognized by contemporaries. At the end of the century, when the Society of

Dilettanti decided to publish a selection of the best classical statues from British galleries, Townley and Richard Payne Knight, who chose the examples, devoted most of the plates to their own collections but selected over half the remaining pieces from Petworth. The specimens indicate the taste of the period. Four heads were chosen: Egremont's famous *Venus*, dated to the age of Praxiteles (fig. 84), and three heads that are now accepted to be Roman derivatives – an *Apollo*, supposedly 'copied from a work in brass of the age of Phidias', an *Athlete*, of especial 'beauty, delicacy and simplicity' (fig. 85), and an *Ajax*, admired for its sublimity, 'which would be felt and discerned, if only a single brow remained', although it had been very heavily restored. Two portraits busts were illustrated, an unknown man of the second century B.C., which was picked out for special notice by Townley, and a woman with coiled hair of the Antonine period. Three statues were also selected: *Apollo with his Lyre*, known as the *Egremont Apollo*, described as 'an original work of a very considerable artist', but, in fact, a Roman statue of the second century A.D., *Silenus with a Basket* (perhaps chosen because he is carrying a phallus and other symbols that appealed to the selectors), and the *Fetialis* or *Attendant at a Sacrifice carrying a Pig*, both of which were described as 'coarse', but were chosen as good representatives of a less competent Roman style. The authors of *Specimens* gave a notable encomium of Brettingham for his work at Petworth and Holkham:

84 *Head of Venus*, The National Trust, Petworth

85 *Head of an Athlete*, The National Trust, Petworth

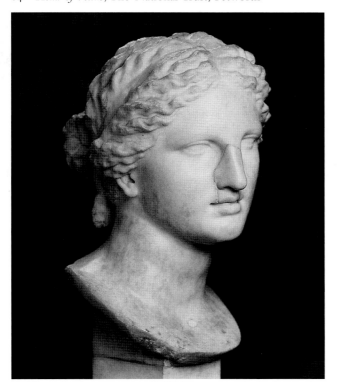

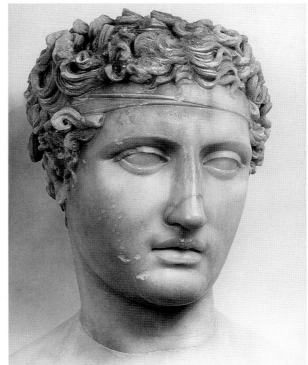

We cannot take leave of the Petworth marbles without bearing our testimony of unqualified approbation to the zeal, skill and fidelity of Mr. Brettingham, the architect, who collected them for the Duke of Somerset [actually for Lord Egremont]; as he also did all those at Holkham, which are good for anything, for the Earl of Leicester. Though under the necessity, in both collections, of adapting particular articles to particular positions, in particular rooms, as furniture, he has contrived to enrich both with many pieces of rare and extraordinary excellence, without encumbering either with any thing spurious or disgracefully bad.[18]

Egremont's attitude towards his distinguished collection is rather puzzling. He had been extremely fortunate in the choice of his agent, who by now had both a good knowledge of antiquities and long experience in handling Roman dealers. His statues were well selected and, although restored, include fine Roman copies of important Greek originals. Many of the busts are of excellent antique workmanship and there is a notable absence of modern forgeries, while the Greek head of *Venus*, an unusually fine piece, shorn from a statue that was probably brought to Rome by an acquisitive emperor, is one of the few antiquities imported from Italy that justifies the standard dealer's claim that it was 'truly Grecian'. In 1763, however, at the time of Egremont's death, some of the sculpture was apparently still in packing cases or even, in the case of the *Silenus*, had not been shipped from Rome and his probate inventory, listing only very meagre furniture in the Gallery, indicates that not all the niches were filled, as if no one had bothered to finalize the display and the room was not much used or visited. It seems that the owner, who was a lavish spender, had taken a decision to copy Leicester's example at Holkham and had given a free hand to Brettingham to form a collection on his behalf and to house it appropriately, but had not taken much personal interest in the process, concentrating his own energies on the collection of paintings in his London house.[19]

Egremont was succeeded by his twelve-year-old son, the third earl. When he grew up, the young man was not at first very enthusiastic about his father's marbles, instructing Brettingham to dispose of some of them. Brettingham offered a selection to Charles Townley in 1778 but no transaction materialized, although a *Diana* was acquired at this time for the Buckingham collection at Stowe. Later, however, Egremont decided to retain the marbles and started to add to the collection, most notably by the acquisition of a *Pan and Daphnis*, bought at Lord Bessborough's sale in 1801 (see fig. 98), but he preferred contemporary sculpture and was a noted patron of Flaxman, Westmacott, Rossi and Carew. In 1824 he decided to increase the display space in the Gallery by opening up the windows in the arcade, demolishing the bow and adding a T-shaped top-lit gallery beyond to contain part of his very extensive collection of paintings by Reynolds, Fuseli, Turner, Opie and Blake and a number of his large modern statuary groups. A few of the antique marbles were moved into this splendid new room and a row of paintings was hung above the statues instead of busts in the original Gallery (fig. 86). Although the walls of the new display space were at first painted grey-blue, the colour scheme was later changed to white, and then, at some time during the nineteenth century, there was a further alteration when the walls were redecorated in a deep red. As a result, the first impressions of the original eighteenth-century Gallery are confusing. Although the basic structure of Brettingham's room remains, the room has been darkened by the new colour

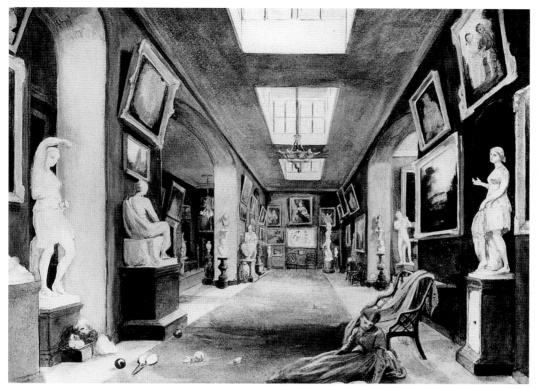

86 Madeline Wyndham, *The Gallery, Petworth, c.*1865, showing the nineteenth-century arrangement with the original Gallery through the arch on the left

scheme and the view into the garden through the windows of the arcade has been replaced by glimpses of the paintings and statues in the extension beyond.[20]

Petworth and its collections were transferred by Egremont's descendants to the National Trust.

WILLIAM WEDDELL OF NEWBY

William Weddell's marbles in their Sculpture Gallery at Newby in Yorkshire form one of the most attractive of all the Grand Tour collections. Weddell, son of a York grocer who had inherited a South Sea fortune from his uncle, was determined to establish his position as a country gentleman. He was educated at Cambridge and, when he set off for Italy in 1764, at the age of twenty-eight, slightly older than many Grand Tourists, he already had clear ideas about remodelling and refurnishing the imposing but by then old-fashioned William and Mary house that his father had bought. He was influenced in this by two of his young neighbours, Lord Rockingham of Wentworth Woodhouse, his future brother-in-law, under whose auspices he was to enter Parliament on his return from his Tour, and Thomas Robinson, his kinsman, who was described as 'that store-

87 Pompeo Batoni, *William Weddell*, Mr Richard Compton, Newby Hall

house and repository of ancient and modern taste'. Weddell knew exactly what he wanted. In Paris he ordered a set of tapestries after designs by Boucher and in Rome he started to buy marbles to fill the intended Sculpture Gallery, for which the local architect John Carr had constructed the shell.[21]

Horace Mann had given him an introduction to Cardinal Albani, who could have been of assistance, but, since Weddell spoke little French and no Italian, Jenkins, introduced by Robinson, proved a more useful contact. As described earlier, the dealer sold Weddell the exceedingly expensive statues of *Venus* and *Minerva* and supplied him with many other pieces, both while he was in Rome and after his return to England. Weddell knew the size of his proposed Sculpture Gallery and the approximate number of statues and busts that he would need to fill it satisfactorily. He was not deterred by the cost of the exercise, because he realized that he could not bring together a substantial collection in a short space of time without paying premium prices. He used other dealers in addition to Jenkins. Piranesi supplied a tripod surmounted by a curling snake, later illustrated in *Vasi, Cande-labri, Cippi*, while Cavaceppi sold him another tripod, formerly in Cardinal Albani's collection, and was probably the source of at least seven other antiquities which he restored for him, including two further tripods, a herm, an *Ibis Struggling with a Snake*, a *Priapus*, an *Apollo* and two heads. In all, nineteen chests of marbles were shipped back to England through John Dick, the consul in Genoa. At the same time, Weddell was buying paintings from Jenkins and Gavin Hamilton, although these have largely disappeared, and he found time to sit for Batoni. The full-length portrait, now above the staircase at Newby, shows the young Tourist wearing an elegantly frogged blue coat and waistcoat, gesticulating towards the *Sleeping Ariadne* (fig. 87), while in a smaller three-quarter-length version the ruins of the Colosseum are substituted for the statue. On his return from a Tour that lasted less than a year, he had amassed 'such a quantity of pictures, marbles etc. as will astonish the West Riding of Yorkshire'.[22]

After consulting a number of architects, Weddell selected Robert Adam to prepare a scheme for the interior of the Sculpture Gallery in which his new marbles could be displayed. Adam divided the exhibition space into three sections. In the centre, a top-lit domed rotunda, inset with four niches and one arched recess for the most important statues, opens onto the garden (fig. 88). It is linked by arched openings to a square room on either side with niches for more sculpture (figs 89 and 90). In all three rooms,

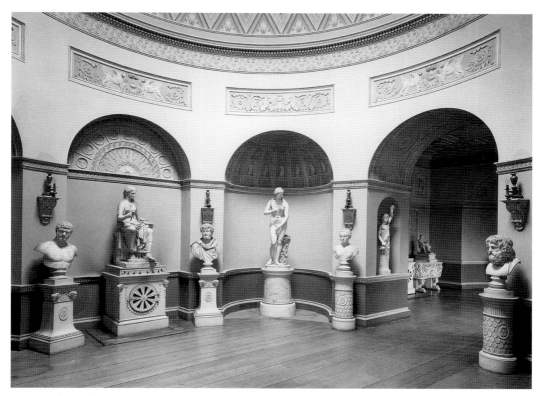

88 Newby Hall, the Sculpture Gallery

delicate plasterwork fills the coves above the niches, panels of arabesques and gryphons are set below friezes of ox skulls and *paterae* and the ceilings are coffered or patterned with stucco inspired by the antique. The walls are painted in different shades of pink and deep red to show off the marbles, with a pale green for the panels of arabesques by way of contrast. Adam also designed the pedestals for some of the statues with pierced grills to provide a hot-air heating system. The only feature of his designs to be omitted was an elaborately patterned marble floor. In this, his only surviving Sculpture Gallery, Adam noticeably disregarded the conventional wisdom that plain surroundings were best suited for showing off marbles. Not everyone approved. After Charles Townley had visited Newby in 1779 he wrote to Jenkins, giving a description of the surroundings in which the collection was displayed. 'It's a Pity Mr. Weddell should have been induced to over-charge his Gallery with Ornaments'; Jenkins replied, 'but the Adams I am told have done it everywhere.'[23]

Weddell arranged his collection to fit the new spaces. In the first room there were five statues, one of them modern, a colossal head of *Hercules* and some antique busts. Of the statues, a *Venus* with her hand on a dolphin, facing the visitor on entry, was a very pretty decorative piece and the standing male figure on the other side of the arch could give rise to long debate as to which Greek philosopher or orator he represented (fig.

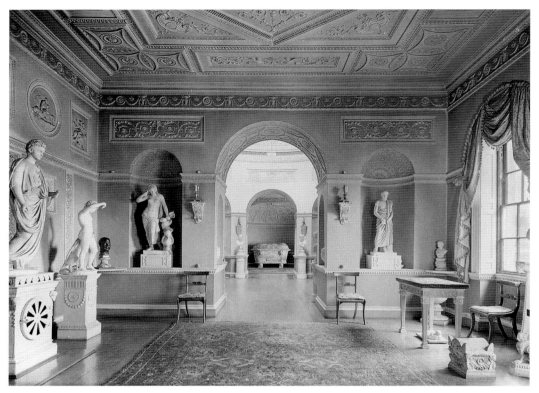

89 Newby Hall, the Sculpture Gallery

89). The two most expensive pieces, the *Venus* and the *Minerva*, took pride of place in the Rotunda with three other statues, while, at the far end of the Gallery, a giant bath of pavonazzetto marble, restored with a beautifully fluted lid, was large enough to provide a focus for the whole ensemble (fig. 90). There were some sarcophagi and vases in this last room and a *Priapus*, whose swelling erection, emphasized by its concealing drapery, could be avoided or observed just inside the door, depending on whether the guests were prudish or broad-minded. Townley's plan of the Gallery shows that the arrangement of the statues was slightly different from that seen today, because Weddell had not completed his purchases at the time of his visit; in particular, there was a simpler display of only five statues in the rotunda and there were more busts in the first room.[24] The nineteenth-century paddle-bat plans of the three rooms, provided for the use of visitors, show that the displays were more or less in their present form at that date.

Weddell was concerned with the overall aesthetic effect of his collection and not with the merit of the individual pieces as antiquities. His statues were to be enjoyed for their beauty (like his figures of *Venus*) or for the stories that they could tell (like the nude torso, equipped with a mean Roman head and a dagger to become a *Brutus*, 'artfully contrived by Mr. Jenkins to suit certain people', as one contemporary sarcastically remarked). He was clearly not worried by the rumours that he must have heard about the restoration work. The *Venus* and the *Minerva*, bought from Jenkins, were not the only

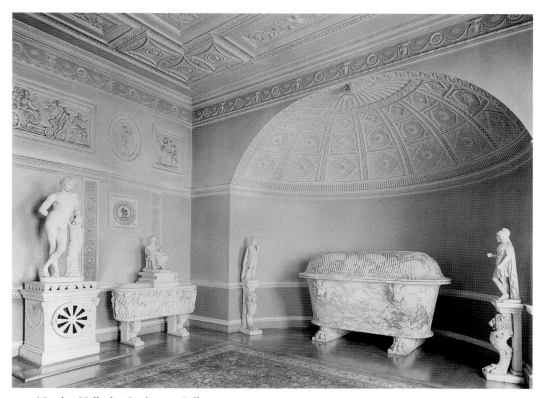

90 Newby Hall, the Sculpture Gallery

composite figures with heads that did not match their bodies.[25] As in many other col-
lections at this period, the surface of the statues was extensively reworked, smoothed and
polished. Weddell interspersed his statues with busts and a number of large ornamental
marbles to enhance the decorative effect and give some of the atmosphere of a Roman
palace, in which tripods, sarcophagi and vases were generally placed between the emper-
ors and deities along the galleries. Judged by today's criteria, few of the statues at Newby
would be acceptable to the antiquities department of a major museum in their present
state, although they would be prominently displayed in rooms devoted to eighteenth-
century culture, but the collection of beautiful and interesting marbles, set out in the
elegance of Robert Adam's Gallery, perfectly illustrates the taste of the Grand Tour
connoisseur.

The position of the Gallery is significant. Although it is in a detached wing, access to
it is through a room (now the Library) which was used until 1807 for dining, the focal
part of the house for entertainment. When he wanted to show off his collection after
dinner, Weddell would have led his guests to the Gallery next door to admire his marbles
by candlelight in the approved fashionable manner. Goethe describes how he visited the
Vatican Museums and the Capitol in this way, and the paintings of Wright of Derby
show that candle-lit viewing was an aesthetic thrill enjoyed by Britons as well. Goethe's
young friend Heinrich Meyer lists the advantages of this illumination:

each work is seen by itself, isolated from all the others, so that the spectator's attention is exclusively focussed on it; second, in the bright light of a torch, the finer nuances of the work become more distinct, the confusing reflections (particularly annoying on highly polished statues) disappear, the shadows become more marked and the illuminated parts stand out clearer. . . . only such illumination can do justice to statues which are unfavourably placed.[26]

Weddell died in 1792, 'suddenly, on entering the cold bath in Surrey-street, in the Strand, tempted by the extreme heat of the day . . . He had walked into the bath up to the middle, when he was seized by a sudden internal chill, and, before he could retire, expired. His name written in his hat discovered who he was to the bath-keeper.'[27] Death in a Roman bath was a fitting end for such a collector of antiquities and it was equally fitting that his monument by Nollekens in Ripon Cathedral should have been based on one of the antique tripods in his Gallery. Since he had no direct heirs, the collection was left to Lord Grantham, son of his kinsman and mentor, Thomas Robinson, whose descendants still own Newby and its marbles. Sadly, the completeness of the collection was broken when the famous *Venus* was sold in 2002.

LORD PALMERSTON AT BROADLANDS

Henry Temple, second Viscount Palmerston, the father of the nineteenth-century Prime Minister, made three trips to Italy and frequently visited the rest of Europe (fig. 91). Most of his antiquities were assembled on his first Grand Tour in 1763–4, when he was in his mid-twenties. In March 1764 he wrote, 'I am now settled at Rome and am regularly going the Round of Antiquity . . . I never had any Idea till I came here what a good Statue was or what Effect it was capable of producing.' Three months later he continued in the same vein, claiming that ancient marbles gave him the greatest pleasure. 'I had seen before I came to Italy Pictures almost as good as those at Rome but I never saw a Statue worth looking at till I cross'd the Alps.' He chose Gavin Hamilton as his agent to buy antiquities and also commissioned from him a large painting of a Homeric subject. His itemized list of purchases, dated 1764, shows that he deliberately set out to assemble a collection that would form a symmetrical display because many of the statues, busts and vases were bought as pairs. He was not at all a lavish spender. The two most expensive items were the statues of *Ceres* and *Hygeia*, which together cost him

91 Angelica Kauffmann, *Lord Palmerston*, Lord Romsey, Broadlands

only £90, a very low price, but they had been extensively restored by Cavaceppi, who had worked them up from headless and limbless trunks. On average Palmerston paid as little as £10 each for his busts and heads, some of which were fakes in Cavaceppi's manner. At the end of his Tour, he had spent about £500 in buying his marbles and the table tops on which to display them (less than half the price that Weddell paid for a single statue), while his paintings had cost £322, a modest outlay for a man with an income of £7000 a year. He also bought a copy by Nollekens of the *Boy on a Dolphin*. This rather sentimental group of a dead child carried on a dolphin's back was supposed to have been designed by Raphael and carved by Lorenzetto, whereas it was, in fact, a modern fake, probably from Cavaceppi's ingenious workshop. It was a piece that caught the fancy of several other Tourists, who commissioned copies for their own collections.[28]

Hamilton supplied further antiquities after Palmerston had returned home. These included a relief of *Maenads* and a candelabrum base, both of which Palmerston had admired in the Barberini Palace. 'I . . . heartily congratulate your Lordship,' Hamilton wrote in August 1765, 'in being the possessor of the finest Bassorelievo in Europe . . . it gives me a singular pleasure to think that it falls into the hands of one that has taste to enjoy it, & hope that it won't be placed over a chimney where the smoke may damage it, but rather near the eye where everybody of refined taste may have an opportunity of doing justice to this exquisite Greek performance.' In fact, the relief was of the Augustan period and had been extensively restored, including part of the upper section with one of the pretty Maenads' heads (fig. 92). At the same time Palmerston bought from Colin Morison a little statue of a *Muse*, a *Sleeping Cupid* and another bas-relief. Sometime later, Piranesi provided three urns, which were illustrated in *Vasi, Candelabri, Cippi* but do not appear in the 1764 list.[29]

92 *Maenads*, bas-relief, Lord Romsey, Broadlands

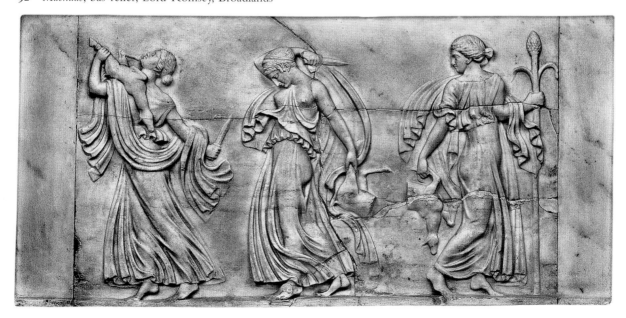

93 Broadlands, the Sculpture Hall

Back in England Palmerston employed the landscape gardener Capability Brown to remodel Broadlands, his country house in Hampshire. A new Sculpture Hall was created out of the old entrance Hall. It was a simple room with niches at either end and a screen of Doric columns to one side (fig. 93). Here the small statues and vases were placed on the marble-topped tables and busts were set on brackets round the walls. The more important statues of *Ceres*, *Hygeia* and the *Boy on a Dolphin* were located in the Saloon. A few years later Henry Holland added a small octagonal vestibule which was also dedicated to sculpture. Despite Palmerston's professed admiration of good statues, his purchases were almost all in the nature of furnishing antiquities. Nevertheless, his modest collection and the simple architectural setting devised for it show the results that could be achieved by a man of taste without extravagant outlays.

In the early twentieth century Palmerston's heirs acquired a few decorative urns from the Hope and Western collections. The marbles remain at Broadlands today, although the original disposition has been changed.

LYDE BROWNE

Unlike most of the collectors considered hitherto Lyde Browne was not a country landowner but a merchant and silver refiner of the City of London, living in Foster

94 *Torso*, drawing, Society of Antiquaries

95 *Silenus*, drawing, Society of Antiquaries

Lane off Cheapside and a suburban villa overlooking Wimbledon Common.[30] He was very prosperous and, in 1768, became a director of the Bank of England (for which it was necessary to own £4000 nominal of Bank Stock as a qualification). In common with many other city merchants and lawyers, he was elected a Fellow of the Society of Antiquaries but, unusually for this class, he was not content with passing Druid knives, old coins and sketches of encampments round the table at the Society's meetings.[31] In 1753 he went to Italy with his wife in order to buy marbles. 'You cannot oblige Mr. Browne any way so sensibly as by laying him on the Scent of Antiquities', Horace Mann was told by the embassy in Turin. When Browne reached Rome, he tried to find a good agent to supply him but it was not until after his return to England that he came across a satisfactorily energetic buyer. Thomas Jenkins had been elected to the Society of Antiquaries in 1757 and, apparently unaware of the members' preference for domestic and medieval antiquities, had started to send to the Society a series of reports concerning current excavations in Rome, together with drawings of the most notable works discovered or on the market and an indication that he would 'be very glad . . . to be honoured with any Commands'.[32] Browne, who had himself been elected a Fellow in 1752, took on Jenkins as his main agent in Rome and, in due course, arranged for drawings to be sent direct to himself so that he could have first refusal of the goods on offer before any communication was passed to the Society (figs 94 and 95).

Although Jenkins was his main supplier, Browne bought from Gavin Hamilton, Cavaceppi, Amadei, Piranesi and other Roman dealers at various times and he acquired pieces from the collections of Cardinal Polignac in France and Hans Ludwig von Walmoden in Hanover. A bust of *Tiberius* that originated in Athens was bought from the heirs of an ambassador to Constantinople, a relief was sent from Cairo and other antiquities came from Naples. A second visit to Rome in 1776 enabled him to view the market there in person. He told Townley that there was not 'a sculptor's shop in Rome which I have not visited . . . Cavaceppi has little & tho' I shall lay out some money with Piranesi, yet you know that they are but Pasticcios.'[33] The list of Roman collections from which he secured marbles is very impressive – the Barberini, Giustiniani, Albani, Spada, Verospi, Mattei, Odescalchi, Massimo, Colonna, Altems, Corsini and even the Medici. He also secured new discoveries from excavations at Tivoli and along the Appian Way. Modern works were added to the antiquities as well as copies of the *Borghese* and *Medici Vases*. The most notable of his non-classical marbles was the original version of Cavaceppi's *Boy on a Dolphin*, formerly in the collection of the ambassador of the Knights of Malta, the Bailli de Bretueil.

Browne was unusual in that he did not invariably require his statues to be fully restored. A nude trunk of *Hercules*, although equipped with a distinguished head which had been illustrated in Joseph Spence's *Polymetis*, was not given new limbs but was left incomplete like the *Belvedere Torso*. In the same way, a relief of the *Sleeping Endymion*, cut off at the waist, was not extended by the addition of lower limbs. Since these marbles had been acquired through Jenkins, who invariably had all his antiquities repaired as if new, Browne must have given explicit instructions that he did not want any further restorations. He took a scholarly interest in his subject – almost his last recorded action at the Society of Antiquaries was to borrow (and return) a copy of Winckelmann's *Monumenti antichi inediti*.[34]

96 *Paris*, sold by Lyde Browne to Lord Rockingham, J. Paul Getty Museum, Los Angeles

Most of the marbles were arranged in Browne's Wimbledon house, where they occupied a Gallery, the Dining and Billiard Rooms, corridors and a garden building. It was a modest villa, never designed to provide extensive gallery space, and visitors complained that the display was 'too cramped and unsuitable'. The original house no longer exists, having been completely rebuilt after a fire.

Being a good merchant, Browne could not resist trading in antiquities. This was not unusual because Tourists often did a certain amount of swapping among themselves on their return in order to fit their purchases more appropriately to their houses or to dispose of duplicates, but Browne was particularly active in this respect. A *Paris*, which was to form part of a group with three god-

desses carved by Nollekens, was among some statues sold to Lord Rockingham (fig. 96), a number of busts went to Lord Egremont, while Charles Townley, Matthew Duane and Lord Bessborough were among the discerning collectors who acquired pieces from him. He even sold four marbles to Cardinal Albani. Finally, in 1784, he shipped most of his collection to St Petersburg to be sold for £20,000 to the Empress Catherine, who had made another block purchase, the Walpole paintings from Houghton, five years previously. The price was a steep one – a note in Townley's papers gives a 'supposed valuation' of only £14,485. He received the first instalment of £10,000 but, when the banker through whom the balance was due to be remitted went bankrupt in 1787, the bad news brought on a stroke from which poor Browne died. Most of his marbles are now divided between the Hermitage and Pavlovsk. The dramatic sale seems surprising for such an enthusiastic collector but it is paralleled by Cardinal Albani's disposals earlier in the century. It in no sense implied that Browne had lost interest in antiquity because he was promptly in touch with Jenkins to buy more statues from the Villa Negroni. As he told Townley, 'all *Virtù* will be bought in future for present enjoyment, & to be parted with when satiated with the possession thereof.'[35]

Browne issued two catalogues of his collection, the first in 1768, listing 80 items as well as 'more than fifty excellent and beautiful vases, mostly from the Giustiniani gallery, which it would take too long to describe', and the second in 1779. By the latter date he had amassed 57 heads, 24 busts, 42 statues, 29 vases, 10 bas-reliefs, 54 sarcophagi and funerary chests and 44 architectural fragments.[36] The second catalogue, with its Italian text and notes of the distinguished collections from which he had bought, must have been intended to circulate information about his marbles with a view to their ultimate sale.

Although his wife was painted by Batoni in Rome, no portrait of Browne seems to have survived, his papers have disappeared and he remains a shadowy figure. He was, however, a connoisseur of exceptional discernment, whose marbles were worthy of an imperial palace. The visitor to St Petersburg today can gain a good idea of the breadth and quality of his collection.

LORD BESSBOROUGH AT ROEHAMPTON

Lord Bessborough has already been mentioned as an early traveller to Greece and a collector of gems (fig. 97). He was a member of the Dilettanti Society and, from 1768, he was a trustee of the British Museum. Although his main estates were in Ireland, his involvement in British politics meant that he was based in England. In 1762, following the death of his wife, he sold Ingress Abbey, his house in Kent, and set about building a suburban villa at Roehampton to the designs of Sir William Chambers. Here he installed his large collection of antique sculpture. The sale catalogue of 1801 states that 'a great part . . . was formed during his travels and residence in Italy', but this is auctioneer's exaggeration because most of the objects were acquired long after his original Tour in 1736–8.

The marbles included an archaistic Greek statue of *Apollo* and a *Lion devouring a Horse*, apparently from Smyrna, and some *stelae* which may have been acquired on his travels. Otherwise they consisted of a medley of statues and busts, some of which were copies,

and numerous decorative altars and reliefs. Two cinerary chests, illustrated in *Vasi, Candelabri, Cippi*, came from Piranesi's workshop and Jenkins was another supplier. 'Lord Bessborough is so deserving,' he told Townley, 'that I am glad to have it in my power to send him anything worthy of his elegant place at Roehampton.' The lascivious group of *Pan and Daphnis*, now at Petworth (fig. 98), as well as the noted torso of *Venus* (a suggestive fragment from the navel to the thighs, formerly in Stosch's collection) and the curious *Suckling Hermaphrodite* (see fig. 113), both subsequently acquired for Ince, may indicate the erotic preoccupations of this noted womaniser, who is said to have had an affair with Princess Amelia, one of George II's daughters, and who was cited in the Worsley divorce case when he was nearly eighty.[37]

The collection, which comprised over a hundred items, is interesting not so much for its contents, long since dispersed, as for the original way in which it was displayed. While some of the statues and busts were exhibited in the Hall, urns and 'Etruscan' vases were kept in the Catacombs. This was the rather misleading name given to a well-lit vaulted and stuccoed passage, fitted with niches, to imitate an ancient columbarium in the manner of Pietro Santi Bartoli's *Gli antichi sepolchri*. It was the prototype for similar displays in, for instance, Sir John Soane's house. Bessborough was also one of the first collectors to devote temples and a greenhouse in the garden for further arrangements of statues, busts and sarcophagi, the Temple of Virtue and Honour being reserved for busts of ancient worthies. The sale in 1801 was a notable occasion at which many of the leading collectors of the day joined in the bidding, including Towneley, Blundell, the Earls of Egremont and Carlisle and the Duke of St Albans.[38]

97 George Knapton, *Lord Bessborough*, Society of Dilettanti

98 *Pan and Daphnis*, The National Trust, Petworth

THOMAS MANSEL TALBOT OF MARGAM

Some collectors behaved very erratically. Thomas Mansel Talbot was a young man who had inherited large estates in south Wales through his grandmother's family, the Mansels. On coming down from Oxford, he spent four years travelling in France and Italy between 1769 and 1773. He seemed to make a promising start, aided by the good fortune of having 'money enough to supply a total want of judgments'. He acquired modern paintings by Canaletto, Mengs and Hackert, some distinguished older masters, including works by Lodovico Carracci, Artemisia Gentileschi and Luca Giordano, marble chimneypieces by Cardelli and Albacini, one of which incorporated gilt bronze decoration by Valadier, portrait busts of himself (fig. 99) and of the pope by Christopher Hewetson and a pioneer work of neo-classical sculpture, *Diomedes stealing the Palladium*, by the Swedish sculptor Johan Sergel. Townley encouraged him to buy antiquities as well. Through Jenkins and Hamilton he rapidly acquired eight statues, seven busts and heads, a sarcophagus, funerary chests and some 'Etruscan' vases. Hamilton supplied a *Satyr Boy* from the Barberini collection, a heroic head which had belonged to the Mattei, together with a statue of a youth, 'one of the Ptolemies', and three busts from his excavations at Hadrian's Villa at Tivoli. Among other marbles, Jenkins provided a statue, which had been given a new head of *Tiberius*, from the Carafa collection in the Columbrano palace in Naples. The most unusual piece was a marble head of *Minerva* which had been equipped with an antique bronze helmet and placed on a new bust, a triumphant confection of the restorer's art (fig. 100), similar to one that Townley owned. As pedestals for some of his

99 Christopher Hewetson, *Thomas Mansel Talbot*, Victoria and Albert Museum

100 *Head of Minerva* on a Roman sepulchral *cippus*, formerly at Margam Abbey

101 The Orangery, Margam Abbey

marbles Talbot bought a number of funerary inscriptions, probably from Piranesi, who dedicated a plate of his *Vasi, Candelabri, Cippi* to the rich young Tourist. In all, Talbot's notebooks record the expenditure of £4662 on sculptures and paintings, which were shipped back to Wales in thirty-one packing cases. He paid high prices for his statues; his *Drunken Hercules* cost £500, his *Tiberius* £250 and a colossal *Lucius Verus* £220, while the *Youth* from Hadrian's Villa, the *Satyr Boy* from the Barberini palace and three of his busts cost £150 each.[39]

Once his travels were over, Talbot seemed to lose interest in his acquisitions. He demolished the Mansels' old-fashioned house attached to the ruins of Margam Abbey and began to build a new seat at Penrice on another family estate further to the west, but work there gradually petered out and the decoration was left unfinished. It remained in that condition until 1792 when he belatedly found a wife, a girl twenty-eight years younger than himself, and the furnishings were completed in anticipation of the wedding. He was equally tardy in displaying his marbles. Since they would have overcrowded Penrice, they remained in their packing cases for over fifteen years. Then in 1786, rather capriciously, in view of the fact that there was no longer a house at Margam, he started to erect an enormous Orangery in the garden there (fig. 101). The antiquities were eventually displayed in rooms at either end of this building, together with some cork models of ancient ruins, but the Mansels' original collection of orange trees remained in every sense the central attraction.[40]

On Talbot's death in 1813 he was succeeded by his son, Christopher, who employed Thomas Hopper to create a new house at Margam in the 1830s. Most of the marbles were transferred to this building, where they were displayed in the Hall and on the Staircase until the contents of the house were sold in 1941.

JAMES BARRY OF MARBURY

James Hugh Smith Barry was another impetuous young Tourist who amassed a large collection in a short time but subsequently lost interest in it.[41] His father was the younger son of Lord Barrymore, an Irish peer, and his mother was the daughter of a rich landowner, Hugh Smith, whose name was worth adopting because of the fortune that went with it. The family had estates not only in Ireland but in Cheshire as well, which may account for their friendship with Charles Townley, a landowner in the adjoining county. It had been hoped that Barry would be able to travel to Italy with the distinguished connoisseur but, when Townley fell ill, the young man set off on his Tour unaccompanied towards the end of 1771. Once in Rome he fell straight into the hands of Jenkins, who started to sell him antiquities. 'As this gentleman is well disposed and has a spirit to pay for fine things,' Jenkins wrote, 'I hope he will not purchase things of mediocrity.' The following year Barry met Townley in Naples and together they visited Sicily, where they bought a large number of Greek coins. Such an expedition with a knowledgeable collector implies a serious interest in antiquity, because Sicily was rarely visited by Tourists at this period. His next step was equally serious, a tour of Greece, Constantinople and Egypt with two other young men, Lord Winchilsea and Thomas Dashwood, accompanied by James Clark, the painter and antiquary, and by Sir William Hamilton's doctor, Alexander Drummond. On this trip he 'picked up some fragments of taste', as Gavin Hamilton described them, including a female head of the fourth century B.C., a small fragment of the Parthenon frieze and a couple of funerary pieces.[42]

After a year and a half in the eastern Mediterranean, where it was quite difficult to spend very much money, Barry's prodigality was unleashed in the final months in Rome before he returned to England. He seems to have resolved to bring back a major collection of antiquities and a gallery of old masters to match them. Jenkins, as ever, was delighted to assist by supplying a number of very expensive items. He had already sold him an *Equestrian Paris*, of which only the bodies of horse and rider were original, the heads and all the limbs being restorations. Gavin Hamilton, who had excavated the statue at Tor Columbaro in 1771, decided that it was in too poor a state to be worthy of Lord Shelburne's gallery, which he was stocking at that time, 'considering it was so much fragmented, and well knowing what nice judges we are in England in horse flesh'. He therefore passed it on to Jenkins, who offered it to Townley as 'a most singular and interesting antiquity', and, when the latter turned it down, sold it to Barry for £300 (figs 102 and 103). The next purchase was what is now known as the *Jenkins Vase,* another heavily restored fabrication, similar to the *Warwick Vase* and other concoctions of Piranesi's workshop (fig. 104). It had originally been a well-head in a palace in Naples, where Jenkins had bought it. He had added a lip and base to turn it into a vase and sold the result to Barry at the high price of £500.[43] He also unloaded five large statues from the Mattei

102 *Equestrian Paris*, formerly at Marbury

103 *Equestrian Paris* before removal of restorations, F. de Clarac, *Musée de Sculpture antique et moderne*

collection, several of which had been substantially 'improved' by the dealer's restoration team. It was, however, Gavin Hamilton and not Jenkins who sold Barry the most expensive piece of all, *Antinous with a Cornucopia as Vertumnus*, which had been excavated at Ostia in 1775. At a cost of £1000 it was indeed the most highly priced statue to be acquired in Italy by a British collector in the whole of the eighteenth century, apart from the Newby *Venus*.

Townley was not satisfied with the condition of all these marbles or their price. Barry, however, did not seek advice and, when he wrote to his father's friend, he filled his letters instead with accounts of the venereal diseases that he had caught from a variety of attractive ladies and of the doctors' recommended cures. He was determined to press ahead with his collection and talked in such grandiose terms about housing it at Belmont, the family house in Cheshire, that, when he returned to England in 1776, Jenkins pursued him with advice about visiting Weddell's recently built gallery at Newby and sent plans for a Sculpture Room prepared by the Roman architect Giovanni Stern. Further designs were in due course offered both by Piranesi and by James Byres, who made proposals for a Greek Temple. Alas, the bundles of these designs have disappeared and, among Piranesi's surviving drawings, there are no sketches to indicate how he could have decorated a British sculpture gallery. The idea of such an architectural work by Piranesi is tantalizing but not surprising, because he had etched the plates of the Hall at Syon, showing the arrangement of the statues, for Robert Adam's *The Works in Architecture* and he therefore knew what might be acceptable to British taste. The ornamentation would certainly have been no less elaborate than that at Newby of which Jenkins had expressed such disapproval.[44]

104 *Jenkins Vase*, National Museum of Wales

Barry's expensive purchases strained his resources. Even though the bills that had been drawn on his father's bankers to pay Jenkins were returned unpaid, the dealer rashly agreed to provide further credit himself. Eventually he advanced over £2000 without security to finance general expenses as well as allowing credit for the acquisition of antiquities and some dubious old masters. When the young man returned to England there must have been questions about the authenticity and market value of his purchases as well as about his financial prudence. Angry disputes ensued and threats of legal action from Jenkins with the result that Townley, who felt some responsibility for encouraging a taste for *virtù*, was called in to mediate a settlement. In the end, although Barry had proposed to return the *Equestrian Paris* and the *Vase*, he sent back only some of the paintings, but his debts were still not fully settled in 1789 when Jenkins was eventually forced to have him distrained in order to obtain some security and a fixed time for repayment. This was a very painful indignity for one so rich; at a meeting of the Society of Dilettanti, Barry publicly threw the blame for his arrest on Townley, who refused to be drawn into the argument but sent round a letter, exculpating himself. '. . . can you possibly think,' he wrote, 'that I, who have lived in intimate friendship with your father, family, yourself, & friends, could advise a Mr. Jenkins, an alien, as I may say to us all, to arrest you?' (How painful it would have been for Jenkins to hear himself so described by his longstanding client!) The following evening, Barry dined with Townley, in the company of Richard Payne Knight and Joseph Banks, and ruefully acknowledged his error.[45]

That was all in the future. Undeterred by financial problems, Barry was back in Italy again in 1779. This time, however, he avoided Jenkins and concentrated on adding to his coin collection with further purchases in the Kingdom of Naples, where his extravagance forced up the price of hotel accommodation. He returned to Rome the following year for Angelica Kauffmann to paint his portrait, rather raffishly posed in unbuttoned negligée (fig. 105). His last major purchase was made after his return to England. Henry Tresham had bought the figure of a *Seated Jupiter*, which formed part of one of the fountains in the Villa d'Este at Tivoli, and sold it on to Gavin Hamilton. The statue was offered first to Townley, who declined it, and then to Catherine the Great, through the intermediation of her architect, Charles Cameron. She demurred at the price of £800, which was reduced to £600 in order to tempt the British collector. The statue, stripped of its eighteenth-century restorations, is now in the J. Paul Getty Museum.

The marbles were arranged at Belmont until Barry inherited his uncle's nearby estate of Marbury in 1787, whereupon they were moved to the Hall in that house. The owner, who had spent over £6000 on an important collection of antiquities, did not, however, go on to build a Gallery for them nor, indeed, did he live at Marbury to enjoy them.

105 Angelica Kauffmann, *James Smith Barry*, private collection

Perhaps he felt that an expensive building programme would have been tactless at a time when he was being dunned by Jenkins. More probably he just lost interest. Soon afterwards he inherited yet another family property at Fota Island, County Cork, where he installed himself like a hermit. A visitor who went there in 1797 records him as 'a spoiled child of fortune'.

> He has travelled much, is very courteous and reasonable, appears to be well educated, is good natured, and would be happy if he had only £500 a year instead of £25,000; but his riches have so surfeited him and disgusted him with the world that he has almost totally retired from society, and lives a rather melancholy life in his island . . .[46]

When he died in 1801, he was succeeded in his estates by the eldest of his five illegiti-

106 Marbury, the Hall, showing the *Seated Jupiter* and the *Antinous* to the left and the *Jenkins Vase* in the centre

mate children. Marbury was rebuilt by Salvin in the mid-nineteenth century, when the marbles were arranged in a low and dark Sculpture Gallery, compared by Michaelis to a cellar (fig. 106). The *Jenkins Vase* and a modern porphyry urn were placed in the centre of this room, while most of the statues and busts were closely packed along the walls. Two colossal figures, which had originally greeted visitors in the Hall, were moved to the courtyard and a few of the livelier pieces (a *Drunken Bacchus with a Bacchante*, a *Satyr on an Ass* and *Hercules and Antaeus*) were placed in the Saloon, but a relief of a *Satyr copulating with a Goat* was modestly excluded from the Gallery. The smaller pieces, bronze statuettes, terracottas, lamps and glass, were displayed in a case in the Hall but, according to a German visitor, some of them, though attractive, were modern – Jenkins had, no doubt, provided the fakes. The collection was gradually dispersed by sales, the final portion being auctioned in 1987, and the house has been demolished.[47]

The collections of Barry and Talbot, who both owned statues of distinction, were amassed with enthusiasm and extravagance but were then totally neglected once the owners had returned from their Tours. The pleasures of antiquity did not always survive when transplanted to British soil.

HENRY BLUNDELL OF INCE BLUNDELL

Henry Blundell assembled the largest private collection of antiquities in Britain (fig. 107).[48] He was a country gentleman, whose family had lived at Ince near Liverpool since the twelfth century, but, being a Roman Catholic, he was prevented by law from taking any part in public life. He was thus spared the burdensome cost of supporting Parliamentary candidates and could afford to spend his income on other projects. Since his father had rebuilt the family seat and since he did not approve of wasting money on architects who might have suggested fashionable alterations, he initially concentrated his energies on improving his estates. Then late in 1776, at the age of fifty-two, he set off for Italy to join Charles Townley, a Lancastrian neighbour and fellow Roman Catholic. They travelled together from Rome to Naples, where they visited Pompeii and Herculaneum and Blundell bought some 'Etruscan' vases and marble table tops on which to stand them. It was on this trip that he was inspired by Townley with a new interest in life. He set about collecting antiquities.

Back in Rome, Blundell made his first acquisition, a small statuette of *Epicurus*, 'much recommended' by Townley, and he followed this up by an unprecedentedly large block purchase of some eighty marbles, formerly at the Villa Mattei,

107 Mather Brown, *Henry Blundell*, the Stonor collection, Stonor Park

from Jenkins. About a quarter of these were statues or busts and the rest were cinerary urns and decorative fragments. After the Papal Antiquary had selected the best of the Mattei pieces in 1770 and other dealers had subsequently picked over the residue for their clients, the remaining marbles were not very distinguished and had been heavily restored. It is, therefore, rather surprising that Townley did not dissuade his friend from making such an undiscriminating purchase, but then Blundell was not a scholar and he was attracted by the quantity rather than the quality of the goods. Not content with this purchase, he went on to buy further antiquities from the Palazzo Capponi and the Villa Borioni, both of which, like the Villa Mattei, had already been ransacked by dealers over a number of years. He also secured statues from Cavaceppi and a decorative shallow vase, much restored, and some fragments from Piranesi, who encouraged further purchases with the dedication of a plate in *Vasi, Candelabri, Cippi*. In addition to these antiquities, he acquired modern copies of ancient busts from the sculptor-restorers Giuseppe Angelini and Carlo Albacini and he bought contemporary paintings as well.

A year abroad was not enough to satisfy Blundell's appetite. He visited Italy three more times, in 1782/3, in 1786 and in 1790. On his two last visits, in the absence of competitive buyers, he bought statues of a higher quality; in 1786 he paid £200 each for a *Minerva* from the Villa Lante and a *Diana* from the excavations of the Emperor Gordian's villa, while in 1790 he acquired twelve statues from the Villa d'Este. His last purchases included a *Theseus*, much admired by Townley, a *Satyr and Hermaphrodite* from the collection of the keeper of the Capitoline Museum, Niccolo La Piccola, which his friend had frequently tried to obtain, and a modern statue of *Psyche* by Canova, which cost 600 *zecchini* and was more expensive than any of his antiquities. He still dealt with Jenkins but he had come to distrust his brand of salesmanship and therefore preferred to use as his intermediary Father John Thorpe, with whom he had studied at the Jesuit College at St Omer in his youth. Thorpe had gone on to become a Jesuit himself and continued to live in Rome after the Order had been disbanded, acting as an agent for British visitors who wanted to purchase paintings and antiquities. For many years he maintained a regular correspondence with Blundell, keeping him in touch with the market in Rome.[49] Antonio d'Este, Cochetto Guastaldi and Giuseppe Volpato were also suppliers of antiquities for the collection.

All these purchases had to be housed. Part of the first batch of Villa Mattei marbles was arranged in the Hall and up the staircase at Ince where statues, balanced on funerary chests, were set in niches on the walls. Other marbles were packed into the main reception rooms. Since there was never sufficient space to display all his antiquities elsewhere in the house, Blundell had to locate the rest of the collection in an existing garden building. 'I do not aim at a collection, or crowding my house with marbles, nor will I ever build a Gallery,' he wrote to Townley in 1787, playing down his own efforts to the senior collector with unnecessary false modesty, 'What I have bought was but, as it were, the sport of a day, and [I] shall be obliged to dispose of many of them at each end of my conservatory in my Garden.'[50] Despite this, his further acquisitions in 1790 necessitated a change of plan. A square temple was erected a short distance away from the house. On the façade, busts and inscriptions flank a Tuscan portico, in the centre of which a giant mask seems to intone the line from Virgil's praises of Italy, carved below, 'HERE THERE IS CONSTANT SPRING AND SUMMER OUT OF SEASON', as if the marbles had power

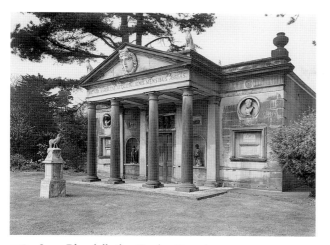

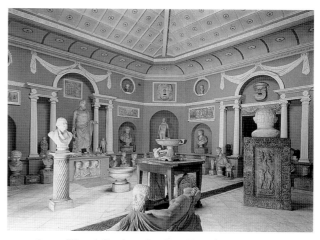

108 Ince Blundell, the Garden Temple

109 Ince Blundell, the Garden Temple interior with a twentieth-century arrangement of sculpture, since removed

to transform chill winds blowing off the Irish Sea into the mild zephyrs of Campania (fig. 108). The portico opens into an octangular room punctuated with Palladian openings, niches and roundels to provide settings for the most important pieces (fig. 109). The Italianate feel of the temple is as much due to the way in which marbles are set into the façade as to the influence of recent buildings in Rome such as Marchionni's Greek Temple in the Villa Albani or Simonetti's Museo Pio Clementino. The architect is unknown, although the design may well be attributed to Blundell himself with the help of William Everard, a Liverpool surveyor.[51]

The collector's last years were embittered by his relations with his son, Charles. In 1800 he complained about his heir, who was then aged thirty-nine, 'he takes no field sports, neither shooting, coursing, or hunting . . . What a different life I led at his years!'[52] To make matters worse, since Charles showed no interest in the opposite sex, it was probable that the male line of the family would become extinct. The old man, now stooping and grim faced, consoled himself by adding to his collection. Fortunately the difficulty of buying in Italy during the Napoleonic wars was compensated by opportunites in the London salerooms. In May 1800 Christie's sold forty-five chests of antiquities that had been captured off a French ship carrying plunder from the papal apartments in Rome. Blundell bought ten lots, including a fine sarcophagus front which he had himself purchased ten years earlier in Rome. When the Papal Antiquary had refused an export licence, Blundell had presented the piece to Pius VI, who had reciprocated with the gift of some marble topped tables and a painting of the relief. Blundell now had to pay £273 for an item that originally cost him £10.[53] The following month he bought eight marbles from Lord Cawdor's sale, in April 1801 twenty-two that had belonged to Lord Bessborough and in May 1802 seven from Lord Mendip. He did not always succumb to temptation: he refused to buy the *Villa Lante Vase* which Tatham had bought as a speculation at the Cawdor sale and had then touted round at an exaggerated price. The Bessborough sale, however, was a major event which so excited

the collector that he sent a stream of letters from Ince, asking for copies of the catalogue and then pencil sketches of the lots that interested him. In his determination not to reveal his identity as a bidder he ended by giving instructions to no less than four agents, including Townley, who was understandably indignant when he found out.[54]

Even that was not the end of the purchases for Ince; when the sculptor Thomas Banks died in 1805, Blundell bought some pieces from his estate, including a headless seated figure from the Arundel collection which had been rescued from the bed of the Thames. The collection grew steadily from some 325 items at the time of Townley's visit in 1792 to 536 in 1803 and 599 at the time of Blundell's death in 1810. It is interesting to note how the London salerooms were now being used to recycle some of the first Grand Tour collections. It was a process that had begun in the previous century but Mr Christie's auctions were now part of the London social scene, worth sketching by Thomas Rowlandson. Although the catalogues were not very informative, they gave occasional references to a provenance where it was known and might enhance the price.

Quite remarkably, Blundell started to plan his Pantheon, the most ambitious of all Grand Tour sculpture galleries, at the advanced age of seventy-eight. In anticipation of the Bessborough sale, he wrote to Townley;

> . . . you say you should judge better what marbles out of Lord Bessborough's collection would best suit, if you knew the size, Plan, and situation of my intended room. It is about 37 feet inside diameter, circular, lighted from the top, as the Pantheon, placed as near the East end of my house as well can be. The walls 6 feet thick to get room for 4 large recesses, so as to be able to see round the principal statues; nothing is yet done about it, but on paper except a model in wood just put in hand. In 4 other smaller recesses I shall place the 4 tables I bt last year at London, and place on them smaller statues &c.

Work started in 1802 and was completed shortly before the owner's death. Although the Pantheon is the most complete ancient building in Rome to survive, it has not been reproduced very often in Britain. Henry Flitcroft designed a lakeside version at Stourhead in the 1750s, Robert Adam imitated the interior in the Saloon at Kedleston and James Wyatt used the form for his Pantheon Assembly Rooms in Oxford Street, opened in 1772, as did Richard Payne Knight for the Dining Room in his Gothick Downton Castle a couple of years later. Townley, however, did not carry out the plans for a domed gallery, which Joseph Bonomi produced for his Lancashire house in 1789 (see fig. 156), and no one else was moved to create any similar building, although the example at Ince showed that it provided ideal display space for sculpture.[55]

The rotunda is canted at a slight angle to the main front of the house to which it was originally linked by a corridor, now absorbed by a nineteenth-century addition to the building. Since the Lancashire climate is not that of Italy, the ribbed lead dome is closed to the sky, unlike the Roman Pantheon, and the simpler portico differs from that of its prototype in being Ionic instead of Corinthian with a large battle relief from the Cawdor collection set in the pediment (fig. 110). The effect of the interior is splendid but sober with no surplus ornament to divert the eye from the marbles; the blue dome is coffered and partly gilded, the plaster ribs being in the form of elongated *fasces*. The yellow walls are enriched by grey marble for the pilasters, skirting and frieze, which

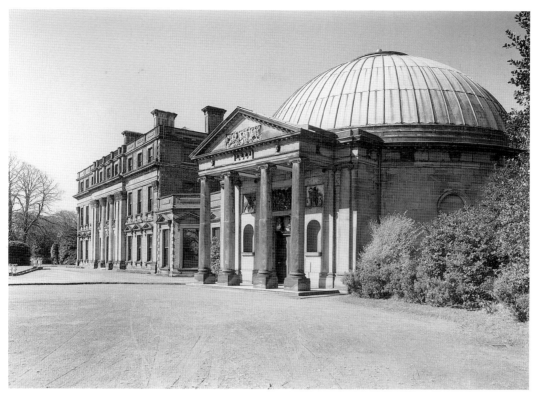

110 Ince Blundell, the Pantheon

contrasts with the variegated marbles of the smaller columns round the walls and in some of the niches (figs 111 and 112). The rhythm of the Palladian openings, niches and roundels replicates the arrangement of the earlier garden temple and, since the architect is unknown, Blundell himself may again have been responsible, although he would certainly have required the assistance of a very competent surveyor for calculating the thrust of the dome.

Blundell now set about rearranging his collection in the new gallery. The simple but effective device of varying the height of the niches enabled statues of different sizes to be grouped harmoniously beside one another. Reliefs were set above the arches and busts were placed in the roundels between the pilasters. A statue of *Diana* from Gordian's villa was placed in the centre of the rotunda and an array of smaller statuettes and busts was grouped on each of the pope's marble topped tables, disposed round the room. Yet more antiquities were set on plinths or placed on the floor. The combination of symmetry and lavish clutter created a grandly idiosyncratic vision of ancient Roman splendour.

Visitors from neighbouring Liverpool came to see the collection in such great numbers that opening had to be restricted to one day a week for pre-booked parties. A catalogue was issued in 1803, followed by an illustrated edition in two volumes, published in 1809. As the introduction to the latter states, the work was begun 'many years ago, by the advice, and with the assistance of a very intelligent friend [Townley]'. A few of the plates

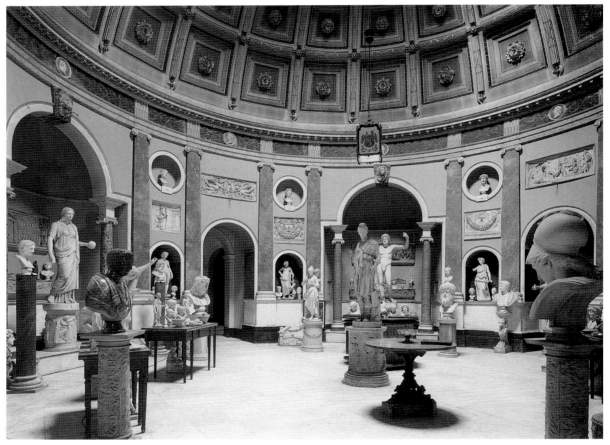

111 Ince Blundell, the Pantheon interior before the removal of the marbles

had been made in Rome before the statues had been shipped, which may indicate that Blundell was planning an illustrated catalogue as early as 1790. In 1799 he persuaded Townley to supervise the engraving of the other plates, a thankless chore, since no 'foreigner' was allowed at Ince to make drawings. To make matters worse, there was a muddle over the text of the first catalogue, which Blundell sent to London for his friend's comments. Townley sourly replied 'Your notions on these subjects differ in general so very widely from mine, and those of many others, who have attended to these matters, that almost a total new wording of your catalogue would take place if I or some other person were to undertake it.' It is easy to see why Townley thought that the old man was 'irresolute, capricious and unintelligent'.

The text accompanying the second edition, dictated to a local schoolmaster by Blundell, when he was in his eighties 'and nearly quite blind', fuses schoolboy memories of ancient history and mythology with a robustly and refreshingly agnostic attitude towards the far-fetched interpretation of symbols attempted by some scholars. He was

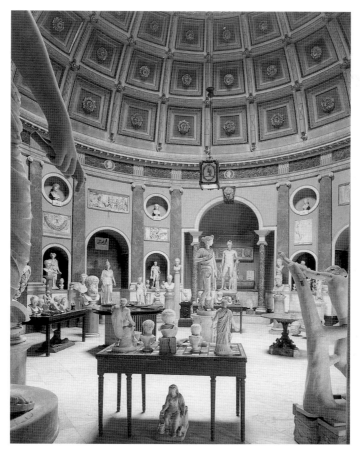

112 Ince Blundell, the Pantheon interior before the removal of the
marbles

particularly scathing about Townley's protégé, d'Hancarville, or D'Ankerville, as he called
him, 'whose work abounds so much with pagan allusions and mystical erudition'. As
Blundell firmly stated, 'The owner of this work does not pretend, nor is he able, to give
such learned dissertations, or cite such a variety of ancient authors as others have done.'
He sought only to provide 'plain descriptions, which will be more suitable to those who
are not much versed in heathen mythology'. It is rather ironic that the sceptic, who was
considered by Townley to be so 'unintelligent', was not taken in by d'Hancarville's effu-
sions, as were so many of his more learned contemporaries.[56]

The text devoted to each illustration generally identifies the subject, gives an ele-
mentary explanation and names the collection in Rome or London from which the
piece had been bought. Occasionally Blundell adds an anecdote. Of one statue he writes:

> Bought at Roehampton, at a sale of Lord Bessborough's, by a friend with a deal of
> erudition about it. When bought, it was in the character of a Hermaphrodite, with
> three little brats crawling about its breast. The figure was unnatural and very disgust-

113 Blundell's *Hermaphrodite* before Blundell's castra-
tion and other alterations, British Museum

114 *Hermaphrodite* restored as a *Sleeping Venus*, National Museums
on Merseyside

ing to the sight; but by means of a little castration and cutting away the little brats, it
became a sleeping Venus and as pleasing a figure as any in this Collection.

A drawing from Townley's collection shows the original condition of the statue, which
the more scholarly collector would never have 'improved' in this way (figs 113 and 114).[57]

Townley maintained that only five or six of the marbles at Ince were of any real merit.
It is certainly true that Blundell was not very selective, buying because he thought that
the subject was interesting and, despite his assertions to the contrary, ignoring the con-
dition of the statue and the extent of the dealers' restorations. In this he was no differ-
ent from most of his contemporaries. The higher quality of some (but by no means all)
of his later purchases may be due to the fact that, in the disturbed conditions of the last
years of the eighteenth century, there were fewer competitors for good sculpture either
in Italy or in the London salerooms. He was exceptional both in his addiction to buying
and in his magnificent architectural ambitions for the housing of his marbles. As he told
his son-in-law, Thomas Stonor, at the time of the sale of the Bessborough marbles, 'You
will think me extravagant about them, but if I lay out £1000 it is no great affair to me;
so don't lose for a few guineas more than I mention purchasing what I want. The money
is no object with me.'[58]

Charles Blundell, who inherited from his father in 1810, never married and, when he
himself died in 1837, he perversely bequeathed Ince and its collection to Thomas Weld,
a distant cousin, rather than to his sisters' families. The marbles in the Pantheon were
well maintained but it seems that, after these had been rearranged by his father, the
residue had been dumped in the garden temple with no attempt at organization. They
remained in that state when Michaelis visited Ince in 1873 and 1877 and were not sorted
out until after the end of the First World War. Then in 1959, when Joseph Weld inher-
ited the estate, he presented the City of Liverpool with most of the ancient marbles,
while the house and gardens were sold to an order of nuns. Some of the sculptures that
had been incorporated into the structure of the buildings were left *in situ*. It is to be
hoped that one day it may be possible to replace the bulk of the collection in its
original setting in the Pantheon.

SIR RICHARD WORSLEY AT APPULDURCOMBE

The only collector at this period to assemble predominantly Greek antiquities was Sir Richard Worsley. At the age of fourteen he was taken to Italy by his parents for a couple of years and he then went on a Grand Tour in 1769 after his father's death. He spent eight months in Lausanne where Edward Gibbon, a family friend, wrote that 'he seldom smiles, never laughs, drinks only water, professes to command his passions and intends to marry in five months'. Such a sober young prig was bound to run into trouble. At the age of twenty-four he married a Miss Seymour Fleming, a match that ended in sensational divorce proceedings seven years later, when Worsley sued a fellow officer of the Hampshire Militia, claiming £20,000 in damages for criminal conversation. He won the case but the judge awarded him only a shilling in compensation after hearing how the husband had hoisted his wife's lover up to a bath window to spy on her like the fabled Gyges (fig. 115). This affair and many others were catalogued with salacious detail in a pamphlet entitled *The Memoirs of Sir Finical Whimsy and his Lady*.[59]

The following year, 1783, Worsley left England for prolonged travels to escape the ridicule of the court case and did not return until 1788. After visiting Portugal, Spain, France and Italy, he sailed for the eastern Mediterranean, anxious, as he wrote,

to view the celebrated remains of sculpture, when it was carried to the highest perfection by the most elegant nation in the universe, the Greeks. I determined to visit Athens, where I arrived early in the spring of the year one thousand seven hundred and eighty five. The view of the superb temple of Minerva in the Acropolis was alone sufficient to obliterate the difficulties of the journey: the beauty and magnificence of that edifice . . . surpassed even my most sanguine expectations.[60]

In Athens he stayed with the French consul, who must have facilitated excavations in and around the old city. For the next two years he toured mainland Greece and the islands, Egypt, the west coast of Turkey, Constantinople and the Black Sea as far as the Crimea. Once in Russia he took in Moscow and St Petersburg before returning to Italy by way of Warsaw and Vienna. His remarkably extensive travels were recorded in 200 drawings made by Willey Reveley, an English artist working in Rome, whom he hired to accompany him, and in two volumes of his own schoolboyishly pedantic journals which he may have intended to publish. These contain long extracts from the ancient Greek authorities as well as from the accounts of recent travellers but give few insights into his own appreciation of the

115 *Sir Richard Worsley*, cartoon

buildings that he saw and only twice mention his purchases – casually referring to his acquisitions of a headless statue of a priestess in Megara ('I thought myself very fortunate to become possessed of it, which I did for a mere trifle') and of an important relief on Paros ('I was so fortunate as to purchase of the proprietor of the Castle a very fine bas-relief of Venus [fig. 116] which had been found in digging a cellar in part of the castle the year before and likewise two very beautiful Intaglios of uncommon merit.') At the end of his Tour he added some more conventional antiquities, bought from Jenkins and Gavin Hamilton in Rome. He began to form a large collection of gems, some of which were acquired in Greece, Egypt and Turkey. In Rome he met Goethe, who was unimpressed by the drawings made on his travels, apart from those 'of bas-reliefs from the Acropolis in Athens, the work of Phidias', of which he declared, 'Nothing could conceivably be more beautiful than these few simple figures.' Encouraged by this enthusiastic support for Greek art, Worsley sought the help of Ennio Quirino Visconti, son of the Papal Antiquary, in preparing the entries for the planned catalogue of his new collection, *Museum Worsleyanum*, which he designed for publication instead of the journals. He also arranged for some of his purchases to be engraved as illustrations for this catalogue and sought the advice of Canova on the restoration of his marbles. It is frustrating that his journals terminate on his arrival in Rome and give no account of his meetings with Goethe, Canova or Visconti.[61]

After a journey of 18,300 miles, he was back in England in 1788, where he met Townley on the introduction of Jenkins. The two collectors became close friends and Worsley was soon issuing invitations to Appuldurcombe, the family seat in the Isle of Wight, where he had arranged his collection. It was Townley who persuaded him to increase his gem collection by the purchase of Sir William Hamilton's outstanding cabinet, in honour of which a 'Gem Cottage' was created at Appuldurcombe, presumably decorated with reproductions of some of his best pieces. Worsley preferred to live abroad, however, and returned to Italy in 1793 as British Resident in Venice, where he continued to add to his collection both of paintings and antiquities until the fall of the republic in 1797.[62]

Worsley's most interesting marbles were the reliefs, most of them fragmentary, that he excavated in Athens, Eleusis and Megara, on Paros and in Turkey. These included the charming fifth-century B.C. grave *stele* of a *Girl with Doves* from Paros (fig. 116), now in the Metropolitan Museum, and some twenty portions of *stelae* dating from the same period (fig. 117). On the advice of Canova, most of these were left unrestored in notable contrast to the heavily repaired Roman marbles that Tourists generally required. At least two statues and some of the busts were also excavated in Greece and a few pieces of sculpture were acquired in Egypt. The principal Roman pieces were an imposing relief of a *Sacrificial Bull* that came from the Columbrano palace in Naples, probably supplied by Jenkins, and the group of *Bacchus and Acratus*.

Museum Worsleyanum was a lavish and extremely expensive publication, restricted to an edition of 250 copies for private distribution. Many of the plates were drawn by Vincenzo Dolcibene, the artist employed by Jenkins and Townley to provide illustrations of statues. He was not a wholly accurate recorder and, in a number of plates, added details to improve the images. The work was divided into six 'classes', which Worsley issued separately over a period of time from 1794 until shortly before his death in 1805.

JUPITER & MINERVA
Part of the Frieze of the Parthenon at Athens

116 Greek *stele*, formerly at Appuldurcombe and Brocklesby, Metropolitan Museum of Art, New York, Fletcher Fund, 1927. (27.45)

117 Greek *stele* fragment, *Museum Worsleyanum*

The first three classes, which were bound up to comprise the first volume, were devoted to his marbles, the fourth class described his gems (fig. 118), the fifth reproduced much of the Parthenon frieze, clumsily etched from drawings which William Pars had done for the Society of Dilettanti half a century before, and the final class showed where the sculptures had come from in two plates of the reconstructed Parthenon and Acropolis (oddly omitting the pediment sculptures on the grounds that the plate was too small) and a series of views of Greece, Turkey, Egypt and the Crimea, drawn by Reveley. The two volumes served to obliterate the image of Sir Finical Whimsy, the comic cuckold, and replace it with that of Worsley, the connoisseur. For the first time a collection of mainly Greek antiquities, some of which were (inaccurately) claimed to have come from the Acropolis, was set out in the context of the buildings of Greece and, in particular,

118 Selection of Worsley's gems, *Museum Worsleyanum*

of the Parthenon frieze. The descriptive text in English and Italian by Ennio Quirino
Visconti is, however, disappointing. Visconti was an excellent scholar, who went on to
become the director of the Louvre, but he concentrated on the iconography of the scenes
depicted without any aesthetic judgements, apart from commenting that the depth of
carving on the Parthenon frieze was calculated to avoid casting heavy shadows. Even
though he was familiar with the writings of Winckelmann, who had been his father's
predecessor as Papal Antiquary, he made no attempt to compare these genuinely Greek
works with any of the sculptures in the galleries of Rome or Florence. Nevertheless,
by emphasizing the excellence of reliefs as opposed to free-standing statues and by
publishing plates of the processional frieze of the Parthenon, Worsley's volumes paved
the way for a better appreciation of the marbles that Lord Elgin was acquiring.[63]

At Appuldurcombe the most important marbles were kept in the Colonnade and
Athenian Rooms. The latter took its name from two large drawings of Athens, made by
Reveley in 1785, which hung with his views of Troy and a capriccio by Henry Tresham
of all the great statues recently taken by the French army as trophies from Rome

119 Brocklesby, the Sculpture Gallery

to Paris. Another painting by Tresham hung prominently over the chimneypiece in the Dining Room, a *View of Athens* in which the Panathenaic festival was combined with an anachronistic parade of famous Athenians from Pericles to Plato. Continuing the Greek theme, Worsley had his own portrait painted 'in the costume of a Greek Philosopher, sitting in one of the Greek chairs which were bought at Rome'. These were marbles from the Villa Negroni which were used to decorate the portico at Appuldurcombe.[64]

On Worsley's death, his collection was left to his sister's daughter, Henrietta Simpson, who married the first Earl of Yarborough. The latter, who had himself inherited a small collection of antiquities from his parents, transferred Worsley's marbles to Brocklesby in Lincolnshire, where a gallery was created in the house to accommodate the combined collection. In the middle of the nineteenth century this gallery was dismantled and the contents were moved to an unadorned orangery in the garden where the collection remains, apart from the relief of the *Girl with Doves* from Paros (fig. 119). Appuldurcombe, which was burned out after it had been sold by the Yarboroughs, now stands as an empty shell.[65]

LORD SHELBURNE IN BERKELEY SQUARE

The only major collections of marbles to be housed in London were those of Charles Townley and Lord Shelburne. While Townley's lifelong accumulations were crammed into his small house in Westminster, Shelburne's marbles were displayed in a noble palace in Berkeley Square.

William Petty, second Earl of Shelburne and later Marquess of Lansdowne, was a great statesman but an unpopular politician, disliked by the king and mistrusted by Parliament (fig. 120). He was First Lord of the Treasury or Prime Minister for one brief period between July 1782 and February 1783, at the end of the War of American Independence, and was created a marquess the following year. He had a large income from his estates in England and Ireland and lived in grand style at Bowood, his Wiltshire house, which was enlarged and redecorated by Robert Adam, and in Shelburne, later Lansdowne, House in Berkeley Square. The latter, also designed by Adam, was bought from Lord Bute, still uncompleted, for £22,000 in 1765. It was one of the most splendid houses ever built in London.[66]

After his first wife's death in 1771, Shelburne took a short break from politics to visit Italy. At this stage the wing at the rear of Shelburne House, allocated as a gallery, was an empty case that needed to be filled. It seemed only natural to complete it with a display of antiquities – he had indeed made a start with minor purchases from the Adam brothers. In Rome he spent 1063.30 *scudi* on decorative urns and reliefs, acquired through Jenkins, and he decided to commission a series of paintings from contemporary artists.[67] This was insufficient for the magnificence of the new mansion. The scale of his project made him a tempting target for Gavin Hamilton, who was excited by the prospect of furnishing an entire sculpture gallery in a great London house on behalf of a rich and powerful patron; it would be a lucrative contract and the gallery, when complete, would serve as an eloquent advertisement for his business. He proposed a scheme for providing sixteen antique statues, twelve busts and twelve bas-reliefs, together with a cycle of history paintings of classical scenes from his own brush, at a cost of £6050, spread over four years. The plan also involved a new design for the gallery, to be provided by Francesco Panini, son of the ruin painter.[68]

120 *The Marquess of Lansdowne*, engraving after Gainsborough

Hamilton, who already had some antiquities in stock from his excavations at Tivoli, immediately despatched marbles to a value of £500, following them up with a colossal bust of *Minerva*, a charming group of *Cupid and Psyche* and a bust of *Antinous* in Egyptian costume, valued at £479 in all, and a request for an advance of £400 to finance further excavations. In January 1772 he wrote to Shelburne, promising that Panini's designs

121 Francesco Panini, Design for Lansdowne House, Sir John Soane Museum

122 Relief from Hadrian's Villa, formerly above the chimney in the Library, Lansdowne House

would be ready by the end of the month and adding that the original plan had now been modified: since it would be difficult to obtain enough good bas-reliefs, which would, in any case, be hard to see high up on the walls, casts would be substituted and the resultant cost savings would be used to increase the number of statues from sixteen to nineteen.

> The use of this gallery is to be a receptacle of fine antique statues. I should therefore advise throwing our whole strength on this point. I don't mean a collection such as has been made hitherto by myself and others. I mean a collection that will make Shelburne House famous not only in England but all over Europe.[69]

Shelburne must have been rather disappointed by Panini's designs, when they arrived. Instead of the elegant neo-classical formulae that Adam had provided for both Bowood and Shelburne House, the Roman scheme was in a baroque idiom, based on the Carracci Gallery of the Palazzo Farnese, which would have looked extremely old-fashioned at that date (fig. 121). It did, however, have one feature that was to remain constant in most of the subsequent designs for the room. A basalt relief from Hadrian's Villa, carved with Homeric scenes, was to be incorporated into the chimneypiece (fig. 122). It had been part of Hamilton's first consignment of marbles.[70]

Throughout 1772 and the early months of the next year a flow of letters from Rome to London kept Shelburne aware both of the quality of the statues that he was acquiring (the *Cincinnatus*, for instance (fig. 123), was boldly described by Hamilton as being from the hand of 'the same artist that made the *Gladiator* at the Villa Borghese') and of the problems in obtaining export licences from the Papal Antiquary. In January 1773 Hamilton wrote:

> His Holiness seems to have very extensive views with regard to the new Museum, and the difficulties of sending away antiques increase daily . . . I beg therefore, my Lord, that you will consider this point seriously and if possible throw your whole force and attention to that one object of antiquity for some time, till the collection is complete, which I can engage to do in the space of this present year, having now ready more than two thirds of the number wanted and all excellent in their kind.

He sometimes tried to smuggle particularly attractive objects, like the head of *Antinous*, but this was not easy. An attempt to conceal a *Discobolus* in 'a snug corner' failed, 'notwithstanding all the art I have used' and the statue had to be offered to the papal collection.[71]

During 1773 Hamilton shipped the *Cincinnatus* from Hadrian's Villa (valued at £500 when offered to the Pope, who considered it too expensive, but sold to Shelburne for £450 – a ruse not unknown in United Kingdom export applications today), a *Meleager* from Tor Columbaro (fig. 124) which, priced at £600, was one of the most costly of Shelburne's acquisitions, a *Marcus Aurelius* which cost £300 and was sent even though Shelburne had specified that he did not want portraits, and the *Wounded Amazon* and the *Fountain Nymph*, which were valued at £200 each. There was, however, an ominous silence about Panini's designs and it became clear that Shelburne had commissioned an alternative scheme from the French artist Charles Louis Clérisseau, a friend of Adam and Piranesi. That was also rejected, as was a subsequent design by another Frenchman, François Joseph Belanger. During this period Shelburne's interests had been diverted in another direction and he had been making large additions to his collection of manuscripts. In July 1773 he told Hamilton that Panini's designs for a Gallery were to be abandoned, because he was thinking of devoting the space to a library instead. Nothing dismayed, Hamilton came back with a counter-proposal for a library 'ornamented with statues and busts so as to form something elegant and beautiful', but Shelburne was not to be persuaded and gave orders that further purchases of sculpture were to be suspended for a couple of years. By that stage, Hamilton had supplied antiquities to a value of £3332.[72]

Despite the moratorium, a further small consignment of marbles for the garden was despatched in 1775 and Shelburne was still sufficiently interested in his sculpture collection to buy a *Narcissus* to match the *Paris* that he had acquired three years earlier, even though he had originally intended to wait until he could find a suitable *Venus* as its pair. When Hamilton heard that he was also considering two of Piranesi's candelabra, priced at 150 *zecchini*, to go between the windows of the gallery, he sent two herms from Hadrian's Villa as a free gift. It was a good ploy because he thereby lured Shelburne into making a further purchase when he wrote next year to offer a *Diomedes carrying off the Palladium*:

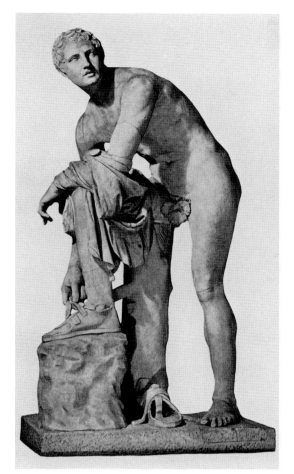

123 *Cincinnatus*, Ny Carlsberg Glyptotek, Copenhagen

124 *Meleager*, correctly *Antinous*, Santa Barbara Museum of Art

Your Lordship when in Rome mentioned to me particularly subjects of this sort as interesting to you, but besides the subject, give me leave to add that the sculpture is first-rate, and exactly in the style and size of the Cincinnatus to which I mean it as a companion, being a Greek hero to match the Roman. The legs and arms are modern, but restored in perfect harmony with the rest . . . Your Lordship will ask me why I suppose this statue to be a Diomede. I answer because it would be to the last degree absurd to suppose it anything else . . .

Hamilton had created a subject that he knew would appeal to his client. The price was £200, a low figure for a work of such boasted importance, but it took account of the amount of restoration (fig. 125). Shelburne duly bought the piece, which, despite Hamilton's vigorous assertions, was formed from the torso of a *Discobolus*, and he also acquired an impressive relief of *Aesculapius* which was eventually placed above the chimney in the Hall.[73]

125 *Discobolus*, restored as *Diomedes*, Private Collection 126 *Young Hercules*, J. Paul Getty Museum, Los Angeles

Buying marbles without having the opportunity of seeing them first was not easy and Shelburne came to regret some of his purchases, especially the *Wounded Amazon*, which Hamilton sought, unsuccessfully, to place with other clients. In 1786 there was even a suggestion that the whole collection should be sold, but Lansdowne, as he had then become, had been buying at the top of the market, when the fashion for Roman antiquities was at its peak. In the years following the American War, money became scarce, confidence declined and collectors' appetites shrunk, a situation that was to deteriorate further during the French Revolutionary Wars. Hamilton wrote to dissuade his client from trying to offload his collection at such a difficult time:

> I must now beg leave to advert [to] one thing in regard to your Lordship's collection of antique statues, and that is that they have no intrinsic value, but rise and fall like the stocks. When I sent these statues to England, all Europe were fond of collecting, and the price of consequence ran high. At present there is not one purchaser in

England and money is scarce. It therefore don't surprise me that at this time your Lordship cannot immediately find a purchaser at the price they cost. Perhaps in another thirty years when antique statues are not to be got, your Lordship's collection will be worth double what they cost.

Lansdowne accepted the advice and even went on to buy one more important statue, the *Young Hercules*, which Jenkins sold to him for £500 in 1792 (fig. 126), but, in his latter years, he was much more interested in the books and manuscripts in his Library.[74]

The collection was one of the best to be brought together at this period. Lansdowne had been willing to pay high prices and it was fortunate that his burst of interest in antiquities coincided with the particularly successful series of excavations that Hamilton was conducting in the early seventies. Although this was the time when Clement XIV and Pius VI were enthusiastically expanding the papal museum, so much material was being discovered that it was possible to export statues of a higher quality than had been permitted in earlier years. The *Young Hercules* (described by Townley and Knight as the finest male statue in England, apart from the Holkham *Faun* (see fig. 47)), the outstanding replica of the *Belvedere Antinous* (always referred to as *Meleager* and considered by Canova to be superior to the Belvedere version), the *Wounded Amazon*, the *Cincinnatus*

127 Joseph Bonomi, Design for the Library, Lansdowne House, Private collection

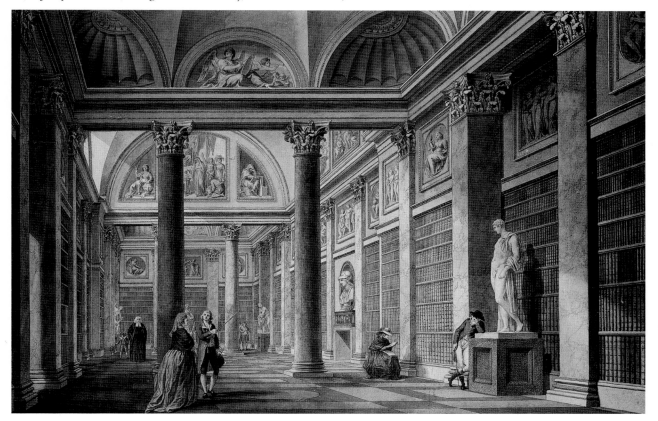

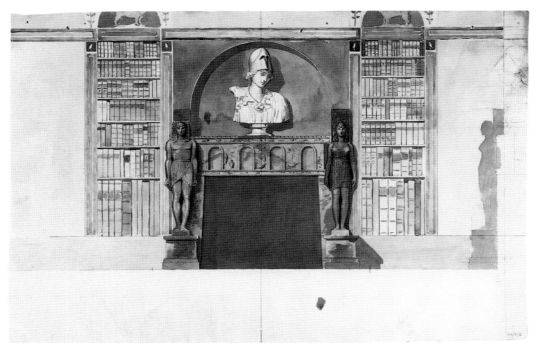

128 George Dance, Design for the Library chimneypiece, Lansdowne House, Sir John Soane's Museum

129 Lansdowne House, the Gallery showing the *Diomedes*, the *Cincinnatus* and the relief above the chimneypiece

or *Mercury tying his Sandal*, the *Cupid and Psyche*, the *Discobolus*, despite its restoration as *Diomedes*, and the *Paris* formed a group which was of exceptional distinction and they were complemented by a number of very fine busts and reliefs. Hamilton had worked hard to carry out the original scheme and must have been sadly disappointed when it was abandoned. It was a measure of the collection's reputation that the value of the principal statues was used as a yardstick for estimating a price for the Elgin Marbles in 1816.[75]

Since Lansdowne was so deeply involved in political life, it is not surprising that he paid less attention to his antiquities after the spell of his visit to Italy had worn off, but he could have been expected to resume his plans for a Gallery when he had retired from government. In 1786, after he had been persuaded by Hamilton not to seek a buyer for the collection, he commissioned Joseph Bonomi to produce a scheme for a magnificent library, which would also contain some of the principal marbles, the *Cincinnatus*, paired with the *Diomedes*, the colossal bust of *Minerva* over the Homeric relief and the *Meleager* (fig. 127). Nothing was done and a few years later George Dance was equally unsuccessful with his plans for a library with a chimneypiece, also incorporating the *Minerva* and the relief (fig. 128). Rather sourly the architect told Joseph Farington that 'his Lordship had a great desire to make his House princely, and such as he had seen abroad, & did so in a great degree but he had no taste'. In the end, the *Meleager*, the *Marcus Aurelius* and the *Aesculapius* relief, together with six of the best busts, were located

130 Lansdowne House, the Gallery showing the *Marcus Aurelius* between the *Meleager* and the *Young Hercules*

in the Third or Blue Drawing Room, opening into the Library that had usurped the place of the still unbuilt Sculpture Gallery.[76]

When Lansdowne died in 1805, his library and manuscripts were sold but the marbles were acquired from his executors by his eldest son who survived his father by only four years. The collection was then put up for sale as a single lot with a sales catalogue that announced that 'any Nobleman, Gentleman, National, or Public Institution, inclined to purchase the Collection' might apply to Henry Tresham for the particulars. When no purchaser materialized the new marquess, Lansdowne's younger son, bought the collection from his brother's widow for £10,680 in 1810 and it was he who finally created a Sculpture Gallery to the designs of Robert Smirke between 1816 and 1819. The decoration was in a severe neo-classical manner with top lit exedrae at either end, coffered ceilings and twelve shallow niches, hung with dark red drapery, to show off the most important statues (figs 129 and 130).[77] After all the delays, the Sculpture Gallery did not contain the whole collection because many of the pieces had found permanent locations in the Hall, up the staircase and in the other reception rooms. It became, in fact, a sparsely decorated ballroom rather than a gallery for the display of the collection. Nevertheless, it was a major loss to London when the house was substantially demolished and the marbles were dispersed by Christie's in 1930. A few of the unsold antiquities, including the *Diomedes*, were then removed to Bowood.

6

The Founders of the British Museum Collections: Hamilton, Knight and Townley

Although some of the collections considered hitherto were put together with aesthetic flair, none was in any sense a scholarly creation. Most of the clients of Brettingham, Jenkins and Hamilton were simply followers of fashion, impelled by an acquisitive ardour as unselective as that which, in the following century, spurred the readers of *Ivanhoe* to buy Eglinton Tournament armour and dubiously medieval caskets for the decoration of their new baronial halls. Serious, if unscientific, interest in the history of classical art developed in Britain only during the latter part of the eighteenth century with the studies of Sir William Hamilton, Richard Payne Knight and Charles Townley.

THE DEVELOPMENT OF IDEAS ABOUT CLASSICAL ART

The British were slow to examine at all critically the antiquities that they were importing in such volume. In 1728, more than a century after Lord Arundel had started landing his marbles in England, those admirable connoisseurs the Jonathan Richardsons added some perceptive comments to a new French edition of their guidebook, *An Account of some of the Statues, Bas-Reliefs, Drawings and Pictures in Italy*, first published six years earlier. They insisted that it was as hard to judge the quality of ancient statues from the few pieces that survived as it would be to judge the importance of a library that had been lost at sea if only a few volumes had been washed ashore. In any case, they argued, after the best works had been removed from Rome to Constantinople and had there suffered from fires, Christian iconoclasm and barbarian pillage, it was unlikely that any great original works remained unscathed. They also pointed out that some famous statues, such as parts of the *Niobe* group, were of insufficient quality to be originals and must, therefore, be copies and that no ancient author mentioned the names of the sculptors whose signatures were to be seen on the few apparently signed antique works – apart from the manifestly wrong names on the Quirinal *Horsetamers*.[1]

These thoughtful but provocative views seem to have been ignored. A typically simplistic account of classical art is given in *Polymetis*, a series of literary dialogues on ancient art and literature by the Reverend Joseph Spence, published in 1747. In the eyes of this Oxford professor, who made two visits to Italy as a bear-leader to young Tourists, the best sculptors in Rome were all Greeks

. . . for the Romans despised the practice of the arts themselves; and a Roman workman in the Aemilian square was probably pretty near on a level with our artists by Hyde-Park-corner [the manufacturers of lead replicas]; even at the very time that they were bringing in all the most beautiful pieces of antiquity from Greece . . .

Among all the statues of the ancients which the moderns have as yet discovered, there are about twenty that might be placed in the first class; each as the chief beauty, in its kind. For example, there is nothing in marble equal to the Venus of Medici, for softness and tenderness; as there is nothing so strong and nervous as the Hercules Farnese. The face of the dying gladiator, is the most expressive of human passion; and the air of the Apollo Belvedere, gives us an idea of something above human . . .

The great age of statuary and painting began a considerable time before the reign of Alexander the Great; and was continued on, successively in Greece, and Italy (without any great interruptions,) down to the times of the Antonines.[2]

Spence and most of his contemporaries were happy to exalt a small number of famous statues as pre-eminent and then to accept the rest with equal and unquestioning reverence, restorations and all. Despite the tons of marble that were being shipped into Britain at this time, no one tried to establish a chronological framework for this sculpture, or to distinguish Greek from Roman, copies from originals. No one made any serious aesthetic judgements about the merits of ancient art (apart from expressing disappointment at the poor quality of surviving wall paintings, which fell far short of the fabled skill of Apelles) and there was no discussion of the only art-historical synopsis to have come down from antiquity, contained in the dry and sometimes obscure notes on classical artists that Pliny the Elder had included, rather incongruously, in the minerals section of his *Natural History*. Pliny's enigmatic statement that the Greeks did not cover their figures was widely quoted to prove that any nude statue was of Greek craftsmanship.[3]

In continental Europe criticism started to become more sophisticated in the 1750s when writers such as the comte de Caylus began to categorize ancient art and emphasize the superiority of Greek works over those produced under the Romans. De Caylus, however, was not a very organized theorist, his massive *Recueil d'Antiquités égyptiennes, étrusques, grecques, romaines et gauloises* being clogged with details of insignificant artefacts from his own collection and the cabinets of his friends – precisely the sort of objects that British connoisseurs ignored. He did, however, base his system of dating on the evidence of objects and not on literary sources.[4]

By far the most eloquent and influential European scholar was Johann Joachim Winckelmann, the Papal Antiquary. In a series of books and essays from 1755, shortly before his arrival in Rome, until his murder in 1768 he set out a systematic theory of the progress of culture. He sought to explain how art (by which he really meant sculpture) was developed first by the Egyptians and then by the Etruscans and had reached a peak of perfection in Greece during the fifth and part of the fourth centuries B.C., before succumbing to a period of relative decline under the Romans. He never went to Greece or saw any original Greek sculpture but, by studying the ancient texts and by a careful examination of the statues in Rome, he recognized instinctively the importance of the Greek achievement. He brought his arguments to life with vivid rhapsodies on the *Apollo Belvedere*, the *Torso* and the *Laocoön* and on the exquisite sensitivity of the Greek genius.

Through his writings he completely refocused the continentals' view of ancient art, even if some of his fellow countrymen, like Raffael Mengs, did not accept all his arguments.[5]

His works were soon translated into French and both Italian and German scholars discussed his theories with enthusiasm. When Goethe was in Rome he wrote, 'It was Winckelmann who first urged on us the need for distinguishing between various epochs and tracing the history of styles in their gradual growth and decadence. Any true lover of art will recognize the justice and importance of this demand.' Any lover of art, that is, except the British. Although Henry Fuseli provided an English translation of some of Winckelmann's essays in 1765 and 1767, few British visitors and collectors showed any interest in his ideas. As Librarian to Cardinal Albani, Winckelmann had to act as *cicerone* to some of the cardinal's British visitors, including the Duke of York, 'the greatest princely brute that I know', the rich Lord Baltimore, 'tired of everything in the world', the Dukes of Roxburghe and Gordon, who were very similar, and John Wilkes, who was more congenial but kept breaking off from sightseeing to make love to his mistress. Winckelmann disliked most of these Tourists and regretted that a race of Philistines was carrying off so many antiquities into undeserved exile. There was mutual antipathy between the brilliant but touchy homosexual aesthete and the irreverent and often uncomprehending British Tourists. In any case, the latter were not temperamentally disposed to make the effort necessary for the detailed scholarship in which the Germans excelled, preferring to form their collections on the basis of their own undogmatic artistic intuitions.[6]

At this period Britain made little contribution to classical studies or the history of ancient art. When the great scholar Richard Bentley died in 1742 he left no successor, the academics of Oxford and Cambridge being comatose in their deep and dull potations, as Gibbon complained, and Gibbon himself devoted most of his own majestic work to a period when ancient art was considered to be in a state of degeneracy. The travelogues published by British visitors to Europe seldom went beyond a few banal comments on the major monuments, while the interesting and important publications on the ruins of Athens and Ionia, Spalato, Baalbec and Palmyra were intended as architectural source books rather than works of learning. Of the three leading collectors of the age neither Hamilton nor Townley was able to press an abundant harvest of experience into vintage scholarship and only the difficult and erratic Knight produced works of acute criticism.

The treatment of the dal Pozzo collection typifies British attitudes towards scholarship. In 1762, in order to provide a dowry for one of his daughters, Cardinal Albani was forced to sell the collection of old master drawings assembled for his uncle, Clement XI, together with the *Museum Cartaceum* or Paper Museum, compiled by Cassiano dal Pozzo in the previous century. This latter consisted of an enormous encyclopaedia of drawings illustrating natural history, geology, fortification, architecture and, above all, every significant surviving antiquity in public or private collections in Rome. Winckelmann had found it a valuable source of material when he was working on his catalogue of the Stosch gem collection.[7] James Adam bought the collection for 14,000 *scudi* on behalf of the young King George III and the volumes were despatched to London – where they simply disappeared from sight. It is a sad reflection on British scholarship that this marvellous resource for studies of art and archaeology was totally neglected after entering

the royal library and is only now being published more than two centuries after arriving in England.

SIR WILLIAM HAMILTON

Sir William Hamilton was the first British collector of antiquities to make a significant impact on national taste through the influence of his collections and the publications devoted to them.[8]

After serving as a young man in the army and in Parliament, he came to Italy in 1764 as British Minister in Naples, a post that he had sought in the hope that a southern climate would suit his first wife's delicate state of health. He was already addicted to collecting and had bought some distinguished paintings in London, including works by Holbein, Poussin and Rosa, which he had been forced to sell in order to clear his debts. 'He is picture-mad,' Walpole warned Horace Mann, 'and will ruin himself in virtù-land.' Many years later Hamilton was to write, 'It is my nature to collect & has been so all my life . . .'[9] He was never a rich man and, since he could not compete with visiting Tourists for the pictures or marbles in the hands of dealers in Rome, he concentrated instead on gems, bronzes and, above all, painted vases which were cheaper and were freely available in the Neapolitan market. He had the eye of a true connoisseur, appreciating excellence in every type of object – the delicate engraving of an Etruscan scarab, the freshness of a drawing by Castiglione, the shape of a Greek vase or the charm of his favourite 'Correggio'. His collection of antiquities was kept in what he called his 'Lumber Room' in the Palazzo Sessa, situated in the Pizzofalcone district of Naples. Goethe records a visit there in 1787:

> Sir William showed us his secret treasure vault, which was crammed with works of art and junk, all in the greatest confusion. Oddments from every period, busts, torsos, vases, bronzes, decorative implements of all kinds made of Sicilian agate, carvings, paintings and chance bargains of every sort, lay about all higgledy-piggeldy.

In this respect, Hamilton differed from most other collectors for whom the fine display of their objects was part of the pleasure of collecting. A couple of years later, however, he arranged some of the vases that he had just acquired in a new apartment. 'Emma often asks me, do you love me?' he wrote, 'But as well as your new apartment?'[10]

Painted earthenware vases were his prime pursuit. Many of these objects, dating to the fifth and fourth centuries B.C., were to be found in the tombs of central and southern Italy. They had formed part of a connoisseur's cabinet of curiosities since renaissance times, although they were not considered to be worth studying in their own right until the seventeenth century. The Tuscan scholars, who were the first to describe and illustrate them, knew that some pots had been found in the cemeteries of Etruria and asserted that those excavated elsewhere were evidence of Etruscan domination throughout Italy. All painted vases were therefore called Etruscan and the label stuck. In 1737, when the Tuscan scholar Anton Francesco Gori published the first two volumes of his *Museum Etruscum*, chauvinism prevented him from asking himself why most of the vases that he illustrated were from collections in Rome and Naples and not from Tuscan cabinets. The situation was no different thirty years later: Giovanni Battista Passeri, the

131 *An Antiquary's shop in Naples*, private collection, Rome

Grand Ducal Antiquary, continued to claim that the vases illustrated in his *Picturae Etruscorum in vasculis* were all Etruscan. At this period, however, the cemeteries round Nola, Capua and S. Agata dei Goti near Naples were being excavated to fill the cabinets and library shelves of Neapolitan priests and lawyers as well as the palaces of the nobility. Several significant collections were assembled and, despite their concentration on work at Herculaneum and Pompeii, the keepers of the royal galleries made sure that the king's holdings of vases were also regularly augmented. In 1759 Raffael Mengs, who had been staying in Naples, was able to return to Rome with a collection of over 300 vases. He was one of the first to say that these antiquities were of Greek workmanship.[11]

As soon as Hamilton came to Naples he too started to buy and he continued to do so throughout his long stay in the city. In June 1765 he wrote to Lord Palmerston,

> I now and then pick up a good little bronze, and have also collected a great number of Etruscan vases . . . I think one day or other of publishing my collection, as I am sure it would be a very valuable present to antiquarians. There is a taste and elegance in their shapes and though the figures are not always correct, yet there is a choice in the attitude, and a *je ne scais quoi*.[12]

His aesthetic sensitivity responded both to vases as objects and to the refinement of their decoration. In 1766 he secured the Porcinari collection and the best pieces from the Mastrilli cabinet, which had both been recently assembled. Two illustrations from a later

132 *Collection of Engravings*, Frontispiece, *A Tomb at Nola*

period show his other sources, dealers and excavations. In a watercolour, dated 1798, a tall thin figure, who is almost certainly to be identified as Hamilton, is shown in an antique shop in Naples among a group of connoisseurs discussing ancient gems. More than forty vases of varying sizes are ranged on shelves above the visitors' heads (fig. 131). The ambassador is also depicted attending an excavation in an engraving made in 1790. Here he and his second wife, the notorious Emma, are portrayed looking into a newly excavated tomb in which a skeleton and an array of vases had been 'found lately at Nola' (fig. 132). He was already engaged in excavations within a year of his arrival in Italy. During his visit to Naples in the autumn of 1766, Winckelmann accompanied the ambassador to explore some tombs above Capua 'near to a place called Trebbia, which is reached by untrodden and toilsome paths. Mr. Hamilton . . . caused these tombs to be opened in his presence, partly for the purpose of seeing the mode of their construction, and partly for the purpose of ascertaining whether vases of the kind would be found in tombs located in places so difficult of access.'[13]

After two years in Naples Hamilton had acquired enough vases to justify publication. Like many collectors, he wanted to make a permanent record of his possessions and he knew that a well-printed catalogue would enhance their value. There was also a more altruistic motive, 'to revive an ancient art'. It was not enough, as he explained, to please the eye. The utilitarian aim was 'to hasten the progress of the Arts, by disclosing their true and first principles'. Whereas the publications of Montfaucon and de Caylus had given no measurements of the few vases that they illustrated, Hamilton intended

> to search out what system the Ancients followed to give their Vases that elegance which all the world acknowledges to be in them, to discover rules the observation of which conduct infallibly to their imitation, and in short to assign exact measures for fixing their proportions; in order that the Artist who would *invent* in the same style, or only *copy* the Monuments . . . may do so with as much truth and precision as if he had the Originals themselves in his possession.[14]

Although he had an enquiring mind and an interest in art and history, he came to these subjects as a late learner. He had never been to a university and, as he told William Beckford with some false modesty, 'You know from my early entering into the Army my

classical knowledge is very scanty indeed.' It was his misfortune that, when he was looking for a scholar to provide a suitable text to accompany the illustrations of his vases, he fell into the hands of a seductive but unscrupulous charmer.

Pierre François Hugues, the self-styled Baron d'Hancarville, had arrived in Naples in 1763 (see fig. 157). He had a brilliant mind, a talent for both ancient and modern languages, a flair for figures, a remarkable memory and boundless powers to fascinate with his imaginative, erudite and eloquent speculations. He had inherited from his father, a bankrupt cloth merchant of Nancy, an inability to manage money and was always in trouble, always on the run from one city to another, always pursued by police and creditors, yet always able to find another patron whom he could wheedle into subsidizing his existence. He fondly aspired to prove himself a scholar on a level with de Caylus and Winckelmann, as if a major work of learning would set him on a pedestal above his creditors' reach. Hamilton's vases seemed to offer an ideal topic and he convinced the collector that he was the man to handle their publication.[15]

The troubles that ensued were severe. It was to be a collaborative exercise in which Hamilton was to provide an initial sum to cover the cost of making the plates, while d'Hancarville was to write the text and a description of the vases, procure artists to draw and engrave the illustrations and see the work through the press in return for half the profits after all expenses had been recouped. The book was advertised and subscribers were sought in London, Naples and Rome in order to provide advance payments. Soon after d'Hancarville had started writing he decided to extend the scope of the work so as to incorporate vases from other collections, in addition to Hamilton's, and the promised number of volumes was raised from two to four. He perplexed Hamilton with impressively detailed memoranda, setting out schedules of expenses and optimistic sales and profit projections with the desperate energy of a failing small trader trying to stop the bank manager from calling in his loan. He soon lost control of the costs of the exercise, spent all the subscriptions and ran into debt. The first volume eventually came out in January 1768 (although the date on the title page is 1766) and the second in October 1769.

The following December, the author disappeared to Florence in order to escape his creditors and threats of prosecution for publishing pornographic books. At first Hamilton thought that he had been driven out by the professional jealousy of rival scholars, but, when no further progress was made with the joint publication, he went to Florence himself, where he found d'Hancarville in a debtors' prison and the copper plates, which he had pawned for the value of the metal, in the hands of his creditors. After prolonged negotiations and considerable extra expense, the plates were retrieved, d'Hancarville was cajoled into finishing the text, and the last two volumes, mendaciously dated 1767, were completed in 1776, although they were not finally available for issue until 1780. The exercise cost Hamilton well over £1000.[16]

For all his faults as a scholar and businessman, d'Hancarville was a superb book designer. The four massive volumes of *Antiquités Etrusques, Grècques et Romaines* . . . are among the most magnificent productions of a century that excelled in fine printing. The text was set in a clear and beautiful type with delicately etched initial letters and vignettes at the head of each chapter (many of them based on antique gems or the plates of Piranesi) and the careful reproductions of the vase paintings were tinted by hand in water-

CHAPTER II.

1. Of the General Uſes the Ancients made of their Vaſes. 2. Where,
When, and by whom, they were made. 3. How they are
found. 4. Of the Manner of painting them.

IN this Chapter It appears to us neceſſary to examine, and collect under one point of view, the propoſitions, which compoſe its title, for they contain queſtions, we have often heard people ask, who for the firſt time ſee a great Collection of Antique Vaſes: Struck with so many forms, unlike thoſe they are uſed to ſee, they immediately ſearch after their ſeveral uſes, and the reaſons why ſuch forms were choſen, in preference

colour (figs 133 and 134). As Hamilton intended, there were also reproductions of most vases with measurements of every profile so that exact copies could be made (figs 135 and 136).

By way of contrast the text, which was in both English and French, was chaotic. Hamilton may indeed have had some qualms about his partner's ability or willingness to provide a suitable commentary on his vases because he tried to persuade Winckelmann to join in the project. The great man approved of the plates that he was shown and was flattered by the complimentary references to himself in d'Hancarville's proof text, but he was reluctant to become too closely involved with someone whom he considered to be a dishonest adventurer. Nevertheless, he seems to have provided notes on the iconography of a number of the vases illustrated in the first volume, along the lines of his catalogue of the Stosch gem collection. Further participation was cut off by his death in 1768, which was honoured by the dedicatory engraving of an imaginary tomb as the frontispiece to d'Hancarville's second volume.

D'Hancarville had no intention of confining himself to the subject of vases. In the first volume the wings of his imagination swept him across Etruscan history, primitive religion, ideal beauty and the origins of architecture and, when he approached the more difficult topic of the style of different periods of painting, he simply referred the reader to Winckelmann's works. The second volume was equally undisciplined. A rhapsody

135 *The Hunt Vase, Antiquités*

136 *The Hunt Vase*, British Museum

on painting and the art of Raphael led him back to an account of vases in antiquity, a suggested dating and speculations on the early peoples of Italy and their links with the Greek world. In the last two volumes he wandered even more widely. 'Antiquity is a vast country', he wrote, 'separated from ours by a long interval of time; some travellers have discovered its coasts almost waste, others more undertaking have dared to push on to its very heart, where they have found but the dismal rubbish of towns formerly magnificent, and Phantoms of incredible description.' His journeys in this territory led him through sculpture and gem carving, while, in the last volume, he announced a change of project (as if he had not sufficiently diverged from the topic of vases) to cover 'the History of [the] Art from its birth to the times that the Greeks brought it to its perfection'. The ostensible subject of the whole work, Hamilton's collection, was forgotten. At the end of the first volume, there is a detailed description of just two vases. The final chapter of the second volume concludes with notes on some of the vases illustrated in the first book, while the last two volumes contain scattered references to the plates but only by way of illustrating d'Hancarville's arguments.[17]

The extraordinary mixture of ancient history, mythology, anthropology, comparative religion, epigraphy, renaissance ideas about the progress of art, criticism of fellow scholars and whatever other topic had been discussed over the dinner table the previous night is fascinating if taken in small doses but the arguments are often obscure and ultimately become tedious. Since he lacked the tools of scientific archaeology, he based his theories about primitive art on the evidence of ancient historians, who were only recording a mythical past, and he then refined their evidence by the application of his own artistic judgement, which was perceptive, and by his knowledge of ancient scripts, which was rudimentary. He was happy to change his views whenever a new idea seemed more attractive, begging his readers to look on each volume as 'a criticism upon them that have had the misfortune to forgo it', and he plagiarized without shame.[18] It is when the author turns aside into a conversational digression that he shows the seductive power of his quicksilver imagination. Today he would have made an enthralling television series out of the material, even if the published book of the programmes would have been torn to pieces by scholarly reviewers. It is not surprising that his theoretical edifices, boldly constructed but on flimsy foundations, were ridiculed by French, Italian and German readers and ignored by most of the British.

The plates, however, were a source of constant delight and made vase collecting so popular that a shelf of Greek urns became as desirable as an array of marble busts. Josiah Wedgwood's practical use of them was alone sufficient justification for the work – even if he did name his pottery works Etruria rather than Magna Graecia.

Although Hamilton realized that d'Hancarville had neither provided a catalogue of his collection nor written a reliable history of ancient art, by the end of the affair his main concern was to see the completion of the embarrassingly delayed project with which he was so closely associated. He had no time to act as editor or publisher, still less to discuss d'Hancarville's more extreme arguments before they went to press, and it was a great relief when the last volumes were delivered to the impatient subscribers.

By then, however, Hamilton had disposed of his vases. In August 1771 he arrived in London on leave from his post, bringing with him his collection of antiquities. 'Mr. Hamilton has brought over a charming Correggio,' Horace Walpole told a friend, 'and a

collection of Tuscan vases, idols, amulets, javelins and casques of bronze, necklaces and ear rings of gold from Herculaneum, Pompeii, and Sicily, sacrificing instruments, dice of amber, ivory, agate, etc., in short, enough antiquity to fill your whole gallery at least.' The following year Parliament voted £8410 to purchase the collection and a further £840 to house it appropriately in the British Museum. Hamilton had been forced to sell his newly acquired treasures in order to recoup the costs of representing his country in Naples, but he must have done well out of the transaction because vases had risen steeply in price since the publication of d'Hancarville's great volumes and the Museum had paid generously. The satirists were swift to question the bargain:

> the world reports (I hope untrue)
> That half Sir William's mugs and gods are new;
> Himself the baker of th' Etruscan Ware
> That made our British Antiquarians stare;
> Nay, that he means ere long to cross the main
> And at his *Naples oven* sweat again,
> And by his late successes render'd bolder,
> To bake new Mugs and Gods some ages older.[19]

He was, however, extremely proud that his collection should have gained prominence in the comparatively recent national institution. In 1772 Josiah Wedgwood and Thomas Bentley produced a portrait medallion of the collector with a dedication recording their gratitude to him for providing 'the means, not only of improving and refining the Public Taste but of keeping alive that Sacred Fire, which his Collection of unestimable models has happily kindled in Great Britain, so long as burnt Earth and Etruscan Painting shall endure.' They had good reasons to be grateful because Wedgwood acknowledged that in two years they had sold reproductions to a value three times the price paid for the collection by the British Museum. Hamilton reciprocated Wedgwood's compliment by telling him that, although he had introduced 'a purer taste of forms & Ornaments by having placed my Collection of Antiquities in the British Museum, . . . a Wedgwood and a Bentley were necessary to diffuse that taste so universally'.[20]

In the four years after the sale of his vases, Hamilton made several gifts of gems and minor marbles to the Museum. 'The presents I have made', he wrote to his nephew, Charles Greville, in January 1776, '& have further to make to the Museum since my return here have, I am sure, cost me near £300, tho' the old dons do not so much as thank me when I send a work of art . . . I do not care, it is the honour of the Hamiltonian collection that spurs me on.'[21]

He set his heart on crowning the collection with the *Warwick Vase* (see fig. 67). As we have seen, he had financed Piranesi's recreation of this superb monument, but little of the vase was antique and, so far from making a gift to the museum, he expected to be paid £500, a premium over his repair costs of £350, even if less than the £600 that he thought the vase would fetch in Rome. Although he had some justification for his price, in that Jenkins had sold a less impressive vase to Barry for £500 (see fig. 104), the museum had not yet started to collect antique sculpture and the trustees were unwilling to pay so much. Eventually Hamilton had to sell the trophy to his nephew, Lord Warwick.[22]

137 Sir Joshua Reynolds,
The Dilettanti, Society of
Dilettanti

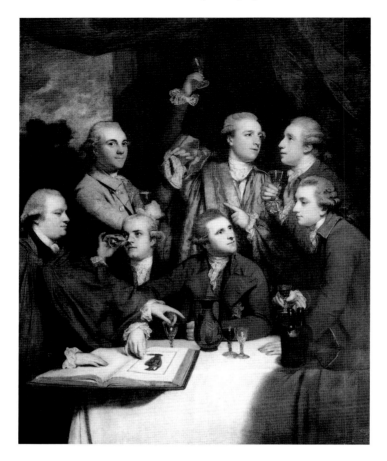

The *Portland Vase* was a far smaller but more distinguished object, the acquisition of which proved irresistible. He bought the cameo glass vessel from James Byres, who had himself bought it from the Barberini family, but its price of £1000 was such that Hamilton could not afford to retain it for more than two years. When he returned to England in 1783 he negotiated to sell it, together with a few small antiquities, for £1800 to the Duchess of Portland, from whom it now takes its name.[23]

He reached his apotheosis as a collector not in the display of his antiquities in the British Museum but in Sir Joshua Reynolds's portrait of a group of members of the Dilettanti Society. Although George Knapton had produced a large number of individual portraits for the Society, this was the first time that the members had commissioned group pictures. The occasion that they selected to commemorate was the meeting in March 1777 at which Hamilton was admitted to membership. He is shown sitting at a table on which he displays one of his vases and a volume of his newly published great work for the admiration of six fellow members, while in the painting's pendant, Charles Greville is at the centre of a group who are examining some gems, perhaps from Hamilton's own collection (figs 137 and 138). These attractive portraits vividly conjure up the connoisseurs' relaxed enjoyment of the classical past, a delight in fine antiquities, mellow wine

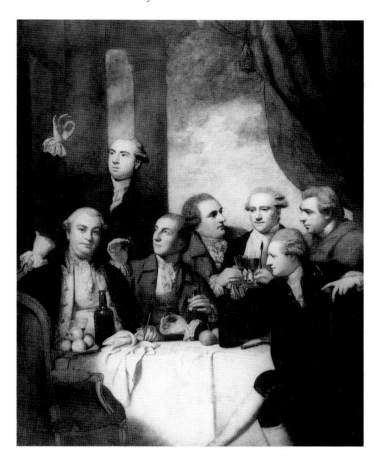

138 Sir Joshua Reynolds, *The Dilettanti*, Society of Dilettanti

and good fellowship. They all hid such scholarly erudition as they possessed under a cloak of frivolity. Even though Hamilton himself looks rather prim in the Reynolds's portrait, he could make mock of his connoisseurship by training a mischievous pet monkey to examine gems and coins with a magnifying glass like a true *virtuoso*, while the lady's garter so provocatively dangled above his head in the portrait indicates that the cult of Venus was devotedly worshipped by most of the Dilettanti.[24]

Hamilton continued to collect throughout his time as British Minister in Naples, making some purchases with a view to selling them on at a later date. He was permanently in debt and he knew that, after he had left Naples, the modest pension of a retired ambassador would be quite insufficient to maintain himself and the young Emma, his nephew's former mistress, whom he had married after the death of his first wife. He hoped that his collections, acquired at low prices in Italy, would be saleable at a good profit margin to provide some capital on which they could live. Sales would, however, require tact, as he explained in a letter to Greville in September 1790:

> . . . I have surely laid out more than £2000 in antiquities since I returned, but I have such a curious collection that must bring me back the double, but I am delicate as

to the manner of selling, as I should hate to be looked upon as a dealer, & some of my vases & bronzes are so extraordinary I should wish them to be in England; my cameos & intaglios I shall probably soon dispose of, which I will do in order not to swell my account with Ross [his banker] too much.[25]

Gems had formed a prominent part of the antiquities that he sold to the British Museum in 1772. His second collection of gems went to Sir Richard Worsley, who acquired them in 1791 on the advice of Townley (fig. 139). The quality of Hamilton's collection was very high because many of the stones came from excavations rather than dealers and it therefore contained fewer forgeries than the cabinets of most of his contemporaries. The same year, during the course of a visit to England, Hamilton and Emma visited Richard Payne Knight at Downton Castle, Herefordshire. It proved to be a successful sales trip because their host subsequently paid £400 for Hamilton's second collection of bronzes. These included some fine candelabra from Herculaneum, which were almost certainly the gift of the King of Naples.[26]

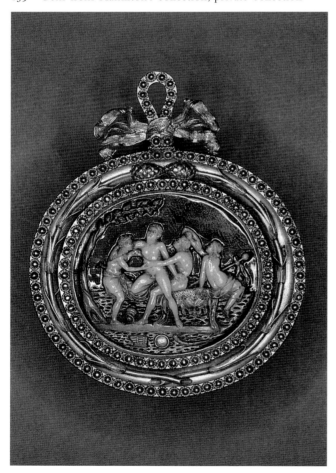

139 Gem from Hamilton's collection, private collection

Vases, however, were always his predominant passion. Whereas, in the years following the sale of his first collection, there were few opportunities for buying, in 1789 the decree restricting excavations was relaxed to bring a new flow of vases onto the market. In March 1790 he wrote:

> A treasure of *Greek*, commonly called *Etruscan*, vases have been discovered within these 12 months, the choice of which are in my possession, tho' at a considerable expense. I do not mean to be such a fool as to give or leave them to the British Museum, but I will contrive to have them published . . . if I choose afterwards to dispose of the collection (of more than 70 capital vases) I may get my own price.

Once again, he was driven both by vanity and by a real love for his vases to make a permanent record of the collection, the sale of which would be boosted by an attractive advertisement. To oversee the project he selected the German artist Wilhelm Tischbein, who had come to Naples with Goethe and had stayed on to become director of the Academy of Fine Arts. Once again, a prospectus was prepared to advertise for subscribers with the offer of 180 plates in three volumes. *Collection of Engravings from*

140 Vase painting from Hamilton's second vase collection, *Collection of Engravings*

Ancient Vases mostly of pure Greek Workmanship . . . was intended to be a much less elaborate production than d'Hancarville's, the plates were confined to the simple outline of the figures without any extra colour or ornaments, while the text avoided flights of fancy and was restricted to sensible arguments by Hamilton himself to prove the Greek origin of the vases and a description of the scenes painted on them, mainly provided by Count Andrei Italinsky, the Russian consul. The plates were in a refined linear style that was to have a great influence on artists such as Flaxman (fig. 140). The first volume, dated 1791, appeared in 1794, while the second and third, both dated 1795, in fact came out in 1796 and 1800 and a final volume of plates without text was issued after Hamilton's death.[27]

After letting it be known that he had invested well over £3000 in his second vase collection, Hamilton set an indicative price of £7000 for a package of vases, half of which had figure decoration. The King of Prussia was the first target. A sale to a royal gallery would keep the collection intact, which would perpetuate Hamilton's reputation, and the vases could be made available as models for the German porcelain factories, which would spread his fame even more widely. Nothing came of the proposal and William Beckford, who might have been tempted to buy if he had seen the vases 'upon the enchanted ground of Naples', jibbed at paying such 'a lumping sum'. In 1798, as the threat of a French invasion of Naples increased, the vases were packed up and despatched for safety to England. It came as a terrible shock to the unhappy Hamilton when he heard that a large part of his collection had been lost in the wreck of the *Colossus* off the Scilly Isles on the homeward voyage.[28]

141 Selection of Hamilton vases bought by Thomas Hope and subsequently acquired by Lord Leverhulme, Lady Lever Art Gallery, Port Sunlight

142 Thomas Rowlandson, *Lady H******** Attitudes*

By this time a younger diplomat was needed in Naples to cope with the new political situation caused by the French revolutionary wars, Hamilton's effectiveness being impaired by his age and increasing ill health. In 1800, after thirty-seven years at his post, he was recalled to London. Worn down by financial problems, the difficulty of adapting to private life and cruel cartoons on the subject of his wife's affair with Nelson, he was at least consoled to find that some vases, which had been stowed in another vessel, had escaped shipwreck. These were eventually sold to a notable connoisseur, as he told Greville in a letter of April 1803 (fig. 141).

> This morning Mr. Thomas Hope came to me and having offered the round sum of four thousand pound down for my whole collection of vases for which I had asked £5000 [his price had been coming down], finding that I could get no more, & considering trouble, risk, & then a little vanity in the collection being kept entire which I made with such pains, I struck with him.[29]

Hamilton endured his last years with quiet dignity, occasionally fishing in the Thames, attending meetings of the Royal Society and visiting the auction rooms, where he could no longer afford to bid, and the British Museum, where he could enjoy the sight of some of his former treasures. He died in 1803, three years after his return from Naples.

Although he never claimed to be a scholar, his advocacy promoted vases from the category of minor curiosities to the front rank of serious art and contributed to the vase-mania that seized British taste at this time.[30] The prominence of his collection in the British Museum and the beauty of his great publications (in spite of the inadequacy of the text) ensured that Wedgwood's imitations of his vases became standard library furnishings as an alternative to classical busts.

There was also an impact on neo-classical sculptors, who imitated the chaste lines of the illustrations of the *Collection of Engravings* at a time when Attic *stelae* were not widely known. It is sad that the reputation of this cultivated and sympathetic collector has been clouded by his notoriety as the cuckolded husband of Emma, whose famous 'attitudes' re-created in living form his beloved antiquities (fig. 142).

RICHARD PAYNE KNIGHT

Richard Payne Knight was an eccentric but original scholar (fig. 143). His background differed from that of most of the other collectors discussed hitherto, his grandfather being an ironmaster from the industrial midlands and his father, a clergyman, having married a carpenter's daughter. An abundance of money and country property, acquired with the profits of industry, were, however, quite sufficient to enable the Knights, within three generations, to take their place among the Herefordshire gentry.[31]

Although delicate health in childhood kept him from school until he was fourteen and he never went to university, Knight received the grounding of an excellent classical education. On coming of age in 1772 the young man decided that he needed a new seat. After calling in a local architect to select a site on his estate at Downton in Herefordshire, he then set about providing a very innovative design himself. The exterior form was to be that of an irregular Gothick castle, while the interior detail was to be classical, including, in due course, an impressive, although not very comfortable, domed Pantheon for the Dining Room. At a time when symmetry was expected for anything larger than a villa, the building of a grand country house on such a picturesque plan was highly unconventional. Work started in 1773 and, although he hoped to be free of builders early in 1778, the Dining Room was still not finished in the summer of 1782.[32]

While construction was going on at Downton, he made two foreign Tours, the first in 1772 at the age of

143 Sir Thomas Lawrence, *Richard Payne Knight*, Whitworth Art Gallery, Manchester

twenty-one, and the second four years later when he took with him John Cozens, the watercolour artist. During the winter of 1776 he was admiring and collecting *virtù* in Rome and the following spring he joined Philipp Hackert and his pupil, the amateur artist Charles Gore, on an excursion from Naples to visit the temples of Paestum and then make a tour of Sicily, concentrating on the Greek sites at Segesta, Selinunte, Agrigento and Syracuse. He maintained a detailed travel diary of the expedition, which was clearly intended to be developed into a fully illustrated publication with reproductions of his companions' sketches. In the event, he did not publish his account, perhaps because it was forestalled by more imposing works on the region such as the volumes of abbé de Saint-Non. Before returning to England, he acquired for Downton some porphyry columns and two marble chimneypieces, one of them incorporating miniature Doric columns, based on those that he had seen on his travels.[33]

In 1780 Knight was elected to Parliament as Member for Leominster and the following year he and Charles Gore both became members of the Dilettanti Society.[34] By this time he had a town house and was well established in antiquarian circles in London and he had thus come into contact with d'Hancarville. The adventurer's progress after the debacle of Hamilton's vase publication is described in a letter from Townley to Knight:

> I must first give you the Secret of his Situation when I picked him up here in the spring 1777; he was then in a manner starving, skulking about in the City and picking up victuals in the meanest pot houses as he could . . . The summer passed and part of winter with his filling his belly frequently at my house and an occasional loan of 5 guineas; on talking of the Ancient Monuments in England it was thought that a publication relative to them would sell well in this country and enable him [to] redeem his effects consisting chiefly of his former works seized by his creditors at Florence; in his application to his purpose and our conversation on how little was known of the origin, system and intention of the Art of the Ancients . . . he directed his whole attention to this latter subject . . .

Townley went on to explain that he had been giving d'Hancarville an average of £180 a year for the last three years and asked if Knight would take over the burden. The latter prudently declined but agreed to make an anonymous contribution to the proposed *History of the Arts* as long as it was paid to Townley himself in the first place.[35]

Just as Knight was coming under the influence of d'Hancarville's theories about the origins of ancient art and religion, Sir William Hamilton made a fascinating discovery which could have been deliberately invented to illustrate them. An engineer, who was supervising road building in the Abruzzo, told the ambassador about the extraordinary festival of 'St Cosmo's big-toe' that still survived in the town of Isernia. Every year, on the feast of St Cosmas and St Damian, women of the region presented ex-voto phalluses of wax to be blessed at the altar by the priests. When Hamilton went there in person he was disappointed to find that the clergy had just suppressed the practice, but he was able to acquire some of the ex-votos, which he later presented to the British Museum. He communicated his discoveries in a letter to Sir Joseph Banks, the president of the Royal Society, with the wish that his 'Great-Toe' might never fail him, and also to the Dilettanti Society, who agreed to publish his account. It was just the sort of ribald subject to appeal to their members.[36]

Knight was appointed to write an essay to accompany Hamilton's original report. The resultant work, *An Account of the Remains of the Worship of Priapus, lately existing at Isernia, in the Kingdom of Naples*, was published in 1787, although it is dated 1786 (fig. 144). Knight's essay, entitled *A Discourse on the Worship of Priapus*, owes a great deal to the ideas of d'Hancarville, which had been published the previous year as *Recherches sur l'Origine, l'Esprit, et le Progres des Arts de la Grèce*. Dissatisfied with conventional explanations, d'Hancarville tried to make sense of the confused stories of classical mythology and the often unrecognizable subjects depicted on coins, gems and vases and in sculpture and architectural ornament. He

144 *An Account of the Remains of the Worship of Priapus*, title page

was fascinated by the freedom with which erotic scenes were depicted not only on Greek and Roman artefacts but also on those that had been brought back from India. Synthesizing his observations, he evolved the proposition that all religions sprang from a common impulse, the worship of the creative urge, the male aspect of which was variously represented by such symbols as the phallus, the Hindu lingam and a bull breaking the female egg of Chaos with its horns. While Knight was attracted by the theories set out in *Recherches*, he recognized d'Hancarville's failings and commented to Townley, 'His work is certainly a very rich mine of learning & ingenuity, but I fear that prolixity & want of method will prevent its being so popular as he expects.'[37]

In his own essay Knight acknowledged his debt: 'Those who wish to know how generally the symbol [the phallus], and the religion which it represented, once prevailed, will consult the great and elaborate work of Mr. d'Hancarville, who, with infinite learning and ingenuity, has traced its progress over the whole earth.' He reserved the right, however, to differ from his opinions 'with the utmost deference and respect'. He proceeded to examine a wide variety of artefacts that represented or symbolized the generative process, including Egyptian lotus capitals, an erotic Hindu carving in Townley's collection and, above all, early Greek coins, which were particularly studied as a source of emblems. He followed d'Hancarville in postulating that the different attributes of the monotheistic Creator had often been misunderstood and over time had come to be regarded as images of separate gods, with the result that some symbols lost their dignity and 'that venerable one, which is the subject of this Discourse, became degraded from the representation of the God of Nature to a subordinate rural Deity . . . expressing the fertility of a Garden, instead of the general Creative Power of the great Active Principle of the Universe'.[38]

The text was so full of erudite speculation that, despite the explicit illustrations of phallic symbols, the essay would have caused little scandal if Knight had not included some remarks which were bound to offend the religious establishment. He claimed that the phallus was sometimes represented as 'a cross, in the form of the letter T, which thus

served as the emblem of creation and generation, before the Church adopted it as the sign of salvation; a lucky coincidence of ideas, which, without doubt, facilitated the reception of it among the Faithful'. To make matters worse, he went on to suggest that early Christian love feasts were 'ecstasies of a very different kind' and to contrast the tolerance of heathen pantheism with 'Dogmatical Theology and its consequent Religious Persecution'. Despite the fact that circulation was restricted to members of the Society of Dilettanti and scholars and learned societies specified by members, the work was fiercely attacked by some of the literary reviews, even though their readers had no means of obtaining a copy of the offending book. Knight himself rather enjoyed the controversy and continued to defend his position in later essays.[39]

He was an outstanding collector who could afford to indulge his tastes on a comfortable income of between £4000 and £6000 a year.[40] His old master drawings, which were of exceptional quality, included a large number of sketches by Claude and distinguished works by Rembrandt, Rubens, Raphael and the Carracci. He owned notable old master paintings and he commissioned pictures from contemporary artists as well. His choice of antiquities was very specialized. Although he bought a few marbles to furnish the large spaces of Downton Castle and some Greek vases as decoration for the tops of bookcases, he did not seek to compete with Townley and Hamilton in their main areas of interest. He concentrated instead on small objects, coins, engraved gems and bronzes, which he kept in a museum room in his town house in Soho Square.

The reason for this specialization can be traced to his interest in the primitive symbols that d'Hancarville expounded with such eloquence. The emblems of heroes and divinities were the parts most frequently broken off ancient marbles (and most inaccurately replaced by restorers), whereas small bronze figures, being more compact and durable, often retained cult objects in their hands, at their feet or as part of their clothing. In the same way, the hard surface of coins and gems provided miniature but intact representations of the emblems of gods and cities. Knight's catalogue of his bronzes, written in his own hand, is now in the British Museum. He listed some 800 objects in all, lovingly describing the details of these little objects which particularly appealed to him and citing appropriate parallels in ancient literature or from contemporary publications. He shrewdly observed that some were copies of much larger figures and, as befitted the grandson of an ironmaster, he was sharp to notice the techniques of manufacture, the hammering, casting, moulding and soldering of components. He also made a brave attempt at dating his bronzes along the lines of Winckelmann's chronology – 'the sculpture is very ancient Greek', for instance, 'of that period, when the art had just begun to emancipate itself from the hard angular lines of the Aegyptian style, & to attempt a free Imitation of Nature, without however aiming at any of the fascinating embellishments of ideal Grace and Beauty' and '[these two figures of Jupiter] afford perhaps more perfect and accurate information concerning the comparative difference in the style of art in the respective ages of Pericles and Alexander the Great than any Monuments extant'.

He recorded the sources and dates of many of his acquisitions. The two earliest were a pantheistic bust of *Bacchus*, said to have been found in 1775 and sent by Byres, and a primitive so-called *Diomedes* which was sold by Jenkins in 1785.[41] Filippo Aurelio Visconti also supplied him from Rome. A number of bronzes were either given to him or swapped by friends, including Sir Richard Worsley, Roger Wilbraham, Lords

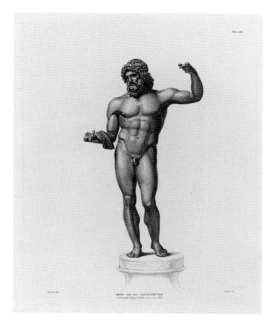

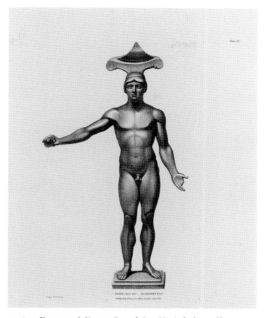

145 *Jupiter*, bronze from Paramythia in Knight's collection, *Specimens of Antient Sculpture*

146 *Bronze Mirror Stand* in Knight's collection, *Specimens of Antient Sculpture*

Lansdowne and Northwick and the Duke of Buccleuch, which indicates British collectors' lack of interest in such objects – if they were to display small bronzes, they generally preferred modern miniature copies of well known statues.[42] Even Townley, who himself owned a number of antique bronzes, was willing to trade specimens with his friend. The most important source, however, was Sir William Hamilton, whose gift of bronzes to the British Museum may have been a spur to Knight's collecting and who sold him his own second collection of these artefacts when he returned from Naples in 1791. At the same period, the turmoil of the French Revolution provided an opportunity for Knight to visit Paris and negotiate some important acquisitions from a dealer, who had bought the collection of the duc de Chaulnes, and from Townley's correspondent, abbé Charles Philippe de Tersan, who supplied some fine pieces excavated in France. Not long afterwards the erotic bronzes belonging to the Venetian humanist Angelo Quirini were added to the collection and in 1803 Knight bought a group of exceptionally beautiful figures found at Paramythia in north-west Greece. Some of these had been taken to Russia for sale to the empress and, when she died before the transaction could be completed, had passed into the hands of a Polish collector from whom Knight acquired them (fig. 145). Since the collection was formed as much for its didactic as for its aesthetic value, it was not appreciated by all his contemporaries. Walpole called him the 'Knight of the brazen Milk-pot' and Flaxman commented that there were only five or six good pieces among many that were indifferent. The latter, however, was looking for ideal beauty in sculpture and did not understand that Knight could be attracted to a bronze because it was representative of an early period (fig. 146) or because it illustrated aspects of the worship of Isis or Bacchus.[43]

Like Hamilton and Townley, Knight was an ardent buyer of cameos and intaglios but his collection was smaller than either of theirs. He acquired some fine gems, including pieces from the Borghese, Strozzi and Albani collections. Sometimes, however, like all other collectors, he was deceived by contemporary fakes – he bought a fragmentary cameo of *Flora*, which, it was claimed, had been made by the medallist Benedetto Pistrucci, a case that was maliciously publicized to discredit his connoisseurship. As was to be expected, his gems were mostly of mythological or symbolic subjects rather than portraits.[44]

It is clear that he had already started to buy Greek coins at the time of writing his essay on Priapus because he refers to several specimens in his own cabinet. Quite rightly, he considered that coins were vital and incorruptible evidence for the history of the past. As he told Townley in a letter of 1786, 'Medals are more important than any other remains of Art, because they were public acts and therefore the devices upon them cannot be attributed to individual caprice.' His aesthete's eye was also attracted by the remarkable beauty of Greek coinage.

> When we consider that all these exquisite specimens of art . . . were only the circulating coin, the common drudge of society, in a parcel of petty republics, few of whose territories exceeded in extent or fertility the smallest English county, we cannot but look upon them as among the most extraordinary phenomena in the history of man.

He spent lavishly on his collection, buying from abbé de Tersan and Michelet d'Ennery in France and from Hamilton in Naples and paying over £1250, a very substantial sum, for part of the hoard accumulated by Sir Robert Ainslie when he was ambassador in Constantinople.[45]

Throughout his life he was not only busy as a collector but as a writer also. An essay on the Greek alphabet (in which he demolished the forgeries of a French epigraphist and castigated d'Hancarville for being deceived by him), didactic poems on landscape gardening and the development of morality, a Latin discourse on the authorship of the *Iliad* and the *Odyssey*, a philosophical enquiry into the principles of taste, a continuation of his research into priapic and other universal symbols, sundry pamphlets and an important work on ancient sculpture were issued over the years.

The volume on sculpture is the most interesting. In 1799 the members of the Dilettanti Society commissioned Knight and Townley, as the leading connoisseurs of the day, to select and publish the best marbles and bronzes that had been imported into the country over the previous half century. They had in the past sponsored excellent books on Greek architecture, but this was their first publication on sculpture, despite the fact that many of them collected antiquities but few built Doric porticoes. Knight was to provide an introductory essay and descriptive notes on each of the chosen statues, which he must have discussed with his co-author before the latter's death in 1805. The book included seventy-five plates of reproductions, which were of exceptional quality, far surpassing the illustrations of marbles in the collections of Worsley and Blundell (figs 145, 146 and 177). The first volume of the resultant work, *Specimens of Antient Sculpture*, was issued in 1809.

In an impressive introduction Knight charted the progress of sculpture from the idols of primitive tribes and the ancient but static art of Egypt to the 'prodigious superiority'

of works produced in Greece, 'the original seat of . . . excellence, and the source, from which all the rest of the world have derived the little, which they have acquired of it'. He then traced the rise and decline of Greek sculpture, quoting from the texts of Pliny and Pausanias, but using his numismatic knowledge to draw illuminating comparisons between the figures on coins and the statues that survived. He accepted Winckelmann's broad ideas as to the development of archaic sculpture into the 'simple, grand and elegant style' of the age of Phidias, the 'squareness' of which was melted down by his successors into 'flowing easy lines, and postures negligently graceful', just as the muscular age of Michelangelo and Raphael was succeeded by the softer lines of Correggio and Guido Reni. After that, under the Macedonian kings, Lysippus and his school showed men not as they actually were but as they appeared to be and 'formed a style of their own, uniting all the merits of their predecessors, and adding others peculiar to themselves'. The Romans were dismissed as a cruel and authoritarian nation, unable to produce great art, which was why only a few statues were selected to illustrate the Roman period. The text of *Specimens* is singularly free from speculations about the mythological symbolism of the works illustrated because Knight intended to devote a full-length essay to that subject in the projected second volume. As this second publication was constantly delayed, he eventually issued the essay separately in 1818 as *An Inquiry into the Symbolical Language of Ancient Art and Mythology*. In it he provides a catalogue of the cults and emblems of gods and legendary heroes from Lapland to China and from Scythia to Spain, but, lacking the mischievous irony of the discourse on priapic symbols, the essay is diffuse and rather dull.

Specimens was not, however, without controversy. Recognizing that many of the marbles in British collections were copies of older bronzes, Knight systematically tried to work out the chronological sequence of the originals. This innovative approach, which called for rigorous selection, did not endear the author to fellow collectors whose masterpieces of supposedly Greek work, bought from Cavaceppi and Jenkins, were excluded from the book as being over-restored replicas of a later period. (Twenty-three plates in *Specimens* were devoted to each of Townley's and Knight's own collections, while Lord Egremont, Lord Lansdowne and Thomas Hope contributed nine, four and two figures respectively and Lord Yarborough and Lord Upper Ossory one each; it is possible, however, that collections such as those at Holkham and Castle Howard were not illustrated because it was not easy to send draughtsmen to obtain drawings from remoter houses.) Even if Knight's efforts at dating were not always successful, he provided an intelligent key to establishing the time scale of the works under discussion. He was certainly not far off the mark in thinking that some of the little bronzes on his own shelves gave a better idea of the Greek originals from which they derived than restored marble copies made in the Roman imperial period.

One group of unquestionably Greek works was, however, most notably absent from the selection in *Specimens*. In 1806 Lord Elgin's sculptures from the Parthenon arrived in London. When Knight met Elgin at a dinner, before the cases had even been unpacked, he told him that he had 'lost his labour', because his marbles were not Greek but Roman 'of the time of Hadrian, when he restored the Parthenon', and (qualifying his opinion), even if they were Greek, they were not by Phidias because he never worked in marble. Unfortunately, he could not bring himself to re-evaluate the sculpture

properly even after he had examined it. In his comment on the work of Phidias in *Specimens* he wrote, rather grudgingly:

> Of Phidias' general style of composition, the [Parthenon] friezes and metopes . . . may afford us competent information; but as these are merely architectural sculptures executed from his designs and under his directions, probably by workmen scarcely ranked among artists, and meant to be seen at the height of more than forty feet from the eye, they can throw but little light upon the more important details of his art. From the degree and mode of relief in the friezes they appear to have been intended to produce an effect like that of the simplest kind of monochromatic painting, when seen from their proper point of sight; which effect must have been extremely light and elegant. The relief in the metopes is much higher, so as to exhibit the figures nearly complete, and the details are more accurately and elaborately made out: but they are so different in their degrees of merit, as to be evidently the works of many different persons; some of whom would not have been entitled to the rank of artists in a much less cultivated and fastidious age.[46]

Knight's failure to appreciate the Parthenon sculpture was very strange, because informed opinion in London was almost unanimous in its admiration of the marbles and it was not as if he had been led astray, like Piranesi, by a prejudice in favour of Roman art – the whole argument of *Specimens* was to emphasize the superiority of Greece. Furthermore, his comments on the frieze show an intelligent understanding of the function of the reliefs. His mental block arose from his view that the true excellence of Greek sculpture resided in large scale bronze figures (although very few of them were then known to survive) and he was, therefore, dismissive of reliefs, only two examples of which were illustrated in *Specimens*. In any case, he probably felt that, although Worsley's recent reproduction of much of the Parthenon frieze in *Museum Worsleianum* had been rather inadequate, it would be superfluous to include further illustrations of the same sculpture. And yet there is no excuse for his neglect of the pediment figures, which he rejected because they were of the period of Hadrian, on the basis of the comments of a seventeenth-century traveller repeated by Stuart and Revett and then by Worsley. It is all too probable that he was just prejudiced by a personal dislike of Elgin and envy of his fine collection of Greek coins and jewellery. In 1816, when a Parliamentary Select Committee was considering the acquisition of Elgin's marbles for the nation, Knight was called to give evidence. He persisted in claiming that the pediment sculptures were Roman and that the collection as a whole, which he had valued at an arbitrarily low figure of £25,000, was 'in the second rank', on the grounds that the surface of the marbles was eroded, although he accepted that both the frieze and the metopes were 'in the first class' for reliefs. His judgement was so much at variance with that of other scholars and artists that his reputation as a connoisseur was severely damaged.[47]

Throughout his life his obstinate and opinionated views brought him into trouble. His personal appearance did not help – portraits show a lack of chin and a protruding lower lip which give the impression of a querulous goldfish. He paid little attention to his critics and prided himself on his independence. Although he was influenced by the theories of Winckelmann and d'Hancarville, he did not hesitate to criticize their authority if he disagreed with them. Unlike many contemporary scholars, he refused to rely

entirely on literary sources but used the evidence of his eyes, backed by some remarkable intuitive insights. He constantly asked why an object had been made in a particular fashion or what purpose it was intended to serve. Typically, when he communicated with the Society of Antiquaries in April 1813, it was to give an opinion on the ancients' use of chisels for cutting and polishing stone. The Elgin Marbles were not his only blind spot – his reverence for Homer blurred his critical sharpness about any objects that he could link to the Homeric age. The best of his connoisseurship is contained in his introduction and notes to *Specimens* which, as Michaelis comments, 'forms a brilliant conclusion to the century of antique dilettantism in England'.[48]

He never married, although he had mistresses in London and kept 'nymphs' in Herefordshire, whose charms Townley was invited to explore. On his death in 1824 he left his estates and paintings to his brother and his coins, gems and bronzes, as well as his old master drawings, valued in all at over £30,000, to the British Museum, where they could be admired beside the collections of his friends Townley and Cracherode.

CHARLES TOWNLEY

Charles Townley is the most prominent figure in the history of antique connoisseurship in eighteenth-century Britain. His marbles, while not as numerous as Blundell's, excelled all others in quality and he also owned important gems, bronzes, terracottas, coins and other antiquities, an encyclopaedia of drawings from the antique and a large library. He was in touch with most of the leading scholars and collectors of his day and he visited many of the galleries of antiquities in England. His voluminous correspondence, diaries, notebooks, accounts and inventories give a fascinating picture of his collection and, although his antiquities were transferred from his London house to a gallery in the British Museum soon after his death, catalogues, watercolours and drawings show how they were originally displayed, while Zoffany's well-known portrait gives a vivid capriccio view of the most famous marbles, their owner and his friends.[49]

He was a member of an ancient Roman Catholic family from Lancashire. Since his father died when he was a child, he came into his large estates at an early age and, after an education in France (Catholics being debarred from British universities), he returned home, where he 'joined in the athletic sports of the field, and partook of the boisterous hospitality for which the country gentlemen of that day, in the provinces remote from the Capital, were ambitious to distinguish themselves'.[50] After a few years, however, sporting pleasures began to pall. In 1767, at the age of thirty, he set off on a Tour of Italy.

Perhaps the casts of the *Medici Venus* and the *Dancing Faun*, acquired by his grandfather for the Hall at Towneley, had inspired an interest in the delights of antiquity or perhaps a priest who taught him at Douai had extolled the marvels of ancient Rome. He may even have inherited Lord Arundel's taste for *virtù* through his grandmother, a daughter of Arundel's descendant the Duke of Norfolk. The diary of his journey through France shows that he was already on the lookout for classical art before he reached Italian soil because he was commenting on the 'grandeur and majesty' of the Maison Carrée at Nîmes and recording a priapic bas-relief of extraordinary size in Aix. He travelled by

147 *'The Cannibal'*, British Museum 148 *Hecate*, British Museum

way of Tuscany to Rome, where he arrived in time for Christmas, and then spent a month in Naples, making a brief excursion to see the temples of Paestum. On this trip he was accompanied by the French landscape artist Pierre-Jacques Volaire and a young architect, Vincenzo Brenna, as his draughtsman. While Volaire sketched the ruins, he himself helped Brenna to take detailed measurements, which were later used to produce careful studies of the three temples. Townley was constantly on the alert for any antiquities that might be available, but a farmer near Paestum would not sell a torso 'much in the style of the *Laocoön*' because it belonged to the landowner and all he could find on this expedition was a small statue in the stables of the Bishop of Salerno, whose coachman was bribed to permit its removal, and a damaged 'Etruscan' vase.[51]

Back in Rome he commissioned a portrait bust from Christopher Hewetson, now in the British Museum, and showed his serious interest in antiquity by a number of purchases.[52] At this stage he had not yet found his feet as a collector and, as a result, the quality of his acquisitions was uneven, so much so, in fact, that he later disposed of several of them. He made it quite clear that he had 'a plan of collecting a variety of different characters of the fine Antique'.[53] Jenkins was his main supplier. He established a good working relationship with the dealer who was to remain his regular correspondent in Rome for the next thirty years. Purchases of antiquities in 1768 from this source totalled £937 and included a statue of a *Young Faun*, four Roman imperial busts, a bas-relief of the *Rape of Deianeira* restored by Cavaceppi, a sarcophagus, an urn carved with a battle scene, a *Fountain Nymph* (called by Townley the *Seated Diana*) and '*The Cannibal*'. The latter, originally in the Barberini palace, had been identified by Winckelmann as one half of a group, *Boys fighting over a Game of Knucklebones*, which had been copied from a lost bronze by Polyclitus, mentioned by Pliny, and it was, therefore, by far the most expen-

sive piece, costing £400 (fig. 147). The sarcophagus was notable in that it had been engraved by Santi Bartoli in 1693. A *Hecate*, bought from another dealer, Pietro Pacilli, with a provenance from the Giustiniani palace, was another well-known statue. Townley's first purchases included a number of pieces that were of serious antiquarian interest and not just decorative items. His enthusiasm for such marbles was unusual: the *Hecate*, for instance, was a striking but not a conventionally attractive figure (fig. 148).

Townley also had dealings with Piranesi, who sold him some furnishing antiques, altars, a sarcophagus, a fountain and one of his chimneypieces composed of classical fragments. His total purchases of marbles on this visit amounted to some £1600. In addition to the antiquities, he acquired old master paintings, mostly copies, from Jenkins, drawings by Brenna, Vernet and others and a quantity of books and prints. As the packing cases were despatched from Rome, they were followed by detailed instructions from Townley to his uncle about handling in the London docks – porters were to be employed, not carts or drays – and about the management of officials: 'I fancy it is better not to let the Customs house officers know what the marbles represent, as fine sounding names or characters given them may make them increase their valuation' and thus increase the duties payable. He even suggested having 'a reasonable Statuary or Judge at hand in case the Blockheads should mistake the wrong way and overvalue them'.[54]

When Brenna sent his completed drawings of the Paestum temples a couple of years later, he tried to persuade Townley to use him as his architect by offering some attractive designs for oval sculpture galleries, top-lit through a dome and decked out with an array of imaginary classical statues. One design was for a gallery with niches for four large statues, nine plinths for smaller ones and a relief over the chimney, while the other was to provide four niches and sixteen plinths with elaborate plasterwork, gryphon and honeysuckle friezes and much richer coffering; the end niche was to be occupied by a bath or sarcophagus like that at Newby (figs 149 and 150). At this stage, however, Townley was concentrating his resources on establishing his collection rather than housing it. Brenna, who was not to build a gallery at Towneley or in London, went on to make his architectural reputation first in Poland and then in Russia.[55]

Late in 1771 Townley started his second tour. After spending a couple of months in northern Italy, he arrived in Rome in February 1772. He then revisited Naples, where he met Sir William Hamilton, and set out on a tour of Apulia and Calabria, accompanied by William Young, another Tourist, and a Scottish artist, John Brown. In Naples he obtained letters of introduction to local landowners and clerics to facilitate travel in this out of the way part of Italy but, although he records in his journal several recent finds of ancient vases, he failed to make any significant purchases. A subsequent visit to Sicily in the company of the improvident Barry was more productive and resulted in the foundation of a collection of Greek coins. Back in Naples later that year he bought from Prince Laurenzano the famous bust known as *Clytie*, a beautiful girl emerging from a lotus flower, which was one of the most popular objects in his collection, copied several times by Nollekens, constantly reproduced in Parian ware during the nineteenth century and still attracting buyers in the British Museum shop (fig. 151). It was to be Townley's favourite piece and the one that he took with him in his coach when the anti-Catholic mob threatened his house during the Gordon Riots in 1780. Although formerly suspected of being an eighteenth-century fake on account of its exceptional state of preser-

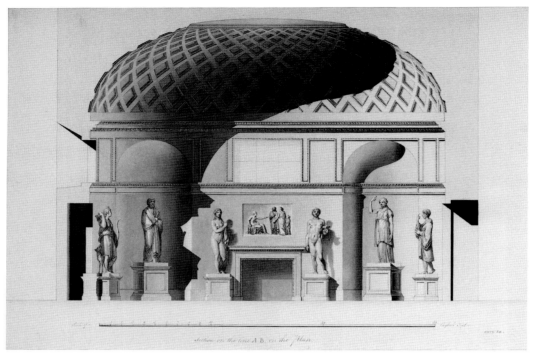

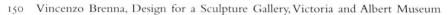

149 Vincenzo Brenna, Design for a Sculpture Gallery, Victoria and Albert Museum

150 Vincenzo Brenna, Design for a Sculpture Gallery, Victoria and Albert Museum

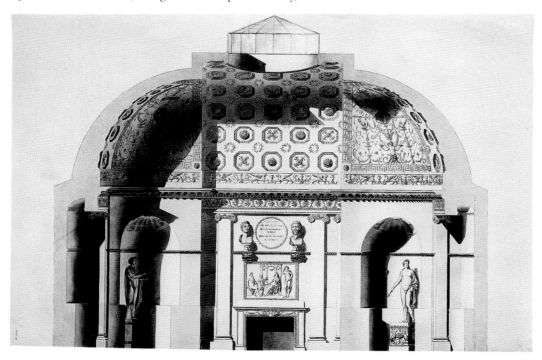

vation, it is now generally considered to be a Roman imperial portrait bust of the first century A.D. With her delicately moulded features and sweetly pensive expression, *Clytie* is one of the most attractive portraits to have graced any British collection.[56]

Much of 1773 was spent in and around Rome. Jenkins continued to offer antiquities and Gavin Hamilton, who had previously only sold to him through other dealers, now began to supply him directly. Townley bought lavishly. Since Talbot, Barry and Shelburne were also spending large sums at this time, he had to show the dealers that he was a serious collector. His choice of subjects was all embracing: heads of heroes, poets and philosophers, imperial busts, an animal group, erotic scenes and, the standard collector's requirement, bases and pedestals on which to mount his statues. He was willing to pay high prices. He gave Jenkins £200 for the head of a *Homeric Hero*, £250 for a statue of *Diana* and £350 for a *Faun ravishing a Nymph*.

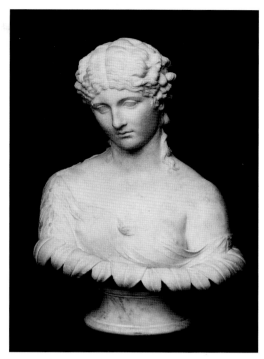

151 *Clytie*, British Museum

A third visit to Italy took place in 1777, when he was aged forty. This time Townley met his friend Henry Blundell to show him the antiquities of Rome and Naples and introduce him to the delights and expenses of collecting. It was to be his last visit to Italy. Thereafter he bought by mail order, albeit on a much reduced scale for reasons both of finance and of space. He did, however, acquire two more expensive statues from Jenkins, a *Caryatid* in 1786 and a *Discobolus* in 1792, each for £400.

Although he was a rich man, his assets were illiquid and he would never consider selling off timber or a farm in order to pay for a statue. His correspondence shows that throughout his life he was a conscientious landlord, well aware of his responsibility to hand on the family estates to his heirs in good condition. Since he was buying out of income and otherwise had to borrow on a long-term basis, he monitored his cashflow carefully. Jenkins, who was a banker as well as a dealer, was quite happy to lend him substantial sums, provided that the interest was paid and the principal was regularly reduced. Occasionally this caused embarrassment when Townley's other commitments meant that he could not afford to bring down his loan as scheduled. In 1781, for instance, when faced with the need to pay back £300 the following year, as well as having to make repayments to Hamilton, Townley wrote to say that he would pay half the agreed sum and would try to retrench sufficiently to find the balance. 'You must be sensible', he wrote, 'that I have always bled freely in your hands and that my finances must be a little shaken in the service of *virtù* . . . You know that even Hercules was obliged to repose betwixt his labours . . . Like ruined gamesters we must content ourselves with over-

looking the cards.' Nevertheless, he was soon back in the market and over time bought antiquities to a value of some £5000 from Jenkins alone.[57]

Gavin Hamilton, who was his next most important supplier, sold him over £3000 of marbles, including some of the most attractive statues in the collection. During Townley's second visit to Rome, he procured for him busts from the Mattei villa, a head that had belonged to Cardinal Albani, a statue of an *Actor with a Mask* that had been recently dug up on the Caelian Hill and some decorative pieces. Then, over the following years, most of the marbles that he provided came from his own extraordinarily successful excavations. 'I voluntarily give you the preference of everything that is most precious of my discoveries', he assured him in 1775, something he could claim with a clear conscience now that Lord Shelburne had scaled down his plans for his gallery. The Bishop Earl of Bristol, himself a keen collector, believed that Hamilton sold skimmed milk to Tourists, while keeping the cream for Townley.[58]

Sometimes, however, Hamilton misjudged his client, as when he disposed of a *Sleeping Mercury* to Jenkins later that year. Jenkins then sold the statue at the substantial price of £300 to Townley, who was furious at having to pay the dealer's mark up when he might have bought more cheaply from Hamilton himself. 'You will know that I desired to purchase capital things only,' he wrote

> and that for such I was ready to pay any price; instead of which you have encumbered me with a number of trifling articles, which run me to a sum, which would have gone a great way towards the purchase of an object of consequence . . . In the *Sleeping Mercury* there is a complaisance, ease and softness . . . the limbs with great propriety lie motionless . . . because in sleep all is calm and relaxed; yet it is animated and seems to breathe; the composition is new and beautiful; and in both of these figures [he was also angry about the sale of a *Bacchante* to Barry] the preservation and the colour of the marble is uncommonly fine. Nothing but great want of feeling could have induced you to part with these two capital objects in the manner you have done. For interest's use if nothing else should have made you prefer an old customer to a *revenditore* . . .

Hamilton protested that he had considered the *Mercury* unsuitable because the subject was not identifiable by any attributes, while the female statue was 'a sweet pretty incorrect figure and very proper for a young dilettante' but not for someone of Townley's discrimination. In fact he probably sold to Jenkins rather than Townley because he knew that the latter would want extended credit whereas Jenkins would pay cash. The exchange sheds interesting light on both the collector's criteria and the supplier's interpretation of them.[59]

As an excavator, Hamilton had the nose of a Texan oilman who can smell oil under the desert sand. At Monte Cagnolo alone, between Genzano and Civita Lavinia, from what he claimed to be the villa of Antoninus Pius, he produced for Townley a large vase, decorated with a scene of Bacchic revels (£250), a group of *Actaeon torn by his Hounds* (£70), two figures of *Bull Sacrifice* (£70 and £50) and a group of a *Bitch caressing a Dog* (£70), the pair to which was secured by the Vatican (fig. 152). In 1775 from excavations at Ostia he supplied a small statue of *Venus* (£100) and an excellent bust of *Trajan* (£100) and the following year two large statues of the Muse of Comedy, *Thalia* (£300) and another *Venus* (£600). The latter, which was described by Canova as the finest female

152 *Bitch caressing a Dog*, British Museum

153 *Venus*, British Museum

statue he had seen in England, would undoubtedly have been reserved for the papal collection but for the fact that it was, unusually, composed of two blocks of marble, the nude upper part of the body forming one half and the draped legs the other (fig. 153). This enabled Hamilton to submit a licence application for each part of the statue separately and thus export the whole. Other favourite pieces that he supplied included a head of *Homer* (£80), a bust of *Pericles* (£50) and a statue of *Cupid bending a Bow* (£60). It was an exceptionally varied and interesting group of marbles.

Lyde Browne, who sold him antiquities to a value of £670, ranked as his third supplier after Jenkins and Hamilton. Townley occasionally bought in the London salerooms and he received generous presents from his friends. He did not restrict his acquisitions to marbles. From Nollekens he acquired a large collection of terracottas, most of which had been excavated from a well near the Porta Latina in Rome in 1765. He frequently bought gems, coins and bronzes from Jenkins, Byres and other dealers in Rome and he was a regular bidder at sales of coins and gems in London. On his first Italian Tour in 1768 he bought gems without much discrimination. Later, however, as he became more selective, he disposed of some of his early purchases to concentrate on stones that were engraved with emblematic devices. Jenkins, whose dishonesty in the field of gems was notorious, supplied as antique a variety of modern pieces, while assuring Townley of his integrity: 'I can with confidence assert that I *never* purchased a thing which I knew or believed to be modern with an intention to dispose of it as an Antique.' Drawings were another item of expenditure as he built up a compendious archive of reproductions of classical antiquities, most of which are now in the library of the Greek and Roman Department of the British Museum. By the time of his death he had spent over £10,000 on marbles and over £4000 on other antiquities, paintings and drawings.[60]

He was well aware of the dangers of over-restoration and, unlike most of his contemporaries, he always preferred a damaged but unscraped marble to one that had been imaginatively recreated. In 1789 he shipped a statue of *Paris* back to Jenkins: 'the condition of its preservation is so very different from that which from your answers in our various conversations [i.e., exchanges of letters] on that point I had conceived of it and which decided my desire to purchase it, [that] it loses all interest with me, and I have not the least wish to possess it in the mutilated state I find it to be in.' On another occasion, when he was acquiring the fine *Caryatid* that Jenkins had acquired from the Villa Negroni, he insisted 'I beg also that it may not in the least be scraped or pomiced to make it look pretty, a kind of sacrilege the Roman restorers are often guilty of, tho' I know that you have too much good taste to allow this to be practised on objects that are of themselves respectable.' The comment on taste was strictly ironical because he was well aware of Jenkins's reputation. The dealer, however, knew how to handle his client. In 1792 he offered a distinguished marble copy of the *Discobolus* of Myron, which had been excavated at Hadrian's Villa and, according to the credulous talk of the trade in Rome, was by the sculptor who had carved the *Borghese Gladiator*. At first he claimed that it had *la pelle sua*, its own skin, to increase the collector's enthusiasm, but then, realizing that Townley would dispute this when the statue arrived in London, he modified his condition report and described it as *logorata*, corroded, but he explained that the Pope's version, which had had the same kind of tartar or incrustation, had been successfully cleaned by the application of acid and sand with a brush. Townley raged against the ignorance of Cavaceppi in trying to remove traces of ancient red paint from one of his busts: 'The face anciently had been stained with a red tint . . . but unfortunately this head, on its discovery, fell into the hands of Francesco [sic] Cavaceppi, an ignorant sculptor, who used every means to expunge the red colour by the spirit of salt and aquafortis.'[61]

Hamilton was not above making detrimental comparisons between the condition of his rival's stock and his own. In March 1775 he sent a sketch of a *Paris*, which was like one belonging to Jenkins 'with this difference that his is pomiced down to make it white & smooth, whereas this is in its virgin state, a little corroded & stained tho' of an equal hue' – Townley bought neither statue. The following year, when Hamilton had a *Venus* on offer, he wrote a scathing description of Jenkins's example of the same subject: 'It has been originally good, but being much corroded they have barbarously given it the *rota* [the wheel] all over . . . they have spared neither muscles nor bones.' On this occasion, Hamilton's comment secured the sale of his version rather than Jenkins's.[62]

After his second visit to Rome Townley had acquired so many marbles that he had to find somewhere to display them. Instead of building a gallery in his country seat at Towneley he decided to acquire a new house in London. Robert Adam eagerly proposed one in his Portland Place development and went so far as to sketch out designs for a Sculpture Gallery. Townley rejected the suggestion and instead employed Samuel Wyatt to build him a new house in Park Street, now Queen Anne's Gate, overlooking St James's Park. It was a standard London terraced house, the only unusual feature being the Library on the first floor, which had no external windows but a skylight to permit top-lighting of the marbles in it. Gavin Hamilton was enthusiastic about Townley's plans to spread his collection through the main rooms instead of creating a Gallery:

I am now in your way of thinking with regard of disposing of your marbles, & that placing them in different rooms is more entertaining than if you was to exhibit them in one point of view. It is the same in every elegant feast, all the nice morsels must not be served up at once, some will like the roast beef & others prefer the maccaroni pie . . . It is more necessary in England than in any other country that they may not be at liberty to run over things too much in a hurry.[63]

The principal statues were displayed in the Hall and in the Dining Room beyond it and in the Library and Drawing Room on the first floor, the largest pieces being restricted to the ground floor because of their weight. From the catalogues that Townley drew up at various dates for the use of visitors it is clear that he frequently rearranged pieces to make space for new acquisitions or to create a more harmonious display, although the larger statues were inevitably less mobile. Two drawings of the Hall and the Dining Room made by William Chambers in 1794, when the collection was virtually complete, show the very crowded arrangement in Park Street, not unlike that in Sir John Soane's house, some rooms of which convey a similar atmosphere of cluttered delight (figs 154 and 155).[64]

Townley eventually considered moving again in order to provide a more spacious setting in which his marbles could be seen all together in a museum display. In 1789 he commissioned Joseph Bonomi to produce designs for a rather low domed gallery at Towneley Hall, more like a nympheum than the Pantheon. The dome was to have been covered with painted grotesques and the walls were to be recessed with niches for the display of free-standing statues (fig. 156).[65] Since, however, a great part of Townley's pleasure came from showing off his collection and discussing it with visitors, which would have been impossible in the wilds of Lancashire, the plan was dropped. Three years later, when he had the opportunity of moving to a house in Soho Square near his friend Knight, he wrote to the Duke of Portland to ask if he would grant an extension of the lease. When the duke refused, he decided to remain where he was.

The interior decoration of some rooms in Park Street was designed to reflect their contents. The Hall, which was painted a deep terracotta red to show up the marbles, contained many of the sepulchral urns and bas-reliefs from sarcophagi, while the coved ceiling was decorated with *trompe l'oeil* frescoes of funerary urns and chests in feigned niches. The chimney maintained the funerary theme with more niches for urns and panels for monumental inscriptions, as if it were part of a columbarium (see fig. 154). In the Dining Room the blue walls were set with half-columns of scagliola in imitation of porphyry. The capitals, which were copied from an example at Terracina recorded by Brenna during Townley's first visit to Italy, were decorated with dramatic masks, corn ears, pinecones and ivy, emblems of Ceres and Bacchus, particularly appropriate for a room devoted to food and drink. The large statues, herms and busts were grouped symmetrically round the walls – Townley was one of the few British collectors who had enough marbles to create such a symmetrical display – and reliefs were set into the upper part of the walls below the gilded cornice. D'Hancarville explained the reason for the colour scheme and the details:

The decoration of this room is principally designed to focus the eye upon each of the marbles which it contains. To that end, the view is deliberately channelled between

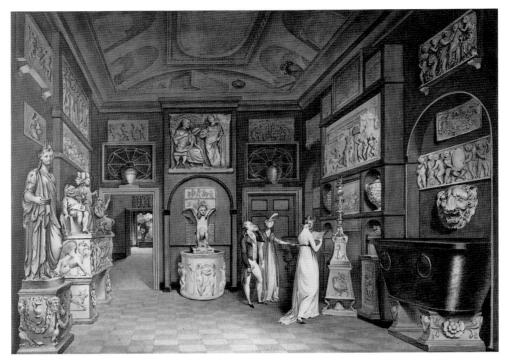

154 William Chambers, *The Hall*, *Park Street*, British Museum

155 William Chambers, *The Dining Room*, *Park Street*, British Museum; the tables and chairs omitted to show off the sculptures

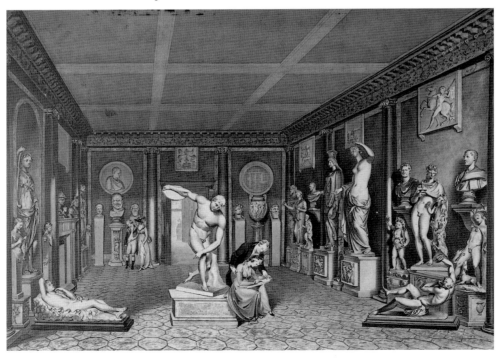

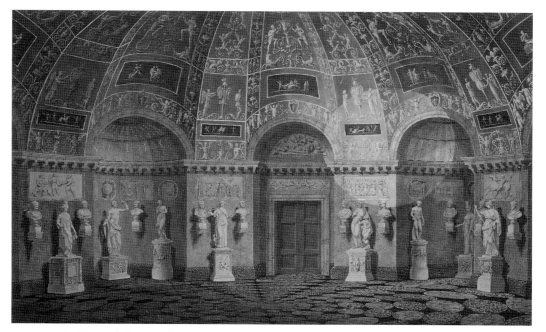

156 Joseph Bonomi, Design for a Sculpture Gallery at Towneley, private Collection

the spaces enclosed by the columns. These are of a dark red colour to check the gaze from wandering over too many objects at once. Standing out against a blue background, they are calculated to emphasise the marbles and prevent them from being confused with adjoining objects . . . All the decorative detail relates to the attributes of those Gods who were supposed by the ancients to preside over the festive table. The Ionic columns . . . support an entablature, the frieze of which is ornamented with festoons of ivy and trophies composed of the instruments used in revels.[66]

To maintain the theme, Townley deliberately selected for this room all his statues, busts and reliefs of Bacchus, fauns, bacchants and anything that could be connected to the mystical rites which, according to d'Hancarville, were at the basis of all religions (see fig. 155).

In February 1778 Gavin Hamilton had offered his advice on an appropriate colour scheme to show off the marbles in the Dining Room:

An imitation of *giallo antico* would set off & harmonise with the colour of the porphyry [columns], a pea green would likewise do well for the columns & for the statues. If you run anything of a surbase behind the columns it will be necessary to recall the porphyry colour in some parts of the same . . . the porphyry columns being a rich tho' sober ornament call immediately for an accompaniment of gold & other colours . . . In Cardinal Albani's *Gabinetto* the porphyry vases do well upon that grey ground because much gold is introduced in the stucco ornament, otherwise it would have the same effect as a man with a fine crimson coat in a cottage.

Although Townley did not adopt his agent's suggestions, the note of opulence was certainly achieved.[67]

On the first floor the Drawing Room looked out over Green Park and opened into the Library. It contained some of Townley's most important imperial busts as well as his beloved *Clytie*. The Library itself is the setting for that icon of British taste for the antique, Zoffany's *Portrait of Townley in his Library* (fig. 157). The famous painting, which was executed between 1781 and 1783 and was then modified in 1798 to include the recently acquired *Discobolus*, is a capriccio view. It accurately represents the form of the room, the skylight with its plasterwork, the chimneypiece, the bookcases and the display of reliefs set in the walls, but the larger statues and many of the busts, which were displayed elsewhere in the house, are grouped in an imaginary arrangement to show off the pick of the collection. Townley is represented seated at ease, with his dog at his feet, debating a point of scholarship with d'Hancarville, whose brow is wrinkled with nervous intensity as he propounds one of his theories. Behind him the young Charles Greville, Sir William Hamilton's nephew, seems to caress the bust of *Clytie*, as if she were his mistress, Emma, while he talks to Thomas Astle, the eminent philologist – and the feather duster, propped beside the chimneypiece, reminds us of the practical care lavished on these treasured objects. It is a painting that encapsulates Townley's delight in beauty, learning and the companionship of friends. Although the Library has been rebuilt, its duplicate survives in the adjoining house, which belonged to the collector William Smith.[68]

Townley's attitude towards antiquity was fundamentally influenced by d'Hancarville. Townley had supported him since 1777, when he started to give him a small allowance, disguising his charity by employing him to prepare a catalogue of the collection in Park Street, while he worked on a projected *History of the Arts*. This catalogue was as disorganized as the volumes on Hamilton's vases, full of digressions on obscure and preferably obscene topics. His *History* never materialized and, when the more modest volumes of his *Recherches* were finally published in 1785 they were so fiercely criticized by reviewers that the author sought new fields in his native France. He was in Paris during the Revolution in 1789, naturally in trouble with creditors, and eventually died in Venice in 1805, still charming everyone with his erudite fantasies. His works continued to be quoted by connoisseurs well into the nineteenth century.[69]

Townley remained under the spell. 'Few books, if any, are void of faults' he wrote to Jenkins in 1785, but the *Recherches* contained 'more discourses and informations towards understanding the monuments of the ancients and the reasons of their compositions than [in] all the books that have been wrote on the subject'. In the end, however, even Townley became disillusioned with his friend, writing on the cover of part of the manuscript catalogue, describing the Park Street collection, 'd'Hancarville's explanations of some of my marbles; some of his observations are just & interesting, but most[ly] are erroneous'. Nevertheless, he continued to be fascinated by theories about the origins of religious cults and he made the dealers in Rome aware of his particular interest in statues and gems representing figures that had unusual attributes. He was, therefore, violently indignant when he discovered that a relief of *Bacchus visiting Icarius*, supplied by Jenkins from Villa Negroni, had recently been restored and that the evidence of the original meaning of the scene had thereby been damaged. 'My only object in purchasing it', he wrote in 1788, '(the Elucidation of the Principles of the ancient theological Mysteries)

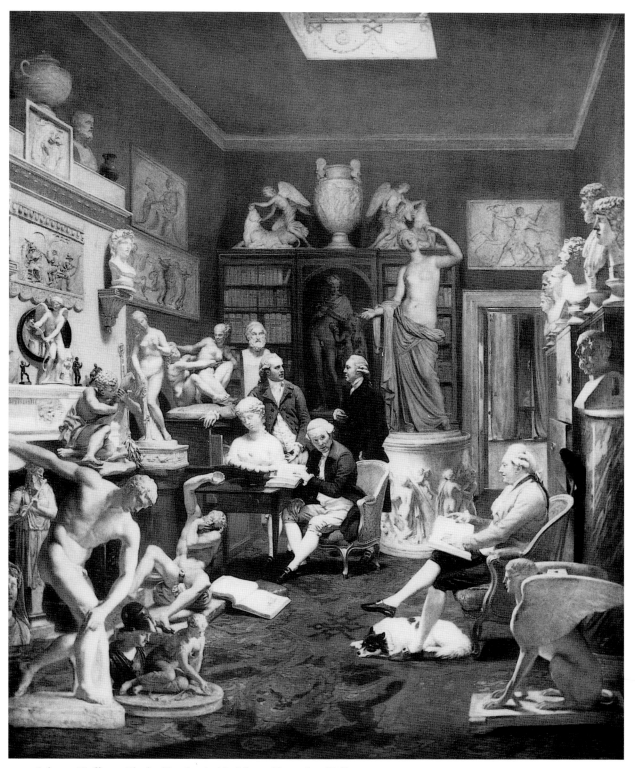

157 Johann Zoffany, *Charles Townley in his Library*, Towneley Hall

is defeated . . . Let me repeat my request that you will dispose of it for me to any Turk, Jew or Christian Dilettante that will give me what I paid for it.' The subject was, however, too intriguing and, in the end, he retained the marble. Curiosity about d'Hancarville's ideas led him to include in his collection erotic Hindu carvings and drawings of Hindu temples, procured through friends in the East India Company.[70]

The room catalogues prepared for visitors to Park Street devote more space to far-fetched symbolism than to dating or aesthetics. A typical example is the description given to a funerary chest carved with rams' heads, festoons and birds and a relief of Leda and the Swan:

> The union of the rams' heads with the festoon of laurel refers to that of the powers of destruction and animation in the Deity; the ram being the acknowledged symbol of Pluto, the God of the *Inferi*, the regions of the dead, and the laurel that of Apollo, the God of Animation. The alternate action of these powers is alluded to by the two doves placed on the festoon, these birds being the occasional symbols of the Dioscuri, who in their alternate return from death to life personify the alternate operation of those powers by the Deity.

The catalogue entry continues with a similarly detailed exposition of the symbolism of Leda and the Swan, lions, the lotus, 'the union of the active and passive means of production' and much more besides. The strange exegesis is not a translation from d'Hancarville's catalogue but seems to have been composed by Townley himself and shows how strongly d'Hancarville's theories continued to influence his patron.[71]

When it came to dating marbles, he was consistently wrong. There were only two significant Greek sculptures in his collection, both funerary reliefs. One was given to him in his last years by the Duke of Bedford and the other, which had been acquired in Greece by Antony Askew in about 1749, was bought by Townley through Browne. Thinking that it represented the father of Pericles, Xanthippus, Townley misdated it by half a century. He also ascribed many of his other heads and reliefs to the fifth century B.C. or earlier, in the erroneous belief that Roman copies of Greek works were Greek originals, which, he assumed, had been imported into Italy by Roman connoisseurs. He was influenced by his supplier, Gavin Hamilton, who had told him, 'Never forget that the most valuable acquisition a man of refined taste can make is a piece of fine Greek sculpture.'[72] After Townley's death, when Knight came to describe the statues that had been chosen to illustrate their joint work, *Specimens of Antient Sculpture*, he was very cautious about the dating of his friend's marbles. He accepted a few pieces as Greek originals of the fourth and third centuries B.C., while firmly cataloguing most of the archaizing heads as Roman copies of the Hadrianic period. He deferentially disagreed with Townley, 'whose judgment in art was nearly as infallible as human judgment can be', about the head of his *Discobolus*, which he considered to belong to another statue, and he excluded the *Boys fighting over a Game of Knucklebones* as being too restored to be worth illustrating in *Specimens*. He did, however, accept the large *Venus*, acquired from Hamilton, as 'an original work from the hand of a great master', which might be 'deservedly ranked among the most precious monuments of Grecian art now existent' and dated it to the period of Scopas. In fact, almost all of Townley's 'Greek' marbles are now considered to be Roman copies or imitations.

The collection was one of the sights of London. Townley welcomed

all who were known in the literary circles as antiquaries or men of taste: and he never disappointed the curiosity of others, less versed in the arts . . . It was delightful to see him frequently joining himself to these visitants, and as often as he found them desirous of more information than the catalogue contained, freely entering into conversation, and with a gracefulness of manner, peculiarly his own, giving a short dissertation upon any piece of sculpture under consideration.[73]

His journal records a constant flow of visitors, both British and foreign, and a noticeably large number of ladies. The drawings by Chambers of the Hall and the Dining Room both show young blue-stockings, one sketching a statue and one examining the catalogue (see figs 154 and 155).

He was the principal authority to be consulted on anything to do with antiquities. Not only did he collaborate with Knight in the Dilettanti Society's *Specimens of Antient Sculpture*, but he provided his future memorialist, James Dallaway, with all the information needed to write the first detailed account of British collecting, *Anecdotes of the Arts in England*. He was also a diligent trustee of the British Museum, in which capacity he lobbied Parliament to provide funds for a worthy building to house the Egyptian antiquities recently captured from the French, he campaigned for a reduction of the import duties on sculpture and works of art, he gave advice to Henry Holland on the abortive scheme to create a gallery of classical sculpture for the Prince of Wales and he helped the Duke of Bedford with ideas for the Temple of Liberty to be erected in his new gallery at Woburn.

It was fortunate for his reputation that he never attempted to produce a work of scholarship himself. His only publication, a brief paper on a Roman helmet in his own collection, communicated to the Society of Antiquaries in 1798, was, as he admitted, full of 'conjectures, the usual recourse in the dark paths of these researches into antiquity' – it could have been ghost-written by d'Hancarville.[74] He did not even publish a catalogue of his collection. It is tempting to regret that he preferred mythological speculations to serious art history. He did, after all, have an extensive library (which included Winckelmann's *History* in both French and Italian translations), he owned a large collection of prints and drawings, which were the equivalent of a modern photographic archive, he had seen many of the most important monuments in France and Italy and he was in touch with the leading scholars of his day. He chose, however, to apply his wide knowledge and his keen aesthetic judgement to the enjoyment of his collection instead of emulating the labours of Winckelmann or Visconti.

To his contemporaries he was, above all, a kindly and genial host who was happiest when showing off the collection to his friends or when entertaining them to dinner in Park Street. He never married, although, in a letter of March 1785, Knight mentions the rumour that he would succumb to a widow, 'who, having already experienced what a Husband is, has a mind to know what real fucking is when illustrated by so great a Professor'. Townley preferred to remain a bachelor but his exploits with the whores of London and Rome were notorious among his friends.[75]

His latter years were affected by increasing ill health, which turned his journal into a hypochondriacal chronicle of bowel movements. As he spent more time on his estates

in Lancashire, he began to think about transferring his precious collection to Towneley. In his last days he therefore altered his will and, instead of leaving his marbles to the British Museum as he originally intended, he added a codicil bequeathing them to his brother, failing whom, to his uncle, on condition that they erected a suitable gallery for the collection either at Towneley or in London. After his death in January 1805 his executors, at Knight's suggestion, ignored the codicil and offered the marbles to the Museum for £20,000. Parliament voted the money, despite the pinched state of the country's wartime finances, but the motive was partly nationalistic. Many visitors to Paris in 1803, during the brief Peace of Amiens, had admired the antiquities recently removed from Italy to the Napoleonic Museum and the acquisition of Towneley's marbles provided some sort of a cultural response. The family retained the other antiquities and the drawings but in 1814 these were sold to the Museum for a further £8200.

The marbles were removed from Park Street in 1806, two years before a special gallery was ready to receive them in Bloomsbury. This building was demolished between 1842 and 1846 to make way for Sir Robert Smirke's new museum and, when the statues were redisplayed, they were mingled with Roman figures from other sources. By then, however, they had been eclipsed by recent acquisitions of Greek antiquities. The bulk of Towneley's marbles were only brought together again as a collection in 1984.

Even though his reputation as a scholar and collector was unquestioned in his lifetime, it did not survive long into the nineteenth century. He was essentially a figure of the Grand Tour era and the memory of his achievements as a connoisseur faded when the Tour ceased to be the proper finishing school for a young man of culture. His collection must be judged by the standards of its time. He assembled a remarkable group of marbles from the best of what was then available on the Italian market in the belief that it included Greek works that had been imported into Italy by the Romans. For variety, beauty and historical interest his antiquities were outstanding not only among British collections but among those formed anywhere else in Europe in the eighteenth century, those of the Vatican alone excepted. It was a considerable achievement for a country gentleman.

THE BRITISH AS COLLECTORS IN THE EIGHTEENTH CENTURY

In 1796 French troops, led by Bonaparte, marched into Italy and, after a series of victorious campaigns, they entered Rome. The following year, under the terms of a humiliating treaty, many of the great masterpieces in the papal and princely galleries were despatched to Paris to provide a novel form of Roman triumph for the republican armies. The invasion brought an end to an era of British collecting. By that time Jenkins, Byres and Gavin Hamilton were dead or had left Italy and only Fagan was left to carry on his risky but still profitable trade. British travellers now had to visit the eastern Mediterranean if they wanted to enjoy classical sites and search for antiquities. A new phase of collecting had begun.

The end of the century provides a convenient point at which to survey the achievements of British connoisseurs. Over the previous sixty or more years, numerous collections had been installed in England and there were several in Scotland, Ireland and Wales.

Substantial sums had been spent in competitive rivalry, particularly in the 1770s, when the mania for antiquities reached its height. And yet, apart from Townley and Knight, who were acknowledged to be in a class of their own, and, in his field of vases, Sir William Hamilton, no collector brought more than good amateur taste to his purchasing. Every notable British collection depended on dealers' flair, Holkham and Petworth on Matthew Brettingham, Lansdowne House on Gavin Hamilton and Castle Howard on Lord Carlisle's various suppliers.

At first sight it seems rather surprising that collectors should have been willing to let these distant mail order agents lay out large sums of money on their behalf on the basis of a short description and some drawings. They might have been expected to spend more time in Italy to supervise their acquisition programmes in person. Their attitude is, however, quite understandable. Only a very limited number of objects came onto the market each year, depending on the success of excavators in making new finds, the work schedules of the restorers and the financial needs of old families, forced to sell heirlooms from their palaces. Even then, exports were permitted only if the Papal Antiquary granted a licence and, in the latter part of the century, Pius VI was himself examining export applications and selecting acquisitions for the new Vatican Museum. There were not enough goods on the market to allow the possibility of making a systematic collection of examples of different periods or a pantheon of divinities or a gallery of imperial portraits in a short time. There was, therefore, no great advantage to the collector in staying in Rome as long as he had a good relationship with one of the dealers who could alert him to buying opportunities. It was, in fact, rather frustrating, as Browne discovered, to rummage through every dealer's stock and find nothing worth buying at the end of it all.

Some collectors set out with a view to acquiring whatever was available at the time of their visit, regardless of cost. Weddell, for instance, who assembled most of his marbles on this basis, had to pay excessively high prices in order to buy enough to furnish his gallery at Newby and even he could not complete his acquisition programme on a single visit. Such hasty purchasing more often failed, because the resultant collection was too heterogeneous to make an aesthetically pleasing arrangement – when he reached home, Talbot was so puzzled as to how he should deal with his purchases that he left them unpacked in their crates for years. Brettingham came up with a better solution by furnishing Lord Egremont's new gallery at Petworth with casts until he had procured sufficient desirable statues to fill the niches. By way of contrast, his other important client, Lord Leicester, was unusual in monitoring all his agent's suggestions very closely and not agreeing to any purchase until he had decided exactly where it would fit into his scheme for Holkham. He, however, could afford to be patient because he was decorating his house over a long period of time.

Very often, the visitor to Italy was only interested in acquiring furnishing antiquities that could proclaim his taste to guests arriving in the entrance hall. It was possible to do this for a modest outlay, as Lord Palmerston proved, if the purchaser was not fussy about the condition of his sculptures and concentrated on finding pieces that could be combined in a harmonious display. It is easy to see why some Tourists preferred casts or replicas that could create the effect of a Roman interior without the problem of finding matching pairs.

158 Joseph Nollekens, *Medici Venus*, measured drawing, Ashmolean Museum

Few visitors today look at the sculpture in the galleries of Rome, Florence and Naples with the awed reverence of the eighteenth-century Tourist. Jonathan Richardson, who claimed that he had spent over ten hours in the Tribuna of the Uffizi, found that he was glancing back at the *Medici Venus* every three minutes. The statue had the same effect on Lord Cork, who was no professed connoisseur and was not rich enough to buy marbles himself. 'Language cannot describe it in its true perfection,' he wrote, 'nor can any copy reach the beauty of the original *Venus*.' After describing the other statues in the Tribuna, he reverted to the *Venus*, 'There I saw *artis summum opus*. Human power can go no further . . . The proportion and symmetry of body, legs, hands and head are just and delicate to the utmost degree of perfection.' As Sir Joshua Reynolds put it, the *Venus* afforded a 'delight resulting from the contemplation of perfect beauty', while the impact of the *Torso* was akin to the 'highest efforts of poetry'. This was the typical response of visitors to Italy and it raises the question. Why were they all so enthusiastic about these statues? The question is even more pertinent when many Tourists considered that the breast measurements of the *Medici Venus* fell far short of their own more generous ideals of female beauty (fig. 158).[76]

Guidebooks, bear-leaders and *ciceroni* repeated in unison the message that the famous works of antiquity, the *Medici Venus*, the *Belvedere Apollo*, the *Farnese Hercules* and the rest of them, by representing the very essence of ideal beauty, had set the standards on which all subsequent art was based. Once again, Reynolds, who himself often froze his sitters into poses derived from antique statues, explains the importance of these models: they were not only perfect in themselves but they were essential prototypes for the contemporary.

> . . . we must trace back the art to its fountain-head; to that source from whence they drew their principal excellences, the monuments of pure antiquity. All the inventions and thoughts of the Ancients, whether conveyed to us in statues, bas-reliefs, intaglios, cameos, or coins, are to be sought after and carefully studied; the genius that hovers over these venerable relics may be called the father of modern art.[77]

No one was going to admit that he failed to see the excellence of these antiquities any more than he would admit that he could not appreciate good wine or judge a good horse. Such treasures always had a special mystique because they were only to be seen in papal or princely collections and were rarely for sale.

Since most Tourists could not tell the difference between the accepted master-pieces in Roman galleries and the well-restored goods in a dealer's warehouse, they were easily persuaded when their guide, who had been enthusing about the marbles on the Capitol, insinuated that a statue only slightly less admirable might be acquired from his own collection. Hints were added that an export licence for such an important work could never be pro-cured without special contacts (which would only be exercised for a truly dis-criminating connoisseur) and there was the tempting suggestion that antiquities were so rare that they were bound to prove an excellent investment – a forecast that often proved incorrect when the buyer tried to realize his assets.[78] Lured by flattery and greed visitors from Great Britain pursued marbles with the undis-criminating ardour of American magnates bidding for portraits by Reynolds and Romney in the 1890s or Japanese indus-trialists vying for French Impressionists in the 1980s.

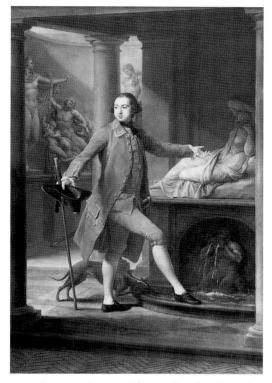

159 Pompeo Batoni, *Thomas Dundas, later First Lord Dundas*, The Marquess of Zetland, Aske Hall

Portraits show how universal the fashion for antiquities had become. Whereas in the earlier years of the century it was sufficient for Tourists to be sketched in masquerade costume by Rosalba, from the 1750s on, many of the young Britons who sat to Pompeo Batoni or to British artists in Italy chose to be represented in front of a Roman ruin or beside the *Laocoön*, the *Sleeping Ariadne* or the *Medici Vase* (fig. 159). Zoffany's scene inside the Tribuna shows a group of visitors in the 1770s admiring the ancient marbles with at least as much attention as the works of Raphael. This conversation piece together with that of Townley sitting with friends in his library epitomizes the earnest pleasures of con-noisseurship (figs 160 and 157). At the other end of the scale, the cheerful Tourist cari-catures that Thomas Patch produced in Florence, although often set among the statues of the Uffizi, reveal much less respectful attitudes towards antiquity (fig. 161). Such atti-tudes are typified by the behaviour of the Duke of Dorset, who acquired a copy of the *Borghese Gladiator* for the entrance quadrangle at Knole and then placed his own coat of arms on the gladiator's shield (fig. 162) and commissioned a nude statue of his mistress in a seductively sprawled pose based on that of the *Hermaphrodite*.[79]

The amount of money spent on any antiquity had less to do with the quality of the piece than with the dealer's perception of the buyer's wealth. Weddell, Barry, Grenville (who was the heir to Lord Temple at Stowe) and Shelburne were all persuaded to spend large sums on marbles that had been heavily repaired, while Townley and Browne, who kept more closely in touch with the market and had shrewder judgement, generally paid

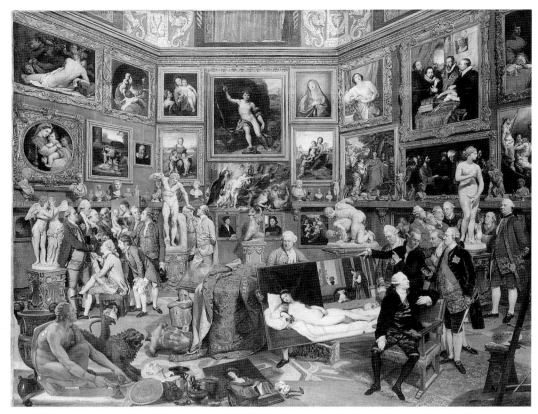

160 Johann Zoffany, *The Tribuna of the Uffizi*, The Royal Collection © 2002, Her Majesty Queen Elizabeth II, Windsor

161 Thomas Patch, *A Gathering of Dilettanti in a Sculpture Hall*, private collection

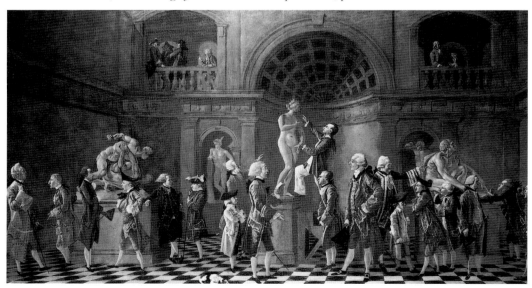

less and bought statues the appearance of which did not owe so much to the restorer's workshop. When Townley did acquire expensive items they were of high quality because the dealers knew that it would be difficult to resell a statue that had been sent on approval to London and been rejected by him. The overall sums involved were not, however, very large: Townley and Shelburne respectively spent about £10,000 and £7000 on their marbles and, apart from Weddell with his *Venus* and Barry with his *Antinous*, no collector paid as much as £1000 for a single statue, although the rich Irish brewer Joseph Leeson offered £2000 for the pair of *Furietti Centaurs*, an offer that was rejected 'with indignation'.[80]

162 Copy of the *Borghese Gladiator* with the Sackville coat of arms on the shield, Knole

By way of contrast, greater sums were spent on paintings, many of which were more highly priced. During the course of the eighteenth century works by Berchem, Dolci, Murillo, Parmigianino, Potter, Poussin, Reni, Rosa, Rubens, Ruysdael, Titian, Van Dyck and Velàsquez all made prices in excess of £500 on the English market. When Sir William Hamilton asked £3000 for his 'Correggio' he did not get his price, but the painting was far more expensive than any of his antiquities. Pictures from Sir Robert Walpole's collection, acquired in the first half of the century, were sold to Catherine the Great at a valuation of £40,555, twice the price that she paid for Lyde Browne's marbles. At the very end of the eighteenth century prices of paintings started to rise sharply. In 1799 William Beckford bought a pair of paintings by Claude and four smaller pictures for £7350 and then resold the Claudes for £10,500 in 1808, while the syndicate of British buyers, who acquired the Orléans collection in 1798, pushed the price of old masters to even higher levels. By way of contrast, prices of antiquities had fallen, as Gavin Hamilton pointed out to Lord Lansdowne. Townley's heirs were fortunate in the timing of their offer to sell his marbles to the British Museum for £20,000. If such an offer had been made only a couple of years later the family would have found it much harder to persuade Parliament to vote so large a sum, as the unfortunate Lord Elgin was to find.[81]

Smollett in 1766 complained about the naivety of British visitors:

> The English . . . are supposed to have more money to throw away; and therefore a greater number of snares are layed for them . . . the moment they set foot in Italy, they are seized with the ambition of becoming connoisseurs in painting, music, statuary, and architecture . . . I have seen in different parts of Italy a number of raw boys, whom Britain seemed to have poured forth on purpose to bring her national character into contempt . . . One engages in play with an infamous gamester . . . another is poxed and pillaged by an antiquated *cantatrice*: a third is bubbled by a knavish antiquarian . . .

Nor were collectors free from such dangers at home. In a comic sketch entitled *Taste*, first staged in 1752, Samuel Foote satirized the attempts of domestic tricksters to impose on connoisseurs – Novice, who is bowled over by a head from Herculaneum, has to admit that he is unsure whether it is male or female, but is reassured by the opinion that it is not fierce enough for the Jupiter of Phidias and not handsome enough for the Venus of Praxiteles and therefore must be an Egyptian Serapis, 'fabricated about eleven hundred and three years before the Mosaic account of the Creation'. Neither taste nor knowledge was a necessary prerequisite for such buyers – they were, after all, the ancestors of those people 'who do not know much about Art but know what they like'. It is clear, however, that the best collections were formed by visitors who waited for several years after leaving university before they made their Tours and started to buy in earnest.[82]

The amateur attitude towards collecting is characteristic of the long-standing British suspicion of professionalism. It was somehow rather ungentlemanly to be too familiar with the technicalities of a marble's state of preservation. In any case, the subject of the statue was generally more important than its condition. Groups of figures were held in highest esteem, followed by full-size statues or busts of recognizable characters and then animals or birds, Lord Clive's *Cat with a Snake* (fig. 163), for instance, or Jennings's *Dog of Alcibiades* (fig. 164) or Walpole's *Eagle*.[83] Bas-reliefs and decorative ornaments were generally least regarded. Townley was unusual in his insistence on quality but he failed to persuade fellow collectors such as Barry to copy his example. It is significant that Knight, who did have scholarly interests and was particularly interested in manufacturing techniques, came from a middle-class rather than an aristocratic background.

It is, of course, unfair to belittle eighteenth-century collections because they were not formed with the eye and knowledge of the keeper of an antiquities department in a twenty-first-century museum. The material was not available and the system of export controls ensured that the famous discoveries of the Renaissance and the most important finds from new excavations could never leave Italy. Nevertherless, despite these restrictions and despite the haphazard collecting methods of British visitors, many excellent and attractive marbles were acquired, almost entirely of the Roman imperial period. Some of them were displayed in extremely beautiful galleries, as the surviving examples at Holkham, Newby and Ince testify. It was not long, however, before they all fell out of fashion, devalued by the swing of taste from Rome to Greece after the exhibition of the Elgin Marbles in 1807. And yet, even when the cult of antiquity was at its highest, not many of these collections were well known because they were widely dispersed. As Winckelmann complained, most statues were exiled in remote country seats. Scattered from Kent to Lancashire and from Yorkshire to South Wales, they could not be com-

163 *Cat with a Snake*, National Trust, Powis Castle 164 *The Dog of Alcibiades*, British Museum

bined in a convenient itinerary for the new pastime of country house visiting. Wilton, Holkham and Castle Howard, for instance, were all regularly open to public view but could hardly be more widely separated. Townley's London house, it is true, was frequently visited, while Blundell's Pantheon was beset by self-improving groups from the growing town of Liverpool nearby, but few others were so conveniently situated to the centres of population. Furthermore, because collectors seldom acquired enough antiquities to justify devoting a separate gallery to them, in many houses the marbles were scattered throughout the reception rooms and lost their impact among other objects of *virtù*. When they are mentioned in visitors' diaries or the descriptions of county historians, the subjects are often noted as if they were zoological specimens, 'a *Hercules*', 'an *Apollo*', 'a *Julius Caesar*' or even 'a busto', without critical comment, which indicates the general level of appreciation. It must also be recorded that not all visitors to country houses treated the antiquities with due respect: in 1771 Lady Beauchamp Proctor noted how some gentlemen, waiting for the housekeeper to take her party round Holkham, 'amused themselves with trying to throw their hats upon the heads of the busts'.[84]

It would be easy to dismiss the collecting of antiquities in the eighteenth century as an exercise in commercial opportunism whereby dealers, while catering for the requirements of a few knowledgeable buyers, successfully exploited the gullibility of the rest. There was, however, a close, if undefinable, link between the fashion for collecting antiquities and the enthusiasm for the neo-classical style in architecture and the decorative arts. Many of the happiest creations of Adam, Chambers and Stuart, of Chippendale, Boulton and Storr were based on classical models (figs 165 and 166). The towering fame of Canova, whose statues featured in several British collections, was based on his perceived ability to create modern masterpieces that equalled the sculptures of antiquity.

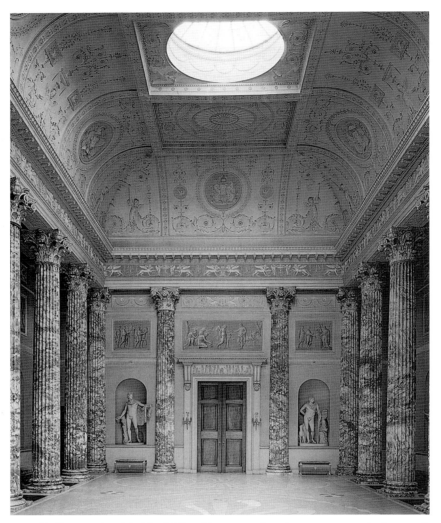

165 Kedleston, the Marble Hall with casts of antique statues and the stools
designed by Robert Adam after the porphyry sarcophagus formerly in the Pantheon

These works appealed to contemporary taste precisely because most of the owners of
great country houses and their friends and relations had been on the Grand Tour and
many of them either had, or thought that they had, antiquities that matched in date the
originals from which the details of their houses and their furnishings were derived.
Typically, in the Hall there was an antique sarcophagus, used practically but unwisely as
a log basket, and the seats were based on the porphyry chest from the Baths of Agrippa,
above the staircase hung Batoni's portrait of the owner on his Tour, posed by the *Sleep-
ing Ariadne*, in the Drawing Room the capitals of the pilasters were based on those of
the Pantheon, on the Dining Room sideboard stood silver gilt cups modelled on com-
positions that Piranesi had illustrated in *Vasi, Candelabri, Cippi* (figs 167 and 168), in the
Library there was an array of Wedgwood's Etruscan urns above bookshelves sagging

166 Sir William Chambers, Lord Charlemont's Medal Cabinet, Courtauld Galleries

under the weight of Piranesi's *Antichità* and *Vasi*, grand cases housed the coin and gem collections and the Library desk was decorated with inlays derived from plates of Hamilton's vases; and in the Morning Room, patterned with grotesques from the *Domus Aurea*, the lady of the house warmed herself by a chimneypiece inset with a miniature relief of the *Borghese Dancers* and surmounted by an array of Zoffoli's bronze versions of statues from the Capitol. Outside the front door statues derived from the *Medici Venus* and the *Farnese Hercules* surveyed the park from follies inspired by the Temples of Vesta and Fortuna Virilis in Rome. Grand Tour trophies were more than holiday souvenirs. By perpetuating memories of the classical experience they fostered the taste for the neo-classical style that British architects and designers so successfully developed.

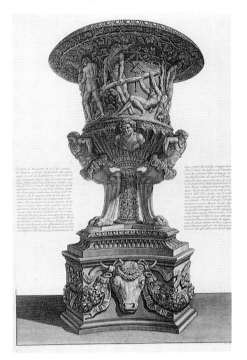

167 Giovanni Battista Piranesi, *Boyd Vase*, *Vasi, Candelabri, Cippi*

168 Rebeccah Emes and Edward Barnard, silver gilt copy of the *Boyd Vase*, 1824, Gilbert Collection

This period may be concluded with a note of one unusual advantage of collecting antiquities. When the Bishop Earl of Bristol died in 1803 his body was shipped back from Naples to England on a British naval vessel, packed and labelled as an antique statue, to avoid the superstitious fears of the crew.[85]

Greek Antiquities

LORD ELGIN AND THE MARBLES

During the last years of the eighteenth century and for most of the first fifteen years of the nineteenth century, continental Europe was disrupted by the turmoil of the Napoleonic wars. French troops controlled Italy, apart from a brief period in 1799 when British forces combined with the Neapolitans to put down the fledgling Roman Republic. On that occasion the Union Jack flew over the Capitol and Commodore (later Admiral Sir) Thomas Troubridge was granted an augmentation of honour to his coat of arms, 'on a canton azure, two [Papal] keys in saltire or', for his services in rescuing part of the Vatican collections. Soon, however, the French returned. Pius VI was deported from the Quirinal to exile in France, Napoleon installed Joachim Murat as King of Naples and almost all the greatest antiquities in Italy were removed to Paris in a triumphant gesture of cultural imperialism. At sea, however, the British navy's control of the Mediterranean permitted safe travel to visitors who wanted to explore Egypt, Greece or the Levant. Such travel did not become an alternative to the Grand Tour because polite society was not to be found among the merchants of Smyrna or the brigands of the Peloponnese, but a number of British gentlemen visited the region and several of them published accounts of their travels, William Gell being the most prolific author. Some visitors also acquired a few relics to bring home along with their diaries and sketchbooks. John Morritt of Rokeby, for instance, visiting Greece and Turkey with his tutor in 1795, recorded the pleasures of walking through the alleys of Athens. 'Over almost every door is an antique statue or basso-rilievo, more or less good though all much broken . . . Some we steal, some we buy, and our court is much adorned with them.' A few days later he wrote to tell his family that he was hoping 'to be in possession of one at least, if not more, of the alto-rilievos of Phidias which are over the grand colonnade', thanks to liberal bribery of the commandant of the Acropolis. Frustrating delays ensued:

> Scruples of conscience had arisen in the mind of the old scoundrel at the citadel; that is to say, he did not think we had offered him enough. We have, however, rather smoothed over his difficulties, and are to have the marble the first opportunity we can find to send it off from Athens. I, only being sensible of the extreme awkwardness of Grecian workmen, tremble lest it should be entirely broken to pieces on taking it out.

After his efforts at removing one or more of the Parthenon metopes had eventually been blocked by the French consul Morritt continued his Tour. He was no more successful

at Amyclae, where he tried to buy a relief of a Spartan lady's toilet set, or at Ephesus, but he did eventually acquire a bronze helmet, which he later gave to Knight, and some *stelae* before returning to Italy. Back in Naples, where he bought coins, he was entranced by a performance of Lady Hamilton's 'attitudes' and in Venice he admired the gems of the British resident Sir Richard Worsley, although he could not help 'thinking of the *peeping* scene' (referring to the scandal of the divorce case) and was rather surprised at him 'as, from his conversation and ideas, he by no means seems as if he had been such an ass'. Morritt's relatively minor trophies were typical of the period.[1]

The Napoleonic wars were, however, the direct cause of the greatest acquisition of antiquities in any period, if not the greatest art acquisition of all time. The export of the Parthenon marbles to London was, in one sense, the culmination of all British collecting activity over the previous two centuries and yet it came about almost by accident as a side effect of British military success in Egypt. Thomas Bruce, seventh Earl of Elgin, was appointed ambassador to the Sublime Porte towards the end of 1798 (fig. 169).[2] He was then aged thirty-two and had already had diplomatic experience in Vienna, Brussels and Berlin. It was a sensitive time in British relations with Turkey because Napoleon had recently invaded Egypt and seemed to have plans for pushing eastwards to threaten India. Elgin's task was to persuade the Turks to turn against their traditional allies, the French, and to help the British to dislodge Napoleon from Egypt.

Elgin had recently employed Thomas Harrison, the eminent Greek Revival architect, to remodel Broomhall, his family seat in Fife, enclosing the central bay with a ring of Ionic columns.[3] Harrison suggested to him that it would be useful if moulds of details of the Greek temples in Athens could be procured so that architects could have exact models to copy instead of having to rely on the illustrations in the Dilettanti Society volumes. Elgin, who was attracted by the idea of making his embassy a cultural as well as a diplomatic success, tried to obtain government support for this venture and, undeterred when it was refused, he went ahead to hire moulders, *formatori*, in Italy, on his way out to Constantinople, and was persuaded by Sir William Hamilton, whom he met in Sicily, to obtain in addition the services of an artist to make accurate drawings of the ruins. Elgin went straight to Constantinople, while his team of copyists, consisting of an excellent water-colourist, Giovanni Battista Lusieri, two moulders and two draughtsmen, sailed to Athens, where they arrived to start work in August 1800.[4] At first, despite being part of the ambassador's entourage, they met the usual difficulties put in the way of all visitors and were told that the Acropolis was a military site, which could not be sketched, still less measured, nor could the architectural details be moulded. Eventually, by February 1801, the authorities were persuaded to allow sketching (fig. 170) in return for a daily fee but, when the workmen started to erect scaffolding for the moulders, there was a sudden change of mind. The military governor of the Acropolis insisted that all operations must be suspended on the grounds that he had had orders to make preparations against a possible attack on Ottoman installations by the French fleet. The only way round this obstacle was to obtain a *firman* or decree from the Porte, specifically ordering the authorities in Athens to allow work to continue.

By lucky chance Elgin's request for the necessary *firman* coincided with the arrival of news that the British forces had triumphantly routed the French in Egypt. The Porte was impressed by this victory which enabled it, for the first time for centuries, to reassert its authority in Cairo. A *firman* was, therefore, issued. Addressed to the Governor and the

169　George Perfect Harding after Anton Graf, *Lord Elgin*, National Portrait Gallery

170　Theodor Ivanovitch, *Section of the Parthenon Frieze*, British Museum

Chief Justice of Athens, it gave permission for Elgin's artists to enter the Acropolis in order to draw and make mouldings, to erect scaffolding and to excavate, and, crucially, 'to take away any sculptures or inscriptions which do not interfere with the works or walls of the Citadel'. To avoid any doubt, a translation was supplied in Italian, the lingua franca of the eastern Mediterranean.[5]

Shortly after obtaining the *firman* in July 1801 Elgin wrote to Lusieri:

> . . . it would be very essential that the *Formatori* should be able to take away exact models of the little ornaments, or detached pieces if any are found, which would be interesting for the Arts. The very great variety in our manufactures, in objects either of elegance or luxury, offers a thousand applications for such details. A chair, a footstool, designs or shapes for porcelain, ornaments for cornices, nothing is indifferent, and whether it be in painting or a model, exact representations of such things would be much to be desired.

At this stage, he was still thinking in terms of providing a reliable source of ornamental detail for British artists, architects and manufacturers, just as his fellow ambassador in Naples had done with his vase publications, but he went on to tell Lusieri that he was much preoccupied with plans for his house in Scotland, which offered

> the means of placing, in a useful, distinguished and agreeable way, the various things that you may perhaps be able to procure for me. The Hall is intended to be adorned with columns . . . Would it be better to get some white columns worked in this country, in order to send them by sea to my house? Or to look out for some different kinds of marble that could be collected together in course of time, and decorate the hall (in the manner of the great Church at Palermo) with columns all different one from another . . . ?[6]

Elgin was planning to decorate Broomhall with a harlequin set of replicas of Doric columns, not with the Parthenon frieze, which he had not yet seen and which was far too large to serve as decoration for his (or anyone else's) country house. At this stage his principal objective was not to amass a large collection of sculpture either on his own account or for the nation.

To take the *firman* to Athens, he selected the Reverend Philip Hunt, the embassy's energetic chaplain, who had actually drafted the document himself.[7] When Hunt had sought authority 'to take away any sculptures or inscriptions which do not interfere with the works or walls of the Citadel', he was only planning to dislodge the fragments of the Parthenon that had been built into the fortifications. He realized, however, that the wording of the document could be interpreted in a much wider sense so as to permit the removal of the metopes, the frieze and the pediment statues as well. It was an opportunity that he felt he had to take. As he told Lord Upper Ossory, 'It grieved me to the heart to see the destruction made daily by the Janizaries of the fortress. They break up the finest bas-reliefs and sculptures in search of the morsels of lead that unite them to the buildings after which they are broken with wanton barbarity.'[8] Elgin himself told the same story to the Parliamentary Committee in London many years later:

> From the period of Stuart's visit to Athens till the time I went to Turkey, a very great destruction had taken place . . . every traveller coming added to the general deface-ment of the statuary in his reach: there are now in London pieces broken off within our day. And the Turks have been continually defacing the heads; and in some instances they have actually acknowledged to me, that they have pounded down the statues to convert them into mortar. It was upon these suggestions . . . that I proceeded to remove as much of the sculpture as I conveniently could; it was no part of my original plan to bring away anything but my models.[9]

Hunt and Elgin spoke with the fervour of a naturalist seeking to transfer a rare and endangered species of lizard to a safer habitat.

There was no opposition. If the Turkish governor had any qualms that the terms of the *firman* were being stretched, they were overcome by gifts of horses, telescopes and capes. The Acropolis was, after all, just another Turkish fort and, as long as the fortifications were not being damaged, he had no reason to complain. As for the indigenous Greeks, they were little concerned about what was going on in a Turkish military installation. As Hunt reported to Elgin in August 1801, 'there was not an individual, either among the Officers of the Porte, or the Greeks of the City, who did not seem to vie with each other in gratifying your wishes.' A plan to demolish the Caryatid porch of the Erechtheum in its entirety was, however, abandoned because no ship large enough was available to carry it away and there might, in this case, have been problems because both Turks and Greeks were attached to the marble ladies if to no other buildings on the Acropolis. Only one of the Caryatids was removed.

Over the ensuing months, the scale of operations changed completely. In addition to Lusieri with his two draughtsmen and two moulders sketching, measuring and taking impressions, a team of demolition workmen was employed to move the massive blocks of marble, wrapped in tow and sunk in beds of sawdust and shavings, down from the Acropolis and on to the port of Piraeus. It was an extremely complex and costly under-

taking, which went far beyond the ambassador's original plans. In December 1801 he was still instructing Lusieri to concentrate on architectural items, with sculpture only added as an afterthought:

> I should wish to have, of the Acropolis, examples in the actual object, of each thing, and architectural ornament – of each cornice, each frieze, each capital – of the decorated ceilings, of the fluted columns – specimens of the different architectural orders, and of the variant forms of the orders – of metopes and the like, as much as possible. Finally everything in the way of sculpture, medals, and curious marbles that can be discovered by means of assiduous and indefatigable excavation.

When Elgin came to Athens with his wife in April 1802 to see what was being done on his behalf, he was duly impressed by the quantities of dismantled marble and the moulds that had been made and he did not flinch from the greatly increased cost implications of the work. His immediate reaction, however, was to ship the sculptures off to Rome for restoration. Fortunately his secretary, William Richard Hamilton, advised against the idea, partly because of the risk that the French might seize them in Italy and partly because 'few would be found who would set a higher value on a work of Phidias or one of his Scholars, with a modern head and modern arms, than they would in their present state'.[10]

On his return to Constantinople Elgin obtained letters from the Porte confirming that all actions taken under the original *firman* had been properly authorized. He was so pleased with Hunt's work in Athens that he gave orders that further excavations should be carried out at Olympia, Mycenae and elsewhere in Greece but he did not wait for the results. In January 1803 he terminated his embassy and set off home across Europe. By great misfortune he happened to be passing through Paris just as war with France broke out once more. He was imprisoned and, despite all efforts to secure his release, he was detained for three years, returning to London in June 1806.

When news of the British operations in Athens became known, French pride was piqued by the removal of trophies that seemed to outshine the spoils of Italy so recently transferred to the Napoleonic Museum. An ambassador was sent out from Paris to Constantinople to restore good relations with the Porte and the French archaeologist Louis François Sébastien Fauvel, who had previously been collecting antiquities in Athens, reappeared to obstruct the activities of Elgin's agents. Lusieri had already arranged for the transport of the first batch of marbles from Piraeus to England in 1803. The quantities, however, were so great that it was a very slow business, particularly since he generally had to rely on British naval vessels which had other preoccupations at a time of war. Elgin's own brig, the *Mentor*, was pressed into service, but it went down in a storm off the island of Cythera with a precious cargo of marbles which were only recovered after two years of difficult salvage operations. Lusieri was left to continue his removals as long as they were permitted and to guard the cases that still remained in Athens. He had an increasingly difficult task as Elgin lay imprisoned in France and his bankers refused to advance further funds. It took considerable diplomacy and the issue of yet another *firman* before the last cases were eventually shipped back to England between 1810 and 1812. It was a triumph, as the former French ambassador to the Porte admitted with rueful grace:

171　C. R. Cockerell, *The Elgin Marbles displayed in a building in the garden of Lord Elgin's house, Park Lane*, the Earl of Elgin, Broomhall

172　Benjamin Robert Haydon, *Sculpture from the Parthenon*, the Earl of Elgin, Broomhall

throughout Greece Lord Elgin has gathered a rich harvest of precious monuments, which I had vainly desired for many years; it is hard for me to avoid a twinge of envy when I see them in his hands, but all art lovers must be pleased to know that these masterpieces have been rescued from the barbarism of the Turks and preserved by an enlightened connoisseur who will allow the public to enjoy them.[11]

On his release from France Elgin rented a large house in London on the corner of Piccadilly and Park Lane, where he erected a temporary building in the garden to display the marbles (fig. 171). The Caryatid from the Erechtheum stood in the centre of the back wall with the slabs of frieze distributed on either side and the pediment sculptures in front of them. In June 1807, when visitors were admitted, their reaction was enthusiastic, even though the layout was inevitably rather crowded and could not begin to do full justice to the frieze or the pediment figures. Flaxman, who had refused to attempt any restoration work, declared that the sculpture was superior to anything from Italy. Benjamin Robert Haydon drew the figures until he was exhausted, convinced that he had discovered the secret to immortal art (fig. 172). Fuseli, the first translator of Winckelmann into English, strode about exclaiming 'De Greeks were Godes! De Greeks were Godes!' Benjamin West (the president of the Royal Academy) and Thomas Lawrence came to sketch and were invited back by Elgin to see the marbles in the company of Sarah Siddons, in hopes of a display of attitudes similar to that which Emma Hamilton used to give in Naples. The great actress obliged with an emotional tear. A comparison with the marbles in the Townley Gallery which was opened in the British Museum the following year only emphasized the magnificence of Elgin's acquisition. Richard Payne Knight alone claimed that he was not very impressed but he, of course, was unwilling to allow these newly imported antiquities to steal the thunder of his Grand Tour pieces, illustrated in *Specimens of Antient Sculpture*, which was due to be published at that time.[12]

The result was not at all what Elgin had intended. The draughtsman employed to turn the measured drawings into prints was so addicted to drink that his utilitarian publication for the benefit of architects and craftsmen never materialized and, while the casts of the column capitals and architectural details would, doubtless, have practical uses, the sculptures, which had never been part of the original plan, attracted all the public attention. Although it was gratifying that the latter were proving to be so popular, they were quite unsuitable for Broomhall and, because of their bulk, they were very difficult to accommodate in London where the creation of a permanent structure in the garden would be expensive and would reduce the house's value. In any case, he had incurred such heavy debts in acquiring the marbles that he could not afford to retain them.

The obvious course of action was to sell the collection to the British Museum. He knew that the trustees were already interested because the principal librarian, Joseph Planta, had made an approach to his secretary, Hamilton. In advance of negotiations he prepared *A Memorandum on the Subject of the Earl of Elgin's pursuits in Greece*, based on a paper that had been drawn up in 1805 by Philip Hunt, who had supervised the exercise. This was necessary both to explain the background of the acquisition and to counter malignant rumours that Elgin had bribed the Turks with funds intended for embassy purposes. Moreover, recent visitors to Athens, while recognizing that he had rescued the sculptures from deliberate damage by the Turks, were complaining about the destruction of the Parthenon cornice, which had been demolished when the metopes were removed.[13]

In 1811 William Smith, the Member of Parliament who called to open talks on behalf of the government, suggested that the collection might be acquired on the basis of a statement of expenditure together with an allowance for interest costs.[14] This suited Elgin who explained that 'the objects were not purchased, or got for fixed prices. They were not selected by the taste of an individual; nor were they, generally speaking, the results of accidental discovery from excavation.' In this respect, they differed from collections like those of Townley or Lansdowne and were not to be valued on an individual basis. Furthermore, all privileges in Turkey had to be paid for on a scale 'proportioned to the rank of the parties, the sacrifice to be made and the eagerness shown for the acquisition'. Elgin's own estimate was £33,200. His calculations were split between the cost of the drawings and moulds and the cost of bringing back the marbles, inscriptions and some vases.

	£
Cost of the artists and moulders for three and a half years	8,400
Cost of one artist's time completing the drawings	800
Travel expenses	1,500
	10,700
Presents to the Turkish authorities and workmen's wages	15,000
Expenses of transport and other charges	2,500
Mentor and salvage costs	5,000
	33,200

On top of this, he added interest costs at 5 per cent (quite unreasonably assessed for a period of fourteen years) amounting to £23,240 and expenses in London of £6000. He therefore required compensation of at least £62,440.[15] When Spencer Perceval, the Prime Minister, responded with an offer of £30,000, if he could prove that he had spent that much, he indignantly refused. The marbles then found a new temporary home in the courtyard of Burlington House.

Elgin had been misled by the enthusiasm of artists and critics into thinking that the nation would gratefully refund the huge costs of his acquisition and would pay for his draughtsmen's expenses even though no publication had been forthcoming. He had not taken account of the fact that the government could not pay generously during a time of war, particularly when Knight, who had only recently given up his seat in the House of Commons, was spreading doubts about the value of the Marbles. Knight's carping was especially unfortunate since he carried with him all the prestige of the Dilettanti Society, the established authority in Greek matters through its continuing series of splendid publications on Athens and Ionia.

Worse was to come. Byron, who had already made mock of Elgin's 'Phidian freaks, Misshapen monuments and maim'd antiques', issued the first two cantos of *Childe Harold's Pilgrimage* in 1812. On the ruins of the Acropolis the poet declaims:

> But who, of all the plunderers of yon fane
> On high – where Pallas linger'd, loth to flee
> The latest relic of her ancient reign;
> The last, the worst, dull spoiler, who was he?
> Blush, Caledonia! such thy son could be!

. . . His mind as barren and his heart as hard,
Is he whose head conceiv'd, whose hand prepar'd,
Aught to displace Athena's poor remains . . .

Cold is the heart, fair Greece! that looks on thee,
Nor feels as lovers o'er the dust they lov'd;
Dull is the eye that will not weep to see
Thy walls defac'd, thy mouldering shrines remov'd
By British hands, which it had best behov'd
To guard those relics ne'er to be restor'd.
Curst be the hour when from their isle they rov'd,
And once again thy hapless bosom gor'd,
And snatch'd thy shrinking Gods to northern climes abhorr'd.

It was very embarrassing to be the object of so fierce an attack from a poet who had become an international celebrity.[16]

The activities of Charles Robert Cockerell, the young trainee architect, provided a modest but helpful counterbalance.[17] Cockerell, together with two German archaeologists, had discovered an important group of pediment sculptures on the island of Aegina in 1811. He transported them to Athens, where they were much admired, and then, to avoid any possible Turkish claims, he shipped them on to Zante or Zacynthus, which was under British control. Since his partners could not settle a price among themselves, it was agreed to hold an auction on the spot. In November 1812 a bid of some £6000 secured the marbles for Prince Ludwig of Bavaria against French opposition and, although a higher offer was later submitted on behalf of the British Museum, it arrived too late to be valid. The Aegina Marbles were despatched to Munich, where they were restored by Thorvaldsen. Cockerell's second discovery was in Arcadia, where he came across the ruins of another temple at Bassae. In August 1812 the frieze of battling Amazons and Lapiths and Centaurs was also shipped to Zante, where it was bought by the British government for £15,000. The prices paid for these fragments from less important temples indicated how much the value of ensembles of classical sculpture had risen in what had become an international market.

In 1815 the proposed sale of Burlington House forced Elgin to offer his collection to the Museum once more, with the added stipulation that he should receive a United Kingdom peerage – his title, being Scottish, did not carry an automatic right to a seat in the House of Lords. Although this condition was sternly rejected, a committee, comprising Lord Aberdeen, Charles Long and Knight, was appointed to review the price. Knight's suggestion of £15,000 to £20,000 was obviously out of line with prices paid for the marbles found by Cockerell, but Long was probably being realistic in his judgement that £35,000 was the highest sum that could be voted through Parliament at that time. Against this, Elgin now claimed that his costs, exclusive of interest, had risen to £46,000. After the interruption of the Waterloo campaign, he received further support from Canova. The sculptor, who was at the height of his reputation and authority, had come to Paris to negotiate the return to Italy of the collections looted by Napoleon. When he visited London in November 1815, his reaction to Elgin's marbles was ecstatic: 'Oh that I had but to begin again!' he exclaimed, 'to unlearn all that I have learned – I now at last see what ought to form the real school of sculpture.' He firmly gave his

opinion that, if the marbles from Bassae were worth £15,000, then the Elgin Marbles were worth £100,000. He also argued strongly against any restoration:

> . . . however greatly it was to be lamented, that these statues should have suffered so much from time and barbarism, yet it was undeniable, that they had never been re-touched; that they were the work of the ablest artists the world had ever seen; executed under the most enlightened patron of the arts; and at a period when genius enjoyed the most liberal encouragement, and had attained the highest degree of perfection; and that they had been found worthy of forming the decoration of the most admired edifice, ever erected in Greece . . . it would be a sacrilege in him, or any man, to presume to touch them with a chisel.

This was a radically new attitude towards restoration, delivered *ex cathedra* by the great man himself. By this stage, however, even if Elgin had wanted to proceed with repairs, the cost would have been far beyond his budget.[18]

The following year, Elgin petitioned Parliament once more and, despite some opposition on the grounds that the economic situation did not allow for such luxuries, yet another committee was appointed 'to enquire whether it be expedient that the collection should be purchased on behalf of the public, and if so, what price it may be reasonable to allow'. Elgin himself was the first witness to be heard, followed by his agent, Hamilton, and then by a series of artists and sculptors. Nollekens, who had been involved in acquiring or restoring Roman statues for many of the leading British collectors, told the committee that the marbles were 'the finest things that ever came to this country' and Flaxman, Westmacott, Chantrey, Rossi and Lawrence all gave warm support. Knight did nothing but harm to his reputation when he gave contrary evidence. While he grudgingly admitted that the frieze and metopes were in the first class of their kind, he continued to maintain that the pediment sculpture was of the age of Hadrian, on the basis of an erroneous description given by a seventeenth-century traveller, and he refused to value the collection at more than £25,000 because it was too damaged for 'furniture', by which he meant that it was unsuitable as decoration for a private house. Other connoisseurs were more generous. John Morritt, who had himself tried to buy metopes during his own visit to Athens a few years earlier, said that the marbles were the purest specimens of the best period of Greek sculpture and he was backed by two other recent travellers to Greece, John Fazakerly, who had supported an offer for the Aegina Marbles, and Lord Aberdeen, who had been a member of the previous Parliamentary committee. To his great disappointment, Benjamin Haydon, the marbles' most eloquent champion, was not called as a witness to give his expert advice as an artist.

The report of the committee's members was favourable to Elgin but, on the key point, deeply disappointing. They concluded that he had removed the Marbles with due authority and that they were 'the finest models, and the most exquisite monuments of antiquity' and were 'admirably adapted to form a school for study, to improve our natural taste for the Fine Arts, and to diffuse a more perfect knowledge of them throughout this kingdom'. When it came to price, however, they ignored both the original suggestion that he should be remunerated on the basis of his costs and the evidence of value compared with that of other collections. They coldly pointed out that in the post-war period there had been a 'depreciation of every commodity, either of necessity or fancy, which

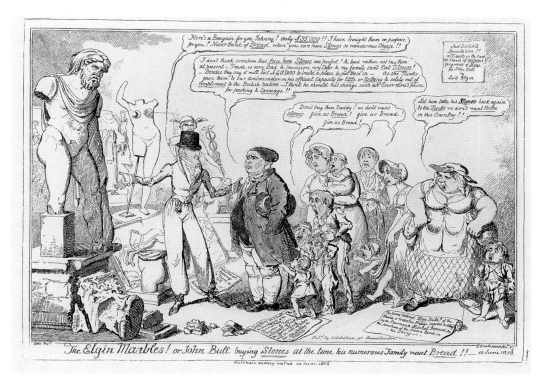

173 George Cruikshank, *The Elgin Marbles*

is brought for sale' and they therefore offered no more than £35,000, the sum suggested by a member of the previous committee. In political terms this was not unreasonable. George Cruikshank was reflecting public opinion when he issued a cartoon captioned 'The Elgin Marbles! or John Bull buying Stones at the time his numerous Family want Bread!' (fig. 173) Even the post-war restitution of imperial booty from Paris to Rome worked against Elgin, because there was no longer any incentive for Britain to acquire antiquities that could outshine Napoleon's looted treasures. He had no choice but to accept. By February 1817, the collection was installed in a temporary display space in the British Museum.

The arrival of the Elgin Marbles brought about a fundamental change in British taste. Whereas numerous writers had extolled the superiority of Greek art and dealers such as Jenkins and Gavin Hamilton had sought to charge their highest prices for polished nude figures which they claimed to be 'truly Grecian', now, for the first time, connoisseurs could assess sculpture that undoubtedly came from Greece, that had manifestly never been restored and that, from the literary evidence, came from the period, and possibly from the very hand, of Phidias. With their own eyes they could see what it was that the ancient writers had admired in the sculpture of the fifth century B.C. When they set these works, so clearly true to nature, sinews, veins and all, against the idealized beauties of Greco-Roman statuary, which had previously been revered as the summit of artistic perfection, they did not need the testimony of every leading artist and sculptor to help

them make their own judgement. The famous statues in the collections of the previous century, Townley's not excepted, were quietly demoted. The display of Elgin's Marbles did not, however, have the effect on British art that had been hoped. As a result of patriotic sentiment during the Napoleonic Wars, a decision was taken to allow British commanders to be commemorated, for the first time, in the great spaces of St Paul's Cathedral. The Committee of Taste that was established to advise on the scheme included Townley and Knight, Sir George Beaumont and Charles Long and it later took in Thomas Hope and Lord Egremont. Taste could not have been better represented. Sadly, however, no practitioner rose to the occasion. None of the sculptors who had so vigorously endorsed the acquisition of the Elgin Marbles seemed capable of bringing the grace of Phidias to their own lumpish memorials of British naval and military valour, nor can it be claimed that their successors in later years were any more inspired.[19]

In addition to the Marbles, Elgin had acquired a variety of sculptural fragments, some excellent vases, ancient jewellery excavated from tombs and a collection of coins, all of which were transferred to Broomhall. These antiquities were dispersed during the twentieth century, the jewellery to the British Museum, some of the sculpture to the Metropolitan and J. Paul Getty Museums and the vases to a variety of different collections.[20]

Elgin's last years were unhappy; his wife left him, the sum that he received for the Marbles was insufficient to clear his loans, he could never carry out the grandiose architectural schemes planned for Broomhall and he was eventually forced to live abroad in order to avoid his creditors. Disappointed, unthanked and still burdened with debt, he died in France in 1841. His name remains inseparable from the greatest treasure in the British Museum, acquired at a cost vastly greater than that borne by any other collector of antiquities. He deserves his fame. Nevertheless, if Thomas Harrison's masons had not had difficulties with the profiles of the Ionic capitals on the façade of Broomhall, the Parthenon frieze might still be crumbling on the Acropolis or, more probably, would now be displayed in Paris or Berlin.

OTHER COLLECTORS IN GREECE AND TURKEY

The unaccustomed presence of so many British warships in the eastern Mediterranean at this period impressed the Turkish authorities to such an extent that they relaxed their previous hostility to excavations. As a result, many of the travellers who were now visiting Greece and the Levant because they were excluded from Italy succeeded in returning home with some Greek trophies. Apart from Elgin, Charles Cockerell, as discussed previously, scored the most notable successes with his excavations of the friezes from Aegina and Bassae, which ended up in the museums of Munich and London. No one else achieved so much, although several tried to exploit the opportunity created by Elgin's activities in Athens. In fact, some visitors behaved so arrogantly that Lusieri was moved to complain to Elgin in 1805: '. . . they conduct themselves in such a way as to disgust everybody, and I think that those who come after will not find the same civility either here or at Argos. These gentlemen have wanted to undertake diggings without *firmans*, without asking permission of the Voivode or of the landowner, and without making any return.'[21]

One of the most energetic but tiresome of these collectors was the mineralogist, the Reverend Edward Clarke. On leaving Cambridge, he had gone to Rome with Lord Berwick in 1792. He claimed that he had prevented his companion from meddling with antiquities and that he had almost cured himself of a similar folly 'by observing the wonderful system of imposition and villany that is practised here upon poor John Bull'. In Naples, however, both Lord Berwick and he succumbed and bought vases and marbles. A few years later, after a prolonged tour of Scandinavia and Russia, he arrived in Turkey by way of the Crimea. Here he came across some members of Elgin's staff in the Troad, quarrelled with them and thereafter conceived an antipathy to Elgin himself. His visit to Athens in 1801 coincided with the removal of sculpture from the Parthenon on the ambassador's behalf, and he later gave Byron a hostile account of the works, although his indignation was probably motivated by the fact that Elgin's operations prevented him from acquiring more for his own collection. He saw nothing incongruous in both attacking Elgin's removal of marbles from the Parthenon and boasting that he himself had persuaded the military governor to let him have one of the metopes – in fact, it was only a fragment of an undistinguished funeral *stele*. His greatest success was the acquisition of the battered upper half of a female deity with a basket on her head, which had long been revered by peasants and admired by visitors at Eleusis (fig. 174).

174 Eleusis fragment, Fitzwilliam Museum

Disregarding local superstition that the fragment still exercised a potent influence on the community's crops and undeterred by the portent of an ox, which broke loose during the exercise and ran bellowing over the fields now deprived of the tutelar's protection, he employed a hundred men and fifty boys to remove the goddess. She and more than thirty other fragments acquired on his travels were presented to Cambridge University and described in a catalogue, the explanations of which are described by Michaelis as 'so thoroughly mistaken that pious regard for the honoured author bids one pass over them in silence'. Clarke was a nuisance as far as Elgin was concerned but his gift set a significant trend. He was collecting for the benefit of the University – and his own reputation – rather than for the decoration of a private house.[22]

The young Lord Aberdeen, the future Prime Minister, was another visitor at this time. He excavated a number of tombs in Athens, from which he acquired some reliefs

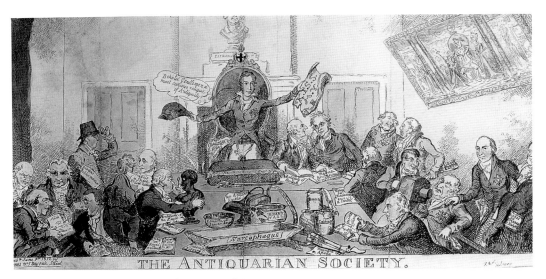

175 *Lord Aberdeen presiding at the Society of Antiquaries*, cartoon

and minor grave goods, and he chipped fragments off the main temples but all that he managed to obtain from the Parthenon was a foot from one of the metopes. He did, however, succeed where Morritt had failed and brought home the relief of a lady's toilet set from Amyclae. These acquisitions, together with an altar from Delos, a female torso from Corinth and some coins, were shipped back by way of Malta. On his death, his antiquities were presented to the British Museum. He would certainly have been more acquisitive if the efforts of his agent, Georg Gropius, had not been blocked by Lusieri in Elgin's interest and this made him complain when he 'saw devastation committed which is indeed continual', as a result of the removal of the Parthenon sculptures. His own lack of success at least spared him from Byron's venom – whereas an early draft of *Childe Harold* contained a reference to 'sullen Aberdeen' among those guilty of pilfering 'all that pilgrims love to see', he was only mentioned in a footnote as 'another noble Lord [who] has done better because he has done less'. He was elected President of the Society of Antiquaries from 1812 until 1846 (fig. 175) but attended so seldom that one of the vice presidents generally took the chair behind the Society's Cocked Hat. The Society did not enjoy a very distinguished reputation during his Presidency. James Millingen in a critical survey of the state of learning in England, published in 1831, complained:

> . . . none of our Societies can properly be called learned. They may contain a few learned and very learned men, but the far greater proportion of members are totally unacquainted with the subjects under discussion . . . With regard to the Society of Antiquaries . . . little can be said. It has slumbered for years, and nothing but the voice of a total reform can rouse it from its lethargy.

He went on to compare its transactions unfavourably with those of the other principal learned societies of Europe.[23]

Then there was Edward Dodwell, who toured Greece at this period, sketching indefatigably, accompanied some of the time by William Gell. He recorded his travels in *A Classical and Topographical Tour through Greece during the years 1801, 1805, and 1806*, which was not published until 1819. By that time, his memories had become rather muddled and he affected more hostile attitudes towards the removal of the Elgin marbles than he expressed on the spot – he acquired some minor fragments from the Parthenon himself. He put together an excellent collection of vases, bronzes, glass and terracottas, as well as Egyptian objects, all of which he meticulously catalogued, and he eventually settled in Rome with them and a strikingly attractive wife, thirty years younger than himself, whose youth and beauty were inevitably contrasted with her husband's antiquities. While he was discoursing on an Egyptian mummy, Lady Blessington observed his wife's arch smile which 'seemed to say that living beauties might be found to compete with dead ones'. His vases and some of his bronzes were sold to the royal collection in Munich.[24]

Lord Strangford, who was ambassador to the Porte between 1820 and 1825, collected antiquities, particularly in Greece and the Ionian islands, while he was based in Constantinople. He assembled a large number of marble and bronze fragments, vases and small terracottas, some of dubious authenticity – fakers were now at work in this region as they had been in Italy in the previous century. In 1844 he gave most of his collection to the little museum in Canterbury, a surprising location, probably chosen to mark the restoration of his family's Kentish links, which had been severed two hundred years earlier, while a few of his marbles, including a good archaic statue of *Apollo* and a fragmentary copy of the *Shield of Minerva* from the Parthenon, were sold to the British Museum after his death. There were no qualms about authenticity at the time because the *Kentish Gazette* records:

> The antiquarian's pleasure is often destroyed by a passing doubt, a dread lest his treasures may be spurious, and he imposed upon; but in viewing these relics of classic taste, there is no such drawback, 'they having been dug and delved up in various parts of Greece and Egypt' by the noble donor himself.[25]

Two other travellers, although not collectors, acquired important fragments. In 1811 Howe Browne, second Marquess of Sligo, chartered a boat and sailed for Greece. Byron, who was his friend, commented that he had 'a brig with 50 men who won't work, 12 guns that refuse to go off, and sails that cut every wind except a contrary one . . . He has en suite a painter, a captain, a gentleman mis-interpreter (who boxes with the painter) besides sundry English varlets.' With this team he excavated and took on board a pair of primitive columns from the Treasury of Atreus at Mycenae but, wisely mistrusting the competence of his crew, he then bribed two British sailors to desert a passing naval vessel and navigate him home – an extremely serious offence at a time of war. On his return he was tried at the Old Bailey, fined £5000 and sentenced to four months in Newgate Prison, which extinguished his interest in antiquity. The strange story has a stranger ending: Sligo's widowed mother married the trial judge. The columns that had caused all the trouble were left in the basement of Westport House, County Mayo, for almost a century until Sligo's descendant presented them to the British Museum in 1906 (fig. 176). A pair of replica columns now decorates the side of the house.[26]

The other acquirer of major fragments was Frederick North, later Earl of Guilford, who first visited Greece in 1791. He was such a hyper-Hellenophile that he was converted to the Orthodox church, although his uncle, an earlier collector of Greek vases, was an Anglican bishop, and on his deathbed he received the last rites according to the Orthodox liturgy from the chaplain of the Russian embassy in London. After a career that included a spell as Governor of Ceylon, he returned to Greece, acting from 1824 until 1827 as Chancellor of the newly founded university on Corfu, where his adoption of ancient Greek dress made him the object of some ridicule, although his ability to compose ancient and speak modern Greek was respected. He brought a few marbles back to London, including a fragment of a particularly fine Attic *stele* of the fourth century B.C., now in the Metropolitan Museum, and a Corinthian wellhead with reliefs in the archaic style, which had been illustrated by Dodwell. The latter was recently identified in use as a planter in the garden of Bretton Hall in Yorkshire where it had been placed by Thomas Beaumont, the purchaser of Guilford's London house.[27]

The account of collecting in Greece at this period must be concluded with a mention of two minor martial collectors. The first is the Byronic hero Thomas Gordon who, after service in the British and Russian armies, joined the Greeks and ended his career as a revolutionary general, ferociously whiskered and girdled with a sash full of pistols like a Corsair. He found time amid his military duties to conduct excavations at Argos from which he brought back to Scotland an excellent *stele* of a warrior, dating to the fifth century B.C., inscriptions and coins. Gordon had a nautical counterpart, Vice Admiral Thomas Spratt, who took the opportunities offered by his hydrographic surveying work with the Royal Navy in the eastern Mediterranean and in the Black Sea to gather material for books on Crete and Lycia and to collect a few marbles. Some of these he presented to the British Museum and to Cambridge University.[28] The acquisitions of Gordon and Spratt show that the classical education of British schoolboys was not always flogged into them in vain, whatever their subsequent careers.

176 One of Lord Sligo's Columns from Mycenae, British Museum

8

The Last Collections

Although the tradition of Grand Tour collecting was not extinguished by the Napoleonic Wars, there was an increasing emphasis on the acquisition of modern sculpture, as exemplified by the galleries of the Dukes of Bedford and Devonshire and Lord Egremont, all of whom preferred the contemporary, even though they bought antiquities as well. Prominent collectors of ancient marbles, such as Thomas Hope and Sir John Soane, arranged their houses like museums to show off examples of the works of ancient civilizations, but they too interspersed modern sculpture among their Roman statues and Greek vases. This change in fashion was in part due to Canova, a sculptor who, in his lifetime, enjoyed a reputation perhaps as great as that of Picasso a century later. Rich visitors to Italy were thrilled by the possibility of acquiring works by someone who was universally regarded as one of the greatest masters of all time, while those who did not have the fortune to secure something from his hand could still be satisfied with productions by one of his very competent followers who flourished in Rome. Sculptors thus began to entice travellers to buy contemporary works instead of restored marbles from rather discredited dealers.

The new strength of the British Museum deterred emulation. Not being based on a royal collection, like the galleries in other European capitals, the museum had made a slow start in collecting antique sculpture and yet, within the first quarter of the nineteenth century, by a series of great acquisitions from private sources (the collections of Townley and Knight, the Elgin Marbles and Cockerell's Bassae frieze) it had established itself in a class of its own. The sculptures from these collections were finally rehoused in Sir Robert Smirke's imposing new temple, where they were, eventually, displayed in some sort of chronological sequence rather than arranged for purely decorative effect. The museum's expanding holdings did not, however, inspire any connoisseur to form a collection like Townley's which might be added to those in Bloomsbury. With few exceptions, marbles in the nineteenth century were bought in the salerooms for house decoration. Although one or two minor collections were formed in the eastern Mediterranean and given to the national collection or to one of the university museums, all vanish under the shadow of the great archaeological ventures that transferred to the British Museum the Lycian Tombs, the remains of the Mausoleum of Halicarnassus and the marbles from Cnidos, Didyma and Ephesus, to say nothing of the spoils of Assyria. These, however, were all acquired by official expeditions, sponsored by the Museum, backed by the Foreign Office and the embassy in Constantinople and supported by the resources of the Royal Engineers and the Royal Navy, without which it would have

been impossible to transport the colossal blocks of marble. It was now a matter of pride to ensure that the British Museum maintained its pre-eminence over the national collections of France and the German states. Since the private collector was not involved in these massive operations, they fall outside the scope of this book.[1]

In 1826 the scholarly dealer James Millingen, who had been seeking subscribers for a second volume of his *Ancient Unedited Monuments* (the first volume, published in 1822, had been devoted to vases in British collections), complained that he could not find enough subscribers to justify the cost of an enlarged edition, despite the abundance of antiquities now in the country – such was the decline in interest in the subject.

> The number of Ancient works of Art of every kind which have been accumulating in England for the space of nearly two centuries, is perhaps greater than in any country of Europe, Italy excepted. It is, however, a frequent subject of complaint, especially with foreigners, that literary [sic] treasures, from which such great benefits could be derived, are so little known. Dispersed in various and different parts of the country, they can only be seen at a great expense, and access to them is often with difficulty obtained.

Significantly, he added a comment that could have been made at any time during the previous century: 'Antiquarian researches are a frequent subject of ridicule to pretended wits . . .' When, after a long delay, the Dilettanti Society issued the second volume of *Specimens of Antient Sculpture* in 1835, few recently imported works of any note were illustrated, the majority of examples being taken from collections formed in the previous century. It was significant that the cost of buying antiquities had been raised because the *ad valorem* duty on all imports had been increased from 20 to 50 and eventually to 70 per cent, ostensibly to protect British manufacturers. In response to indignant lobbyists who pointed out the absurdity of applying this measure to antiquities, the Treasury referred the matter to the Customs, whose officials blandly replied that it would be dangerous to apply differential rates of duty 'because modern wares might be entered as ancient, and the revenue defrauded'.[2]

Entrepreneurs no longer found it worth their while to undertake costly speculative excavations in the Roman Campagna, as Gavin Hamilton and Jenkins had done. There was a feeling that the best finds had all been made and that it would be impossible to obtain export licences for any important sculpture from Rome now that Carlo Fea, the Papal Antiquary, was keeping a sharp eye on licence applications. He was responsible for implementing the *Chirografo* of Pius VII intended to protect ancient monuments, to prohibit (yet again) unauthorized excavations, to check exports and to utilize the 10,000 *scudi* a year originally set aside from papal revenues for additional purchases to make good in some way the losses caused by the French expropriations. In any case, Roman sculpture was now less highly regarded than marbles from Greece, but the search for the latter was impractical during the struggle for Greek independence and was discouraged once a Bavarian monarch had been installed in Athens and nationalist sentiment started to emerge. When British visitors to Italy, such as Lord Kinnaird or the Duke of Buckingham, organized digs on their own account, their motivation was the excitement of treasure hunting rather than the expectation of making major discoveries. Lord Hertford, the model of aristocratic depravity for Lord Steyne in Thackeray's *Vanity Fair*

and Lord Monmouth in Disraeli's *Coningsby*, confessed to his agent that he had become 'marble-mad' while living in Italy in 1829. His purchases were not, however, very serious – a sarcophagus was sent home to be used as a drinking trough for his cows and a so-called *meta* or turning post from the Circus Maximus in Rome was planted among the rose bushes in the garden of his villa in Regent's Park. Lord Egremont, who had inherited a distinguished collection of antique marbles, was typical of his generation in preferring to concentrate on modern sculpture for his greatly expanded new Gallery at Petworth (see fig. 86).[3]

The decline in the quality of British collecting is exemplified by the objects acquired by John Disney, whose father had inherited some Grand Tour antiquities on the death of Thomas Brand-Hollis in 1804. Disney went out to Italy to buy marbles and bronzes in the 1820s, extracted polite comments on his purchases from friends such as Westmacott and Flaxman and the curators at the British Museum and then proceeded to quote them all in a pretentious three-volume catalogue, *Museum Disneianum*, which he published in 1846. He subsequently gave most of his collection to Cambridge University, but it was 'trash rather than treasure' according to Michaelis. Even if visitors continued, naturally enough, to buy lesser antiquities in Italy as souvenirs, for the most part their purchases were modest. On Tours that were romantically as well as classically inspired, they were more likely to have Byron in their pockets than Horace and to be thrilled by Alpine landscapes than by the ruins of the Colosseum.[4]

When an old collection was reorganized, the new layout reflected contemporary enthusiasm for the picturesque, not antiquarian correctness. In 1801 the eleventh Earl of Pembroke, great-grandson of the Stuart collector, called in James Wyatt to remodel the historic but inconvenient old house at Wilton. Wyatt, who had been active locally at Salisbury Cathedral and Fonthill Abbey, created a Gothick cloister in which the principal marbles were to be reorganized, but he was so dilatory and his work was so ill contrived that he was dismissed in 1810 and Westmacott was summoned to advise on the display (see fig. 28). By this time it was realized that many of the marbles were not antique. Joseph Farington's diary entry for 14 September 1809 records, 'The Collection of Busts & Statues were formerly much spoken of; but have been found at the present time by our best Artists to be much below their reputation. A gallery has been lately built from a design by Mr. Wyatt, it forms a quadrangle & when completed is to contain the Collection of works in marble.' Although Westmacott was to be responsible for the reorganization of the marbles in the British Museum, he, or more probably his employer, made no attempt at a display that separated the charming seventeenth-century reliefs and heads from the genuinely antique Arundel and Mazarin marbles. They were all interspersed with family busts and portraits and Scheemaker's statue of Shakespeare in an arrangement that emphasized the antiquity both of the house itself and of the dynasty that had owned it since the dissolution of the monasteries (see fig. 28).[5]

THOMAS HOPE

A few connoisseurs approached the classical past with a more serious attitude. The activities of one of the most distinguished nineteenth-century collectors of antiquities, Thomas

Hope, started in the previous century. He was a contradictory character, a foreigner, straight from the pages of a novel by Disraeli (who dedicated his *Coningsby* to Hope's son). He was born in 1769 in Amsterdam, where his family, of Scottish extraction, ran a highly profitable international bank. Wealth from this source enabled him to buy antique marbles and Greek vases on a grand scale and to give lavish patronage to contemporary painters and sculptors. As a vigorous propagandist for his very personal vision of neo-classical style, he opened his London house to the world in order to show off his avant-garde interiors and he publicized their displays in a beautifully illustrated book, which is one of the key texts for the taste of the age. And yet, he was shy, retiring and socially inept. He was the author of a best-selling novel, *Anastasius*, which Byron said made him weep for two reasons, 'the first that *he* had not written it, and secondly that Hope *had*', but in conversation he was only capable of speaking broken English. Although he never stinted on the cost of giving magnificent receptions in his glittering London house, he remained an outsider – at one of his parties, as he stood leaning forlornly against the chimney, a guest remarked to him, 'Sir, as neither of us is acquainted with any of the people here, I think we had best go home.' His unfamiliarity with the subtle snobberies of British society misled him into trying to bribe the Duke of Wellington to obtain him a peerage.[6]

As a young man he travelled widely throughout Europe and round the eastern Mediterranean, where he visited Turkey, Egypt, Syria and Greece. In January 1795 his family left Amsterdam for London to escape the French invasion which established a revolutionary republic in Holland. Later that year he and his two brothers arrived in Rome, where they began to buy antiquities, acquiring over a dozen large statues as well as several attractive smaller pieces in a short period. They were supplied by the dealers Pacetti, Pierantoni and d'Este and they also bought from Prince Sigismondo Chigi, who had been conducting excavations on his family estates. Such extensive purchases would have been extremely difficult a few years earlier but in these troubled times there were no competitors in the market. Pacetti, for instance, was prepared to halve the price of six statues that he had in stock.[7] The most notable of Hope's acquisitions, later illustrated in the Dilettanti Society's *Specimens*, were two large statues of *Minerva* (fig. 177) and *Hygeia* (Roman imperial copies of Greek originals, obtained in 1797 from Robert Fagan who had found them in his excavations at Ostia) together with fine busts of *Septimius Severus* and *Lucius Verus*. On his return Hope was painted by Sir William Beechey, wearing Turkish costume against a background of oriental minarets (fig. 178), like the hero of his novel, but he was soon off on his travels once more, revisiting Athens on his way to Egypt. It was probably on this occasion that he acquired what he thought (incorrectly) was an arm from one of the Lapith metopes of the Parthenon.

Back in London in 1800 Hope was elected to the Dilettanti Society and the following year he confirmed his interest in antiquity by negotiating the purchase of Sir William Hamilton's second vase collection for £4000 (see fig. 141). This was enough to put him in the forefront of British collectors even before his marbles – he had by then acquired his brother's purchases as well – had arrived from Rome. Later that year he was a prominent buyer of statues, cinerary urns and other pieces at the sales of Lord Bessborough and the Duke of St Albans and in 1801 he added some important pieces at Sir William Hamilton's sale. The marbles that he acquired, admittedly prior to the arrival of

177 *Minerva, Specimens of Antient Sculpture*

178 Sir William Beechey, *Thomas Hope*, National Portrait Gallery

the Parthenon frieze, were all Grand Tour pieces that originated from the dealers and restorers of Rome. Despite his advocacy of the elegance of Greek models, his personal taste in sculpture was for highly ornamented candelabra and cinerary chests in the manner of Piranesi. It is typical of Hope that he should have bought from Sir William Hamilton's sale a porphyry head of *Nero* that had been set in a showy gilt bronze bust made by Valadier.

In an article in *The Director* he dismissed both those who scoffed at the collecting of fragmentary relics of the past and those who admired such relics because they were so evidently decayed:

> There exists an idea, with some persons, that remains of antiquity are only valued, because they are old, and consequently scarce; and that therefore, the more, by being cracked or mutilated, corroded with rust, or covered with dirt, reduced to a shapeless mass, or mouldered away to an insignificant fragment, they bear the external marks of age and decay, the more they rise in the estimation of their admirers.[8]

He made sure, however, that his own marbles were all smoothly repaired because mere fragments would not have fitted in with the elegance of his decorative schemes.

All his acquisitions had to be housed. In 1799 he had bought an Adam mansion, built round a courtyard, in Duchess Street off Portland Place. This was radically refurbished to receive his collection and the remarkable neo-classical and Egyptian furniture that he designed to offset it. The Peace of Amiens in 1803 permitted a further visit to Rome in order to negotiate the release and shipment of some of the marbles for which export licences had been refused, with the result that by January 1804 the displays were sufficiently complete for him to invite sixty members of the Royal Academy to admire the redecoration of the house and his collections. Unfortunately, only a few weeks after the invitations were issued, he chose to publish a pamphlet attacking the plans for Downing College, Cambridge, by James Wyatt, a prominent member of the Academy and soon to be its President. In this pamphlet Hope had the effrontery to claim that he was uniquely qualified as a critic of architecture because of his taste and judgement, which he had 'done more to obtain than almost any other person . . . living'. As if that was not enough, he continued: 'the world has given me credit, in the mode of decorating an old house, for an elegance and unity of design, and a classic taste, which I confess to have myself in vain sought in the habitations of my neighbours'.[9] The Academicians were indignant at the presumptions of this arrogant foreigner and they felt insulted to have been invited to his house not 'to meet Company but as professional men to publish his fine place'. In the row that followed, not only was Hope excluded from the annual Academy dinner but Henry Tresham sought to lampoon him in verse:

> Lo! TOMMY HOPE, beyond conjecture,
> Sits Judge Supreme of Architecture,
> Contracts his brows, and with a *fiat*,
> Blights the fair fame of classic WYATT,
> And gravely proves himself alone is able
> To form a Palace very like – a Stable.

The mockery of this upstart, 'fam'd for fine festivals and feeding', continues for six stanzas. In the end the affair was closed with apologies to Hope but with damage to his ambitions of establishing himself as the arbiter of taste and connoisseurship in London. It did not deter Townley from paying a visit and noting the antiquities, as he recorded in his diary, 'To Hope's house with Mr. Rogers. In the Statue Gallery are 8 large statues, five fine busts along with 14 other marbles, viz candelabra, cinerary urns, small figures. These and marbles in other places amount to about 56 pieces.' Townley's friend Samuel Rogers would have been very much at home looking at Hope's collection. He was rebuilding his own house in St James's Place at precisely this time and had consulted Hope on the design of his furniture, the marble work was by Hope's favoured sculptor, Flaxman, his cabinet of antiquities was decorated with paintings by Stothard, an artist patronized by Hope, and his notable collection of Greek vases was displayed in arched mahogany recesses 'copied from Mr. Hope's design'.[10]

Hope provided an exact record of many of the rooms in his Duchess Street house in *Household Furniture and Interior Decoration*, which he published in 1807 with exquisite illustrations and a full explanatory text. The aim of this book was to provide examples of furniture and decoration in the most advanced neo-classical manner, which could both influence the taste of contemporary patrons and provide detailed examples for designers

and craftsmen to imitate. He did not confine himself to the styles of Greece and Rome but included Egyptian and Indian, or rather, Islamic rooms, the latter decorated in what he described as the 'Saracenic or Moorish' manner, like a pavilion on the Bosphorus. Of all the rooms, the top-lit Sculpture Gallery had the austerest decoration. As he explained:

> As this room is destined solely for the reception of ancient marbles, the walls are left perfectly plain, in order that the back-ground, against which are placed the statues, might offer no inferior ornaments, or breaks, capable of interfering, through their outline, with the contour of more important works of art. The ceiling admits the light through three lanterns.

The marbles were arranged in balanced pairs against the walls in a didactic display that mingled his best statues with smaller statuettes, busts, cinerary urns and candelabra (fig. 179). There were probably more than forty pieces on view when the gallery was opened to the public in 1804 and as many as sixty-three are recorded twenty years later.

Four small statues and some cinerary urns were placed in the Picture Gallery, which was an extraordinarily bold re-creation of a Greek temple supported on Doric columns, copied from those of the Propylaea on the Acropolis, and incorporating an organ, disguised as an Ionic shrine to Apollo. The Hamilton vase collection, which had more than doubled by purchases in the London salerooms, was arranged on shelves and in *columbarium* niches in three separate museum rooms (figs 180 and 181).[11] The decorative detail of these displays comprised heads of Bacchus, Bacchic panthers and the ivy wand of Bacchants, relating 'chiefly to Bacchanalian rites, which were partly connected with the representations of mystic death and regeneration'. They were introduced to reflect the orgiastic nature of many of the subjects depicted on the vases, just as Townley had introduced the symbolism of Bacchic emblems in his Dining Room in Park Street – d'Hancarville's influence lingered on long after he had left England. In the Anteroom close by, a colossal porphyry foot and some vases were displayed along with modern replicas of the *Medici Venus* and *Apollino* and an *Apollo* and a *Mercury*. The antiquity that Hope treated with special veneration was the arm that was supposed to have come from the Parthenon. This, the only unrestored fragment in his house, was placed on a velvet cushion in a glass case and paired with a stalactite from the grotto at Antiparos, both elevated like holy relics in shrines on either side of Flaxman's delicate group of *Cephalus and Aurora*.

The novelty of Hope's brilliant colour schemes, some of them derived from Turkey and the east, his exotic Egyptian and Greek furniture and the fame of his collections attracted numerous visitors. Although he urged them to imitate the interior decoration, described in *Household Furniture*, few were bold enough to copy his example – or could afford to do so. Egyptomania never caught the British imagination as it did the French after Napoleon's Egyptian campaigns. Hope was not disappointed because his principal aim was to make his visitors and readers go back to study as their patterns the originals on which his own designs were based. As he explained in a letter of 1805 to Matthew Boulton:

> . . . if there was any novelty in my house, it was only in the application of very *old* forms. That if the forms of my furniture were more agreeable than the generality of those one meets with, it was only owing to my having, not servilely imitated, but

179 The Sculpture Gallery, Duchess Street, *Household Furniture and interior Decoration*

endeavoured to make myself master of *the spirit* of the Antique. That consequently imitating me was only imitating the imitator; and that he would do better still by applying at once to the fountain-head, to those sources of beauty which lay open to everybody: I mean the most approved books on ancient Art: Sir Wm. Hamilton's Vases, Winckelmann, Piranesi, Stuart's Athens, Ionian Antiquities &c. &c.[12]

After the publication of views of the Duchess Street interiors, a volume on the collections might have been expected to follow. Outline engravings of the most notable statues and urns were indeed prepared as if for publication, but no volume was issued. Hope probably considered that the modern decoration of his house was of greater importance than its antique contents, but a more significant factor was the arrival of Lord Elgin's marbles in London. Once they had been displayed to such universal applause, Hope's own Roman pieces would have suffered by comparison.[13]

In 1807 he bought a boskily romantic estate at the Deepdene in Surrey and, over a number of years, he proceeded to rebuild the house there as the epitome of the Picturesque. By the end of 1824 a new wing, which had been extended at an angle from the main block, was ready to be furnished. Instead of making fresh acquisitions to fill the new spaces, he transferred many of the marbles from his London house to Surrey. It seems strange that, after devoting so much care to designing and publishing the displays in Duchess Street, he should have then disrupted them to adorn his country house, but his Sculpture Gallery in London must have always been rather crowded. In any case, by this time he had lost the urge to add to his antiquities. Although he bought some decorative porphyry heads when visiting Rome in 1815, when he returned there

180 Vase Gallery, Duchess Street, *Household Furniture and interior decoration*

181 Vase Gallery, Duchess Street, *Household Furniture and interior decoration*

182 (*right*) Penry
Williams, *The Sculpture
Gallery*, *the Deepdene*,
Minet Library, Lambeth

183 (*facing page*) Penry
Williams, *The Amphitheatre*,
the Deepdene, Minet
Library, Lambeth

the next year, he had been more interested in persuading Thorvaldsen to complete a
statue of *Jason*, commissioned many years previously, and in securing a *Venus* from
Canova. Specifically for the Deepdene, he seems only to have acquired a couple of
antique heads from James Millingen, who was then living in Italy.[14]

The new Sculpture Gallery in the country was a smaller version of the one in London.
It was top-lit, the walls were plain and the sculptures were set symmetrically in pairs
against the walls, statue matched with statue, bust with bust, and candelabrum with can-
delabrum. Down the centre were placed a large cinerary urn and two elaborate marble
bowls, none of which is likely to have been a genuine antiquity (fig. 182). Some family
portrait busts were mingled with the sculptures in the Gallery. The Amphitheatre, which
led out of the adjacent Conservatory, was also devoted to antiquities. Three curved tiers
of seats, facing a blank proscenium wall, were occupied by rows of busts and cinerary
chests and urns, while five larger statues filled niches above the seats. The curious struc-
ture, which can never have been very appropriate for displaying sculpture, was probably
intended at the outset for massed horticultural tableaux like the overwhelming arrange-

ments at Chelsea Flower Show today, but was then made over to marbles instead of orchids (fig. 183). Other antiquities and replicas were placed in the Hall and the Orangery.

This arrangement lasted only a few years. Hope died in 1831, to be succeeded by his son, Henry. The new owner moved the marbles from the Deepdene Sculpture Gallery back to London, probably because he thought that Duchess Street had been stripped too bare, although he left the Amphitheatre undisturbed. He then remodelled his father's country house as a grand Italian palace with a huge new Hall for the display of the replicas and the large modern statues. He went on to sell his father's Duchess Street house for redevelopment and built himself a new mansion in Piccadilly. The statues were moved back to the Deepdene once more, where they were crammed into the Hall and Orangery, along corridors and under the colonnade. On his death in 1862 the family's interest in the collection faded and eventually the Deepdene and its contents were sold by his grandson in 1917. Although most of the major statues were widely dispersed, a number of them and some of the decorative items were acquired by Lord Leverhulme and are now preserved in his gallery in Port Sunlight (see fig. 204).

SIR JOHN SOANE

Sir John Soane's collection, which remains intact in his house in Lincoln's Inn Fields, conveys something of the picturesquely crowded displays of Charles Townley's marbles (fig. 184). Fortunately, an Act of Parliament has preserved the house from changes in fashion, pedantry or taste.[15] In 1778, as a young man of twenty-five, Soane set out for Rome on a travelling scholarship from the Royal Academy, taking with him a letter of introduction from Sir William Chambers to the ageing Piranesi. He remained in Italy for two years, studying the buildings of all periods from the antique to the renaissance before returning to England in the hope of a major commission from the Bishop Earl of Bristol. Although nothing came of this project, his subsequent architectural career was highly successful and his prosperity was crowned by the inheritance that his wife received from an uncle in 1790. This enabled him to build the house in Lincoln's Inn Fields and, ten years later, to renovate Pitzhanger Manor, a country villa in Ealing just outside London. The latter acquisition gave him the impulse to start buying antiquities.

As a student he had brought home nothing but books and drawings from his Italian travels, but he had gained a taste for the paintings, drawings, majolica and, above all, the antiquities that his richer compatriots were buying on their Grand Tours. The acquisition of property that spurred him to make more serious purchases coincided with a series

184 Bust of Sir John Soane surveying his fragments and vases, Sir John Soane's Museum

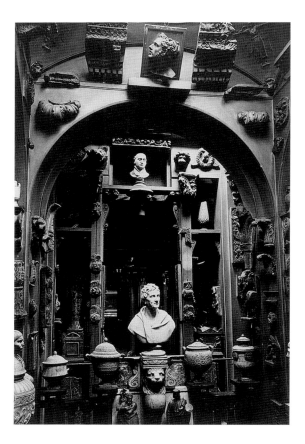

of sales in which some of the collections, put together during the previous century, were being offered at auction. The first was Lord Cawdor's sale in 1800 when Soane bought a massive Apulian vase, now in the Dining Room of the Museum but originally at Pitzhanger (fig. 185). The following year he was a bidder at the Bessborough sale that had stirred Henry Blundell to such a frenzy. Although Soane was quite unable to compete with collectors for whom money was no object, on this occasion he managed to buy a number of cinerary urns, an altar and two statuettes, an *Aesculapius* and a *Diana of the Ephesians*, for a total of £210. In 1802 he was active again, buying more urns, including one that had belonged to Piranesi, at Lord Mendip's sale and a batch of Greek vases at the sale of the dealer and *cicerone* James Clark, who had recently died in Naples. At this stage he could not afford to

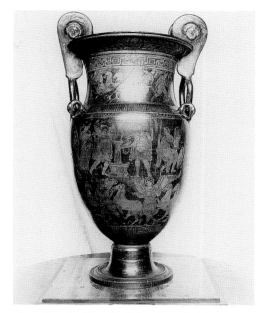

185 *Cawdor Vase*, Sir John Soane's Museum

bid for large-scale statues and later on he had no room for them. The newly acquired marbles were arranged symmetrically in niches in his house at Ealing. Soane's austere reinterpretation of classical motifs in his own architectural works contrasts surprisingly with the ornate decorative antiquities, many of them fakes, that he bought for himself. It seems that his personal taste was still pervaded by Piranesi's influence long after his return to England.

In 1810 he sold Pitzhanger and moved the antiquities to his London house, which he continued to fill with a remarkable collection of paintings, contemporary sculpture, models, gems, books, manuscripts, drawings, historical curiosities, an Egyptian sarcophagus, bought for the huge sum of £2000, and architectural fragments and casts. It is the latter that give so much atmosphere to his house today. They came from a variety of sources but principally from the collections of fellow architects, including Robert Adam and Henry Holland.

It was useful for an architect to have a stock of casts and fragments, rather as interior decorators today keep samples of wallpapers and fabrics in their showrooms. Three-dimensional examples proved the authenticity of designs taken from the antique and gave clients a better idea of decorative details than could be gained from drawings and they also provided models for the craftsmen who had to carve the pilaster capitals or model the cornices in plaster. As discussed previously, the Parthenon frieze arrived in London almost as a by-product of Thomas Harrison's request for moulds of architectural elements taken from the buildings of Athens. Half a century before, when Robert Adam was in Rome in 1755–7, he had assiduously filled a whole room in the Casa Guarnieri where he was staying with 'antique vases, antique altars and some lions' heads, capitals, pieces of friezes &ca . . . all the antique ornaments that I am to use in my architecture, of which none ever had the like'. On his return to London a selection of these was

186 Robert Adam, *Sketch of the Manner of placing the Ancient Marbles under the Room in my Area*, Sir John Soane's Museum

arranged in a building at the end of the garden of his house in Lower Grosvenor Street to inspire clients' interest (fig. 186). Robert Adam was, however, quite willing to trade in these antique fragments, while his brother James, who made his Italian Tour in 1760–63, actively bought statues and cinerary urns for resale, as well as making purchases on behalf of clients such as Lord Shelburne and the Duke of Northumberland and securing the dal Pozzo drawings of antiquities for the royal collection. In the end, the brothers were forced to sell most of their antiquities in 1773 to recoup the losses on their Adelphi project, but they retained the casts, which were eventually bought by Soane in 1818.[16]

Prior to the purchase of the Adams' stock, Soane bought the details of buildings in Rome that had been acquired by the Scottish architect James Playfair and by Willey ('Athenian') Reveley, the artist employed by Worsley on his Greek trip, and, more importantly, the collection of fragments and casts put together by Charles Heathcote Tatham for Henry Holland in 1795–6. Tatham had been sent to Rome for this purpose and, thanks to the assistance of Canova and the absence of competitive purchasers at that dangerous period, he was able to assemble some 250 items for shipment back to England. He wrote home to suggest that they would be best displayed on a large horse-shoe shaped table, covered with baize, 'One would have them all placed sideways to the light to show them off in greater relief. Indeed by candlelight you have the finest effect of objects of the kind, held by the hand of a *Sapiente*. The gesses [casts] may be placed round the walls of the room indiscriminately.' It was, he claimed, the largest collection of its kind, apart from those of Piranesi and another architect in France. He had every reason to congratulate himself because he had assembled some exceptionally attractive fragments from a variety of interesting sources, including Hadrian's Villa, the Baths of Caracalla, the Palatine, Prince Borghese's park and Piranesi's own museum. Holland arranged them in his house in Sloane Street and after his death they were bought by Soane to add to his collection.[17]

These antique fragments and casts of details of the famous buildings still standing in Rome had a great appeal for Soane, who covered the walls of his house with a dense pattern of decorative items, Gothic as well as classical. It was as if he had spread out the jumbled pieces of an enormous jigsaw puzzle which, when put together, would re-create a picture of antiquity, exactly as Piranesi had crowded the plates of his polemical works with details of buildings that combined to represent *The Magnificence of the Romans*. More casts were arranged on the walls of the drawing office to inspire his draughtsmen as they sat at work, preparing detailed plans for his architectural practice. In his own description of his house Soane explains how these fragments, both originals and copies, had a potent significance for him:

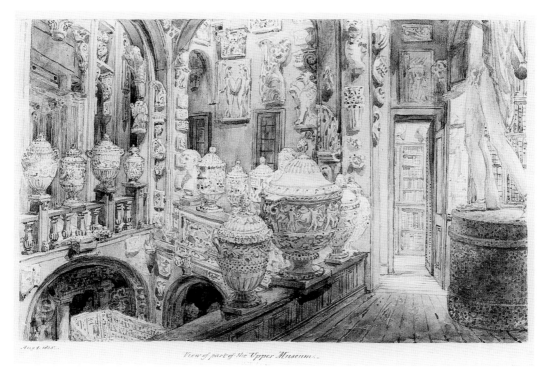

187 *Antiquities under the Dome, Sir John Soane Museum*, Sir John Soane's Museum

On every side are objects of deep interest alike to the antiquary, who loves to explore and retrace them through ages past; the student, who, in cultivating a classic taste, becomes enamoured of their forms; and the imaginative man, whose excursive fancy gives to each 'a local habitation and a name' in association with the most interesting events and the most noble personages the page of history has transmitted for our contemplation.

The capital of a pilaster from the Pantheon was typical of the stones that conveyed the authentic atmosphere of ancient Rome.[18]

The rear part of the house was almost wholly devoted to antiquities. A display of cinerary urns ('all in excellent preservation, and generally of great beauty' in Soane's own words) crowns the opening through which the Egyptian sarcophagus can be glimpsed in the basement crypt below (fig. 187). This section of the collection is watched over by a cast of the *Apollo Belvedere*, which had formerly belonged to Lord Burlington at Chiswick, and the surrounding walls are densely set with casts and architectural fragments.[19] In the crypt itself part of the space is enclosed as a *columbarium* for more cinerary urns and, near by, a cork model of an Etruscan tomb reminds the visitor of the funereal purposes for which so many of the urns and vases were originally intended. Other cork models of antique temples and also of Stonehenge indicate the popularity that these fragile tourist souvenirs used to enjoy.

These were not the only representations of antiquity that Soane collected. He had vases, both Greek originals and Wedgwood reproductions, above his bookcases, bronzes, terracottas, some busts (mostly fake) from Nollekens's collection and two glazed cases of gems bought from the Duke of Buckingham in about 1834. In addition to all this, his enormous collection of drawings included a large number of views of the principal monuments of antiquity, some of them dating back to the renaissance. Disappointed that his sons were unwilling to follow him into the architectural profession, he left his house with all its contents to the nation on condition that it was kept exactly as it was at the time of his death. The whole ensemble is thus preserved not only as a shrine to one of England's greatest architects but also as a perfect representation of antiquarian taste at the end of the age of the Grand Tour. Michaelis was disgusted: ' . . . this labyrinth stuffed full of fragments is the most tasteless arrangement that can be seen; it has the same kind of perplexing and oppressive effect on the spectator as if the whole large stock of an old-clothes-dealer had been squeezed into a doll's house.'[20] The stern professor could not understand the charm of such a display of personal taste.

LORD CARLISLE

The fifth Earl of Carlisle, son of the connoisseur who had filled Castle Howard with marbles and gems in the first half of the eighteenth century, continued to add to his father's collection throughout his life. Since, however, he rebuilt his galleries in the nineteenth century, his activities are best surveyed during this period. On his Tour as a young man in 1768, he complained that the guards at Herculaneum prevented him from buying anything from the excavators as they worked, but he acquired some minor antiquities and replicas from Jenkins in Rome and from Patch in Florence. For some years thereafter, firm trustees, an addiction to gambling and his political involvements all combined to restrict his collecting activities.

Later, however, he was a member of the triumvirate that successfully bought the great Orléans collection of paintings in 1798, the other two members being his father-in-law, Lord Gower, and the Duke of Bridgewater, and around this time he started to collect more antiquities, including some 195 Greek vases from Henry Tresham and a *Minerva*, a number of busts, urns and an altar at the Bessborough sale, as well as a relief, described by Ennio Quirino Visconti in an erudite discourse on drunkenness, and an altar from Delphi, both of which had previously belonged to Sir William Hamilton. The altar, which had been acquired by Hamilton's predecessor in Naples, was installed beneath a set of limping verses explaining how it had originally formed the base to which the Delphic Sybil's tripod had been fixed, and how Lord Nelson had brought it to England. Another Hamilton antiquity, an antique relief of *Two Fauns fighting*, was given to the earl by Charles Greville after his uncle's death.

In 1801, to house his expanding collections, Carlisle instigated changes in the west wing at Castle Howard by commissioning Charles Heathcote Tatham to decorate the rooms that Sir Thomas Robinson had altered from Vanbrugh's original design but had left unfinished. The Palladian, which had replaced the Baroque, was thus in its turn modified by the neo-classical. Tatham devised an enfilade 160 feet long, comprising two

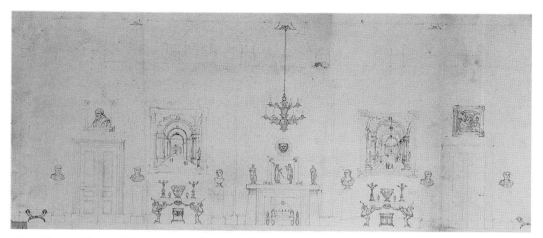

188 Charles Henry Tatham, *Design for the Gallery at Castle Howard*, Victoria and Albert Museum

sparsely decorated galleries on either side of the central octagon. This Long Gallery was approached through the Museum Room, which was intended to display busts on shelves round the walls. Below them stood tables that carried an array of urns, according to the illustration in Tatham's *The Gallery at Castle Howard*, published in 1811. In fact Carlisle's probate inventory indicates that the display was far more crowded than that shown in Tatham's plate; the tables were loaded with busts and bronzes, both ancient and modern, ten cinerary urns, seven cases of casts of the earl's gems, a Chinese manuscript roll and sundry antique fragments. The Long Gallery was hung with a series of family portraits and with the Panini ruin scenes, bought by Carlisle's father, but, although a few classical busts were mingled with works by Nollekens, surprisingly little of the sculpture collection was used to fill the newly decorated spaces in the way that was intended at the outset, as shown in Tatham's drawings (fig. 188). At the time of Carlisle's death in 1825 many of the marbles were displayed in what appears to be a temporary arrangement down the Antique Corridor, a passage leading to the Hall, where they still remain (see fig. 43). When the Museum Room was dismantled and redecorated later in the nineteenth century its contents were redistributed through the house. The major part of the vase collection was sold in 1826.[21]

THE DUKE OF BEDFORD

The collection of marbles in the Sculpture Gallery at Woburn Abbey was the most attractive of all the assemblages of antiquities put together in the nineteenth century. The Russells were a great Whig family, deeply involved in British politics, magnificently rich and splendidly housed at Woburn Abbey, their seat in Bedfordshire. During the heyday of collecting antiquities in the eighteenth century, their acquisitions were modest. After John Russell, fourth Duke of Bedford, had ordered some replicas of well known antique statues from Laurent Delvaux to decorate his London house, his son, Francis, Marquess

of Tavistock, indulged himself by acquiring a few ancient marbles and some miniature bronze copies by Zoffoli while he was in Rome in 1762.[22] Francis, the fifth duke, who succeeded his grandfather in 1771, was an unlettered and bucolic character – as a young man he was reluctant to address the House of Lords because he was unable to speak grammatical English. He went on a Tour in 1785–6 and, when he came of age, he employed Henry Holland to alter the south wing at Woburn and to add a Conservatory, as well as a Riding School and a Tennis Court. Although the Conservatory was planned as a botanical building the duke later decided that it would also be convenient to use it for keeping the marbles and replicas that had been displayed in his recently demolished London house. At this point Tatham, fresh back from buying architectural fragments for Holland in Rome, got wind of the duke's intentions and, imagining that there were plans to create a great scuplture collection, he bought a sarcophagus for 15 guineas and the very expensive *Villa Lante Vase* for 700 guineas at Lord Cawdor's sale, with a view to selling them on at a profit for the Woburn Conservatory. The *Villa Lante Vase* was similar in size to the *Warwick Vase* and, like it, was supposed to have that desirable provenance, Hadrian's Villa. When the duke jibbed at the price Tatham offered the vase to Henry Blundell, whose agent had been the underbidder at the sale. 'It has been puffed off and offered to me by several letters', Blundell wrote to Thomas Stonor, 'but there has been so much chicanery about it, that I am now quite indifferent whether I have it or not, nor would I now give as much for it by several hundreds, as I bid for it.'[23] In the end, however, Holland persuaded the duke to buy the vase and install it in the centre of the Conservatory, surrounded by some of Delvaux's replicas and a cast of the *Apollo Belvedere* that his father had brought back from Italy (fig. 189).

The duke had always been a loyal supporter of Charles James Fox, the leader of the Whig party in the House of Commons. In 1801 he commissioned a bust of his friend from Nollekens and, to house it and the portraits of other like-minded Whigs, he instructed Holland to remodel one end of the Conservatory into a Temple of Liberty. This was constructed with an internal portico, derived from the temple on the Ilissus in Stuart's *Antiquities of Athens*. He died before work was finished but his brother, John, the sixth duke, completed the temple as a shrine to his predecessor and his fellow Whig partisans. Townley, who was consulted about the form of the temple, was rewarded for his advice with a couple of antiquities (one of them a Greek relief improved by Cavaceppi). These had been bought in Rome by the duke's father some forty years earlier but had never been unpacked from their cases. At this stage, at any rate, there were no plans to form a large sculpture collection, although eight antique columns were acquired in 1802 as decoration for the Conservatory.[24]

Some years later the duke and his wife made a tour of Portugal and Italy, visiting Rome in 1815. Here they became enchanted by the delights of sculpture, even though the most famous statues had been removed by the French and were at that time decorating the Napoleonic Museum. The best statues in the papal museums had been expropriated as well as the pick of the Albani, Borghese and Braschi collections, and there were no excavations in progress to replace the losses. Although there was not much on the market, the duke did acquire seven excellent sarcophagus fragments, most of them carved with mythological scenes, from the dealer Pietro Camuccini. These came from the Villa Aldobrandini at Frascati and, in Rome's denuded state, were considered to be

189 The Sculpture gallery, Woburn Abbey, showing the *Villa Lante Vase* and the mosaic in front of it before the removal of the marbles

of such importance that an export licence was only obtained with considerable difficulty. It was an unusual purchase because bas-reliefs were generally regarded as an inferior category of antiquity, ranked well below free-standing statues or busts. The duke, however, had a strong preference for decorative sculpture that told a story. The same taste led him to buy two modern reliefs depicting Homeric scenes by Bertel Thorvaldsen, the Danish sculptor working in Rome. These represented *The Wrath of Achilles* and *The Embassy of Priam*.[25]

By far the most important purchase made in Rome was another modern work, *The Three Graces*. Canova had carved the group for the Empress Josephine but had not completed it before she died in 1814. The duke, who had seen the statue in the artist's studio, had hoped to buy it and, when it was despatched to Josephine's son, he commissioned a second version. Canova's price was 6000 *zecchini* or about £3000, three times the price paid for the most expensive antique statue at the height of the boom in the previous century. The finished work did not arrive at Woburn until 1819, which gave plenty of time for the creation of a new Temple of the Graces, designed by Jeffry Wyatt (later Sir Jeffry Wyatville) to match the Temple of Liberty at the opposite end of the Conserva-

190 A. Canova, *The Three Graces* in their original position in the Temple at Woburn Abbey

tory (fig. 190). *The Three Graces*, the embodiment of neo-classical elegance and refinement, was regarded by Canova's contemporaries as a masterpiece on a par with the greatest statues of antiquity and the arrival of the group in England was greeted with enthusiastically admiring verse. As an act of patronage it is hard to think of any more significant British commission from a major international artist between the works that Rubens and Van Dyck executed for Charles I and Picasso's *Weeping Woman*, painted for Roland Penrose. The statue is one of the very small number of sculptures that, like Rodin's *The Thinker*, is such an instantly recognizable image that it can feature in newspaper cartoons.

In addition to these marbles, the duke bought a few other pieces from James Millingen including a large vase carved with scenes of putti in Bacchic revelry which had, in fact, been skilfully concocted out of sarcophagus fragments, although a provenance from Hadrian's Villa was claimed. When the duke moved on to the French court in Naples, he was greeted warmly by Murat and his wife, Queen Caroline, on account of his friendship with Fox, a popular figure with the French because of his early support for the Revolution. He was given special permission to excavate at Pompeii where an attractive little bronze herm of a *Satyr* was tactfully hidden for him to find (fig. 191). A drawing by Sir George Hayter shows him gloating over his discovery (fig. 192). (The

Bourbons did these things less elegantly on their return to the throne – when the fourth Duke of Northumberland, a keen archaeologist, was given a permit to excavate at Pompeii and found nothing, King Ferdinand gave him only some trifles from the royal collection as a consolation prize.)

When Canova visited England in 1815, soon after the duke's return from Italy, he was entertained at Woburn. Since the acquisitions had not yet been arranged, it seems likely that the sculptor gave advice as to how they should be displayed in the Conservatory and how the large central spaces should be filled now that a decision had been taken to remove the botanical specimens. Further acquisitions were made from Roman dealers, from friends (Lord Holland provided a statue bought in Italy by his uncle, Lord Upper Ossory, some sixty years earlier), from Richard Westmacott, who sold the duke two antique busts as well as a pair of reliefs from his own hand, again illustrating stories from Greek mythology, and from Francis Chantrey, who carved an additional pair of Homeric scenes. John Flaxman was employed to execute the allegorical figures in the pediment of the Temple of Liberty.

By 1822 work on the Conservatory, now renamed the Sculpture Gallery, had been completed and the sculpture collection had been installed. The duke celebrated by distributing to his friends and to suitable institutions a lavish volume, *Outline Engravings and*

191 Bronze *Satyr* from Pompeii, the Duke of Bedford and the Trustees of the Bedford Estates, Woburn Abbey

192 George Hayter, *The Duke of Bedford with his Bronze Satyr*, the Duke of Bedford and the Trustees of the Bedford Estates, Woburn Abbey

Descriptions of the Woburn Abbey Marbles, with illustrations of the Gallery and its contents, both ancient and modern, and a descriptive text written by the Reverend Philip Hunt, who had been so active in securing the Elgin Marbles. The catalogue describes the principal objects in the collection, explaining the subjects with quotations from the classics and, in many cases, recording their provenance, but the modern works are given at least as much emphasis as the antiquities and *The Three Graces* receives far more coverage than anything else in the Gallery. Many of the antiquities are described as 'Grecian', presumably at the duke's insistence, although Hunt himself, with his first-hand experience of the Parthenon frieze, must have been well aware that this was not the case. It was probably Hunt who suggested that casts of the equestrian procession from the Parthenon should, very appropriately, be installed in the Riding School.

Although the duke had acquired sixteen large modern urns in Italy to occupy some of the floor space, the Gallery was still rather empty at this stage. *The Three Graces* were enclosed within their separate temple and the other important purchases, the bas-reliefs, were all inset along the walls. The task of filling the gaps fell to the duke's second son, Lord William Russell, during his visit to Rome in 1822–3. The duke wanted an array of smaller marbles to complete the decorative scheme, 'very good and *cheap*', as he stipulated, but he was quite vague as to the period or subject, 'any small objects of a good class and age of sculpture'. The only specific instruction that he gave was that a sarcophagus should be found to form a pair to one that he had already acquired – as usual, symmetry was all important. Lord William was initially confined to an absurdly modest overall price limit of £200, which was subsequently doubled and then raised to £500, and the total was further increased to over £800 by freight and packaging costs and customs dues. On his father's orders, he kept detailed accounts of every transaction as he bought from a variety of agents and used the distinguished young antiquarian Antonio Nibby as a consultant to check the authenticity of his purchases. Within a short period he acquired thirty-seven heads and busts, not all of them antique, six cinerary chests, a torso, seven reliefs and a candelabrum, as well as numerous terracottas, fragments and modern pieces. No sarcophagus was to be found, but the duke supplied this deficiency at a neighbour's sale in 1824. The most ambitious purchase was part of a large mosaic pavement, excavated near Porta Portuensis in Rome (see fig. 189). It was acquired jointly with Lord Kinnaird, who took the rest of it back to Scotland.[26]

Even at this late stage, the duke almost had second thoughts about the whole plan. 'I should like to have two sculpture Galleries,' he wrote to Lord William in March 1822, 'one for antiques, and one for modern Sculpture, but I must content myself with what I have got and "dream the rest".' He had probably been influenced by the new gallery for modern sculpture that Wyatville was creating for the Duke of Devonshire. The dream, however, remained unrealized because it would have been far too much trouble to divide the Gallery into two sections, rearranging all the reliefs and then commissioning enough modern sculpture to complement the antiquities.

An engraving of the Gallery made in 1827 for the new edition of *Vitruvius Britannicus* shows the layout at that time (fig. 193).[27] The ancient and modern reliefs were inset along the walls and on either side of the entrance to the internal Temple of the Graces. Busts were placed on antique brackets between the windows. Statues and busts on plinths were marshalled against the back wall and in two rows down the length of the Gallery,

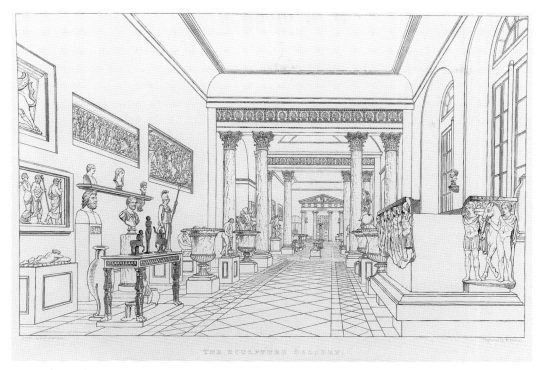

193　The Sculpture Gallery, Woburn Abbey in 1827, from *Vitruvius Britannicus, History of Woburn Abbey*

interspersed with tables on which the bronzes and decorative fragments were arranged. The sixteen large marble urns, set in pairs along the Gallery, gave a coherence to the whole display. The massive *Villa Lante Vase* kept its position in the central niche and, in front of it under the cupola, stood a tazza from the Aldobrandini collection, later to be replaced by the mosaic pavement. It was a spectacular room, saved from frigidity by the pink of the walls and the cloud effects painted on the ceiling. The richest detailing was reserved for the two temples devoted to modern sculpture: the pattern of the marble floor in the Temple of the Graces was designed to curve elegantly round the plinth on which the group was placed, the mahogany doors to the Temple of Liberty were panelled with fine bronze grilles, the ceilings within the temples were elaborately coffered and the exteriors were also decorated with reliefs by Westmacott, whose free-standing figures of *Cupid* and *Psyche* were prominently displayed in the centre of the Gallery.

　The duke spent freely to create a superb building and he was munificent in his patronage of contemporary sculptors. He was not, however, much concerned with antiquity as such. His own purchases were made as casually as those of the most headstrong young Tourist in the previous century. His instructions to Lord William show a marked lack both of interest in the objects to be acquired and of trust in his son's judgement. It is hard to escape the view that his principal concern was to create a magnificent ensemble to offset *The Three Graces*, one of the grandest trophies brought back from Italy by any Tourist. This is emphasized by the fact that the Anteroom to the Gallery was

194 (*right*) The Sculpture Gallery, view towards the Temple of the Graces, Woburn Abbey, before the removal of the marbles

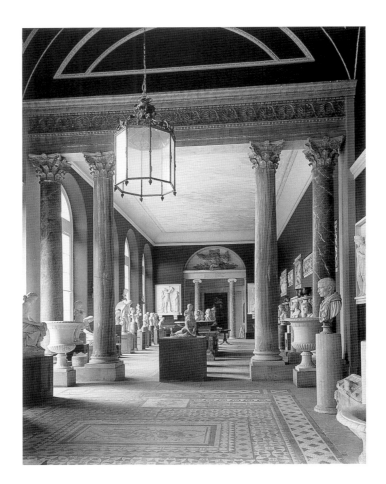

195 (*below*) The Sculpture Gallery, view towards the Temple of Liberty, Woburn Abbey, before the removal of the marbles

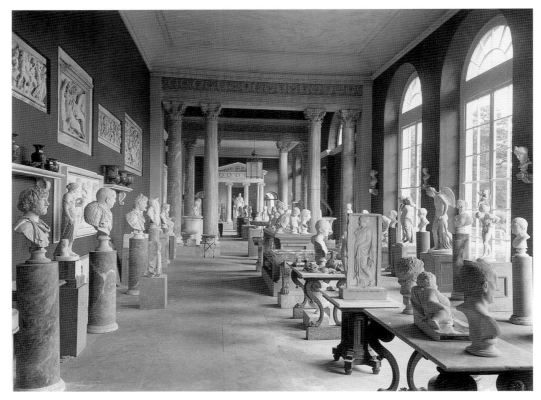

hung with prints of Canova's other important works, not of the famous antiquities of Greece and Rome. As time went by, the duke lost interest, a scheme to build an annexe to house the mosaic was shelved and when, in 1838, the year before his death, he wrote to assure his son that the Sculpture Gallery was 'not out of favour', his tone was unconvincing.

Although some changes were made to the arrangement of the sculptures from time to time, the basic disposition remained intact until the 1960s (figs 194 and 195), when most of the marbles were cleared so that the Gallery could be used for entertainment purposes. *The Three Graces* has now been acquired jointly by the Victoria and Albert Museum and the National Gallery of Scotland but the bas-reliefs have been arranged along a corridor adjacent to the Gallery and the busts and smaller statues have been distributed through the house.

BUCKINGHAM AND OTHER DUKES

Just as the Duke of Bedford was completing his Gallery at Woburn, his neighbour, the Duke of Buckingham, began to organize a new collection of antiquities at Stowe in Buckinghamshire. The house there was one of the noblest seats in England and its Elysian landscape was planted with numerous temples dedicated to classical deities. Stowe, however, boasted only a few antiquities at the start of the nineteenth century, although several replicas of classical statues stood in the grounds. The duke's father had bought some antique statuary from Gavin Hamilton, a couple of reconstructed vases and a chimneypiece from Piranesi and a gem of *Phocion* from Jenkins, costing £400, but that was all.[28]

Stowe was such a grand house and so obviously called for grand entertaining (Louis XVIII and his family were guests there during their Napoleonic exile) that it was very expensive to keep up, particularly at a time when it was becoming less easy to replenish fortunes by means of political sinecures. If economies were required, it was generally reckoned to be prudent for a nobleman to leave home and travel on the Continent where he did not need to maintain a large establishment of retainers on full board. Accordingly, in 1817, the Marquess of Buckingham (the dukedom did not come until 1822) set off for Italy and a second trip was made ten years later with an even more urgent purpose of reducing expenditure. For a duke this meant only a comparative cut in living costs, because Buckingham toured the Mediterranean in a yacht and collected both mineral specimens and antiquities as he travelled. He even conducted excavations at Roma Vecchia and Tivoli and on the the Appian Way when he was in Italy, but these were not on the scale of the operations of Hamilton and Jenkins in the previous century. In Rome he bought a collection of gems, some antique and some post-classical, from the Braschi family and in the kingdom of Naples he acquired a similar collection from Monsignor Capece Latro, the Archbishop of Tarentum. Back in England in 1829, he, like Bedford, turned his Conservatory into a Gallery for some of the statues and busts that he had acquired, while other antiquities were displayed in the North Hall and the Music Room and along corridors. Only a few years later, in about 1834, the need for retrenchment forced him to sell the gems to Sir John Soane for £1000.

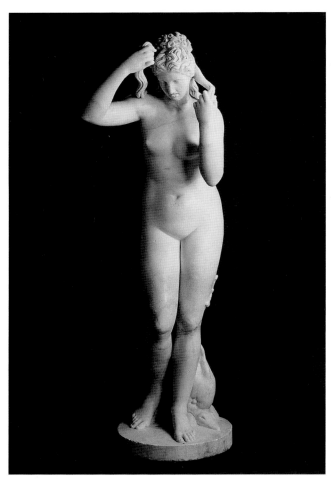

196 *Marine Venus*, Osborne House, the Royal Collection © 2002, Her Majesty Queen Elizabeth II

The duke's son, who succeeded in 1839, also toured Italy and excavated like his father. So far from trying to improve his family's finances, he entertained Queen Victoria and Prince Albert in great style at Stowe and borrowed money recklessly to increase his landed estates. In 1847, two years after the royal visit, the bailiffs took possession and the contents of Stowe were dispersed for £75,562. Although the sale of the contents of the great ducal house was a sensation, the prices paid for the antiquities showed how fashions had changed over a period of fifty years. Few of the life-size statues went for more than £50, considerably less than half the price that they would have achieved towards the end of the previous century. Queen Victoria used an agent to buy a nude *Marine Venus* at a cost of £163 16s. as a birthday present for Prince Albert, because he had admired it during their visit (fig. 196). It was the most expensive antiquity in the whole sale, apart from a *Consular Figure*, knocked down to the Duke of Hamilton for £168. One of the Piranesi vases fetched only £23 2s., perhaps a tenth of the price that the duke's grandfather had paid for it in Rome. 'Etruscan' vases, some of which had been given by Lucien Bonaparte from his excavations, fetched a few pounds each, many being bought by Purnell Purnell of Stancombe in Gloucestershire.[29]

By far the most expensive classical statue at the sale was not an antique at all but a modern bronze copy of the *Laocoön*, which went for £567, also to the Duke of Hamilton. The duke seems to have made these purchases not from any enthusiasm for antiquity but because he felt that Hamilton Palace was insufficiently palatial without a larger quota of marbles and bronzes than had been acquired by his predecessor, the eighth duke, on his Tour in the previous century. It was a short-lived display because the contents of Hamilton Palace were sold less than fifty years later in 1882. In the same spirit as Hamilton's purchases, replicas and a few genuine antiquities were acquired in about 1840 for the Duke of Sutherland's great house and garden, designed by Sir Charles Barry at Trentham in Staffordshire; they included two decorative bowls that originated from Piranesi's workshop and are now in the British Museum. The Duke of Wellington also thought that antiquities were appropriate decoration for a ducal seat – he bought some busts at the sale of Cardinal Fesch in 1816 and used them to line the Hall at Apsley House.[30]

QUEEN VICTORIA AT OSBORNE

Queen Victoria's purchase of the *Venus* from Stowe just qualifies her for inclusion as a collector. This nude, one of a series of surprisingly erotic statues and paintings that were acquired for the Queen's private apartments, was taken to Osborne House, the new royal residence in the Isle of Wight, where it was displayed in a corridor decorated with Raphael grotesques and plaster reliefs derived from the Elgin Marbles (fig. 196). It was offset by a few antiquities, a number of contemporary works and miniature bronze replicas of some famous antique statues in a didactic arrangement typical of the Prince Consort's taste. He was clearly seeking to reproduce a display similar to those that were to be seen in the princely palaces of several German states. Elsewhere at Osborne there were portraits of the royal couple, archaically sculpted in Roman garb. The collection might have been extended if Prince Albert had lived longer.[31]

THE DUKE OF DEVONSHIRE

William Cavendish, sixth Duke of Devonshire, was another ducal buyer of antiquities who collected without any serious interest in the subject, although he bought extensively on his visits to Italy and the eastern Mediterranean as well as in the London salerooms – it was just something that rich dukes did. His serious passion was for contemporary sculpture, espe-

cially the works of Canova, but he also patron-ized many of the other sculptors working in Rome at that time, including Thorvaldsen, Tadolini, Schadow, Campbell, Gibson, Gott, Trentanove and Richard Wyatt. Whereas the duke displayed the best of his modern statues at Chatsworth in a purpose built top-lit gallery, designed by Wyattville, most of his antiquities were consigned to a small room beside the Porter's Lodge in an arrangement as pic-turesquely crowded as those in the houses of Charles Townley or Sir John Soane (fig. 197). The duke explained his preferences in his *Handbook of Chatsworth and Hardwick*: 'My Gallery was intended for modern sculpture, and I have almost entirely abstained from mixing it with any fragments of antiquity: it was in vain to hope for time or opportunities of collecting really fine ancient marbles.' His collection of neo-classical sculpture was (and remains) one of the best in Europe. Since, however, the quality of the antiquities available at that time could not match that of his modern works, he decided not to try to form a major collection of antique statues.

197 The Antique Sculpture Gallery, Chatsworth

He was an erratic collector, making expensive additions to the family coin cabinet, only to dispose of them at a heavy loss some years later when he was short of ready cash. In 1819, when he was in Rome, he bought a variety of marble fragments and terracottas and two great columns of Egyptian alabaster, which cost £2000 but which he had to cede to the Vatican Museum after he had failed to obtain an export licence. Then in 1822, on the death of Canova, he added some antique herms and busts that had been part of the furnishings of the sculptor's studio out of pious reverence for the great man's memory. He could not resist picking up further antiquities on subsequent travels, the most distinguished being a beautiful bronze head of *Apollo* (now in the British Museum), acquired in Smyrna in 1839, while on a cruise. He also bought statues and busts as interior decoration for halls and corridors, considering that a house the size of Chatsworth was incomplete without an array of antique classical figures, just like those other Dukes – Bedford, Buckingham, Hamilton, Sutherland and Wellington. His purchases included three statues from the sale of the contents of Wanstead House in 1822, a male figure and a mother and daughter group from Apt in Provence, notable because illustrated by Montfaucon. Other marbles came by way of gift. Sections of a column from the temple on Cape Sunium were, for instance, sent by his half-brother, Admiral Sir Augustus Clifford, who, as the duke records in his *Handbook*, 'had not robbed the shrine, for they had already been rolled down to the sea-beach, where sand and waves would soon have concealed them'. As late as 1844 he was still buying cinerary urns and an interesting Hadrianic relief in the London salerooms. Nevertheless, the casual disposal of most of his acquisitions, tucked away beside the office of the Clerk of the Works and the Gunroom, indicates the importance that their owner attached to them.[32]

THE KINNAIRDS AT ROSSIE PRIORY

In the years following the end of the Napoleonic Wars, a number of British collectors travelled round Europe, taking advantage of the recent turmoil to acquire paintings. One such was Charles, eighth Lord Kinnaird, a Scotsman who went to live in Italy, where his son, George, was educated. Kinnaird, who was principally interested in Italian art, acquired a good collection of old masters. His son, however, enjoyed treasure hunting, as he explained:

> In my youth I was allowed, after my day's studies were over, to go with my Italian tutor in quest of relics; and in furtherance of this design I went among the peasantry and learned from them the localities where antiquities were to be found; and I often purchased for a trifle articles which had been recently dug up, besides carrying on excavations myself.

The family's activities were actually rather more sophisticated than this deprecating account would suggest. A large miscellany of articles was assembled, comprising busts (several of which were fakes and one of which had been restored by Thorvaldsen), numerous funerary urns, inscriptions, decorative fragments and vases. These were despatched to Scotland and arranged along the Gothick cloisters of Rossie Priory in Perthshire in a modest version of Lord Pembroke's display in the cloisters at Wilton. The emphasis was on decorative pieces but there were some interesting Etruscan finds, espe-

cially from the Warrior Tomb at Corneto. The most ambitious item was the mosaic pavement that was discovered in Rome in 1822 and shared with Lord William Russell. After a douceur to the Papal Antiquary an export licence was given 'on the express stipulation that it was to be shipped off direct from Civita Vecchia without anyone seeing it'. The fragments of the pavement, heavily restored and rearranged, were divided between Woburn and Rossie Priory. Most of the Kinnaird marbles were dispersed in 1948 and a few remaining pieces were transferred to the National Galleries of Scotland in 2001.[33] Although Scottish dealers in Italy shared with Jenkins a virtual monopoly of the trade in antiquities during the previous century, Kinnaird was the first Scotsman to bring a significant collection of marbles back to his native land. His predecessors had been cannier than to succumb to their fellow countrymen's wiles.

LORD LONSDALE

The aristocratic collecting habit lingered on until the middle years of the nineteenth century, the last major purchaser being the second Earl of Lonsdale. He ranked among the richest men in England with an income well in excess of £100,000 a year, largely derived from the coal mines under his estates in the north of England. As a long serving government minister and colleague of Liverpool, Wellington and Peel, he lived much of his time in London rather than at Lowther Castle, the Gothick mansion in Cumberland that had been built for his father by Robert Smirke. He loved French furniture and porcelain and the opera or, more accurately, opera singers, several of whom bore him illegitimate children. Although he may have acquired one or two items as early as 1842 at the dispersal of the Anson collection from Shugborough, he did not start to buy antiquities on a large scale until he had succeeded to the title and estates in 1844. His collection was formed out of the sales of earlier agglomerations, including those of the Duke of Buckingham in 1847, Lord Bessborough in 1850 and Lord Hertford in 1855. The dubious chariot race post from the latter was boldly re-labelled 'The Olympian Meta'. He also bought an important *stele* that Lord Guilford had brought back from Greece. Prices at the Anson sale (brought about by the parliamentary expenses, gaming debts and general extravagance of the first Earl of Lichfield) gave a foretaste of the results of the sale at Stowe, showing the reduced interest in classical marbles and the preference for modern works: most of the antique busts fetched between £5 and £6 and statues were sold for as little as £50, far less than in the previous century, whereas two works by Nollekens made £157 and £320.

Michaelis lists over a hundred statues, busts, reliefs and sarcophagi at Lowther, most of them housed in two galleries added for this purpose in 1866 (fig. 198), as well as over 120 funerary inscriptions that had belonged to Lord Bessborough. It seems, however, that Lonsdale had no serious interest in antiquity but bought on a rich man's whim because the material happened to come on the market and, in a rather out-dated fashion, he deemed it to be an appropriate addition to a grand nobleman's seat. He was not even a member of the Society of Dilettanti who, from the middle years of the century, elected connoisseurs of old master paintings instead of antiquity collectors because, in their view, the latter were an extinct species. Taste had moved on. By this time the neo-Grecian had been abandoned as a style for domestic architecture and most owners of country houses

198 The Sculpture Gallery, Lowther Castle

who had been newly building or rebuilding their seats in Gothick or Tudor styles, the most favoured architectural fashions, quite rightly felt that armour, tapestries and the heavy gilt frames of oil paintings would offset the decoration of their halls more suitably than classical marbles. On the other hand, those who opted to erect an Italian palazzo or a French château were more likely to fill their houses with modern sculpture than to buy antiquities.

The contents of Lowther Castle were dispersed in 1947 and the building itself was dismantled and left as a vast shell.[34]

VASES

Vases were to be found in British collections of antiquities before Sir William Hamilton's publications. Dr Mead and Sir Hans Sloane both owned examples and a number of Tourists made purchases, including Lords Charlemont and Bessborough, Charles Frederick, James Barry and Henry Jennings. Hamilton himself encouraged the taste by occasionally giving a vase to one of his visitors; Henrietta, wife of the second Lord Clive, received one and was probably responsible for going on to acquire a few

similar vases now at Powis Castle. The Scottish painter and dealer James Clark, who settled in Naples, specialized in this field of antiquities, offering his most decorative pieces 'as elegant Ornaments for Chimney-Pieces, or upon Tables in Drawing-Rooms', less finished examples 'as suitable decorations for Libraries, placed over the Book-Cases, or upon Brackets against the Wall', while his smallest vases were intended for 'Ladies Toilets, small Museums, &c.&c.'[35]

The fashion took hold in the early nineteenth century. When the Irish artist Adam Buck announced his intention to publish by subscription a series of plates of vases from British collections in the same format as Hamilton's publications, he proposed to draw on almost two dozen collections, including those of the Earls of Carlisle and Elgin, Lord Northwick, Sir John Soane, Sir Richard Westmacott, George Saunders (the designer of the Townley Gallery in the British Museum), William Chinnery (brother of the painter, George) and the bookseller James Edwards, who was improbably rumoured to have paid the enormous sum of £1000 for a single vase (now in the Metropolitan Museum, New York). Although nothing came of Buck's scheme, two collections were published in imitation of Hamilton's second publication, James Millingen's *Peintures antiques de Vases Grecs de la Collection de Sir J. Coghill, Bart.* in 1817 and Henry Moses's *Vases from the Collection of Sir Henry Englefield, Bart.* in 1819.[36] Copies also continued to be acceptable. In 1813 Lord Lansdowne ordered sixteen large vases from Wedgwood for the tops of his library bookcases at Bowood.

Throughout the century vases were acquired. As discussed earlier, they featured in the galleries of most of the principal collectors of antiquities, Thomas Hope, Samuel Rogers, Sir John Soane, the Dukes of Bedford and Buckingham, and Lords Carlisle and Kinnaird. Many collectors bought in the London salerooms. As Knight wrote to Lord Aberdeen in 1812, 'We collectors have been preying upon each other's spoils lately, like cray fish in a pond, which immediately begin sucking the shell of a deceased brother. Chinnery's vases went chiefly to Hope, Sir H. Englefield, Rogers & myself, and brought good prices.' He went on to explain that his own purchases were destined 'to make the tops of my cases uniform', as if he was concerned only with decorative effects.[37] Most collectors copied this fashion, elevating their vases to a height at which they were safe from the parlour maid's duster but the figure painting was invisible to all but the very keen-sighted.

James Christie, the auctioneer, who was himself a vase lover, conducted many of these sales. He had been introduced to the subject by Townley, who transmitted to him some of d'Hancarville's fanciful notions. In 1806 Christie circulated privately *A Disquisition upon Etruscan Vases displaying their Probable Connection with the Shows at Eleusis and the Chinese Feast of Lanterns*. In this rambling essay, illustrated by vases from the collections of Townley, Chinnery, Edwards, Hope and Arthur Champernowne, he sought to link the subjects painted on vases not only with the Eleusinian mysteries of death and regeneration but also with the Hindu festival of Diwali and lantern celebrations in China. When the essay was republished nineteen years later, the vases were described as Greek rather than Etruscan but the exotic theories were still maintained. He subsequently offered an equally speculative discourse on the origins of ancient sculpture as an introduction to the second volume of the Society of Dilettanti's *Specimens*. It was rejected and was published posthumously in 1833.[38]

Most vases were relatively cheap. At Christie's sales in the early nineteenth century they fetched an average of £10 to £20, although Henry Hope paid an exceptionally high price of £180 for a vase at the sale of William Chinnery in 1812 and Rogers paid £59 17s. for one lot at Coghill's sale in 1819. Townley recorded in his diary for 1 May 1800 a visit to an exhibition of vases formerly belonging to Guy Head, a British artist, who had died recently in Rome: 'He had about 30 vases of a moderate size amongst which about ten good ones worth from £15 to £30 each, and about forty small and inferior vases of little value. The whole are valued at £1000.'[39]

Not everyone relied on the salerooms. Substantial collections were still formed overseas. George Grenville, second Lord Nugent, for instance, took advantage of his position as High Commissioner for the Ionian Islands between 1832 and 1835 to outdo his elder brother, the Duke of Buckingham, in collecting vases. An interesting collection was acquired in Naples by Charles Winn of Nostell Priory in Yorkshire. His elder brother, John, had entered into negotiations with the abbé H. Campbell but had died in 1817 before the transaction was completed. Charles Winn then used the services of an English doctor, Richard Harrison, who was resident in Naples, to finalize the deal on his behalf. John Winn had not had any 'knowledge or taste for such things', as Harrison agreed; 'with him it was solely the laudable ambition of embellishing his house with objects of real value', whereas Charles did have 'a taste for antiques'. Harrison insisted that prompt action was necessary because the abbé could not be expected to hold his price at £500 when Lord Belmore, who was also interested, returned from a visit to Cairo. Winn gave his agreement and the collection of some fifty pieces, mostly Greek painted wares, was shipped to England in 1819. Harrison's correspondence indicates the extra costs that had been causing such complaints among collectors at this period: if they declared the full value of the antiquities being imported they faced import duties at the rate of 70 per cent but, if they gave a low valuation, the Customs officers were liable to check the insurance values given in the accompanying shipping documents or they might impose their own arbitrary valuations as a basis for calculating the duties.[40]

Perhaps the most important collection made at this period was that of Spencer Compton, second Marquess of Northampton, who went to Italy in 1820 with his wife for the sake of her health and stayed there for ten years. He brought back to Castle Ashby in Northamptonshire over one hundred vases, some purchased from dealers in Italy, some obtained direct from excavations and one or two acquired from Thomas Hope. He had an eye for selecting the highest quality and the most attractive examples, almost all from the fifth century B.C., and his taste was so reliable that the equally serious collector Samuel Rogers used his services to acquire good specimens for him while he was in Italy. In 1836, as a trustee of the British Museum, he urged the acquisition for the nation of vases from the French Durand collection both for reasons of scholarship and, like Hamilton before him, on commercial grounds to improve industrial design. The Northampton, Winn and Nugent collections have all been dispersed but a typical, although more modest, display of vases from the first half of the nineteenth century is still to be seen at Charlecote in Warwickshire, where George Hammond Lucy installed them above the bookcases in his new Jacobean Library (fig. 199). Some of the examples were brought back from Italy in 1842 but others had been supplied a few years earlier by Browne & Co., the decorators who also provided chimneypieces for the house. Lucy's

199 The Library, Charlecote, with a typical array of vases

Greek antiquities contrast strikingly with his other spectacular purchases of eclectic anti-
quarian furniture from William Beckford's collection.[41]

The market for vases from Italian sources was exploited by the Campanari brothers
of Toscanella, the ancient Tuscania. The eldest, Carlo, was in charge of excavations, some-
times in partnership with the state or with the Bavarian or Prussian governments,
Secondiano published papers on their finds, while Domenico, the youngest, set up in
London as a dealer in antiquities. The business was cleverly marketed. The garden of the
family's house in Toscanella was laid out as an Etruscan necropolis and when, in 1837,
they took a house in Pall Mall to stage an exhibition of antiquities in London, the rooms
were lit by torches and the walls were covered with facsimiles of tomb paintings. The
exhibition was a triumph; Sir Robert Peel came, the Duke of Wellington visited and
narrowly missed meeting Napoleon's nephew, son of Lucien Bonaparte, Prince of Canino,
Wordsworth commemorated the occasion with a gloomy sonnet and many of the
visitors, including Lord Northampton, Richard Westmacott, Samuel Rogers, Colonel
Martin Leake, Henry Hope and William Hamilton, signed a petition that the collection
should be bought for the British Museum – in vain because the trustees considered that
such vases were already well represented in the collection. As a result of the exhibition,

Mrs Hamilton Gray, an amateur enthusiast, was inspired to go to Italy herself and produce a popular guide on Etruscan sites and vase collecting. 'I write for the ignorant and pleasure-loving traveller', she explained, 'and not for the learned and antiquarian.' In addition to describing the locations of the main Etruscan tombs with maps, plans and some illustrations, she very practically listed the inns to select or avoid off the main tourist routes and the names of the most reliable Roman dealers. She recommended buying in Rome rather than Naples because the antiquaries were more honest, fewer fakes were in circulation and, most importantly, the export licensing system was more relaxed. A few years later, in 1848, George Dennis published a more scholarly work on the same topic, correcting some of Mrs Gray's errors and giving a more detailed account of the tombs. He provides an intriguing link with the age of the Grand Tour in the previous century. While visiting the tombs of Tarquinia, he met the aged antiquarian Carlo Avvolta, who could remember how James Byres and Piranesi had stayed with his father some eighty years before when Byres was working on his abortive Etruscan History.[42]

Vases continued to be popular in the second half of the century and prices remained moderate. When Samuel Rogers's outstanding collection was dispersed in 212 lots in May 1856, the average price was only £11, no more than eight pieces reached £50 and the top price of £173 for a Corinthian *hydria* was quite exceptional. The diversity of bidders recorded at this sale, private as well as trade, indicates that there were no major buyers seeking to establish a collection but numerous amateurs. This is confirmed by the catalogue of the exhibition of Greek vases and terracottas displayed in 1888 by the Burlington Fine Arts Club: exhibits were contributed from seventeen different collections, although more than half came from the cabinet of a lawyer from Constantinople, Alphonse van Branteghem, who had recently been elected a Fellow of the Society of Antiquaries.

The Connoisseur, a new magazine launched in 1901 for the collecting public, devoted little space to antiquities, because they were relatively unfashionable at that time, but it published one article on Greek vases, in which it advised its readers that there was no difficulty in acquiring run of the mill specimens to handle and study 'for a comparatively small sum', although, 'in the case of vases of . . . quality . . . the examples in the market are few, the competition is confined to a few buyers, and the prices are very long'. Such buyers included, for instance, two scholarly amateurs, both Balliol men, Lord St Audries, a government Whip, and Lord Revelstoke, who found time from the international transactions of Barings bank to form a notable collection.[43]

GEMS

Gems ceased to be valued at the high prices attained in the eighteenth century. The market never recovered from the effects of the sale of the notorious collection of Prince Stanislas Poniatowski. This collector, the nephew of Catherine the Great's favourite, the King of Poland, bought more than 2600 gems while he was living in Rome and claimed that his intaglios, depicting scenes from Greek mythology and bearing the signatures of some of the famous carvers of antiquity, were ancient masterpieces. Many of them were indeed masterpieces, but of neo-classical craftsmen such as Giovanni and Luigi Pichler.

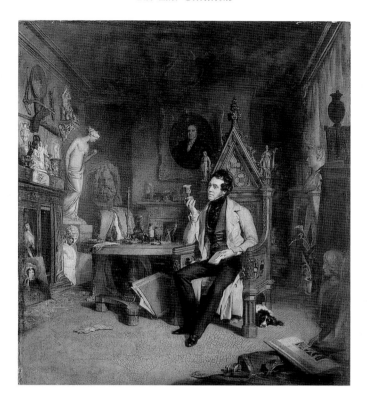

200 William Daniels, *Joseph Mayer*, Walker Art Gallery, Liverpool

When the collection was brought for sale to London in 1839, six years after the Prince's death, loud doubts were raised about its authenticity and, although some enthusiasts continued to uphold the merit of the intaglios, including John Tyrrell, who bought almost half the items on offer, the affair cast suspicion on all classical gems that had not been acquired direct from excavations.[44]

The effects were felt in 1856, at the sale of a cabinet containing over 1700 cameos and intaglios, amassed by Bram Hertz, a German collector living in London. The collection was bought for £12,000 on behalf of a syndicate led by Joseph Mayer, the Liverpool goldsmith and jeweller, who intended to present the gems to his native city, but rumour spread that the price was excessive, the syndicate fell apart and the collection had to be resold at a loss. In fact both Mayer and the British Museum bought some of the best gems at this second sale. Mayer, who liked to buy collections wholesale, swallowed with equal zeal and lack of discrimination Anglo-Saxon relics, medieval ivories, Limoges enamels, Italian majolica, oriental porcelain, Egyptian antiquities, Etruscan bronzes and Napoleonic memorabilia. Many of his trophies were given to Liverpool, where they remain, together with a charming portrait by William Daniels. In this Mayer is depicted sitting on a Gothick throne, admiring a Greek vase, in a study littered with armour, paintings and classical sculpture, like some latter day Horace Walpole (fig. 200).[45]

Gems were often regarded as little more than costume jewellery. The Duke of Devonshire had some of his ancestor's collection of important antique and renaissance gems set as a magnificent *parure* for his niece, the Countess Granville, when she accompanied her

201 The Devonshire *parure*, design by C. F. Hancock, the Duke of Devonshire and the Trustees of
the Chatsworth Settlement, Chatsworth

husband to represent Queen Victoria at the Tsar's coronation in 1856 (fig. 201). The
display of these gems was a particularly flamboyant gesture, challenging comparison with
the choicest examples in the Russian imperial collection, which had formerly belonged
to Catherine the Great. The duke would have been well aware of this, because he had
himself been Ambassador Extraordinary to St Petersburg at an earlier period.[46] Arthur
Wellesley, second Duke of Wellington, son of the Iron Duke, bought a large quantity of
intaglios, some antique but including many Poniatowski gems, all of which he had ele-
gantly mounted and strung on linked gold chains. A century later James Lees-Milne,
staying with the duke's great-nephew, recorded in his diary the pleasure of handling them:
'When held against the oil lights some of the stones were very beautiful.' The duke, who
was a classicist, acquired his gems as attractive illustrations of mythology rather than as
the antiquities which they were not.[47]

Despite the Poniatowski affair, gem collections were formed throughout the nineteenth
and early twentieth centuries by connoisseurs attracted by the fascinating glow of cor-
nelians and agates. Arthur Evans, the excavator of Knossos, could never resist the lure of
intaglios, although he had to sell most of them to finance his digs; the scholarly Scottish
general, Lord Southesk, started a collection because he wanted to compare Gnostic
and Mithraic symbols 'with those graven on the ancient memorial stones of Pictland';

Alexander Ionides, a Greek collector who enriched the Victoria and Albert Museum with his donations, bought some fine gems at the dispersal of the Marlborough cabinet in 1899 and went on to form a distinguished collection from other sources; and Ralph Harari, an Egyptian administrator and later a London merchant banker, included almost a hundred antique specimens in his collection of finger rings. One of the last notable collectors was Captain George Spencer Churchill of Northwick Park, Gloucestershire, a descendant of two great gem connoisseurs, the Duke of Marlborough and Lord Northwick; he owned the exquisite *The Theft of the Palladium*, once in Lord Arundel's collection and now in the Ashmolean (see fig. 11). All of these cabinets have been dispersed.[48]

THE LAST COLLECTORS

In Peacock's novel *Crotchet Castle*, published in 1831, the vulgar City profiteer Mr Crotchet orders casts of a large number of different Venuses to decorate his villa on the Thames, in rather the same way that Joseph Neeld, the heir to a rich goldsmith, filled his new house at Grittleton in Wiltshire with nude marble ladies by modern sculptors. Crotchet's taste shocks the local parson who, although 'disposed . . . to hold that whatever had been in Greece was right . . . was more than doubtful of the propriety of throwing open the classical *adytum* to the illiterate profane'. Pointing to one of the statues, he asks Mr Crotchet whether 'as a grave *paterfamilias*, with a fair nubile daughter,' he would consider one of the Venuses 'to be altogether delicate' and falls off his chair in horror when his host replies that he would be happy for the girl to pose unclothed for Canova. Throughout the century, *nouveau riche* patrons bought modern paintings and statues of female nudes and frequently gave them to the provincial galleries that they fostered. Such works were, however, much less likely to be added to the collections of old families who had been the chief enthusiasts for ancient marbles. It seems as if, from the middle of the century onwards, aristocratic country house chatelaines no longer tolerated displays of nudity, ancient or modern, while new lords of the manor, such as Neeld, preferred to buy contemporary representations of the naked figure rather than antiquities.[49]

A foreign visitor records the attitude towards ancient marbles in the 1880s:

> Anyone who observes the collections at country houses with unprejudiced eyes, cannot fail to notice on how few of them the glance of the present possessor rests with real affection, and how different are his feelings to those of the amateurs who collected them. In one house the marbles stand in dark rooms like warehouses; in another they are perishing in a damp summer-house; in a third they lie about disorderly in the corners; many collections cannot be found at all.

This neglect was part of a generally philistine attitude affected by most upper-class owners towards their collections at this period. While some interest was shown in the relics of Olde England, no attention was paid to classical mansions, their contents or their surroundings, apart from the conservatory, the billiard room, the gunroom and the stables.[50]

In 1882 Adolf Michaelis, the Professor of Classical Archaeology in the University of Strasbourg, published his great work *Ancient Marbles*, which has been quoted so often in these pages. If the proprietors of Wilton or Ince Blundell or Newby even noticed the

learned professor, shuffling round their houses with his notebook, they would have been amazed that he thought it worthwhile to scrutinize their dull old marbles with such attention. Basing his itineraries on the list of collections given by Dallaway in his *Anecdotes of the Arts in England*, he visited almost every major cabinet in the United Kingdom and catalogued the contents with impressive thoroughness and accuracy. The book was written by a scholar for other scholars, but it contained a polemical message. Like Winckelmann, Michaelis felt that most British collections were wasted on their current owners, who would only be making a small sacrifice if they were to 'forego in favour of the community their private rights in possessions which they regard, like other antiquated house-furniture, rather as cumbersome heirlooms and survivals of an obsolete fashion than as a source of real artistic pleasure'. He made an eloquent plea that they should somehow be absorbed into the national collection – a proposal that was totally ignored.[51] Nevertheless, the publication of his work stirred some scholarly interest in British holdings of classical marbles. The British Museum's Keeper of Greek and Roman Antiquities, Arthur Smith, published catalogues of the collections at Lansdowne House in 1889, at Brocklesby in 1897 and at Woburn in 1900. Belatedly, in 1903, the Burlington Fine Arts Club devoted its annual exhibition for the first and only time to antiquities (apart from the display of vases in 1888) and published a fully illustrated catalogue to accompany the show. On this occasion, the difficulty of moving large marbles restricted the exhibits to heads and statuettes and excluded full-size statues. Lansdowne House, Castle Howard, Petworth and Broadlands were the principal eighteenth-century collections represented and the Duke of Devonshire and Lord Northampton were among the lenders, but many new collectors of vases, statuettes, bronzes, terracottas and gems lent to the exhibition, including Sir Francis Cook, Ludwig Mond, Sir Charles Robinson and Henry Oppenheimer. The extended list of lenders of such things bears out another foreigner's comment, quoted by Michaelis: 'The numerous travellers in Italy, Greece, and Asia Minor constantly bring home such objects [minor antiquities] as mementos, but they do not form large collections, and the next generation sells them to art-dealers and jewellers.' Although the exhibition was supposedly devoted to Greek art, the organizers breezily allowed Roman works to intrude on the grounds that it was very difficult to differentiate between Greek and Roman artefacts in late antiquity. Sir Charles Robinson, the connoisseur responsible for some of the most important acquisitions made by the Victoria and Albert Museum, shamelessly exhibited as Greek a marble urn, then in his and now in the author's collection, although it is clearly an eighteenth-century fake by Piranesi.[52]

The last significant load of antiquities to be imported into England was, in fact, assembled by an American citizen, William Waldorf Astor. After serving as United States ambassador to Italy from 1882 to 1885, he stayed on in Europe and acquired a large quantity of statues, busts, sarcophagi, vases and fragments both from dealers and from various princely gardens in Italy, most notably from those of the Borghese. Life abroad persuaded him that his native country was not a fit place for a gentleman. He therefore decided to settle in England and shipped his statuary over to Hever Castle as ornaments for the extravagantly large Italian garden that he laid out adjacent to his medieval castle in the heart of the Kentish countryside (fig. 202). He also installed a group of fine Roman sarcophagi in the garden of one of his other properties, Cliveden, in Buckinghamshire.

202 Antiquities displayed in the garden, Hever Castle

His marbles, which included many renaissance shields and wellheads, were intended as evocations of Italy rather than as examples of antique sculpture and there was no attempt at an archaeological display. The columns, busts and cinerary urns were arranged down the herbaceous borders like so many rose bushes or clumps of dahlias.[53] Astor was not, in fact, the only ambassador to Italy who collected while he was *en poste* at this period. Lord Savile, the British representative in Rome from 1883 to 1887, conducted excavations at Lanuvium, but, instead of retaining the fragments that he found, he distributed them between the British Museum and the museum in his local city of Leeds, while his successor, Lord Dufferin, who occupied the British embassy between 1888 and 1891, kept the terracotta busts and statuettes that he obtained while in Italy and despatched them to Clandeboye in Northern Ireland to add to the other trophies of his proconsular service.[54]

Long after the Grand Tour had come to an end, a few *nouveaux riches* acquired antiquities for their houses in imitation of the aristocratic connoisseurs of an earlier age. Sir Francis Cook, for instance, a wholesale merchant of Manchester cottons who formed a wonderful collection of old master paintings between 1860 and 1890, bought ancient marbles as an appropriate accompaniment for them in his Gallery (fig. 203) and Dining Room at Doughty House, Richmond, and further antiquities were displayed in the basement and in a Museum Room in the garden. Cook bought from a wide variety of sources, including the London salerooms, dealers in Paris, Rome and Naples and excavations in Greece

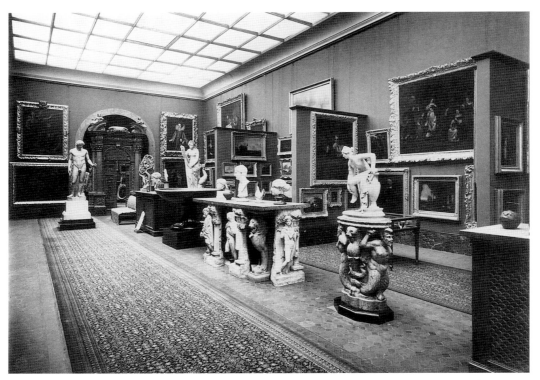

203 The Gallery at Doughty House, Richmond, showing part of the Cook collection of paintings and antique and renaissance sculpture

– he acquired all the silver and bronze articles from a grave in Thrace opened in 1879. The quality of the marbles, bronzes, gems, vases and terracottas was as high as that of his paintings. He owned some Greek *stelae* formerly in a Venetian collection, a few Grand Tour statues (a *Venus* that had belonged to Cardinal Mazarin and two marbles from the Anson collection at Shugborough), a number of attractive Hellenistic statuettes and some grand sarcophagi. Perhaps his most spectacular acquisition was an agate vase, dating to the late fourth century A.D., now in Baltimore; it is carved with a pattern of vine leaves and goats' heads and had formerly been in the collections of Rubens and of Beckford. It was a particularly appropriate trophy because Beckford's romantic castle of Monserrat was the Cooks' Portuguese seat. On the death of Sir Francis in 1901 his property was divided between his two sons. Some of his marbles subsequently passed to the British Museum and the Ashmolean, while his bronzes and gems were sold by Christie's in 1925.[55]

The sale of the Hope collection from the Deepdene in July 1917 gave an unexpected stimulus to other new collectors. It may have seemed an unpropitious time for such an event when British forces on the Western Front were fiercely engaged in the build-up to the Battle of Ypres, but the auction was well promoted and attracted unprecedented interest. *The Times* commented that no such sale had been held in England for several generations and falsely prophesied that it was not likely that another collection of equal

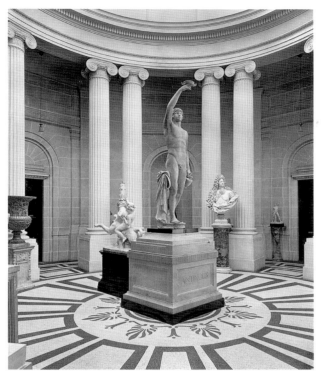

204 The Rotunda, Lady Lever Gallery, Port Sunlight, with the Hope *Antinous*

importance would be offered to the public in the time of anyone living. Crowds spilled onto the pavement as the auctioneer conducted the bidding from the gallery above Christie's King Street entrance where the large statues were placed. Lord Leverhulme, the soap magnate, Lord Cowdray, the contractor, and Lord Melchett, one of the founders of I.C.I., competed with Sir Henry Wellcome, the chemist, Gordon Selfridge, the American department store owner, and Michael Embiricos, the Greek shipbroker. In aggressive bidding a few statues reached prices never previously attained for individual classical sculptures in England. Hope's *Minerva* (see fig. 177), bought by Lord Cowdray for £7140, was the most expensive lot, followed by the *Antinous*, which Lord Leverhulme secured for £5850 (fig. 204), and the *Hygeia*, which was knocked down to Lord Melchett for £4200. Wellcome was outbid by Selfridge for the *Aesculapius* because he had not given his agent any discretion to exceed his bidding limit.[56]

The objectives of these bidders varied. Leverhulme, who had projected the creation of a public gallery at Port Sunlight in 1913, was taking the first available opportunity to fill a gap in the wide-ranging didactic collection that he intended to give to his new model town in memory of his wife. He was, in fact, the largest buyer at the sale, acquiring not only the *Antinous* (fig. 204) but four other antique statues (a *Seated Silenus*, an archaizing Greek female, called *Isis* by Hope, a *Venus* that Hope had bought from the Duke of St Albans and a *Hermaphrodite* originally acquired in Rome) as well as a can-

delabrum, a tripod, some cinerary urns and terracottas, more than sixty of Hope's vases (see fig. 141) and a few Egyptian antiquities. He also bought Flaxman's exquisite *Cephalus and Aurora*. He had good reason to be pleased with his purchases because, even if they were not Greek originals as the catalogue improperly suggested, they were an attractive selection of decorative pieces, well suited to the classical rotonda that was to be built for his new museum. No antiquities were retained for his own home. In the same way, Sir Henry Wellcome also had a didactic purpose (in his case, to illustrate the history of medicine) when he was making the collection of marbles that he later presented, together with a number of Greek vases, to his Charitable Foundation.[57]

Lord Melchett, the politician and industrialist, was rather a different type of collector, in the studious German mould. His father, Dr Ludwig Mond, had come to England from Cassel in 1862 and, having made a fortune in chemicals, had assembled an important collection of old masters under the guidance of the art historian Jean-Paul Richter, who was given instructions that 'the pictures bought for him should be of a quality entitling them to hang with honour in any public gallery', as many of them now do. Like Cook, Mond had bought a few marbles to decorate his own gallery in appropriate continental style. His son, the first Lord Melchett, followed his father's example in employing experts to buy for him. Henriette Hertz, the founder of the Biblioteca Hertziana in Rome, who had enlarged his father's collection of antiquities, contributed many pieces, while Sir Charles Robinson sold him a number of busts and statuettes from his own collection. The marbles were arranged in Melchett's country house, Melchet Court in Hampshire, while his bronzes and vases were kept in his London house. Many of the marbles were unrestored museum pieces rather than picturesque Grand Tour statues and the scholarly collection lacked any ostentatious trophy until the Hope *Hygeia* was purchased at the Deepdene sale, together with a small torso and statuettes of *Pan* and *Bacchus*. The freakish nature of the Hope sale was all too clearly shown when Melchett's collection was sold in 1936: the *Hygeia*, which had been bought for £4200, only made £598 10s., a seventh of its cost.[58]

Lord Cowdray was a formidable entrepreneur who made his fortune from contracting and from his Mexican oil interests. He apparently acquired his expensive marbles only because he felt that the owner of a large country house was expected to have some Grand Tour souvenirs to decorate his rooms. He bought Hope's towering statue of *Minerva*, excavated by Fagan in 1797 (see fig. 177), and some busts. His purchases, like those of Melchett, were not a good investment. The great statue, for which he had paid £7140, failed to find a buyer at £200 in 1936 and was eventually sold to the American tycoon William Randolph Hearst, and four imperial busts, which had cost £1212, fetched just £260.[59]

THE END OF THE AFFAIR

This handful of *nouveau riche* collections revived no fashion. None of them was retained by the original collector's heirs, apart from the Astors' garden displays. The dealers, Spinks, had difficulty in disposing of all the lots that they had bought at the Deepdene sale and another dealer, Crowther of Syon Lodge, Isleworth, sold off antiquities as garden orna-

ments. The attitude towards such marbles, deplored by Michaelis in the nineteenth century, had not changed in the twentieth. The sale of the Lansdowne House collection in 1930 and the first of the Marbury Hall sales in 1933 showed that, contrary to the expectations of *The Times*, the Deepdene sale was not to be an unrepeated phenomenon.[60] No effort was made to retain these ensembles, although museums in Europe and the United States and American collectors like Hearst were delighted to have an opportunity of acquiring statues that had been the envy of connoisseurs in the eighteenth century. The British Museum considered that Grand Tour collecting was adequately represented by the Townley Marbles.

205 Lord Pembroke at the sculpture sale, Wilton

During and after the Second World War, one collection disappeared after another. In 1952, after the publication of the Waverley Committee's report on the protection of works of art in Britain, the American scholar Cornelius Vermeule wrote a letter to *Country Life*, making a special plea for the safeguarding of antiquities: 'The story of the dissolution of British classical collections in the past two generations is particularly tragic in view of their once outstanding merit and the influence which they exerted on the tastes of the past two centuries.'[61] No one paid any notice. The Talbot statues and decorative pieces at Margam Abbey had already gone; the rest of the Barry marbles at Marbury, a large proportion of Lord Pembroke's busts (fig. 205) and reliefs (seventeenth-century fakes along with a number of Cardinal Mazarin's purchases – some of which were sold as little more than garden gnomes), the Badminton sarcophagus, the Rossie Priory antiquities, the contents of Lowther Castle and Cobham Hall and the Greek antiquities from Broomhall, all these and many other important collections melted away in the succeeding years, while the Blundell and Bedford marbles were removed from the noble buildings designed for their display. In 2002 the famous *Venus* was sold from the hitherto untouched Sculpture Gallery at Newby. Nor were smaller antiquities retained. The Northampton and Winn vases, the Wellington, Southesk, Ionides and Harari gems and many other less important collections were similarly dispersed.

There was no public demand to preserve even the most important of Grand Tour ensembles. After all, these collections were almost wholly devoted to Roman statuary and Roman copies of Greek originals, a type of art that the British Museum had been demoting for over a century. They were regarded as examples of the misguided taste that had prevailed before the pure light of the Elgin Marbles had revealed the truth about antique sculpture. In the post-war period most of the Townley collection, which, on its acquisition, had been considered to be the most important group of marbles in England, was consigned to basement storerooms and was not displayed again as a unity until 1984. British scholars were interested in other aspects of the classical past such as the Minoan civilization and the decipherment of Linear B, while studies of taste and the history

of collecting were not yet fashionable. It is typical of the British that, after almost three centuries of importing marbles, scholarly research into the subject should have barely extended beyond the British Museum's own holdings. The reasons are not hard to discern: the great publications of the Dilettanti Society had been intended as architectural and topographical studies rather than aesthetic critiques and there was no tradition of scholarship in antiquities in the United Kingdom comparable with that in Germany, where learned professors maintained an almost apostolic succession back to Winckelmann. Just as it was a German, Michaelis, who produced the first serious catalogue of antiquities in British collections, so it was an American, Vermeule, who updated Michaelis's original lists in the 1950s and recorded the sad process of the dispersals.[62] Even today, it is the University of Cologne that is responsible for photographing and publishing the classical marbles in British collections.

The contents of Sir John Soane's house and the marbles at Farnborough and Petworth, owned by the National Trust, are the only collections in their original settings to have passed into public ownership, although most of the antiquities acquired by Lord Carlisle, Lord Leicester, William Weddell, Lord Palmerston, Sir Richard Worsley and the Duke of Devonshire still belong to their heirs and are to be seen at Castle Howard, Holkham, Newby, Broadlands, Brocklesby and Chatsworth. The Devonshire, Northumberland and Worsley gem cabinets survive and large parts of the Pembroke and Bedford collections remain at Wilton and Woburn. Other National Trust properties, Knole, Powis Castle and Charlecote, display marbles bought by the Duke of Dorset and Lord Clive and the Clive and Lucy vases. Of more recent collections, the only survivors are a few of Astor's garden antiquities and the purchases made at the Hope sale by Lord Leverhulme for his museum at Port Sunlight. Inevitably, many of the great collections have migrated to museums over the centuries. The British Museum holds the collections of Townley and Knight, many of Sir William Hamilton's vases and lesser antiquities, innumerable pieces from other cabinets and, above all, the Elgin Marbles, while most of the relics of the Arundel Marbles are to be seen in the Ashmolean and Blundell's collection is held by the National Museums and Galleries on Merseyside. Much has been lost, including many fakes and botched pieces, but a great number of Grand Tour antiquities still belong to British public institutions.

Private collections, comparable with those made in the heyday of the Grand Tour, will never be replicated, at any rate in the United Kingdom. Nowadays, antiquity is regarded as public property and it is generally considered that ancient artefacts, discovered in recent excavations, are most appropriately housed in public museums where they can be studied as part of a nation's history or as part of the culture of mankind. The opprobrium attached to illegal digs and clandestine exports is sufficient to deter most potential buyers in the United Kingdom, even if the activities of *tombaroli* are fostered by some collectors, who purchase illicitly extracted goods, and by sections of the art trade, which continue to provide a market for unprovenanced items. Ironically, the contents of historic collections have now become more valuable because they have a known provenance and were exported with a licence from the Papal Antiquary or at a period when licences were not required. They are, therefore, more freely tradeable and have a higher value.

There is, of course, the question of restitution. Should some of the antiquities collected in previous centuries be returned to the countries in which they were found? The

debate centres on the Elgin Marbles from the Parthenon, although it could with equal justice be extended, for instance, to the friezes from Aegina and Bassae, to the great Altar of Pergamum or to some of the finds made at Hadrian's Villa at Tivoli – to say nothing of Egyptian, Middle Eastern, Asiatic or Central American antiquities, of Benin bronzes and Papuan masks. The basic facts of the Elgin debate are clear: the ambassador's officers removed the marbles with valid consent from the proper authorities and, if they had not done so, the steady destruction caused by the Turkish garrison and by casual tourists would have substantially reduced the surviving relics that we see today – unless, that is, the French or Germans had gained permission to carry out an exercise similar to Lord Elgin's, in which case the debate would now involve Paris or Munich or Berlin rather than London. Furthermore, Elgin's removals took place over several years with minimal complaints from the natives of Greece, a country that, at that date, had no separate existence. His actions were chiefly regretted by Lord Byron and other romantic British visitors, who were concerned for the appearance of the Parthenon as a picturesque ruin rather than the preservation of its sculptures as works of art.

Since the founding of an independent Greek state in 1833, requests that the frieze and pediment statues should be sent back to Athens have been consistently rejected, except at times when politicians have thought that it might be diplomatically convenient to offer inducements to the Greek government. Otherwise, the British authorities have maintained that the marbles were legally acquired and, as part of the common cultural heritage of the Western world, are best studied in the context of the other great civilisations that are uniquely well represented and visited in the British Museum. This point can be argued even more robustly now that levels of atmospheric pollution in Athens are so high that the marbles could not be replaced on the Parthenon itself but would have to be exhibited in a separate museum off the Acropolis. Claims for restitution rely, therefore, on the importance of the marbles to national sentiment. And yet the processional figures have no religious significance. It is not as if they were part of a temple that was still in active use and sacrifices were daily performed in honour of Pallas Athene. The sculptures are not the national symbol but rather the Acropolis itself – even if native Greeks are as rare as Athena's owl among the crowds that visit the site. The British Museum, which has displayed the marbles for nearly two hundred years, has itself strong claims, based not only on legal ownership but also on its unrivalled ability to exhibit the sculptures alongside other examples of the greatest cultural achievements of mankind. The British Museum and its collections are themselves now a part of Western culture and knowledge. Any form of sharing seems impractical because the individual blocks are too large to be regularly shuttled round and exposed to the dangers of frequent travel.

In the twenty-first century private galleries of antiquities have a different value from that which they had in the past. As visitors hasten through them, no one seeks to appreciate the ideal perfection of a *Venus* or an *Apollo* in the way that they did 250 years ago. It is quite enough to have identified the deities by their attributes, which was, after all, as far as most Grand Tourists went, and, perhaps, to note the date on the label. Even the more studious visitor tends to be influenced by the modern concern for originality, with the result that copies, even good antique copies, of lost originals are generally ignored. The Elgin Marbles are reverently – and justly – admired but this is to the exclusion of almost all antiquities of a later period. The significance of collections at houses such

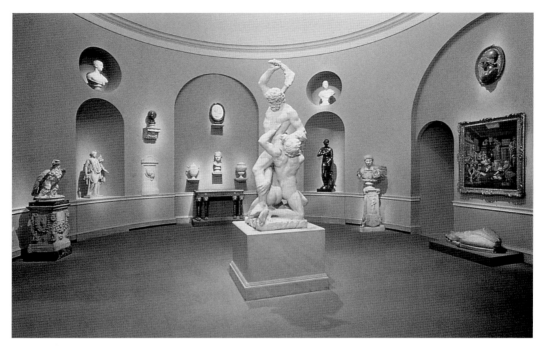

206 The Sculpture Rotunda, *The Treasure Houses of Britain* exhibition, National Gallery, Washington

as Castle Howard, Holkham and Newby has, therefore, altered. Today these ensembles are not important because they contain masterpieces of antique sculpture, even though some statues are indeed of great beauty, but because the galleries so perfectly represent the spirit of an age. In the famous exhibition *The Treasure Houses of Britain*, held in Washington in 1985, the Sculpture Rotunda, which recreated a typical Grand Tour arrangement, was quite rightly one of the most important rooms in the display, because it brought together so many of the key influences on the taste of the leading patrons, artists and architects throughout the eighteenth and early nineteenth centuries (fig. 206). An ephemeral exhibition gives only a temporary snapshot. It is essential that the few remaining antique sculpture galleries should be preserved with their contents intact so that we may continue to appreciate the force that moulded our cultural life for so many generations.

Notes

Certain works that appear frequently in the notes are abbreviated as follows:

Michaelis	A. Michaelis, *Ancient Marbles*, 1882
Vermeule 1955	C. C. Vermeule, 'Notes on a New Edition of Michaelis', *American Journal of Archaeology*, lix, 1955
Vermeule 1956 and Vermeule 1959	C. C. Vermeule and D. von Bothmer, 'Notes on a New Edition of Michaelis', *American Journal of Archaeology*, lx, 1956 and lxiii, 1959
Ingamells	J. Ingamells, *A Dictionary of British Travellers in Italy 1701–1800*, 1997
BM, TY	British Museum, Townley Archive

CHAPTER I

1 For the foundation of the Vatican collections and, indeed, for the whole background to the history of collecting antiquities, see F. Haskell and N. Penny, *Taste and the Antique*, 1981, pp. 7–15 and *passim*, and for the origins of other Roman collections, pp. 23–8, and P. P. Bober and R. O. Rubinstein, *Renaissance Artists and Antique Sculpture*, 1986, pp. 471–80. See also M. Winner et al., *Il Cortile delle Statue*, 1992.

2 W. Cavendish (attr.), *Horae Subsecivae*, 1620, pp. 348–9.

3 For Venetian collections, see K. Pomian, *Collectioneurs, amateurs et curieux, Paris, Venise: XVIe–XVIIIe siècle*, 1987.

For the gallery in Turin, which was destroyed half a century later, see G. Claretta, *Il pittore Federigo Zuccaro*, 1895, p. 53.

4 For the Fontainebleau casts and the later acquisitions in France and Spain, see Haskell and Penny, *op. cit.* (n. 1.1), pp. 1–6, 32–5 and 37–42.

5 For Strada's commission and the Bavarian collection, see D. J. Jansen, 'Jacopo Strada et le commerce d'art', *Revue de l'Art*, lxxvii, 1987, pp. 11–21.

6 *Anatomy of Melancholy*, 1978, pt. 2, pp. 86–7. The book was originally published in 1621.

7 For Lumley's collection, see L. Cust, 'The Lumley Inventories', *Walpole Society*, vi, 1917–18, pp. 16, 39 and 42. The coin collections of Burghley and Pembroke do not survive, see J. G. Pollard, 'England and the Italian Medal', in *England and the Continental Renaissance*, ed. E. Chaney and P. Mack, 1990, pp. 194–5.

8 G. P. Lomazzo's *Trattato dell'Arte de la Pittura*, which was 'Englished' in 1598 by Richard Haydocke as *A Tracte Containing the Artes of curious Paintinge, Carvinge & Buildinge*, was the first Italian book on art theory to appear in England.

9 R. Ascham (1515–1568), *The Schoolmaster*, ed. L. V. Ryan, 1967, pp. 60, 62, 66, 67 and 72. It was first published posthumously in 1570.

10 T. Nash (1567–1601), *The Works of Thomas Nashe*, 1958, ii, p. 301. The story becomes notably more sadistic once the Traveller reaches Italy.

11 For licences to travel, see, for instance, J. Howell, *Epistolae Ho-Elianae*, 1650, pp. 5–6: 'I have got a Warrant from the Lords of the Council to travel for three years anywhere, Rome and St Omer excepted. 20 March 1618'.

For suspicions of popery and the dangers of Rome, see E. Chaney, *The Grand Tour and the Great Rebellion*, 1985, p. 352, and Lord Clarendon's description of his father's visit to Rome 'which was not only strictly inhibited to all the queen's subjects, but was very dangerous to all the English nation who did not profess themselves Roman catholics', *The Life of Edward Earl of Clarendon*, 1857, i, p. 2.

12 For the dangers of Rome for a Protestant, see Sir R. Dallington, *A Method for Travell*, 1604. For a minute description of the precautions necessary to avoid religious disputes and embarassments during festival processions or at Mass, see Cavendish, *op. cit.* (n. 1.2), pp. 408–17, and F. Moryson, *An Itinerary*, i, 1907, pp. 308, 334 and 362; Moryson's journey was made in the 1590s.

Thomas Coryat (?1577–?1617) claimed that he had been warned that he would be tortured by the Inquisition to make him renounce his faith if he fell into the hands of Spaniards in the Duchy of Milan but he probably added this story just to spice his travelogue, first published in 1611, *Coryat's Crudities*, 1905, ii, p. 58.

13 Moryson, *op. cit.* (n. 1.12), p. 226.

14 The discourse *Of Travel* in Francis Bacon's *Essays*, recommends: 'That Young Men travel under some Tutor, or grave Servant, I allow well; so that he be such a one, that hath the Language, and hath been in the Country before; whereby he may be able to tell them, what Things are worthy to be seen in the Country where they go . . .' This essay, which was one of those added to later editions of the collection after 1625, only mentions 'Cabinets and Rarities' at the end of a list of more utilitarian sights that should be noted.

For visitors to Italy at this period, see J. Stoye, *English Travellers Abroad 1604–1667*, 1989, *passim*. See also Moryson, *op. cit.* (n. 1.12), ii, pp. 125, 375–9, 391–3 and 402.

15 T. Palmer, *An Essay of the Meanes how to make our Travailes, into forraine Countries, the more profitable and honourable*, 1606, pp. 42–4 and J. Hall, *Quo Vadis?*, 1617, pp. 2, 5, 9 and 12–13.

16 For Prince Henry (1594–1612), his collections and employees, see R. Strong, *Henry, Prince of Wales and England's Lost Renaissance*, 1986.

17 For Henry's bronzes, see Strong, *op. cit.* (n. 1.16), pp. 194–7 and for the coins and gems, see pp. 197–200.

For Abraham Gorlaeus or van Goorle of Delft (1549–1609), see *Nieuw Nederlandsch Biografisch Woordenboek*, v, 1921, pp. 208–9. His *Dactyliotheca*, published in 1601, was reissued with copious notes by Jacob Gronovius in 1695. He also produced a coin catalogue, *Thesaurus Numismatum Romanorum*, 1609.

18 For the importance of coins, see F. Haskell, *History and its Images*, 1993, pp. 13–25, and for Roe's letter, Michaelis, p. 199.

For contemporary gems, see D. Scarisbrick, 'The Devonshire Parure', *Archaeologia*, cviii, 1986, pp. 244–5. For the study of antique gems and their values at this period, see D. Jaffé, 'Aspects of Gem Collecting in the Early Seventeenth Century: Nicolas-Claude Peiresc and Lelio Pasqualini', *Burlington Magazine*, cxxxv, 1993, pp. 103–20.

19 For Thomas Howard, Earl of Arundel (1585–1646), see M. F. S. Hervey, *The Life, Correspondence & Collections of Thomas Howard, Earl of Arundel*, 1921, and D. Howarth, *Lord Arundel and his Circle*, 1985.

20 Arundel was prompted to antiquity by Lords Lumley, William Howard of Naworth and Northampton. Thomas, Lord Lumley, Arundel's great-uncle by marriage, was not only a keen bibliophile, whose splendid library was acquired by James I, but an ardent genealogist and a collector of portraits, many of which were later inherited by Arundel. There were 'vi old Emperors in marble' at Lumley Castle in 1609 as well as emperors' heads in his London house, L. Cust, 'The Lumley Inventories', *Walpole Society*, vi, 1917–18, pp. 42 and 16.

Lord William Howard of Naworth and the Earl of Northampton, Arundel's uncle and great uncle, introduced their nephew to those great antiquarians, William Camden, the father of British history, and Sir Robert Cotton, the bibliophile.

21 For Arundel's travels, see Howarth, *op. cit.* (n. 1.19), pp. 31–52 and 228–30, and E. Chaney, 'Inigo Jones in Naples', in *English Architecture Public and Private*, ed. J. Bold and E. Chaney, 1993, pp. 31–53.

For the Giustiniani collection, which was published in two large volumes of plates, *Gallerie Giustiniani*, 1636 and 1637, see E. Cropper, 'Vincenzo Giustiniani's "Galleria"', in *Cassiano dal Pozzo's Paper Museum*, 1992, ii, pp. 101–26, F. Haskell, *Patrons and Painters*, 1980, pp. 29–30 and 94–5, and *Caravaggio e i Giustiniani*, exh. cat., Palazzo Giustiniani, Rome, ed. S. D. Squarzina, 2001.

The ambassador in Venice, Sir Dudley Carleton, reported, 'The common recourse of his Majesty's subjects to Rome, notwithstanding their direct inhibitions on their licences for travel, to the contrary, is continued with that freedom that both the Earl of Arundel and his Lady have spent many days in that place.' Hervey, *op. cit.* (n. 1.19), pp. 83–4.

22 For the portraits, see Howarth, *op. cit.* (n. 1.19), pp. 57–9. The sculpture gallery later contained other antiquities in addition to statues, as John Evelyn records, see n. 35 below.

23 An aerial view of Arundel House in Wenceslas Hollar's map of London in 1646 shows two separate gardens to the east, divided by the raised walk that connected the back of the Hall

to Arundel Stairs on the Thames. The principal garden, overlooked by the Long Gallery on the west and by the terrace in front of the main block of Arundel House to the north, was divided into four elaborate rectangular parterres. The garden on the further side of these parterres was divided into four grass plots. The head of Jupiter presented by Carleton in 1616 was 'in his [Lord Arundel's] utmost [i.e. eastern] garden, so opposite to the Gallery doors, as being open, so soon as you enter into the first Garden you have the head in your eye all the way' Hervey, *op. cit.* (n. 1.19), p. 101. At that stage, therefore, there was a vista from the side door of the Long Gallery through both gardens. Other statues and fragments were probably placed under the colonnade along the west front of the Long Gallery and in the west garden between it and the boundary wall with Somerset House as shown in one of the portraits. For the problems of reconciling the different views of the garden, see R. Strong, *The Artist and the Garden*, 2000, pp. 47–53.

For the foreign visitor, see J. van Sandrart, who visited London in 1627, *Teutsche Akademie*, 1675, quoted in Hervey, *op. cit.* (n. 1.19), pp. 255–6.

24 J. Newman, 'A Draft Will of the Earl of Arundel', *Burlington Magazine*, cxxii, 1980, pp. 692–6. For de Gheyn's visit, see J. Q. van Regteren Altena, *Jacques de Gheyn Three Generations*, i, 1983, pp. 126–7; de Gheyn sketched a head of *Faustina* uncomfortably perched above a small funerary chest, as if the marbles were stacked in a furniture repository, a presumed bust of *Marcus Aurelius* and another funerary inscription, as well as some of the statues later etched by J. de Bisschop. Hollar did an etching of a *Faustina*, see M. Vickers, 'Hollar and the Arundel Marbles', *Country Life*, clxv, 1979, pp. 916–17.

25 T. Tenison, *Baconiana*, 1679, *Remains*, p. 57. The date of Bacon's visit is said to have been 1627. William Camden composed an inscription to go above the entrance to the Sculpture Gallery, Howarth, *op. cit.* (n. 1.19), p. 241, n. 12.

26 For early collections of Roman inscriptions from British sources, see D. Sturdy and A. Brueggeman, 'British Gardens 1590–1740 and the Origins of the Museum', *Apollo*, cxlvi, September 1997, pp. 3–8. Cotton lined the walls of his summer house at Conington, near Huntingdon, with Roman finds, most of which he had made on a trip to Hadrian's Wall in 1599; these were given to Trinity College, Cambridge, in the eighteenth century and are now in the Cambridge Museum of Archaeology (D.

McKitterick, 'From Camden to Cambridge: Sir Robert Cotton's Roman Inscriptions, and their Subsequent Treatment', in *Sir Robert Cotton as Collector*, ed. C. J. Wright, 1997, pp. 105–28). Other assemblages included the inscriptions built into the wall of a bathing establishment in Bath, owned by Robert Chambers, in 1592 and the array of eighteen plaques that Reginald Bainbrigg set into the façade of a summer house in Appleby a few years later.

27 For the marbles that Carleton bought for Somerset and then swapped with Rubens, see Howarth, *op. cit.* (n. 1.19), pp. 59–63, W. N. Sainsbury, *Original Unpublished Papers Illustrative of the Life of Sir Peter Paul Rubens*, 1859, pp. 23–47, 269–78 and 299–303, and T. Wilks, 'The Picture Collection of Robert Carr, Earl of Somerset', *Journal of the History of Collections*, i, 2, 1989, pp. 167–77.

William Cecil, Lord Roos (1590–1618), a son of Lord Burleigh, was given a licence to travel for three years in 1605 but spent much longer abroad. He was in Rome at the same time as Arundel in 1614 and seems to have spread malicious rumours about him, but, stricken with remorse, gave him 'all the Statues he brought out of Italy in one clap', in October 1616 (Sainsbury, pp. 272–3). There is no indication of the quality or origin of the statues which he was probably acquiring at the same time as, and in emulation of, Arundel's first purchases.

28 For the Turkey trade and the Levant Company, which was established in 1581, see A. C. Wood, *A History of the Levant Company*, 1935, and for Arundel's currant dues, Hervey, *op. cit.* (n. 1.19), p. 192, and *Calendar of State Papers, Venetian, 1628–9*, xxi, 1916, pp. 552–4. The word currant is derived from *raisins de Corinthe.*

29 Selections from Roe's fascinating reports to Arundel and Buckingham are reprinted in Michaelis, pp. 185–204. For travel conditions, see Moryson, *op. cit.* (n. 1.12), ii, pp. 89 and 108.

30 P. Gassendi, *Viri illustris Nicolai Claudii Fabricii de Peiresc . . . Vita*, 1641, pp. 226–7, and J. Selden, *Marmora Arundelliana*, 1629, preface. John Price, another scholar of this group, included some illustrations of marbles in Arundel's collection and quoted from the inscriptions in his edition of Apuleius's *Apologia*, 1635. Selden himself acquired some inscriptions, mostly from Smyrna, which he bequeathed to Oxford University on his death in 1654, see Michaelis, pp. 572–9.

31 For the restoration pavilion on the river, where George Conn, the papal agent, was taken for a 'noble repast' by Lady Arundel in 1637, see

Hervey, *op. cit.* (n. 1.19), p. 400, and for the employment of Clemente Coltrecci as a restorer, see D. Howarth, 'Lord Arundel as an Entrepreneur of the Arts', *Burlington Magazine*, cxxii, 1980, pp. 690–92. For the use of fragments, see J. Harris, 'The Link between a Roman Second-Century Sculptor, Van Dyck, Inigo Jones and Queen Henrietta Maria', *Burlington Magazine*, cxv, 1973, pp. 526–30, and Howarth, *op. cit.* (n. 1.19), p. 157. For the royal visit, see T. Birch, *The Court and Times of Charles the First*, 1848, i, p. 451.

32 For Petty's subsequent labours in Italy, see Hervey, *op. cit.* (n. 1.19), pp. 383–406 *passim*, and Howarth, *op. cit.* (n. 1.19), pp. 111–13 and 130–48. The *Meleager* is now in the Vatican and the *Torso* in the Uffizi. Arundel's enthusiasm for the *Meleager* and his attempt on the obelisk were still remembered some years later, see R. Lassels, *The Voyage of Italy*, 1670, ii, pp. 224 and 96, and entries for November 1644 and February 1645 in J. Evelyn, *Diary*, ed. E. S. de Beer, 1955, ii, pp. 217 and 362 respectively. For Trajan's column, see D. Jaffé et al., 'The Earl and Countess of Arundel', *Apollo*, cxliv, August 1996, p. 35, n. 160, and for the Lerma collection, Hervey, *op. cit.* (n. 1.19), pp. 403–4.

For export licences, see A. Bertolotti, 'Esportazione di oggetti di belle arti da Roma nei secoli xvi, xvii, xviii e xix', *Archivio Storico Artistico Archeologico e Letterario*, 1875–80, *passim* (Arundel's exports in 1617 and 1626 being listed in iv, 1880, pp. 74–7), and B. Jestaz, 'L'exportation des marbres de Rome', *Mélanges d'Archéologie et d'Histoire*, lxxv, 1963, pp. 415–66.

33 The bronze head of a poet, once identified with Homer and now renamed *Sophocles*, is in the British Museum. There was also a 'head of a Macedonian King cast in brass, found at Smyrna' (Society of Antiquaries, Minute Book, viii, p. 25).

For the gems, see D. Scarisbrick, 'The Arundel Gem Cabinet', *Apollo*, cxliv, August 1996, pp. 45–8, and the journal of Edward Browne, quoted in J. Martin Robinson, *The Dukes of Norfolk*, 1982, p. 128. John Evelyn told Samuel Pepys in a letter of 12 August 1689 that the cost of the Nys cabinet was £10,000, but this is a figure beyond even Arundel's extravagance and, if it had been worth that much, Nys would have redeemed it, when it was pledged, in order to extricate himself from his financial problems, rather than waiting until 1637, see Sainsbury, *op. cit.* (n. 1.27), pp. 296–8. The 1731 inventory of Arundel's gems lists 133 intaglios and 130 cameos (British Library, Add. MS 38166),

but prior to this Arundel's grandson had given away items to his mistress, to John Evelyn and to Elias Ashmole, among others.

34 For the full character sketch of Arundel in Clarendon's *History of the Rebellion and Civil Wars in England*, see Howarth, *op. cit.* (n. 1.19), pp. 219–20.

35 For Evelyn's visit, see his *Diary* in Beer, *op. cit.* (n. 1.32), ii, p. 479.

36 For the sad story of the Arundel marbles and their dispersal, see Michaelis, pp. 6–41, D. E. L. Haynes, *The Arundel Marbles*, 1975, and *Apollo*, cxliv, August 1996, *passim*.

For Evelyn's acquisition of the inscriptions, see his *Diary* 19 September 1667 in Beer, *op. cit* (n. 1.32), iii, pp. 495–6.

For the fragments at Fawley Court and Hall Barn, see D. E. L. Haynes, 'The Fawley Court Relief', *Apollo*, cxvi, 1972, pp. 6–11, and Christie's sale catalogue, 10 December 1985.

For Lord Pembroke's purchase of whole statues and columns, excluding fragments, see British Library, Stowe MS 1018, ff. 6r–7v.

For the statues in Sir Francis St John's garden at Thorpe, see W. Stukeley, *Itinerarium Curiosum*, 1724, p. 79, B. A. Bailey, *Northamptonshire in the Early Eighteenth Century*, 1996, p. 112, pl. 158, and the catalogue of the sale of the effects of Sir Robert Bernard Bart. at Thorpe, 19 October 1789.

For the recent discoveries, see B. F. Cook, 'The Classical Marbles from the Arundel House Site', *Transactions of the London & Middlesex Archaeological Society*, xxvi, 1975, pp. 247–51. Some of these fragments are now at Arundel Castle.

Further antiquities were sold in Lord Stafford's sale in 1720.

37 H. Peacham (?1576–?1643), *The Complete Gentleman*, 1962, p. 120.

38 B. Gerbier (1592–1663), *To all Men that love Truth*, 1646. For an account of his career, see H. R. Williamson, *Four Stuart Portraits*, 1949, pp. 26–60. He was knighted in 1628. His taste was controversial; Orazio Gentileschi refused to confirm his judgement of various statues and pictures procured by him for Buckingham and the king, *Calendar of State Papers, Domestic, 1628–1629*, 1859, p. 460.

39 For the formation of Buckingham's collection, see the correspondence with Roe, Michaelis, pp. 187–204, and Sainsbury, *op. cit.* (n. 1.27), pp. 64–6. For Rubens's collection and Peiresc's regrets, see J. M. Muller, 'Rubens's Museum of Antique Sculpture', *Art Bulletin*, lix, 1977, pp. 571–82, and *Rubens: The Artist as Collector*, 1989,

pp. 57, 77–8, 82–7 and 150–52. It is not possible to separate the cost of the antiquities from that of the pictures; a total price of 100,000 florins was agreed, but 6000 were deducted because one painting was excluded and agents, Gerbier and Michel Le Blon, took a commission of 10,000.

There is a view of Rubens's Sculpture Gallery in the background of *The Studio of Apelles* by Willem van Haecht in the Mauritshuis.

Knowledge of Buckingham's interest in sculpture was widespread because Sir Dudley Carleton offered him some marbles from Holland to secure his support for a London appointment in January 1625 (although this offering may have been of contemporary works rather than antiquities), see J. H. Barcroft, 'Carleton and Buckingham: The Quest for Office', in *Early Stuart Studies*, ed. H. S. Reinmuth, 1970, pp. 122–36, and *Calendar of State Papers Domestic, 1623–25*, 1859, pp. 450 and 457.

40 'At York House, also, the galleries and rooms are ennobled with the possession of those Roman heads and statues which lately belonged to Sir Peter Paul Rubens, knight.' Peacham, *op. cit.* (n. 1.37), p. 121. For Buckingham's inventory, see Bodleian Library, Rawlinson MS A 341, and L. Halkin, 'Inscriptions et Antiquités romaines . . . signalées dans les Itineraires de Dubuisson-Aubenay (1627–1638)', *Serta Leodiensia*, 1930, pp. 184–6.

41 For the sale of Buckingham's collection, see J. Stoye, *op. cit.* (n. 1.14), pp. 212–30, and P. McEvansoneya, 'The Sequestration and Dispersal of the Buckingham Collection', *Journal of the History of Collections*, viii, 2, 1996, pp. 133–54. It was suggested that an illustrated catalogue would assist the sale of the gems, when this was being arranged by Henry, Lord Jermyn, later Earl of St Albans.

42 The basic documents for the Mantuan saga are published in Sainsbury, *op. cit.* (n. 1.27), pp. 320–40, and A. Luzio, *La Galleria dei Gonzaga venduta all'Inghilterra nel 1627–28*, 1913, *passim*. See also the key article by A. H. Scott Elliot, 'The Statues from Mantua in the Collection of King Charles I', *Burlington Magazine*, ci, 1959, pp. 218–27, and P. F. Norton, 'The Lost *Sleeping Cupid* of Michaelangelo', *Art Bulletin*, xxxix, 1957, pp. 251–7. It is not possible to work out the price of the marbles because the royal accounts do not distinguish between them and Mantegna's *Triumphs*. The final price seems to have been considerably higher than £10,500, see Sainsbury, *op. cit.*, p. 321.

43 For the royal accounts, see *The History of the King's Works*, ed. H. M. Colvin, iv, 1982, pp. 250–51 and 268, and D. Howarth, 'Charles I, Sculpture and Sculptors', in *The Late King's Goods*, ed. A. MacGregor, 1989, pp. 104–5 and 113.

44 For the comment on the gardens at St James's, see J. Puget de la Serre, *Histoire de l'Entrée de la Reyne Mère . . . dans la Grande Bretaigne*, 1639.

45 For the casts, see Haskell and Penny, *op. cit.* (n. 1.1), pp. 31–2, and C. Avery, 'Hubert Le Sueur, the "unworthy Praxiteles" of King Charles I', *Walpole Society*, xlviii, 1982, pp. 148–51. Henrietta Maria's mother was a Medici.

46 K. Digby, *Journal of a Voyage into the Mediterranean by Sir Kenelm Digby A.D. 1628, Camden Society*, 1868, p. 57. A payment referred to in the accounts of the King's Works for 1628–9, may relate to repairs to damage caused by Digby's sailors: 'for going divers times to two ships that lay in the Pool, viewing of divers figures and statues in them, taking them out in lighters . . . and carrying of them in cars and storing them' (Colvin, *op. cit.* (n. 1.43), p. 268); the Mantuan marbles had not arrived at that date. 'Some of the old Greek marble bases, columns, and altars were brought from the ruins of Apollo's Temple at Delos by that noble and absolutely complete gentleman, Sir Kenelm Digby, knight.' Peacham, *op. cit.* (n. 1.37), p. 120.

47 Peacham, *op. cit.* (n. 1.37), p. 120, and O. Millar, 'Abraham van der Doort's Catalogue of the Collections of Charles I', *Walpole Society*, xxxvii, 1960, pp. 72 and 225. The king's real preference for paintings is shown by a letter of 1637 from Arundel to Petty: 'His Majesty thanks you for the care in it [an antique statue], but desires I should take it, saying he hath much more mind to some good picture, and means to employ you to buy for him that of Bronzino, which you mentioned.' Hervey, *op. cit.* (n. 1.19), p. 402.

48 O. Millar, 'The Inventories and Valuations of the King's Goods 1649–1651', *Walpole Society*, xliii, 1972, *passim*.

49 For the syndicates, see W. L. F. Nuttal, 'King Charles I's Pictures and the Commonwealth Sale', *Apollo*, lxxxii, 1965, pp. 302–9.

50 For hostile attitudes towards antiquities, see K. Thomas, 'English Protestantism and Classical Art', in *Albion's Classicism: The Visual Arts in Britain, 1550–1660*, ed. L. Gent, 1995, pp. 221–38.

For the transfer of some statues from St James's to Whitehall and the request for a decision on moving the rest so that there would be room for quartering soldiers, see *Calendar of State Papers Domestic, 1651*, 1877, pp. 243–4.

The Privy Garden in Whitehall was divided into sixteen asymmetric plots with a pedestal for a statue in the middle of each; see L. Magalotti, *Un principe di Toscana in Inghilterra e in Irlanda nel 1669*, ed. A. M. Crino, 1968, p. 189, 'The other gallery . . . is quite bare, its sole attraction being the view over a fine lawn divided up as a garden with trees and delightful rose bushes and four rows of statues, some of which are standing figures of bronze and some of which are marble figures, for the most part seated.' The layout of the garden in 1670 is illustrated in *Survey of London, The Parish of St. Margaret, Westminster*, Part II, 1930, pl. I; see also pp. 90–91.

51 For the recovery of part of the royal collection, see S. Gleissner, 'Reassembling a Royal Art Collection for the Restored King', *Journal of the History of Collections*, vi, 1, 1994, pp. 103–15, and *Royal Commission on Historical Manuscripts*, 7th Report, 1879, pp. 88–93. Neither the head nor the *Venus* in the portrait of Chiffinch can be identified in the Mantuan inventory. Samuel Pepys refers to seeing in Whitehall 'many fine Antique heads of marble that my Lord Northumberland hath given the king', *Diary*, 30 June 1660. Northumberland, like Lord Lisle, had bought some of King Charles's marbles during the Commonwealth (H. Maddicott, 'A Collection of the Interregnum period', *Journal of the History of Collections*, xi, 1, 1999, pp. 9–11).

For the marbles under the later Stuarts, see *Vertue Note Books*, iv, *Walpole Society*, xxiv, 1936, p. 77: 'The Statues belonging to the Crown (mostly lost) before this fire happened were crowded in an old useless guard room and some others were put in King James 2d demolished Catholic Chapel.' For the remains in the royal collection today, see *Splendours of the Gonzaga*, exh. cat., Victoria and Albert Museum, London, ed. D. Chambers and J. Martineau, 1981, pp. 229–31.

Although some of the gems were sold (Millar, *op. cit.* (n. 1.48), p. 428) John Evelyn saw 'a vast number of agates, onyxes, and intaglios' in the Cabinet Room in Whitehall, when he went there in November 1660, and in 1672 Elias Ashmole took wax impressions of gems that had been in Prince Henry's collection, bought from Gorlaeus; see D. Scarisbrick, 'English Collectors of Engraved Gems; Aristocrats, Antiquaries and Aesthetes', in M. Henig, *Classical Gems*, 1994, pp. xiii–xiv and xxi. Most of these seem to have vanished after the 1698 Whitehall fire, see C. D. E. Fortnum, 'Notes on some of the Antique and Renaissance Gems . . . at Windsor Castle', *Archaeologia*, xlv, 1880, pp. 1–28.

52 Peacham, *op. cit.* (n. 1.37), p. 117.

53 Shakerley Marmion (1603–1639) was a minor poet who wrote several plays during the reign of Charles I. *The Antiquary* was revived in 1718 to coincide with the reestablishment of the Society of Antiquaries.

CHAPTER 2

1 For dealing by Killigrew and Digby, see E. Chaney, *op. cit.* (n. 1.11), p. 281.

2 Evelyn, *op. cit.* (n. 1.32), iii, pp. 143 and 338–9 and iv, p. 216.

3 J. Bargrave, *Pope Alexander the Seventh and the College of Cardinals*, ed. J. C. Robinson, *Camden Society*, xcii, 1867, reprints the owner's catalogue of his collection.

4 C. Wren, *Parentalia*, 1750, pp. 265–7 and 296 and J. Strype, *Stow's Survey of London*, 1720, ii, Appendix, ch. 5, pp. 21–4.

5 John Conyers, who lived in Fleet Street, 'hath both with great Industry and Charge, for above 30 years together, made it his business, upon all occasions to procure such Subjects, either of nature or Art as had any thing of rarity in them . . . both Egyptian, Jewish, Grecian, Roman, British, Saxon, Danish etc. viz. their Deities or Idols, Icunculae, Amulets, Talismans, ancient vessels used in sacrifices, Sepulchral Urns, Lachrymatories, Lamps, Gems, Medals, Coins, Seals, Tesserae, Rings, Armour, Shields, Weapons . . .', *Athenian Mercury*, 21 November 1691. Some of his hoard was acquired by Kemp and Woodward but the best things were bought by Arthur Charlett (1655–1722), the Master of University College, Oxford.

John Bagford (d. 1716), was described by Thomas Hearne as 'a Man of very surprising Genius and had his education (for he was first a Shoemaker, and afterwards for some time a Bookseller) been equal to his natural Genius, he would have proved a much greater Man than he was', *Hemingi Cartularium*, 1723, p. 656.

John Kemp (1665–1717) became a Fellow of the Royal Society in 1712. He stipulated in his will that his collection was to be offered in the first instance to the Earl of Oxford or his son for £2000 and, if they refused, was to be sold. The sale in 1721 raised £1090 8s. 6d, which shows that Oxford was wise to turn the offer down. A catalogue by R. Ainsworth, *Monumenta Vetustatis Kempiana*, was published in 1720.

For accounts of visits to his collection, see Z. K. von Uffenbach, *London in 1710*, ed. W. H. Quarrell and M. Mare, 1934, pp. 36–8, and P. C. D. Brears, 'Ralph Thoresby in Stuart

England', *Journal of the History of Collections*, i, 2, 1989, p. 218.

Jacob Spon, the author of *Voyage d'Italie, de Dalmatie, de Grèce, et du Levant fait en 1675 & 1676*, 1678–80, had accompanied George Wheler as his doctor on an unusually early and adventurous tour of the eastern Mediterranean. Wheler, whose own account of this expedition, *A Journey into Greece*, was published in 1682, presented to Oxford University the marbles that he acquired on this trip (Michaelis, pp. 572–9).

Kemp also bought many of the antiquities acquired in France by Jean Gailhard, who had been tutor to George, first Lord Carteret (1667–1695), presumably in the 1680s; Gailhard disposed of this collection to his pupil in return for an annuity of £200 and then went to Italy to buy more, but everything was sold on Carteret's death, according to the third Earl of Winchelsea, who had seen Gailhard's original collection, first in Angers in 1676 and then in Paris in 1683 (manuscript note in the British Library copy of *Monumenta Vetustatis Kempiana*, which had originally been presented to Lord Coleraine).

6 For the controversies aroused by John Woodward (*c.*1667–1728) and the scholarly atmosphere at this time, see J. M. Levine, *Dr Woodward's Shield*, 1977. For his collection, see R. Thoresby, *Diary*, i, 1830, p. 340. The shield was bequeathed to the British Museum by John Wilkinson in 1818.

7 A. Pope, *Works*, 1742, iii, part ii, *Memoirs of Martin Scriblerus*.

8 J. Horsley's *Britannia Romana*, 1732, includes reproductions of all the Roman inscriptions then known in the United Kingdom. There were two collections of inscriptions in Scotland, one belonging to Glasgow University, the other to Sir John Clerk of Penicuik, while the main English collections were along the Borders at Housesteads, at Naworth, originally assembled by Lord Arundel's uncle, Lord William Howard of Naworth, at Elenborough Hall (belonging to Mr Senhouse, whose ancestor had entertained Camden and Cotton on their visit to the Wall in 1599), Scaleby Castle (belonging to Mr Gilpin) and Cleugh (belonging to Mr Appleby). The Dean and Chapter of Durham had secured the monuments acquired by John Warburton, who had made a special study of Hadrian's Wall, but, as Horsley sadly remarks, Warburton had broken many of the stones to make them more portable, only preserving the face with the inscription, and many inscriptions had been damaged by 'this unhappy frugality' (Horsley, i, p. 182). Horsley also lamented the deterioration

of Cotton's collection at Conington because the summer house in which they were kept had become ruinous. The other main collections that he records were in Yorkshire, at Ribston, where Sir Henry Goodrick carefully kept his antiquities under cover in the garden, at Rokeby, belonging to Sir Thomas Robinson, and at Moreton, near Gretabridge. Mr George at Caerleon had a 'valuable collection of medals and other curiosities', while in Cirencester Isaac Tilbot preserved the monument of Julia Casta, together with her skull, from which all the teeth had been stolen 'for amulets against the ague'.

For the casual attitude to the preservation of the past, exemplified by the destruction of the Stonesfield mosaic, which now survives only in prints and an embroidered carpet, see J. M. Levine, *Humanism and History*, 1987, pp. 107–22.

G. Ogle, *Antiquities Explained*, 1737, p. v; the book was devoted to literary explanations of poorly reproduced gems.

H. Walpole, March 1780, *Correspondence*, ii, p. 204–6. Although Walpole sometimes attended meetings of the Society of Antiquaries after his election in 1753, he soon lost interest. Noticeably few peers were elected to the Society and, if they were, they seldom attended meetings.

9 The Memoirs of Sir John Clerk (1676–1755) were published as '*Memoirs of the Life of Sir John Clerk*', ed. J. M. Gray, *Scottish History Society*, xiii, 1892. For his work as an amateur architect, see H. Colvin, *A Biographical Dictionary of British Architects 1600–1840*, 1995, pp. 254–5.

10 As a result of this expedition, Alexander Gordon produced his *Itinerarium Septentrionale*, 1726, with *Additions and Corrections*, incorporating some of Clerk's observations, in 1732. Some of Clerk's correspondence with Gale is published in *Reliquiae Galeanae, Bibliotheca Topographica Britannica*, iii, 1790.

11 The draft letter is given in an appendix to the 'Memoirs', Gray, *op. cit.* (n. 2.9), pp. 237–8.

Some of Clerk's antiquities remain at Penicuik, although Sir John's house has gone and its replacement, built by his son, is a ruin. Many antiquities were presented by the family to the Society of Antiquities of Scotland in 1857 and are now in the Scottish National Museum of Antiquities.

12 Scottish Record Office, GD18/4791.

13 Examples of European polymaths' cabinets are illustrated in A. Schnapp, *The Discovery of the Past*, 1996, pp. 167–77. The Royal Society itself maintained a Repository of such curiosities, now dispersed. The Apartment of the Society's 'Elaboratory-keeper' is satirically described as containing 'Aegyptian Mummies, Old Musty

Skeletons, and other Antiquated Trumpery' as well as a magnet, shell-flies almost as big as lobsters, a unicorn's horn, an aviary of dead birds, serpents and pickled abortions, *The London Spy Compleat*, 1706, pp. 60–61.

14 For the career and collections of Sir Hans Sloane (1660–1753), see *Sir Hans Sloane, Collector, Scientist, Antiquary*, ed. A. MacGregor, 1994.

15 William Courten (1642–1702), or Charleton as he later called himself, owned 'perhaps the most noble collection of natural and artificial curiosities, of ancient and modern coins and medals, that any private person in the world enjoys', according to Ralph Thoresby, who visited it in 1695, *Diary*, 1830, i, p. 299. Evelyn admired his 'Miniatures, Drawings, Shells, Insects, Medals, & natural things, Animals whereof divers were kept in glasses of spirits of wine, I think an hundred, Minerals, precious stones, vessels & curiosities in Amber, Agate, crystal, &c.' in his house in the Middle Temple (Evelyn, *op. cit.* (n. 1.32), iv, pp. 531–2, entry for 16 December 1686). For his collection, see C. Gibson-Wood, 'Classification and Value in a Seventeenth-Century Museum', *Journal of the History of Collections*, ix, 1, 1997, pp. 61–77.

For some of the other sources of Sloane's antiquities, including the collections of Lord Arundel, Lord Pembroke, John Kemp, Austin Oldsworth and Peter Lely, see I. Jenkins, 'Classical Antiquities, Sloane's Repository of Time', in MacGregor, *op. cit.* (n. 2.14), pp. 167–73, and MacGregor, 'Egyptian Antiquities', *ibid.*, pp. 174–9. Sloane sent objects to be examined at meetings of the Society of Antiquities but did not attend himself. At the time of his death he owned 23,000 coins, over 1000 antiquities and some 700 engraved gems.

For the abbate Bernardo Sterbini, see J. Speier and J. Kagan, 'Sir Charles Frederick and the Forgery of Ancient Coins in Eighteenth-Century Rome', *Journal of the History of Collections*, xii, 1, 2000, pp. 35–90. For his trading and his sales of coins to Lord Pembroke, see W. C. Lukis, ed., *The Family Memoirs of the Rev. William Stukeley . . . , vol.* i, Surtees Society, lxxiii, 1882, pp. 468 and 470.

16 H. Walpole, *Correspondence*, xx, p. 358, letter to H. Mann, 14 February 1753.

17 R. Mead (1673–1754) also owned 'Etruscan' vases, Egyptian antiquities, including a mummy, and a large coin collection. Among the several pieces of ancient painting 'that of the Court of Augustus, found at Rome in 1737, had cost him vast sums', M. Maty, *Authentic Memoirs of the Life*

of Richard Mead, M.D., 1755, pp. 51–2 and 57–8. Maty, another doctor, was Secretary to the Royal Society and Librarian of the British Museum. For his 'huge paintings of the antique as big as life', acquired in 1738, but now apparently crumbled away, see Lukis, *op. cit.* (n. 2.15), pp. 303 and 312, and G. Turnbull, *A Curious Collection of Ancient Paintings*, 1741. Mead also owned drawings of paintings; he paid £200 for Pietro Santi Bartoli's record of the tomb of the Nasonii, see J. Fleming, *Robert Adam and his Circle*, 1962, p. 332, and C. Pace, 'Pietro Santi Bartoli: Drawings in Glasgow University Library after Roman Paintings and Mosaics', *Papers of the British School at Rome*, xlvii, 1979, pp. 117–55, an important account of such drawings. Some fragments of the original paintings from the tomb were bought in London by the artist George Richmond in 1865 and were eventually acquired by the British Museum, see J. B. Trapp, 'Ovid's Tomb', *Journal of the Warburg and Courtauld Institutes*, xxxvi, 1973, pp. 35–76.

The British Library's annotated copy of the sale catalogue, *Museum Meadianum*, 1755, lists the buyers, who included Horace Walpole, Sir Paul Methuen, Lords Carlisle, Exeter, Duncannon and Rockingham, and General Campbell, and on p. 59 sadly records the fate of one lot, 'Some of the most valuable Coins in this lot had been taken away, & others, common ones, left in their room', a problem that is not confined to eighteenth-century salerooms. Lord Chesterfield bought one of the painting fragments.

The proceeds of Mead's sale were

	£	s	d
Books	5,518	10	11
Medals	1,977	17	0
Antiquities	3,246	15	6
Pictures	3,417	11	0
Prints and drawings	1,908	14	6
	16,069	8	11

Elizabeth Montagu thought that Mead's collection was better than Sloane's, see E. J. Climenson, *Elizabeth Montagu, the Queen of the Blue-Stockings*, i, 1906, p. 128.

For the Bacchic Mask, see I. Jenkins, 'The Masks of Dionysus/Pan-Osiris-Apis', *Jahrbuch der Deutschen Archäologischen Instituts*, 1994, 109, pp. 273–99.

18 For the collection of Edward Harley, second Earl of Oxford (1689–1741), see *Catalogue of the Collection of . . . Edward, Earl of Oxford, Deceased*, 1742. He also had a large collection of coins. There are watercolour illustrations of some of his bronzes and vases, Society of Antiquaries,

'Greek and Latin Antiquities', i, pl. 26–31. His engraved portrait by Vertue includes vignettes showing the busts and urns above his bookcases and a selection of his antiquities.

19 J. Evelyn, *A Discourse of Medals*, 1697, pp. 198–200 and 209, and his letter of 12 August 1689 to Samuel Pepys in *Diary and Correspondence of John Evelyn*, iii, 1852, pp. 294–311. His work was preceeded by O. Walker, *The Greek and Roman History Illustrated by Coins & Medals*, 1692; see also n. 1.18 above. J. Addison (1672–1719) wrote his *Dialogues upon the Usefulness of Ancient Medals* in 1702, shortly after his return from Italy, but it was published posthumously in 1726. He 'did not go any depth in the study of medals' and received 'not more than twenty lessons' from the *cicerone*, Francesco de' Ficoroni, Ingamells, p. 9.

For Nicola Francesco Haym (1678–1729), see *The New Grove Dictionary of Music and Musicians*, viii, 1980, pp. 415–16. Haym planned his work to be in four parts, the first, consisting of three volumes, on coins, the second on gems, the third on statues and busts and the fourth on inscriptions, utensils, lamps and urns. Only the first two volumes on coins were published.

John Carteret, Earl Granville (1690–1763), was another collector of coins; 'with a Singularity, scarce to be justified, he carried away more Greek, Latin and Philosophy, than properly became a Person of his Rank; indeed much more of each than most of those who are forced to live by their Learning will be at the unnecessary Pains to load their Heads with' (J. Swift, *Irish Tracts*, ed. H. Davis, 1955, pp. 153–4).

20 Ralph Thoresby (1658–1725) also had a few domestic antiquities as well as geological and natural curiosities. 'Some of the Roman Monuments . . . are now placed in the Form of an antique Alcove, which is covered by an Arch of Marble, of very curious Workmanship, which once belonged to a Shrine in the Lady's Chapel at York Minster.' R. Thoresby, *Ducatus Leodiensis*, 1713, p. 567, and Brears, *op. cit.* (n. 2.5), pp. 213–24.

For a list of coin auctions during the eighteenth century, see H. E. Manville and T. J. Robertson, *British Numismatic Auction Catalogues 1710–1984*, 1986. There were several sales of goldsmith's estates as well as those of the dealers, Francesco Benedetti and John Kemp, and of a number of peers in the reigns of Queen Anne and George I.

21 For the typical furnishing of houses of this period, see O. Hill and J. Cornforth, *English Country Houses: Caroline*, 1966, and J.

Lees-Milne, *English Country Houses: Baroque*, 1970. Classical busts formed part of the designs for Webb's Lamport (1654–7) where the architect specified that casts should be taken from moulds of the antique, and Pratt's Coleshill (1649–62) but these were reproductions, not originals. When Sir Thomas Isham visited Rome in 1676–7, he did not buy antique replacements for Lamport. In the same way, some forty years earlier, Sir William Paston, visiting Italy and the Levant in 1638, came back with 'a world of curiosities and some very rich ones, as cabinets and jewels', but employed Nicholas Stone to supply heads of the twelve Caesars and statues of Roman deities for Oxnead, his house in Norfolk, instead of buying antique figures, see R. W. Ketton Cremer, *Norfolk Assembly*, 1957, pp. 22–6. Sir Henry Parker (1639–1713), a City merchant who decorated the façade of Honington Hall, Warwickshire, with a set of busts of Caesars in the 1680s, may, however, have acquired genuine antiquities if the *cinerarium* still in the house was his.

22 For the collection of Thomas Herbert, eighth Earl of Pembroke (1656–1733), see Michaelis, pp. 42–7 and 665–715, F. Poulsen, *Greek and Roman Portraits in English Country Houses*, 1923, pp. 7–11, 30, 36–8, 44–5, 50–51, 57–60, 74, 84, 86–7, 91, 93, 100, 103 and 107, and Vermeule, 1955, pp. 148–9, and 1956, pp. 347–8. See also J. Cornforth, 'Conversations with Old Heroes', *Country Life*, cxliv, September 1968, pp. 748–51. Pembroke gave the Le Sueur *Gladiator* to Sir Robert Walpole for Houghton, where it remains. His great uncle, the third earl, may have considered buying antiquities in rivalry with Arundel, D. Howarth, *op. cit.* (n. 1.19). p. 95.

For the Italian visit, see *Calendar of Treasury Books, 1676–1679*, i, 1911, p. 382, November 1676. Prince Cosimo de' Medici's stay at Wilton in 1669 on his way to London may have given the young Thomas an interest in Italy.

Pembroke did not visit Italy again later in life, although in 1702 he was planning to meet Sir Andrew Fountaine in Naples, see A. W. Moore, *Norfolk & the Grand Tour*, 1985, p. 94. His son, the future ninth earl, made a Grand Tour from 1711 to 1713.

For Pembroke's character, see J. Macky, *Memoirs of the Secret Services*, 1733, pp. 21–2. Most of his portraits show him uncharacteristically armed and periwigged as an admiral, but there is an idealized print of him with his books and medals as the frontispiece of W. Nicol, *De Literis inventis*, 1711; George Vertue's pen portrait in casual attire (British Library, Add. MS 22042,

f. 18) is inscribed by Horace Walpole 'This is very exact & like him'.

23 For a description of the marbles with comments on their sources and imaginative details about their earlier history, see British Library, Stowe MS 1018, 'A Copy of ye Book of Antiquities at Wilton'. This seems to have been composed at the end of Lord Pembroke's life; most of it refers to 'my Lord's' acquisitions but the text occasionally lapses into the first person singular, as if Pembroke dictated some passages himself. The Egyptian granite column was later moved from the courtyard to the garden.

24 For visits to his coin collection, see, for instance, Brears, *op. cit.* (n. 2.5), pp. 219–20.

25 For agents, see A. Pope, *Moral Essays, Epistle IV*, and *The Correspondence of Jonathan Swift*, ed. H. Williams, i, 1963, p. 140.

26 Michaelis identifies the marbles acquired from the Mazarin collection. For the marbles that Mazarin might have bought from the collection of Charles I, see A. H. Scott Elliott, *op. cit.* (n. 1.42). The Stowe MS f. 10v., quoted above (n. 2.23), cites on f. 10v. a catalogue of the Mazarin collection that has now disappeared. The collection seems to have come to Wilton in 1723–4, because William Stukeley in the preface to his *Itinerarium Curiosum*, 1724, refers to the fact that it had not arrived when he made his initial notes for the work.

27 Giuseppe Valletta of Naples (1635–1714), a tailor's son, married a rich merchant's widow after the great plague in 1656, and thus founded his fortune. He became a distinguished forensic speaker, but abandoned law for learning. He corresponded with many international scholars and sent an account of the eruptions of Vesuvius to the Royal Society in 1713. He amassed a vast library, to complement which he collected inscriptions, coins, vases, busts and statues. See V. I. Comparato, *Giuseppe Valletta*, 1970. His collection of statues was sold for 1100 ducats in 1720, while some of his vases and library went to the Oratory of the Gerolomini for 14,000 ducats in 1726 and his best manuscripts were acquired by Lord Oxford and Thomas Coke. His main vase collection, which was bought by Cardinal Filippo Antonio Gualtieri (d. 1728), passed to the Vatican galleries.

28 For the *columbarium*, see A. F. Gori, *Monumentum sive Columbarium Libertorum et Servorum Liviae Augustae et Caesarum*, 1727. The sarcophagi were illustrated by G. B. Piranesi, *Antichità Romane*, iii, pl. xxvii–xxx. For the Duke of Beaufort's sarcophagus, see p. 62. For the waggon loads, see

Roger Gale's letter to William Stukeley, Lukis, *op. cit.* (n. 2.15), p. 203. A couple of years earlier, in 1726, after a visit to Wilton, Gale told Sir John Clerk that he had found 'a large addition of statues, bustos, and basse relievos, to what I had seen there 2 years ago', W. C. Lukis, *The Family Memoirs of the Rev. William Stukeley . . . ,* vol. II, Surtees Society, lxxx, 1885, p. 92.

29 For Pembroke's methodology, see the Stowe MS, quoted above, n. 2.23, and the accounts of the collection based on it in n. 2.38. By 1730, Pembroke's wife had started to collect small bronzes, Lukis, *op. cit.* (n. 2.15), p. 229.

30 For the interest in busts, see J. Kennedy, *A Description of the Antiquities and Curiosities in Wilton House*, 1769, pp. iv–v. Spanheim is cited in the manuscript 'Book of Antiquities'. H. Walpole, *Anecdotes, of Painting in England*, v, 1828, p. 281.

For the plinths, see S. Markham, *John Loveday of Caversham 1711–1789*, 1984, p. 99, and *The Treasure Houses of Britain*, exh. cat., Washington, 1985, pp. 270–71.

31 R. Thoresby, *Diary*, 1830, i, pp. 335–9. For coin fakes, see n. 2.15.

32 Scottish Record Office GD 18, 5030, 1, 25 September 1723, quoted in Levine, *op. cit.* (n. 2.6), p. 284. On a previous visit in 1722, Pembroke opened up a barrow near Stonehenge for his guest's benefit, see W. Stukeley, *Stonehenge, A Temple restor'd to the British Druids*, 1740, p. 44.

William Stukeley (1687–1765), one of the founders of the Society of Antiquaries, studied medicine under Dr Mead but later became a clergyman. His diary and correspondence, published by the Surtees Society (vols lxxiii, lxxvi and lxxx in 1882, 1883 and 1887 ed. W. C. Lukis), give a vivid account of the interests of an eighteenth-century antiquary. Pembroke told him that he owned 'the three oldest Statues in the World, the Isis, the Jupiter Ammon set up in Thrace by Sesostris, & this Diana [of the Ephesians]', Lukis, *op. cit.* (n. 2.15), p. 69. For Stukeley's abortive catalogue (now in the Bodleian Library, MS Top. Wilts e6), see R. Guilding, *Marble Mania*, exh. cat., Sir John Soane's Museum, London, 2001, p. 24.

Stukeley describes his own house at Grantham in a letter to Samuel Gale, 25 October 1727: 'I have adorned my study with heads, bas-reliefs, bustos, urns & drawings of Roman antiquities, as my bedchamber adjoining with Egyptian.' (Lukis, *op. cit.* (n. 2.15), p. 198).

For Newton's view, see J. Spence, *Observations, Anecdotes and Characters of Books and Men*, i,

1966, p. 350. The Venetian connoisseur Antonio Maria Zanetti was shocked at the philistine way in which Pembroke cropped drawings, even those of Raphael and Correggio, to fit his albums, see D. Scarisbrick, 'Gem Connoisseurship – the 4th Earl of Carlisle's Correspondence with Francesco de' Ficoroni and Antonio Maria Zanetti', *Burlington Magazine*, cxxix, 1987, p. 103.

33 Sir Andrew Fountaine (1676–1753), a distinguished connoisseur, amassed a large collection of coins, drawings and majolica, probably for the most part on his second visit to Italy in 1715–16 (Ingamells, pp. 376–7, and Moore, *op. cit.* (n. 2.22), pp. 26–31 and 93–113). He sold Pembroke part of his coin collection and presented him with a mosaic, which was an eighteenth-century forgery (H. E. Pagan, 'Andreas Fountaine Eques Auratus A.A.A.F III VIR', *British Numismatic Journal*, lxiii, 1993, pp. 114–22, and Michaelis, p. 678). He also sold coins to the Duke of Devonshire. Pope refers to him in the *Dunciad* as, 'False as his gems and cankered as his coins', which was a justifiable slur if the story of his collusion with Francesco de' Ficoroni to cheat an ancient abate is true (J. Nicolls, *Literary Anecdotes*, ix, 1815, p. 603). He is said to have chalked obscene graffiti on some of the statues at Wilton together with Pembroke's stepson, Richard Arundell.

34 Gale told Clerk in September 1726 that he had recently spent ten days with Pembroke at Wilton where he had found 'a large addition of statues, busts and basse relievos' to those that he had seen two years previously; 'the whole collection is without doubt not to be paralleled on this side the Alps.' *Reliquiae Galeanae, op. cit.* (n. 2.10) p. 251, and Scottish Record Office, Penicuik MS GD. 18, 5030, 26 and 2107. For Townley's comments, see BM, TY/15/8/1.

35 C. Creed, *The Marble Antiquities of the Right Honble. the Earl of Pembroke at Wilton*. The first edition of 1729 contained forty plates, the second of 1731 contained seventy and four more were added shortly afterwards. More plates were planned, because the manuscript 'Book of Antiquities' states, f. 15r, 'Mr. Creed has graved all the Statues & that the Hieroglyphics might be very exact, those Hieroglyphics taken off were sent to him to abridge them the more exactly.'

For Clerk's views, see *Reliquiae Galeanae, op. cit.* (n. 2.10), p. 300, and for Winckelmann's, see *Histoire de l'Art chez les Anciens*, 1766, preface, pp. viii–ix, the first version likely to have been read by the English.

The coin collection, which had been started by the second earl, see n. 1.7 above, was published posthumously, *Numismata antiqua . . . collegit olim et aeri incidi vivens curavit Thomas Pembrochiae et Montis Gomerici Comes*, 1746. The catalogue, prepared by Haym, consists of over 300 plates, illustrating the choicest coins in the collection and including, as a warning, several plates of the most distinguished fakes, coins of Priam, Aesop, Artemisia of Halicarnassus, Julius Caesar and Otho (precisely those that Evelyn had warned against in *A Discourse of Medals*), but there is no text. Publication was delayed because 100 of the plates were mislaid, see the letter from Roger Gale to William Stukeley, in Lukis, *op. cit.* (n. 2.15), p. 267. Haym says that he deliberately illustrated only a few of Pembroke's coins in his own work because the owner intended to publish his whole collection (see *Tesoro Britannico*, i, *The British Treasury*, p. x, which indicates that Pembroke was already contemplating a catalogue of his coins as early as 1719).

Pembroke's paintings were published by Carlo Gambarini in *Description of the Earl of Pembroke's Pictures*, 1731. Pembroke's catalogue was not, in fact, the first of its kind in England because it was preceeded by H. Winstanley's engravings of some of Lord Derby's pictures in 1729 and by the plates of the second Duke of Devonshire's gems, produced in about 1724.

For catalogues, see H. Walpole's comments in *Aedes Walpolianae*, 1752, vii–ix, 'In Italy, the native soil of almost all Vertu, descriptions of great Collections are much more common and much more ample. The Princes and Noblemen there, who lov'd and countenanc'd the Arts, were fond of letting the world know the Curiosities in their possession . . . Their Gems, their Statues, and Antiquities are all publish'd . . . How many valuable Collections of Pictures are there established in England on the frequent ruins and dispersions of the finest Galleries in Rome and other Cities! . . . Statues are not so numerous, and consequently come seldomer, besides that the chief are prohibited from being sold out of Rome.'

36 For writing on the wainscot (removed by his successor), see Markham, *op. cit.* (n. 2.30), pp. 98 and 298. For measurements, see British Library, Stowe MS 1018, f. 46v. 'My Lord at Rome . . . measured them [the letters] full four Inches high, and half an Inch broad.' The same MS, f. 50r, indicates that Pembroke's agent instructed Dr Sherard, the consul in Smyrna, to procure such inscriptions 'at any Expense'. For Hearne's comments, see Thomas Hearne to James West, 13 December 1733, British Library,

Lansdowne MS 778, f. 259 and ff. 261, 263 and 265.

Some of the faked inscriptions on reliefs at Wilton may have been added before entering Pembroke's collection because they are in a different script to the fictitious names added to the plinths of his busts, see Michaelis, p. 683.

37 For a plan of the layout of the busts and statues in the rooms, some two deep, see Bodleian Library, MS Gough Drawings a1, f. 14.

For the 1000-foot gallery, see the Stowe MS *op. cit.* (n. 2.23), f. 4v. One visitor in 1776 complained that 'the whole house gives one an idea of a statuary's shop', *Passages from the Diaries of Mrs Philip Lybbe Powys*, ed. E. J. Climenson, 1899, p. 166.

38 R. Cowdry, *A Description of the Pictures, Statues, Busto's, Basso-Relievo's and other Curiosities . . . at Wilton*, 1751, dedicated to Sir Andrew Fountaine, who had provided the author with much of the information when at Wilton; 'you were pleased not only to obtain Leave from my late honoured Lord for me to attempt something of this Kind, but also to assist me in doing it'. Cowdry was the steward at Wilton.

J. Kennedy, *A Description of the Antiquities and Curiosities in Wilton House*, 1769, which is largely based on the 'Book of Antiquities' with Pembroke's romantic theories, contains twenty-five plates of the most important statues. A description of the house and contents, room by room, is also given by P. Russell, *England Displayed*, 1769, pp. 75–84.

39 For the change in attitudes, see C. Hussey, *Country Life*, cxxxiv, 1963, p. 316. The main sales of the marbles were Christie's 3 July 1961, 28 April 1964 and 2 June 1964.

40 There were one or two other antiquarian peers, in addition to Lord Carteret (see n. 2.5 above) and the Dukes of Somerset and Devonshire and Lord Halifax (see n. 5.15 and n. 2.44 below). Heneage Finch, third Earl of Winchilsea (1627–1689), acquired a taste for antiquity while he was ambassador in Constantinople from 1660 to 1669. He collected part of a frieze in Athens to send back to London (Spon, *op. cit.* (n. 2.5), ii, p. 187) and took the trouble to look at antiquities in France. Classical coins belonging to his son, Heneage, fifth Earl of Winchilsea (1657–1726), described as the 'father of antiquities' by Samuel Gale, Lukis, *op. cit.* (n. 2.15), p. 193, are noted by Haym, but this must have been a new collection if Walpole is correct in saying that the third earl's collection was sold to Thomas Hall.

Mention should also be made of James, first Earl Stanhope (1674–1721), who, as commander

of the British forces in Spain in 1708, was presented with a series of Roman dedicatory inscriptions from Taragona, one of which is now in the British Museum, while the others remain at Chevening, his house in Kent. This surprising gift to a successful general indicates the importance attached to epigraphical antiquities at this period. Details of the inscriptions were reported to a meeting of the Society of Antiquaries in April 1733.

Some of the speculators who had profited from the South Sea Bubble bought dubious antiquities in 1720 'when many gave very great Prices for what they liked' (British Library, Stowe MS 1018, f. 25r).

41 Modern versions of classical statues or busts, generally for exterior decoration, appeared at Boughton, Chatsworth, Coleshill, Drayton, Ham, Honington, Oxnead and Thoresby, all before 1702, and possibly Monmouth House, Soho Square. Although the plates of views, drawn by Leonard Knyff and engraved by Jan Kip for *Britannia Illustrata*, 1707, are on too small a scale to express the detail of the sculptures, the formal settings of over a dozen of the eighty houses illustrated contain statues, many of which could have been versions of the antique. See also the illustrations of statues in gardens in J. Harris, *The Artist and the Country House*, 1979, especially the unidentified house with numerous statues, including a *Medici Venus* and a *Borghese Gladiator*, c.1662–4, p. 50, and Denham Place, pre-1674 and c.1705, pp. 80 and 123.

By the 1720s antiquities had been acquired for the decoration of Easton Neston, Thorpe and Wilton (all from Arundel's collection), Badminton, Cannons, Chatsworth, Holkham, Houghton, Kiveton, Narford and Petworth and copies for Blenheim, Castle Howard, Knowsley, Shirburn, Wentworth Castle and Wrest. James Gibbs included a large number of replicas in his design for the Hall at Kedleston in 1726.

Arthur Pond (1701–1758), the artist and dealer, and George Knapton (1698–1778), the artist who was to paint so many of the Dilettanti Society portraits, were engaged in exporting plaster casts of antique statues when they were in Italy in 1725 (L. Lippincott, *Selling Art in Georgian England*, 1983, p. 22).

42 For William III's proposed purchases, see Vertue Notebooks, *Walpole Society*, xxiv, 1936, iv, p. 78. For the Blenheim statues and the bronzes by Massimiliano Soldani Benzi, see Vanbrugh's letters of 1709 and 1710 in L. Whistler, *The Imagination of Vanbrugh and his Fellow Architects*, 1954, pp. 233–6, H. Honour, 'English Patrons and Italian Sculptors in the First Half of the

Eighteenth Century', *Connoisseur*, cxli, 1958, pp. 220–28, and *Gli Ultimi Medici*, exh. cat., Palazzo Pitti, Florence, 1974, pp. 118–19. Christopher Crowe (1682–1749), the consul at Leghorn, also helped Lord Strafford of Wentworth Castle and James Stanhope to acquire copies. His portrait by Francesco Trevisani shows him as a connoisseur holding a cameo against a background of ruins, see *Masterpieces from Yorkshire Houses*, exh. cat., City Art Gallery, York, 1994, p. 88.

43 For the acquisition by William Fermor, first Lord Lemster (1648–1711), see John Evelyn, *Diary*, v, pp. 44–5, 21 March 1691, 'Dined at Sir William Fermor's who shewed me many good pictures . . . Sir William had now bought all the remaining statues collected with so much expense &c by the famous Thomas Earl of Arundel . . . & sent them to his seat in Northamptonshire.' Lemster did not immediately decide on the disposition of the marbles because, in a letter to John Covell of Christ's College, Cambridge, dated August 1708, he wrote, 'I am now setting up all my marbles in the manner I intend to leave them in.' British Library, Add. MS 22911, f. 77. The statues were placed on pedestals inscribed with Lemster's cipher and coronet. Some years later William Stukeley recorded that Lemster's successor, the first Earl of Pomfret, 'has it in his thoughts to build a large room or gallery to receive this invaluable treasure' (*Itinerarium Curiosum*, 1724, pp. 35–8). The garden layout is shown in a series of drawings by Peter Tillemans, see Bailey, *op. cit.* (n. 1.36), pp. 50–69. For the imaginary tomb, see Vertue Notebooks (n. 2.42), iv, p. 40, and M. Vickers, 'Germanicus's Tomb', *The Ashmolean*, xv, 1, 1989, pp. 6–8. Lord Pomfret considered that the statues were in an unsatisfactory condition, which was not surprising after the rough treatment that they had received since arriving in England, and he therefore employed Giovanni Battista Guelfi in about 1721 to make botched repairs which roused the furious indignation of Michaelis, p. 39. Guelfi's additions were removed after the transfer of the marbles to the Ashmolean Museum in Oxford.

44 For John Talman (1677–1726), see T. Friedman, 'The English Appreciation of Italian Decoration', *Burlington Magazine*, cxvii, 1975, pp. 841–7, G. Parry, 'The John Talman Letter-Book', *Walpole Society*, lix, 1996–7, pp. 82–3. The inventory of 1719 lists a number of antiquities and bronzes, pp. 253–6. William Talman had, in fact, been superseded as architect at Chatsworth by Thomas Archer at the time of the letter quoted but John Talman may well have acted as agent for Lord Pembroke's acquisition of an obelisk, p. 27.

The second Duke of Devonshire (1672–1729) collected antiquities, including coins and gems. William Stukeley recorded 'several antique marbles', including inscriptions, 'an admirable antique Plato in the duke's library . . . also an antique ram's head' (*Itinerarium Curiosum*, ii, 1776, p. 26). The 1739 sale catalogue of George Montagu, Earl of Halifax (*c.*1685–1739), gives an unimpressive list of bronzes, lamps, busts and intaglios, probably inherited from his uncle, Charles Montagu, Earl of Halifax (1661–1715), who 'had a nice taste in antiquities and painting, and was a curious collector of them' (*Historical Manuscripts Commission, Egmont*, i, 1920, p. 106). For ancient busts, 'brought from Italy very curious', at Kiveton, another house with which Talman is connected, see T. Friedman and D. Linstrum, 'A Tour of Architectural Splendour', *Country Life*, cliii, 1973, p. 336. Kiveton belonged to the Duke of Leeds, Lord Lemster's father-in-law.

CHAPTER 3

1 For the Grand Tour, see Ingamells, and *Grand Tour*, exh. cat., Tate Gallery, London, ed. A. Wilton and I. Bignamini, 1996.

The term *cicerone* was in use by the early eighteenth century but it is unclear why the name of the Roman orator became attached to the profession of guide.

2 For Alessandro Albani (1692–1779), see *Dizionario biografico degli Italiani*, i, pp. 595–8. For his dealing activities, see L. Lewis, *Connoisseurs and Secret Agents*, 1961, pp. 154–61. Albani also enabled Lord Northumberland to obtain copies of famous paintings for the gallery of Northumberland House.

3 For Francesco de' Ficoroni (1664–1747), see *Dizionario biografico degli Italiani*, xlvii, pp. 395–6, and J. Spence, *Letters from the Grand Tour*, 1975, pp. 130–31, which gives an account of his troubles over the attempted sale of some green marble columns; in 1735 he was heavily fined for his illegal export activities. For Baron Philipp von Stosch (1691–1757), see Lewis, *op. cit.* (n. 3.2), *passim*.

4 H. Walpole, *Correspondence*, xiii, p. 231, and L. Sterne, *Tristram Shandy*, vii, iv. For the guide books, see E. Chaney, 'The Grand Tour and the Evolution of the Travel Book', in Wilton and Bignamini, *op. cit.* (n. 3.1), pp. 95–7.

5 Jonathan Richardson (1694–1771) was not a major artist but he and his father exercised considerable influence on British taste both through the *Account*, which was edited by the father,

and by their fine connoisseurship of old master drawings, based on the collection of padre Resta. For an account of his career, see C. Gibson-Wood, *Jonathan Richardson*, 2000.

6 Bear-leading was a miserable *pis aller* for some clergymen who could not obtain a benefice. See, for instance, the comments of Dr Syntax in William Combe's *A Tour in Search of the Picturesque by the Reverend Doctor Syntax*:

> And as I almost wanted bread,
> I undertook a bear to lead,
> To see the brute perform his dance,
> Through Holland, Italy, and France;
> But it was such a very Bruin,
> To be with him was worse than ruin;
> So, having pac'd o'er classic ground,
> And sail'd the Grecian isles around,
> (A pleasure, sure, beyond compare,
> Though link'd in couples with a bear)
> I took my leave and left the cub . . .

W. Combe (1741–1823) visited Italy 1765–6 (Ingamells, p. 232).

The Tour could be unkindly tantalizing, see the complaint in William Shenstone's *The Progress of Taste*, 'how great a Misfortune it is, for a Man of small Estate to have much Taste',

> And check me, when my bosom burns
> For statues, paintings, coins and urns.

7 For the papal edict of 1686, caused by French exports, see *Correspondance des Directeurs de l'Académie de France à Rome*, i, 1887, p. 153. For subsequent edicts, see R. T. Ridley, 'To protect the Monuments: The Papal Antiquarian (1534–1870)', *Xenia Antiqua*, i, 1992, pp. 117–54. See also A. Emiliani, *Leggi, Bandi e Provvedimenti per la Tutela dei Beni artistici e culturali negli antichi Stati Italiani 1571–1860*, 1978.

8 For Willem Bentinck (1704–1774), see Ingamells, pp. 78–80.

9 For Hamlet Winstanley (1694–1756), see Ingamells, pp. 1012–13, and F. Russell, 'The Derby Collection (1721–1735)', *Walpole Society*, liii, 1987, p. 151. Stukeley recorded some apparently antique busts and a number of statuettes at Knowsley, see *Itinerarium Curiosum*, 1776 ed., ii, p. 35.

10 For George Parker, second Earl of Macclesfield (*c.*1697–1764), see Ingamells, pp. 737–8, and T. P. Connor, 'The Fruits of a Grand Tour, Edward Wright and Lord Parker in Italy, 1720–22', *Apollo*, cxlviii, July 1998, pp. 23–30. The group of small bronzes cost £300. The leather mats, cut to size, are marked in Parker's hand with the name of the appropriate statue.

Molesworth wrote, 'As for statues and urns, it is of them, as of pictures, that good copies are better than scurvy originals: £500 would go but a little way in such ware made by the best hands here.' (*Historical Manuscripts Commission, Various Collections*, 1913, viii, p. 328).

Edward Wright (1680–1750) published *Some Observations made in Travelling through France, Italy &c in the Years 1720, 1721 and 1722* in 1730. For his comments on statues, see i, pp. 343–4.

For other early collections of miniature bronzes (Lord Harrold for Wrest in 1716, Lord Egmont, whose collection of paintings, antiquities and books, acquired in 1707, was captured by French privateers, and Lord Strafford for Wentworth Castle in 1715), see T. Friedman, 'Lord Harrold in Italy', *Burlington Magazine*, cxxx, 1988, pp. 836–45.

11 For James Dormer (1679–1741) and Rousham Park, Oxfordshire, see C. Hussey, *Country Life*, xcix, 1946, pp. 900–03 and 946–9, M. Jourdain, *ibid.*, civ, 1948, pp. 384–5, and Christie's sale, 11 December 1984, lot 106. For Kent's comment that the general was 'still bronzo mad', adding that he had just bought copies of the *Four Slaves* by Pietro Tacca at Leghorn, see A. H. Tipping, 'Four Unpublished Letters of William Kent', *Architectural Review*, lxiii, 1928, p. 209.

For the numerous classical replicas made by Scheemakers for Chiswick, Corsham, Stowe and other houses, see I. Roscoe, 'Peter Scheemakers', *Walpole Society*, lxi, 1999, pp. 163–304.

12 For James Johnston, second Marquess of Annandale (1688–1730), see J. Fleming, *op. cit.* (n. 2.17), pp. 8–13 and pl. 5, which shows the collector elegantly proffering an antique statuette. His marbles were probably destined for the decoration of Hopetoun House which his brother-in-law was redecorating at this time. Despite his views on Ficoroni, the antiquarian published a pamphlet addressed to him, *Lettera scritta all' Ill., ed Eccell. Sig. Giacomo Lord Johnstone . . . sovra un nuovo Cameo*, 1718.

13 For Richard Topham (1671–1730), see G. Parry, *op. cit.* (n. 2.44), H. Macandrew, 'A Group of Batoni Drawings at Eton College', *Master Drawings*, xvi, 2, 1978, pp. 131–50, and L. M. Connor, 'The Topham Collection of Drawings', *Eutopia*, ii, 1, 1993, pp. 25–39. Topham, who may have visited Italy himself between 1692 and 1695, owned 703 prints and 2432 drawings but only three statues, a bas-relief and a few inscriptions. Dr Mead was his executor.

14 For typical problems of obtaining reproductions, see, for instance, Spence, *op. cit.* (n. 3.3), p. 334,

writing to Dr Antonio Cocchi in 1740, 'When I was at Florence, I went two or three times to see the labours of Hercules on an old marble at the Niccolini palace, but never could get the sight of it. If they are . . . good work, I should be extremely obliged to you if you could get them drawn for me by the best hand you have in Florence, on a large sheet of paper of a fit size for a folio book.'

For the importance of P. A. Maffei's *Raccolta di Statue antiche e moderne*, see Haskell and Penny, *op. cit.* (n. 1.1), p. 23.

15 For Henry Hare, third Lord Coleraine (1693–1749), see Ingamells, p. 229; he also had a modest collection of coins, busts and vases, sold in 1754. His grandfather, the second Lord Coleraine, bought books and coins from William Courten to whom he wrote on St Valentine's day 1695, 'Medals are now become my Mistresses.', British Library, Sloane MS 3962, f. 258.

For his trip with Middleton to Italy where he met Scipio Maffei and became a member of the Arcadians, see J. Nichols, *Literary Anecdotes*, v, 1812, pp. 347–52. The number of different bindings and bookplates indicates that Coleraine's extensive library of Italian books on history, art, antiquities and religion was built up over a number of years both from English and Italian sources.

16 For Conyers Middleton (1683–1750), see Ingamells, pp. 658–9 and Walpole, *Correspondence*, xv, pp. 1–25. For his correspondence with Ficoroni, see Speier and Kagan, *op. cit.* (n. 2.15), pp. 52–63. For some of the other antiquities collected by Horace Walpole (1717–1797), see M. Brownell, *The Prime Minister of Taste*, 2001, pp. 12–24.

17 For Henry Somerset, third Duke of Beaufort (1707–1745), see Ingamells, pp. 67–9, and Christie's sale catalogue, 5 July 1990. For the sarcophagus, confusingly described as an 'urn' in the correspondence, see *Bulletin of the Metropolitan Museum of Art*, xiv, 1955–6, pp. 15 and 39–47. For Beaufort's proposed acquisition of sarcophagi from the *columbarium*, see A. F. Gori, *Monumentum sive columbarium libertorum et servorum Liviae Augustae*, 1727, p. xx. Guernieri's letters to the duke are in the 'Red Folder', Badminton Archives. He told the duke that the sarcophagus had been valued by the Customs officers at 2000 *scudi* for the purposes of calculating the 3 per cent export duty but he had negotiated the duty down from 60 *scudi* to 10. Beaufort also bought some unimportant marble busts and vases and the nefarious William

Philips, his tutor, seems to have bought busts for resale in London; he offered these at Cock's auction rooms together with some of the duke's own acquisitions, which he had purloined.

18 For Houghton, see C. Campbell, *Vitruvius Britannicus*, iii, 1725, p. 8, H. Walpole, *Aedes Walpolianae*, 1752, Moore, *op. cit.* (n. 2.22), p. 24, *Houghton Hall*, exh. cat., Norwich Castle Museum, ed. A. W. Moore, 1996, pp. 110–16, and Poulsen, *op. cit.* (n. 2.22), pp. 11–12, 34–5, 39, 47–9, 69, 75, 98 and 102.

For E. Walpole (1706–1784), who may have bought some of the busts, see Ingamells, p. 974. For O. Swiney or McSwiney (1676–1754), see Ingamells, pp. 919–20. For General Charles Churchill (*c*.1679–1745), see Ingamells, pp. 204–5. Two busts were acquired from a Mrs Vernon of Twickenham. The rest were probably bought by Kent through agents in Italy.

Kent was keen on introducing an antique atmosphere in his interiors: there is *trompe l'oeil* statuary on the staircase at Raynham and at Moor Park and gilded lead classical replicas in Kensington Palace. In 1730 he also proposed an astonishing painted frieze showing an antique procession circling the Painted Chamber in the Palace of Westminster, see J. Harris, *William Kent 1685–1748*, exh. cat., Sir John Soane's Museum, London, 1998, p. 22.

19 For Richard Boyle, third Earl of Burlington (1694–1753), see Ingamells, pp. 160–61, and J. Harris, *The Palladian Revival*, 1994, pp. 40, 62 and 184. The Arundel fragments were re-excavated from the Kennington wharf in about 1712, but it is improbable that Burlington acquired them as early as this. He is said to have met the excavator's son at the Royal Society or at Sir Hans Sloane's house; since he was not elected F. R. S. until 1722, the acquisition is more likely to have occurred after that date (*Gentleman's Magazine*, July 1769, p. 352). The relief was not installed under the obelisk until 1732. For the senators' seats, see T. Faulkner, *The History and Antiquities of Brentford, Ealing and Chiswick*, 1845, p. 430.

It is not possible to construct a coherent philosophical theme from the statues set in the exedra because Kent was not particular about the statues that he used. He chose replicas of the *Dying Gladiator* and the *Lion attacking a Horse* from the Capitol to adorn, beautifully but quite incongruously, the Arcadian vistas of his landscape at Rousham for General Dormer.

20 For the purchase of statues in 1723 by Charles Howard, third Earl of Carlisle (1669–1738), see R. Gunnis, *Dictionary of British Sculptors*, pp.

82–3, which gives a list of the statues that Carpentière could supply, and C. Saumarez Smith, *The Building of Castle Howard*, 1990, p. 139. See also Whistler, *op. cit.* (n. 2.42), p. 80. For the poor quality of the reproductions, see J. Dallaway, *Anecdotes of the Arts in England*, 1800, p. 270, 'In the beginning of the [eighteenth] century, these magazines of images were in Piccadilly, and excited a constant topic of national ridicule from all foreigners of taste. Their imitations of the antique were wretched beyond all criticism.'

For the decay of the antiquities, see W. Stukeley's comment: 'In the garden are many altars and inscriptions . . .: with much regret I saw these noble monuments quite neglected and exposed: some cut in half to make gate-posts.', *Itinerarium Curiosum* (n. 2.44), ii, 1776, p. 58. For the collection of busts, reliefs and statues, some of them antique, belonging to Sir Thomas Robinson (*c.*1702–1777), see P. Russell, *England Displayed*, 1769, ii, p. 154. A few of these marbles are still at Rokeby.

For the distribution of replicas at this period, see n. 2.41 above. Alexander Pope describes the statues at Timon's Villa, *Epistle to Lord Burlington: Of the Use of Riches*, 1731:

> Here Amphitrite sails thro' myrtle bow'rs;
> There Gladiators fight, or die, in flow'rs,
> Unwater'd see the drooping sea-horse
> mourn,
> And swallows roost in Nilus' dusty Urn.

It is probable that the 'virtues and busts' brought to Dublin from Italy in the 1720s by Robert Clayton, Bishop of Killala, were also copies (Ingamells, p. 213).

21 For Henry Howard, fourth earl of Carlisle (1694–1758), see Ingamells, p. 181, Michaelis, pp. 325–32, and 'Ancient Marbles in Great Britain', *Journal of Hellenic Studies*, vi, 1885, pp. 33–41, Vermeule, 1955, pp. 136–7, and C. Ridgway, Introduction to Sotheby's sale catalogue, 14 December 1995. His eldest son, Lord Morpeth, predeceased his father in 1741.

22 For Amadei's anxiety and also the involvement of Girolamo Odam, see Castle Howard Archives J 12/11/8. For the ruses of Rosa, see J 12/11/2. Carlisle continued to correspond with Ficoroni until the death of the latter in 1747, J 12/11/7.

23 For the offer of drawings, see Amadei's letter of July 1745, 'If you want to see drawings first, I shall have them made.' (Castle Howard Archives J 12/11/10). Amadei also sent a priced list of ten antiquities from the villa and palace of an unspecified Roman family, describing their locations as an *aide memoire*, as if Carlisle had already seen the originals *in situ*, J 12/11/11. For references to restoration, see J 12/11/6 (restoration costs of 150 *scudi*), 12/11/8 (restoration of the *Bacchus*, now in the Hall), 12/11/14 (costs), 12/11/16 (the choice of a cheaper restorer) and 12/11/17 ('the head, shoulders, arms and feet are so well restored you could not tell the difference' – the recumbent statue was, nevertheless, placed high up in the Hall, where it was not easy to investigate).

24 For Gale's visit, see Lukis, *op. cit.* (n. 2.15), p. 361. The probate inventory of 1759 records nine unspecified statues, eight busts and two urns in the Hall, which is very much the current disposition of marbles (Castle Howard Archives, F 4/1, f. 13). The inventory lists more antiquities in the Saloon, the State Drawing Room, the State Dressing Room, the East End Room or Gallery, the Dressing Room to the North and the Library. A description of the contents of the Hall in 1769 lists *Marcus Aurelius, Bacchus, Ceres* and *Augustus* which are still there today (Russell, *op. cit.* (n. 3.20), ii, p. 145).

25 For Carlisle's gems, see Scarisbrick, *op. cit.* (n. 2.32) which publishes Zanetti's correspondence, O. M. Dalton, *Catalogue of the Engraved Gems of the Post-Classical Periods*, 1915, H. B. Walters, *Catalogue of the Engraved Gems and Cameos, Greek, Etruscan and Roman*, 1926, *The Treasure Houses of Britain* (n. 2.30), pp. 285–6, and Walpole, *Correspondence*, xiii, p. 214.

The inventory of 1759 lists 'a curiously inlaid chest containing the late Lord Carlisle's Cameos &c sealed up', which had been brought from Carlisle's London house (Castle Howard Archives, F 4/1, f. 84).

Zanetti's own collection was published in 1750 by Antonio Francesco Gori, *Dactyliotheca Zanettiana*, illustrating his best pieces with a commentary and, in many cases, their provenance. A *Triumph of Galatea* had been acquired from Conte Gioseffo Calvi, who had turned down offers from 'several rich English gentlemen', p. 112.

26 Castle Howard Archives, J 14/1/600. See also the comment of another future collector, Lord Palmerston, in 1760, 'a great collection of fine Marbles and Busts', D. Grassinger, *Antike Marmorskulpturen auf Schloss Broadlands*, 1994, p. 16.

27 For Thomas Coke, Earl of Leicester (1697–1759), see Ingamells, pp. 225–6, J. Lees Milne, *The Earls of Creation*, 1962, pp. 221–63, Moore, *op. cit.* (n. 2.22), pp. 32–9. It is worth noting that his grandmother, Anne Coke, was daughter of the Duke of Leeds, who collected antiqui-

ties, and sister-in-law of the Lord Lemster who acquired some of the Arundel Marbles.

The ilexes round Holkham are said to have grown from acorns used as packaging for Coke's marbles. A similar story is told about the trees at Broadlands.

28 Holkham Archives, Papers of the Coke Family, ii, f. 46, Coke to his grandfather, Sir John Newton, 24 May 1714.

29 For Kent's letter to Burrell Massingbeard, dated 15 June 1717, see M. Jourdain, 'Early Life and Letters of William Kent' in *Country Life*, xcvi, 1944, p. 334.

For the statues of *Diana* and the consular figure, then called *Lucius Antonius*, see P. A. Maffei, *Raccolta di Statue antiche e moderne*, 1704, pls cxlv and cxlvii and pp. 136–40.

Francesco Bartoli (1675–1730) supplied Coke with many of the original drawings for the archaeological works by his father, Pietro Santi Bartoli (1635–1700), as well as an outsize drawing of the altar of St Ignatius in the church of the Gesù, with little figures of a Jesuit priest showing off the baroque splendours to Hobart and his charge. There are frequent references in the account books to payments to Bartoli, 'the servant of Monsignor Bianchini', Ficoroni and others for drawings of antique statues, paintings, stucco work and intaglios. The archaeological drawings are similar to some of those acquired by Richard Topham. Bartoli sold other drawings to John Talman. For the lives of Bartoli, father and son, see *Dizionario Biografico degli Italiani*, vi, pp. 572 and 586–8.

30 Kent supplied Coke with a 'consular Statue' for 200 *scudi* in 1718 and two cinerary urns for 15 *scudi*, after the latter had left Italy. For the grand entertainment given by John Talman for Lord Cornbury, see Friedman, *op. cit.* (n. 2.44). Talman urged Cornbury to commission a vast allegorical painting from Giuseppe Chiari, an artist subsequently employed by Coke.

31 For Leicester's collection, see M. Brettingham, *The Plans, Elevations, and Sections of Holkham . . . and also, a Descriptive Account of the Statues, Pictures, and Drawings*, 1773, Michaelis, pp. 302–23, Vermeule 1955, p. 136, and 1959, pp. 153–6, Poulsen, *op. cit.* (n. 2.22), pp. 13–14, 27–9, 32–3, 46–7, 53–4, 62, 79–80, 82–3, 87–8, 96–8, 103–4, 106, 108 and 112, J. Kenworthy-Brown, 'Matthew Brettingham's Rome Account Book 1747–1754', *Walpole Society*, xlix, 1983, pp. 37–132, and E. Angelicoussis, *The Holkham Collection of Classical Sculptures*, 2001, in which it is argued that the statues are arranged in a thematic programme.

For Carlo Costanzi (1705–1781), one of the best gem carvers of his day, see *Dizionario biografico degli Italiani*, xxx, pp. 369–70. Cardinal Silvio Valenti Gonzaga (1690–1756) was himself a cultivated collector.

32 Bartolomeo Cavaceppi (c.1716–1799) was the leading restorer in Rome. For his work on statues for Holkham, see S. Howard, *Bartolomeo Cavaceppi, Eighteenth-Century Restorer*, 1982, pp. 32–44. For a rehabilitation of Cavaceppi's practices, see Angelicoussis, *op. cit.* (n. 3.31), pp. 136 and 138–9. For the practices of restorers in Rome at a slightly earlier period, see J. Montagu, *Roman Baroque Sculpture*, 1989, pp. 151–69.

33 *Specimens of Antient Sculpture, Aegyptian, Etruscan, Greek, and Roman: selected from different Collections in Great Britain by the Society of Dilettanti*, i, 1809, on pl. xl.

34 Holkham Archives, Letters from Leicester to M. Brettingham senior. The sarcophagus was not bought for the niche and the final arrangement of statues in the gallery was changed, the *Diana* being swapped for an *Apollo* over the chimney. In the same letter Leicester tells Brettingham that he is not interested in the remains of the Arundel Marbles from Lord Pomfret's collection, which would have been too numerous for Holkham.

35 For a detailed account of Leicester's adaptation of his plans for Holkham to accommodate his growing collection, see Angelicoussis, *op. cit.* (n. 3.31), pp. 43–72.

36 A. Young, *A Six Weeks Tour, through the Southern Counties of England and Wales*, 1768, p. 11. Lord Palmerston noticed the 'very fine antique statues and busts' on his visit in 1758 (Grassinger, *op. cit.* (n. 3.26), p. 15).

37 For the letter to Brettingham, see Lees-Milne, *op. cit.* (n. 3.27), p. 262. Coke had published in 1723 the remarkable manuscript of the Scottish lawyer, Thomas Dempster (d. 1625), which formed the basis of most subsequent studies of the Etruscans.

38 For William Holbech (c.1699–1771), see Ingamells, pp. 507–8. For the marbles, see the account of the anonymous antiquary who visited Farnborough in 1746 and saw 'several busts of white marble, one of black; and two alto relievos, one of Socrates, and the other (as it seems) of Lucius Verus. All brought from Rome with two pictures, one of the Rotunda, and the other of diverse buildings by Panino', British Library, Add. MS 6230, f. 32v, and A. Scholl, *Die antiken Skulpturen in Farnborough Hall*, 1995. For the letter to Carlisle, see Castle Howard Archives, J 12/11/10.

CHAPTER 4

1 For difficulties in seeing the discoveries, see, for instance, Walpole, *Correspondence*, xiii, p. 223.

J. W. Goethe, *Italian Journey*, 1962, p. 203, 13 March 1787.

2 For the Museo Pio Clementino and its contents, see Wilton and Bignamini, *op. cit.* (n. 3.1), pp. 241–9.

3 For the Villa Albani, see W. O. Collier, 'The Villa of Cardinal Alessandro Albani, Hon. F. S. A.', *Antiquaries Journal*, lxvii, 1987, pp. 338–47. The cardinal was elected to the Society of Antiquaries of London in 1761.

4 For Sir Roger Newdigate (1719–1806), see Ingamells, pp. 704–5. For his letters about the acquisition and for his offer in 1806 to pay £2000 to rehouse the marbles, see *The Correspondence of Sir Roger Newdigate*, Dugdale Society, xxxvii, 1995, pp. 76–9, and pp. 315–19. The Gothic building of the 1757 Almanac is perhaps in deference to the tastes of Lady Pomfret and Sir Roger, who both built houses in Gothick revival style.

Richard Chandler's *Marmora Oxoniensia*, 1763, published the marbles and transcribed the inscriptions presented through John Evelyn's efforts as well as subsequent acquisitions.

5 *Ionian Antiquities*, apparently inaccurately, gives the date of the Society's foundation as 1734, p. i. Walpole, *Correspondence*, xviii, p. 211, refers to the drunken behaviour of the members. For travel in the eastern Mediterranean, see J. Mordaunt Crook, *The Greek Revival*, 1972. For William Ponsonby's collections, see nn. 4.40 and 5.37 below. Sir Francis Dashwood, Lord Le Despencer (1708–1781), also collected a few antiquities; for a sarcophagus at West Wycombe, see Vermeule 1956, p. 346.

6 For John Montagu, fourth Earl of Sandwich (1718–1792), see Ingamells, pp. 839–40. His journal, *A Voyage performed by the Late Earl of Sandwich round the Mediterranean in the years 1738 and 1739*, 1799, was edited by his chaplain, John Cooke.

J. Spence, *Letters*, 1975, p. 249.

7 For James Caulfield, first Earl of Charlemont (1728–1799), see Ingamells, pp. 196–9, and *The Travels of Lord Charlemont in Greece & Turkey*, ed. W. B. Stanford and E. J. Finopoulos, 1984. He acquired a Greek *stele* and some Egyptian antiquities on his voyage but in Italy he concentrated on reproductions of busts and statues both in bronze and marble. He did, however, obtain a licence to export three antique heads (Bertolotti, *op. cit.* (n. 1.32), iv, 1880, p. 82). He bought coins from the apothecary Borioni

which he kept in a magnificent medal cabinet, designed by Sir William Chambers, now in Somerset House. His tutor, Edward Murphy (1707–1777), commissioned from Simon Vierpyl copies of 100 antique busts and statues which were placed in Charlemont's Dublin house. Most of these are now in the Royal Irish Academy but the rest of Charlemont's collection was dispersed in the nineteenth century (C. O'Connor, *The Pleasing Hours*, 1999, and *Lord Charlemont and his Circle*, ed. M. McCarthy, 2001).

For Richard Dalton (?1713–1791), see Ingamells, pp. 267–70; some of his drawings of the Parthenon sculpture and the frieze at Halicarnassus are in the British Museum. Piranesi, *Della Magnificenza ed Architettura de'Romani*, 1761, p. cxci.

For the relief acquired by Stratford Canning, first Viscount Stratford de Redcliffe (1786–1880), the distinguished British ambassador to the Porte, see A. H. Smith, *A Catalogue of Sculpture in the Department of Greek and Roman Antiquities, British Museum*, ii, 1900, pp. 139–40.

8 J. Stuart and N. Revett, *The Antiquities of Athens*, 1762, i, preface, p. i.

For James Stuart (1713–1788) and Nicholas Revett (1720–1804), see Colvin, *op. cit.* (n. 2.9), pp. 938–42 and 806–8. The third volume of *The Antiquities of Athens* was published in 1795, edited by Willey Reveley, and a fourth was issued by Josiah Taylor in 1816, with a memoir of its authors by Joseph Woods. Such marbles as were acquired were entrusted to Thomas Brand, on whose death in 1771 they went to Lord Clanbrasil and then to Lord Bessborough. A fragment from the Parthenon was lent to the Royal Academy and stayed there until 1817, when it was given to the British Museum. The inscriptions were given to the Museum in 1784.

9 For James Dawkins (1722–1757) and Robert Wood (?1717–1771), see Ingamells, pp. 283 and 1015–16.

10 R. Chandler, *Travels in Greece*, 1776, p. 50.

For Richard Chandler (1738–1810), see *Dictionary of National Biography*, x, pp. 40–41. Revett's copy of Chandler's *Travels in Asia Minor*, 1775, in the British Library contains his disparaging manuscript comments on his travel companion's narrative. His fragments of heads of a man and a horse are now in the British Museum.

11 Peacham, *op. cit.* (n. 1.37), pp. 119–20.

Inscriptions were, for instance, brought back by Antony Askew (1722–1774), for whom, see Ingamells, p. 31. In about 1748 he 'brought

home with him a large number of Inscriptions, never taken notice of before, which he collected in the islands of the Archipelago', British Library, Add. MS 41169, f. 36. Lyde Browne acquired three of these in the sale after Askew's death and passed them on to Charles Townley, including a fine Attic grave relief of Xanthippus. Edward Wortley Montagu (1678–1761) acquired a few Greek inscriptions while he was ambassador to the Porte. These were presented to Trinity College, Cambridge, after his death, Michaelis, pp. 114 and 269–70. For other acquisitions made in the eastern Mediterranean at this period, see Michaelis, pp. 113–14.

12 For the papal licensing system, see J. Dallaway, *Anecdotes of the Arts in England*, 1800, p. 274, Ridley, *op. cit.* (n. 3.7), and *The Pope's Archaeologist*, 2000, pp. 101–23, and C. Pietrangeli, 'The Discovery of Classical Art in Eighteenth-Century Rome', *Apollo*, cxvii, 1983, pp. 380–91. The decree of Clement XI, who was the uncle of Cardinal Albani, was followed by similar regulations in 1717, 1726, 1733 and 1750. There were restrictions on exports in Tuscany from 1754, while Pierre Mariette's correspondent, padre Paolo Maria Paciaudi, wrote from Naples in 1761, 'The Etruscan [*sic*] vases will leave for Marseilles in a little box . . . Antiquities are not meant to leave the country and any export of this sort is contraband. I haven't made an application for a licence because it would be refused. I have used the expedient of sending them out described as porcelain.' (*Lettres de Paciaudi au Comte de Caylus*, 1802, p. 275).

J. Addison, *Remarks on Several Parts of Italy, &c. in the Years 1701, 1702, 1703, 1705*, pp. 335–7. For a later period, see G. Hamilton's letters to Lord Shelburne in 1772, reprinted in Christie's Catalogue, 5 March 1930, p. 78, 'the purchase of ground at Albano', and p. 83, 'Monte Rotondo, where I have purchased my chance, as I did at Tivoli' and Genzano, which 'will cost me dear, as the proprietor is a rich man and not ignorant of the value of this spot'. See also BM, TY7/554, November 1773, 'I have given a sum of money . . . for my chance in the *cava* at Civita Lavinia'.

13 For Hamilton's account, see BM, TY7/633. The text is given by A. H. Smith, 'Gavin Hamilton's letters to Charles Townley', *Journal of Hellenic Studies*, xxi, 1901, pp. 306–21.

14 Gavin Hamilton frequently complains about the problems of obtaining export licences. 'January 1772, I have paid to the Pope's Treasurer the value of the 3rd part of the antiquities of my Cava at Columbaro, and consequently may call

the Meleager and everything else my own, yet there is a strong party formed against me . . . They have informed the Pope that it is the original and the one at the Belvedere the copy.' Christie's Catalogue, 5 March 1930, p. 79. 'January 1773, His Holiness seems to have very extensive views with regard to the new Museum, and the difficulties of sending away antiques increase daily. They have laid hold of my fine statue that I found at Albano [a *Discobolus*], notwithstanding that I had already got my licence signed; a thing never practised before.' *ibid.*, p. 85. By way of contrast, 'February 1775, I am now full of fine things, but we want dilettanti. Never was a time so apropos for sending off antiques as at present, having no Pope [following the death of Clement XIV], nor are we likely to have one soon.' *ibid.*, p. 91.

15 G. B. Visconti (1722–1784) was responsible for the organization of the new Pio Clementino museum. He started to publish the catalogue of the sculpture in the Vatican, which was continued by E. Q. Visconti (1751–1818).

16 For the successful retention of virtually all major statues, see Haskell and Penny, *op. cit.* (n. 1.1), p. 67. Sir William Hamilton, who visited Clement XIV in 1773, reported that the papal collection had been formed 'to curb prodigious exportation of valuable monuments of antiquity' (PRO 93/28, 12 and 19 January, 1773).

Pius VI was so keen on archaeology that he occasionally authorized the Antiquary himself to undertake excavations.

For smuggling, see G. Hamilton in Christie's Catalogue, *op. cit.* (n. 4.14), July 1772, and August 1772, p. 81, 'The Under Antiquarian alone is in the secret, to whom I have made an additional present, and hope everything will go well.'

17 G. G. de Rossi (1754–1827), *Il Calzolaio Inglese in Roma*, published in 1790 but written earlier. The author had a collection of Greek vases which he sold to Sir John Coghill.

18 For the dispersal of the Mattei collection, see L. Hautecoeur, 'La Vente de la Collection Mattei', *Mélanges d'Archéologie et d'Histoire, Ecole Française de Rome*, xxx, 1910, pp. 57–75. The selection of marbles for the pope was made by the sculptor Gaspare Sibilla and the Papal Antiquary, G. B. Visconti. Visconti was a friend of Jenkins and was not, perhaps, an entirely impartial appraiser of his export licence applications, because his son, E. Q. Visconti, edited a catalogue of Jenkins's inscriptions, *Catalogo di Monumenti Scritti del Museo del Signor Tommaso Jenkins*, 1787.

In the year that the Mattei sculptures entered the papal collection, the Pighini *Meleager*, which

Arundel had sought to buy, was acquired for 6000 *scudi*, payable over six years.

For the dispersal of the statues from Villa d'Este, see T. Ashby, 'The Villa d'Este at Tivoli', *Archaeologia*, lxi, 1909, pp. 219–56. In 1753 Benedict XIV secured fourteen pieces for the Capitoline Museum at a price of 5000 *scudi*, after which the rest of the collection was broken up among dealers.

19 J. Richardson, *An Essay on the Theory of Painting*, 1725, pp. 222–3.

20 For Thomas Jenkins (1722–1798), see B. Ford, *Apollo*, xcix, 1974, pp. 416–25, and Ingamells, pp. 553–6. His correspondence with Townley is in the British Museum (BM, TY7/297–550). For hostile views, see the letter to the Duke of Dorset, 25 January 1772, at the Centre for Kentish Studies, Maidstone, Sackville Archives, U 269c 194. For his purchase of the contents of Villa Negroni, see BM, TY7/427 and 428 and, for the price list, 450. He occasionally conducted syndicated excavations as in 1779, when he combined with Thomas Brand and Aubrey Beauclerk, later Duke of St Albans (BM, TY7/387).

21 J. T. Smith, *Nollekens and his Times*, 1828, i, pp. 11 and 250, and ii, p. 62. For J. Nollekens (1737–1823), see Ingamells, pp. 709–11. He combined his very successful practice as a sculptor with dealing in antiquities and, on his return to England, supplied clients such as Sir Christopher Sykes at Sledmere with marbles for his Hall.

22 For these transactions, see Michaelis, pp. 527–30, where alternative versions of the notorious deals are given. For the restorations declared on the *Venus*, see Bertolotti, *op. cit.* (n. 1.32), 1878, ii, p. 216.

For a dubious transaction, for which Jenkins was threatened with exile in 1753 at the start of his career, see Lewis, *op. cit.* (n. 3.2), pp. 167–9.

For Jenkins's supply of drawings to Townley, see I. Jenkins in Wilton and Bignamini (eds), *op. cit.* (n. 3.1), pp. 228–9, 257 and 263–9.

23 For Jenkins's lending, see n. 5.45 below. He arrived in England wearing 'a girdle containing many cameos and intaglios' (BM, TY1/10).

24 For G. Hamilton (1723–1798), see Ingamells, pp. 447–50. His correspondence with Townley is in the British Museum (BM, TY7/551–672). His account of his excavations up to 1780 is given in a memorandum to Townley, BM, TY7/638.

For his problem of reconciling clients' priorities, see Townley's complaints in 1775 (BM, TY7/580/2) and again in 1776 (BM, TY7/606/2), 'You have sent your most valuable articles to other persons and your more inferior ones to me.' Cardinal Albani also expected to receive favoured treatment (BM, TY7/563).

25 For C. Morison (1732–1810), see Ingamells, pp. 679–82. The relief, improved by the addition of a Priapus, is illustrated in G. B. Piranesi, *Vasi, Candelabri, Cippi*, i, pl. 43, J. Wilton Ely, *Giovanni Battista Piranesi, the Complete Etchings*, ii, 1994, p. 1006, no. 928.

26 For R. Fagan (1761–1816), see Ingamells, pp. 346–7, and R. Trevelyan, 'Robert Fagan: An Irish Bohemian in Italy', *Apollo*, xcvi, 1972, pp. 298–311.

27 For J. Byres (1734–1817), see Ford, *op. cit.* (n. 4.20), pp. 446–61, Ingamells, pp. 169–72, and D. Ridgway, 'James Byres and the ancient State of Italy', *Atti*, Second International Etruscan Congress, 1985, published as Supplement to *Studi Etruschi*, 1989, pp. 213–29. Byres was recognized as a serious scholar but, when he visited London in 1767 to solicit subscriptions for his planned volume on the history of the Etruscans, he failed to arouse sufficient interest and the work never materialized. He left Rome in 1790 and retired to his family estates in Scotland, where he died.

Other *ciceroni* who dealt in antiquities included Mark Parker (*c.*1698–1775), described as 'a noted antiquarian' by Horace Mann, James Russel (*c.*1720–1763), the artist and author of *Letters from a young Artist abroad*, Matthew Nulty (*c.*1716–1778), whose collection, sold in London after his death, indicates that he kept a stock of antiquities for sale to Tourists, James Clark (*c.*1745–1800), a Scottish artist who specialized in vases, and Patrick Moir (1769–1810), James Byres's nephew and successor, see Ingamells, pp. 739–40, 830–32, 717–18, 208–9 and 665.

Although Sir William Hamilton acted as middleman in several major transactions, including the sale of the *Warwick Vase*, he was careful to avoid being categorized as a dealer.

28 Cavaceppi accompanied Winckelmann in 1768 on the expedition back to Germany that was brought to a tragic end when the Papal Antiquary decided to return to Italy and was murdered in Trieste. For his British customers, who included Charles Townley, Henry Blundell, Thomas Anson and William Lock of Norbury, see S. Howard, *op. cit.* (n. 3.32), pp. 31–100. His other customers included Frederick II of Prussia, who bought through Giovanni Ludovico Bianconi, Catherine of Russia and José Nicolas de Azara, the Spanish ambassador. He left his collections to the Accademia di S.

Luca, but his family contested the will and his property was dispersed, see *Bartolomeo Cavaceppi*, exh. cat., Palazzo di Venezia, Rome, ed. M. G. Barberini and C. Gasparri, 1994.

29 For Piranesi (1720–1778), see J. Wilton Ely, *The Mind and Art of Giovanni Battista Piranesi*, 1978, and J. Scott, *Piranesi*, 1975.

For his Pantanello confections, see J. Scott, 'Some Sculpture from Hadrian's Villa, Tivoli', in *Piranesi e la Cultura antiquaria*, 1983, pp. 339–47. Piranesi also used antique fragments to decorate marble chimneypieces, which he sold to British visitors, including Grenville, see J. Scott, 'Another Chimney Piece by Piranesi', in *Piranesi tra Venezia e l'Europa*, ed. A. Bettagno, 1983, pp. 51–7.

For the clutter in his house, see Jenkins's letter, 12 December 1770 (BM, TY7/304).

30 For the *Warwick Vase*, see I. Jenkins, in *Vases & Volcanoes*, exh. cat., British Museum, London, ed. I. Jenkins and K. Sloan, 1996, pp. 220–22.

31 For the Townley fake, see B. F. Cook, *The Townley Marbles*, 1985, pp. 49–50. In a letter to Townley in November 1768, Jenkins mockingly calls Piranesi 'Cavaliere Candelabri' because of the three massive candelabra (the two now in Oxford and one in the Louvre) which he claimed to have found at Hadrian's Villa (BM, TY7/298).

32 For the comment on Tavistock, see J. Dallaway in J. Nichols, *Illustrations of the Literary History of the Eighteenth Century*, iii, 1819, p. 728. The unrestored fragments in the collections of Lord Bessborough and Lyde Browne were unusual.

33 For C. Albacini, see G. Vaughan, 'Albacini and his English Patrons', *Journal of the History of Collections*, iii, 2, 1991, pp. 183–97.

Smith in his life of Nollekens, *op. cit.* (n. 4.21), ii, p. 62, relates that Roubiliac used to mend broken antiquities by adding to his plaster a mixture of grated Gloucester cheese, the grounds of porter and the yolk of an egg, which, when dry, forms a very hard cement.

Edward Gibbon, writing in 1764 after a visit to the Uffizi, expressed concern about building theories, like those of A. F. Gori, on the whims of a modern sculptor since most of the attributes of gods and heroes were new, see *Gibbon's Journey from Geneva to Rome*, 1961, p. 178.

34 A. Cunningham, *The Lives of the Most Eminent British, Painters, Sculptors, and Architects*, iii, 1830, pp. 78–9.

35 J. Barry (1741–1806), *Works*, i, 1809, pp. 125–6. He was in Italy 1766–71. Jenkins told Townley that he had invited Piranesi and Cavaceppi to his New Year's Day dinner and expected

'kicking or cuffing will be the event, as there is much ill blood between them, Cavaceppi having in a book he published, strongly hinted at the Cavalier's *pasticci*, which he has fixed to himself by taking notice of it' (12 December 1770, BM, TY7/304).

36 Jenkins describes gems as 'being objects of a small bulk, consequently not subject to the caprice of absolute Despotism' (BM, TY7/491).

Lord Chesterfield, *Letters to his Son*, 1975, p. 124.

37 Tassie's impressions (see n. 4.42 below) included gems from the collections of all the Dilettanti members in the Reynolds group portrait (Lord Mulgrave, Lord Dundas, Lord Seaforth, Charles Greville, John Crowle, Joseph Banks and Lord Carmathen) apart from Crowle and Banks. Seaforth, then Lord Fortrose, acquired minor antiquities in Naples, as is shown in the paintings of his rooms there by Pietro Fabris, now in the Scottish National Portrait Gallery.

For the wearing of cameos, see Walpole, *Correspondence*, xxxix, p. 241, and J. B. S. Morritt, *A Grand Tour Letters and Journeys 1794–96*, 1985, p. 306. Gems are, however, worn in portraits of Lord Newborough and Thomas Robinson by N. Dance and of Lord Bristol by H. D. Hamilton, as well as that of John Smyth by Batoni, while the latter's portraits of Sir Edward Dering shows him both wearing a ring and holding a cameo. For the general subject of wearing rings and cameo brooches and necklaces, see D. Scarisbrick, *Jewellery in Britain 1066–1837*, 1994, pp. 254–7 and 330–34. The fifth Duke of Devonshire certainly wore gems: a ring is recorded as 'Taken out by the Duke and lost off His Grace's finger, March 1771', see E. Strong, typescript list of gems at Chatsworth, p. 11.

38 For L. Natter (1705–1763), see J. Kagan and O. Neverov, 'Lorenz Natter's *Museum Britannicum*', *Apollo*, cxx, 1984, pp. 114–21 and 162–9. Natter's *Treatise* is illustrated with examples of a few gems from the collections of the Duke of Devonshire, Lords Carlisle and Duncannon (later Bessborough) and Dr Mead. His catalogue may not, however, be accurate about some collections, notably that of Thomas Hollis, see T. V. Buttery, 'Natter on Gem Collecting', *Journal of the History of Collections*, ii, 2, 1990, pp. 219–26. Natter's manuscript catalogue of the Devonshire gem collection is at Chatsworth.

For a defence of forgery, see G. Cumberland, *Thoughts on Outline . . .*, 1796, p. 23, quoting with approval the biographer of the engraver

Johann Anton Pichler (1734–1791), the best of whose gems 'may be said to be now no longer his, because having been already adjudged to be antiques by the first rate *intendenti*, it would be criminal to lift up the veil that conceals them, and restore them to their author'. Cumberland blamed the dealers who were responsible for passing off the new as old rather than the maker.

39 For William Cavendish, second Duke of Devonshire (1672–1729), see J. Grove, 'The Life of William, the Second Duke of Devonshire', in *The Lives of all the Earls and Dukes of Devonshire*, 1764, p. 114. The fourth Duke is probably the collector who was rumoured to have paid Stosch the unbelievable sum of £1000 for a fragment of a gem, signed by Apollonides, depicting a cow. For the signed gems at Chatsworth, see G. M. A. Richter, *Engraved Gems of the Romans*, 1971, pp. 136, 140 and 142.

40 The Bessborough gem collection was published in 1761 as *Catalogue des Pierres Gravées . . . de Mylord Comte de Bessborough*. Much of it was acquired before his father's death, when he was styled Viscount Duncannon. He bought one gem from Stosch for 100 *zecchini*, according to H. Walpole, who was exceedingly covetous of it, 'You know I cannot live without Stosch's intaglio of the gladiator with the vase . . . You know I offered him fifty pounds.' *Correspondence*, xvii, p. 212. For Bessborough's other antiquities, see n. 5.37 below.

41 The series of T. Worlidge (1700–1766) was continued by his pupils and issued posthumously in 1768. J. Spilsbury (*c*.1730–1795) kept a print shop in Covent Garden; his etchings of gems were published by John Boydell. The fashion for such publications was taken even further by Marchant who published *A Catalogue of One Hundred Impressions from Gems engraved by Nathaniel Marchant*, 1792, together with two cases of impressions of his carvings, bound as a folio volume, to advertise his skill at reproducing a variety of antique statues in miniaturized gem form.

Neither the improvident Antony Browne, seventh Viscount Montagu (1728–1787) nor James Hamilton, second Earl of Clanbrassil (1730–1798) seems to have visited Italy. For Thomas Moore Slade (d. 1824), Charles Greville (1749–1809) and Lord Algernon Percy, later Earl of Beverley (1750–1830), see Ingamells, pp. 863–4, 429–30 and 758–9. For the Beverley Gems, see A. E. Knight, *The Collection of Camei and Intagli at Alnwick Castle*, 1921. They comprise some 200 stones, many of them acquired

from a French collection, but they are mostly renaissance or neo-classical rather than antique gems.

Mention should be made of the collection of gems belonging to Joseph Smith, the Resident in Venice, which was sold to George III in 1762 and elaborately published in 1767 as *Dactyliotheca Smithiana*, with text by A. F. Gori and illustrations of ninety-nine of the gems (one was engraved on both sides). All but two were modern. The royal collection at Windsor still retains about two thirds of Smith's gems, see K. Aschengreen Piacenti, 'Consul Smith's Gems', *Connoisseur*, cxcv, 1977, pp. 79–83.

42 In 1773 J. Wedgwood issued *A Catalogue of Cameos, Intaglios, Medals, and Bas-reliefs made by Wedgwood and Bentley and sold at their Rooms in Great Newport Street, London*. They were advertised as suitable not only for rings and bracelets but for 'inlaying in fine Cabinets, Writing Tables, Book-cases, &c.'

For James Tassie (1735–1799) and the methods of mass-reproducing gems, see J. M. Gray, *James and William Tassie*, 1894, J. P. Smith, *James Tassie 1735–1799*, exh. cat., Mallet & Son, London, 1995, and E. R. Raspe, *A Descriptive Catalogue of a General Collection of Ancient and Modern Engraved Gems, Cameos as well as Intaglios, taken from the Most Celebrated Cabinets in Europe; and cast in Coloured Pastes, White Enamel, and Sulphur, by James Tassie, Modeller*, 1791. Raspe was strongly critical of gem cutters such as Natter who carved replicas that were not differentiated from originals.

Philipp Daniel Lippert of Dresden (1702–1785) also produced a *Dactyliotheca*, a similar collection of casts of important gems, a sample of which was exhibited to the Society of Antiquaries in November 1759. He was assisted in producing the catalogue to his 2000 impressions by Johann Friedrich Christ of Leipzig University.

43 For George Spencer, fourth Duke of Marlborough (1739–1817), see Ingamells, p. 642, M. H. N. Story Maskelyne, *The Marlborough Gems*, 1870, and G. Seidman, 'An Eighteenth-Century Collector as Patron', in *Engraved Gems: Survivals and Revivals*, National Gallery of Art, Washington, ed. C. M. Brown, 1997, pp. 262–79. The sumptuous edition of his collection, limited to 100 copies, was issued as *Gemmarum antiquarum dilectus . . . quae in dactyliothecis Ducis Marlburiensis conservantur*. Some of the plates, which were drawn by Cipriani and etched by Bartolozzi, were issued individually. For the dates of issue, see Seidman, p. 275, n. 15.

The *Tryphon* gem is now in the Museum of Fine Arts, Boston.

In January 1762 Horace Walpole gave an exaggerated report that 'the Duke of Marlborough has purchased most of Zanetti's gems at Venice', see *Correspondence*, xxi, p. 561. For Edward Dering (1732–1798), see Ingamells, p. 293, and A. M. Clark, *Pompeo Batoni*, 1985, pp. 274–5 and pls 201 and 202. For the price of the Bessborough collection, see Seidman, p. 275, n. 23.

For the Portland *Augustus*, see *Historical Manuscripts Commission*, Rutland, iii, 1894, p. 311. It seems that the Duke of Rutland was also interested in it.

The gold settings of many of the gems in the collections of the Duke of Devonshire, Lord Carlisle and Lord Bessborough were beautifully chased or carved, probably by Roman goldsmiths. English settings tend to be plainer.

44 For other collectors, see Scarisbick's compendious account, *op. cit.* (n. 1.51), pp. xiii–xxiii.

45 For C. M. Cracherode (1730–1799), see A. Griffiths, 'The Reverend Clayton Mordaunt Cracherode' in *Landmarks in Print Collecting*, 1996, pp. 43–64.

CHAPTER 5

1 In addition to those mentioned in this chapter, the list of those who collected antiquities with varying degrees of seriousness at this period includes, among others, Horace Walpole (who in addition to the pieces acquired from Conyers Middleton, paid 100 *zecchini* for a notable marble eagle from the Boccapaduli collection, now at Gosford, and bought a basalt head of *Serapis* at the Duchess of Portland's sale), George Bubb Doddington, who used Cardinal Albani to buy for him, the republican Thomas Hollis (part of whose collection is now in the Fitzwilliam Museum in Cambridge), Sir Charles Frederick (some of whose collection was bought by Townley), Sir Thomas Robinson (Lord Carlisle's brother-in-law, who had a large collection of antiquities and replicas at Rokeby, where a few of them remain), Lord Charlemont (who brought back a few Greek and Egyptian antiquities to Ireland in addition to copies and casts from Rome), Charles Hamilton, Sir William Hamilton's uncle (who imported marbles for Painshill), Thomas Anson of Shugborough (who bought marbles from Cavaceppi, Jenkins and Nollekens and acquired the important collection of coins, published in 1763 as *Catalogus Numismaticus Musei Lefroyani Liburni*, from the Leghorn merchant, Anthony Lefroy), Lord Brudenell, son of the Duke of Montagu (who bought some heads, mosaics and bronzes for Montagu House as well as modern bronze copies), Lord Exeter (who bought antiquities in Rome and presented Lord Arundel's *Head of Sophocles* to the British Museum), Thomas Worsley (whose modest collection of heads and reliefs, ancient and modern, and some casts is still at Hovingham), William Lock of Norbury (whose collection was sold at Christie's in 1785 within ten years of its purchase), the Duke of Hamilton (who bought a *Venus* from Gavin Hamilton and was with difficulty deterred from acquiring expensive gems on a tour described by his bear-leader, John Moore, in *View of Society and Manners in Italy*), George Grenville, later Marquess of Buckingham (who bought antiquities from Hamilton, Morison and Piranesi to decorate the Saloon of his uncle's house, Stowe, and a gem of *Phocion* from Jenkins for £400), Sir John Boyd (who bought a massive vase concocted from Hadrian's Villa fragments from Piranesi), the Duke of Dorset (who bought a number of busts, statues and reliefs for Knole, where some of them remain), Aubrey Beauclerk, later Duke of St Albans (who sold much of the collection which he acquired in Rome in order to finance the rebuilding of his house at Hanworth after a fire in 1797), Lord Fortrose (whose bronzes and Greek vases are displayed in Pietro Fabris's drawing of his apartment in Naples and who bought a cameo from Byres for £500), Henry Jennings (who bought the so-called *Dog of Alcibiades* for 400 *scudi* from Cavaceppi and sold it for £1050 some twenty years later in 1778), Charles Duncombe (who bought Jennings's *Dog* and also owned an important *Discobolus*), Lord Clive (who bought the *Cat with a Snake* in Rome in 1774 as well as a statue from Gavin Hamilton's excavations at Monte Cagnolo and some other figures, intended for Claremont but now at Powis Castle), Lord Tavistock (who started the collection of antiquities at Woburn, buying statues from Gavin Hamilton and some Zoffoli bronzes), Lord Upper Ossory (another Gavin Hamilton client), Sir Watkin Williams Wynn (an extremely rich Welshman, who bought gems and a few marbles), Lord Cawdor (chiefly famed for his capture of the French invaders at Fishguard in 1797 but a collector whose *Villa Lante Vase*, lesser marbles and Greek vases were displayed in a Museum in his London house), Roger Wilbraham (a collector of bronzes and gems who was a close friend of Townley and

d'Hancarville), Lord Mendip (yet another Gavin Hamilton client), the Bishop Earl of Bristol (who shipped marbles and casts back to make a didactic display in his houses in Ireland and bought some of the paintings from the Villa Negroni from Tresham but much of whose collection was impounded by the French revolutionary troops in Italy), Lord Darnley (who filled Cobham Hall with marbles and old masters after his Grand Tour in 1790), and Sir George Strickland (who bought marbles from Jenkins and Byres and casts of gems from Alessandro Cades), while Bishop Brownlow North, Lord Fitzwilliam, Lord Berwick, Guy Head, David La Touche, George Graves and William Danby were among the travellers who were inspired to buy 'Etruscan' vases following the publication of Hamilton's collection, although Fitzwilliam grumbled about having to subscribe to the volumes. All these collectors visited Italy and are recorded in Ingamells.

2 For the Dukes of Gloucester and Sussex, see Ingamells, pp. 402–4 and 35–8 and I. Bignamini, 'The "Campo Iemini Venus" rediscovered', *Burlington Magazine*, cxxxvi, 1994, pp. 548–52. Neither of the king's other brothers who visited Italy, the Dukes of York and Cumberland, showed any cultural interest whatsoever. For Consul Smith's gems, see n. 4.41 above.

Jenkins had a project to sell antiquities to the Prince of Wales through Henry Holland in 1788–9 but it came to nothing (BM, TY1/9 and TY7/478, 483 and 491), while a later proposal that the Prince should have antiquities from the excavations of his brother, Prince Augustus, was overtaken by the French invasion of Italy. When he was given some Roman remains from Leptis Magna by the Bashaw of Tripoli in 1818, he left them in the forecourt of the British Museum for eight years before having them erected by Wyatville as a mock ruin beside Virginia Water.

The Gallery of Antiques in the gardens at Kew, created by George III's mother, was filled with contemporary statues of deities, not Roman antiquities, see J. Coutu in *Sir William Chambers*, exh. cat., Courtauld Gallery, London, ed. J. Harris and M. Snodin, 1997, pp. 176–8.

3 For Cardinal Stuart (1725–1807), see Ingamells, pp. 482–4, and R. Lanciani, *New Tales of old Rome*, 1901, pp. 321–4.

4 The client was Sir James Clerk, son of Sir John, the early archaeologist and collector (see n. 2.9 above). The statues, together with a satisfactorily draped *Flora*, cost £80 (A. Rowan, *Country Life*, cxliv, 1968, p. 449). For J. Baxter, see Ingamells, pp. 61–2.

5 For Charles Wentworth Watson, second Marquess of Rockingham (1730–1782), see Ingamells, pp. 631–3. In addition to the marble copies, he bought plaster casts for the Lower Hall, which also housed the massive *Samson and the Philistines* by Vincenzo Foggini, and busts and a colossal female figure for the stairs. The collection included other antique marbles, some of them, such as the *Paris*, bought from Lyde Browne. Rockingham planned a Sculpture Gallery for which sculpture from 'Mr — near Wimbledon', i.e. Lyde Browne, was earmarked, but this was never executed (Sheffield Archives, Wentworth Woodhouse Muniments, R 185/12–16 and Misc. 232). For the sculpture, see N. Penny, 'Lord Rockingham's Sculpture Collection and *The Judgment of Paris* by Nollekens', *J. Paul Getty Museum Journal*, xix, 1991, pp. 5–34, and Vermeule 1955, p. 148, and for the coins, bought from abbé Visconti in 1774, see Vermeule 1956, pp. 345–6. The vase collection at Wentworth Woodhouse, sold by Christie's in July 1948, was probably acquired by William, fourth Earl Fitzwilliam (1748–1833), whose mother was the sister of the second Marquess of Rockingham and who married a daughter of another collector, Lord Bessborough (Vermeule 1956, p. 346 and 1959, p. 346). Most of the sculpture was sold by Henry Spencer and Sons in July 1949 but the Nollekens group was sold by Christie's, 15 July 1986. The *Antinous* and the *Germanicus* in the Hall were relegated to the garden and replaced by neo-classical pieces in the nineteenth century, but they have now been instated in the Lower Hall.

6 For Brettingham's casts, see Kenworthy Brown, *op. cit.* (n. 3.31), pp. 42–4. Brettingham probably sold his moulds to John Cheere, who supplied casts for Croome in 1767, see N. Penny, 'Imposing Decor', *Country Life*, clxxxiv, 1990, p. 250. Casts of the *Medici Venus* and the *Dancing Faun* had been installed at Towneley Hall in 1730. In 1756 Sir George Lyttleton asked Horace Walpole to use the good offices of Horace Mann in Florence to procure a number of casts of classical statues for the Hall at Hagley.

7 Brettingham provided casts for Kedleston. Originally there were casts in the niches of the Saloon as well as in the Hall but they were more practically replaced by altar stoves. See J. Kenworthy Brown, 'Designing around the Statues, Matthew Brettingham's Casts at Kedleston', *Apollo*, cxxxvii, April 1993, pp. 248–52. Adam provided a design for a Grotto Room for antiquities in one of the pavilions at Kedleston

but it was not executed (Guilding, *op. cit.* (n. 2.32), p. 38). Neither Sir Nathaniel Curzon, first Lord Scarsdale, nor George Coventry, sixth Earl of Coventry, had been to Italy, yet both wanted Adam's fashionably Roman interiors.

8 For Hugh Smithson, later first Duke of Northumberland (1715–1786), see Ingamells, p. 873.

9 For Luigi Valadier (1726–1785), see *L'Oro di Valadier*, exh. cat., Villa Medici, Rome, ed. A. Gonzalez-Palacios, 1997. He supplied tableware and lavish centrepieces for Pius VI, the Cardinal Duke of York, the Chigi and Borghese families and a number of visiting foreigners. He also mounted an antique bust of Nero, which passed from Sir William Hamilton to Thomas Hope. He probably designed the marble topped tables that Pius VI gave to Henry Blundell, see n. 5.53 below. Another version of the *Antinous* by Valadier was in the sale of Matthew Nulty's collection in 1783.

For the antiquities at Syon, see Vermeule 1955, pp. 147–8. Piranesi in R. Adam, *The Works in Architecture*, ii, 1779, shows the Hall at Syon with an arrangement that differs from the present one: the *Gladiator* faces a *Laocoön* instead of the *Apollo Belvedere*, which is placed with other casts down the wall opposite the entrance door. Neither the *Laocoön* nor the *Consular Figure* ordered by the duke from James Adam materialized. For Adam's work at Syon and the arrangement of the statues, see E. Harris, *The Genius of Robert Adam*, 2001, pp. 65–83. The Hall colouring was modified by John Fowler in 1974.

10 Walpole, *Correspondence*, xxxviii, p. 429. Guilding, *op. cit.* (n. 2.32), p. 34, quoting Northumberland Archives, Misc. MSS G/1/4.

Robert, Lord Clive (1725–1774), was another extremely rich collector who was content with casts. 'With regard to statues for the Niches of the Grand Staircase [at Claremont], I shall have them all of Casts from the most famous ones of Antiquity taking care that they shall be modest ones, these will cost a Trifle', he told his wife from Rome in 1774 (C. Rowell, '"That delightful and magnificent Villa", Clive of India's Claremont and its Collections', *Apollo*, cliii, April 2001, p. 20). Clive shipped from Rome three 'Figures of Plaister' and a few small antique statues, of which his *Cat with a Serpent* is the most notable. The marbles are now at Powis Castle.

11 For Sir Roger Newdigate, see n. 4.4 above. For Newdigate's serious interest in archaeology, see M. McCarthy, 'Sir Roger Newdigate in Rome',

Apollo, cxlvii, May 1998, pp. 41–8. For the Dining Room, see M. Hall, *Country Life*, cxciii, 1999, pp. 40–43.

12 For the Richmond House academy and its successors, see M. Postle, 'Naked Authority? Reproducing Antique Statuary in the English Academy', in *Sculpture and its Reproductions*, 1997, ed. A. Hughes and E. Ranfft, pp. 79–99, and H. Walpole, *Anecdotes of Painting*, i, 1762, preface, p. xii. The Duke of Richmond (1735–1806) was in Rome with his tutor in 1755 and established the academy soon after his return. For the lapse of his support, see A. Cunningham, *The Lives of the Most Eminent British Painters, Sculptors and Architects*, iii, 1830, p. 70. See also D. Kurtz, *The Reception of Classical Art in Britain*, 2000.

L. Cust, *History of the Society of Dilettanti*, 1914, pp. 58–9.

13 In addition to the commissions mentioned, the Duke of Argyll had a small display of sculpture at Adderbury and Rysbrack produced Saxon deities and busts of British Worthies for Lord Cobham at Stowe.

14 For Charles Wyndham, second Earl of Egremont (1710–1763), see Ingamells, pp. 1026–7. He went on his Tour with George Lyttleton, who bought no antiquities while he was in Italy but started to acquire casts of classical statues for Hagley at the time that the Petworth collection was being formed, see n. 5.6 above.

H. Walpole, who complained in 1758 about the way in which rich collectors, like Egremont, upset the market for paintings (*Correspondence*, xxi, p. 200), commented on his death (*Correspondence*, xxii, pp. 158–9), '. . . Lord Egremont died suddenly, though everyone knew he would die suddenly; he used no exercise and could not be kept from eating . . . : a day or two before he died, he said, "Well, I have but three turtle dinners to come, and if I survive them, I shall be immortal.". . . He has left eighteen thousand pounds a year, and they say, an hundred and seventy thousand pounds in money.'

15 The inventory of the seventh Duke of Somerset, who died shortly after his father, the Proud Duke, Charles Seymour, sixth Duke of Somerset (1662–1748), taken in March 1750, lists the two statues in the Marble Hall and a marble bust, probably the *Faustina*, in the adjacent Red Leather Chair Room.

16 Townley's comment that Hamilton's head of *Venus* had restorations to the nose and lip proves that he was the supplier (BM, TY15/1/2) and not Cavaceppi who also supplied Brettingham with

a head of *Venus*. The head, 'of very fine Greek sculpture', was then in a niche in the Hall.

17 For the Gallery see C. Rowell, 'The North Gallery at Petworth', *Apollo*, cxxxviii, July 1993, pp. 29–36, and R. Guilding, 'The 2nd Earl of Egremont's Sculpture Gallery at Petworth', *Apollo*, cli, 2000, pp. 27–9, suggesting that some of the collection was intended for display in London. There appears to be no surviving correspondence between Egremont and Leicester, but for their links, see C. Rowell, *Petworth House*, 1997, p. 76.

For Townley's complaint, see BM, TY15/1/3. He considered that the two *Sitting Philosophers* were 'of the most excellent style of Greek sculpture, superior to any statues of philosophers existing in Italy', while the *Young Faun* (now described as *Marsyas*) was 'Greek sculpture of the time when softness was added to precision, truth and character' and had been sold by Gavin Hamilton for 700 *scudi* (TY15/1/2).

18 *Specimens*, i (n. 3.33), comment on pls lxxii and lxxiii. One of Egremont's seated philosophers, an imperial figure from the Proud Duke's collection and a better reproduction of the *Apollo* were included in the second volume of *Specimens*, which appeared in 1835.

For the Egremont collection, see Michaelis, pp. 596–617, M. Wyndham, *Catalogue of the Collection of Greek and Roman Antiquities in the Possession of Lord Leconfield*, 1915, and Vermeule 1955, pp. 144–5, and 1956, p. 340, 'The Ancient Marbles at Petworth', *Apollo*, cv, 1977, pp. 340–45, and J. Raeder, *Die antiken Skulpturen in Petworth House*, 2000.

Jenkins bought the *Attendant at a Sacrifice* and an *Annius Verus* from Conte Cardelli in about 1760 but, on being told that he would not get an export licence, had sold them to Cavaceppi, who in turn sold them to Gavin Hamilton (BM, TY7/393). For Cavaceppi's restorations, see Howard, *op. cit.* (n. 3.32), pp. 45–9; three of the statues at Petworth were illustrated in his *Raccolta*.

19 For contemporary views of the collection, see J. Dallaway, *Anecdotes of the Arts in England*, 1800, pp. 278–90, and *Of Statuary and Sculpture among the Antients*, 1816, pp. 318–22; the latter states 'at the time of his death, in 1763, the cases containing these statues were not unpacked, so that their distribution and arrangement were by the direction of their present noble possessor', although the probate inventory of 1764 makes it clear that most of the sculpture was in place by then.

For the probate inventory, see Raeder, *op. cit.* (n. 5.18), p. 29, recording that there were nine

statues in niches on the chimney side, two seated statues in niches, six busts in the oval recesses on the window side and six busts on brackets in the bow.

20 For the collection of George Wyndham, third Earl of Egremont (1751–1837), see J. Kenworthy Brown, 'The Third Earl of Egremont and Neo-Classical Sculpture', *Apollo*, cv, 1977, pp. 367–73.

On his first visit to Italy, Townley bought *Pan and Daphnis* from Pacilli for 800 *scudi* but he discarded it when he learned how to appreciate the condition of statues, exchanging it for other marbles with Jenkins, who sold it to Bessborough (BM, TY10/2, f. 24v. and TY10/3, f. 10r). Bessborough paid £150 but, at his sale, the group only fetched £120, indicating the increasingly cautious attitude towards heavily restored pieces. The original export licence from Rome described it as 'good sculpture but with very many restorations' (Bertolotti, *op. cit.* (n. 1.32), ii, 1877, p. 222). There is a drawing of the group by V. Pacetti in the Greek and Roman Department of the British Museum. There was a cast of *Pan and Daphnis* in the Saloon at Castle Hill in Devon, destroyed with casts of other antiquities and of the Giambologna *Mercury* in the fire of 1934, see C. Hussey, *Country Life*, lxxv, 1934, pp. 300–05.

21 For William Weddell (1736–1792) and his collection, see Ingamells, pp. 986–7, Michaelis, pp. 522–35, Vermeule 1955, p. 143, and Harris, *op. cit.* (n. 5.9), pp. 213–31. For Weddell's travelling companion, the Reverend William Palgrave (*c.*1735–1799), who described Robinson, and for Thomas Robinson, later second Lord Grantham (1738–1786), see Ingamells, pp. 732 and 816–17. A portrait of Weddell and Palgrave is at Upton House, Warwickshire.

22 For Weddell's purchases from Jenkins, see n. 4.22 above and S. R. Pierce, 'Thomas Jenkins in Rome', *Antiquaries Journal*, xlv, 1965, pp. 219–21, which mentions the bath, two colossal heads, a bust of *Minerva*, the *Ibis* and the *Brutus* and Jenkins's notes on where they had been found. Weddell is listed as exporting twelve cases of marbles and eighty-six paintings in April and May 1765, see Bertolotti, *op. cit.* (n. 1.32). Jenkins mentioned to Townley in 1774 that Weddell still lacked a statue for his fourth niche (BM, TY7/336), and in 1779 that he wanted 'a few things to complete his excellent collection' (BM, TY7/385). For Cavaceppi's restorations, see Howard, *op. cit.* (n. 3.32), pp. 64–70. For the herm and two of the tripods, see *The Treasure Houses of Britain* (n. 2.30), pp. 306–7 and 310.

Two antique columns, erected at the foot of the staircase, were also acquired in Rome.

For surprising the West Riding, see letter of James Grant to Palgrave, 31 March 1765, quoted Harris, *op. cit.* (n. 5.9), p. 356, n. 13.

23 For the disapproval of Townley and Jenkins, see BM, TY7/387, 15 July 1779.

24 Townley's plan of the gallery at Newby is BM, TY15/1/4.

25 For the comment on the *Brutus*, see H. Blundell, *Engravings and Etchings of the principal Statues, . . . &c . . . at Ince*, 1809, i, preface, and Blundell's letter to Townley, 6 December 1799, 'I am quite of your opinion that every statue should have some remains of its real character, otherwise without its head & extremities, it . . . may be made into an emperor or a Merry Andrew or a Brutus, as that at Newby is so dubbed by having a severe countenanced head put on its shoulders and hands on with the dagger in them.' (BM, TY15/11).

The *Priapus*, the *Apollo*, a herm of *Eros* and several other pieces were also repaired with heads that were not their own, that of *Eros* being completely modern. It is noticeable that Townley did not consider any sculpture at Newby worthy of inclusion in *Specimens* (n. 3.33), although distance from London may have been a factor.

26 In 1802 a visitor commented that the light from alabaster vases in the Dining Room enhanced 'the magic effect with which the mind is impressed when we look through the door at the . . . *penetralia* of the Temple' (C. Hussey, *English Country Houses Mid Georgian*, 1956, p. 144). For night viewing, see J. W. Goethe, *op. cit.* (n. 4.1), p. 421, and the description of Townley's rooms 'Lamps were placed so as to form the happiest contrast of light and shade; and the improved effect of the marbles amounted, by these means, almost to animation.' (Dallaway, *op. cit.* (n. 4.32), p. 730).

27 For his death, see *Gentleman's Magazine*, 1792, p. 481.

28 For Henry Temple, second Viscount Palmerston (1739–1802), see Ingamells, pp. 733–5, G. Jackson Stops, *Country Life*, clxviii, 1980, pp. 2246–50 and 2334–7, and B. Connell, *Portrait of a Whig Peer*, 1957, and for the collection, Michaelis, pp. 217–26, Vermeule 1955, p. 131, and 1959, pp. 139–41, and D. Grassinger, *Antike Marmorskulpturen auf Schloss Broadlands*, 1994. For Cavaceppi's involvement, see Howard, *op. cit.* (n. 3.32), pp. 62–4; the two statues and a head of *Africa* were illustrated in the *Raccolta* and other heads and busts were restored or created in his workshop.

Palmerston had seen classical sculpture before because, as a youth, he had precociously noted the marbles at Holkham and at Castle Howard in his journals for 1758 and 1760 (D. Grassinger, pp. 15 and 16).

The 1764 list, incorrectly totalled in the original, sets out the following purchases:

	£	
Sarcophagus	6	
Two Busts	22	
Two Medallions	22	
Vase	12	10
Two Statues Ceres & Hygeia	90	
Two Small statues Venus & Min[erva]	75	
Two Busts Apollo & Mercury	35	
Bust of Ptolemy	13	
Bust of Africa	17	10
Two small Busts	6	
A Bust of Juno a fragment damaged	5	
A Basso Relievo of a Muse	10	
A Basso Relievo two figures	10	
A small copy of the Hermaphr[odite]	8	
A Bust a Boy's head	5	
Head of Diadumenus	10	
Bust of Agrippina	10	
Two cinerary Altars & an urn & a small basso relievo	17	
Two Granite Tables	30	
Two Tables of green Porphyry with Alabaster Borders	37	
A Term	5	
Copy of ye Boy and Dolphin Nollekens	30	
	476	

An item, 'Basso Relievo Aldobrandini Wedding', costing £50, has been deleted from the list. Seals, bronzes and gesses (casts) added £55 to the total.

For his income, see Connell, p. 17.

For the *Boy on a Dolphin*, see S. Howard, 'Boy on a Dolphin: Nollekens and Cavaceppi', *Art Bulletin*, xlvi, 1964, pp. 177–89, and *Art in Rome in the Eighteenth Century*, ed. E. P. Bowron and J. J. Rishel, exh. cat., Philadelphia Museum of Art, 2000, pp. 269–70. Tourists who acquired copies included Lords Exeter, Spencer and Bristol and David Garrick.

29 For Hamilton's later sales, see Grassinger, *op. cit.* (n. 5.28), pp. 117 and 88–91.

The marbles were small enough to carry round; when Townley visited Broadlands in July

1799, he was told that the antiquities had been moved to Palmerston's house at Cheam (BM, TY1/11).

30 For Lyde Browne (d.1787), see Ingamells, pp. 141–2, Michaelis, pp. 88–90, Howard, *op. cit.* (n. 3.32), pp. 52–4, X. Gorbunova, 'Classical Sculpture from the Lyde Browne Collection', *Apollo*, c, 1974, pp. 460–7, and O. Neverov, 'The Lyde Browne Collection', *American Journal of Archaeology*, lxxxviii, 1984, pp. 33–42, and pls.7–15, and 'La Collection . . . formée par Lyde Browne', *Rivista di Archeologia*, Supp. 21, 1999, ed. G. Traversari, pp. 154–60. The 1779 catalogue of his collection states that it had been formed 'over a period of thirty years'. He also collected bronzes and gems.

31 Horace Walpole was scathing about the Society, writing in 1778: 'The antiquaries will be as ridiculous as they used to be; and since it is impossible to infuse taste into them, they will be as dry and dull as their predecessors . . . Bishop Lyttleton used to torment me with barrows and Roman camps, and I would as soon have attended to the turf graves in our churchyards.' (*Correspondence*, ii, p. 116). Browne was elected a Fellow of the Society in 1752 but resigned in 1772, probably because the meetings were at that time mainly devoted to topics from the Middle Ages and most of the classical antiquities considered were domestic finds. Although Sir William Hamilton communicated the discoveries round Naples to the Antiquaries in 1775, he planned to publish a more substantial work on the subject through the Dilettanti (Jenkins, *op. cit.* (n. 4.30), pp. 43–5.)

32 When in Rome, Browne appointed Simon Vierpyl to buy for him, but the sculptor was too busy on an enormous commission to produce copies of twenty-two statues and seventy-eight busts of Roman emperors and other figures in the Capitoline Museum for Edward Murphy, Lord Charlemont's tutor, see Ingamells, pp. 967–8 and *Historical Manuscripts Commission, Charlemont*, i, 1891, p. 323. He also tried abbé William Wilkins, who had promptly died. For his use of Jenkins, see Pierce, *op. cit.* (n. 5.22), pp. 216–29.

33 BM, TY7/1497.

34 The head (illustrated in J. Spence, *Polymetis*, 1747, pl. xix, when it was in the Barberini collection) has now been removed from the *Hercules Torso* in the Hermitage. In *Monumenti antichi inediti*, Winckelmann refers to the *Paris* in Browne's collection but corrects the description to a *Priest of Cybele*, ii, 1767, p. 205.

35 *Gentleman's Magazine*, 1787, p. 840, and Dallaway, *op. cit.* (n. 5.19), 1800, p. 389 and 1816, p. 274.

He noted that Browne's marbles were 'very frequently changed by sale and purchase'. The sale price of £20,000 given in British Library, Add. MS 21118, seems more likely than £23,000 quoted by Dallaway.

Townley's notes (BM, TY14/16 and 14/18) give the following valuations:

	£
57 heads	2655
29 vases	2000
10 bas-reliefs	290
4 candelabra	260
2 medallions	180
3 votive feet	200
35 columns and pedestals	1225
24 busts	2770
54 sarcophagi and urns	950
42 statues	3955
	14,485

Even if the *Hercules* and the *Torso* were expensively priced at £550 each, the average value of the statues and busts was high when compared with prices charged to Tourists in Rome. The remains of Browne's collection were sold by Christie's 30 May 1788. He had retained or subsequently acquired a large number of busts, funerary chests and reliefs, both ancient and modern, as well as casts and copies, and some works by Quellin, Algardi and Rysbrack. Among his pictures were works by or attributed to Claude, Poussin, Guido Reni, Domenichino and Bassano.

Jenkins had heard from Townley of the proposed Russian sale by November 1783 (BM, TY7/421), but it had been rumoured as early as February 1780, 'I am curious to know, and shall be exceedingly glad to hear, that the Wimbledon Collection travels to Russia' (BM, TY7/391). A note in Townley's papers states that Jenkins sold statues from Villa Negroni for £900 to Browne, who sent them 'on speculation' to St Petersburg in 1787, priced at £2200 (BM, TY1/21); some of the statues listed together with various others were valued by Townley at £938 (BM, TY7/1504).

For buying for enjoyment, see BM, TY7/1491.

Catanzaro House stands on the site of Browne's Wimbledon villa.

36 *Catalogus veteris aevi varii generis monumentorum, quae Cimeliarchio Lyde Browne, Arm. Ant. Soc. Soc. apud Wimbledon asservantur*, 1768, and *Catalogo dei piu scelti e preziosi marmi, che si conservano nella Galleria del Sigr. Lyde Browne, . . . raccolti con gran spesa nel corso di Trent' Anni . . .*, 1779. It is possible to identify much of the collection in the

museums of St Petersburg from his catalogues and from two sets of drawings, Jenkins's sketches, sent to the Society of Antiquaries, and a second series, British Library, Add. MS 21118, comprising twenty-three drawings by Cipriani, mainly of busts, which may have been intended to illustrate a more elaborate catalogue.

37 For William Ponsonby, second Earl of Bessborough (1704–1793), see Ingamells, p. 781, and for his gems, n. 4.40 above. Two of his daughters married collectors of antiquities, the Duke of St Albans and Lord Fitzwilliam. For the Worsley divorce case, see n. 5.59.

For Chambers's work at the villa, now called Manresa House, see Harris and Snodin, *op. cit.* (n. 5.2), pp. 128–33.

The two pieces from Piranesi can probably be identified with the double funerary chest with masks and festoons and the semi-circular one found in Siena, bought by Cavaceppi and 'now in England', illustrated in *Vasi, Candelabri, Cippi*, Wilton Ely, *op. cit.* (n. 4.25), ii, p. 967, no. 892. One of them was bought by Sir John Soane and is still in his museum. For Jenkins's letter of August 1770, see BM, TY7/303.

It is noticeable that Bessborough's paintings included Romanelli's *Triumph of Venus* and Rosa's *Phryne seducing Xenocrates*.

38 The shelves have been removed from the niches in the Catacombs and the garden temples are demolished. The sale catalogue lists in the Hall an impossibly dense concentration of sculptures, which must have been placed there for the purposes of the auction; a more limited display is recorded in the Hall (BM, TY15/10). It is possible that some marbles were bought by Bessborough's son, when he was in Italy in 1777–8 or 1792–4 (see Ingamells, pp. 318–20), although he is only mentioned as a collector of gems. Since some of the marbles acquired by Lord Lonsdale in the mid-nineteenth century are said to have come from the Bessborough collection, a number of antiquities may have been kept back from the 1801 sale and retained by the family until 1850.

For the busts in the temple, see J. Christie, *A Disquisition upon Etruscan Vases . . .* , 1806, pp. 38–9.

39 For Thomas Mansel Talbot (c.1747–1813), see Ingamells, pp. 923–4, *The Penrice Letters 1768–1795*, ed. J. Martin, 1993, and J. Cornforth, *Country Life*, clviii, 1975, pp. 694–7 and 754–7, and for his collection, see Michaelis, pp. 516–22, Vermeule 1955, pp. 142–3, 1956, p. 337, and 1959, pp. 337–8, and Christie's sale catalogue, 29 October 1941. For the possibility that at least one of the busts,

that of a Roman child, was a fake by Cavaceppi, see Howard, *op. cit.* (n. 3.32), p. 98.

Townley's helmeted *Minerva* was restored by Albacini, who may well have improved Talbot's version, see Vaughan, *op. cit.* (n. 4.33), p. 190. On the prices, see Martin, pp. 23 and 27.

40 For the Orangery, one of the largest garden buildings in the British Isles, erected in 1786–90, see *The Beauties of England and Wales*, xviii, 1815, p. 706. 'It is three hundred and twenty seven feet in length and eighty one feet in width. At each end a square room has been parted off, in which are deposited some curious cork models of remarkable buildings in Italy, and several fine statues and other antiques of exquisite workmanship.'

Cork models were a speciality of the period, see Wilton and Bignamini, *op. cit.* (n. 3.1), p. 299. One fabricator was Agosto Rosa, a descendant of the artist Salvator Rosa, working in his ancestor's house a few doors up from Piranesi's shop.

A sarcophagus survives at Penrice.

41 For James Hugh Smith Barry (1746–1801), see Ingamells, pp. 56–7, Michaelis, pp. 500–15, and G. Vaughan, 'James Smith Barry as a Collector of Antiquities', *Apollo*, cxxvi, 1987, pp. 4–11. Jenkins's dealings with Barry are chronicled in his letters to Townley (BM, TY7/311–393 *passim*).

42 For Hamilton's comment on Barry's return from Greece, see BM, TY7/583. The Greek head is in the Asmolean, while the Parthenon fragment was presented to the British Museum by the family in 1850, Smith, *op. cit.* (n. 4.7), 1892, i, p. 177.

43 For the Jenkins Vase, see Wilton and Bignamini, *op.cit.* (n. 3.1), pp. 268–9.

44 For Townley's disapproval of some of Barry's purchases, see BM, TY7/1094/2, draft dated April 1775, 'You must remember that I always looked upon this Paris [the *Equestrian Paris*] as too mutilated an object for England . . . You know I have often differed with both him [Jenkins] and yourself of estimation of things.' Barry's lubricious correspondence with Townley is contained in BM, TY7/1090–1097.

'I have made drawings of a museum for him, with Galleries for Sculpture, paintings, Books, Natural History &c. all contained in the form of a Greek Temple. It does well enough in a drawing, but I am afraid will never go further.' BM, TY7/688 and TY7/363.

45 For the arrest and reconciliation, see BM, TY7/488 and TY7/1096–7.

46 For the cost of his collection, see BM, TY11/4/2, which gives a list of marbles totalling £5330,

and TY11/4/3, which enumerates further shipments to Liverpool, including the Villa d'Este *Jupiter*. In all, there were 21 statues, 19 busts, including some that were modern, 10 vases of various sorts, 6 reliefs and 9 cinerary urns, Michaelis, p. 501. For the *Antinous*, see H. Meyer, *Antinoos*, 1991 pp. 92–3 and pl. 82.

De Latocayne, quoted in J. Cornforth, *Country Life*, clxxx, 1986, p. 866.

47 G. Waagen, *Treasures of Art*, supplement, iv, 1857, p. 407. For the sales (Brown, 15 and 16 March 1933, and Sotheby's, 27 July 1933 and 29 July 1946), see Vermeule 1955, p. 142, and 1956, pp. 336–7, and Christie's, 6 July 1976 and 10 July 1987. A few battered eighteenth-century imperial and other busts are in the Conservatory at Port Eliot, Cornwall.

48 For Henry Blundell (1724–1810), see Ingamells, pp. 101–2, Michaelis, pp. 333–415, Vermeule 1955, p. 137, and 1959, pp. 156–9, G. Vaughan, 'Henry Blundell's Sculpture Collection at Ince Hall', in *Patronage and Practice: Sculpture on Merseyside*, ed. P. Curtis, 1989, pp. 13–21, C. Hussey, *Country Life*, cxxiii, 1958, pp. 756–9, 816–19 and 876–9, B. Ashmole, *A Catalogue of the Ancient Marbles at Ince Blundell Hall*, 1929, J. Fejfer and E. Southworth, *The Ince Blundell Collection of Classical Sculpture*, i, 1991, and J. Fejfer, ii, 1997. For the Mattei marbles, see G. Davies, 'Roman Cineraria in "Monumenta Mattheiana" and the Collection of Henry Blundell at Ince', *Antiquaries Journal*, lxx, 1990, pp. 34–9.

49 For Father John Thorpe (1726–1792), see Ingamells, pp. 939–42 with details of his correspondence.

50 BM, TY7/1318, dated 29 November 1787, and see BM, TY/7/1316, dated 2 January 1787 'What I have done was only, as it were, ye sport of a day, as I would not be thought to be idle, while abroad . . .' Lists show that marbles were located in the Hall, Drawing Room and Dining Room as well as on the stairs (BM, TY15/1/6).

51 For William Everard, a Liverpool schoolmaster turned architect, see Colvin, *op. cit.* (n. 2.9), p. 358. The mask in the pediment of the temple was a later insertion, acquired at the Cawdor sale in 1801.

52 For the trouble with his son, see Stonor Papers, Box 256, 26 October 1800. Townley was used as a go-between, see BM, TY7/1359 which includes a draft of a letter from Townley trying to persuade Blundell to treat his son more tactfully.

53 For the tables given by Pius VI, see Anthony Coleridge in *Christie's International Magazine*, March 1997, pp. 44–7.

54 Blundell gave his views on the *Villa Lante Vase* in a letter of 2 July 1800 to his son-in-law, Thomas Stonor, Stonor Papers, Box 256; his instructions to Townley, Stonor, John Waddilove and Richard Westmacott are in BM, TY7/1329–35 and Stonor Papers. He confessed to Stonor in a letter of 5 April 1801, 'I can't help feeling awkward in my commission to Mr Townley but having wrote for his opinion and his offering his service, I thought it better to give an order for a lot or 2 he so strongly recommended, as they were not on our list, and limited him not to exceed £2 or £300.'

55 BM, TY7,1330, dated 23 March 1801.

For the form of Sculpture Galleries, see R. Guilding, 'Robert Adam and Charles Townley', *Apollo*, cxliii, March 1996, pp. 27–32.

56 The copy of the illustrated catalogue presented by John Townley to the Society of Antiquaries in February 1810 has an inscription recording that the text had been compiled when Blundell was at 'an advanced Age and nearly quite blind'. For Blundell's instructions about the catalogue, see BM, TY7/1341–55 and 15/11–19.

57 For the *Hermaphrodite*, see S. Howard, 'Henry Blundell's *Sleeping Venus*', *Art Quarterly*, xxxi, 1968, pp. 405–20.

58 Stonor Papers, letter 5 April 1801. Blundell's annual income from his Lancashire estates amounted to £12,000 and his total income is said to have been £20,000.

59 For Sir Richard Worsley (1751–1805), see Ingamells, pp. 1018–19, Michaelis, pp. 226–40, A. H. Smith, *A Catalogue of the Antiquities in the Collection of the Earl of Yarborough at Brocklesby Park*, 1897, and Vermeule 1955, p. 131, 1956, pp. 324–5. His correspondence with Townley is BM, TY7/2035–75. For the continuing memories of the scandal, see n. 7.1.

60 Preface to *Museum Worsleyanum*. He explored the quarries on Hymettus to get an impression of true Greek marble, see E. Q. Visconti, *Monumenti scelti Borghesiani*, 1837, p. 207, and MS Worsley 23, f. 215, in the Lincolnshire Archives, Lincoln.

61 For Willey Reveley (1760–1799), see Ingamells, pp. 807–8. He edited the third volume of *The Antiquities of Athens*, 1795. Christie's sale of 'Athenian' Reveley's effects included plaster casts of architectural details of the temples of Rome, drawings of his travels with Worsley and a 'folio of manuscript observations made . . . in the course of his travels'.

Worsley's journals at Lincoln are Worsley MSS 23 and 24 and further details of the travels are set out in Worsley MS 38, 'Catalogue containing

an accurate description of the original Draw-
ings taken on the spot in the Travels of . . . Sir
Richard Worsley in the years 1785, 1786 and
1787'. For the references to acquisitions, see
Worsley MS 23, ff. 146 and 240. He recorded the
purchases of gems more carefully than those of
marbles, Worsley MS 24, ff. 245–61 and Worsley
MS 42, 'Inventory of movables taken at Venice
1793', which lists gems acquired from the
Mantua, Orléans, Zanetti, Colonna, S. Croce,
Braschi and Giustiniani collections, as well as
from Townley, Wilbraham, Duane, Jenkins and
Byres. Some of the provenances are not above
suspicion, 'belonged to the Prince
of Condé whose valet de chambre sold it for
the Prince in Milan' and 'stole out of the
Florentine gallery'.

For the purchase from Gavin Hamilton of an
Amorino for £120, see Worsley MS 55/12.

Goethe, *op. cit.* (n. 4.1), pp. 377–8.

62 For the gems bought from Hamilton, see
Jenkins and Sloan *op. cit.* (n. 4.30), pp. 101–4. For
the Gem Cottage, see BM, TY7/2053, December
1791 'I am building a Gem Cottage which I
hope in the spring you will permit me to show
you.'

63 For the issue of the 'classes' of *Museum Wors-
leyanum*, see Jenkins, *op. cit.* (n. 4.30), p. 102. The
cost of publication amounted to around £2800.
The plates of the Parthenon frieze are, naturally,
very similar to those in the second volume of
Stuart and Revett's *The Antiquities of Athens*,
issued in 1789, since both were taken from
William Pars's drawings, made in 1765. Worsley,
however, concentrated on the equestrian part of
the procession and omitted most of the other
figures, since they had been reproduced by
Stuart and Revett and he completely ignored
the pediment statues, believing the old and
misinformed report that they were Roman. He
claimed to have discussed the Parthenon exten-
sively with Visconti. 'I have been at great trouble
in conjunction with the President of the
Museum at Rome to attempt at an explanation
of every part of the remaining sculpture which
I observed daily for 3 months at Athens in the
Parthenon.' (BM, TY7/2041). According to
Visconti's editor, Giovanni Labus, the text to
Museum Worsleyanum was not considered to be
one of his best works (*Museo Worsleiano*, 1834,
p. xi).

For reproductions of the frieze, see E. Berger
and M. Gisler-Huwiler, *Der Parthenon in Basel*,
1996, pp. 21–3.

For Vincenzo Dolcibene (*c.* 1746–1820), see
Wilton and Bignamini, *op. cit.* (n. 3.1), pp. 228–9.

The letters of thanks from the recipients of the
Museum Worsleyanum are bound together in
Worsley MS 31. They include letters from
Charles Townley, Sir William Hamilton, who
was 'a little disappointed in not finding any of
my Gems engraved yet', Richard Payne Knight,
Lord Nelson, the Duke of Bedford and Henry
Tresham, who recalled 'the many agreeable days
I spent at your Villa in Rome [the Villa
Negroni], where you arranged the materials,
and to the delight of having gathered ideas,
superadded the pleasure of imparting them'.

64 The collection of marbles and the distinguished
old masters acquired by Worsley were published
as *A Catalogue Raisonné of the Principal Paintings,
Sculptures, and Drawings &c. &c. at Appuldurcombe
House . . . taken June 1 1804.* The gems and small
antiquities were kept in an inlaid cabinet in the
Picture Cabinet Room. The collection included
a cast by Albacini of the *Apollo Belvedere* and a
bust of *Caracalla* and a head of *Venus*, given by
Townley. Worsley's cast of the *Medici Venus* had
been given to Lord Burlington by the Grand
Duke of Tuscany.

The portrait of Worsley as a Greek philoso-
pher is no longer at Brocklesby.

65 For Charles Pelham, first Lord Yarborough
(1749–1823), and his father-in-law, George
Aufrere (1715–1801), see Ingamells, pp. 751 and
35, and Michaelis, pp. 226–40. Lord Yarborough's
marbles included a boat, restored and improved
by Piranesi, and a *cinerarium*, from the same
source, both illustrated in *Vasi, Candelabri, Cippi*
and acquired from the St Albans sale. There was
also a fine version of the head of *Niobe*, acquired
from Nollekens for £200 by Lord Exeter, who
gave it to Lord Yarborough (BM, TY7/299).
Charles Pelham, first Earl of Yarborough
(1781–1846), was responsible for moving the
Worsley collection to Brocklesby.

66 For William Petty, Marquess of Lansdowne
(1737–1805), see Ingamells, p. 852. For the col-
lection, see Michaelis, pp. 435–71, Vermeule
1955, pp. 131 and 139–40, 1956, pp. 334–5, and
1959, p. 330, and Christie's Catalogues, 5 March
1930 and 5 July 1995. For Lansdowne House,
see Harris, *op. cit.* (n. 5.9), pp. 113–31.

67 For the fifty-five antiquities bought through
Jenkins, including marbles from Cavaceppi,
Albacini and Cardelli, see Christie's Catalogue,
1930, pp. 106–7. Shelburne had previously
acquired from the Adams some busts, most of
which he later described as 'indifferent', pp.
97–8.

68 Christie's Catalogue, 1930, p. 77. The original
estimate was:

	£
16 fine antique statues	2500
12 antique busts	700
12 antique basso-relievos	400
11 large historical pictures	2200
4 landscapes with figures relative to the Trojan War	250
	6050

69 Christie's Catalogue, 1930, p. 79. The new cost estimate was

	£
19 statues	5000
10 busts	600
Ceiling picture and casts	400
	6000

70 For the evolution of designs for the Gallery from Adam to Panini to Clérisseau to Bellanger to Bonomi to Dance to Smirke, see D. Stillman, 'The Gallery for Lansdowne House', *Art Bulletin*, lii, 1970, pp. 75–80, and, for the room's final appearance, A. B. Jameson, *Companion to the Most Celebrated Private Galleries of Art in London*, 1844, p. 334.

The relief, which was unsold in 1930, was finally sold by Christie's, 5 July 1995.

71 For the problems over export licences, see Christie's Catalogue 1930, pp. 81 and 85.

72 For the value of marbles sent, see Christie's Catalogue, 1930, pp. 77, 78, 82, 86 and 88. There were, in addition, packaging and freight costs and fees to the Antiquary.

73 For the *Diomedes*, see Christie's Catalogue, 1930, pp. 94–5, and S. Howard, 'Some Eighteenth-Century Restorations of Myron's Discobolus', *Journal of the Warburg and Courtauld Institutes*, xxv, 1962, pp. 330–34. Hamilton explained to Townley that he had not sent it to him first on approval because its sale prospects would have been harmed if he had rejected it. 'You will ask me why I call it a Diomed. I answer because I have proved everything else absurd.' (BM, TY7/599).

74 Hamilton told Townley, 18 May 1774, that Shelburne was pleased with everything that he had sent except the *Amazon*, 'having already a duplicate sent by Adams so that he would willingly part with it for what it cost him being £200' (BM, TY7/568). The statue was shipped back to Rome but returned unsold.

The total cost of the collection is said to have been £7000 (*Report for the Select Committee of the House of Commons on the Earl of Elgin's Collection of Sculptured Marbles*, 1816, p. 98) but this figure must have been grossed up to include freight charges etc. because the amounts paid to the dealers seem to have been about £4000.

For the comment on market values, see Christie's Catalogue, 1930, p. 101.

For fluctuations in economic cycles, the impact of wars and the availability of bank credit, which all affected confidence and building activity, see T. S. Ashton, *Economic Fluctuations in England, 1700–1800*, 1959, and J. P. Lewis, *Building Cycles and Britain's Growth*, 1965.

75 For the *Young Hercules*, see A. Stewart, *Skopas in Malibu*, 1982, pp. 49–52, and *Specimens of Antient Sculpture*, 1809, i, pl. 40.

For the comparison of prices in relation to the Elgin Marbles, see R. P. Knight's evidence in the *Report from the Select Committee of the House of Commons on the Earl of Elgin's Collection of Sculptured Marbles*, 1816, pp. 94–9.

76 J. Farington, *Diary*, xi, 1983, p. 4114.

For the location of marbles in the Blue Room, see Christie's Catalogue, 1930, pp. 97–8. At that stage, the relief of *Aesculapius* (later in the Hall) was also there as well as six vases, one of them bought from Hugh Primrose Dean, the painter, who had himself bought it from Piranesi.

77 Jameson, *op cit.* (n. 5.70), p. 334

CHAPTER 6

1 For the Richardsons, see n. 3.5 above. *Traité de la Peinture et de la Sculture*, iii, 1728, pp. 100, 205, 208, 581–9 and 597–600. The title page of the third volume states that the work had been 'corrected and considerably augmented in this translation by the authors' but their views may owe something to their Dutch translator, Antoine Rutgers, and the connoisseur Lambert Ten Kate. For an appreciation of the Richardsons' impact, see Haskell and Penny, *op. cit.* (n. 1.1), pp. 99–100.

2 For the Reverend Joseph Spence (1699–1768), see Ingamells, p. 881.

Polymetis, 1747, pp. 5, 83 and 300.

3 Pliny, *Natural History*, xxxiii–xxxv; *Graeca res nil velare*, xxxiv, x, 18.

4 For the views of Anne-Claude-Philippe de Tubières, Comte de Caylus (1692–1765), published in his *Recueil d'Antiquités*, 1752–67, see F. Haskell, *History and its Images*, 1993, pp. 180–86.

5 For the theories of Johann Joachim Winckelmann (1718–1768), who was elected to the Society of Antiquaries in 1761 and was appointed Papal Antiquary from 1763, and the influence of his friend R. Mengs, see A. Potts, *Flesh and the Ideal*, 1994, and 'Greek Sculpture and Roman Copies', *Journal of the Warburg and Courtauld Institutes*, xliii, 1980, pp. 150–73.

Description des Pierres gravées du feu Baron de Stosch, 1760, and *Monumenti antichi inediti*, 1767, are the two works by Winckelmann regularly cited by British collectors because they were useful as iconographical source books. Typically, the only books by him in the library of the Society of Antiquaries were these two volumes and a pamphlet on the eruption of Vesuvius; in *Museum Worsleyanum* E. Q. Visconti and Sir R. Worsley (see n. 5.60 above) refer to *Monumenti* but to none of Winckelmann's theoretical works, despite their emphasis on Greece.

Daniel Webb (*c*.1719–1798), who visited Italy in 1755, plagiarized a manuscript lent to him by Mengs in his *Inquiry into the Beauties of Painting*, published in 1760, to Winckelmann's indignation, but his praises of Greek art are set in the tritest clichés (Ingamells, p. 983, and L. Salerno, *English Miscellany*, ii, 1951, pp. 279–85). Webb's level of scholarship is indicated by his subsequent essay, *Some Reasons for thinking that the Greek Language was borrowed from the Chinese*, 1787. Peter Beckford (1740–1811), the foxhunting author of *Familiar Letters from Italy*, 1805, composed from letters written in 1787, is one of the few English visitors who seems familiar with Winckelmann's ideas. He refers to him as 'a good antiquarian', ii, p. 273. The tiresome Irish clegyman, the Reverend Martin Sherlock (*c*.1750–1797), in his *Letters from an English Traveller*, 1780, p. 37, models his description of the *Apollo Belvedere* on that of Winckelmann.

6 For H. Fuseli (1741–1825), see Ingamells, pp. 385–6. He later withdrew his support for neo-classicism, rebuking a German author for failing 'to kick aside the tripod from which Winckelmann, Lessing and Mengs promulgated their false and frigid oracles' (Review of Stolberg's *Travels*, *Analytical Review*, December 1797, p. 548). For Fuseli's ambivalence towards the Greek cause, see E. Mason, *The Mind of Henry Fuseli*, 1951, pp. 221–31.

Goethe, *op. cit.* (n. 4.1), p. 167.

For Winckelmann's views on the British, see *Briefe*, ii, 1954, p. 285, and iii, 1956, p. 40.

7 For Winckelmann's use, see the Stosch catalogue, *op. cit.* (n. 6.5), p. iv, 'The rich collection of drawings after the antique belonging to H. E. Monsignor Alessandro Albani has been invaluable to me for this work . . . It contains not only everything that survives in Rome today, but also everything that was to be seen about two centuries ago.'

8 For Sir William Hamilton (1730–1803), see Ingamells, pp. 453–60, Jenkins and Sloan *op. cit.* (n. 4.30), B. Fothergill, *Sir William Hamilton*, 1969, and D. Constantine, *Fields of Fire*, 2001.

9 Walpole, *Correspondence*, xxii, p. 243, and British Library, Add. MS 42069, f. 149v, 5 November 1793.

10 Goethe, *op. cit.* (n. 4.1), p. 315.

Hamilton refers to his lumber room, 18 April 1769, and to the new apartment, 26 May 1789 (A. Morrison, *The Collection of Autograph Letters and Historical Documents formed by Alfred Morrison. The Hamilton and Nelson Papers*, i, 1893, p. 12, no. 18, and p. 140, no. 177).

11 A. F. Gori (1691–1757) argued that Cyclopean masonry, which was attributed to the Etruscans, was equally to be found in the walls of ancient Tuscan cities and in the Cloaca Maxima in Rome, proof that Etruscan culture was not confined to Tuscany. His friend G. B. Passeri (1694–1780), Antiquary to the Grand Duke of Tuscany, contributed several dissertations to *Museum Etruscum*. For the change of opinion about the vases' origins, see L. Burn, 'Sir William Hamilton and the Greekness of Greek Vases', *Journal of the History of Collections*, ix, 2, 1997, pp. 241–52. For vase collecting in Naples, see C. L. Lyons, 'The *Museo Mastrilli* and the Culture of Collecting in Naples, 1700–1755', and 'The Neapolitan Context of Hamilton's Antiquities Collection', *Journal of the History of Collections*, iv, 1992, pp. 1–26, and ix, 2, 1997, pp. 229–39.

12 For Hamilton's collecting, see N. H. Ramage, 'Sir William Hamilton as Collector, Exporter, and Dealer', *American Journal of Archaeology*, xciv, 1990, pp. 469–80, and I. Jenkins, 'Seeking the Bubble Reputation', and K. Sloan, 'Sir William Hamilton's "insuperable taste for painting"', *Journal of the History of Collections*, ix, 2, 1997, pp. 191–203 and 205–27.

For the letter to Palmerston, see Jenkins and Sloan, *op. cit.* (n. 4.30), p. 51.

13 For the representations of Hamilton, see Jenkins and Sloan, *op. cit.* (n. 4.30), pp. 53 and 144.

For the Capuan excavation, see Jenkins and Sloan, *op. cit.* (n. 4.30), p. 141. Winckelmann's account goes on to record that Hamilton himself made a drawing of the tomb. This was to provide the basis for a plate in the second volume of *Antiquités Etrusques, Grècques et Romaines*.

14 *Antiquités* (n. 6.13), i, preface, p. vi.

15 For Pierre François Hugues, Baron d'Hancarville (1719?–1805), see F. Haskell, *Past and Present in Art and Taste*, 1987, pp. 30–45.

16 For the troubled production of *Antiquités*, *op. cit.* (n. 6.13), see P. Griener, *Le antichità Etrusche, Greche e Romane 1766–1776 di Pierre Hugues*

d'Hancarville, 1992, especially the appendix which contains d'Hancarville's lengthy memoranda and estimates. D'Hancarville himself mentions a figure of £1350, p. 136, while Horace Mann, who told Walpole that d'Hancarville had 'talents that only wanted honesty to make a brilliant figure', set the cost at £1000 (*Correspondence*, xxiii, pp. 448–9 and 456). The pornographic works, *Monumens de la vie privée des douze Cesars* and *Monumens du culte secret des Dames Romaines*, contain supposed reproductions of gems depicting erotic scenes with a descriptive text.

17 *Antiquités, op. cit.* (n. 6.13), iii, p. 3, and iv, p. iii.

The descriptions of vases in the second volume were probably at least in part by Winckelmann (Jenkins and Sloan, *op. cit.* (n. 4.30), p. 48).

18 *Antiquités, op. cit.* (n. 6.13), iii, p. 3.

For an account of d'Hancarville's theories, see Jenkins and Sloan, *op. cit.* (n. 4.30), pp. 45–51, 93–100 and 149–59. For his plagiarism of Ottaviano di Guasco, *De l'Usage des Statues chez les Anciens*, 1768, see Griener, *op. cit.* (n. 6.16), pp. 81–2, and for his critics (only Leopoldo Cicognara praised his 'immense erudition'), pp. 87–8. For some of d'Hancarville's pictorial sources, see F. Lissarrague and M. Reed, 'The Collector's Books', *Journal of the History of Collections*, ix, 2, 1997, pp. 275–94.

19 Walpole, *Correspondence*, xxxii, p. 70. The Correggio has now been attributed to Luca Cambiaso.

Peter Pindar quoted in Fothergill, *op. cit.* (n. 6.8), pp. 118–19.

Hamilton must have used his influence with the king to allow him to export his collection. For export restrictions in Naples, confirmed in laws of 1755, 1766 and 1769, see Ramage, *op. cit.* (n. 6.12), pp. 471–2 and n. 4.12 above.

20 For Wedgwood's copies, see *The Genius of Wedgwood*, exh. cat., Victoria and Albert Museum, London, ed. H. Young, 1995, pp. 59–61, 70–71 and 75–8.

21 Morrison, *op. cit.* (n. 6.10), p. 44, no. 61.

For Charles Greville (1749–1809), who was responsible for passing off his mistress, Emma Hart, on his uncle, see Ingamells, pp. 429–30. Hamilton described him as one of the three best connoisseurs in England, together with Townley and William Lock (British Library, Add. MS 36495, f. 267). Greville, who chiefly specialized in geological specimens, was never rich enough to be a major collector of antiquities. He had strong views on the display of collections, telling his uncle that he had advised Lord Cawdor 'to

make a passage gallery, to take in some marbles, & introduce only furniture & agreeable *virtù* in his apartments, whereby he will set off a few fine things well. I am now satisfied that a small space will contain a great collection, & that a great collection need not be numerous.' (Morrison, *op. cit.* (n. 6.10), p. 149, no. 187). For John Campbell, first Lord Cawdor (1755–1821), see Ingamells, pp. 176–7. His collection, which was arranged in the museum of his London house, was sold in 1800; it included the *Villa Lante Vase*, now at Woburn, and a large display of 'Etruscan' vases.

22 For the *Warwick Vase*, see Jenkins and Sloan, *op. cit.* (n. 4.30), pp. 220–22. Hamilton wrote to C. Greville in January 1776, 'I have the collection at the museum so much at heart that tho' I can ill afford to lose such a sum as £350, which is (I believe) about the cost of my vase, I should rather give it to that collection than let it go elsewhere for twice the sum.' (Morrison, *op. cit.* (n. 6.10), p. 44, no. 61).

23 For the *Portland Vase*, see Jenkins and Sloan, *op. cit.* (n. 4.30), pp. 187–91. The Duchess (1715–1785), wife of the second Duke of Portland, was the daughter of the great bibliophile the second Earl of Oxford (see n. 2.18 above). Her museum at Bulstrode contained butterflies, corals, seashells and fossils but very few antiquities. She was probably attracted to the Vase because of its manufacturing technique, being herself a skilled turner in wood, jet, ivory and amber. She died the year after she had bought the Vase, which her son had to repurchase for £1029 and which her grandson deposited in the British Museum.

24 For the monkey, see Morrison, *op. cit.* (n. 6.10); p. 63, no. 95. The monkey, called Jack, 'diverts himself with my magnifying glass to look at objects, & I was teaching him to look at medals by way of laughing at antiquarians'.

25 Morrison, *op. cit.* (n. 6.10), p. 148, no. 185.

For the sale of the gems to Worsley, see Jenkins and Sloan, *op. cit.* (n. 4.30), pp. 101–3. Several of the gems were incorporated into the decorative initials of *Antiquités*.

26 For the sale of the bronzes and Goethe's suspicion that Hamilton had stolen some pieces from the royal excavations, see Jenkins and Sloan, *op. cit.* (n. 4.30), pp. 216–19, and Goethe, *op. cit.* (n. 4.1), p. 315.

27 Morrison, *op. cit.* (n. 6.10), p. 142, no. 180.

For the publication of *Collection of Engravings from Ancient Vases mostly of pure Greek Workmanship . . .*, 1793–1803, see Jenkins and Sloan, *op. cit.* (n. 4.30), pp. 55–7.

28 Tischbein, presumably taking his figures from Hamilton, estimated the cost at 20,000 ducats (£3333) (Jenkins and Sloan, *op. cit.* (n. 4.30), p. 58), but this is more than the amount quoted by Hamilton himself to Greville in the letter cited under n. 6.27 above. For the offers to the King of Prussia and Beckford, see Morrison, *op. cit.* (n. 6.10), p. 227, no. 292, and Fothergill, *op. cit.* (n. 6.8), pp. 292 and 402–3.

29 Morrison, *op. cit.* (n. 6.10), ii, p. 132, no. 552. For Thomas Hope (1769–1831), see Ingamells, pp. 521–2 and n. 8.6 below. A. L. Millin, *Monumens antiques inedits*, ii, 1806, p. 15, says that the price was £4725. Hamilton sold some minor antiquities as well as pictures at Christie's in March and April 1801.

30 The list of British subscribers to A. F. Gori's *Museum Etruscum*, 1737 (including Sir Thomas Dereham, Martin Folkes, the Duke of Kent, the Earls of Marchmont and Scarborough, Consul Joseph Smith and Sir Hugh Smithson, later Duke of Northumberland), indicates an interest in Etruscan vases at an earlier date. For some other early vase collectors, see n. 5.1 above, and the specialist dealer, James Clark, n. 4.27 above.

31 For Richard Payne Knight (1751–1824), see Ingamells, pp. 583–4, and *The Arrogant Connoisseur*, exh. cat., Whitworth Art Gallery, Manchester, ed. M. Clarke and N. Penny, 1982. He was always referred to as Richard Payne Knight to differentiate him from other Richard Knights in his family. He refers to himself as 'Payne Knight' in the manuscript notes added to a copy of *An Inquiry . . .* , 1818, in the British Library, pp. 156 and 160. He is abbreviated to Knight in these pages.

32 For the building of Downton, see Clarke and Penny, *op. cit.* (n. 6.31), pp. 32–49.

33 The journal *Expedition into Sicily* was published in 1986, ed. C. Stumpf, but it had been partly translated and published in Goethe's biography of Hackert in 1810. The original journal was probably given by Knight to Charles Gore and taken by the latter to Weimar when he settled there. See also Wilton and Bignamini, *op. cit.* (n. 3.1), pp. 239–40.

34 Knight had met Townley as early as 1774 and was presumptuously offering advice to him about the importance of a 'Skylight Room deserving of your Marbles' in William Lock's house, which was then on the market (BM, TY7/2076).

35 Townley's correspondence with Knight about d'Hancarville is the British Museum, BM, TY7/2079 and 2080.

36 For the festival of 'St Cosmo', see British Library, Add. MS 34,048, ff. 12–14, and Jenkins and Sloan, *op. cit.* (n. 4.30), pp. 238–9. Richard Colt Hoare visited Isernia in 1790 and bought an *ex-voto* although sales had been officially banned (*Recollections Abroad during the Years 1790, 1791*, 1818, p. 24).

Townley's correspondence with, for instance, Knight, Browne and Barry is full of very explicit detail about their sexual encounters.

37 BM, TY7/2081.

38 R. P. Knight, *A Discourse on the Worship of Priapus*, pp. 25 and 175–6.

39 *A Discourse*, pp. 48, 185 and 188.

For the controversy over the *Discourse* and Knight's defence of it in the preface to *The Progress of Civil Society*, 1796, and *An Inquiry into the Symbolical Language of Ancient Art and Mythology*, 1818, see Clarke and Penny, *op. cit.* (n. 6.31), pp. 50–64.

40 His income in 1807 was variously estimated at £6000 and £4000 (Farington, *Diary*, viii, pp. 2847 and 3005).

41 On at least one occasion in 1788, Townley dealt with Jenkins on Knight's behalf for the purchase of a bronze helmeted head, offered at 60 *zecchini*, because he could negotiate better terms as a frequent buyer (BM, TY7/468 and TY 7/2107). Knight said that he would consider it 'as a large medal' and place it upon the top of his cabinet.

42 For miniature bronze copies, see the collections of George Parker and General Dormer, nn. 3.10 and 3.11 above, and for the continuing attraction of such bronzes, many of them supplied by Francesco Righetti and Giacomo and Giovanni Zoffoli, see Haskell and Penny, *op. cit.* (n. 1.1), pp. 93–4 and *The Treasure Houses of Briitain, op. cit.* (n. 2.30), pp. 356–61. Zoffany's portrait of Sir Lawrence Dundas and his grandson shows an arrangement of bronzes on the chimneypiece. Similar bronzes were also bought by Lord Tavistock for Woburn, Lord Boringdon for Saltram and the Duke of Northumberland for Syon, among others, while Charles Heathcote Tatham ordered ten pieces for the Prince of Wales's Carlton House.

43 For his collections, see Clarke and Penny, *op. cit.* (n. 6.31), pp. 65–81 and 125–37. For the bronzes from Paramythia, see *Specimens*, ii, 1835, p. lxv, and H. B. Walters, *British Museum Select Bronzes, Greek, Roman and Etruscan*, 1915, p. 2. For Flaxman's remark, see J. Farington, *Diary*, ii, p. 452. See also his comment, made in 1806, vii, p. 2761, that Knight and Townley, 'had a certain degree of information from having been long

accustomed to look at Sculptural works', but 'their judgment could not be depended upon'. The gem engraver, Nathaniel Marchant, thought that 'Knight had more Classical information respecting Sculpture than Charles Townley, but the latter knew good sculpture from bad better than the former' (viii, p. 3084).

44 Knight had III gems, as opposed to Townley's 511.

For the Pistrucci case, see Clarke and Penny, *op. cit.* (n. 6.31), pp. 74–5.

45 BM, TY7/2092. *Specimens, op. cit.* (n. 3.33), pp. xliv–xlv.

Charles Philippe Campion de Tersan (1736–1819) and Michelet d'Ennery (1709–1786) both owned distinguished coin collections. Sir Robert Ainsley (?1730–1804) acquired, as a financial speculation, over 20,000 coins while he was ambassador to the Porte from 1776 until 1792, as well as gems, inscriptions, marbles and bronzes, using Domenico Sestini as his agent. The tone of Sestini's catalogues of the coins changed abruptly between *Lettere . . . sopra alcune Medaglie rare della Collezione Ainsleiana*, 1789, and *Descriptio Numorum* [*sic*] *Veterum*, 1796, after he discovered that his employer regarded the collection as a trading asset, 'true to his nature and the character of his nation'. In 1788 Knight commented to Townley 'Sir Robert professes to collect upon speculation, but does not choose at present to part with any but his Duplicates . . . He seems to expect to do as Sir William Hamilton did, but in this he will be disappointed.' (BM, TY7/2113). Knight's passion for Greek coins, of which he owned some 5200, is clear from a paper read to the Society of Antiquaries in February 1821, *Observations on the Large Silver Coins of Syracuse*.

James Millingen, *Ancient Coins of Greek Cities and Kings from various Collections principally in Great Britain*, 1831, complained that, following Haym's publication, see n. 2.19 above, there had been no serious work on numismatics in Britain for a century, whereas Italian, French and German scholars had produced important studies; the catalogues of the collections of Lord Pembroke and Dr William Hunter were useful but contained no explanations and the catalogue of Knight's collection, published from some of the donor's old notes after its transfer to the British Museum, was inaccurate and out of date. William Hunter (1718–1783), the anatomist, was the most notable coin collector of the century; his museum, which contained shells and corals as well as coins and which is said to have cost

him £20,000, was bequeathed to Glasgow University, although Knight tried to divert the legacy to the British Museum. Other important collections were made by Matthew Duane (1707–1785), whose coins were sold to Hunter in 1776, and the Reverend Clayton Mordaunt Cracherode, for whom, see n. 4.45 above.

46 For Knight's comment, see B. Haydon, *Lectures on Painting and Design*, ii, 1846, lecture xiii, pp. 215–16. Haydon was not present at the dinner himself.

Specimens, i, p. xxxix. See also the note to i, pl. xiv, commenting on a relief in Townley's collection, which was flattened to resemble chiaroscuro, 'The style was probably adopted for the sake of lightness of appearance; and to prevent that disagreeable effect of a projecting figure hanging over the head of the spectator, and threatening him like the sword of Damocles . . . the critics who have censured the lowness of relief in the internal friezes of the Parthenon . . . have only shown how narrow and confined their own views and principles have been, compared with those of the great artist, who designed them.'

47 For Knight's attitude towards the Elgin Marbles, see W. St Clair, *Lord Elgin and the Marbles*, 1998, pp. 167–72, 249–50 and 253–4. See also the views expressed in letters to his friend Lord Aberdeen in R. W. Liscombe, 'Richard Payne Knight: Some Unpublished Correspondence', *Art Bulletin*, lxi, 1979, pp. 604–10.

Reliefs were not highly esteemed, as can be judged from the fact that only five (the Albani *Antinous*, the *Weeping Dacia*, the *Borghese Dancers*, the *Curtius* and the group of *Marcus Aurelius* reliefs) are included among a recent selection of the ninety-five most famous statues of antiquity at the time of the Grand Tour (Haskell and Penny, *op. cit.* (n. 1.1), 1981). Nothing came of the suggestion made in 1787 by George Cumberland (1754–1848) about creating a collection of casts of the best bas-reliefs; he wrote to Sir William Hamilton, who agreed that it would be 'the very best means of enlarging the confined ideas of our artists' and suggested an approach to the Dilettanti (British Library, Add. MS 36495, f. 267).

48 For the comment on *Specimens*, see Michaelis, pp. 122–3.

49 For Charles Townley (1737–1805), see Ingamells, pp. 946–8, B. F. Cook, *The Townley Marbles*, 1985, and Wilton and Bignamini, *op. cit.* (n. 3.1), pp. 257–69.

50 J. Dallaway in the memoir of Townley in Nichols, *op. cit.* (n. 4.32), p. 723.

51 For the first visit to Italy, see BM, TY1/1–1/3.

52 For Christopher Hewetson (1737–1798), see Ingamells, pp. 494–5. He was a very successful portrait sculptor whose sitters included Clement XIV, Gavin Hamilton, Thomas Mansel Talbot, the Bishop Earl of Bristol and Raffael Mengs.

53 For Townley's collecting plan, made on his second Tour, see the letter from G. Hamilton, 1773, BM, TY7/558.

54 For the lists of marbles bought in Rome, see BM, TY10/3 and for the shipping expenses, BM, TY7/920 and 923–5, and TY10/2, ff. 51–2, where the total is given as 735.79 *scudi*. It is clear from the accounts of duties paid in 1772–4, that Townley grossly understated the value of his marbles; busts of L. Verus and M. Aurelius, which cost £120 were, for instance, declared at £20 (BM, TY9/3, and TY10/3, p. 37). The Piranesi chimneypiece was probably dismantled to extract the ancient fragments when Townley's marbles were moved to the British Museum.

55 For the career of Vincenzo Brenna (1745–1814), see *Dizionario Biografico degli Italiani*, xiv, pp. 144–6, and G. Vaughan, 'Vincenzo Brenna Romanus: Architectus et Pictor', *Apollo*, cxliv, March 1996, pp. 37–41. For his drawings, see Wilton and Bignamini, *op. cit.* (n. 3.1), pp. 236–8.

The designs are Victoria and Albert Museum, Prints and Drawings, 8478/55-9 and 64 and 66.

56 For William Young (1749–1815) and John Brown (1749–1787), see Ingamells, pp. 1037 and 137–9. There is a volume of Brown's sculptural studies made in 1771–2 in the Victoria and Albert Museum in addition to the drawings done for Townley in the British Museum.

For *Clytie*, see S. Walker, 'Clytie – a False Woman?', in M. Jones (ed.), *Why Fakes Matter*, 1992, pp. 32–40.

57 Townley's income in 1798 was assessed at £6217, although this was reduced to £2890 for the purposes of his tax return by heavy payments of annuities to members of his family, interest and estate outgoings (BM, TY8/17).

BM, TY6/1, draft letter of August 1781.

58 BM, TY7/577 and 389.

59 BM, TY7/584, 585, 590/2 and 594.

60 He bought at numerous London sales, including those of Matthew Duane, 1785, Sir Charles Frederick, 1786, the Duke of St Albans, 1797, and Lord Cawdor, 1800. Cawdor had previously given him a marble urn and a statue of an acrobat. In May 1804 the Duke of Bedford sent him an altar and a restored bas-relief, which had been bought by his father, Lord Tavistock, some forty years earlier but had only recently been unpacked (BM, TY1/20).

For Jenkins's assertion of honesty in gem dealing, see BM, TY7/501.

For a signed gem, previously thought to be a fake, see J. Rudoe, 'The faking of gems in the 18th century', in Jones, *op. cit.* (n. 6.56), pp. 23–31.

61 BM, TY7/487, 432 and 510.

For Cavaceppi, see BM, TY12/6/164.

62 BM, TY7/582 and 609.

63 For the building costs and the disagreement with Robert Adam, see BM, TY3/1–18.

For Adam's designs, see Soane Museum, Adam vol. 27/65 and 66, and Guilding, *op. cit.* (n. 5.55).

The interior of Townley's house has been altered and the chimneypieces removed but replicas of the columns have been replaced in the Dining Room. For a description of the house, see Smith, *op. cit.* (n. 4.21), pp. 261–6. BM, TY7/625.

64 For an account of the additions to the collection after Townley's third Italian visit, see Cook, *op. cit.* (n. 6.49), pp. 26–55. For the drawings of the Hall and Dining Room by William Chambers, see Wilton and Bignamini, *op. cit.* (n. 3.1), pp. 258–60. The latter room is depicted without table or chairs so as not to interrupt the view of the marbles. For the importance of top-lighting, see Knight's letter of July 1774, quoted in n. 6.34.

65 For the design by Bonomi, see C. Saumarez Smith, *Eighteenth-Century Decoration*, 1993, pp. 344–5.

66 For the description of the room and the Ionic capital, see d'Hancarville's MS catalogue in the British Museum and Wilton and Bignamini, *op. cit.* (n. 3.1), p. 260. Brenna's drawing for the capital is Victoria and Albert Museum, Prints and Drawings, 8478.45.

67 For Hamilton's advice, see BM, TY7/626.

68 For Zoffany's portrait, see Wilton and Bignamini, *op. cit.* (n. 3.1), pp. 260–62. Townley left d'Hancarville to supervise Zoffany at work (BM, TY7/198).

For Wiliam Smith, see n. 7.14 below.

69 C. Greville wrote to Hamilton, 'D'Hankerville is again *sur le pavé*, his creditors have taken his hotel at Paris, in which I am told he had some fine furniture . . . ; he disappeared without giving the least hint to anyone; it is a matter of curiosity to me where he will find an asylum' (Morrison, *op. cit.* (n. 6.10), p. 150, no. 187).

70 Townley's correspondence with d'Hancarville is BM, TY/7/161-294 and TY/6, 11 February 1783.

BM, TY7/427/2, draft of 21 October 1785.

BM, TY7/466/2, draft of 7 March 1788.

71 BM, TY12/6/68.

72 BM, TY7/638.

73 J. Dallaway, *Of Statuary and Sculpture*, 1816, pp. 328–9. For the Reverend James Dallaway (1763–1834), see *Dictionary of National Biography*, xiii, pp. 398–9. He was chaplain to the British embassy to the Porte, which enabled him to write *Constantinople, Ancient and Modern*, 1797. He was introduced to Townley through his patron, the Duke of Norfolk. His very useful account of British collecting owes much to his conversations with Townley, who checked his notes (BM, TY1/11, 29 May, 7 and 10 June 1799, and TY1/12, 18 November 1799). Dallaway's list of the most important statues in Italy, which could well reflect Townley's views, comprised the equestrian *Marcus Aurelius*, the *Torso*, the *Laocoön*, the Vatican *Antinous*, the *Medici Venus*, the Spada *Pompey*, the Farnese *Bull*, the Farnese *Hercules*, the *Apollo Belvedere*, the Barberini *Sleeping Faun*, the *Dying Gladiator*, the Capitoline *Harpocrates*, the Capitoline *Venus* and the Pighini *Meleager*.

74 The paper was printed in *Monumenta Vetusta*, iv, 1815, pp. 1–12. The helmet was found at Ribchester in Lancashire.

75 BM, TY7/2082. See also the letters from Barry, 'compared to you I am an amateur [in judging whores]', from Browne, 'I see several of your acquaintance in Hyde Park on Sundays', and T. Assheton, 'Pray let me know what sort of whores you have in Italy.' (BM, TY7/1090, 1496 and 1546).

76 J. Richardson, *Account of some of the Statues, Bas-reliefs, Drawings and Pictures*, 1722, pp. 55–6. John Boyle, fifth Earl of Cork and Orrery (1707–1762), *Letters from Italy in the years 1754 and 1755*, 1773, pp. 75–6 and 79–80, and Sir J. Reynolds, *Discourses on Art*, x. Reynolds also warned that 'it must be confessed of the many thousand ancient statues which we have, that their general characteristic is bordering at least on inanimate insipidity', *Discourses on Art*, viii.

For a connoisseur's view of proportion and the ideal mathematical relationship between the parts of the body, see L. Ten Kate's essay, *Discours préliminaire sur le Beau Idéal*, prefaced to J. Richardson's *Traité de la Peinture*, iii, 1728, pp. lv–lxxii, which, in turn, goes back to Gerard Audran's *Les Proportions du Corps Humain mesurées sur les plus belles Figures de l'Antiquité*, 1683, and, for the carefully measured drawings which Nollekens made of the statue in the Uffizi, *The Most Beautiful Statues*, exh. cat., Ashmolean Museum, Oxford, ed. F. Haskell and N. Penny, 1981, p. 16.

77 Reynolds, *Discourses on Art*, vi.

78 Townley records that Mr Beaumont sold marbles at Christie's in 1776 for £216, having paid £404 for them, and that Chace Price sold marbles for £253, having paid £546 (BM, TY/15/1/6 and 15/1/11). See also Lansdowne's potential loss, n. 5.74 above.

79 For John Frederick Sackville, third Duke of Dorset (1745–1799), see Ingamells, p. 306, and Michaelis, pp. 416–23.

80 For Joseph Leeson, later first Earl of Milltown (1711–1783), see Ingamells, pp. 593–4. For Shelburne's costs, see n. 5.74.

81 For art prices over the centuries, see G. Reitlinger, *The Economics of Taste*, 1961. By 1793 Hamilton had reduced the asking price for his 'Correggio' to £1200 (Morrison, *op. cit.* (n. 6.10), p. 176, no. 220).

For the fall in prices of marbles, see nn. 5.20 and 5.74 above and the prices at the Stowe sale in 1847, n. 8.29.

82 T. Smollett, *Travels through France and Italy*, ii, 1766, pp. 91–2.

For extracts from *Taste* by S. Foote (1720–1777), see F. H. Taylor, *The Taste of Angels*, 1948, pp. 460–64, an interesting compilation on the history of collecting.

83 For the *Cat*, the *Dog* and the *Eagle*, see *The Treasure Houses of Britain* (n. 2.30), pp. 300 and 318–19. To these could be added Townley's *Bitch caressing a Dog*, Weddell's *Ibis*, Barry's *Equestrian Paris*, Newdigate's Crane candelabrum and various goats, satyrs and dolphins in other collections. The *Dog*, acquired by the British Museum in 2001, was bought for 400 *scudi* by Henry Constantine Jennings (1731–1819), who was in Rome c.1753–61, Ingamells p. 557. When he was forced to sell it to meet his gaming debts, Charles Duncombe acquired it at Christie's for £1050. Casts were made to decorate the halls of several country houses.

84 For the dispersal, see also E. Gibbon, *Autobiography*, 1959 edn, p. 126, 'We should be astonished at our own riches, if . . . the spoils of Italy and Greece, which are now scattered from Inverary to Wilton, were accumulated in a few streets between Marylebone and Westminster.' Inverary is a puzzling reference – perhaps Gibbon thought that the Campbell Lord Cawdor kept his collection there.

For the behaviour of visitors to Holkham, see E. Moir, *The Discovery of Britain*, 1964, pp. 60–61.

85 In the same way, Jenkins had shipped the body of Dr John Gifford, labelled as a marble statue, from Rome to Leghorn for burial in 1779 (Ingamells, p. 400).

CHAPTER 7

1 For John Bacon Sawrey Morritt of Rokeby (1771–1843), see *A Grand Tour, Letters and Journeys 1794–96*, 1985, pp. 175, 179–81, 207, 266 and 305–6, Michaelis, pp. 643–6, and Vermeule 1955, p. 146. For the peeping scene, see n. 5.59 above. He acquired a few marbles and two fine cameos in Italy; some of the former are still at Rokeby, although the Greek *stelae* have been sold. His *Seated Girl* is in the British Museum.

Other visitors to Greece included the Reverend Edward Daniel Clarke (1769–1822), Edward Dodwell (1767–1832), John Nicholas Fazakerly (d. 1852), Sir William Gell (1777–1836), Benjamin Gott (d. 1817), John Cam Hobhouse, Lord Broughton (1786–1869), Colonel William Martin Leake (1777–1860), Thomas Legh (d. 1857) and, of course, George Gordon, sixth Lord Byron (1788–1824), see J. Mordaunt Crook, *The Greek Revival*, 1972, pp. 29–62.

Much information was collated by another traveller, the Reverend Robert Walpole (1781–1856), in *Travels in various Countries of the East*, 1820, and more is to be found in the visitors' own accounts. For Gell, whose works were extensively published by the Dilettanti Society, but who was not himself a collector, see E. Clay, *Sir William Gell in Italy*, 1976. Gott's sepulchral marbles were presented to the museum in Leeds (Vermeule 1955, p. 138). Leake's collection was divided between the British Museum and Cambridge. Thomas Legh, one of the part-owners of the frieze from Bassae and author of *Narrative of a Journey in Egypt, and the Country beyond the Cataracts*, 1816, was 'fortunate enough to discover numerous vases, inscriptions and bas-reliefs' when in Greece in 1812. Three of his *stelae* were taken to Lyme Park, Cheshire (E. Strong, 'Three Sculptured Stelai in the Possession of Lord Newton at Lyme Park', *Journal of Hellenic Studies*, xxiii, 1903, pp. 356–9). Walpole gave a torso from Cnidos to the British Museum.

2 For Thomas Bruce, seventh Earl of Elgin (1766–1841), and the acquisition of his marbles, see St. Clair, *op. cit.* (n. 6.47), and A. H. Smith, 'Lord Elgin and his Collection', *Journal of Hellenic Studies*, xxxvi, 1916, pp. 163–370, which quotes many of Elgin's letters. For a balanced overview see also, M. Beard, *The Parthenon*, 2002.

3 For Thomas Harrison (1744–1829), see Colvin, *op. cit.* (n. 2.9), pp. 466–70, and Ingamells, pp.

467–8. While in Italy in 1773, he made proposals for a new sculpture gallery for the Vatican. His Doric designs for Chester Castle predate Elgin's embassy. For his work at Broomhall, see J. Mordaunt Crook, *Country Life*, cxlvii, 1970, pp. 242–6.

Harrison wrote to Townley in February 1803 to say that he was glad that Townley approved of what Elgin was doing in Greece (BM, TY 7/1607).

4 G. B. Lusieri (*c.*1755–1821) continued in Athens until his death. Sadly, almost all of his views of Athens were lost in a shipwreck. For his views of Italy acquired by Elgin, see Sotheby's sale, 30 June 1986. Theodor Ivanovitch, a Tartar from Central Asia, who had been brought up in St Petersburg and sent to Rome to study as an artist, was another member of the team.

5 For the *firman*, see St Clair, pp. 337–41, and Smith, p. 190, both *op. cit.* (n. 7.2).

6 Smith, *op. cit.* (n. 7.2), pp. 191–2.

7 For the career of the Reverend P. Hunt (1772–1838), see E. Stockdale, 'Law and Order in Georgian Bedfordshire', *Bedfordshire Historical Record Society*, lxi, 1982, pp. 31–65.

8 Hunt to Lord Upper Ossory, in St Clair, *op. cit.* (n. 7.2), p. 95.

9 *Report from the Select Committee . . . on the Earl of Elgin's Collection*, 1816, pp. 40–41.

10 For the casts of architectural details, see Smith, *op. cit.* (n. 7.2), p. 207, and for advice against restoration, p. 227. William Richard Hamilton (1777–1859) went on to become one of the British representatives in Paris to oversee the return of Napoleonic spoils in 1815. As Secretary of the Dilettanti Society, he wrote to Elgin in 1831 to inform him that he had been elected to the society, an honour that was declined. His house in Fulham is still decorated with casts of the frieze.

Lusieri's account book at Broomhall records the care taken to dismantle the marbles and convey them to the port and the problems of carting water by mule up to the Acropolis to supply the moulders.

Elgin's father-in-law, William Nisbet, who visited Athens in 1801, also profited from the works. The Archbishop gave him a marble throne which had formerly been in the Panathenaic stadium. It was shipped to Biel, Nisbet's house in East Lothian, where it remained until its acquisition by the British Museum. See also Smith, *op. cit.* (n. 7.2), pp. 186–8, and D. Williams, 'The Biel Throne', *British Museum Magazine*, Autumn/Winter 2001, p. 40.

11 Marie Gabriel Auguste Florent, Comte de Choiseul-Gouffier, French ambassador to the Porte (1784–1792), *Voyage Pittoresque de la Grèce*, 1809, ii, pp. 85–6.

12 Knight was more conciliatory to Elgin in 1808, when he was trying to buy his coin collection, 'Since our conversation concerning the marbles, I have been considering the best Method of fulfilling your liberal Intentions of appropriating them to the Public.' (J. Rothenberg, *'Descensus ad Terram', The Acquisition and Reception of the Elgin Marbles*, 1977, p. 225).

13 E. Dodwell, E. D. Clarke and J. Galt (1779–1839), the author of a verse satire on Elgin, were among those who complained.

14 William Smith (1756–1835) had a notable collection of paintings at his Park Street house, which was adjacent to Townley's.

15 For the costs, see *Report from the Select Committee, op. cit.* (n. 7.9), pp. x–xiv.

16 Byron's first attack appeared in *English Bards and Scotch Reviewers*, 1810.

17 C. R. Cockerell (1788–1863) described his explorations in *Travels in Southern Europe and the Levant, 1810–1817*. For his architectural career, see Colvin, *op. cit.* (n. 2.9), pp. 256–62. He used casts of the Bassae frieze to decorate the staircase at Oakly Park, Shropshire.

18 For Canova's approval, see Smith, *op. cit.* (n. 7.2), p. 333, and for his views on restoration, Dallaway, *op. cit.* (n. 5.19), 1816, p. 363. E. Q. Visconti had given an equally enthusiastic appraisal as an antiquarian.

19 M. Whinney, *Sculpture in Britain 1530–1830*, 1988, p. 382, points out that the war monuments had been almost completed by the time the Elgin Marbles were on public display, but the marbles had been available for artists to study since their arrival in England.

20 For the collections at Broomhall, see A. Michaelis, 'Ancient Marbles in Great Britain', supplement, *Journal of Hellenic Studies*, v, pp. 143–56, Vermeule 1955, p. 132 and 1959, pp. 141–2, and R. A. Higgins 'The Elgin Jewellery', *British Museum Quarterly*, xxiii, 1960/61, pp. 101–7. Elgin also secured some fragments from the Treasury of Atreus at Mycenae.

21 Smith, *op. cit.* (n. 7.2), p. 261.

22 For E. D. Clarke (1769–1822) and his collection, see his own *Greek Marbles brought from the Shores of the Euxine, Archipelago, and Mediterranean* . . . , 1809, W. Otter, *The Life and Remains of the Rev. Edward Daniel Clarke*, 1824, Michaelis, pp. 241–52, and Ingamells, pp. 210–11. He did not check the collecting interests of Lord Berwick who bought 'Etruscan' vases and some marbles,

restored by John Deare and dispersed at the Attingham sale of 1827 (Ingamells, pp. 87–8). For the friction with Elgin's party, see Smith, *op. cit.* (n. 7.2) p. 185, and for Clarke's disapproval of Elgin, see his *Travels in Various Countries of Europe, Asia and Africa*, 1814, ii, part ii, pp. 483–6, and for some of his acquisitions, p. 529.

23 George Gordon, fourth Earl of Aberdeen (1784–1860), *Diary*, 24 April 1803, f. 36, British Museum, Department of Greek and Roman Antiquities, for the Parthenon 'devastation'. The next day he recorded that he 'walked over the town in order to procure antiques, but could scarcely pick up anything'. Returning to Athens in September, after a visit to Turkey where he copied a number of inscriptions, he met Lusieri, bought a damaged inscription from the Governor and opened a small excavation on the Pnyx (*Diary*, ff. 128–32). For a list of the antiquities that were shipped to Malta for him in September 1808, see British Library, Add. MS 43256, f. 6. See also n. 6.47 above. For the relief of the toilet set and other pieces from his collection, see Smith, *op. cit.* (n. 4.7), pp. 370–71 and *passim*.

J. Millingen, *Some Remarks on the State of Learning and the Fine Arts in Great Britain*, 1831, pp. 13–14.

James Millingen (1774–1845), born in London of Dutch parents, was brought up in France at the time of the Revolution. He was encouraged to study coins by Cracherode, who was a friend of his father, but broadened his interests and, after he had moved to Italy for health reasons, he acted as buying agent for several collections, including that of the British Museum. He prepared the catalogue of Sir John Coghill's vases in 1817, two years before their sale, as well as a number of other books on vases and coins.

24 For Dodwell's re-adjusted memory of the removal of the Elgin Marbles, see M. R. Bruce, 'A Tourist in Athens', *Journal of Hellenic Studies*, xcii, 1972, pp. 173–5. For his collection, see *Notice sur le Musée Dodwell* . . . , 1837. For his wife, see R. R. Madden, *The Literary Life and Correspondence of the Countess of Blessington*, 1855, ii, p. 147.

25 For the collection of Percy Smythe, sixth Viscount Strangford (1780–1855), see Michaelis, pp. 272–6, Vermeule 1959, pp. 145–6, and *Kentish Gazette*, 17 December 1844. Lord Sligo's son married a daughter of Lord Strangford.

26 For Howe Browne, second Marquess of Sligo (1788–1845), see Marquess of Sligo, *Westport House and the Brownes*, 1981, pp. 33–5.

27 For the marbles of Frederick North, fifth Earl of Guilford (1766–1827), see Michaelis, pp. 432–3 and 492, and for the wellhead, p. 161, *Journal of Hellenic Studies*, vi, 1885, pp. 46–9, and E. Dodwell, *A Classical and Topographical Tour through Greece . . .*, 1819, p. 200. From the same source, Thomas Beaumont (1792–1848) prob-ably also removed to Bretton Park an altar of second century B.C. from Delos; the altar was sold at Christie's 15 May 2002. Guilford's uncle, Brownlow North, Bishop of Winchester (1741–1820), was a collector of antiquities (Ingamells, pp. 711–12).

28 For Thomas Gordon of Buthlaw and Cairness (1788–1841), see J. D. Beazley, 'Stele of a Warrior', *Journal of Hellenic Studies*, xlix, 1929, pp. 1–6, and *Dictionary of National Biography*, xxii, pp. 230–32. Some of his antiquities were disposed of in June 1851 and his *stelae* were sold at Sotheby's, July 1936.

For Admiral Thomas Abel Brimage Spratt (1811–1888), see *Dictionary of National Biography*, xviii, pp. 832–3, and I. Jenkins, *Archaeologists & Aesthetes*, 1992, pp. 174–5, 179–80 and 193. In 1860 he persuaded the British Museum to buy two sarcophagi from Crete, to be shipped home by the Royal Navy (T. Spratt, *Travels and Researches in Crete*, i, 1865, p. 274). His favourite antiquity, a small *Venus*, retained by his family and later sold, was acquired by the British Museum in 2000.

Other acquisitive visitors to Greece included John Hawkins (1761–1841), who spent some time at Zante at the turn of the eighteenth century, and acquired a few fine bronzes in northern Greece and five marble reliefs, which he installed in a summer house at Bignor in Sussex (Ingamells, p. 474; Michaelis, pp. 118–19 and 212–13; Vermeule 1955, p. 130, and *Country Life*, cxix, 1956, pp. 860–63); Thomas Burgon (1782–1858), a Turkey merchant who travelled in Greece 1811–14 before moving back to London where, on his bankruptcy in 1841, his collec-tion was sold to the British Museum and he found charitable employment in the Coin Department; Sandford Graham M.P., another vase collector; and Mary, Lady Ruthven (d. 1885), who lived at Athens during the 1820s, when she obtained some vases and funerary reliefs from tombs in the region (Michaelis, pp. 161 and 721, and Vermeule 1955, p. 135). Lady Ruthven, who presented her collection to the Antiquarian Museum in Edinburgh in 1884, was assisted in her search for antiquities by Ali Pasha (G. Baldwin Brown, 'Sepulchral Relief from Attica, at Winton Castle', *Journal of Hellenic Studies*, vi, 1885, pp. 16–18.

A number of merchants based in Smyrna col-lected and dealt during the nineteenth century, including George Dennis, the British consul, Dr Hyde Clarke and Edward O'Halley, who both presented some antiquities to the Ashmolean, the Whittall family, Henry Borrell, who specialized in coins, W. R. Paton, whose finds from Myndos are in the British Museum, and George McLeahy.

CHAPTER 8

1 For the slow evolution from the aesthetic to the historical method of display in the British Museum, see Jenkins, *op. cit.* (n. 7.28), pp. 56–9 and 65–70. The first chronological display was in the Glyptothek in Munich. For the activities of Charles Fellows, Charles Newton and others on behalf of the British Museum, see Jenkins, pp. 140–95.

2 J. Millingen, *Ancient Unedited Monuments*, 1826, ii, i–ii, and *Some Remarks on the State of Learning and the Fine-Arts in Great Britain*, 1831, p. 15.

The objects illustrated in *Specimens*, ii, were from the collections of Townley, Knight and Hamilton, all by then in the British Museum, Leicester, Egremont, Lansdowne, Barry, Blundell, Weddell, Walpole and Hawkins from the eighteenth century and of Bedford, Samuel Rogers, Colonel William Martin Leake, Edward Drummond Hay (a Scottish antiquarian who gave the bronze illustrated to the British Museum), William Hamilton (Elgin's secretary), William Bankes of Kingston Lacy (an important collector whose interest in antiquity was con-centrated on Egyptian artefacts) and Richard Westmacott, the sculptor, from the nineteenth century, while Hope's collecting straddles both centuries. Approximately two thirds of the objects illustrated had been acquired during the eighteenth century and the balance came from more recent collections.

Townley joined a Dilettanti Society meeting on 9 June 1800 at Hope's house to ask the gov-ernment to moderate import duties (BM, TY1/15).

3 For Carlo Fea (1753–1836), Papal Antiquary from 1800, see Ridley, *op. cit.* (n. 4.12), 2000.

Valentine Lawless, second Lord Cloncurry (1773–1853), was exceptional in buying marbles in Rome in 1805–6, despite the French, but he was probably tolerated because of his recent imprisonment in the Tower of London for sup-posed treasonable sentiments. He was granted an excavation licence and bought antiquities

and paintings from indigent Roman families but some of his purchases were lost when the boat bringing them back to Ireland foundered off Dublin. A *Minerva* from the Giustiniani collection was salvaged as were several other statues and busts, a sarcophagus, marble tabletops and vases and four antique columns. Three of these, originally part of the Golden House of Nero, had been moved to the Farnesina, where Lawless acquired them; to make up a fourth he bought a much larger column from the Baths of Titus and had it chiselled down and polished to match the other three. The four columns now front the portico of Lyons, his house near Dublin. See *Personal Recollections of the Life and Times, with Extracts from the Correspondence of, Valentine, Lord Cloncurry*, 1849, pp. 191–3, and J. Eiffe, 'Lyons, Co. Kildare', *Bulletin of the Irish Georgian Society*, xxvii, 1984.

For Francis Charles Seymour-Conway, third Marquess of Hertford (1777–1842), see D. Mallett, *The Greatest Collector*, 1979, pp. 31 and 74. On his death, his London villa was left to one of his mistresses, who sold the contents in 1855. The fourth Marquess (1800–1870), who was responsible for much of the contents of the Wallace Collection, was not interested in antiquities.

For Lord Egremont's collection of contemporary sculpture at Petworth, see n. 5.20 above.

4 For John Disney (1779–1857) see Michaelis, pp. 159, 255–67 and 333, and D. W. J. Gill, ' "Ancient fictile vases" from the Disney Collection', *Journal of the History of Collections*, ii, 2, 1990, pp. 227–31.

For another East Anglian collection of this period, bought in Rome in 1825–6 by Charles Callis Western, Lord Western (1767–1844) of Felix Hall, Kelvedon, Essex, see J. H. Ramsden, *A Descriptive Sketch of the Collection of Works of Greek and Roman Art at Felix Hall*, 1864. It comprised some 'Etruscan' vases, various sarcophagi (one excavated at Ostia), urns, Piranesian *tazze*, a candelabrum and busts, including one of *Faustina*, bought on the recommendation of the sculptor Gibson.

At the same time General George Cockburn (1763–1847), who had seen action in Sicily during the Napoleonic Wars, returned to Italy in 1824–5, when he bought marbles and vases, many of which are now in the Classical Museum of University College, Dublin (Ingamells, p. 222).

5 Farington, *Diary*, x, 1982, p. 3541.

For Westmacott's reorganization, see R. Guilding, 'Wilton House in the Early Nineteenth Century', *Apollo*, cliv, November 2001, pp. 42–8.

A collection of antiquities was used to decorate another Gothick house when the marbles were removed from the Orangery to adorn Thomas Hopper's Margam Abbey in the 1830s. See also nn. 8.33 and 8.34.

6 For Thomas Hope (1769–1831), see Ingamells, pp. 521–2; Michaelis, pp. 279–93; Vermeule 1955, pp. 134–5, 1956, pp. 327–9, and 1959, p. 150; D. Watkin, *Thomas Hope and the Neoclassical Idea*, 1968; G. B. Waywell's thorough reconstruction, *The Lever and Hope Sculptures*, 1986; E. M. W. Tillyard, *The Hope Vases*, 1923; Jenkins, *op. cit.* (n. 6.12), pp. 197–9; and P. Thornton and D. Watkin, 'New Light on the Hope Mansion in Duchess Street', *Apollo*, cxxvi, 1987, pp. 162–77.

7 C. H. Tatham included drawings of the six Pacetti statues in his compilation of decorative architectural details, Victoria and Albert Museum, Prints and Drawings, E 1310-165-2001. In August 1795 he noted that statues of *Mars, Mercury, Hygeia, Bacchus and Hope, Aesculapius* and an unidentified figure had been priced at 12,200 *scudi*, but were now to be had for 6000 *scudi*, 'to be paid at the will & pleasure of the purchaser as to time, mode of payment &c.' Hope eventually bargained Pacetti down to 2800 *scudi*, including restoration costs, for three statues, two of which, *Bacchus and Hope* and *Aesculapius*, were in the group offered to Tatham and the third, an *Antinous as Ganymede*, was bought from Giovanni Pierantoni (A. Montaiglon, *Correspondance des Directeurs*, xvi, 1907, pp. 412–13). The export records, however, show that, although Hope had applied for an export licence for thirteen cases valued at 6000 *scudi* in 1798, the licence was then withdrawn because the French had so denuded Rome that it was desirable to retain such major statues; eventually Hope's agent, Gioachino Marino, secured licences for *Apollo and Hyacinthus* (1000 *scudi*), *Antinous* (1800 *scudi*) and an *Apollo Sauroctonus* (700 *scudi*) in 1803, but the vendors' names are confused in the sources and the exact prices may have been exaggerated by art-world gossip and then reduced for export licence purposes (Bertolotti, *op. cit.* (n. 1.20), iv, 1880, p. 89, and Ridley, *op. cit.* (n. 3.7), 2000, p. 117).

For Vincenzo Pacetti (1746–1820), see Wilton and Bignamini, *op. cit.* (n. 3.1), p. 216. Since he had acquired the famous *Barberini Faun* in 1799, he must have offered it to Hope who probably decided, quite correctly, that its export would cause even more difficulties.

8 T. Hope, 'The Utility of Remains of Antiquity', *The Director*, ii, 1807, p. 198.

9 *Observations on the Plans and Elevations designed by James Wyatt Architect, for Downing College, Cambridge,* 1804, pp. 7–10.

10 BM, TY1/20, 23 February 1804.

 For the decoration of the house of Samuel Rogers (1763–1855), the man of letters, see P. W. Clayden, *The Early Life of Samuel Rogers,* 1887, pp. 448–9, and the sale particulars of 22 St James's Place in 1856. There were casts of some of the Elgin Marbles round the staircase. He bought marbles from Fagan and vases from Millingen. An antique marble hand, kept in a glass case, was said to be so exquisite that Canova insisted on kissing it.

11 He bought at the Cawdor, Chinnery, Edwards and Coghill sales (Michaelis, p. 293, and Christie's Deepdene sale catalogue, July 1917).

12 The letter is quoted at length in Watkin, *op. cit.* (n. 8.6), pp. 198–9. In similarly didactic mode Henry Moses published in 1814 *A Collection of Antique Vases, Altars, Paterae, Tripods, Candelabra, Sarcophagi &c.* As he explained in his preface, 'The study of the unrivalled works of the ancients is essential to the establishment of good taste and correct judgment, and has laid the foundation of those excellencies which have given celebrity to all the distinguished artists of modern times.' He therefore illustrated a variety of antique forms and, usefully, gave an explanation of the original functions of the esoteric objects which were so frequently copied by designers and architects.

13 Copies of the plates by T. D. Fosbroke are in the National Art Library, Victoria and Albert Museum. See Waywell, *op. cit.* (n. 8.6), pp. 37–8.

14 Waywell, *op. cit.* (n. 8.6), pp. 49–50.

15 For the collection of Sir John Soane (1753–1837), see C. C. Vermeule, 'Sir John Soane, His Classical Antiquities', *Archaeology,* vi, 1, 1953, pp. 68–74, and *Catalogue of the Classical Antiquities in Sir John Soane's Museum,* typescript, 1975, and P. Thornton and H. Dorey, *A Miscellany of Objects from Sir John Soane's Museum,* 1992.

16 For the Adams' collection, see Fleming, *op. cit.* (n. 2.17), pp. 227–8, 251 and 296–7. James Adam bought 'a good many fragments of bas-reliefs and little statues that were in Baron Stosch's collection'. John Nash was another architect who displayed casts and busts together with models of Greek and Roman temples in his house in Regent Street (J. Britton and A. Pugin, *Illustrations of the Public Buildings of London,* ii, 1838, pp. 288–9), while Decimus Burton (1800–1881) had a collection of casts of architectural details, some of which are now in the Victoria and Albert Museum.

17 For Charles Heathcote Tatham (1772–1842), see Ingamells, pp. 927–8, and Colvin, *op. cit.* (n. 2.9), pp. 955–7. His correspondence with Holland is Victoria and Albert Museum, Prints and Drawings, 99 A 3. His books illustrating examples of Greek and Roman decoration, based on sketches made during his Italian stay 1794–6, were important sources for neo-classical detail; when he was copying a fragment in the Villa Medici, Canova came in, patted his shoulder and said, 'Bravo, bravo. Well drawn. That's the *Apollo* of ornaments.' (Victoria and Albert Museum, E 1310-81-2001).

 Tatham also published his designs for the Galleries at Castle Howard and Brocklesby.

18 J. Soane, *Description of the House and Museum on the North side of Lincoln's-Inn-Fields,* 1836, p. 13.

 The Pantheon capital was bought in 1823 from Sir Henry Englefield's sale, having formerly been in the collection of the Duke of St Albans. Soane noted d'Hancarville's theories on the symbolism of the lotus, represented on a terracotta that had passed from Lyde Browne to Matthew Duane and thence to himself, p. 11.

19 Soane, *op. cit.* (n. 8.18), p. 36. The *Apollo* was given by the fifth Duke of Devonshire, who then owned Chiswick, to John White, the architect who made alterations to the house.

20 Michaelis, p. 164.

21 For Frederick Howard, fifth Earl of Carlisle (1748–1825), see Ingamells pp. 179–81. In February 1811 he agreed to pay Tresham an annuity of £300 a year for some paintings and the 'entire Collection of Antique Vases, Pictures, Drawings, Gems, marble fragments, Bronze & silver Medals and a Terra Cotta Vase and also a Bronze Vase' (Castle Howard Archives J 14/29/12). For the Hamilton acquisitions, see Jenkins, *op. cit.* (n. 6.12), pp. 199–200. Hamilton wrote approvingly of the verses (Castle Howard Archives, J 14/1/600). The fifth earl's son, George Howard, sixth Earl (1773–1848) met Tatham in Rome while on his Tour in 1794, and one of his daughters married Lord Cawdor, another collector – yet another instance of intermarriage among collecting families.

 For the richer display of antiquities that was suggested by Tatham, see the Tatham album, Victoria and Albert Museum, E1311–256 2001.

22 For the Woburn Abbey collection, see Michaelis, pp. 721–53, Vermeule 1955, p. 150, 1956, pp. 348–50, and 1959, pp. 347–8, and E. Angelicoussis's full account, *The Woburn Abbey Collection of Classical Antiquities,* 1992, with quotations from the sixth Duke of Bedford's correspondence with his son. For John Russell,

fourth Duke of Bedford (1710–1771), who acquired the famous Canalettos at Woburn, and his son, Francis Russell, Marquess of Tavistock (1739–1767), see Ingamells, pp. 832–3 and 929.

23 Letter of 2 July 1800, Stonor Papers, Box 256, and BM, TY15/11, 5 July 1800. Some Greek vases, acquired by the duke at the Cawdor sale when the *Villa Lante Vase* was bought, were not displayed in the Conservatory but in the North Corridor.

24 For the temple, see J. Kenworthy Brown, 'The Temple of Liberty at Woburn Abbey', *Apollo*, cxxx, 1989, pp. 27–32. For Townley's involvement, see Holland's letter, 18 April 1802, suggesting a pronaos and altars 'calculated to give the effect of an ancient Temple adapted for a modern purpose, but the Duke wishes to know if *you* see any impropriety' (BM, TY7/963, and Townley's diary, BM, TY1/20, 14 May 1804). For the relief given to Townley, see Cook, *op. cit.* (n. 6.49), p. 58.

The columns were bought at the sale of Thomas Brand of Kimpton Hoo in Hertfordshire in 1802 and may have come from his cousin, another Thomas Brand, later Brand-Hollis, the friend of the collector Thomas Hollis (E. Angelicoussis, *op. cit* (8. 22), p. 109).

25 For the Thorvaldsen reliefs, see *The Age of Neo-Classicism*, exh. cat., Royal Academy and Victoria and Albert Museum, London, 1972, pp. 286–7. The Duke of Devonshire bought copies for Chatsworth.

26 For Lord William Russell (1790–1846), see G. Blakiston, *Lord George William Russell and his Wife*, 1972. For his purchases and the duke's letters, see Angelicoussis, *op. cit.* (n. 8.22), *passim*. The sarcophagus, originally found at Ephesus, was bought for £210 at the sale of Sir Gregory Page Turner of Battlesden Park, Bedfordshire (Angelicoussis, *op. cit.* (n. 8.22), pp. 79–83). Antonio Nibby (1792–1839), professor of archaeology at Rome University, worked closely with William Gell on Roman topography. For Lord Kinnaird, see n. 8.33 below.

27 P. F. Robinson, *Vitruvius Britannicus, History of Woburn Abbey*, with engravings by H. Moses after drawings by J. G. Jackson, was published in 1833.

28 For George Grenville, first Marquess of Buckingham (1753–1813), see Ingamells, p. 428. Jenkins told Townley that he would exchange his *Phocion* gem for antiquities from his catalogue to a value of £500 (BM, TY7/334).

29 Richard Temple-Nugent-Brydges-Chandos-Grenville, first Duke of Buckingham and Chandos (1776–1839) was created a duke to ensure his family's support for Lord Liverpool's administration. His son, the second Duke (1797–1861), had the same extended name. For their collecting activities, see the Stowe sale catalogue, August 1848. For the sale of further items, see Vermeule 1955, p. 147. The Braschi gems came from the family of Pius VI. Monsignor Capece Latro (1744–1836) was Minister of the Interior in Naples under Murat.

Purnell Bransby Purnell (1791–1866) of Stancombe, Gloucestershire, was a notable philanthropist whose collection of antiquities was sold at Sotheby's in May 1872.

30 For the purchases of Alexander Hamilton, tenth Duke of Hamilton (1767–1852), see Michaelis, pp. 300–01, Vermeule 1955, pp. 135–6, and A. A. Tait, 'The Duke of Hamilton's Palace', *Burlington Magazine*, cxxv, 1983, pp. 394–401. He was the son-in-law of William Beckford of Fonthill, who was a great collector of almost everything except ancient marbles, although he was tempted by Hamilton's vases and eventually bought some examples for his rooms in Bath after the sale of Fonthill.

George Granville, second Duke of Sutherland (1786–1861), acquired some Greek vases and a notable Greek female figure that was seriously damaged by exposure in the garden at Trentham (now in the British Museum), E. A. Gardiner, 'A Statue from an Attic Tomb', *Journal of Hellenic Studies*, xxviii. 1908, pp. 142–7. The Piranesi marbles from Trentham have recently been identified in the British Museum by Ian Jenkins.

For Wellington's busts, now moved to Stratfield Saye, see Michaelis pp. 429–31, and Vermeule 1956, p. 332.

31 For Queen Victoria at Osborne, see Guilding, *op. cit.* (n. 2.32), pp. 49–50, Michaelis, pp. 535–8, and Vermeule 1955, p. 144, and 1956, pp. 339–40.

32 For William Cavendish, sixth Duke of Devonshire (1790–1858), see J. Lees-Milne, *The Bachelor Duke*, 1991, pp. 23, 43–6, 57, 112 and 139, and R. Guilding, *Country Life*, cxcv, 2001, pp. 162–5. See also Michaelis, pp. 276–7, A. Furtwangler, 'Ancient Statues at Chatsworth House', *Journal of Hellenic Studies*, xxi, 1901, pp. 209–28, Vermeule 1955, p. 132, and 1956, pp. 325–6, and D. Boschung, H. von Hesberg and A. Linfert, *Die antiken Skulpturen in Chatsworth*, 1997. For his collection of modern sculpture, see J. Kenworthy Brown, 'A Ducal Patron of Sculptors', *Apollo*, xcvi, 1972, pp. 322–31. Whereas the duke paid £1500 for Canova's *Endymion*, he only needed to bid £105 for the so-called *Agrippina and her Daughter*, his most expensive purchase at

the Wanstead sale. The statue was illustrated by A. Montfaucon, *L'Antiquité expliquée*, supplement, iii, 1724. The marbles seem to have been acquired for Wanstead by Sir James Tylney Long (1736–1794), for whom, see Ingamells, p. 611.

The duke's *Handbook* is conveniently quoted in Duchess of Devonshire, *The House, a Portrait of Chatsworth*, 1982.

33 For the collections of Charles, eighth Lord Kinnaird (1780–1826) and George, ninth Lord Kinnaird (1807–1878), see Michaelis, pp. 648–58, Vermeule 1955, pp. 146–7, Poulsen, *op. cit.* (n. 2.22), pp. 23–5, 38, 52, 55–6, 63, 81, 86, 88–9 and 99, G. Waagen, *Galleries and Cabinets of Art*, 1857, pp. 445–8 and A. H. Millar, *The Historical Castles and Mansions of Scotland*, 1890, pp. 15–21. A visitor to Italy denied that Kinnaird 'had been exceedingly disappointed in his excavations' but only on the evidence of the antiquary, Carlo Avvolta, who had sold him some Etruscan artefacts (E. C. Hamilton Gray, *Tour of the Sepulchres of Etruria in 1839*, 1840, p. 219).

34 For the collection formerly at Lowther, see Michaelis, pp. 487–500, and Vermeule 1955, pp. 141–2, and 1959, pp. 334–5. The so-called *Diana*, acquired from Stowe, had originally been in Lord Egremont's collection. William Lowther, second Earl of Lonsdale (1787–1872), is the model for Lord Eskdale, the relaxed 'fixer' in Disraeli's *Coningsby* and *Tancred*. There is a charming sketch of Lonsdale, the hedonistic grandee, by Reginald Brett, Viscount Esher, *Cloud-capp'd Towers*, 1927, pp. 1–16.

Francis Charteris, eighth Earl of Wemyss (1772–1853), was another saleroom buyer at this time. He bought a head of *Bacchus* at the 1842 Strawberry Hill sale, when he acquired Horace Walpole's famous *Eagle*, now at Gosford, Michaelis, p. 486, as well as acquiring busts and vases at the Wanstead sale.

35 For James Clark, see Ingamells, pp. 208–9.

36 For A. Buck (1759–1833), see I. Jenkins, 'Adam Buck and the Vogue for Greek Vases', *Burlington Magazine*, cxxx, 1988, pp. 448–57.

The collections published belonged to Sir John Coghill (1766–1817), who had bought his in Italy, and to Sir Henry Englefield (1752–1822). The latter was a distinguished antiquarian, geologist and astronomer, who was appointed President of the Society of Antiquaries in 1811 on the death of the serving President but was not re-elected the following year because his Roman Catholicism and, more significantly, his appearance in a noted divorce case some years previously were held against him (B. Nurse, 'George Cruikshank's "The

Antiquarian Society"', 1812, and Sir Henry Charles Englefield', *Antiquaries Journal*, lxxx, 2000, pp. 316–21). Englefield bought many lots from Coghill's sale.

Samuel Rogers acquired his important collection of vases with the help of James Millingen (Michaelis, p. 154). Thomas Rowlandson, the satirical artist, was a rather surprising vase collector, *The Artist as a Portrait*, exh. cat., Fine Art Society, London, ed. R. Davids, 2000, p. 148. The plutocratic Robert Stayner Holford (1808–1892) acquired a large collection for display both at Dorchester House, London, and at his Gloucestershire seat, Westonbirt (Vermeule 1959, pp. 346–7). John Ruskin (1819–1900) also had a modest vase collection, sold at Sotheby's in June 1931.

37 For Knight's comments, see Liscombe, *op. cit.* (n. 6.47), pp. 606–7.

38 James Christie (1773–1831), son of the founder of the auctioneering firm, was elected to the Dilettanti Society in 1824. He also provided an essay on the *Villa Lante Vase* for the publication on the Woburn Abbey marbles, linking it to his pet subject, the Eleusinian Mysteries.

39 For Guy Head (1760–1800), see Ingamells, pp. 479–80. For his vases, see BM, TY1/15.

40 For the Winn collection, which was sold at Christie's in April 1975, see Vermeule 1959, pp. 339–41, and the Christie's catalogue which quotes the correspondence. In addition to abbé Campbell's collection, Winn seems to have bought a few specimens from one of the Mainwaring family of Lincolnshire. Somerset Lowry-Corry, second Earl of Belmore (1774–1841) acquired a number of Greek *stelae*, which passed to the British Museum on his death.

41 For the collection of Spencer Compton, second Marquess of Northampton (1790–1851), see Sir J. Beazley, 'Notes on the Vases in Castle Ashby', *Papers of the British School in Rome*, xi, 1929, pp. 1–29. For his views on the use of vases, see I. Jenkins, 'La Vente des vases Durand', p. 277, in *L'Anticomanie*, ed. A.-F. Laurens and K. Pomian, 1988. In 1840 he sold vases to the British Museum, of which he was a trustee. His collection was sold at Christie's, 2 July 1980.

For the vases in the Library at Charlecote, Warwickshire, bought by George Hammond Lucy (d. 1845), see Vermeule 1959, p. 149, *The Treasure Houses of Britain* (n. 2.30), pp. 313–14, and C. Wainwright, *The Romantic Interior*, 1989, pp. 215–40. Vases also appeared in the Gothick displays of Charles Tennyson d'Eyncourt's Bayons Manor (M. Girouard, *The Victorian Country House*, 1979, p. 108). For another typical

display of *c*.1850, see the vases acquired in Italy by the Reverend Walter Davenport Bromley (1787–1862) in the Library at Wootton Hall, Staffordshire (J. Cornforth, *English Interiors 1790–1848*, 1978, p. 117). Some of them were transferred to Capesthorne, Cheshire (Vermeule 1959, pp. 146–9, which also lists the marbles acquired at the same period).

See also the vases on top of display cases in the view of Sir Richard Westmacott's Study (N. Penny, 'The Sculpture of Sir Richard Westmacott', *Apollo*, cii, August 1975, pp. 120–27).

Charles Eyre of Hallingbury Place, Essex (d. 1855), also acquired a few good vases on a Tour in the 1830s.

42 Hamilton Gray, *op. cit.* (n. 8.33).

G. Dennis, *The Cities and Cemeteries of Etruria*, 1848. For the link with Byres, see i, pp. 316–17. The fact that the plates of Byres's *Hypogaei*, a work on Etruscan tombs, were published in 1842, twenty-five years after his death, is a further indication of interest in the subject.

Although the trustees of the British Museum turned down the chance of buying the collection of Lucien Bonaparte, because the price of £7000 was considered too high, they later bought a selection of vases from the Princess of Canino for £515.

43 A. H. Smith, 'Greek Vases', *The Connoisseur*, ii, 1902, pp. 239–44. In an article a few months later, iv, 1902, p. 24, the collector Philip Nelson warned against collecting marbles because of the frequency of forgeries.

Part of the collection of Alexander Fuller Acland Hood, first Lord St Audries (1853–1917), was sold by Sotheby's in July 1925. For the collection of Cecil Baring, third Lord Revelstoke (1864–1934), much of it acquired in the salerooms, see Vermeule 1959, pp. 330–31. It was sold at Puttick and Simpson in April 1935.

Lord Leverhulme bought vases for his museum at the Hope sale and Sir Frederick Cook and Lord Melchett also owned a few vases, see nn. 57, 55 and 58 below. For the vases collected by Sir Henry Wellcome (1853–1936) for his medical museum, see Vermeule 1959, p. 334.

44 For the collection of S. Poniatowski (1754–1833), some of whose gems were bought by the Duke of Wellinton, John Tyrrell and Lord Monson, see A. Busiri Vici, *I Poniatowski e Roma*, 1971, pp. 313–23. A catalogue with photographic illustrations, remarkable for the period, was issued after Tyrrell's death (J. Prendeville, *Photographic Facsimiles of the Ancient Gems formerly possessed by . . . Prince Poniatowski*, 1857–9).

For some of the gem collections made by later nineteenth-century travellers, including the Reverend G. F. Nott, E. Waterton, the Reverend C. W. King and the Reverend S. S. Lewis (the latter now at Corpus Christi College, Cambridge), see Scarisbrick, *op. cit.* (n. 1.51), pp. xix–xx.

For anxiety about fakes, see M. J. Tyszkiewicz, *Memories of an Old Collector*, 1898, *passim*. He died in 1897.

Modern gems were fed to turkeys mixed with grit so that the polished surfaces could be gently scuffed by the digestive processes in the craw. J. H. Middleton, *The Engraved Gems of Classical Times*, 1891, p. 101.

45 For Joseph Mayer, see *Joseph Mayer of Liverpool 1803–1886*, ed. M. Gibson and S. M. Wright, 1988. Other buyers at the Hertz sale included Matthew Uzielli, whose collection was sold in 1861, W. H. Forman, Sir Gardiner Wilkinson, the Egyptologist, who left his collection to Harrow School, J. C. Robinson and the Duke of Northumberland, who was adding to the Beverley Gems.

Despite the Poniatowski affair, in 1866 the British Museum bought the collection of the ducs de Blacas, which contained some notable gems, as well as the great Esquiline silver toilet set. At this period it also benefited by the acquisition of the bronzes, vases and other small objects collected by Sir William Temple (1788–1856) when ambassador in Naples, the antique glass of Felix Slade (1790–1868) who endowed the Slade professorships and scholarships, and the coin collection of John Rushout, second Lord Northwick (1770–1859), who gave up 'his whole time to it from morning to night' (Ingamells, pp. 829–30). The quality of Northwick's collection is indicated by G. H. Noehden, *Specimens of Ancient Coins of Magna Graecia and Sicily selected from the Cabinet of the Right Hon. The Lord Northwick*, 1826. For his collecting of coins and gems, see O. Bradbury and N. Penny, 'The Picture Collecting of Lord Northwick', *Burlington Magazine*, cxliv, 2002, pp. 488–9.

46 D. Scarisbrick, 'The Devonshire Parure', *Archaeologia*, cviii, 1986, pp. 239–54.

47 For the gems bought by Arthur Wellesley, second Duke of Wellington (1807–1884), see D. Scarisbrick, *The Wellington Gems*, catalogue of the sale by S. J. Phillips, 1977, and J. Lees-Milne, *Prophesying Peace*, 1995, p. 303.

48 For later gem collections, see Scarisbrick, *op. cit.* (n. 1.51), pp. xx–xxi. For Sir Arthur Evans (1851–1941), see J. Evans, *Time and Chance: The*

Story of Arthur Evans and his Forebears, 1943. For the gems of James Carnegie, ninth Earl of Southesk (1827–1905), whose mother was the daughter of the antiquary and topographer Daniel Lysons, see H. Carnegie (ed.), *Catalogue of the Collection of Antique Gems formed by James ninth Earl of Southesk*, 1908. His collection, which he began in 1878, was mostly formed at sales in London and Paris; it was sold by Spinks in the late 1950s. For Constantine Alexander Ionides (1833–1900) and his son, Alexander Constantine Ionides (1862–1931), see J. Boardman, *Engraved Gems, the Ionides Collection*, 1968, and M. Evans, 'Blake, Calvert – and Palmer? The Album of Alexander Constantine Ionides', *Burlington Magazine*, cxliv, 2002, pp. 539–49; another member of the family, Alexander Alexander Ionides (1840–98), was an early collector of Tanagra figurines; the family collected Greek vases as well. For Ralph Harari (1893–1969), see J. Boardman and D. Scarisbrick, *The Ralph Harari Collection of Finger Rings*, 1977. The collection of George Spencer Churchill (1876–1964) was sold at Christie's in December 1965. He acquired a few fine gems himself, the collection of his ancestor the second Lord Northwick (which included many Poniatowski pieces) having been sold in 1859. He also bought vases, some of which he left to the Ashmolean, and other minor antiquities (Vermeule 1959, p. 339). The great Marlborough collection was catalogued in 1870 and was sold five years later for £36,750 to David Bromilow of Battlesden, Bedfordshire. It was dispersed by Christie's in June 1899. The catalogue was prepared by Mervyn Story-Maskelyne (1823–1911), a distinguished mineralogist, who served both Oxford University and the British Museum and himself owned a gem collection, sold at Sotheby's in July 1921.

Albert Denison, first Lord Londesborough (1805–1860), owned some classical pieces, including an Etruscan gold wreath that had belonged to Lucien Bonaparte, in his collection of antique jewellery. It was sold together with a few marbles at Christie's in May 1884.

49 For attitudes towards nudity in Victorian art, see *Exposed*, exh. cat., Tate Gallery, London, ed. A. Smith, 2001. For J. Neeld (d. 1856), see Christie's sale catalogue 22 September 1966.

50 For 'the impression that it is both ungodly and unmanly to be a virtuoso', see Girouard, *op. cit.* (n. 8.41), p. 15; the lack of antiquities displayed in almost all the Victorian country houses illustrated in this book indicates how thoroughly antique marbles had fallen out of fashion. For the taste for Olde England, see P. Mandler, *The Fall and Rise of the Stately Home*, 1997, pp. 21–69.

Michaelis, p. 179, quoting Ferencz Pulszky.

51 A. Michaelis (1835–1910) first visited England in 1861, when he devoted his attention to the British Museum and Lansdowne House. Subsequent visits were made to collections outside London in 1873 and 1877, Castle Howard being the only major gallery that he failed to visit.

Michaelis, pp. 181–2.

52 For the exhibitions of the Burlington Fine Arts Club, see F. Haskell, *The Ephemeral Museum*, 2000, pp. 93–7. For later collections, unmentioned by Michaelis, all comparatively minor, see E. Strong, 'Antiques in the Collection of Sir Frederick Cook Bart.', *Journal of Hellenic Studies*, xxviii, 1908, p. 1, n. 1.

53 William Waldorf Astor, first Viscount Astor (1848–1919), took British citizenship in 1899. For his work at Hever, see C. Aslet, *The Last Country Houses*, 1982, pp. 190–98 and 302, and for his collection, D. Strong, 'Some Unknown Classical Sculpture', *Connoisseur*, clviii, 1965, pp. 215–25. A few other marbles were located at Cliveden. Most of the collection was transferred to England in 1907 but a few pieces were brought over from Astor's villa in Sorrento in 1919 after his death. For one of his more important antiquities, a relief that may have come from the Arch of Claudius in Rome, see *The Treasure Houses of Britain, op. cit.* (n. 2.30), pp. 296–7.

Another American collector should be mentioned. Edward Perry Warren (1860–1928), who came to live at Lewes House, Sussex, collected classical antiquities, including gems and erotica, some noted fakes and Rodin's *The Kiss* (D. Sox, *Bachelors of Art*, 1991).

54 For the collection of John, first Lord Savile (1818–1896), see Vermeule 1955, p. 138. The terra cottas of Frederick Temple, first Marquess of Dufferin and Ava (1826–1902), seem to be unpublished.

55 For the collection of Sir Francis Cook, first Baronet (1817–1901), see Michaelis, pp. 619–43, Strong, *op. cit.* (n. 8.52), pp. 1–45, and Vermeule 1955, pp. 133–4, and 1956, pp. 326–7.

56 For the Hope sale, see Waywell, *op. cit.* (n. 8.6), pp. 64–6. Apart from the Duke of Newcastle, who bought a few lots out of family piety, the vendor being his younger brother, Wilfred Ashley of Broadlands was the only owner of an old collection to buy at the Deepdene sale. No British institution tried to acquire any marbles or vases.

57 For the collection of William Hesketh Lever, first Viscount Leverhulme (1851–1925) see

Waywell, *op. cit.* (n. 8.6), pp. 17–18, and for the Greek vases that he bought from the Hope, Ionides and Sutherland collections see M. Robertson, *Greek, Etruscan and Roman Vases in the Lady Lever Gallery, Port Sunlight*, 1987. For the collection of marbles formed by Sir Henry Wellcome, see Vermeule 1959, pp. 332–4.

58 For the collection of Alfred Moritz Mond, first Lord Melchett (1868–1930), see E. Strong, *Catalogue of the Greek & Roman Antiques in the Possession of . . . Lord Melchett*, 1928, and Vermeule 1956, pp. 337–9. His brother, Sir Robert Ludwig Mond (1867–1938), was a distinguished Egyptologist. Their parents were close friends of Henriette Hertz (1846–1913), see *Neue deutsche Biographie*, 1969, 8, pp. 714–15.

59 Weetman Dickenson Pearson, first Viscount Cowdray (1856–1927), had a large country house at Paddockhurst, Sussex. The four busts, which include the *Nero* from the Hamilton collection, are now in the Royal Ontario Museum.

60 The prices at the Lansdowne House sale were less than those achieved at the Hope sale thirteen years earlier, although the quality was generally higher. The most expensive item was the *Young Hercules*, now in the Getty Museum, at £4830, while the *Cincinnatus* fetched £2100, the *Mercury* £1575, the *Wounded Amazon* £2835 and a *Diana* £2205. The *Diomedes* was unsold at £714.

61 *Country Life*, cxii, 1952, pp. 1575–6.

62 Michaelis had been preceded by another German, G. F. Waagen, whose *Treasures of Art in Great Britain*, 1854–7, catalogued the paintings in the principal British collections over a period of some twenty years in the middle of the nineteenth century and mentioned some of the main galleries of antiquities as well.

Index

Photograph Credits